"An Education in Rebellion: The Biography of Nikki Sixx"

by Jake Brown

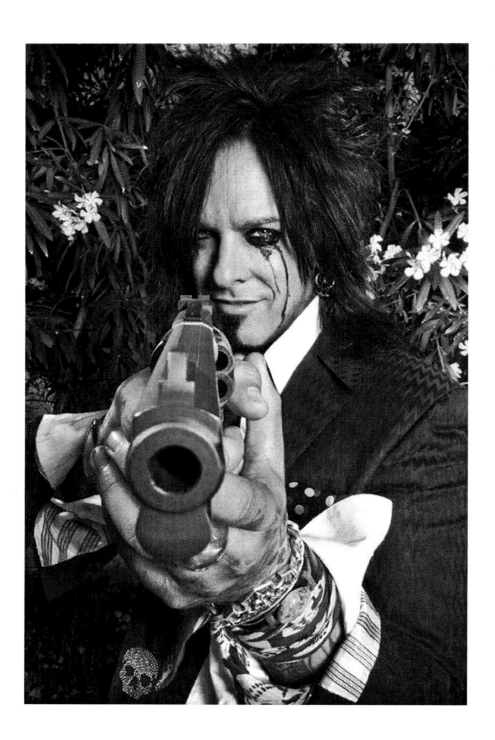

"An Education in Rebellion: The Biography of Nikki Sixx" by Jake Brown

Published by:
Rock 'N' Roll Books
Nashville, TN
rocknrollbooks@yahoo.com
www.rocknrollbooks.com
Distributed by SCB Distributors
www.scbdistributors.com

(Originally Published in 2002 by Black Market Publishing;
Re-issued by Rock 'N' Roll Books, Copyright 2010.)

ALL RIGHTS RESERVED

No part of this book may be reproduced or transmitted in any form or by any means- electronic or mechanical, including photocopying, recording, or by any other information storage or retrieval system without written permission from the authors, except for the inclusion or brief quotation in a review.

The Publication is designed to provide accurate and authoritative information in regard to the subject matter covered. It is sold with the understanding that the Publisher is not engaged in rendering legal, accounting, or other professional services. If legal advice or other expert assistance is required, the services of a competent professional should be sought.

Rock N' Roll Books titles are available at special discounts for bulk purchases, sales promotions, fund raising or educational purposes.

Copyright 2010 by Jake Brown and Rock N' Roll Books
Associate Publishers: Michael R. Wolters; David Wakefield, Alex Wakefield and Deanna Wakefield; and Samuel D. Sacco.

Cover Photo/Design by Katherine Sandalls
Layout/Design by Byju M. Devan

Library of Congress Cataloging in Publication Date Available
ISBN: 0-9726142-5-7

First Printing, December, 2002;
Second Printing, May 2010

Dedication: As in 2002, this book is still dedicated to my brother, Joshua T. Brown, only with an even higher level of admiration for everything you've accomplished in the last 10 years!

Project Thanks: First and foremost to Nikki Sixx for inspiring this book and most of all, thank you for getting my favorite band back together; to Shaun Pollitt for supporting this book for so many years via Swagrox.com, Nikkisixx.net, and the other sites you (w/Sixx's blessing) sold this book on when it was out of print; to the following artists whose exclusive interviews helped to round out this remarkable story, including Bob Timmons (R.I.P.), Kevin Dubrow (R.I.P.), Lita Ford, Bob Rock, Tommy Lee, James Michael, John Corabi, Tom Werman, Neil Zlozower, Scott Humphrey, Lonn Friend, Lizzy Grey, John Purdell, Michael Hannon, Dave Darling, and any and everyone else who contributed to this book kicking as much ass as possible; to Katherine Sandalls for designing the AMAZING new cover; and to Byju M. Devan for designing the new layout; to Paul Miles for keeping Chronological Crue going and being a consistently excellent source of reference on everything Crue; to Andrew at Melodicrock.com for supporting this book over the years, as well as to Blabbermouth.net, Cheryl Hoahing at Metal Edge Magazine, Kevin at Antimusic.com, the Rock & Roll Report, and 'Metal' Tim Henderson at Brave Words/Bloody Knuckles for all doing the same; and finally to all the bands who participated in the Bonus Sampler, reflecting the new Millennium generation of bands who grew up on the songs of Nikki Sixx (Bios available in back of book)! Perhaps most importantly, a VERY VERY special thanks to Sean Peace and David Prohaska at Songvest.com, without whom this book would NOT have been released! Finally, to our 'Associate Publishers' who played an equally as important role to that end: Michael R. Wolters; David Wakefield, Alex Wakefield and Deanna Wakefield; and Samuel D. Sacco.

Personal Thank Yous: to my wonderful parents, James and Christina Brown, my brother Sgt. Joshua 'Jerry' Brown (RET!!!), congrats on K-9 Catalyst!, the extended Brown and Thieme families; Alex and Jackson Schuchard; Andrew and Sarah McDermott; Chris Ellauri (Ongking.com!); Sean and Amy Fillinich; Richard, Lisa and Regan Kendrick; Paul and Helen; Adam 'The Skipper' Perri; Matt and Eileen Pietz, congrats on the little one; Tim Woolsey; Penelope Ellis; Reed Gibbons; Alexandra 'The Clown' Federov (Welcome to New Orleans!!); Aaron 'DJ Whippit'

Harmon for getting me back in the studio!; The entire Conspiracy Channel cast; to my bandmates Rose Reiter and Alex Schuchard (www.myspace.com/projectjaxon); Ed Seamen, Rachel, Dave, Larry, Burt Goldstein and everyone else at MVD/Big Daddy Music Distribution who keep Versailles Records' product out there in stores; my atty/marketing guru, John Lavallo (www.takeoutmarketing.com); my lit. rep. Al Longden (thank you for all your hard work placing Jasmin's book!); Harry Slash; Tony & Yvonne Rose and everyone else at my long-time US publisher Amber Books for everything you've always done and continue to do to support my career, please get well soon (Tony); Jack David, David, Crissy, Simon, and everyone at ECW Press who have supported the advancement of my writing career with your publication of 'Heart: in the Studio, (Authorized)' 'Rick Rubin: in the Studio,' and forthcoming 'Tori Amos: in the Studio'; Kurt and Cris Kirkwood for 'Meat Puppets: in the Studio' (In Stores June, 2011!!); Lemmy Kilmister, Lucian and everyone at John Blake Publishing Co. involved in the publishing of 'Motorhead: in the Studio'; Aaron, Gabriel, and everyone at Rock 'N' Roll Books' distributor SCB Distribution; Ben Ohmart and everyone at BearManor Media; Jasmin St. Claire/Rhea, can't wait for the book to be out in 2010- its been a blast!!; and to my man Tracii Guns, thanks again for trusting me to put your life story to page w/you, a real privledge!

Table of Contents

Chapter 1	London Calling…The Demise of Frank Carlton Feranna and Birth of Nikki Sixx	
Chapter 2	In the Beginning…	
Chapter 3	*Shout at the Devil*	
Chapter 4	The Metal Years	
Chapter 5	*Theatre of Pain*	
Chapter 6	Wild Side	
Chapter 7	*Girls, Girls, Girls*	
Chapter 8	Highway to Hell…	
Chapter 9	All My Heroes are Dead Now	
Chapter 10	*Dr. Feelgood*	
Chapter 11	"Matthew Trippe"	
Chapter 12	The End of a Decade, & Doc McGhee..and VINCE NEIL!!!	
Chapter 13	Hooligan's Holiday	
Chapter 14	The Exit of John Corabi / Return of Vince Neil	
Chapter 15	*Generation Swine*	
Chapter 16	*58*	
Chapter 17	The Decline of Grunge and Second Coming of Mötley Crüe	
Chapter 18	Rodeo	
Chapter 19	Maximum Rock	
Chapter 20	Confessions	
Chapter 21	Lessons in Letting Go	
Chapter 22	The Brides of Destruction	
Chapter 23	2003	
Chapter 24	2004	
Chapter 25	Motley Crue is Back!!	
Chapter 26	Carnival of Sins	
Chapter 27	The Royal Underground	
Chapter 28	*The Heroin Diaries*	
Chapter 29	*The Saints of Los Angeles* Head Out On Cruefest!	
Chapter 30	2009 and Beyond…	
Conclusion	A Star in Rock 'N' Roll's Sky…	

Chapter 1

London Calling…
The Demise of Frank Carlton Serafino Ferrana, Jr. and Birth of Nikki Sixx

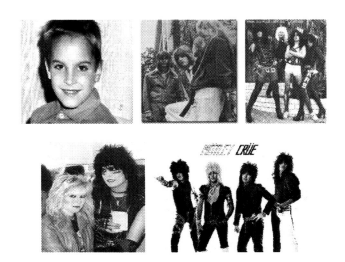

When Nikki Sixx first arrived in Hollywood, California, he was a mess- messy hair, messy mascara, messy clothes, messy attitude- a messy life. All because he didn't give a fuck, with the exception of one neatly kept goal that ultimately made his seemingly messy self look cool, and gave his life some sense of purpose- rock and roll. Nikki's name at the time was Frank Carlton Serafino Ferrana, Jr., and with the exception of two loving grandparents who had largely reared him in the course of his early formative years, he had been the product of several broken homes in the course of his seventeen years on what had been a brutal earth.

Hollywood's seedy underground was no brighter, but there the shadows were more deliberate, the creatures that stirred within were all freaks out of the same horror movie. The greater world's rejection was their basis for acceptance. And Nikki Sixx fit right in.

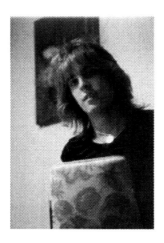

Historically, many of pop culture's greatest heroes, particularly its rock stars, started out as societal rejects, small town outcasts who were preyed upon by local police; bullied by jocks; ignored or abused by disapproving parents; written off by conservative, bible-belt teachers and preachers; and driven out of their suburban hell by a common, desperate angst. That angst led to outlets like rock and roll music and the dream of being something bigger than small town America was capable of offering, let alone accepting. Hollywood to such small-minded people was like a graveyard at night, a place they would never step foot, where only the bad boys would roam. As Perry Farrell, who like Nikki Sixx had come to Hollywood to escape small town rejection, had written in 'Whores', an ode to the sense of belonging offered in Hollywood's gutters, "Way down low where the streets are littered, I find my fun with the freaks and the niggers…I love whores cause they never judge you…(and) they take their chances if they get 'em." To that end, when Frank Feranna started out in Hollywood in late 1978, he was in effect starting his life over, only in an environment where instead of having nothing to gain by being anarchical, he instead had nothing to lose, "coming to LA was my way of starting over. And I had my guitar, and I had my dream, and I thought I would learn my lessons."

On the Sunset Strip in Hollywood, even as a societal throwaway, Nikki Sixx had immediate star potential. As Lita Ford recalled their first meeting in describing Nikki, "we met at a club, it was the Troubadour I believe, and I was sitting at a table with some girlfriends, I don't know how the subject came up, but we we're talking about guys, and someone said to me, 'Well, what kind of guy do you like Lita? What do you look for in a guy?' And I looked over and saw Nikki...and I said to my friends, 'Oh, I like someone like that!' Kind of, you know, messy and scruffy, and looks like they just got out of jail. Women seem to go for the bad guy, I don't know what it is...His clothes looked like they had been borrowed from everybody, they didn't fit him right, they were all second hand clothes, and his hair was all messed up. He was, just pretty much tattered and lost. But he had still then, he still had this certain aura about him that was special."

"While making the rounds at the Starwood (a now defunct Hollywood den of iniquity wherein young rock cocks...could score indefinite amounts of free drinks, free drugs, and free sex)," remembers former band mate Lizzie Grey in describing the Hollywood scene prior to 1978 and his meeting Frank Feranna and forming London, "I ran into a seasoned Hollywood dog named Blackie (Lawless, who would go on to front WASP in the 1980s), who had already made a bit of a name for himself as the front man for shock-rock staple Sister, complete with an Elvira-esque stage show of fire, skulls, smoke, swords, and oh yes, live night crawlers (worms) which were swallowed alive and wiggling by the Blackster. Besides turning stomachs, it gave him a bit of a reputation, which was why I approached him in the first place." Lizzie Grey, born Steven Perry, was raised in the San Fernando Valley, which may as well have been Lafayette, Indiana, or any other Midwest wasteland that shunned dreamers, and drove them all toward the same City of Angels where dreams at least held a peripheral inkling of hope for coming true. If nothing else, Hollywood-dominated Los Angeles provided at least a place where it was a lot cooler to be a fuck up than the Bible belt, or typical conservative community equivalent. As Lizzie remembers, he began as just another "kid from the Valley...enthralled by the whole Hollywood scene, and would have been content to be playing just about any kind of music, as long as the guitars were loud and the fans were screaming."

After tooling around with a generation-too-early grunge band, Tear Garden, bent on a "manic depressive binge that would make Nico seem like Shirley Temple", Lizzie upped his ambitious ante by working his way into Blackie Lawless's new, nameless outlet, where by way of Los Angeles' constellation maker, the Recycler (a legendary and virtually free dream seeker's yellow pages, catering to all imaginable facets of the entertainment industry, notably including a musician's free posting section), London would be born. As Lizzie recalled, "we started rehearsing together in a run down hole of a studio on Gower St. with some drummer (Blackie) had found under a dumpster somewhere, as Blackie took on the role of bass player/vocalist. I told him that he should simply be a front man, and forget about being Gene Simmons...(and) the search for a bassist with 'star quality', as Blackie put it, was on, and eventually led to a response from the Recycler classifieds from a spikey-haired wanna-be-John Waite looking guy named Frank Feranna."

(from left to right)
Nikki Sixx, Michael White, Dane Rage & Lizzie Grey

(Nikki & Blackie Lawless in late 70s)

In an almost immediate clash of ego between Frank Feranna and Blackie Lawless, while Lizzie recalled Nikki being "one hell of a partier and an absolute blast to be in band mates with", his musical chops fell immediately short of Blackie Lawless's liking. The disdain came to the surface when the band went into the studio to cut their first demo, where, as Lizzie recalled, because "Blackie couldn't stand his bass playing... we went into some funky studio in the South Bay to record a demo, and it was only moments after the tape reels had stopped spinning that Blackie wisked his finger through the air and booted both Frank and the nameless drummer-guy from the band."

Blackie Lawless wasn't the only rock and roll rival to write Nikki Sixx off in his earliest days in Hollywood. As another Hollywood hard rock veteran, Quiet Riot singer Kevin Dubrow recalled the time Nikki Sixx tried out for Quiet Riot prior to forming London, even Metal Guitar legend Randy Rhodes, at the time Quiet Riot's lead guitarist prior to joining forces with Ozzy Osbourne, dismissed Nikki's musical abilities at a time when he was still in the earliest stages of searching out his own rock and roll pulse, "Nikki Sixx used to come see Quiet Riot when we played the Starwood with Randy Rhodes in the 70s, we started playing the Starwood in 1975. I met him as I used to hang out at the Starwood, as did everyone else. He came up to me a number of times, just the nicest guy there was, said he was a bass player, and that he understood what we were trying to do, because we were the only band doing what we were doing at that time. You didn't really have a name for it, it was sort of glamish, but

he got it, and we became friends just by him coming to hang out and see us. What happened then was, in June of 1978, Kelly left Quiet Riot, and we did our last show with him at the Santa Monica Civic opening for a band called Angel, and then we needed to find a bass player to replace him, and of course …Frank, who I had seen all over the place, I knew he was a great looking guy, had just the right attitude, a very, very nice guy. So I arranged for him to do an audition with us."

Continuing, Dubrow recalled that "at the time we were rehearsing in somebody's converted garage in Burbank, California, and it wasn't what you would call all that impressive. So he came down, and he had blonde hair at the time, or very light brown, and he always reminded me of Shawn Cassidy, I mean, he looked like a pop star. And I introduced him to Randy Rhodes, and the song we had him learn was Killer Girls, which was off the second Quiet Riot Japanese record, and we sat down, and Randy was going to show it to him, and Randy says to him, 'Well, its in the key of F.' And Nikki says 'Where's F?' So, everyone knew Randy was a guitar teacher, so he says 'Its here', and he starts to show him the riff, and he… as nice of a guy as he was, and as great looking as he was, he couldn't play the instrument. I mean, he just hadn't learned it yet. So, Randy takes me outside and says to me 'Don't do this to me. He doesn't know the names of the notes on the neck.' I said, 'He's a really nice guy, he looks great…' Randy said 'I don't want to go through this again, at least we should get someone who's better than Kelly, I mean, he's a really nice guy, he's good looking and stuff, but he doesn't know how to play the instrument at all.' I said 'Ah fuck.' I was a little embarrassed, I assumed he knew more about the instrument than he did. The next time I saw Nikki, he had put the band London together, and had dyed his hair black."

Sixx took the dismissals in stride, recalling that "I was thinking about sitting in Kevin's Apt in 1979…I had just been over to Randy Rhoades (Who still lived with his Mom at the time) Learning some of their songs…Randy called Kevin while I was there and told him they should get me to be the bass player in Quiet Riot. I passed…Cause we all had a destiny…Today is a sad day….He always did what he loved most, Music and always said what was on his mind….And that is the measure of a man….He will be missed….I'm grateful to have those early memories…. Before the fame…Just kids with dreams." Confident enough in his own early sensibilities as a visionary to see the dark times for the

glitter, shortly thereafter the Quiet Riot rejection, Nikki teamed up with Lizzy Grey to venture down their own musical path, leading along the way to the beginning of Nikki Sixx, London, and ultimately the next step toward Mötley Crüe. In essence, Nikki couldn't realize his own potential playing anyone else's music, leaving him with no other choice but to helm his own band, playing his own songs. In retrospect, almost-band mate Kevin Dubrow has agreed with this assessment, reflecting that "when he tried out for Quiet Riot, he was still searching…I think what it was is, he wasn't a good enough musician to join some else's band as a bass player, so the only way he was going to crack it was on his own. I think pretty much that hits it on the head….Nikki didn't have the chops or the musical ability to get a job as a bass player in someone else's group, he was only going to make it if he formed his own band around people like himself. And that's what he did with London, and then with Mötley Crüe."

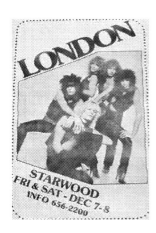

London was the perfect experimental atmosphere for Nikki to hone a combination of his punk musical influence, appetite for debauchery-laden showmanship, and still-rough-around-the-edges songwriting skill into a potent formula that would translate into an almost instantaneous explosion of local superstardom. Lizzie's instinctive departure from Lawless's company for Sixx's served as the catalyst for the band's birth, beginning when Lizzie grew frustrated with Blackie's "firing frenzy, (whereafter)…about a day or two… I went over to Frank's house (he was living with a raunchy punk band called the Vidiots), and…told him Blackie was an asshole, and that Frank and I should start up a band together, a

glitter band, a band that would put the New York Dolls, The Sweet, Kiss, and about any rock and roller who ever donned a pair of high heels to shame. Shortly thereafter, we were busy shopping for stage clothes at Frederick's of Hollywood, and Frank decided he needed a new moniker…So Frank Feranna became Nikki Sixx (I think he stole the name from some former boyfriend of his girlfriend Angie's)…After several member changes, and endless searches through the Recycler, we managed to pull together a pretty strong group that included Nikki on bass, John St. John on keyboards, Dane Rage on drums, Henri Valentine on vocals, and myself as guitarist, and we called ourselves London. We knew exactly what and who our influences were, so it made a ton of sense…to us." Through a combination power punk pop, flamboyant looks, pyromania, and just plain old cool, London became almost an overnight staple on Hollywood's fledgling hard rock scene in mid 1978. The true catalyst for the band's instant success came via one of Hollywood's hottest clubs, The Starwood, where, as Lizzie recalls, "a few strong shows at the Starwood made us an instant draw, and shortly thereafter the extremely gay management…made a move (in more ways than one, although we remained hereto to a fault) on the band, and we were on our way to being the house band at the most happening club in Hollywood."

 Part of Frank Feranna's transition into Nikki Sixx implied an opportunity to leave behind the identity of a painful childhood, allowing Frank to start over as Nikki in a place where time had no memory, and raced at the pace speed might through Hollywood's ambitiously pumping veins. Of the decision, Sixx recalled that "I used to date this girl, Angie Saxon. I was going through her scrapbook and I saw a guy that she used to date named Niki Syxx in a band called Jon & the Nightriders. So I stole his name. I just liked it." Nikki Sixx became the times, and had no trouble keeping up, as he finally had found a place in a band where he helped define the trend of what was cool. Most importantly, London gave Nikki an opportunity to become someone who hundreds of rock hungry fans looked up to night after night, helping to round out Nikki Sixx's identity as a rock star in the making. He had always known his calling, and finally that was crying out for him. Whether girls or record company A&R men, London had quickly become Hollywood's hottest draw, such that, as Lizzie remembers, "with Nikki and I collaborating on the majority of (London's) glitter/punk/pop material, we rose through the ranks of Hollywood stardom and even acquired former Mott the Hoople front man Nigel

Benjamin as lead vocalist...In 1979, and through early 1980, the band was selling out weekend shows at the Starwood, and we had increased our stage show into a massive New Year's Eve ball kind of affair, complete with balloons, lighted Go-Go boxes, confetti, and smoke. It was The Rocky Horror Picture Show meets The Sweet...The likes of Mick Jagger and Keith Richards even made it to our shows!...The band had all the coke, drinks, and teen-queen sluts we could handle, but we wanted more. We wanted to be ROCK STARS. We wanted a HIT RECORD."

Despite the band's desires for a record deal, their main attraction was the live show that Nikki almost single-handedly assembled, and which in the eyes of many onlookers at the time was more dazzling then the band's music ever had potential for being. To that end, Nikki spent much of his time in London honing his skills as a showman, cultivating his rock star image to the point where the difference between a great live show and the quality of the band's material wasn't that important, as most were too dizzy from the scene surrounding London at the time to care. As Kevin Dubrow remembered from his days as a young rocker on the Sunset Strip, the Starwood was one of Hollywood's hottest night clubs to hang out at, and London benefited richly from the club's popularity as its house band, "I remember when Nikki formed London, we went and saw them, and they

were what they were. They were what they were…They were terrible…Lizzy Grey had the worst guitar sound on the living planet. The worst guitar sound I have ever fucking heard. It was just trash…They were just awful…They (made it) because they drew people. Nikki had the same kind of idea that he had for Mötley, it was the whole big make up and funny clothes.Based on the New York Dolls. There was nothing around Hollywood like that. He hit on, they were glamorous, got a lot of girls, but they were terrible musically…Starwood (the club they played), was a great place too. I used to go there all the time. The guy who booked the place was also Quiet Riot's manager, David Forest. The guy who had the people in the Wonderland Murders killed owned the Starwood, Eddie Nash. He owned the Starwood and two other clubs. But the Starwood was great because it was a huge complex, it had the big room where the bands played, it dates back to the 60s when it was called PJs, when the house act was Trinnie Lopez. The big concert room had a downstairs and an upstairs with 3 bars, it was a nice big stage, better than a lot of clubs we play now. There was a hallway that went to a back part of the club that had another bar, with an area where they sold jewelry, and had clothing. Then they had a whole other dance area on the other side, where there used to be a second band, but they turned it into a whole dance floor…The dressing rooms had offices, it was like a big entertainment complex. This is the 70s…when Quaaludes made you want to fuck everybody. That was the days when there was just more pussy, and it was just so easy to get, it was just the greatest, me and Randy Rhodes just used to live there. I just loved it."

As with most bands who achieved a certain level of live success on the Sunset Strip during the late 1970s and early 1980s, record company vultures eventually came circling around London. Unfortunately, for any number of indeterminable reasons, the band were almost too popular for their own good within local circles to ever translate into a signed entity with a major label. This may have been attributable to the large populous of egos within London's inner member circle, or perhaps it was the band's management's big head that cost the boys their shot. The latter explanation is the one favored by guitarist Lizzie Grey, wherein "I'll never forget near the end when Bud Scoppa, then from Arista Records, came up to us at The Starwood and said he wanted this Hollywood sensation London on his label. David Forrest, part of the club's management team, laughed at him and said 'You better have a million dollars to sign these guys, or

forget it.' Well, he forgot it, as eventually did the rest of the labels." Perhaps the lack of label interest to match the band's Sunset strip popularity allowed Nikki to draw a conclusion that the band's chances for a nationwide translation of their cult success were not credible? More likely, however, Nikki held a singular musical vision, that, while honed in London, could not be achieved with so many collaborators guiding its maturity. As he had earlier clashed with Blackie Lawless, and later with his own London band mates, which Lizzie remembers namely consisting of "internal strife between Nigel Benjamin and Nikki...and as we continued the quick fall from grace...a final conflict (between) drummer Dane and Nikki."

Sixx, in order to realize the vision of Mötley Crüe, needed to be the sole author of his band's sound and image, with limited collaboration to distract his direction. By Nikki's own estimation, he did not have time for a band preoccupied by creative infighting, no matter their commercial potential. In the musicians that became Mötley Crüe, Nikki found a perfect combination of an immensely talented but grossly (and appropriately, as he was only 17) immature and hyperactive drummer named Tommy Lee, a solid but insecure lead guitar player named Mick Mars, and a charismatic front man whose strengths were more in his showmanship and prowess than natural (though unique) vocal ability, Vince Neil. All had three principle components to their collective chemistry that allowed Nikki to remain creatively the most electric ingredient. First and foremost, their live blending was potent, a perfect coupling of sexual, energetic bright and decadently dark colors and sounds that eclipsed anything else Hollywood had to offer in 1981, coupled with the wisdom of their collective instinct to entrust to Nikki the responsibility for authoring band's entire song catalog and the majority of their stage show.

Girlfriend Lita Ford remembered in the band's earliest days that "Nikki was absolutely the leader of the group. He would help Mick with his guitar parts, such that he would almost write the guitar parts for Mick. He helped Mick so much. I think that if Nikki hadn't been around, Mick wouldn't have gotten up out of bed. I don't mean to stir the shit, but that was pretty much what happened with Nikki (and Mötley). Nikki believed in Mick, and created Mick. Nikki created all of Mötley Crüe. He helped Mick with guitar riffs, he helped Vince with his voice, he wrote all the raps for all the shows, Nikki did, even though he wasn't the one saying it. Vince was the one saying the raps, but Nikki created all that stuff. He would take

him into rehearsals, and write everything out for Vince. He'd say 'Here, this is what I want you to say after this song. If it doesn't work, and you don't say it right, then we're going to re-write it, and we're going to do it again, we're going to put it somewhere else in the set.' Nikki was the one with all the theatrical ideas, bringing in the blood, and mannequins, and fire…It was his whole life, he never gave a shit about nothing else. That was everything. His whole, living, breathing everything was Mötley Crüe, and how to make it happen…Mötley Crüe were like pieces of the puzzle, and that, including Mick and Vince, being blonde, they all had their weaknesses, and Nikki would take them and work with those weaknesses, and make them all happen, and put them together as the right pieces of the puzzle for Mötley Crüe, and he knew they couldn't be replaced without that special link. He made it all work." Most importantly, the four members of Mötley Crüe operated off of pure talent, wherein no shorts were possible with the band's hunger for stardom, and implied work ethic toward that end. As Nikki himself summarized, "I needed 3 or 4 other guys like myself, who had nothing to live for other than this band. (Vince, Mick and Tommy) were 3 of the hungriest guys I'd ever met in my life."

 A key part of Nikki and the Crüe's hunger was their collective appetite for being as over the top as possible in their live performance, and therein their image as a band on the busy Sunset Strip in the wake of London's breakup, and the dawn of glam-driven hard rock. As Nikki sought to pick up where London had left off, creating something even more over the top in the process, his greatest challenge with Mötley Crüe was to create something that was in effect the next generation of London, a role he took on both on and off the stage. As Lita Ford remembers, in the course of the couple's home life in Mötley Crüe's early days, "Nikki was always a business man. He was always on the on the phone. Trying to set up deals, talking to Mick, trying to work on the actual stage performance for the show. He was always coming up with ideas, trying to come up with raps for the show, talking to booking agents, he was doing the actual business for the band. And if he wasn't doing that, he was reading a lot of rock and roll magazines, like Circus, working on a lot of stage stuff."

 Co-manager Mike Flaherty concurred, remarking that, even in Mötley Crüe's very early days, "Nikki was a very astute businessman… Everything was very calculated, and I mean that in a good way." On stage was where Nikki really made his mark on the Sunset Strip with Mötley Crüe. Where

most bands of the genre were just beginning to turn their intensity up, Mötley Crüe came out of the gate with the speakers already blown. Staying several decimals ahead of the crowd was a contrived feat that complimented the band's lack of limits as everything in their being was an extreme- such that their on-and off-stage reputation as Hollywood's wildest band spread like wildfire, as fast as the women they bedded, the sports cars they wrecked carelessly, and the illegal party favors they consumed. All of the latter was ornamental to Nikki, however, as he was as much a student of excess behind the scenes as he was a teacher onstage.

As Lita Ford remembers, Nikki's method with Mötley was to redefine excess by understanding the fundamentals of its collective underpinning, which one hand had been achieved through pure experience tearing up the Hollywood live scene night after night with London, and on another, had been mastered through a careful study of what went into being a professional at specific elements of his craft, notably including pyromania, "the volume of the music for one, he wanted to be louder than any fucking body on the planet. He worked on the way his sound would hit the audience. He tried to put PA's in the back of the audience as well as in front, just to try to blow their fuckin' brains out. Anything that he could think of he would make happen…All the pyrotechnics and explosions, and that sort of thing, that is a whole ball of wax in itself. You have to stay clear of the stage, that's dangerous. It started from nothing and worked

itself into something, Nikki didn't just dive in and do that. He started from lighting his legs on fire in the early days, and it just exploded, and grew and grew. I mean, I would never light my fucking legs on fire! It didn't faze him though....He would work with people that actually worked with explosives, he would go and have meetings with these people, and say 'I want you to teach me how to light myself on fire, but I don't want it to go up past my waste.' He was the one who did all that sort of thing. We would wake up in the morning next to half-put together mannequins...You know, he would say 'I want to do this, how do I make it work?' And he would go out and make it work...He wasn't like 'Oh, I'm going to fucking burn to death.' I don't think that ever entered his mind. Not to mention how much aqua net he had in his hair. His hair could have caught on fire easily! He was just chasing something."

Lead singer Vince Neil recounted the band's efforts to stand apart from anything else around them at the time, specifically in their live show, as one constant, over-the-top experiment, wherein "we used to experiment in our apartment, and we would blow stuff up all the time. That's where we learned to light Nikki on fire." Drummer Tommy Lee elaborated on the latter process of setting Nikki aflame, which became a mainstay of the band's live act, "one day (Nikki) goes 'Hey T-Bone, we got any rubbing alcohol lying around?' And I said 'Yeah, I think there's some in the bathroom.' We all lived in this one apartment together, and I go grab the rubbing alcohol, and Vince and I were dousing Nikki, and he was wearing leather pants so he wouldn't get burned, we were trying to be safe about this, right, so we just light him on fire, and he was standing there burning, and we took it to the stage."

Nikki's strategy for breaking Mötley Crüe in pop-soaked Hollywood in 1981 was establishing their credibility both off an on the stage, and to that end, Nikki, Tommy, Mick, and Vince were the ultimate promotional machine, utilizing every moment they weren't onstage to brand Mötley Crüe's stamp for bad boy debauchery on Hollywood's collective ass. They achieved this end namely by talking a talk and walking a walk that was too razor sharp not to cut through the barriers, and most importantly, in a time when the seams on Hollywood's chastity were begging to burst. Mötley Crüe were the first boys to pop the cherry. As fellow hard rocker Kevin Dubrow, Quiet Riot's front man, recalled, what stood out about Mötley Crüe's earliest days on the scene, they did their best to piss off as much of

the sunset establishment as possible in the process of making a name for themselves, "before Mötley Crüe released their first album, they were going out every night putting the posters up all over the place, and starting fights with everybody. And this was their whole reputation... I kid you not. These guys, they talked the talk, and walked the walk...They used to walk around in army fatigues, in army clothes, this was their street image when they were putting up the posters, and I remember they (once) got into it with some Sheriffs in front of the Rainbow. And this was their whole reputation...(So) when Mötley came out, a bunch of other bands like them started to come out at that same time, so it was definitely much more of a scene."

 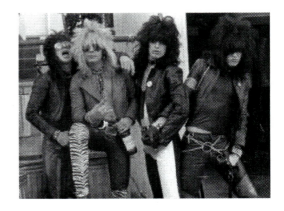

Another important element of Mötley Crüe's early popularity along Hollywood's sunset strip, principally in their serving as a catalyst for the (creation) of a new niche of hard rock, was the fact that their look and sound were quickly being emulated by the other up and coming bands that opened Mötley's sold out shows at clubs like the Troubadour and Whiskey A-Go Go. As bands and fans began to embrace the aesthetics of hard rock's newest interpretation, Mötley Crüe were not only given recognition as the creators of the new style, but also looked to constantly for guidance on where the bar of outrage should be raised to next.

As Nikki remembered during the early period of Mötley Crüe's transition from local phenomenon to national trend setter, "all of these bands appeared...and then all of a sudden the audiences started to dress like us and it grew and grew." Girlfriend Lita Ford also recalled the early Mötley Crüe emulation-period as something similar to an oil gush, as once it was clear that Mötley Crüe had tapped into something, everyone else

quickly came after them digging, "Mötley Crüe definitely had a huge effect with the image they portrayed. Everybody started doing their hair like Crüe, cut the way it stuck up with all the shag and stuff. And of course the tattoos wend fucking awol. People started doing the tattoos from Mötley Crüe." While Nikki Sixx didn't mind the copy catting as it served to further push Mötley Crüe to the genre's forefront as it evolved, Mötley Crüe singer Vince Neil took it a little more personally that the band had so many imitators, "they'll wonder over and talk about us and stuff, but you can just tell they're just jealous, envious that we have the look and they don't."

Vince Neil's role as the band's front man and lead shit talker was something of a cliché during the band's first year together, as Vince's onstage persona was both a mix of his own character and the one that Nikki created for him to play. While Vince was enough of a professional to keep his insecurities to himself while the band was onstage, they were transparent in most offstage settings, as Nikki continually took on the role of compensating for Vince's deficits as a person, particularly in the effects his ego had on others in terms of his reckless inability to think before acting or speaking out. As Lita Ford remembered in interpreting Nikki's attitude toward managing Vince's instabilities offstage, it was a twenty-four hour a day job at times, that was regarded by Nikki as a necessary liability for the band, given Vince's star power as a front man, "Vince was always an asshole. He was always in trouble. All the guys in the band had their downfalls, but Vince was just kind of a fucker. He just sort of did shitty things to people, and you know, Nikki put up with a lot from Vince. Tried to cover for his problems."

Nikki's friendship with Vince embodied the same contradiction, acting as something of a double-edged sword, where on one hand Neil's antics were required and encouraged on stage, and on the other, deplored and tolerated to a large extent offstage. While an expert at honing Vince's raw strengths as a front man as they would be most adaptable and effective for Mötley Crüe's purposes, Nikki also privately contended with a love/hate emotion toward his role as Vince's keeper. As Nikki recalled to one journalist regarding a notorious incident outside the Whisky where he had gotten involved in an altercation that resulted in the cops arresting Nikki for assault on an officer, Vince assisted in starting the brawl, but stood by and did nothing while Nikki was taken downtown. By Neil's

account, "Nikki and I were coming out of the Rainbow one night when these guys started to hassle us. So we got into a fight and, all of a sudden, the cops pull up. Nikki had this guy down on the ground and was swinging a chain but when one of the cops came over he caught right in the head…I didn't go to jail that night, though (Nikki) did, and by the time I picked him up…the cops nailed him good."

Nikki remembered the incident in a slightly different light regarding Neil's involvement in aiding him at all, where "the biker hit me in the eye, and left a dent. Not too bad. And Vince- Vince is such a great guy that he stood there and watched me get the shit kicked out of me." By the time the LAPD had taken Nikki into custody and charged him with assault, it was not Vince who came to Nikki's aid, but Lita, where "they wanted to send me to state prison for five years with no probation or parole- assaulting a police officer with a deadly weapon. But the system is so corrupt (in LA) that (Lita) hocked her car, got $1000 and gave the money to the cops. After that the charges were dropped."

Vince took his propensity for getting into constant trouble offstage in a naturally arrogant stride, and as his behavior was largely consistent with the band's notorious image as Hollywood's ultimate bad boys, there was little the band could do with Vince directly to discourage him, "We were always in jail for one reason or another, we just seem to attract trouble. When Nikki, Tommy, and myself were living in an apartment up by the Whiskey-A-Go-Go, we couldn't even shut the front door properly because the police had kicked it in so many times. I was bad." Whether Nikki and Vince's relationship was more a matter of professional necessity than personal choice is left largely to individual interpretation, though it may best be described as a healthy blur of lines, wherein Nikki felt a musical kinship with Vince that was strong enough to hold up against any of their interpersonal conflicts which flailed around that center. Tom Werman, for one, interpreted the relationship between the two as one where Vince recognized his role as student to Nikki's teacher in all things fundamental to Mötley Crüe's inter workings as a band, and that while their friendship outside of that center was tenuous at times, the Crüe-glue provided their motivation to stick it out, "Vince and Nikki's relationship on the surface… they would kid with each other, fool around, goat each other on, egg each other on. They were tight. Vince is a real friendly guy, very warm, but realizes he would be pumping gas if he wasn't a singer…Vince did what

Nikki told him to do…Nikki had a far more serious approach to his craft, to the music I think than Vince."

Nevertheless, in Mötley Crüe's early days, whatever their excesses, their inner-turmoil as a band, were worn inside out, and purposely put on display for the world to watch and learn from. Nikki proved to be a master at taking whatever chaos was going on around him and turning it into something pliable for Mötley Crüe's momentum, such that as the band got bigger, as Lita Ford remembers, Nikki took it all in as a measured breath of chaotic air, never losing his footing under the pressure, "it was like he knew it was going to happen, and he expected it. There was no other way for him. That was the way it was going to be, and that was what his vision was, and it was happening, and he was like 'Yes, I know, of course!'" A key component of Mötley Crüe's rise in the early days depended on their reputation not only getting around, but maintaining a certain consistency in terms of its outrageous nature, such that as far as Nikki was concerned, himself, Vince Neil, or any other band member who could lend gasoline to the band's fire was ultimately welcome to do so. The irony of the band's calculated yet seemingly free-spirited anarchy laid in the fact that the sunset strip, as a public, bought into it as though it was completely uncontrived. Nikki played up on that impression as much as possible as the band made a name for themselves, taking his I-Don't-Give-A-Fuck attitude not only to any possible height but also to any reporter that would pay attention enough to write about the band in LA's local entertainment news columns.

As Lita Ford herself recalled, "people would say shitty things about him, and Nikki would say, 'Hey, any press is good press. It doesn't matter what they say as long as you're in the press." To that end, he relied on two kinds of media for the band, street buzz and printed gossip, working in unison, and in some ways, off of one another to create a perfect humming sound, much like an amplifier when a guitar is first plugged in. Rock and roll's calm before the storm. When that humming augmented into a ferocious medley of screaming crowd, ear-shattering guitars, and glitter-gutter debauchery, all the elements of Mötley Crüe would explode in perfect unison onstage- as Mötley Crüe was born.

Chapter 2

In the Beginning...

In the Beginning...
Good always overpowered the evils
Of all man's sins.......
But in time
The nations grew weak
And our cities fell to slums
While evil stood strong
In the dusts of hell
Lurked the blackest of hates
For he whom they feared
Awaited them.......
Now many many life times later
Lay destroyed, beaten, beaten down,
Only corpses of rebels
Ashes of dreams
And blood-stained streets.......

It has been written
"Those who have the youth
Have the future"
So come now children of the beast
Be strong
And Shout at the Devil

Nikki Sixx, the family man and entrepreneur, was a portrait of an icon thirty years in the making. At the dawn of Mötley Crüe's rising star in 1982, he was still very much a rock star-in-progress who, according to then-girlfriend Lita Ford, "had no tattoos. He was very, very skinny. He was wearing thigh high red boots that were about 4 sizes too small for him. I don't know how he got his foot into them and just some clothes that he picked up at the nearest Good Will." Clearly, Nikki Sixx, at the start of his career was a starving artist like many other up and coming Hollywood acts, nevertheless his hunger, specifically his appetite for destruction of everything conventional, spread well beyond what his fellow up and comers were capable of conceptualizing. It was undoubtedly Nikki's vision that fueled the wildfire that LA Hard Rock was quickly becoming along Hollywood's infamous Sunset Strip.

Aside from writing songs, one of Nikki's other favored hobbies, in his very early days, was to challenge authority, literally, by starting fights with anyone who would take him on. This hobby of his included the good ole' LAPD, who later became the stuff of legend in Mötley Crüe's early classic *Knock 'Em Dead Kid*; based in part on a bar altercation wherein, by Lita Ford's account, "Nikki accidentally hit…(an LAPD) Sheriff with my belt. I gave him my belt because there were all these guys fighting. I said 'Here, Nikki use this.' So I pulled off my belt…a chain belt, and he was swinging this belt trying to hit one of the guys that were giving him a hard time, and he accidentally hit one of the Sheriffs. So they threw him in jail. Nikki was always in jail."

Living a truly decadent life style implied random run-ins with the law. Nikki's difference seemed to lay principally in that he knew how to apply his debauchery and anarchic attitude constructively; and went straight after it, from the stage to jail and back to the stage again, all the way to the top. As Lita Ford (who herself was, at the time, a member of legendary female rock band The Runaways, who also featured Joan Jett) characterized

Nikki's destructive drive that launched Mötley Crüe: "I enjoyed (Mötley Crüe) as people because they were so young and kind of like, rebels. Especially Nikki. He was a real go-getter, you know. He had his mind set on what he was going to do with his life. He knew exactly what he was going to call the albums. He pictured it…He took the best of Kiss and the best of Alice Cooper and the best of Wasp and put it all together. There you had the best of Mötley Crüe and they were sort of bigger and better than those bands at that time in their career…The whole band looked to Nikki for guidance (during this time), every single member…He was the ringleader of the show."

In short, Nikki Sixx was Mötley Crüe. This statement served not so much a boast as an important historical acknowledgement in rock and roll's annals, as his band would go on to play the role it did in reshaping rock and roll's commercial presence in the 1980s. Revitalizing the genre to be current with the age of MTV and Ronald Regan dollars, Mötley Crüe would ultimately emerge as hard rock's most dominant presence in the decade to come. Mötley Crüe was a concept that Nikki Sixx had been conjuring up for years, in his head, analytically, in terms of what rock and roll needed to become if it was really to be a progressive influence in music throughout the 1980s. It was a battle Nikki jumped head first into, decked out in as much blood, makeup, ambition, and talent as he could center in any one direction. As Lita Ford remembered Nikki telling her, "he had a vision in his mind and he made it all bigger than life- larger than life."

In that stratum, Mötley Crüe was a very independent entity in its infancy. Possibly because they could trust no one else but one another, or because Nikki would trust no one else to carry out his vision but his band mates, or because the band was so far removed from convention's map, that no one could figure out what to do with them until they came up with a game plan of their own. That meant recording the band's debut album, *Too Fast For Love*, for just over $7,000 and releasing it on their own independent label imprint, Leathur Records, largely because they were too big not to have product out, yet too out of control as a concept for any major label to embrace. As Nikki recalled, Mötley Crüe clearly had to sell their concept and image to the record buying public before anyone else would; such that " when I started my career, I was on an independent label that my band started. When we sold enough records on our own, we drew the attention of the major labels."

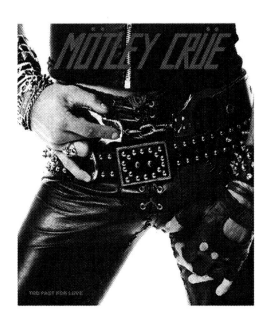

It was the success of their independent release of Too Fast For Love that motivated Elektra Records to sign Mötley Crüe in early 1982, just a year after they had formed. Even in his early days, Nikki had the benefit of both a vision and a business acumen that would serve him well in the band's negotiations with Elektra. By releasing and selling thousands of records on their own, Mötley Crüe proved themselves a commodity, leaving the only untested waters to be the sales potential for 20,000 records times as many US markets outside of Los Angeles that the band could tour in. More immediately however, the band got off to a promising financial start with a deal that paid them an unheard of 16% royalty rate for Too Fast For Love's national release. As Nikki recalled, "Mötley started (with Elektra) at 16%. It helped that we were proven on our own, and the marketing expense was so low cause we'd already set a fire. When Elektra took us on, their only expense was to bring Roy Thomas Baker to go over the indie record and make it more magical. We were building and promoting." To that end, MTV would grant the band immediate exposure to the rock and metal masses, and the transition from local to national audiences was extremely natural as Mötley Crüe were already seasoned theatrical performers in their stage shows.

Ironically, for all the excitement that Mötley Crüe generated among their live following, the band created almost an opposite reaction among their record label's senior staff, who regarded the band as a necessary evil in their early days. Because Elektra had no other marquee hard rock acts to fall back on, Mötley Crüe quickly became the label's bread and butter with the success of *Too Fast for Love*. Nevertheless, despite the platinum success of the band's debut release, when Bob Krasnow took over as president of Elektra in early 1982, his first order of business was to rid the label of the band. Ironically, a lunch that he held with two of Elektra's top A&R staff, future Mötley Crüe producer Tom Werman and Tom Zataut, would serve not only to settle the fate of the band, but also secure Werman's position as their ringmaster. As Tom remembered the events leading up to that afternoon lunch meeting, "I had met Mötley as head of A&R at Elektra. As part of my separation deal with the label, I agreed to (produce) two albums a year, and the first was Mötley. I had a lunch in January, 1982 with Tom Zataut and Bob Krasnow (who had recently taken over as head of Elektra) at a place in Beverly Hills, and I remember him saying 'The first thing I want to do is drop Mötley Crüe from this label. They are an embarrassment, and that is not want this label to be about.' We said 'Who is going to pay the bills? Why don't you let us deal with the meat and potatoes, and do your job.' Then later *Shout at the Devil* took off so quickly, (and) he had no choice but to keep them"

Ironically, the manner in which Elektra viewed Mötley Crüe was well suited to the bad boy image Nikki constantly sought to expand to new heights, even if those included the board rooms of Elektra's corporate office tower. Nevertheless, he quietly resented the fact that the band was Elektra's misunderstood wild child. As Tom Werman confirmed regarding Elektra's love-hate relationship with the band, "Krasnow was a musical elitist. Mötley Crüe was something to be tolerated. They were the money maker. Nikki always had a grudge against Elektra for that. He never thought Elektra understood anything about Mötley Crüe." The feeling of constant under-appreciation would haunt Nikki for the entirety of his 16-year relationship with the label.

Mötley Crüe's real secret in their early days was the band's live show. The energy they put behind Nikki's songs was unmatched. While other bands were teasing their hair, Nikki Sixx was setting himself on fire. As Nikki told a reporter in describing the band's early touring days, "We play

blood n'guts rock and roll. We bleed for the audience…We're always trying to upgrade our show. We have skulls, pentagrams, and all kinds of Satanic symbols on stage, but that's basically just to make a stand, to show that we're bad boys. We're all from the street." The national effect that Mötley's over the top live show would have on the fast rising glam rock scene was almost an immediate translation from what the band had done locally to shape Los Angeles' Sunset Strip hard rock scene. Lita Ford, Nikki's live in girlfriend during Mötley Crüe's early days, remembers Nikki working constantly, on and off the stage to push the band's live show to the next level, so much so that "Nikki would play (or show) me something and say 'What do you think about this?' He took his work very seriously…(For the band's show), Nikki took the best of Alice Cooper that worked for him, the theatrical side of Alice Cooper, he took the hair and tattoos from Hanoi Rocks, the fire and theatrical explosions and high boots, and some of the clothing ideas from Kiss, and sort of put it all together, and threw in Mötley Crüe, with their own ideas and Vibes."

The subsequent copy cat effect of the band's live show among other up and coming Sunset Strip bands annoyed Nikki, but his answer to it was to distinguish Mötley Crüe in the press from their imitators by making clear that Mötley Crüe had started the trend, and would define it as it evolved: " We're always developing, changing…Nobody looks or dresses like us onstage, but now all these bands are starting to copy us, dressing like us, dyeing their hair black or white, so we have to go one step further, keep one step ahead of everybody." That one step ahead turned out, ultimately, to be a giant leap for the band, launching them into the commercial stratosphere. The band would build up to the release of Shout at the Devil with a year of solid touring on *Too Fast For Love*, which was certified Platinum in 1983 as a result of the band's tireless work to reach new fans. As Nikki described the experience that the band and their fans shared, he clearly felt is was something singular to the other rock bands they went to see, something that could only exist on intimate terms based on what kids took away from Nikki's songs, and Mötley Crüe's unique brand of hard rock, "(touring) is a good way to meet the kids…You get to talk to them and find out where they're coming from and why they like you. They seem to like us basically because we don't care about what anybody says. They like the freedom." As Mötley's touring audience became broader, so too did his belief in the band's resonation with fans over and above what else rock had to offer. This perspective was less

arrogant than ambitious, and consistent with what the band sought to accomplish with their message. Gunning down the road toward stardom, looking to the future, Nikki later recalled feeling that "when you're always in forward motion, you tend not to look back. So when you get an opportunity like this to sit down and listen to old tracks, you're able to reflect on what those albums were about and what was going on at the time. It's almost like you get to be a fan of your own band."

Chapter 3

Shout at the Devil

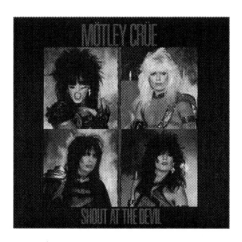

Heading into the recording of their sophomore LP- *Shout at the Devil*- which most within the rock world felt- a foregone conclusion- would be the band's break-out LP, already-renowned producer Tom Werman was brought in by the band's new label, Elektra Records, to oversee production, recalling at the outset of even meeting the band that "when I first heard Mötley Crüe's *Too Fast for Love*, I said 'This is not my cup of tea.' Power without control is not power at all. Pitch, rhythm, meter. Without that, you lose all power. When I went to see Mötley Crüe live, it was different." Ultimately, Werman's catalyst for his interest in working with the band came primarily from hearing Tommy Lee play live, such that, in Werman's estimation, "definitely technically, Tommy is the musical heart of the band. Regardless of that four on the floor style, he was a

mechanically fabulous drummer, on the cutting edge of technology and sound."

While Werman found Tommy to be in the pocket, reigning in the rest of the band proved to be among the producer's most challenging assignments up to that point, explaining that "Motley Crue was the messiest rock band I'd work with at that time, the band who substituted attitude for musicianship the most. There weren't that many new things I did with them- there were a small group of tried and true successful approaches that I brought to that session from other sessions that I had done before that, where I went 'Well, this will work, this will work.' It was 'Mick, double this guitar, and Tommy, I want you to do this fill. And Mick, when I work with you on the solo.' Mick would write the solo to a certain point, and I would help him bring it home. And I think it was just all around general production approach that helped that album. If you'd really let them run away with it- I tried to clean it up, neaten it up. I tried to make the sound sharp and focused. And so I guess I would have taken it farther if the band had been able to do it. I always thought *Shout at the Devil* was a very dirty sounding album, and that's what its appeal is. I didn't do that on purpose, I would have made it cleaner if could have. It was an accident, a combination accident that was probably forseen by Tom Zutaut who said 'You would be the perfect producer for this band.' In the beginning, nobody could really understand them. I had a format by then, there was a way I went about recording albums, trying to make them as compelling a possible. I saw my job as getting bands on the radio, getting them their hits. I wanted to make their songs as infectious as possible. People came to me with band's that couldn't get recorded, and said you are the only one who can make a hit record with this band. It worked with Mötley, they didn't have to compromise their creative direction to conform to my format."

Detailing his preproduction process for the band, Werman recalled establishing a stripped down format for transitioning the band's songs from Nikki's head into the studio, which consisted of a garage-band approach which presented no surface pressure for the band in terms of how a song should sound beyond how it came out of their live performance, where the magic of Mötley's collective sound had always been rooted, "Nikki would go and make demos, bring them to me, rework them in rehearsals, make rough book box tapes…They were very good about rehearsing, and (in that context), taking direction, changing arrangements. (The boom box

tapes) worked pretty well...(we'd) take them into the studio, and use them as models for songs, incorporating changes I had suggested." In discussing his individual work with each band member in the course of making '*Shout At the Devil*', Werman recalled that he worked most closely with the band's principal songwriter, Nikki Sixx, recalling that in his initial creative interfaces with the bassist, "Nikki didn't really open up to me, and was kind of difficult at our first meeting. I remember Tommy saying 'If this guy's going to produce our album, let's listen to him." Once Nikki started to open up to Werman, the producer found that "Nikki was a real pioneer. He wasn't afraid to do anything, wasn't afraid of anything. He was a pissed off, bad ass, dark side kid who had something to prove, no one was going to fuck with him. With '*Shout at the Devil*', at the time, you had not heard songs like that." Without doubt, by this point, Nikki Sixx had clearly become identified by both rock fans and the media as the brain behind Mötley Crüe, as one journalist plainly stated in a profile of the band in 1984, stating conclusively that "unquestionably, the driving force behind any Crüe project is Nikki Sixx, the man responsible for all the lyrics- and most of the music- that graces each Mötley Crüe platter." As Tom Werman recalled regarding Nikki's position of influence within the band, "Nikki was always the brains, vibe, direction, for everything about Mötley Crüe. He was the one who said 'this is where we are going to go next.' He was the main author of the group."

Nikki confirmed the latter in an interview, remarking that while the group had started to collaborate a bit on songwriting, he still took most of the responsibility on himself, "When the band started in 1980 and 1981, I wrote mostly all the music, but now its gotten to the point where we all four contribute, cause we're all 4 together all the time, and it comes across in the music...I do about 80% (of the songwriting)...but we're doing more collaborating as a band, as we mature." If Nikki took on the role of author of Mötley Crüe's music and image, Tom Werman, in the band's early period, definitely filled the shoes of editor. While the collaboration was at times both tense and tenuous, the latter due principally to the band's excesses on and off record and stage, it was ultimately an extremely successful and potent union. As Tom remembered regarding his approach to melding Mötley's sound into a commercially viable medium in the course of recording Shout at the Devil, the secret lay in Werman's principle expertise, melding the band's raw, energetic sound into his formula for mainstream hit making without compromising their edge as a

band, such that in the beginning, "nobody could really understand them. I had a format by then, there was a way I went about recording albums, trying to make them as compelling a possible...I saw my job as getting bands on the radio, getting them their hits...I wanted to make their songs as infectious as possible. People came to me with band's that couldn't get recorded, and said you are the only one who can make a hit record with this band...It worked with Mötley, they didn't have to compromise their creative direction to conform to my format."

Part of successfully applying that format meant getting inside Nikki's head enough to understand his songwriting process, which Tom remembered as something of a challenge in the early days given Nikki's singular focus and position as Mötley's creative director, so much so that the first challenge was to get Nikki to even talk about what he was seeking to achieve with the band's sound. Establishing a trust was clearly the first challenge Tom Werman had to overcome as the band's producer, "he didn't really open up to me, and was kind of difficult at our first meeting. I remember Tommy saying 'If this guy's going to produce our album, let's listen to him.'" Despite the producer's role as the group's editor, Tom recognized early on that Nikki's songwriting instincts were largely intact, specifically with respect to his potential for writing hits, which the producer quickly sought to develop, "I helped him now and then with lyrics, some, in very small ways. They wouldn't scan, so I would take out a syllable or two, suggest a word or phrase. Sometimes he would take suggestions. He knew which songs would be paid attention to. I pushed him in terms of precision as a bass player, (but) if I had pushed him one way or the other (on his songwriting), he would have resisted. He would have mad up some reason why he didn't want to be pushed. There were typical changes that were made, (but) they were subtle, having to do with song structure, dynamics, drum and guitar parts." Ironically, as Tom remembered, despite Nikki's firm confidence in musically instructing the band in the studio, in his early days as a musician, Sixx was worlds more accomplished as a songwriter than at his designated instrument within the band, the bass, so much so that "Nikki, (though in his later years has) become a very accomplished bass player, (during the recording of Shout at the Devil), took an entire afternoon to do his bass parts. It would take three to four hours to overdub his bass parts to a drum track. I wouldn't call him a (technically) serious musician back then. He was more of a songwriter and a stylist. A creative director."

Mötley Crüe's designated dark horse in the studio was guitarist Mick Mars, who took his orders dutifully, and quietly contributed where he felt appropriate. Perhaps Mars' non-intrusive style of playing was part of what allowed Nikki's songs their solid structure. As Tom Werman remembered, no one got in Mick's way, and he in turn didn't go out of his way to step on many creative toes, such that "Mick's responsibilities and duties were clearly defined by Mick, and possibly by Nikki. Mick contributed and came in with definite solo ideas. He would readily admit he was not into the recording process. He watched cartoons, and kept the shades down. He was a simple guy. When he was finished, he would go home. He was kind of the Bunny Carlos of the group. You couldn't even see him leave he was gone so fast from the studio. He had a lifestyle that was separate from the band's. He was in that way the odd man out within the band. Ultimately, Nikki had a lot of suggestions, and Mick would take them. He did what he had to do. He did what he had to do, but as a player I feel has always been very underrated, and was definitely the musical anchor of the band along with Tommy. He was very, very solid. He was always a pleasure to record"

While Nikki typically brought the band's songs to the table, the producer also recalled feeling that once in the studio, "Tommy's drums were always key to making any recording. I tried to make the songs more articulate. Tommy had a lot of ideas. He had some incredible ideas. The only thing I would do with Tommy would be to change a symbol, make suggestions on changing a kick drum pattern. He was a very inventive, creative, solid drummer. He and Nikki were definitely the Paul and John of the group." The relationship between Nikki Sixx and Tommy Lee stood in stark contrast to the approach Nikki took with Vince Neil in the course of recording, where Vince was more the sloppy player, and Nikki the determined coach. As Tom remembered, "Vince and Nikki's relationship on the surface, they would kid with each other, fool around, goat each other on, egg each other on. They were tight. Vince is a real friendly guy, very warm, but realizes he would be pumping gas if he wasn't a singer. Vince did what Nikki told him to do. He would say 'I want the song like this, I want the melody to go this way.' It was hard, and (Vince) would work at it till he got it. Vince was, in terms of the musical contributions, the last. He would do what he was told, and work hard at it. Nikki had a far more serious approach to his craft, to the music I think than Vince. But Vince did work hard to get it right for Nikki and I."

By the time the band wrapped recording on Shout at the Devil, which Nikki had written almost entirely as the band's trump card, their gamble was about to put them in Rock and Roll's high rollers suite. They would handle it in what had become typical Mötley fashion by that point, metaphorically inviting their fans up to the room for a party, then trashing it in the name of unbridled rock and roll. This was exactly Sixx's goal at the time, "We're appealing to a generation of kids who are too young to have ever seen Alice Cooper in his prime...Maybe they're too young to even have seen Kiss. They want a band that they can relate to - guys who are about what they're experiencing. A bunch of old farts in their thirties and forties can't do that. We're not gonna go out there and play 20-minute songs... We're not into the half-hour solos and the riff, riff, riff style that so many European bands are into. That's pure heavy metal.- that's not us. Our biggest influences were bands like Aerosmith and Kiss, where there were some great tunes being played. That's the American tradition. We're an American rock and roll band and we're proud of it...(and we represent the youth). People are always saying, 'Awe, they're just dumb kids.' And that really pisses me off. They're not dumb kids. I wasn't a dumb kid. Just cause you like rock n roll doesn't make you stupid or insignificant...I think we're educating the youth." What, to parents and critics, was Mötley's trash was every teenager's treasure, and it only emboldened Nikki and the boys in their antics in pursuit of claiming a stranglehold on America's teenage record buying audience. In Nikki's eyes, Mötley Crüe had become the mirror that every disgruntled teenage rock fan styled their rebellion in, at one point proclaiming boldly "we are America's youth...We're intellectuals on a crotch level. We're the guys in high school your parents warned you to stay away from. That's what we're like on stage and off. The kids won't buy albums from phonies. They can see right through that crap. They'll run your ass out of the country if you aren't the real thing. We are the extremely real thing."

Interestingly, Nikki sometimes found a perfect medium for his songwriting formula in the band's excess. To that end, in late 1983, when Nikki dislocated his shoulder in a drunken car accident outside a party a producer Roy Thomas Baker's home, he took the incident in stride as a natural affect of his lifestyle, such that, as he put explained it, "we live life to the fullest. Just the other day I smashed my Porsche into a tree at 70 miles per hour. All it's good for now is scrap metal. I broke my shoulder.

But that's o.k. We're enjoying every aspect of being in a rock and roll group. Mötley Crüe is more than just a band - it's a way of life." The bottom line at the time was that the harder he worked at partying, the more he got accomplished artistically in terms of inspiration for the band's new material. As he explained it, "I put the experiences I have partying with friends into my lyrics, so when I'm partying, I'm actually doing song research." In other instances, the band's material was clearly more personal to its creator, and a far cry from the subject of sex, for example, was the subject of dark, spiritual hedonism and the occult, which by the middle of 1983, was clearly influencing Nikki's songwriting. To that end, Shout at the Devil clearly reflected a mix of very introspective beliefs and outward explanations for what those beliefs meant, in a larger sense, to the three million listeners who would buy the record upon its initial release. What would have been a problematic aspect of the commercial translation of Shout at the Devil for most fans proved to only fuel what was quickly becoming branded as Mötley Crüe's literally satanic fire.

By late 1983, when Shout at the Devil was released, the religious right was in full swing as a multi-million dollar enterprise. Sunday Morning religious fast food for the masses was served up by fast talking bible concept salesmen like Jimmy Swaggert and Jerry Fallwell, who demonized the music of bands like Mötley Crüe, who they deemed devil worshipers, but at the same time lived offstage like the rock stars they criticized; with the millions of dollars in revenue the Sunday morning phenomenon of shows like the Old Time Gospel Hour brought in. The hypocrisy was obvious, but no one sought to point it out because both parties benefited mutually from the cultural conflict they had created. As the television preachers became more vocal with their protests of Mötley Crüe records, their donations doubled. Meanwhile, as Mötley Crüe became the Judas of the religious right, they gained access to an entirely new avenue of press, and that intrigue alone brought in more record buyers. To that end, Nikki's alleged fascination with the Occult in the rock media was only indulged, and therein, encouraged. As one Mötley Crüe insider, Tom Zataut, allegedly recalled during the period when Nikki was writing Shout at the Devil, "as time passed, (Nikki and Lita's) house kept getting creepier. I'd drop by and see The Necronomicon, a black-magic spell book, lying on the table. Nikki was getting heavy into satanic stuff…I went over one night to have a discussion with Nikki…(and) he and Lita were huddled on the couch. "I'm kind of freaked out.' Lita said. 'Weird things are happening in

this apartment.' 'What do you mean?' I asked, looking around at the freshly painted pentagrams and Gothic paintings Nikki had on the walls and floor...When I returned two nights later, there were forks and knives sticking in the walls and ceiling, and Nikki and Lita looked much paler than usual...and I swear to God, I saw this with my own eyes, a knife and a fork rose off the table, and stuck into the ceiling just above where I was sitting...To this day, the incident remains one of the most bizarre things I've ever seen in my life."

Others close to Nikki and Mötley Crüe during this period are quick to dispute the notion that Nikki Sixx's indulgence in the Occult was anything more than part of his effort to increase the band's record sales and notoriety among fans by letting the press read into his lyrics what they would, when in fact he had no real interest vested in black magic beyond a commercial one. Lita Ford, for one, is quick to repel any notion of truth to the stories of her and Nikki's fascination with Satanic worshiping, joking that "forks were sticking in the ceiling because we threw them there...We didn't sit around and worship the devil or anything like that, that's ridiculous." The best-kept secret about Shout at the Devil was the fact that the song was actually written in an anti-Semitic vein, and was supposed to be taken literally to mean, "Shout at the Devil". Few seemed to catch that fact, and Elektra Records, let alone the band, weren't about to blow their single biggest marketing edge-intrigue. Intrigue brought fans to the record bins, and Mötley Crüe's 'Shout at the Devil' became one of 1983's best selling rock albums as a result. Nevertheless, in that period, Nikki had no problem letting stand the impression that he had in fact developed an affinity for dabbling with black magic that exceeded the boundaries of a surface marketing ploy, something he readily admitted to reporters, once remarking matter of factly that "I've always flirted with the devil." Looking back historically on the first of his three recording collaborations with Crue, Werman feels that "*Shout At the Devil* was the most important of Mötley Crüe's albums, and always will be. It shaped attitudes. It didn't occur to me at the time that people would take Shout to heart quite in the way they did." In fact, an entire generation was born out of *Shout at the Devil*, which launched the band and the hair-metal scene into national stardom. Moving 3 million copies, Rolling Stone Magazine in its 1983 review of the album hailed the band's "promise of sex, rowdiness and rock & roll", delivering Motley Crue would as they next hit the road- and the

big time- via an A-List opening spot on Ozzy Osbourne's 'Bark at the Moon' tour.

The commercial release of Shout at the Devil put the band back on the road, and back once again into the endless cycle of partying, sex, drugs, and at the same time, a grueling performance schedule, that would have tore most bands down. Mötley Crüe seemed, instead, to thrive on it. That may have, at least in part, have been because the band, in support of Shout at the Devil, played the opening slot on Ozzy Osbourne's tour between late 1983 and 1984. Aside from the outrage that was thematic off the stage, in front of the crowds, Mötley Crüe dedicated themselves to giving a hundred and fifty percent. As Nikki recalled, the Shout at the Devil tour was the band's first legitimate chance to combine the band's penchant for excess and live energy into a wrecking ball that fans eagerly walked into, "it was a rowdy tour!...A lot of people got to notice us and started taking us seriously. I think they realized that Mötley Crüe is for the kids, the songs are written for the kids, and we're genuine...We're honest to the kids. We go out there and kick ass and we want to a do a great show. I always say, you're paying 20 bucks, I want to give you a $50 dollar show. I think that's going to give us staying power."

In further describing the band's outlook at the time, Nikki seemed to feel a part of something close to a family, between himself, the band, and the fans, for the first time in his life, "all I ever wanted to do was what we are doing...Just playing good rock n roll, putting on a good show, and having a good time. And people go 'Wow, you guys must be rich, you must be driving Lamborginis.' We ain't rich, we haven't seen no money, and that's good for us, because the money part of it ruins a lot of good bands. We're getting laid, we're getting lots of free booze, and having a good time...We do what we do best, we just have fun. We definitely have a different sound, our sound is very root-oriented, its very much from where we come from, and I just don't hear many other bands sound like us, I think a lot of bands take this whole trip too seriously. We like to have a good time, and there's a good bond between us and the fans. We really enjoy the kids, we like to meet them, hang out with them."

The well publicized excesses of the *Shout at the Devil* tour made fast legends legends of Nikki and the boys, as they tour up the US night after night, trying their best to keep pace with Heavy Metal's premier bad boy,

former Black Sabbath vocalist, Ozzy Osbourne, who, at the time, had come to represent everything that America's bible belt conservatives had come to stand against. On Ozzy's skid row, Mötley Crüe fit right in. In the metal legend, the band found both a mentor and a soul mate in debauchery. As the boys looked to test in the top percentile of every extreme, Ozzy was a perfect teacher. Highlights from his own rock and roll reel included bans from Texas for urinating on the Alamo, and from his own record label's offices for infamously biting the head off of a living dove during a production meeting; in the presence of the label president among others. The incident was also caught onstage for the whole world to interpret. The bible belters were duly horrified, the fans impressed, and Mötley Crüe enthralled.

While the tour story involving Ozzy freebasing a procession of ants is already legendary, an equally as fantastic story, as recalled by Nikki, captures as unequivocally the extreme nature of the band's indulgence and excess on the 1983 tour with Ozzy. As Nikki remembered, "(Ozzy) hiked up his sundress, grabbed his dick, and pissed on the pavement...(then) knelt down and, and getting the dress soggy in the puddle, lapped it up...Then he stood and, eyes blazing and mouth wet with urine, looked straight at me. 'Sixx, do that!'...I swallowed and sweated, but this was peer pressure that I could not refuse...If we wanted to maintain our reputation as rock's most cretinous band, I couldn't back down, not with everyone watching. I unzipped my pants and whipped out my dick in full view of everybody in the bar and around the pool...as I made my puddle...but, as I bent down to finish what I had begun, Ozzy swooped in and beat me to it. There he was, on all fours at my feet, licking up my pee."

As America's favorite rock and roll nightmare, Mötley Crüe's brand of cool and sleazy was resonating with a new legion of fans. The multi-platinum success of Shout at the Devil was another step forward in the band's evolution, and their impact was beginning to pop up in the second generation of bands like Ratt and Twisted Sister who were fast following in Mötley Crüe's footsteps. Lacking the band's sophistication for the mastery of their craft, most of Mötley's competition was second-class. Looking back years later, Sixx would reflect with no regrets on the latter period as one in which things got so wild he developed an alternate party personality, Sikki, who the bassist described as "a prankster, but to the point where he

would burn a hotel down, not thinking that he would burn all the families in the hotel, too. When he's out in full regalia, he's evil. The way I look at it is, there's a very long hallway, and it's full of the most demonic characters, and I got out of that hallway and people have said, it must be nice to be free from that. But to be honest, I have my rearview mirror focused on that hallway at all times because I believe any addict who forgets his past is condemned to relive it." Nikki's philosophy on staying ahead of the competition was a simple mix of sheer songwriting savvy and a clear commercial translation of that material's concept- be it Satanism, or the mix of punk and glam that had been the essence of their debut, *Too Fast For Love*.

In that battle to stand apart, Nikki also sought to poke fun at the critics and conservatives of the time who sought to brand the band as a bad influence among America's youth, arguing that in fact, Mötley's sound was in some ways a very light-hearted one that sought to parody the establishment in the name of the kids who bought their records, "we're a rock n roll band, its not classical music, its not pop music, its not bubblegum music, we're a rock n roll band, and we do get in trouble now and then, everyone's gotten in trouble, but the bottom line is we want to have a whole lot of fun...We chuckle about everything, you know, its humorous. People who take life too seriously, that's who we aim out music at. And that tends to be the conservatives of the world. We're having fun, that is what rock n roll is about...We've always had a sense of humor, I think nobody got it but us, and with this whole album (Shout), that's what we're trying to get across. We are a rock n roll band...we don't want to hurt anybody, and we want to bring across the fact that we and the fans are one."

Mötley Crüe's secret was constantly reinventing them selves with every new record, and how they achieved that feat lay chiefly in the mind of the genre's creator. As Nikki once described how he redefined the trend when it began to seem saturated with imitations, "people say 'look how much they've changed' but it's been a gradual thing, not overnight...It took us years to perfect this sleazy look...Nobody looked or dressed like us onstage. But now all these bands are starting to copy us, dressing like us, dyeing their hair black or white, so we have to go one step further, keep one step ahead of everybody...(The important thing in metal music) is the sleaze factor. There's some records that have got it, but not enough. I

listen to the radio all the time, right- I listen to it before I go out at night, and I listen to it when I get back and sometimes I listen to it in between...and what I listen for is a sleaze factor. Mötley Crüe has got the sleaze factor." Not surprisingly, the blood and the makeup had only begun to run...

Chapter 4

The Metal Years

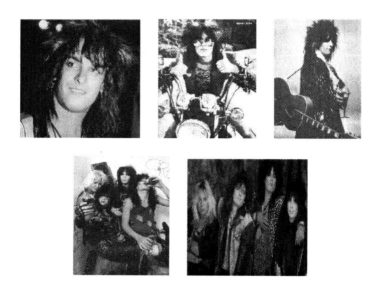

In late 1983, Mötley Crüe had busted the collective cherry of mainstream pop music with the release of their seminal album *Shout at the Devil*, a giant middle finger for the band to both their record label and the establishment as the record sold three million copies in under a year. *Shout at the Devil* was Mötley Crüe's, and a new wave of LA hard rock's, first masterpiece, violating conventionalism and conformity with a sound that spoke like the devil's sleaziest voice seductively into Bible-belt Middle America's innocent ear, too tempting to refuse, coupled with an audacious bad-boy look to good to miss, let alone resist. As the band completed arena stints throughout the United States with the master of decadent

ceremonies, Ozzy Osbourne, their sound held immediate resonation with fans around the country.

As former Metal Edge editor-in-chief Gerri Miller recalled of her first encounter with the band at one of their concerts, it was the combination of their sound and antic and attitude-laden live show that made the band go over above and beyond the typical hard rock band in 1984, "They were wild, they were good, they were crazy, wild. They were over the top...(In terms of what made them an immediate favorite with their fans, it was) a combination of the music, image and attitude... They didn't hold back. Not only were they good players, but it was like the attitude, nothing restrained them. I think the audience really picked up on that. It was like that all-for-what-they-were-doing attitude."

With nothing to lose, Mötley Crüe held nothing back. Applying the same combination of adrenaline and anarchy they had to taking the Sunset strip by storm to the greater country, the band started a glam-laden gold rush, striking the perfect pair of conflicting nerves simultaneously- pissing off parents by providing rebellious refuge to their alienated offspring. By defining the rebellion that millions of America's disgruntled youth were quickly embracing, rather than merely emulating it as so many imitation bands had in the months immediately following the release of *Shout at the Devil*, Mötley Crüe were able to maintain a crucial leg up in their quick climb to the top. To that end, while writing *Shout at the Devil*, which had originally been titled *Shout with the Devil*, Nikki Sixx had only a peripheral glimpse into the glam-metal revolution his masterpiece would spark. Possibly knowing that a statement speaks loudest when it is the type that can be screamed, let alone spoken by anyone, Nikki designed *Shout at the Devil* largely around his own discontent with the direction popular music was heading in the early 1980s, away from the underground reality of punk, and more toward the electronic and synthesized saturation of new wave, which was dominated by an artificial gloss that was naturally forgotten on punk's edginess.

Understanding the impact *Shout at the Devil* was potentially capable of having, Nikki put 100% into every facet of preparation for the album's release, reflecting his understanding not only of the significance the album's musical, but also its visual substance. To that end, when a photo shoot for *Shout at the Devil's* release with Neil Zlozower at Hollywood's historic

Perkins Palace presented itself as an opportunity to make visual rock history, Nikki took the horse by the bit, literally, snorting a ton of his favorite candy with the Zlozower, who, by this point had become one of Nikki's closest friends, before letting loose following the rest of the band's departure, for what would become one of the 1980's most permanently striking displays of Sixx's mastery of the concept of debauchery.

As Zlozower remembers, "Perkins Palace where I did the first offstage shots was an old theatre, built a long time ago, and I always liked grungy, peeling paint, broken glass, rusted, twisted metal, old texture and walls, and there was plenty of that, so I don't think Nikki had much creativity at all in the first shoots. I was just like 'Look you guys, I want to set you up here in this hallway, I'll put a red drape behind you, and we'll shoot. I would say probably the first, big major shoot I did with them (where he had any real input) was what's now referred to as the blood shoot. My idea was to throw red, lacquer paint on the back drop, I think Nikki's idea was, he told me specifically, go out and get some blood, so that was his idea, the blood. My idea was to put the shit on the background, his idea was to be drenched in the blood, and so for that shoot, we bought the very highest grade theatrical blood you could buy."

Continuing, the photographer recalled that "in the old days, I mean, if you look at Blackie with Wasp, with any of the shit he did with blood, he had this dark, ugly looking shit that looked like water, it looked like red water. The shit we used, man, was like the nastiest, most vibrant, and looked fucking shocking because of the way it caught the light and everything so fantastic. With the blood shoot, Vince was getting married the next day, to one of his wives, he was married quite a few times, I remember, I could read it in Vince's face, when you're a photographer, you can read what people are thinking. And so the whole shoot, Vince just wasn't there 100% mentally. He was like, 'Look, I'm getting married tomorrow, I don't want to be here.' So, if I remember correctly, everybody split at around 7 o'clock, and Nikki wanted to hang, so we ended up getting some goodies to help motivate us, and proceeded to get, basically, all tore down, and rotted out of our minds, and just sort of let our creative juices flow, and that's what basically ended up as the blood shoot. I mean, we had shots with everybody with a little blood, but Nikki let it all hang out after everybody left. I mean, we got fucking sick, and

insane. The result was one of the music industry's greatest fucking displays of rock and roll's visual madness."

What the blood shoot captured, above all else, was a brilliantly reckless and rebellious statement of how outrageous Mötley Crüe was willing to be in order to reach, and in the process, truly impact their outraged fans. Both had to be equally on par with one another, which came off perfectly in the grand presentation as, at heart, Nikki was just another pissed off kid hunting for the next great rock and roll anthem to rebel along with his generation to. Fate just had it that he also happened to be the kid who penned that anthem. As Tom Werman recalled during the recording of *Shout at the Devil*, "at the time, you had not heard songs like that. Nikki was a real pioneer. He wasn't afraid to do anything, wasn't afraid of anything. He was a pissed off, bad ass, dark side kid who had something to prove, no one was going to fuck with him."

The beauty in the irony of the latter statement was that, by Nikki's formula, Mötley Crüe won either way, as the more heat Mötley Crüe got for *Shout at the Devil*'s satanic overtones, the more press they received, and the more records they in turn sold. Where Disco had driven the record industry to the verge of bankruptcy at the time of its demise in 1980, the decade had not gotten off to a fabulous start with any sure fire record-selling format aside from the new wave boom. Heavy Metal was on uneven ground for the first time in a decade with the break up of Led Zepplin and the departure of Ozzy Osbourne from Black Sabbath after a 10 year multi-platinum streak. As punk had dyed off as the latest craze a few years earlier, FM radio had largely turned a def ear to classic rock, leaving the broader genre without a central voice, until *Shout at the Devil's* release and breakthrough in late 1983. The album's greatest resonance among fans, critics, industry heads, and the band itself, laid in the collective surprise it caused for everyone equally in the impact the record had on shaping hard rock for the 1980's in real time with the genre's evolution. As Tom Werman himself recalled in retrospect concerning the impact of the band sophomore release, it was if nothing else unexpected, and in grander examination, nearly unheard of, as was the genre *Shout at the Devil* is largely credited with establishing as a mainstream force, "Shout was the most important of Mötley Crüe's albums, and always will be. It shaped attitudes. It didn't occur to me at the time that people would take Shout to heart quite in the way they did."

From ghetto blaster to car stereo to MTV to concert stage, *Shout at the Devil* reigned in the fall of 1983. The band had already made their platinum bones with the release a year earlier of their debut, *Too Fast for Love*, and as such, their name and image was already familiar to rock fans nationwide. If *Too Fast for Love* had been designed as a foundation for Mötley Crüe and stepping stone for the genre, then *Shout at the Devil* was nothing less than a springboard constructed with the sole purpose of launching glam rock for the 1980s into the mainstream stratosphere. Helping the band out in their quest was the opening slot on Ozzy Osbourne's *Blizzard of Ozz* tour in throughout late 1983 and the majority of 1984. The highlight reel was so over the top that Ozzy Osbourne himself has joked since that the off-stage parties were more memorable than the shows themselves, such that he doesn't recall most of the live performances. Nevertheless, the thousands of fans that came out to see metal's godfather each night picked up the slack, as his step children's live show made an equally as indelible impression.

One aspect of Mötley Crüe's live act that helped stir the appropriate record-selling shit with the conservatives in the Bible Belt of America's Midwest was the theme of Satanism, which the band privately regarded as little more than a casual dabbling or curiosity of Nikki's. Nevertheless, no one rushed out to refute the rumors of the band's preoccupation with Satanism or the Occult, rather they worked instead to fuel the hellish flame that was at a central element of hard rock's mystique and allure among alienated teenagers, tearing up the charts and down the conservative boundaries that society had worked so hard to set for millions of Mötley Crüe's youngest and most impressionable music fans. At heart, Satanism within the record industry at large was nothing more than a marketing tool, and a tool that Nikki knew how to master handily, as Lita Ford remembers, with a mix of humor and matter-of-factness, "it was a part of the show, Nikki's not a fucking devil worshiper…It was a theatrical stage thing…People actually did think though, that Mötley Crüe were devil worshipers. Nikki loved it. He would love stuff like that. The Christian Coalition would picked the shows in certain parts of the US…like when they would play the Bible Belt, the South, Mississippi, those places, saying 'Mötley Crüe were Devil worshippers!' and 'Don't let your kids go to the shows.' Nikki loved it! Fuck yeah, absolutely loved it!"

Nikki described his use of pentagrams as a concept in the course of recording, and marketing the Shout album more matter of factly, in the process revealing some of the intelligence behind Mötley Crüe's writing to the world, and in the same time, exposing the naiveté of the religious right for criticizing the band with such a closed mind, "the Pentagram that we use on our album covers, in the bible, it is actually a good luck symbol, and the English used it, in the 1800s, the pub owners were very superstitious, and used it to ward off evil. That's where it came from, its actually a good luck symbol, and for whatever reason, the people you were talking about, the Washington wives, didn't really do their homework, and (in the process), I think they kind of embarrassed themselves… This album has absolutely nothing to do with the devil. We're about as anti-Satan as you can get…We're trying to say that the devil is any authority that tells you what you can do and what you can't do. It can be your parents, it can be your teachers, or it can be your boss. We're saying shout at that fucker - don't let 'em get you down. That's our philosophy. It's got absolutely nothing to do with the devil- believe me."

If Nikki ever did answer the rumors and allegations concerning the Satanic elements of Mötley's music, he did so as a call to arms for the legions of fans the band was building, painting his accusers as the real demons for attempting to twist the band's message, "There was nothing demonic about *Shout at the Devil*!…What a crock of shit!…As soon as the album came out, people were calling us Satanists…All we were saying was that everyone should stand up and shout at those people who are holding them down, whether its' their parents, their teachers, or their bosses." As the fans ate the message up, their embrace was two-fold, classic rock and roll formula taking hold of a new, revitalized generation of hard rock fans. Mötley Crüe had succeeded in making rock and roll relevant again as a social statement, and they had done so most directly through their live shows.

There, fans got an opportunity to witness the mayhem first hand, and it was refreshing, as Nikki remembers, his band saw eye to eye with their fans in a new way, "I think Mötley Crüe…broke down a lot of barriers as far as what you can get away with. I don't think people will soon forget us because we are true to our art. We live and breathe it…The true heavy metal and hard rock, sleazy rock n roll followers are the kids in the streets, like me and you…(In many ways), Mötley Crüe is simply a mirror. We

reflect what we see." A master at channeling discontent, Nikki had succeeded in capturing a moment and an emotion that every kid in America seemed to be feeling simultaneously, such that as the Shout tour with Ozzy wore on, Mötley Crüe's music was rapidly giving way to a wider popularity among the masses that was undeniable.

For Mötley Crüe, the greatest thrill came in experiencing the affect their music was having first hand, which in turn worked to keep them ahead of the learning curve among the new generation of hard rock bands like Ratt and Quiet Riot. As Nikki recalled witnessing the resonation his music was having first hand on America's youth during the end of 1983 and dawn of 1984, "we stopped in this small town called Nephi, with a population of like 2…I swear, no less than 20 kids, and we're talking a population of like 2 here, 20 kids come out of the backroom, dishwashers, cooks, busboys, wearing Mötley Crüe shirts, Twisted Sister shirts, Iron Maiden shirts, and I just went 'Fuck man!' Just goes to show you that no matter where you are there is rock n roll!" For Nikki personally, this period in the band's career served to fill a more personal void that would have otherwise been left gaping open, that being the absence of family in his personal life. With the exception of phone calls home to his grandparents, who had raised him but remained on their farm in Boise, Idaho, and Lita Ford and her parents, who acted as sometimes-surrogate or holiday family presence for Nikki, his kin laid largely with the fans who embraced his music.

As Lita recalled regarding the importance of the relationship between Mötley Crüe's music and its resonation with fans to Nikki personally, it was in many ways all he had to live for, "He had a real hard time accepting love from my parents. They would send him Christmas presents, and he would be real happy to get them, but at the same time it almost hurt him. It was painful for him to accept things from them. Obviously it was from what he had gone through (as a child). My mom and dad would invite him to dinner, and he just couldn't go, couldn't do it. It hurt him, it was real hard for him to be a part of that, which is why he sunk his teeth so hard into his music. Just had tunnel vision for that. Whenever anything else would try to get in his way, you know, love, a relationship, whether it be with me or my parents, or someone else's parents, he just kept on plowing right through it. But at the same time, he would try to accept it and be grateful, he would never really (be able to) show that side."

As the number of fans embracing Mötley Crüe grew, Nikki's his role as a songwriter matured, his themes broadened, as he had more and more fans to speak for, and to be accountable to. One hand naturally washed the other, as Mötley Crüe plowed on through 1984 with their fan base and status as a nationally-established live act growing faster than had been witnessed in modern times within the hard rock genre. In this way, Mötley Crüe also worked to help speed up the timetable for the expectation of success that a label would have for a hard rock band. Where Mötley Crüe would establish themselves as an arena act within the span of two albums with *Too Fast for Love* and *Shout at the Devil* between 1982 and 1984, the second wave of hard glam rockers, like Ratt, were able to do so in a single album with their hit single Round and Round a year later in 1985.

Mötley Crüe had established the formula for the 1980s in real time with their own rise to the genre's forefront, and perhaps to everyone's collective surprise, Nikki aside. As Lita remembers, nothing about Mötley Crüe's success, neither in terms of its rapidity or heights, seemed to come as anything of a revelation to Nikki, "He knew exactly what he was going to do…He seemed to, what I remember about him, is that he seemed to have the next few years of his life planned. He knew what he was going to look like, he knew what he was going to sing, he knew what the album titles were. He pretty much saw a vision…It was like he knew it was going to happen, and he expected it." As it was Nikki's iron confidence that led Mötley Crüe through the foundation years of their career, it was his confidence that would also sustain the band through their wildly successful and self-destructive period, which had yet to follow.

The center of this struggle would root in a series of highly publicized and lethal incidents involving band members Vince Neil, the catalyst for a instantaneously fatal alcohol-induced car wreck several months after the conclusion of the Shout at the Devil tour in 1984, and Nikki's lethal heroine overdose four years later in 1988, which would occur much the opposite of Neil's tragedy, slowly and deliberately on Sixx's part, beginning in 1983 when he first began mainlining Cocaine on the road with Ozzy Osbourne. Where the band had dabbled in the basics of narcotics (marijuana, cocaine, and Quaaludes) in their early period, they were not exposed to the possibilities for high-class narcotics till they took off as a commercial band. The potential, promise, and appetite for the excess such narcotics provided access too was ripe within the band early on, but it was

ironically Nikki's poverty in the early days of Mötley Crüe that spared him introduction to the drug that would eventually, if however briefly, take his mortality from him.

Lita Ford recalled the practical limitations of the bands access to high line drugs in the early 1980s as something that didn't end till they came under Doc McGhee's managerial wing, such that in those days "it was just getting started. (Nikki's drug habit) wasn't anything major, because at that point they didn't have the right drug connection. When you're just piss poor on the streets, you just kinda don't know as many people as when you're rich and famous, and you get the really good drugs. (Nikki) would drink, and pop a pill, and do little things, but it wasn't anything major at first. Back then, it was just casual, you know, we'd have a drink, we would get stoned, someone had some blow, it was totally casual, there wasn't that many drugs around…When you get to be bigger, then you get into the really heavy drugs, they're there…Doc had the money, the right connections…I think that's when the drugs started getting heavy too, with Doc…You know, they didn't have to do it, they weren't held at gunpoint." Ironically, years later in its hey day, Nikki's drug habit never managed to get in the way of his overriding musical ambition and direction, which inevitably steered the band along their course through rock superstardom, "Nikki was very much in control, with or without drugs. Drugs never really affected him…I think he was right there the whole way, he didn't change as an individual that much, from album to album at all (with the drug use)…I never saw him get sloppy (until the Theatre of Pain album)."

Nikki himself has emoted mixed signals with regard to the role he felt his drug use played in benefiting or impeding Mötley Crüe's direction during the band's early period. He clearly felt personally as though reckless excess was as natural a direction for him as was Mötley Crüe's success, echoing his faith in the paths that his rock and roll heroes had taken with similar gambles, "I was destined for alcoholism and drug abuse because of my mother being an alcoholic. Finding out I later years my father was an alcoholic…My heroes had either died or were addicted. And so I figured this is my destiny." Though he would live as wildly as all of the aforementioned, and outlive all of those whom he had based the first ten years of his lifestyle as a rock star on, it would be years before Nikki would come full-circle with his destiny as it pertained to a rock and roll legacy was concerned.

In the meanwhile, as the band wound down off of the *Shout at the Devil* tour in late 1984, Mötley Crüe had achieved a new commercial height unrivaled by any rock band in recent times only three and a half years into their career. Evidence of the impact of the band's popularity would come late in 1984 when Vince Neil would take the life of Hanoi Rocks drummer Razzle in a tragically fatal car accident that would result in a charge of Vehicular Manslaughter for the laid back singer. Publicly, the incident would further bolster the band's notoriety, as Vince Neil was let off with little more than a slap on the wrist, that being several million dollars in financial compensation to the victims (picked up largely by the band's insurance policy), and a 30-day jail sentence, where Vince was allowed to bring groupies back to his cell for conjugal visits. Nikki himself had been out of town on vacation with roommate Ratt guitarist Robyn Crosby in Martinique when the accident occurred, and upon returning to the United States, had a private fit over the accident, while at the same time recognizing and respecting the additional notoriety it provided the band's constantly expanding image as America's most dangerous rock band.

Ironically, before the impact of the accident would hit Nikki personally or the band publicly, he, for a precious period of two weeks during the first vacation of his life on the tropical island of Martinique, was completely oblivious to the accident's impending reality. As famed rock photographer and close friend at the time Neil Zlozower remembered concerning the premise of the vacation, Nikki, having just finished the Shout at the Devil tour, wanted to get literally as far away from Mötley Crüe as possible, " I was like, 'Let's go have some fun! Let's pick an island.' And we didn't know if wanted to go to Martinique, and we were going to go to Guadalupe for a while, but, they went for two weeks, you

know, cause they're rock stars, so when they get off the road, they don't have nothing to do except write songs, and my thing was I'll go for a week. First of all, I got to pay bills, you know, I got a life, I got to pay rent, I got a girl friend, so I just went for a week, they went for two weeks. We all hung together, we all shared a room. Usually its two people to a room, we had three people to our room, so we had a lot of fun. Nikki was hanging with this French chick, who was to me, probably the finest chick on the island. I forgot her name, but she was really nice, probably the cutest chick. I was having a good time, handcuffin' girls and squeeze 'em right on the beach, doin' whatever. Robbyn had more pressure on him, cause he was getting ready for the next Ratt album at the time, he was trying to write songs for that, while me and Nikki were more care free. I mean, Nikki, Nikki wasn't ever a real big pot smoker, but he actually smoked pot on that trip because the pot was so shitty, so he would smoke the shitty pot. He didn't want the good pot here in LA, he wanted the shitty pot there."

Continuing, Zlozower recalled that "we all hung, I mean, Sixx and I probably hung more on that trip than Robbyn and I, Robbyn was a little distant, cause of the pressures he had on him. I don't think Robbyn had written many songs for the other Ratt albums, so I think he wanted to try to contribute more to this new record, obviously cause everyone wants publishing, so he wanted to get some songs on there for that. So, when the news of Vince's car accident came, I was already coming home to LAX, and my girlfriend at the time, Heather, picked me up, and hadn't seen her for a week, you know, we're at the turnbuckle getting the stuff, and I could tell she was a little weird. So I was like 'What's going on?' And she was like, 'Well you know Vince, he was driving with this guy Razzle from Hanoi Rocks, and they got into a car accident, and the guy got killed, he died.' And I'm like 'What!?? Are you kidding me!?' And she goes 'No.' And I'm like 'Oh my god, I wonder if Sixx knows about this?' Cause there was really no phones in Martinique, and it wasn't like there were American Newspapers and stuff, so I don't think Nikki knew, and I was like, does he want to know when he's on vacation? What can he really do? So, when Sixx got back to town a week later, he told me, if I remember correctly, I think he said he got to Florida...I mean, to go to Martinique, you have to fly to Florida, then you have to fly to Haiti, which is like the poorest nation in the world, then you fly to Port Prince, which is Martinique, so its a lot of flights, a lot of time, so I think he said he got to Florida, and some guy in

the airport came up and said 'Hey, aren't you that guy in Mötley Crüe who just killed that guy in the car accident?' And Sixx was like 'What? What are you talking about?' And so here some guy came up to him, and sort of said Mötley Crüe killed, and I guess, it wasn't really on the front pages of the newspapers outside LA, so I don't think he would have really seen it, so here he's flying back five hours on a plane from Florida to LA, going 'What the fuck was that guy talking about?' Then when he got back to LA, all this shit hit the fan."

As the reality of the potential impact of Vince's drunken driving accident began to sink in, Nikki experienced a full range of emotions concerning Vince, spanning concern, toward the band's welfare, to rage, at Vince's reckless disregard toward the latter. What remains largely in question to this day was, in the face of the mammoth responsibility Nikki had in shouldering Mötley Crüe's fate, where his importance of the loss of Razzle's life shown on his radar. In terms of how driven he was to keep Mötley Crüe moving ahead as hard rock's driving force, that guilt was largely left on Vince's conscience. Rather than viewing Nikki's reaction to the accident as insensitive, then-girlfriend Lita Ford preferred to classify it as logical considering Nikki's position within the band. Such that, while Nikki was clearly upset at the whole incident, he had no choice but to be more concerned with the potential fare Vince's action could have had on the band's own, "Nikki was totally upset, angry, it was a horrible, horrible thing…At the same time, Nikki said any press was good press. It gave the band a lot of press at the time. It just didn't seem to, it was a terrible thing, and…Nikki felt bad that it happened, but Vince just pretty much bought his way out of it. They had the money at the time, and they were shooting up so fast, that it would have been stupid not to keep going because a guy got killed. I mean, (Nikki felt) you just gotta keep going." And so they did.

Chapter 5

Theatre of Pain

 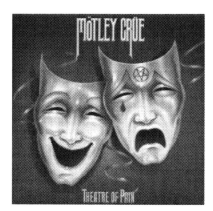

While Vince awaited his fate, the band as an organization wagered their own against the success of Mötley Crüe's third album, *Theatre of Pain*, which would, by all accounts, be the band's least favorite album personally, but their commercial turning point in terms of serving as a reflection of how popular the band truly had become. Highlights included the release of the band's first ballad, Home Sweet Home, which became the most requested video in MTV's history from 1981 through 1985, Nikki's very public, though brief, engagement to Vanity, Tommy Lee's courtship of television star Heather Locklear, and a band comic book recounting Vince's car accident, and the especially light 30-day prison sentence he received. Though the band considered most of the album a throwaway, with the exception of the aforementioned ballad, and the band's first top ten single, a cover of Brownsville Station's Smokin' in the Boys Room, they had in four short years come full circle as hard rock's infamous and most successful act as far as the 1980s were concerned. Nikki, during this period, identified *Theatre of Pain* as being most in synch with what the band was focusing on in the course of their first headlining tour, their image as a

live band, such that it was ultimately less important how substantive the material on the band's third album really was, "I fond a book called 'The Italian Comedy', and I was just flipping through it, and got the whole idea for comedy and tragedy masks, the idea for the album cover, its not a conceptual album. Its just the idea behind the stage show mostly. I wanted to do something different and real theatrical, which is what we're really about."

Following Vince's car accident, from which the band walked away virtually unscathed, most who were close to Mötley Crüe, and Nikki personally, agree that they had begun to feel invulnerable, and in the process, more and more open to redefining the limits of excess with no one attempting to keep them at all in check. While what would eventually become Vince's manslaughter conviction cost the band's label hundreds of thousands of immediate dollars, the incident served to fuel their longer term notoriety among rock fans, and as such, Elektra did very little in attempting to reel the band in from what was becoming the perfect storm. A ready example of the latter point was an incident in which Elektra Records had planned to release a Christmas 1984 limited edition Mötley Crüe EP featuring photo outtakes from Nikki's blood shoot with Neil Zlozower, wherein, as Neil remembers, "at the time, I had already done the blood session, I took it over to Elektra to show to Tom, who was their A&R guy, he wanted to buy the shoot and come out with this special sort-of Christmas CD, with the whole Helter Skelter blood thing, which they actually pressed up, with the photos on the cd, dripping blood, it was just a much more visual presentation, and I guess, Elektra pressed a whole bunch of them, and were even going to go beyond promo, and sell them, but they canned the whole deal, they thought at the time it was quote unquote 'bad taste' at that time because of Vince's accident."

To further the band's feeling of invulnerability, rather than making Vince directly responsible for the financial restitution included as part of his legal settlement, Mötley Crüe's management turned Vince's fatal drive with Razzle to the liquor store into a business meeting so the band's insurance would be liable for the settlement, rather than the singer personally. As Vince recalled in the band's official biography Dirt, "when we flew back to L.A. in between legs of the (*Theatre of Pain*) tour, my lawyer arranged for a meeting in court with the district attorney and the families of the others involved in the accident. In order to avoid a trial, he

advised me to plead guilty to vehicular manslaughter and strike a compromise. He figured that since the people drinking at my house were mostly in Mötley Crüe and Hanoi Rocks, the party could be explained as a business meeting we would be able to pay damages to the families through the band's liability insurance." Another facet of the beginnings of the band's downward spiral toward self destruction during this period was Nikki's escalating heroine use, much of which began with his close friend Robbyn Crosby, who tragically would contract H.I.V., and eventually AIDs, as a result of the same Heroine addiction he had pioneered with Nikki beginning in late 1984, and increasingly steadily throughout the beginning of 1985, during the recording of the *Theatre of Pain* album. As Neil Zlozower remembers concerning the earliest days of Nikki's heroine addiction, "I remember, when I first met him, Robin Crosby was living in an apartment below his apartment on Coldwater, right by Riverside, and we used to go there. I remember hanging out there, getting rotted at his house, and he had these chicks over all the time, and we were, you know, messing around with them… We used to all go out and get fucked up all the time. Robbyn and Nikki had different preferences in their methods of getting fucked up, which wasn't my choice, but I still hung with them."

For Sixx personally, this period began with what Neil Zlozower remembers being the beginning of Nikki's development of something of a God complex, and as such, "(before 1986), I considered Nikki back in 84, 85, back during those two years, probably as one of my best friends. I mean, he had a really fun side. You know, the band was pretty huge, he was getting a little taste of wealth, and a taste of recognition, and he could basically, fuck any girl he wanted to fuck. You know, he had chicks hanging all over him…but as they got bigger, and bigger, and bigger, they sort of lost track of reality, and they really were." Tom Werman agreed with this assessment from more of a musical point of view, identifying the recording of *Theatre of Pain* as the first period in which the band had, due to enraptured excess, begun to lose sight of their creative edge, "Theatre of Pain was our low point behaviorally." Though it started out as a joke, the producer humorously recalling that when reflecting on Theatre of Pain's lack of creative soul, what "Nikki neglects to say is that, 'While we were working with Tom (on that album), we were injecting Heroine in our bodies.'"

As the band worked with Werman on the recording of *Theatre of Pain* while Vince served out his 30-day prison sentence, the producer recalled that as wild as the band's partying continued to be, "with Motley, the drugs and boozing and partying didn't really get in the way of recording, except during *Theatre of Pain*, it did. Nikki would do things that were very strange, that didn't have any reason. I remember, there was one song, a ballad, where Nikki came in with a set of lyrics, and said 'Here are the lyrics to this song.' And I said 'Wait a minute, we finished this song.' And he said 'No we didn't, here are the lyrics.' And he wrote completely new lyrics, never mentioned anything, I think we'd done the final vocal. And that was when I turned to my engineer, and said 'What's the deal with these guys...' And he said 'Dude, he's a junkie!' But I have to hand it to them, they handled it really well. Nikki was a good junkie, he was a practiced junkie. And I later realized that I had spent time with Nikki and Vanity at Nikki's house when they were both shooting up, but I didn't see them. I just knew they were doing something. Because Cocaine's as far as I ever went, and believe me, I enjoyed it. But I found to work around it."

Elaborating, Werman candidly explains that "the *Theatre of Pain* album was a very hard album to finish. I think their focus- they were tired, they were road weary, they were under pressure to write another album quickly, and their focus was not clear. The second album, any album that follows a big hit- always a tough one, always a tough one. Because there's pressure, people don't leave you alone. There are people who want to be in the studio, and people are calling you up, and you're flush with success, and you're famous now. Its just so distracting, everything's distracting. And they were enjoying the fruits of their success, and now they had to duplicate it or better it, and that puts alot of pressure on a band. And they tend to try to escape more, and take more drugs, and the whole thing isn't healthy for the creative process. I was used to that by then, but all you can do is try to move things along in the studio, and get it while the getting's good, and pay attention to deadlines. Try to work hard. I think there was more... either the third album, or the first album, but never the second album is fun. You never think of the follow-up album is fun. If there's a time to be serious, and not to have and not to have girls or drugs or booze in the studio, this is it. As far as partying myself, Cocaine's as far as I ever went, and believe me, I enjoyed it. But I found a way to work around it."

With drugs as a dominating theme on the *Theatre of Pain* sessions, Werman explained that "as a producer, there really wasn't that much adapting to do with regard to working around that sort of stuff. There's not a whole lot of difference between being high on weed, or drunk, or high on coke, or junked out. There's not that much difference. Motley would not nod out, they would not come in and lie down and go to sleep, they would not slur their words. They were ok. I mean, I actually had to be informed that they were shooting up. I never noticed it with Tommy, ever. I just noticed it with Nikki. There was really no adapting, because Motley Crue was probably more reasonable on heroine than they were when they drank. Because then they weren't rowdy."

One tactic Tom Werman employed to motivate the band to focus during recording was consistent with an already-dominant theme in Motley's music, that being the constant presence of beautiful women. As the producer explains, "I always urged bands to bring girls into the studio. Not only was it personally a great diversion to observe this kind of thing, but I found that the bands performed much better. If you're in there with Motley Crue, just the guys, or Poison, just the guys, there's just peer pressure. But if there are girls watching, especially strange girls that you don't know, then you're going to perform at your very best, and I always tried to make that happen. So there was only good to be gained, benefit to be gained from having girls in the studio. I hated it when it was just a boys club. It ain't rock n' roll. Pure guys writing songs about girls, singing to girls- without girls? No, girls belong in the studio, and sexy girls, young girls, rockin' girls. That was good, all good. There were no activities, its just that they would get a little noisy, and you had to ask people to step outside if they wanted to talk, or tell them to shut up. But, it was good. Everybody was happy when there was pretty girls in the studio. Nobody was bummed out, nobody was pissed. Things happened."

Theatre of Pain would produce the hits 'Smoking in the Boys Room', 'Keep Your Eyes On the Money', and most notably, 'Home Sweet Home', which Werman recalled was unique for the band in that it was their first power-ballad, but in what may be surprising to the ears of fans, involved what had become a mainstay by that point in the band's music- the presence of "alot of Hammond B3, which was on all the Motley Crue records, just people never heard it, but it was there. Because as Deep Purple proved, the combination of a distorted electric guitar, a distorted Leslie, and a Hammond B3 is a really great combination. And they kind of work together." In recalling the specifics of how 'Home Sweet Home' came together, Werman remembered "Tommy sitting at the piano, playing this little riff over and over, and Nikki suddenly got really excited about it, and came in the next day with the complete lyric set. He fleshed out the music some, and Mick added a really nice guitar solo over it. The song came together very quickly."

While Werman like most of the band's management was quick to link this artistic low point directly to the band's excesses, he found it that much more frustrating to live with because, while it got in the way in the studio, it paradoxically served to fuel Mötley Crüe's public bad boy image among fans. At the core of Mötley Crüe's creative deterioration was Nikki Sixx's heroine usage in the studio, such that "at its worst, (Nikki's heroine use)

clouded his sense of direction." In short, as the wear and tear of the band's excess began to show its ugly potential, no one knew how to slow the band, specifically Nikki, down. Some within their management tried, though most were forced to turn a blind eye. In doing so, the band's management was forced to look for upsides, one of which their producer remembers, tounge-in-cheekly, as being that "perhaps, the fact Mötley were using drugs regularly, made them as a band more agreeable, less likely to object to things. Whatever the musical decisions were, they probably agreed to my decisions more readily doing drugs." While humorous in retrospect, Werman's observation points to one of the band's most strenuous underlying tensions during this period, that being the relationship between Nikki and singer Vince Neil, specifically in Nikki's struggle to come to terms with the fact that, despite his role as Mötley Crüe's creative center, Vince was an equally as integral component to the band's continued success. Within Nikki's own ego as it pertained to controlling Mötley Crüe's destiny, this was a reality that never sat well.

A potent reminder of the latter was Nikki's reaction in the immediate aftermath of Vince's car accident, where, after returning from Martinique, he went into a rage, threatening repeatedly to eject Vince from the band permanently, usually to anyone who would listen. Unfortunately, Nikki, as well as everyone else around him, knew that Vince was ultimately irreplaceable. As Neil Zlozower recalls Nikki's reaction to the news of Razzle's death, "more than once, Nikki was like, 'Dude, that guy, I fuckin' hate him, he's a beaner, I'm gonna kick him out of the band.' So he was pretty livid after that, 'That fuckin' Vince, that motherfucker, that fuckin' asshole, I'm gonna kick him out of the band!'…But You gotta understand, Nikki and Vince sort of had a love/hate relationship… I mean, Vince is a good front man, but Nikki knew there were better singers in the world. I mean, to me, John Corabi, vocally will wrap circles around Vince, but Vince is made for Mötley Crüe. Vince is the front man for Mötley Crüe, period. No one wants to see another front man in Mötley Crüe. Just like no one wants to see Gary Charone in Van Halen. So, Vince is the guy for Mötley Crüe. But at the time, there was a lot of back and forth about getting rid of Vince."

Interestingly, while Vince was keenly aware of his importance to the band's continued commercial success, displayed most visibly through his reckless disregard for the band's welfare via incidents like the drunken

driving incident knowing he would get away with it, he, in the same time, experienced a ready paranoia about his fate knowing it ultimately laid in Nikki's hands. As he recalled in the band's biography, Dirt, while sitting in his jail cell serving a 30 day sentence for the vehicular manslaughter conviction, which the DA had agreed to postpone until after the conclusion of the Theatre of Pain tour, Vince was constantly caught in the midst of a rock and roll paradox, reveling in his celebrity status while worrying Nikki would be working behind his back to end it, where possibly he was incapable of deciphering the right from wrong of his behavior, "In jail…on the weekends, the guards would bring us burgers and a six pack…One afternoon, a blonde fan who had figured out what jail I was in stopped by to visit. She was wearing Daisy Dukes and a Lycra tie-front halter top, and the sergeant on duty said I could bring her back to my cell for an hour…I took her to my cell, shut the door, and fucked her on my cot…(Even from the first nights in jail following my initial arrest), I imagined Nikki auditioning new singers and leaving me to seven years in prison and a life of scorn as a walking murderer."

It wasn't until years later, following the band's departure with Neil in 1991, and they re-connection in 1996, that Nikki would come to full term with the reality that Vince was as essential to Mötley Crüe as Nikki was, that as a team they worked best together. While neither band member would be big enough at the time to look beyond their own respective egos to discover that truth, it was one Nikki reflected on fifteen years later in the band's biography, remarking that while Vince was in jail, "I didn't call him, I didn't visit him, I didn't support him in any way whatsoever. I was, as usual, only interested in indulging myself. Why wasn't I there for him? What was the reason?…When I thought about Vince, it wasn't with pity; it was with anger, as if he was the bad guy and the rest of the band members were innocent victims of his wrongdoing. But we all did drugs, and drove drunk. It could have happened to any of us. But it didn't, it happened to Vince…And (I thought) Mötley Crüe was dead at the starting gate." Ultimately, and perhaps ironically, according to Nikki, Vince's accident brought the band closer, "we've always been tight, and the accident just helped to make us closer. I've been in a bad car accident, and so has Tommy, and we were both very drunk when it happened, and it happened to Vince, who wasn't nearly as under the influence as us, so it made us tighter."

With perseverance in mind, the band moved on, releasing *Theatre of Pain* on June 21st, 1985, peaking at # 6 on the Billboard Top 200 Album Chart, their highest ranking yet, going on to sell in excess of 4 million copies. The band thereafter commenced on the Theatre of Pain tour with Vince back in the fold, riding high and successfully into what would prove to be the band's most notorious and destructive period. Still, things had gotten better for the band overall, and this period in 1985 was one of growth for Mötley Crüe commercially, and therein personally, at least in terms of the off-stage lifestyle there were able to lead materially, as Nikki recalled, Crüe had become a more worldly band, "during *Shout at the Devil* there were a lot of down and hard times for Mötley Crüe, that came across very violently (in our music). With *Theatre of Pain*, we've moved forward in the sense that we've seen a lot, just in life we've seen a lot. We've been all around the world, and I think that shows (now) in the music a lot."

In describing the band's on-the-road schedule, Nikki and company lived the typical rock n roll lifestyle, "we sleep a lot (during the day), recuperating from the night before. We're definitely vampires, like night people, we usually stay up pretty late. An average day'd be, we get up at around 2 o'clock, do some interviews, then we go to the hall, do sound check, make sure the set's right, by then its time for the opening act to go on, time for us to drink, and it takes us like an hour to get ready, which gives us more time to drink, we have a good time…I had this major orgy scene going in my room. There were maybe 20 people there, snorting coke, having sex, smoking opium, you name it. These porn stars come over and hand out pills that were like elephant tranquilizers. They freaked me out. I went completely paranoid, convinced that someone was outside the door, waiting to get me. I thought the smart thing to do at that point was to smoke a rock. That really sent me over the edge. It was truly hellish. Did it stop me repeating the experience? Hell, no." Nikki and company had already experienced a lifetime of fame, drugs, wealth, and unbridled excess in just five years, and had done it all in the name of rock and roll. Now it was time for *Girls, Girls, Girls*, a level of overload that rock and roll had never before seen, and one that would ultimately cost Nikki Sixx his life, for a few brief, but ultimately sobering moments.

Chapter 6

"Name-droppin' no-names, glamorized cocaine puppets with strings of gold…" – N. Sixx

"Heroin addicts are extremely clever and extremely functional. William Burroughs took his addiction to his grave. He was the gentleman junkie. He wrote books. Nobody would say he's a dysfunctional person." – N. Sixx

Wild Side

When Mötley Crüe came off the road in late 1985 following the conclusion of the *Theatre of Pain* world tour, they were bonafied rock and roll super stars. Where just four years earlier they had been starving Hollywood street musicians clawing their way to the top, the members of Mötley Crüe were now millionaires living a life very far removed from those hungry roots, at least for lead vocalist Vince Neil, who now lived in a

beach front mansion in Redondo Beach, and drummer Tommy Lee, who was involved in a serious relationship with TJ Hooker/Dynasty television star Heather Locklear. Interestingly, in spite of their meteoric rise out of Hollywood's gutters, Mötley Crüe had defined their first four years as a national act, and largely in the process the genre's, as the quintessential trend setters, from leather to pentagrams, to glammed out bad boys, largely by emulating nationally in real time what was occurring locally in their home town of Los Angeles. Per every new Crüe album, a slew of copy-cat acts had trailed behind them onto radio and MTV, wherein, whether or not they had preceded Mötley Crüe locally in Hollywood, the majority followed them out onto the national stage. As such, the next generation of Mötley Crüe offspring were constantly in fertility at home in Hollywood.

What had mystified Record executives and critics time and again had been Mötley Crüe's uncanny ability to stay one step ahead of the national trend, thereby setting many of hard rock's platinum trails ablaze. Their formula was two-fold, rooted in radio-oriented hit records and a live act that showcased a happy medium of thematically-fueled adrenaline hard rock that was accompanied by an undeniably bad ass on-stage presentation that fans couldn't help but eat up. What those pondering Mötley Crüe's secret often missed was the simple brilliance of Nikki Sixx's strategy for keeping Mötley Crüe one step ahead of the competition- never forget the place that made you. To that end, whenever the band was off the road, Nikki, due in part to his escalating heroine addiction, and desire to keep his ear to the street, spending much of his time soaking up the latest and hottest trends on Hollywood's underground scene, which, divulging a central part of Mötley Crüe's recipe for staying ahead of the game, he would incorporate into the band's next album concept, taking it nationally before anyone else had the chance to.

As Nikki himself joked to one reporter at the time when asked what he thought of his status as a rock star when he wasn't onstage playing the role, "if you want to find Nikki Sixx when he's not onstage, go look for him on the streets, hanging with the kids, sharing a beer and a sandwich 'cause that's where I'll be, man…on the streets where I belong." The reality was that while Nikki was still hanging out, it wasn't just for the socializing. In reality, Nikki was very much the student, doing his homework on the latest underground trend going around in the one place where it always started-

the streets of Hollywood. As former Salty Dog/Dangerous Toys bassist Michael Hannon recalled Mötley Crüe's sustained physical presence in Hollywood locally long after they had established themselves nationally, "I remember Mötley Crüe going around in 1986 on the LA Club scene, copying that, putting their albums out, and it looked like they were the trend setters, when they were actually just following what was going on in LA. If you remember, they were that hard ass glam, on Shout at the Devil, that was when bands like WASP and Malice were big, and it was all real metal looking, all that black leather stuff, and then Poison became the big...bigger than Guns N Roses, they were the biggest thing out there (locally in Hollywood, but they couldn't get signed). But everybody was glam, wearing pink and orange, and scarves and shit. They were selling out The Country Club, which was huge, probably held 1500 people, and they were selling this out without a record deal, like two nights in a row. And Nikki Sixx was always there, you would always see the som'bitch...So then Mötley put out Theatre of Pain, and they went from black leather metal looking to all of a sudden, they were glam as fuck. And then the rest of the country was thinking 'God damn, they started the whole trend.'"

In describing Hollywood's Sunset Strip as it had evolved from the Starwood to the Cat House, from 1981 to 1985, Nikki would have had to have had at least one foot still planted in the scene to stay current, as it was constantly vibrant and full of a hungry energy that was the stuff of legends in the making. Ironically, in the end of the day, one of the fundamental realities that kept Nikki connected to the latest wave of rock's ambassadors to his roots was the fact that, at heart, he still was just another runaway from the Midwest who had come to LA to start over. In describing the scene, Michael Hannon recalled that, "there was basically that one strip there between the Whisky A-Go Go, and Gazaris, that one side of the street, that would have been the Northside of Hollywood Boulevard, between those two clubs, and you just walked back and forth, picking up chicks, or chicks picking up guys. Everybody was painted up good. Everybody dressed up, everybody was a star, it was great. That's what grunge killed, was the star thing. It was just great, the weather was always nice, so it was great, you could wear whatever you wanted, all these skimpy outfits, it was great for sex. AIDS wasn't a real popular sport yet, so it was like you know, regular venereal disease then, Gonneria or something that would put you down for ten days at best, I mean Herpies was the big problem then. But there was no AIDS, we didn't even know

what that was. Glam was the flavor of the month, and it was great because all these guys came from all over the United States to LA to do it, so there was this huge influx, where all of Hollywood was basically just rock people. It was great, it was our own community. There were black communities, there were oriental communities, and there was a rock community! It was all long hairs, and so trying to stick out was the thing, because everybody starting out was just another band."

Continuing with his description of the Sunset Strip bar scene, the Salty Dog bassist recalled such hair metal hotspots as including "Gazari's, The Roxy, and the Whisky, those were the big clubs back at that time, on that North side of Sunset. And then there was the Troubadour, which was great, because it had a front bar, which was free, to walk in this front bar and sit there and drink. And there was a window behind the bar, and you could see the band if you wanted. There was this toilet in there were everybody did coke, but you couldn't get a blow job in there because there were too many people knocking on the door all the time. Above that was the dressing rooms for the band. They were little shitholes, just basically for you to put your makeup on, the most important thing at the time. (Back then) everybody had big hair, from Poison to Guns N Roses. There were two types of glam, pretty boy poofy, bright colors and shiny stuff, like Poison, and then dirty, evil, rotten heroine-looking glam, like Guns N Roses looked at the time. You would always see Nikki around, studying, he was smart as hell. He saw how big Poison and Guns N Roses were in LA, and he (had the foresight to know) that was the trend that was going to go across the country."

While Nikki Sixx wasn't ripping anyone's ideas off due to the fact that he was essentially refining what he saw as unpolished diamonds and giving them a national shine, he was certainly collecting residuals from the scene that had made him, and that in essence, he had helped to very much make. In reality, it was very much one hand washing the other. As Hannon concurs in recalling the impact that *Girls, Girls, Girls* release had on turning the nation's hard rock scene from eyeliner and spandex back into denim, leather and Harley Davidson's, Nikki's method for defining LA's home turf as the nations' concerning Hard Rock was essential to keeping it fresh. And moreover, in the long run, crucial to the industry in terms of breaking Guns N Roses, who would go on alongside Mötley Crüe and a select handful of fellow rock giants to define the latter half the 1980s. Ironically,

no matter how big it got, Hard Rock's creative heart was still actively centered in Los Angeles, "once (Nikki) saw Guns N Roses wearing denim and black leather, Mötley stopped poofing up their hair, which had been the biggest thing in LA, and all of a sudden you had Girls, Girls, Girls with the Harleys. And if you look at the records, look back at the years, they kind of jumped on that bandwagon (and took it national), and it made it look like they were starting it again...Nikki Sixx was smart as hell, he kept his ear to the street, watch what the fashion was, and to all the other bands out there at the time knew that Mötley was just following what was going on in LA. It was pretty obvious to us cause we were there, we were ahead of the game at the time, LA was the capital of Rock and Roll. And you could always see, Mötley would nationally be what was the most happening club band in LA."

Nikki took his role as Mötley Crüe's, and essentially hard rock's national trend setter, seriously enough to not just soak up the latest version of the Hollywood scene peripherally, but instead to remain an active influence in guiding and shaping many of the Sunset Strip's hottest up and coming talent. One band which Nikki took under his wing was Guns N' Roses, whose guitar players were regulars at Nikki's Hollywood Hills home during their early days as Hollywood's local starlets. As Nikki recalled, Guns N Roses in their earliest days were almost a carbon copy of what Mötley Crüe had been when they were starting out four years earlier in terms of the bands' local celebrity. In addition to keeping current with the trends, Nikki felt something of a paternal instinct toward the band, taking them under his wing, and in the process, under his influence, "basically by the time (in 1986, when we got off) the road we had got to the point where we couldn't go anywhere. We had to hide because it was so overwhelming being Mötley Crüe that you couldn't even go into a grocery store without getting bombarded with people. And (Guns N Roses) had not reached a status like that yet, so we ended up hanging out."

Nikki's role in mentoring Guns N Roses, at the time the hottest band on the sunset strip, was that of a tenured professor at Rock and Roll University, with a curriculum that combined Advanced Debauchery 101 and Basics in Living the High Life. Guns N Roses at the time were already honors students in the subjects of partying hard and living fast. Little did they know that a short year later their teacher would be eligible to offer a course in dying young- as almost two thirds of the band's members would

be partying with Nikki Sixx the night of his lethal overdose. More importantly, Guns drummer Steven Adler would be one of those present who Nikki later would owe his resuscitated heart and life to. Still, a year earlier, Guns N Roses, among a number of other hard rock up and comers, were eager be affiliated with a band they regarded as a living legend. As Slash recalled, from the early 1980s, "the kings of the Sunset Strip were definitely Mötley Crüe." Another fledgling rock star, and ironically former member of Guns N Roses first incarnation, Hollywood Rose, Tracii Guns, lead guitar player for LA GUNS, elaborated on the Sunset Strip's continued vitality in the mid-1980s, as a result of Mötley Crüe's continued influence, and his desire to be a part of it, recalling that "when (Mötley) started popping, everything in town got groovy. I must have been around 15 or 16, and I would see…Nikki Sixx driving a giant car. And the girls- I mean, I'm 16, and there are all these hot girls with big boobs everywhere. I had to be a part of that, somehow. And by 1985 or '86, we were those guys. We took advantage of the situation and had a really good time."

By 1986, Sixx was a local Godfather to the Sunset Strip's next generation of hard rockers, and he relished the role. While Mötley Crüe vocalist Vince Neil preferred the country club circuit and Drummer Tommy Lee, while maintaining some presence in LA's underground, was by that time married to Heather Locklear, exported off into the social limelight of Hollywood television and movie stars, and therein inherently removed from the streets that had made him. Mick Mars was an absentee in any social regard, which more times than not left Nikki Sixx as the Crüe's sole liaison to the newest crop of up and coming rockers. In truth, they were source of Nikki's inspiration for Wild Side, among a variety of other songs on *Girls, Girls, Girls,* which has been credited historically with being among the most accurate reflections of LA's Sunset Strip scene as it had evolved throughout the first half of the 1980s. Though Nikki was no longer a street kid, with a million-dollar home and a $10,000 dollar-a-week drug habit, he still kept one foot firmly rooted in the gutter, and by associating with LA's hottest and hardest partying bands, Nikki kept his edge in a time when he could have lost touch with the reality that composed so much of Mötley Crüe's edge at the time in sound and image.

As he recalled the process of his inspiration forming for what conceptually became the *Girls* album, Nikki readily admitted his latch-on to the streets was in part the only way the band could maintain clarity in the

face of what he described as a time when "we came out with Theatre Of Pain and it was about mainlining cocaine and we were on a hallucinogenic trip from hell. Somewhere along the way people thought we were a glam band. We were fuckin' high. We were a fuckin' dope band. We were The Dolls, man, on more drugs. Confusion...(My life was) like a razor that was going to split me in two...I'm sure there were red flags everywhere. But I obviously ignored them. Let's get one thing straight- drugs can be good, you can have a great time on them. When debauchery is good it's great. But when it's bad it's awful. And for me that was the point I'd got to. For me it was no good any more. You crash your Porsche into a tree at 90mph and dislocate your shoulder. And you get out and carry on. It's like what do you need to stop you? A brick wall? I got my brick wall and walked away." Through his continued association with LA's underground of upcoming rock bands, Nikki was able to weed out what he felt were the legitimate contenders to carry on the legacy that Mötley had created (like Guns N Roses), from those who he viewed as posers (like Poison). Nikki admitted as much in an interview with Spin Magazine in a retrospective on LA's Hair Metal days, recalling that "when I first saw the aftermath of the second generation of bands, I was a bit bitter. I was like 'These fucking bands like Warrant and Poison- awww! You gotta be kidding, man! They're not serious.' And there we were, giving interviews where they talked about partying and being crazy, and I was like 'They don't know. They're faking it.' But the bottom line is we did spawn some of those bands."

By accepting the reality of bands like Poison, Nikki was, through being aware, able to hone his radar in on which bands were the real deal at the time with the kids who streamed in from all over the surrounding Valley to party on the Sunset Strip weekend in and out. As a fan base reflective of a national demographic, Nikki was able to see which bands they were hot for, and what stylistically Mötley Crüe needed to be hip to in their own look and sound. In support of the latter, Guns N Roses' original lead guitarist Slash remembers that it was, at the time, vitally important to be able to draw a distinction as a young band between what Mötley Crüe has represented historically and what newer, more generic bands like Poison could do to corrupt that legacy, "it was basically (still) a scene, but I always thought it (had become) pretty cheap and basically poseur central, because everything was so plastic... That was part of the reason we hated it so much...(Back) in'81...(Crüe had been) all about publicizing themselves and creating an image and creating a whole atmosphere (to

follow)… Poison was sort of the band that was going to carry Mötley Crüe's torch, but by that point, Hollywood had no balls."

In light of the latter, by befriending bands like Guns N Roses at a time when the Sunset Strip was starting to drip in toxic aqua-net saturation, Nikki was able to inject his own little dose of influence into what they projected as cool. Toward that end, alongside the basic object of making new friends who were runaways at heart just as he was, Nikki was creating for himself the closest thing to a family outside of the band as he could, and keeping those newer bands he deemed to be worthy hip to tips he felt might keep them ahead in the struggle toward fame. In many ways, Nikki's kin at this point in his life were his fans and fellow Hollywood rock n' roll suicide kings, and he did everything he could to make them all feel like royalty, "Back in LA of course…everyone (would) just hang out and would go to the Cathouse and go get tattooed and a lot of times people would just come and hang out at my house, I had a kind of party house in the Hollywood Hills. Everyone would taste every substance we could get our hands on, it was just really good times."

While rock and roll ran through the Sixx gang's veins during many a late night party, so too did plenty of substances (both of a narcotic and alcoholic nature), as the Sunset Strip was basking in its own version of the glow of the roaring 1980s. As Sixx recalled a typical night of partying, "it wasn't like a glass of champagne and a little line of cocaine. It was half a pound of cocaine and the whole champagne truck. I remember being at (L.A. rock club) the Cathouse. Riki Rachtman and Taime Downe were running it at the time. I asked them if they had a beer bottle cap. I spit in it, poured some cocaine in it, and shot up right in front of them. They flipped out. I was like, 'What's the problem?' I didn't get it, because that's who we were." Still, while partying was always a central theme to Sixx's gatherings, he also went out of his way to make himself accessible as a person to his fledgling rock star friends, opening not only his house but also his mind to hear what anyone had to say in conversation that ranged from their own struggle making the climb toward stardom to the historical hard rock influences both bands had in common, namely in Aerosmith. For Nikki, those times brought nothing short of the best of times, dominated by "fond memories…just hanging out real late, early in the morning, the fire burning, just talking about music man. They were good people…I

mean me and Slash and Duff and Steven, and even Izzy, have always hung out at my house."

Through developing relationships with most of the members of Guns N Roses, Nikki, in addition to striking up friendships with his fellow rockers, also experienced a chance to witness firsthand how hard it still was for up and coming bands, even those who went on to be as huge as Guns N Roses did, to just get by. By the time Guns N Roses were the top club act on the Hollywood Strip, the scene itself had become saturated by more the success of more generic pop metal bands like Poison, who spit confetti into the crowds at their shows while Slash & Co. spit their own blood. Perhaps Nikki's kinship with Guns N Roses rooted itself partly in the fact that they lived a similar lifestyle to the one Mötley Crüe had in its early days in terms of its extremities, both in the context of the partying and the survival. Nikki has in the past clarified the distinction between bands like Guns N Roses and their later 1980s counterparts, remarking that "except for (Mötley Crüe) and Guns N Roses, I felt that most of the bands of the mid-to-late 1980s were faking it...For me, the likes of Poison and Warrant are enough to make me sick." As Steven Adler, Guns N Roses original drummer recounted some of the band's toughest times on their way to the top, many, such as their relying on female fans to survive, were similar to those which Mötley Crüe had gotten by on, such that, as Adler recalled, "we'd (Slash & Adler) go out and meet chicks - older women - who would take us back to their Beverly Hills homes. They'd give us booze, coke, they'd feed us, really. All we'd have to do was fuck them."

Other avenues that Adler had to resort to in order to feed both his stomach and his drug habit, were less glamorous, and marked a road less traveled by Sixx and Co. back in the early 1980s. As Adler confirmed, he at times became too desperate that he would prostitute himself out to generate income, "occasionally a guy would pick me up. In return for a blow job, I'd get a little dope and 30 or 40 bucks." By witnessing the severity of the struggle that a band like Guns N Roses endured, Nikki also gained a perspective on how lucky he had been to avoid such travails as Adler's', experiencing a somewhat purer form of sacrifice that had what at the time was a still largely untapped pool of resources from which to pillage. Looking back at what the Sunset Strip was in early 1981, in contrast to its later incarnation at the height of hair metal's popularity, Nikki illustrated the contrast in what at the time had been a virgin vein in

contrast to the bruised and battered one that the second wave of LA hard rock bands, the Baby Mötleys, had to ensure on their way toward the top, "Where ever we went (in our early days on the Strip), it was like a swarm of bees around us. People had to be close to us and touch us, and girls were like, 'I'm gonna fuck you tonight.' And guys were like, 'You're gonna do my drugs tonight.' And it sort of became the norm. I didn't think anything about it (till later)."

Nikki opening his home to bands like Guns N Roses could be seen, at least in part, as Rock n Roll charity, his way of giving back to the community that he had made and that had made him. Still, there was undoubtedly a commercial angle to his associations as the Crüe worked late in 1986 on their fourth and most debaucherous album, *Girls, Girls, Girls*. While historically one of the Crüe's most popular albums among fans, and certainly their most accurate depiction of the Sunset Strip since *Too Fast For Love*, with the *Girls* album, Mötley Crüe had essentially gone local again, getting back in touch with the core fan base that had made them stars to begin with. Possibly fearing what the next generation of hair metal would do to the legacy Mötley had been central in molding, Nikki sought with *Girls, Girls, Girls* to put LA back on the map in a harder, edgier shade than had been portrayed nationally in recent years, one that exposed both the limelight and the shadows.

From the opening lyrics of the album's first cut, *Wild Side*, Nikki was channeling a new generation of angst among Hollywood's runaways into the national spotlight, "Kneel down ye sinners, to streetwise religion, greed's been crowned the king, Hollywood dream teens, yesterday's trash queens…Name dropping no names, Glamorize cocaine, Puppets with strings of gold." Again, like *Too Fast For Love* when it took off, at the time, no one was doing anything on a national level like Mötley was with the *Girls* album. Bands like Poison, who had signed a deal with Enigma a year earlier and released their debut LP *'Look What the Cat Dragged In'* to platinum success, were dressing in colorful, neon spandex and dressing like women, reflecting what had become a viable but poppier and more generic offshoot of LA's hard rock scene, and labels were taking notice.

As Guns N Roses former lead guitarist Slash (who ironically once tried out for Poison only to be beat out by C.C. Deville based on his glammy look) depicted the scene locally in 1986, Guns N Roses represented the

closest thing to Mötley Crüe at the time, principally in terms of their authentic representation of Hollywood's runaway root, while bands like Poison had diluted the reality of the struggle that many bands went through with their candy-pop image, "Hollywood had no balls (by 1986), which is part of why we hated it so much. Now, I did audition for Poison; that is true. There was a point where I was willing to do anything, and- as much as I hated what Poison was about- you have to do whatever it takes to make it. So it came down to me and C.C. Deville auditioning to replace their old guitar player, and C.C. was perfect. I could play the shit out of their material, but I definitely didn't look the part. I don't think C.C. was really the greatest guitar player- which you didn't need to be in that band- but he had the look."

It was Motley Crue who took art and made it imitate life and visa versa as they headed into the studio to record their fourth album, '*Girls Girls Girls*,' with Billboard Magazine highlighting the aforementioned fact that "the Crüe really plays up the sleaze factor on this album, trying to recapture some of the street-tough grittiness that fueled *Too Fast for Love* — even appearing on the cover astride motorcycles and wearing leather; this time around, the influence of Aerosmith is felt to a much greater degree. The production is too polished to really give the record a raw, dirty feel, but the raunchiness comes through all the same."

Chapter 7

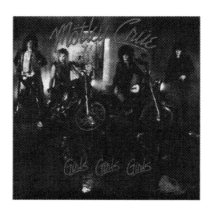

Girls, Girls, Girls

As the band entered the studio in October of 1986 to begin recording, Tom Werman was more excited than ever based on the demos he'd worked with in pre-production. Looking back in hindsight, Werman felt that "Motley Crue arrived sonically with '*Girls, Girls, Girls*', that's always where I wanted to hear them." Because of the band's natural experience after 6 years together, Werman- as a former top A&R man in the 1970s- was able to fine-tune the singles Nikki Sixx had presented him for radio, producing what he felt instinctively were going to be "3 or 4 really good singles, and that's all you needed. *Girls, Girls, Girls* was obviously going to be their biggest hit single to date, and then *Wild Side* was a fantastic, indulgent, sonically wonderful FM cut, which you knew would never be a single. So we fucked around, did some great things with it. Man that was good. I just thought *Wild Side* was one of the best things they ever did."

Highlighting the creative nerve-center of the band's artistic process as it came to life in the studio, engineer John Purdell recalled that "Nikki would come into the studio with these great songs, and from basic tracks on up, he was the songwriter. Nikki was the real straight-ahead, pro guy who knew what he wanted, and he would come in with the ideas 80 to 85% done. Mick Mars would write some riffs with him, and Nikki would

then be pretty much the leader in the songwriting end of it around those riffs. It was mainly Sixx and Mick with the guitar riffs, and then Nikki took care of everything else lyrically. It was Mick who had the guitar riff, that outstanding guitar riff, and from what I remember, Nikki wrote most of the lyrics on everything, on the whole record. It never was a real struggle with Sixx, he did most of it outside of the studio, and come in knowing what he'd want. He maintained the same ethic throughout the whole recording process. From what I remember, he was probably the most easy, professional, laid-back guy there out of the band. Tommy was real high-strung, that was the energy he brings into the band, and then Nikki would know, between what was going on with the band and the recording process, that he'd be happy with the way it would come out. But everyone really played an important role in recording that album, especially Tommy with all the experimental drumming he was doing, and Mick with just really solid playing. Nikki did most of the writing, but they all played a pretty equal role in fleshing those songs out onto tape."

The recording of the *Girls, Girls, Girls* LP marked the first real time that the band collaborated on songwriting, with Nikki still helming the majority of the basic musical structure of the songs, and all of the lyric writing, and Tommy contributing rhythm ideas and Mick Mars riffs which Nikki would construct songs around. The recording of the album also offered an interesting insight into the collaborative in-studio relationship that had developed between Tommy Lee and Nikki Sixx, wherein Nikki was more willing to share in the songwriting process, reflecting a trust with his band mate that acknowledged growth as a group, but had natural limitations in Tommy Lee's ability to write songs. Though the latter point would be one of contention between Sixx and Lee following Tommy's departure from the band in 1998 to launch a solo career, when he attempted to take credit in interviews for many of the songs Nikki had principally penned, claiming in one interview after another that "a lot of the Mötley songs like, *'Girls, Girls, Girls'*, *'Wild Side'* and *'Home Sweet Home'* I wrote, (and) a lot of stuff playing guitar…I wrote and sang a lot of Mötley stuff on our demos, then (Mötley Crüe singer) Vince (Neil) would come in and re-sing the melody I wrote." Nikki later responded with an angry e-mail chiding Tommy for trying to turn his back on Mötley Crüe while still taking fallacious credit for writing the band's material to gain credibility in his own right. Nikki took it to heart both as a friend, and as a matter of pride and in the clear interest of protecting his legacy as Crüe's main

songwriter, "it's getting harder and harder to keep saying I support Tommy when he continues to slag and lie (about writing *Girls, Girls, Girls* and *Wild Side*)…Its not fair to Mick (who helped write the riffs), and…the lyrics…were written 100% by me."

Nikki also attacked the charge in an interview discussing publishing, pointing out that he is the principle recipient of Mötley Crüe's songwriting points because "I write or co-write in Mötley, so I get songwriting royalties, and we split album royalties. Mostly me and Mick wrote the stuff. Tommy only really got involved in the Generation Swine album." Engineer John Purdell would further refute Lee's claims by adding that "from my recollection, pretty much the whole band centered around Nikki in that he was pretty much the main writer. He was doing all the lyric writing. If Tommy did come in with stuff that's news to me, but he and I worked really closely on all his drum parts, which were very much a center-piece of that record. I remember that Nikki was the lyricist, and if Tommy did write any lyrics, I'd be real surprised to know about it. Nikki used to come in and he'd have it about 80% together, and he'd always leave enough open creatively for the rest of the band to participate."

As recording progressed on the album, producer Tom Werman explained that "it would get serious sometimes, Tommy was very serious in the studio, they all were. But they all weren't. In other words, when they were in the studio, they were as serious as they ever were, anywhere. But, its how they arrived at the studio- sometimes they were high, sometimes they were hung-over. Sometimes they were about to get hung-over, or about to get high. But they all did take their music seriously, even Vince. But he would come in, and do anything we asked him to do- I would keep him in front of the mic for 3 hours straight- and he would put out 100% percent. The problem was, he could have been completely trashed the night before. So, he would never take it seriously outside the studio. He'd say 'Ok, that's it for the studio, let's party.' And he would go party all night long, and he would show up all night, and he would try, but wouldn't go 'Well shit, I've got to go to the studio and sing tomorrow, I'm going to take very good care of myself, and go to bed.' So in a very real way, their lifestyle showed up in the music, on the tapes. Absolutely, yes. But on that album, the tone was definitely more serious overall. Especially on Nikki and Tommy's parts."

A highlight for the producer on the *Girls* album was the innovation he captured and accomplished with Tommy Lee, recalling that "Tommy was doing some really great drum work then with triggers, loops, and things. He had electronic gizmos that he was getting into." Additionally, the band's recording process was aided by the fact that, according to Werman, "Nikki could play the bass by then, he was an accomplished bass player by then, which made things go much more quickly. So it left more time for creative overdubbing. And Mick had achieved a great guitar sound, and a great guitar tech, so the band sounded good. And by the time you're working with a band on their 3rd album, you know them very well, and you know what their weaknesses are, and you can tend to avoid most of them. You don't make mistakes, you don't get into holes. And, I don't know, everything seemed to work really well."

Perhaps Werman's favorite- and one of the coolest introductions ever captured on tape- moments on the *Girls, Girls, Girls* LP was the opening moments of the aforementioned single, wherein the producer thought "it would be a good idea on the *Girls, Girls, Girls* single to get a Harley on the record somewhere, because Harleys were so big in the band, they all had them. And they would ride them to work, and so I decided to put a Harley rhythmically in the front. Which we did in the courtyard of Conway Studios, we brought the mics outside, and I got on it and played it. And since it was on the front, I figured we would take somebody else's Harley and put it on the end. So we went up to Franklin Canyon with a stereo mic, and I drove Vince's Harley back and forth, shifting as quickly as I could. And it turned out to be a great attention getter, and when that song starts up, you always know which song it is, and its an unmistakable Harley sound."

Ironically, during the recording of *Girls, Girls, Girls*, Nikki would encounter for the first time in the two years since their breakup, his former live-in love Lita Ford, who was working on her '*Kiss Me Deadly*' album in the same studio where Mötley Crüe were recording Girls. Shocked at how he had deteriorated physically due to his heroine addiction, Lita took some time to sit down with Nikki to talk about his condition and where things were heading. The meeting resulted in the two collaborating on a song for Lita's 1987 album entitled '*Falling In and Out of Love*' which some have speculated was a reflective biopic of their relationship. Lita, looking back, disputes that characterization, classifying 'Falling' as "just a song. It wasn't

reflective on our relationship or anything. We were in the studio in the same time and same place, they had a piano in the side room, the same place I wrote *'Close My Eyes Forever'* with Ozzy, and Nikki and I just went in there and banged it out. Nikki had some lyrical ideas, and that was pretty much it. It wasn't reflective on our relationship or anything." Lita closed the book on the subject by concluding that, more than anything else, the collaboration happened in part through an effort on Sixx's part to help out an old friend, "You know, Nikki is a good friend to people…We had gone through some major things together, musically, the whole era, the LA scene, the whole rock and roll scene, being poor, being broke and helping each other out." As Nikki recalled in the band's biography, Lita did give him parting words of sympathy and hope that he would get his act together, telling Nikki that "you used to be ready to take on the world, but now you look as if you let the world take you down."

Offering fans an insight into why he felt so empty at the time, the root of his deepening heroine habit, Nikki began by reasoning that while "it sounds like a cliché but heroin was my only friend at the time. The rest of the band had families and things, even if they were misbehaving too. I had my addictions. You have to understand that at the time I felt cut off from everyone, I was alone with my addiction…The thing with success is it doesn't buy you happiness. It buys you things. And puts you in an unreal place. I guess it's up to you where you decide to go from there. I was happy with some things. And clearly unhappy with others. People are like onions. Many layers. Strip mine away and you find my core was rotten…I had no purpose to be alive. I had my music but my music was slipping away. There's a saying that some people have to die so the rest of us can live. I always thought I was the person who would have to die and I didn't care."

As the band recorded their fourth album throughout the early spring of 1987, Nikki Sixx's personal life was in almost as bad a shape as he was. The previous year, after coming off the *Theatre of Pain* tour, he'd purchased a house on Valley Vista Boulevard in Sherman Oaks, his first, and had become something of a recluse outside of the recording studio, shooting upward of $1000 of heroine a day, and developing such paranoia that it was not uncommon for him to pull fire arms on personnel from his home security company, and even to shoot random sprays of bullets from his bedroom outward into the front of his home in the midst of drug-induced rages. In May of 1986, Nikki had been best man at Tommy Lee's wedding,

but due to his worsening drug habit, could not perform most of the ceremonial duties which accompanied his role. As Tommy Lee recalled in the band's biography, "(the wedding) was one of the happiest days of my life...The only problem that afternoon was Nikki. I asked him to be my best man, and he showed up a mess. He was emaciated; he sweated constantly; and his skin was pure yellow, dude. He kept excusing himself to go to the bathroom, and then he'd return and start nodding off in the middle of the ceremony. As a best man, he was so fucked up on heroine he was useless."

That same month, Nikki received a letter from the band's accountant, Chuck Shapiro, warning him that his heroine habit was costing him over $100,000 per month, at $5000 a day, and that he would go broke within a year and a half if he continued at that rate. After a faulty rehab stint, Nikki returned home to a then-sober girlfriend Nicole only to find that the couple were no longer compatible without drug use in common. Nikki was alone again by the summer of that year, while at the same time, his Grandmother Nona, who he had credited, along with his grandfather, as largely raising him, was falling terminally ill. By July, Nona had passed away, and sadly, Nikki's heroine-induced haze had kept him from seeing her while she was still alive in the hospital, as well as from attending her funeral.

(Nikki's Grandmother Nona and his grandfather Tom Reese)

As Nikki himself recalled his shame and regret over missing the funeral, "My grandfather called crying one afternoon and gave me directions to her funeral, which was to take place the following Saturday. I promised I would be there...When Saturday rolled around, I'd been awake

for two days straight...I just couldn't get my act together. I sat back down on my couch, cooked up some freebase, and turned on the TV...I sat there...and the guilt started to seep in. She was the woman who had put up with me...like I was her own son...Without her willingness to take me in every time...I probably never would have been sitting in a giant rockstar house shooting up. I'd be doing it under a bridge in Seattle."

In describing the ode he composed to his departed grandparent and surrogate mother, Nikki described the circumstance surrounding Nona's inspiration as one in which "(it was) a song I wrote about my grandmother. My grandparents raised me and when I found out she was ill, I was addicted to heroine and I wasn't able to make it back up to see her before she passed away and didn't make it for her funeral. The line in there is 'Nona, I couldn't make it without you.' "Though Nikki vowed thereafter to clean up, and managed to pull from his emotional wreckage an ode to his grandmother in the ballad Nona, Nikki was only destined for further decline as he began dating Prince protégé Vanity at the urging of his live-in assistant Jesse James, who though he had been hired to help keep Nikki clean, ended up an accomplice in aiding Nikki's drug habit, himself becoming a user. Rather than entering Nikki's life as a positive influence toward sobriety and cleaner living, Vanity only worked to make Nikki's addiction more severe, introducing him to the pastime of shooting Cocaine, and despite his getting a V tattooed on his shoulder in her honor, and Vanity's announcement on a December, 1986 television show in a drugged-out stupor that the two were engaged to be wed, Nikki managed to break free of the destructive relationship a short time later in the Spring of 1987.

Looking back on his relationship with Vanity, Nikki has since characterized it as "one of the strangest, most self-destructive ones I've ever had." Still, it was during this period of free-fall that Nikki's management wisely decided to attempt to steer the band back into the studio with Tom Werman for what would be their most successful and destructive album to date, *Girls, Girls, Girls*. Perhaps it was appropriate that as Nikki's relationship with Vanity deteriorated, he try to enter into a more seemingly constructive period of recording, but, as Nikki recollected in the band's biography, by the time they got around beginning production, he was in his worst personal shape yet, "While I was dating Vanity, our managers started trying to put the band back into communication to record

an album. By that time, I was not only freebasing, I was strung out on heroine again."

Werman didn't himself realize the extent of Nikki's habit, such that "I had to be told by my engineer that there were hard drugs involved. When Nikki came in with a shopping bag full of candy bars, my engineer turned to me and said, 'Dude, they're junkies.'" That Nikki managed to maintain order in the one area of his life that was most vital to his overall system of survival and sense of purpose, that of music, may have been the one thing that kept him alive during the most destructive period of Nikki's personal life preceding his overdose. Longtime Sixx friend and music journalist Lonn Friend agrees with the latter assessment, remarking retrospectively that "maybe that's what kept him alive is the fact that he kept writing during the period of addiction, if he had stopped writing, he probably would have died. It probably saved his life to keep developing his songwriting and developing his craft."

The band wrapped production on *Girls* in March, 1987, after recording between One to One Recording Studios, Rumbo Recorders, and Conway Recording Studios. Upon release on May 15th, 1987, *Girls, Girls, Girls* would prove Motley Crue's true pop-breakthrough hit, debuting at # 2 on the Billboard Top 200 Album Chart, producing crossover hits including *Wildside, Girls, Girls, Girls,* and *You're All I Need*, and going on to sell over 4 million copies. Still, in spite of their triumph, the album would mark producer Tom Werman's last collaboration with the band, recalling of the departure that " in the end, its just that 'See ya, I'm out of here, I'm down the road, off on my next adventure' kind of thing. I just really enjoyed doing that album, I think we really accomplished something on that record that was superior to most of what had come out up to that point in the genre of pop metal. I felt with that record we proved that Motley Crue was, again, one of a kind."

Chapter 8:

"Punk rock primal donnas
addicts dressed in rags
Playboy serial killer dime store dreamers
Packed our future in a paper bag
Some hotel city somewhere anywhere
Nothin new except gettin old
Welcome to Yesterday, same as any other day
And tomorrow is a story still untold" - N. Sixx

 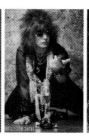

Highway to Hell...

The album's release returned Nikki to the road, and at the time, the only real family he had outside of a very dysfunctional Mötley Crüe. Tommy Lee recalled the *Girls, Girls, Girls* tour in the band's official biography as a time when "we had a huge-ass jet, we had endless cash, and we could do whatever the fuck we wanted. *Girls, Girls, Girls* was the raddest time I ever had in my life, or at least I think it was, because nothing stands out but a blur of fucking insanity. We partied like clockwork, bro...Everyday was a battle between a band bent on destruction and a record company determined to keep us in check." Vince also recounted the *Girls* tour as the most decadent in the band's history up to that point, recalling that the constant drug and alcohol abuse had started to take a toll, "on the *Girls, Girls, Girls* tour, we we're a mess, I mean each one of us was just like totally out of control. We were doing drugs and drinking like you couldn't even imagine. Nikki went to jail in Tokyo cause we almost started

a riot on the bullet train, and I almost got killed- I had a gun pulled on me in a club cause I was so drunk."

As Nikki himself recounted in the band's biography, the road was still very rocky as drugs consumed much of his personal attention, "early in the *Girls* tour, I stopped dating Vanity…Now I was truly alone. I had no girlfriend, my grandmother was dead, my dad was probably dead, and I didn't talk to my mom…After six months of touring *Girls*, my existence had disintegrated to the point where every waking moment was about drugs." Even Nikki's future guardian angel, Bob Timmons, remembered that on the *Girls* tour, "when I first got involved (with Mötley Crüe it) was in supporting Vince, and basically, what Nikki Sixx did was he said was I couldn't be allowed backstage or in their dressing room." Though less than a year later Nikki would be working in reverse of his position on the *Girls* tour with Bob Timmons in attempting to save his own life following his momentarily lethal heroine overdose, at the time, Nikki was on a mission: Suicide through self destruction. Sixx characterized this period in his life years later in looking back as one in which "I (spent my nights) backstage mainlining cocaine in my *dick* and fucking getting blowjobs from 14-year-old girls… It's just one of the very many insane things I did back then…It was never just 'Party dude!' Somebody confused our message. It was about destruction and anarchy."

Sadly, to the rest of the band, he was spiraling downward beneath a veil of communal debauchery that at the time could only have been ended through one of the band member's demise. As Mick Mars recalled, while Nikki was not shy about his drug abuse, he was extremely guarded about the motivation behind it, his pain, "Nikki was never one to sit around and tell you how much pain he was in…He'd keep it to himself, but everyone around him could see he was hurting." Still, amidst all the mayhem, Nikki did manage to reconnect with his fans, and through that bond, he found some comfort for his very lost soul, "it's a combination of the fans and the band together that creates the energy that you get onstage…So we work together on creating the energy, and I think its really healthy, that everyone just gets it out on stage and in the audience…. I've always thought of us as the psychiatrists of rock n' roll because the kids come to see us, get all this anxiety and pent-up aggression out. No one can take it away. No parent can tell them to turn it down."

Touring again during arguably the most empty period in Nikki's personal life offstage also allowed him a sense of purpose that at the time he desperately craved, "I think it's the same for all of us, whether we're grown up, or still growing up, you have a lot of pent up aggressions and anxieties, and the (pressures) you have to grow up with and deal with, just being the youth. And to be able to get them out, to scream obscenities and profanities at the top of your lungs, its their hour and a half on stage, and nobody can take that away from them. A parent can't come and tell them to turn it down…The same parent that's telling their kid to turn down Mötley Crüe…is the same kid that was being told to turn down Elvis Presley and the Beatles…There's no age barrier where you have to be a certain age to listen to Mötley Crüe…You can be any age, race, any religion…Mötley Crüe is a people's band…(and because of that) we're going to continue to grow and evolve, we're not going to stagnate."

Quite to the contrary personally, by the time the *Girls* tour wrapped in December, 1987 with a particularly destructive Japanese leg of the tour, which was highlighted by Nikki's being so high on a bullet train that he successfully threw a Jack Daniels bottle into the back of the head of an unassuming Japanese business man, and his being warned by a fortune teller that he would lose his life before the end of the year if he didn't clean up. Sadly, the fortune-teller also informed Nikki that he didn't believe Sixx was capable doing so before the prediction would come to fruition…

Chapter 9

Your exit had such charm
And you - you ran a fortune
Through your arm
You lived your life like
A Molotov cocktail
Always set to explode
Behind the veil
I wanted to be like you
All my heroes are dead now
Left me here
In this wasted ghost town... - N. Sixx

All My Heroes are Dead Now

The winter of 1987 marked the darkest season of Nikki's lifetime. As his heroin addiction had spiraled further and further out of control, Sixx detailed his downward whirlwind as one where "99 percent of my friends can take it or leave it. They can go outside the studio, have a couple of hits

on a joint, go in and play an amazing solo. I have a couple of hits on a joint and I'm calling the dealer. I don't just fall in love, I fall hopelessly, totally, romantically in love. I can't just start a rock band, I have to start Motley fucking Crue. I had to blow everything up… it's like you're being flushed down the toilet and you know all you have to do is hold onto the rim and haul yourself out, but you just don't want to. That's the hold it can have on you." Nikki seemed to have felt, in part, that he'd been on this inevitable path for years, beginning in childhood rebellions where he remembered "being anti-everything as a child. And my childhood background I'd have to say. Usual teenage stuff like getting drunk and getting high. Feeling the room spinning round and round. And that's where most kids get off. Not me." Once the high had faded, Nikki revealed a hell wherein "the worst thing is… the psychosis that comes with mixing heroin and cocaine. Thinking people are watching you, that the police are looking through your windows. And of course they're not. I know rock stars who have gone out and bought cameras and taken pictures of people they know, at the time, are there, and the next day, when they look again there's no one in the picture. It's like going to a mental institution and looking at a mad person talking to someone who's not there. You know no one's there, but they don't. And when you're clear you know that's the case, but you have a hit and the drugs start kicking in and you feel the paranoia creeping up on you again."

Despite the runaway platinum success of the band's fourth album, *Girls, Girls, Girls,* when he got off the road from the Japanese leg of the *Girls* tour, Nikki was ready to end the year, and temporarily, his life, in a drug-binged freefall that would act to exercise his demons once and for all. Ironically, Nikki's father would die on Christmas day of that year by way of a heart attack in his shower. In classic 'To-Live-and-Die-in-LA' fashion, Nikki later reconstructed the timeline leading up to his temporarily fatal overdose, "I fly home and pick up the phone and call Slash, and say, 'Hey dude, I'm going to get a car, a couple bottles of Jack, and I'm coming over. And we're going out." Arguably based on his reconnecting with Hollywood's underground during the writing of the Girls album a year earlier, Nikki, in the band's biography, The Dirt, described feeling like he needed "to go out on the scene to escape from my own decay and loneliness…I picked up Robbyn (Crosby) at his house…(then Slash and some guys from Megadeth who were also staying at the Franklin Plaza Hotel) and we all piled into the

limo…Robbyn scored some junk from his dealer…and we all did drugs till our minds went blank."

Following their first heroine binge of the evening, Nikki recalled in an interview with Spin that "First, we went out to the Cat House and you know, doing everything that we could get our hands on, and I was asking around to get some smack…(Robbyn's dealer) had showed up after we had gone back to the Franklin Plaza Hotel." Back at the Franklin Plaza, the heroine VIP club was in effect, and it was members only as Nikki recalled that "Slash (had) passed out, and I think his girlfriend was stumbling around, and Steven (Adler) was stumbling around out somewhere in the hallway, and I think there were some other people in the hotel they were hanging out with, and the drug dealer came." Due to his intoxication level, Nikki was caught between the rock and a hard place of needing a fix but being physically incapable because of his state to inject himself. As a result, he broke the cardinal rule in the heroine junkie's rulebook, namely that "(Behind the music sentence)…and almost always you shoot yourself up, you never let anybody shoot you up. Drug addicts are very particular about that…When I did the last hit of smack, I already had valium, heroine, cocaine, whiskey, and beer in me…And I don't know why, I guess I was so drunk…and fucked up that I said ' You go ahead and fix me', and I fuckin' turned blue instantly…This guy has just killed Nikki Sixx from Mötley Crüe."

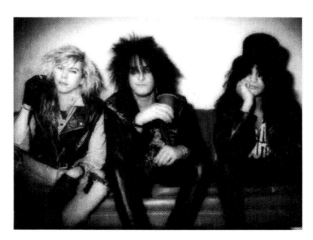

The aftermath happened almost as a slow-motion smear of scenes out of a movie, where "Steven Adler and Slash's girlfriend at the time came around the corner and there I was turning blue, and they started beating on

my chest, and they sent me into the shower, and they called the paramedics." While the frantic junkies waited for the paramedics to arrive, it was ironically original Guns N Roses drummer Steven Adler, who had a broken arm at the time (and who was later fired from his own band for an out-of-control heroine habit), who would work to save Nikki's life that night. As Adler recalled the evening's events, "I saved Nikki's life. I dragged him into the shower and put cold water on him. I had a broken arm and I was slapping him in the face with my cast. Then I finally got Slash's stupid girlfriend to call the paramedics." At the same time, as chronicled by longtime Crüe junkie and Mötley historian Paul Miles, "the dealer then jumped out of the hotel room window and ran down the street yelling out that he just killed Nikki Sixx…(meanwhile), someone removed any further drugs from the room." In a rare moment of reflective humor, Nikki recalled that "Slash was passed out through the whole thing."

Megadeth bassist Dave Elefson was also present that night as a member of Nikki's entourage, and recounted the evening's mood turning quickly from (party) to tragedy, "I was there the night (Nikki's overdose) happened. I was hanging out with Steven Adler, who had broken his arm at the time. So I went over to hang out with Steven (at the Franklin Plaza) and do what rock guys do, and I was in the suite next door to Nikki's, and he and Slash came in, and everyone was hanging around. All of a sudden, Nikki leaves (to go back next door), and a half hour goes by, and then someone comes bursting in screaming 'Oh my god, Nikki's blue passed out in the tub', and I remember hearing helicopters (and sirens) and everything, and going 'Wow, this is a little bit too heavy!'"

By the time the paramedics arrived, they were unable to revive Nikki's lifeless body as his heart had stopped beating. Carried out of the hotel on a gurney, a white sheet pulled over his head, Nikki was loaded into an ambulance. Almost as miraculous as his revival shortly following his heart's ceasing to palpitate, Nikki experienced an out-of-body experience, which he described as "a moment where I see the ambulance, and I see the gurney, and I see my body covered, I see the limo backed up to the hotel, I see lights, I see people crying, I see this from above. And it's a strange vision, because basically at this point I have left my body, and I'm gone. When the needles hit me, the only other vision I have is of coming down fast." What brought Nikki's soul back down to earth and into his shell of a body was a mix of miracle and medicine, as he remembered in the

band's biography, "(losing) consciousness. When I opened my eyes, everything was a blur of light, color and motion. I was on my back, moving through some kind of corridor. Sounds whooshed in and out of my ears, unrecognizable at first, until a voice emerged out of the white noise...Some-thing rough and impatient, grabbed my foot. And in an instant I shot down through the air, through the roof of the ambulance, and landed with a painful jerk back into my body. I struggled to open my eyes and I saw adrenaline needles- not one, like in Pulp Fiction, but two. One was sticking out of the left flank of my chest, the other was in my right. 'No one's gone die in my fucking ambulance', I heard a man's voice say. Then I passed out."

Sixx would quip years later in reflection on the surreality of the experience that "I'd done a VH1 Behind The Music a few years ago which first brought up what has always sort of been in my head. You see I sort of remember things like… I remember sort of seeing the event even though I was actually lying on the ground with a sheet over my head. There was a part of me that thought, *'God did I really die? Is it real or is it fake?'* It was very confusing and I kind of blurted it out those feelings on Behind The Music. Then later I was like, *'God I wish I hadn't said that'*, because I just didn't want people to think I was fuckin' nuts. But then when I found the diaries and read that part of it, I was fuckin' blown away. I was like *'fuck that was exactly what was in my head'*. And it was scary." Though Nikki and those medical personnel immediately around him knew he had lived, word had already gotten out on the street that Nikki Sixx was dead from a heroine overdose. Among the first of Mötley Crüe's band members to get the news was vocalist Vince Neil.

As recapped in the band's authorized biography, Vince recalled "I rolled over and answered the phone, half asleep. I was the first one to get the call (from our tour manager Rich Fisher), 'Nikki's in the hospital. He OD'd.'…I started to dress so I could visit him in the hospital- if he was alive. The phone rang again. It was Boris, the limo driver who always worked for Nikki. He said that he'd seen Nikki's drug dealer jump out of a hotel-room window and run down the street yelling, 'I just killed Nikki Sixx!' Then he saw an ambulance pull up and medics carry Nikki out on a stretcher with a sheet covering his face…Then (the phone) rang again…Chuck Shapiro was calling. A reporter had woken him up asking for a quote for an obituary for Nikki…Chuck made me wait on the line

while he placed a call to Cedars-Sinai…'I'm calling about Nikki Sixx,' Chuck blurted out when the receptionist answered. 'He just left,' she told him. 'He just left? What do you mean? I thought he was dead?' 'Yeah, he just left. He pulled the tubes out of his nose, tore the IV out of his arms, and told everyone to fuck off. He walked out with only a pair of leather pants on.'"

Upon returning to his home via a hitch-hiked ride from two fans, Nikki continued his quest to kill himself, leaving a cryptic answering machine message that said "Hi, this is Nikki, I'm not here right now because I'm dead", before proceeding into his bathroom, where he did the unimaginable to anyone outside of his drug-addled reality, and the very opposite of someone wanting at all to go on living. Clearly, Nikki Sixx, despite surviving death, had given up on life, "I hung up the phone and cooked up the largest shot of heroine I've ever had, and shot it into my arm, and passed out. When I woke up the next day, the needle was still in my arm, and blood had run down my arm and run into the palm of my hand, and had dried in the palm of my hand. And the needle was still dangling there bruised and disgusting, and I was like 'I can't believe it, I can't stop. I cannot stop." Nikki would admit to his suicidal binge years later, remarking that "I was tryin' to fuckin' *die*. I was Johnny Thunders, in my opinion. That's what I was doin', in my opinion. I was Johnny Thunders in an arena. That was what it was about, man."

According to friends and associates, while the near-death experience had shaken Nikki up, his general demeanor and reaction was largely anti-climatic, such that what should have been a very big wake up call to Nikki was ultimately overshadowed by the fact that he cared so little about his own larger existence. Addiction recovery expert Bob Timmons, who would largely be credited with saving Nikki's life, agreed with the latter assessment, downplaying the overdose as being the singular event that acted as catalyst for turning Nikki toward the road to sobriety, "I think the awareness of almost losing his life came afterward looking back, I don't think at the time it made a big difference…I don't really believe it had to do with the overdose…I think looking back that he would say 'Yeah, I almost died', but I don't think that's what really got his attention. It was not a single event." As Steven Adler, who saved Nikki's life by summoning the paramedics remembers, Nikki hardly displayed any conscience of what had happened the day following the near-fatal overdose, joking that "Nikki

called me the next day and said, 'Dude, what happened? My face is killing me.' " Longtime Mötley producer Tom Werman echoed Adler's recollection of Nikki's non-challant behavior on the day immediately following the overdose, "I called him (the day) after he came home from the hospital, and he asked I wanted to go out for Sushi...He told me about the incident, and the overdose...and said it definitely shook him up, but he didn't act any different at the time."

Based on Nikki's detached perspective at the time of his overdose, his initial indifference to the fact that he had almost died, and failure to realize he had in fact been given a second chance, was not surprising in hindsight. Nikki himself admitted as much in retrospect, reasoning that "all my heros had either died or were addicted." In that light, Nikki's actions following his return home from the hospital could arguably be construed as a genuine attempt at suicide. It would be sometime before he would truly thaw from his indifference enough to care about the future, let alone see that his drug abuse could play no role aside that of obstructionist in continuing his musical career. In short, Nikki's recovery process would not begin with the overdose, but with the gradual realization that he had credible reasons to live for the future, and not just for the moment. According to Nikki's recovery specialist Bob Timmons, Nikki's process of realization began with his first love, music, as Sixx began to come around to the mediocrity both his life and music had become "He's always been very creative, and very much a visionary person. And I think losing that is part of what got him to look at his life for what he has become...He began to see that he had lost his edge."

Among Nikki's first challenges, according to former manager Doc McGhee, was in overcoming the limitations his own ego had in the past presented in being open to the opinions of medical professionals such as Bob Timmons who had diagnosed him as an addict. As McGhee recalled in the band's official biography, by the time Nikki overdosed, it didn't take a medical expert to conclude he had a death wish, and that heroine was his weapon of choice in inflicting that end upon himself. Their only hope was that Nikki would come around personally to acknowledging the threat his addiction posed both to his and the band's future, "(the day following the overdose), we went in search of Nikki. No one answered his phone, but he had changed his answering machine message, so we knew he had been there. We drove to his house, and found him knocked out in his bathroom

with blood all over the walls. He was lying there in leather pants and no shirt, smacked out and incoherent. I talked him into coming to my house to detox. The problem with Nikki is that as far as he's concerned, nothing controls him. He controls everything. But in this case, heroine was a much bigger power than he was prepared to reckon with." In fact, Doc had championed the band's attempts at recovery for several years prior, beginning with Vince Neil's drunk driving accident. Ironically, it was Vince who Bob Timmons was first brought in to treat, and Nikki who played the principal role of obstructionist during that period.

Though Timmons' approach to recovery involved a team-effort, he initially had received massive resistance from Nikki, and, as Timmons recalled, it wasn't until Nikki's overdose that he began to buy into the concept of team sobriety. This, as Timmons viewed it, was largely because Nikki wasn't yet ready to face up to the truth that he had as severe a problem as he did, still, despite his objections to facing his addiction, he was still exposed to its existence through Vince's treatment, "I was acquainted to Nikki prior to his overdose, and it was pretty clear that he had an addiction problem, and that was clear... (but) I had been asked to come in and help Vince. Now when I go to work, you always deal with a system, and that can be a wife, a husband, so you always have the identifying patient, but its always a system...So...I came in primarily for Vince, but in treating Vince, I had to treat the whole system." Perhaps by the time Nikki came around to the notion of a team recovery effort, it was because he felt he couldn't do it alone, or perhaps because he knew in the context of Mötley Crüe as a group, as much as their collective energy had been the channel for some major accomplishments, it had also been the alley down which they had collectively ended up as a group of drug-addicted losers.

Either way, by the time Nikki came on board, the band was already acquainted with the concept of a team-recovery atmosphere, and finally had begun to embrace it, with Timmons recalling that "(as) I had originally I got involved with the band because Doc McGhee got a hold of me in regards to Vince and Vince's accident. That's what kind of first brought me into that system. And then of course coming into that and dealing with Vince, I had to deal with all the other members of the band... Part of what I was doing with Vince was exposing the whole band to recovery...I think the band understood, which is, that having all been to enough of the private

groups, cause one thing that I did was groups with them, starting with Vince, so I think what happened over a period of time is, all of them, all four of them understood that if they were going to have a chance they had to do it together." Vince remembered that sobriety for the band was never an option till all four members were on tour, and that it was Nikki's overdose which sent the band a clear message that the same fate that had almost befallen Nikki could easily have become another band member's if they didn't stop dead in their tracks and commit to drastic change, "we were supposed to go to Europe, and in that time between Japan and Europe is when Nikki OD'd, and our tour manager Rich said 'If you send these guys to Europe, one of them is coming home in a body bag." It was Tommy who first took the initiative to enter rehab, recounting that it was Nikki's overdose that had put him over the edge, "I got really scared that this was going to be over, so I was the (first) guy who said 'I'm going to rehab.' "

Once Nikki was on board, he quickly found in Bob Timmons an ally where he had for years viewed him as an enemy, principally by beginning to reverse the order in which Sixx had prioritized things, i.e. his life over his addiction, rather than letting his addiction continue to matter in value over his life. Part of Nikki's coming around was rooted in understanding that he was vulnerable, no matter how God-like his rock-stardom made him feel, "I wasn't going to hear from anybody that I was an addict. But Bob's very convincing…He's seen badder, and he's seen tougher, and he's seen them die." For Sixx, his catalyst for fully committing to sobriety came with "just completely giving up. If there's anything that I can pass on to anybody, it's that by completely giving up and letting go of any possibility that I can control this, that's what aided me the most. There's no doubt in my mind, no doubt, that I can not have one of anything. I'm just—I don't have that ability…The end of '87 I think was a major crossroad for me."

Another important component of Nikki's recovery process involved disassociating from friends outside of the band who were still drug users, and who could possibly have exposed Nikki to potential relapse, including former roommate and drug buddy Robbyn Crosby, who did not take the separation well, remarking retrospectively that "Nikki Sixx and I had gotten into the heroin thing together. He was supposed to be the best man at my wedding and he didn't even come 'cause there was going to be

people drinking and that was when he had just gone through his rehab thing. That really fried my ass." As Timmons later recalled with some irony, this, even as a first step, was a long way from the days when Nikki had the councilor banned from the group's dressing room, " (when that was going on, I had gone to Doc and said) 'There's no point in having me if I don't have access', so Doc somehow managed to convince Nikki to let me into the dressing room and backstage area, but it was like, again, it was, its nice to look back cause he's alive and clean, but I would literally come into the dressing room and he wouldn't even look at me. I understand, I don't ever take it personally, I know what I represent is what they're afraid of, but that was basically my introduction to Nikki was his not wanting me there."

Once he had all four band members on board, Timmons' began to employ another of what over the years has proven to be among his most effective methods of waking rock stars and entertainers up to the fact that they are not alone in their battle with addiction, one of the key mind tricks that drug abuse can tend to play in the course of its inherent isolation of the addict- in this case, Nikki Sixx. To that end, Timmons enlisted older rock stars who had fought similar battles as the Crüe's to help in introducing the band to a larger community of sober Rock n Roll elders who had been down the same road, and more importantly, had bought into the same system, and had it work for them as a result, "part of (what I did in introducing Mötley Crüe to a team-sobriety orientation) was bringing other sober musicians, and even ones they really looked up to and respected, into the system." For Nikki personally, this required bringing in the one rock legend who not only had rivaled Sixx's drug abuse in his heyday, but who also held enough respect in Nikki's eyes to truly get through to him. To that end, Bob Timmons called Aerosmith front man Steven Tyler to come in and mentor Nikki, "I'm the one who called Steven and asked him to help." Nikki himself later expressed gratitude for Tyler's presence during his recovery, citing his respect for the legendary front man as a key motivator for his own initiative to stay sober, "(during my recovery), I got to know Steven, and that was like the icing on the cake. He's a great person, really in to of it, and I know he wasn't always on top of it, like myself."

Even with Tyler on board, transitioning Nikki from user to recovering addict was no easy road. According to Timmons, Nikki was among his

most challenging assignments from the get-go, due to both the severity of his addiction and illness and the depth of its roots, as well as the fact that Nikki had for years hidden from his painful past through drug abuse. As a result, the more haunting Nikki's youth had become, the more heightened his drug use had followed, starting with Cocaine, and moving onto heroine. Nikki himself recounted the latter, admitting that at the height of his heroine abuse, "my childhood was haunting me, and when I was sober it hurt, and when I was on smack, I was ok." As a result, Nikki's recovery process was an especially delicate one in that he had to come to terms not only with his addictions, but also to begin to face up to those painful experiences that had driven him to abuse himself in such a severe manner, "I would say that Nikki was one of the more, at-risk clients, top at-risk clients from his addiction and behavior, so what I'm saying is put him up in the very top as far as news at 11. And then the rest of it is kind of what I go through with people, it was a process, as it is with most people. So with Nikki, at first it was about as much resistance as you can get from a human being, from being banned from the dressing room and backstage to seeking my council, and calling me and saying he's ready for help and what should he do. That was his process."

Reconciling his past was a process that would take years beyond his sobriety to work through, and so Timmons began the band on a routine of group therapy to deal with their inner-band issues, the goal being a group sobriety for the sake of the band's future. As a result, while Timmons would work one-on-one with Sixx in the years to come, he chose an approach based on his interaction with each band member individually that favored strength in numbers. His principle objective ultimately being to bring Nikki back into contact with the medicine which had nurtured and nursed his lost soul for years- making music with his band mates, and subsequently to revitalize Nikki's creative vision in forward motion toward the end of making a new Mötley Crüe album. In describing his approach with the aforementioned in mind, Timmons reasoned that by starting the Crüe out as a group, they would be more honest as individuals with one another, leading them to better understand the roots of each's addictions, and ultimately, become a stronger band because of it, "Everybody's unique in that sense as an individual (in their recovery process), each person, whether their a rock star, or a movie star, or a regular person, everybody's treated the same in terms of an assessment to evaluate what is the best thing to do to help them make it…You come into, any system, even if it's a

family, its going to create a change, and you want people obviously to not be enabling somebody to stay sick, and to get them to be supportive, and often times, then they're having to look at what's going on with their own lives, so you might say that one person might be the identified patient, but the whole system is under scrutiny." By doing so, the band began to better understand Nikki's songwriting process, as the majority of the Crüe's lyrical material was autobiographical, based on the horrors of Nikki's past exercised through a multi-platinum excess that over the years had made the band rich and therein materially removed from that pain, but much more married to it in the process because they had never dealt with it as a group.

Where in other bands it would matter less how one band member's past affected an entire band's future, but as Mötley Crüe was creatively very much driven by Nikki, it was in their interest to better understand what drove him to try to end his career, and very possibly, the bands'. Vince recalled that at first, "it took a while for all four of us to do it, it took about 2 months or so (to get together as a group.)" As Tommy recalled in the band's official biography, the group therapy sessions allowed the band just that sort of access, "everyone in the band was in a different program, but after a week or so, Bob Timmons thought we should be together as a group…The counselor asked us to visualize ourselves as little boys, and all of a sudden Nikki broke down. His face turned all red, and he was so choked up he couldn't speak a word. Later, he said that he visualized himself at one end of a street with his mother at the other end, and he realized that all his unresolved bitterness and resentment toward his mother and father were still haunting him. If I was the goofball that they were learning had a genuine sadness behind the mask, Nikki was the madly charging ram who we learned had a tender spot, where real feelings and emotions lay…For the first time, I saw a weakness in Mötley Crüe that I had never noticed before."

In exposing their respective weaknesses, the Crüe learned strength through sharing with one another. In effect, opening up to one another made it much easier to function as a group of recovering addicts, namely by the fact that they were now able to relate to one another as people in a way they never had, and as musicians, recognize that they hadn't been suffering only as people, but that their music had also been afflicted as a result. Nikki would support the latter assertion years later, reflecting that as the band's drug use intensified, "we started to suffer as human beings, which

started to affect our music." Once the band's music came into focus, their sobriety took on a new clarity that inspired not only a tighter bond as a band, but also a renewed sense of direction toward creating their first truly sober album, and in the process, their first true collaboration as a band- Dr. Feelgood.

"We've been in a haze for nine years, a serious haze. It wasn't a 'Hey, let's party dude,' or 'Let's have a few beers!' It was hard, hard drug use…(So now) the band is really doing some growing without losing sight of the fact that we're still a rock n roll band, cause when we get together, the vibe of Mötley Crüe comes out through the music, its not contrived. That feels really good to me." Nikki Sixx in an interview with MTV.com

Chapter 10

Dr. Feelgood

As writing for the band's fifth studio LP got underway, Sixx- not surprisingly- drew from his battles with addiction as a natural well of inspiration the album's material, including the band's most popular and potent anthem to date, which appropriate started out as Nikki's first new song for the *Dr. Feelgood* sessions, "the experiences of the last year had given me more than enough material, with my near-death overdose inspiring the album's first song, '*Kickstart My Heart*… That was a song I had written very quickly and had brought into rehearsal. I thought it was a throwaway, something that would belong on *Too Fast For Love*. It just really took on a life of its own and fit on the album a lot better than it should." The album in reality would serve as a purge of the band's collective demons, with producer Bob Rock recalling that once "I had heard a couple of their songs for the new album, and I thought for these guys, it sounded like the demos had been made while they were sober. So in talking to them, and then listening to their songs, it sounded like this could be really good."

On a personal level, while inside his heroine whirlwind, Nikki had lost touch with the two things that had kept him going for years prior when

he could find nothing else to live for- his music and his fans: they were his family. In the course of his recovery, Nikki "I didn't feel I had to give up music, but I definitely had to give up these people that some would call my friends. I had to have a major social shift, and I moved to a new home and started over…It was really getting the right treatment and the right support group, and finally, in working a program that I'm able to stay in recovery. When I was (making *Dr. Feelgood*)…I was sober 100 per cent, but I wasn't 100 per cent comfortable in my skin. Therapy is such an important part of this in my opinion, because a lot of people who are addicts, yes, it's in their family. But a lot of this stuff also goes back to unresolved issues that people are using the drugs and alcohol to mask."

With the overdose, he was forced to face the fact that his reckless and ultimately suicidal way of living had been killed off, leaving him with only the future to look toward, and a life to rebuild around only those things that would work to keep him focused in that direction: *Dr. Feelgood* in this sense provided Sixx with that opportunity to start his life over. Vince complimented Nikki's new perspective, and credited sobriety with being the catalyst for their collective success as a band in refocusing, with an improved outlook, and subsequently, improved material, "as soon as we cleaned up, so many ideas…started flowing out of us." Sixx felt, as a songwriter, that for the first time in years, "personally, I was on my game… I look at an album like *Dr. Feelgood* and I see it as one of our best albums and that was done at a time when the band all had their act together. And then I look at the other albums where we were really smashed and out of it and they were what they were. No one will ever know. In my case, drugs and alcohol don't make me more creative, they make me less creative. So I can only imagine…(that) I'm probably a better artist when my I'm clearer…I know I write better music when I'm sober. A lot of my friends have told me they don't know how to write when they're sober. For me, the addiction had to do with running from my past, and not living in the present. When you're writing music, you need to live in the present. The music wasn't getting the attention it should have gotten…(until) that period… It was a wonderful time. It was like being reborn, emotionally. The music flowed easily…(and the band) sounded its best. It's amazing what happens when all the cylinders are firing."

Delving into the specific lyrical inspiration behind some of his favorite of the album's tracks, Sixx, beginning with the album's title track, *Dr. Feelgood,* recalled that "it had a whole other set of lyrics. I had sort of

forgotten that and I found them in a box recently. I was like, 'oh, wow.' It had a whole different theme to it. It was called '*Dr. Feelgood*,' but a whole different thing lyrically. In the end it was inspired by drug dealers. Is there ever just one? A good drug addict always has more than one dealer." Of another album hit 'Same Ol'Situation', Nikki explained that the song "was about a girl leaving a guy for a girl. The subject plagues men worldwide. I love it because when Elektra heard it they were like, 'Oh, this is perfect for a single.' In a Mötley fashion, we were like, 'Wonderful. We'll tell you later that it's about lesbians.' " With his writing on another of the biggest hits from the album, '*Don't Go Away Mad (Just Go Away)*', Nikki shared that "I saw that line in a movie somewhere, I can't even remember what movie. I thought, 'Great idea for a song.' A little tongue in check. A little sarcasm there."

Adding perspective on the band's songwriting process, producer Bob Rock explained that "Nikki is so much the lifeblood of Motley, he's the idea guy in that band, its fair to say he's the pulse of Motley Crue. To me, he knows where Motley should be, he knows what it should be all about. I think the guys in the band generally trust Nikki on that, but they also question him where its appropriate, and the other guys really add all those other elements that make the band work. Nikki brings the kind of wildness to Motley, he's the wild guy in terms of ideas. All his ideas are always just all over the place. So if he writes a lyric, it's the most extreme lyric. If he writes a riff, he goes 'I want it loud, I want it punky.' He's the extreme guy in terms of ideas. And I think the balance in terms of Nikki and Mick Mars is Mick's a little older, he's a little more blues-based, he's a little more entrenched in 70's rock, instead of punk, where Nikki's a little more rooted in punk. A little younger. I think what Tommy always brought to Motley was pushing the muso-quality of the band. He was always trying to push, like with the different beats."

Heading into pre-production, producer Bob Rock explained that the process "with me for every band is the same, and that is every time I've short-changed pre-production, its never really worked for me. So I try to get into a rehearsal hall with a really basic tape recorder, and work on all the songs- the structure, the riffs, and find out what's missing. Work on the drum beats, guitar parts, and vocal parts, and figure out what needs to be worked on. It just always works, and any song worth recording should stand on its own with just one mic in the room. So that's what I try to do."

Commenting for his own part on the positives he thought were possible in the course of their collaboration with Rock, Sixx "We made a conscious effort to all be really together on it. Bob Rock really brought the best out in us...As were the band, and we worked very well together and made amazing music. And that just proves to me that having a clear head is better for creativity...On ('*Dr. Feelgood*,') the band is all clean. You can tell which one. The clean one was the biggest album we ever made."

Once the Crüe had gotten focused in the studio, Rock recalled that, from a sonic perspective, with "*Dr. Feelgood*, I was just trying to make everything as big and powerful as I possibly could. My production at that point was more to do with sonics, being in the 80s, production for the most part, a lot of times was about sonics, about the sound. And coming from an engineering/mixing background, I went into Motley with that in mind. Just to make it big and powerful, and there was no preconception as to what I was doing, it was more like 'Okay, lets just get in there.' So we just went in the studio, and I tried to make each instrument and Vince's voice kind of big and as real as possible."

The recording of the *Dr. Feelgood* record took place at Little Mountain Studios, in Vancouver, Canada. According to Mötley Crüe historian Paul Miles, the sessions for the album were intense and often rigorous, metaphorically, and often literally, resembling a continual physical work-out session, wherein "under the guidance of rehab specialist, Bob Timmons, Aerosmith (worked) on their Pump album next door to Mötley, so they often (drank) water together and go for jogs after a day in the studio. The Crüe (had) a personal weight trainer with them in Vancouver, over-seeing daily work outs and jogs...Twenty four songs (were) demoed, including a two minute metal rap song Monstrous rumored to be on the Ghostbusters II soundtrack and also to be the title of new album. The chorus was inspired by The Wizard of Oz and was stuck in Nikki's head for weeks. Another rumored title (was) Sex, Sex, and Rock N Roll. They also (wrote and recorded) a 10 min song called Say Yeah about Nikki Sixx impostor, Matthew Trippe. A Mick Mars concerto with cello, viola, flute, guitar and drums (was) also touted for inclusion on the album. Other titles of songs written included Stop Pulling My Chain, Brotherhood, Too Hot To Handle, Rodeo and the bluesy Get It For Free, which (was) about a girl supposedly selling Bibles door to door except she's not really selling Bibles. Nikki (phoned) the guys from Skid Row and...(invited) them to come to

the studio and sing on the album. They also (jammed) with Cheap Trick at their local show, and (invited) them to participate on the album."

Delving into the specifics of his approach to capturing the monstrous drum sound he did with Motley Crue on *Dr. Feelgood*, Bob Rock recalls that "going back then, it was always a combination of really I think Tommy and Nikki, mainly Tommy in terms of the drums. Basically, back then, it was the whole beginnings of hip hop, and I think bottom was becoming bigger and bigger. My mic techniques that I had at that point were all ones I'd picked up from working with the different people I had worked with, and then in time adopted my own sound. Everything is derivative, so for instance, when Claremont was in the studio working with Brian Adams, I'd go in at night after session, and look at all the mics, and combine that with other people I had worked with through the years. But it really was a question of learning good micing techniques, but really the difference was its pretty much stayed the drum sound without being mixed, is pretty much what I get these days. Back then, I used a 421 in the kick, an RA 20, and usually a 57 or 86 on the snare, for overheads, I used 87s or 460s, and room mics were condensers, and for tom mics I've always double-miced my toms, top and bottom. And that's stayed the same pretty much to today. By comparison, Metallica records are slightly different- with the Black Album, there was maybe another 40% of top end on everything, so I think everything became a little tighter, and there was a lot more dampening. But as far as Motley, alot of Tommy's drumming, back then, I think the big shocker was I had to open up the mics because he was such a loud hitter that he would actually compress the drums. He just hit so hard that the drum would almost compress itself, so I would have to back off the mics, and I remember doing that. It was really just a question of trying to tame that energy, and getting the right distance on the cymbal mics because of the size of the cymbals."

Continuing, Rock explains that "I think the big thing with the sound of the drums on the album came in the mixing, and in the mixing, it was pretty much Tommy pushing me, and me kind of figuring out a way to make it happen. By using samples in conjunction with the drum kit to get the weight of the drums, and the size of the drums. For instance, we'd want to get a nice big bottom, and he'd tap me on the shoulder and say 'Rockhead, could I have a little more bottom.' And then, of course, we'd add bottom to the kick, and then the kick would be thumping, and there

wouldn't be bass. Then we'd increase the bass, and then the definition would be gone. If you listen to the beginning of *Dr. Feelgood*, what I did was, with an AMF, I triggered a bass tone just like one hit on the bass that's hammered. And that's with the kick drum. So in mixing the drums on that record, it was just a question of detuning, and finding the right balance between all of those drums and the guitars. The best thing I can do to describe that and then what I did on the *Black* album in comparison was weight. I tried to give as much weight to the drums as possible."

Contrasting Lee from any other of the A-List drummers he'd previously recorded, Rock shared that "to me, Tommy as a drummer is kind of like an open nerve end, whereas Lars, to me, is probably closer to Keith Moon than anything. Tommy is a classic back-beat drummer, he is the basis, he's a rhythm kind of guy. And he does have syncopation and all the other kind of stuff, but he's a rhythm machine. With *Dr. Feelgood,* things got a little funkier. I think, in terms of the rhythms and stuff before, it had always been pretty straight-ahead. So all of a sudden with Feelgood, Tommy sort of broke away from what had been their traditional drumming sound…(and) because he's added a lot more rhythm and syncopation. So Tommy was always pushing that aspect of it. So I think it's a combination musically of the three of them that gives the band its sound. To me, its really interesting listening…(and) really hearing those qualities come out. Like Mars, he's the backbone musically, he's the one who strings it all together. And Tommy's so solid as a drummer, that he adds all those accents and stuff."

As recording progressed, producer Bob Rock was all business, with his biggest strength, as Nikki recalled it, lying his ability to push the band to new places, and in new directions that they had not gone on prior albums, such that the studio atmosphere, according to Sixx in the band's official biography, was reflective of the latter philosophy, in which "for once the studio wasn't a place to party and bring chicks, it was a place to work. And work it was…It was (Bob Rock's) job to get us to be Mötley Crüe again after having been decimated by a decade of drugs and deaths and marriages and rehab…Bob whipped us like galley slaves…Nothing was good enough…Bob was critical, demanding, and a stickler for punctuality…In eight years together and with millions of albums sold, we had never recorded properly. No one had ever pushed us to the limits of our abilities

before or kept demanding more than we thought we could give until we actually did have more to give…I wanted an album I was finally proud of."

Where working with Tommy proved to be a breeze for Rock in the course of recording *Feelgood*, perhaps his two most intense focuses came in recording Mick Mars guitar parts and Vince Neil's vocals, albeit for very different reasons. Regarding Mick Mars, Rock's first goal was to get on the same page with Mars in terms of how he- Mick- ideally wanted to hear his guitar sound defined and captured on tape, such that "back in *Dr. Feelgood*, I think Mick was pretty rattled from his experiences prior to me, so we took a lot of time to get his confidence back, and just take the time and get the feel back. Like with Mars, he kind of said all the sounds he'd gotten previously- and I'm certainly not criticizing Tom or anyone else- but they'd all been mini and small, and he said 'This is my sound.' And he played it for me, and I went 'Woah! That's not what I've been hearing on the record.' "

Mars, for his own part, recalled that "I took things a little more seriously this time, and the results show that the effort I put into the album paid off. Maybe it's because I was sober throughout the entire recording process that things turned out as well as they did. Being sober gives you a lot more patience. On our earlier albums, it wasn't unusual for me to finish all my guitar parts in a couple of weeks. I'd lay something down and if I liked the feel of it, I'd think that it was good enough. On *Dr. Feelgood*, I didn't let myself get satisfied so easily. I went over things that everyone else was telling me were great, but which *I* wasn't satisfied with. We spent 6 months in the studio this time, and the guitar parts on the record show the difference."

Being particularly sympathetic to Mars' frustration as a guitar player in his own right, Bob Rock set out to accomplish with Mars what he had always sought to in his prior collaborations with guitar players, that being to "always try to get the guitar player involved, and get what he wants. I think that comes from my engineering background, and being a guitar player myself. Just knowing that- I had some early experiences in the late 1970s and early 1980s when I started, literally the producer and the engineer used to, in some cases, would supply the drum kits and amplifiers, and say 'Here's the drums you're using, here's the amps you're using. I don't do this…' There were so many rules, and growing up in the

industry, I was thinking, 'You guys got it all wrong. You're supposed to try and capture what these guys are doing, rather than trying to force them into sounding like this or that.' So I think right from the beginning, I learned to get in synch with the guitar player and his sound. In the case of Mars, Mick's sound is about size and sheer volume, not unlike James Hetfield or John Sykes, or other players who have a big, monster sound. That has a lot to do with Black Sabbath- Tony Iommi, that style of playing with single-note riffs that sound like a monstrous power-chord. It's the size. That has to do with the playing, and Mars has this style that is very much his. Very light strings and a very soft touch, but very loud. So I just tried to get on tape what I heard."

Specifically, Rock's approach to collaborating with Mick Mars involved "going through all the cabinets, and getting him involved in the control room, and we just did it till we got it right, and that was it. The big thing is- Mars, like James Hetfield- has different amps, and you get four different Marshalls, you get four different sounds. Really I think the big thing that I brought to both Mick, and James Hetfield, was using multiple amps and using the differences in fazing and cabs and heads all combined to get one sound. Different volumes on different amps for different frequencies and clarities, and that's basically what I've always done to record guitars. Multiple amps and multiple mics, and just finding that sound."

Once Rock and Mars had established a foundation for what their desired guitar sound would be upon completion, they began the process of building a wall of layered guitars that stacked literally higher than Mick's Marshalls in the studio. According to the producer, the resulting sound they achieved became a bedrock for many of the producer's future collaborations, explaining that "its basically just a process of building the sound in the studio, because some people, like Eddie Van Halen, throw one mic in front of an amp and make it work. Whereas I think realistically, sometimes you have to build that sound. I use 57s, 421s, 87s when I'm micing amps. I think the big thing with amps for Mars' sound was that he used Jose-modified Marshalls, which John Sykes was using, and I used that same amp on the Black album, and really every album I've made since. That became a main-stay."

With a clear mutual respect intact following the completion of *Dr. Feelgood*'s guitar tracks, Rock to date is extremely vocal in praise for Mars'

abilities as a player, further elaborating on Mick's importance within Motley Crue's larger sound as being a matter of "him being solid as a rock, I think that's what it comes down to. I think he's highly underrated, and to me, this goes back to some of the better players that have had these great signature sounds in bands- its Tony Iommi, James Hetfield, Mick Mars… These guys are the backbone of the band, there's always the drummers that are responsible for the rhythm and everything. But I think one of the reasons why Tommy works is because the guitar playing is so solid. Tommy can't do what he wants, all the syncopation, and all the other stuff he likes to do without a solid player behind him. Mars is like Pete Townsend, he's really rock solid. Instead of being ahead of the beat, kind of get that feel, to where it felt comfortable and natural for Mick. Like now, listening to the DVD, he's just right on the money. When I group Mick Mars and James Hetfield together, I do so for what they bring to their bands. As players, make no mistake, I would say James Hetfield is absolutely the best rhythm signature sound guy I've ever recorded. Its just phenomenal, I can pick up the same guitar with the same amp a minute after he's played, and it will sound like crap compared to him. He's just got that. Mick Mars is much the same way too, I can't pick up Mick Mars' guitar after he's played and can't make it sound like he does. I would say the sound of Metallica is built more around James, where I would say Mars is the collective in Motley. They have the same function as guitar players because they're so rock-solid. Mick just brings it all together, the wildness that Nikki and Tommy have respectively, Mars makes it solid. Even in his solos and the little things he does in terms of accentuation, nothing is wild. It sounds wild, but its really well played and executed."

Highlighting some of their favorite instrumentals from the album as that aspect of the recording completed, Nikki recalled of *'Rattlesnake Shake'* that "there were some really good grooves going on with the music. I think we touched more back into the feels that were having with *Shout at the Devil*, which had a real sexy Zeppelin backbeat to it," with Vince adding that "it's got a good swing beat to it, and we added a horn section in. It's got a good vibe to it. It's almost got a little blues to it." During the recording of *Dr. Feelgood*, Nikki had begun to get his personal life back in some semblance of order, working closely with addiction recovery specialist Bob Timmons to stay clean in his off-time, and to focus within that effort on what personal weaknesses he could work on reconstructing into allies of a continued sobriety.

Among those who witnessed Nikki's personal recovery process during this period was music journalist Lonn Friend, who interviewed Nikki in a period when he was very in the midst of a very open dialogue within himself about his past, what had drove him to addiction, and how his will to live had withered in his most desperate period preceding the overdose, "the first time I interviewed Nikki (following his overdose and subsequent commitment to sobriety)...I started the tape recorder, and he started to purge on his addiction, without any fear or judgment, he just spewed and regurgitated on the darkest period in his life...That he was an addict, that he had gone into addiction borne of success and fortune, and all of the puebels that the devil hands you at that moment in time, and I guess it was a near death experience that sent him into the realization that if he didn't stop, (he'd die). He's different than other artists who have also had that near death experience and continued to use, because he had the strength of character that he could stop." In this same time of personal reconstruction, Nikki began dating Playboy playmate Brandi Brandt, a period he described in the band's official biography as one that "felt so empty without drugs that I let Brandi fill the void. It was so exciting to actually be hanging out with someone of the opposite sex and enjoying it that I leapt into the relationship...Just a couple weeks after Brandi and I met, I had moved to Vancouver to record the *Dr. Feelgood* album, and the distance added more fuel to the illusion of being in love."

Back in the studio, in contrast to the pleasure of recording Mick Mars' guitars, Bob Rock found more challenge working to capture Vince Neil's vocals for the record- a process that Rock matter-of-factly described as "just a question of getting Vince in tune and in time, and just trying to get the best performance out of him. I used to multiple takes and comp, and it was very laborious. When I record Vince, I think the big thing is he just wants to get it done." Over the course of their 15+ year collaboration together, Rock, much like a teacher admiring a pupil's progress, is quick to point out that "I do a shorter version of that now with him, because while everyone else has been doing solo projects, Vince has had to make a living by being on the road, so he's been singing non-stop. I think he's been singing long enough that he just does it straight. The last time I worked with him, he was real pro, he does what he does very well now. I think the only trouble he has as a vocalist is pronunciation, but that's everyone."

Where Rock may have spent more time working with Vince in the studio than the other band members, the producer is quick to give Vince Neil his proper due in terms of what he irreplaceably brings to Motley Crue as their front man, explaining that "I think the greatest thing about Vince is he's exactly at the level of what people want Motley Crue to be. Right from the image to the name, he is the singer for that band. Any kind of difference, if he had more of a range or level, it wouldn't work, it doesn't work. It is L.A. rock n' roll, its kind of like Morrison in a way that Morrison had his sound that was L.A., and Vince has his sound that is very much Motley. His voice is a signature voice, and has its limitations like every singer has. But I think it works really well for what he does, and it is what it is."

Continuing his compliments on Vince Neil's attributes as part of a larger reflective commentary on the band greatest strengths being very much the sum of its players, Rock explains that "I think one of the reasons why Motley Crue became popular was the combination of the four of them, what each one brings to it. And I think Vince is the blonde, surfer bling-bling kind of singer that has a very unique kind of voice. Its Vince's sound that makes him unique. He's got his thing. To me, if you look at Jagger, and you look at David Johansen, or Johnny Rotten from the Sex Pistols, or Bob Dylan for that matter, they've got their limitations, and they've got their sound, and Vince sits within that. His voice has a very definitive, L.A. surfer, 80's rock sound. With Vince, I think he likes to do his thing and that's it. I don't think there's any conscious effort on his part to say like 'I want to be somebody else, I want to work on this and improve.' Vince is a realistic guy who knows what he is and what he does and that's fine with him. Vince gets it, that's the funny thing, is Vince really gets where he is in the band, and really gets Motley Crue. He is, in a funny way, kind of the perfect Motley Crue guy, realistically. He just gets the whole thing, he's part of the charm of it all, because he almost epitomizes what they stand for along with Nikki. Nikki is the punk rocker, where Vince is the California surfer who just doesn't give a fuck. Not musically, but in his image and attitude. The best evidence of why the four of them work is when the Corabi thing happened, and they almost thought that Vince was holding them back, and what they soon and quickly realized, and actually I realized before we started recording the *94* album, was that its not Motley. And the reason its not Motley was that it's the balance between the four original members that makes their sound appealing."

Recalling one few of his favorite vocal moments from the album's recording, Vince- in an interview with Rolling Stone Magazine- began with *'Sticky Sweet'*, recalling that "Bryan Adams and Jack Blades and Steven Tyler are on background vocals on it. We recorded this album in Vancouver, that's where Bryan lives. It just so happens that we were recording *Feelgood* next to Aerosmith in the same studio recording *Pump*. Steven would come by and sing background vocals." Of the band's smash ballad, *'Without You,'* Neil characterized the song as "a great ballad. I love singing that song…For me, it's a great song to sing. It really lets me go and get my voice out there. I remember shooting the video down in Corpus Christ, Texas. We had a black panther and all kinds of crap. It was a goofy video, but it's a great song." Turning their attention to *'She Goes Down,'* the singer revealed that "there's some sex being done in the background of that song if you listen real closely. We can't say who's doing it though, but prostitution is legal in Vancouver." Nikki added that "Robin Zander is on background vocals. Cheap Trick was always one of our biggest influences. We love that band."

Once principle tracking on the album had been completed, the accomplishment of producing the most creatively clear and synergetic musical effort of their career provided Mötley Crüe with an opportunity to get back to what they had started out trying to be 10 years earlier, a bare-knuckles, we-don't-give-a fuck rock n roll band that lived authentically and in real time for its fans. Over the years, platinum commercialism had naturally moved the band away from their roots, and with sobriety, they now had the conceptual clarity of both sound and image to chart a course back in that direction, without compromising their mainstream appeal in the process. Lead guitarist Mick Mars elaborated on the band's collective happiness with the medium *Dr. Feelgood* achieved, remarking that, with the result, while their sound had not lost its bad-boy edginess, they had gotten back to their roots, with the new material a more natural reflection of what the band truly sought to represent with fans, "I'm kind of glad we've toned down the image a bit recently. We had gotten kind of heavily into the whole glam thing around the time of Theatre of Pain, and I really wasn't comfortable with that. Now when people say Mötley Crüe, I want them to think of us as just a great rock and roll band. We don't do drugs anymore, we don't drink anymore -- though we still can get pretty wild at times. But yeah, it's still as much fun as ever. It's really kind of cool."

Nikki complimented Mars' assessment with his own reflection on Mötley's coming full circle, pointing out that with the new album, the band had effectively captured the essence of the new horizon that their sobriety had provided them- personally and musically, and in the process, allowed them to let go of many of the expectations that can steer an album conceptually, and thus commercially, in the wrong direction in the course of the album's writing/recording and subsequent release, "You don't get any respect the 1st 10 years. We're done proving ourselves. We've said all we got to say. Now its just music. That's it. We're not out to try and get critical acclaim. We feel we deserve respect at this point (with *Dr. Feelgood*), and that's it. We got one of the best shows in rock 'n' roll. We have a very serious track record. So yeah, we're proud. We love being Mötley Crüe."

By the time *Dr. Feelgood's* recording was wrapped, Nikki Sixx was engaged to playmate Brandt and heading toward the alter. Though the band would tour the world for almost a full year before he heard wedding bells, Nikki had finally reached one of the happiest and most productive periods in career, and in some respects, personally. Above most else, Nikki was looking forward to getting back out on the road and in touch again with the millions of fans who had stuck by him for years and years prior like an extended family. No matter how well their albums sold, or how close Nikki finally was to a stable personal life, he described his happiest moments as those when "I'll be looking down (in the audience) and see somebody singing the song back to me word for word. I hear Vince in the background singing it, and I'm watching this kid and he's singing it back to me, and he knows every word (I wrote), and man, that rocks my world…(That's) the best feeling I'll ever get." Vince echoed Nikki's sentiment, recalling that "for those years of touring and doing (*Dr. Feelgood*), we were all sober, it was cool. We were a machine." Tommy Lee also felt the band's sobriety was key to bringing them back into the pocket musically, recounting that "it was like a pact. We were a gang again, but in a different way. We got along better, people felt better, we played better- that's important!"

For the producer, the sound he'd achieved in the course of his collaboration with Motley Crue was sonically perfect, such that, according to the producer, "Metallica told me that they sought me out to produce the Black Album based on the drum sound I'd gotten for Tommy on *Dr.*

Feelgood." Looking back, even to this day, at the musical feat he accomplished with *Dr. Feelgood*, in essence laying the foundation for a whole new sonic blueprint for hard rock that would dominate the next two decades, Rock feels that "there isn't a signature Bob Rock sound, because I've worked this many years so that doesn't happen. Its not a Bob Rock record, its never been about me. On a personal level, its always been about trying to make the band happy, because I know- through personal experience- what its like to make a record and not be happy with it. I lived with that earlier on in my career, and its just the worst thing. So I've always been an artist-driven producer. I guess its as simple as wanting to be remembered for helping the bands I work with make the best albums they could, but the intro to *Dr. Feelgood* and the *Black Album*, I'll take those. *Dr. Feelgood* and the *Black Album* will be just fine, if they go 'Yeah, this is the guy who did that.' I could live with that, that's enough for me."

Billboard Magazine's review of the band's fifth studio album- and first to debut at number one on the Billboard Top 200 Album Chart- hailed the LP as groundbreaking both in its review as both "infectious and hard to resist...(making) this the best-selling Mötley Crüe album ever." Heading into release on September 1, 1989, the band had a simple goal became clear for the album- to hit number 1 on the pop charts for the first time in the band's almost decade-long career. As Nikki recalled the band's attitude, "When *Girls, Girls, Girls* went to number 2, and we knew what the sales were that week, all of a sudden were like… when you're about to go #1, you find out a lot of stuff, you get very interested. That week, Whitney Houston debuted at # 1, but we sold the most albums in the nation, and that really pissed us off." In truth, as much as Mötley Crüe had been a hard rock's closest thing to a punk act for the majority of their career, bucking conventionalism and commercialism as much as possible through their decadent and rebellious music and lifestyle, they were finally mature enough as a band to seek commercial acknowledgement for what they felt was the most accomplished album yet. Nikki elaborated on the band's desire for mainstream acceptance, admitting that, as the band regained its focus, by that time "no matter how much a band says 'We don't care,' 'We don't read our reviews,' that's true to a point, but to be accepted is a really good feeling too."

*** Chapter Disclaimer: All Studders (and therein Oddly Spelled Words), Bullshit & Lies, and Every Other Bit of Nonsense Due Courtesy of Mr. Trippe

Chapter 11

"Matthew Trippe"

Just as things were getting back on track for the band with the *Dr. Feelgood* tour getting underway, things began to heat up in a lawsuit that Mötley Crüe manager Doc McGhee had been slapped with in what has gone down in the annals of music history as among the most bizarre allegations and subsequent lawsuits the industry had ever seen. The plaintiff was a convicted felon, former mental patient and failed musician named Mathew John Trippe, who, in January, 1988, filed a lawsuit against Mötley Crüe's management company, McGhee Enterprises, Inc., alleging that, from around June of 1983 through an unspecified period in early 1986, he acted as a full-time stand-in for Nikki Sixx, who allegedly spent the three years recovering from a car accident outside of producer Roy Thomas Baker's house in which he had dislocated his shoulder. In the suit, Trippe alleged civil theft and claimed he had written songs including *Danger, Knock 'Em Dead Kid, Girls Girls Girls, You're All I Need, Dancing On Glass,* and *Wild Side,* and had not received royalties to date.

Though Trippe bore little resemblance to Sixx, coupled with the fact that his story was full of enough inconsistencies to discredit him from the start, and despite the fact that Trippe would eventually go onto drop his lawsuit in the early 1990s when it proved to have no legal merit, the damage he attempted to cause to Nikki's hard-fought reputation and ultimate legacy as Mötley Crüe's lead songwriter and conceptualist was weathered only by what had become a common-sense understanding early on among the Crüe's fans, as well as anyone within the larger hard-rock community, that such a move never could have happened simply because Nikki wouldn't have allowed it. Simply put, Mötley Crüe was Nikki's

baby, especially during the period when Trippe claimed to have been inserted into the line-up, when the band was still in the early stages of its creative evolution and Nikki was still responsible for 90% of the songwriting and creative conceptualizing for the band's sound and image. Though video-taped appearance after appearance during the period of 1983 through 1986, over the course of which two separate albums, *'Shout at the Devil'* and *'Theatre of Pain'* were released, clearly refuted Trippe's claim by featuring Nikki Sixx with the band, and often leading them, through interview after interview, offstage and onstage at live performances, and in both the studio and on video sets, Trippe still stuck to his unsubstantiated story, talking on record to anyone who would listen.

In an interview with one reporter, Trippe had described his ascension into Mötley Crüe's fold as originating by way of his relationship with the band's guitarist, who from the start was identified as having the least amount of pull in the band, even by his own admission. Still, according to our stuttering imposter, Mick played a key role in bringing him into the band, "I'd been a friend of Mick Mars, I met him at the Trooooooouuu-bador when I first got out here. I didn't know a thing about who he was or who Mötley Crüe was, my main influuu-ence was Kiss. And you know, he likes Kiss too...and we got to talking. When I went in the bar, I tried to be a rock star type thing, I wore a big black wig, I just tried to fit in with the crowd, I was just trying to be one of them...And that's how I met Mick, and he said 'Do you play in a rock band?' And I said 'No, I used to, but I'm looking for one, I used to have one.' I was lying to him. And he goes 'How long have you been play- play- plaaaaying guitar for?' And I said 'About 12 years.' And of course I lied again. And he said 'Are- Are-Arrrre you good?' And I said 'Yeah.' And he says 'Oh really?'...And then after a few days passed, you know, Mick kept me in the same bar, and we would talk...But then, after Mick and I became friends...he seemed depressed, on the third day, the fourth day, something like that, he was sitting there depressed...and I had to drag it out of him...and he says, 'Well, you know, we need a new bass player, da-da-da-da-da.' And then he began to ask me, 'Well, what are the names of the songs you wrote?' Things like that. And I said, well, 'I Got a little bit of songs here. I don't re-re-reeeeally think their very good, but I think they'll sell.' I was trying to plaaay it up to him like I knew something...And then he says ok, and he had me hum a few tunes of what I wrote, and one of them was 'Danger'."

Continuing with his farce, Trippe recalled that "then (Mick) says, 'I would like you to meet a friend of mine.' And I said 'Ok, fine.' And I go up and meet…to this o-o-oooffice up there on the strip, and it was Doc McGhee. Well I didn't know it at the time, and so I went in there, and you know, it was more for a tryout for the band is what he tried to explain to me. Its not like I'm in the band, it's a try out. So I said 'Fine.' And so I tried out, then they asked me to leave the room, you know, I had played my songs, and then I had to leave the room. And I tried to listen in, and I heard a few things, which I can't remember off hand. Then they ca-call-caaaalllled me back in, and they had all these coooon-tracts laid out, and its not like they said 'We want you!' Its more like they acted like 'Well, ok, I think we can use you.' And I said, 'For what?' I didn't know what they were really going to do, and…Oh, but first Mick asked me if I thought I could play bass guitar, and I said 'I've never picked it up, but I can try, I'm sure its quite easy since it's the same as the guitar. And I wasn't that great, but at least I could hold a beat. And I played so fast, you couldn't tell what I was doing, just trying to flaunt…And then they started saying, 'Well, you know, we want to start using some of your songs.' And that's when I signed all this junk, you know, and they say 'Well, will you sign here?' And I say 'What's all this?' And they said, 'This is our record contract. This is a contract with Doc McGhee and McGhee management,' and I wanted to read over it, and they said 'Well, we just don't have any time, you sign this now.' And I was like 'Fine', and so I signed it, and they said 'What's that?!' And I said 'What? That's my name!' And they said, 'No, we're going to give you a stage name…Your real name now is going to be Nikki Sixx.' And I'm like, 'Nikki Sixx?' I didn't really care, I was thinking money, money, money. (Responding to a question from the journalist concerning whether anyone had explained to Trippe at that time what had happened to the original bass player, he said 'No, not at that time.') Ok, then I had to sign it all in Nii-Niiii-Niiiikki Siiiix. And that was it."

During one portion of the interviews, Trippe was asked by a reporter what his age was in 1983, and he became confused, claiming that "Oh god, hold on, waa-aaiit a minute, I'm giving you the Frankie story, I get screwed up…I tell a lot of people that I'm 27 years old. That's my fuck up…I signed the contracts when I was twenty years old. But I'm really 24." Sadly, at this point, it started to become clear that Trippe was in fact nothing more than a sad groupie who had an obsession with Nikki Sixx from early in the band's career, and while he may have genuinely fantasized

about being Nikki Sixx, lacked both the physical resemblance or the credibility within his story to authenticate such a claim. The first blatant contradiction to Trippe's allegation came from his own mouth, claiming that he had signed his contract with Doc McGhee when he was 20, which would have been four years prior, however, Trippe didn't give the interview or file his lawsuit until early in 1988, almost a full year in actual time beyond what Trippe claimed had passed.

Additionally, Doc McGhee was among the first to go on record in emphatic denial of having ever met Trippe, and arguably was most flabbergasted by the lawsuit since it charged him as the sole complainant, "well this was somebody that wanted to have their fifteen minutes of fame, you know, and it cost me a lot of money because he sued me. He didn't even sue the band, he sued me…So he didn't sue Mötley, he sued me and I had to defend it. I had this crazy guy who I had never met in my whole life, sat in… and when he walked in – we did a deposition in front of him – he was like, 'Hey Doc.' I go, 'You are one sick puppy buddy.' You know… 'What are you doing?' It was bizarre because I had never had (met him)."

One of the oddest elements of Trippe's lawsuit was his decision to go solely after Doc McGhee in litigation, as opposed to the entire band, despite his claim that they were complicit in the conspiracy to cover up that Trippe had been part of the band. This was principally strange because in interview after interview, Trippe spoke with both trepidation and fear of Doc McGhee, characterizing him as an almost-mythically dangerous man, who "has clout…Dude, Doc is no one to screw around with…He is not a family type thing, he just knows so many people…Doc holds a lot of pull…Doc McGhee is also owned by Warner Bros. Communication..(and) they're hefty into the mob, big time. I mean, racketeering, everything, they're big time. You just don't fuck with them, they own like half the world." *(Why then would Trippe sue him?)*

Trippe, in continuing with his preposterous allegations, opened an entirely different can of worms worth of criticism when he started attempting to take credit for writing many of Nikki's most personal and life-inspired songs from the Shout at the Devil album. Not only would Nikki never have authorized anyone to write in his place, especially a loon like Trippe, but witness after witness has gone on record contradicting Trippe's claim song for song. According to Trippe, "Frankie already had a

few songs written that I had to clean up too. A lot of his songs were really drou- drag...so I rewrote a lot...like *'Shout at the Devil'*, the lyrics were changed a lot, I would say 'Here Doc, here are the words the way I want them.' And he said 'Fine,' and then he changed them, because he and Tom We-wer-maan didn't want anything like that...On the Shout album, there is *'Danger'* (and *'Looks that Kill'* and *'Knock 'Em Dead Kid.'*)"

The most credible personality within the Crüe organization during this period to refute Trippe's claim that he was involved with the band, let alone with the *Shout at the Devil* recording sessions, was Mötley Crüe producer Tom Werman, who was among the first to go on the record emphatically contesting Trippe's allegation, stating unequivocally that "in the (six years that) I produced Mötley Crüe, I only knew one Nikki Sixx and worked with one Nikki Sixx, (I never) knew or saw Trippe, Nikki was Nikki, he was unmistakably Nikki Sixx the whole time...(During the *Shout* recording sessions), Nikki would go and make demos, bring them to me, rework them in rehearsals...take them into the studio, and use them for models as songs...In fact, for the majority of the recording of the *Shout* album, Nikki had to play bass with a pin in his arm (due to his accident)." In characterizing Nikki's own feelings toward Trippe's allegations at the time the lawsuit was filed, according to Werman, Nikki was nothing short of pissed, "when you are Nikki Sixx, you invite that kind of thing. He was pissed off and freaked. He wanted to put a stop to it. He had worked very hard to (establish his reputation), and he didn't want anyone ruining it."

In claiming he had written songs like *'Looks that Kill'*, Lita Ford, who lived with Nikki Sixx through the making of the *Shout* album, contradicted Trippe's claim by recounting that she had been present when Nikki wrote many that song among others, which included lines about her, "(we would be at home), and Nikki would play something and say 'What do you think of this? Do you like this song?'...The song...that he told me he wrote for me (was) *'Looks That Kill'*...I don't think he wrote the whole song (for me)...but (some lines) in the song. More with me in mind when he wrote it, you know?" Another unforgettable Mötley classic, *'Knock Em Dead Kid'*, Nikki wrote about the LAPD following a very publicized physical altercation between himself and the LAPD outside of the Rainbow, witnessed by both Quiet Riot's Kevin Dubrow and Lita Ford.

Nikki personally described in an interview in December, 1983 as an incident in which "Vince and I had gotten into a fight with some bikers a while back…It was really a life- or-death situation. Evidently some cops arrived on the scene and tried to stop the battle. I was so busy fighting for my life, that I didn't even notice them. All I knew was that this guy was running towards me with a mean look on his face, so I hit him with a chain. He turned out to be a cop. The next thing I know, I'm in jail and they're telling me that they're charging me with aggravated assault." To further authenticate Nikki's recounting of the circumstance surrounding the song's inspiration, Lita Ford remembers that "Nikki accidentally hit one of the Sheriffs with my belt. I gave him my belt because there were all these guys fighting. I said, 'Here Nikki use this.' So I pulled off my belt… a chain belt, and he was swinging this belt trying to hit one of the guys that were giving him a hard time, and he accidentally hit one of the Sheriffs. Oops. So they threw him in jail. Nikki was in jail and I didn't have any money to get him out and neither did Nikki. So I put up my Firebird Trans Am as collateral…He later told me that was the (inspiration) for 'Knock 'Em Dead Kid.'"

Trippe would ultimately discredit his claim by violating the timeline with a prison term that he landed in mid-1985, the result of a conviction for participating in an armed robbery, while Crüe was still on tour supporting *Theatre of Pain*. He would later spend time in a mental institution, before he even found time to concoct his utterly ridiculous allegations and file his lawsuit in 1988, which he would ultimately drop in 1993, though he still gathered some press as a result of it. Only a psychiatrist could truly attempt to figure out what could have possibly inspired Matthew Trippe to wage such a frivolous and potentially damaging attack on Nikki Sixx's hard-earned reputation and legacy, one that will go down in hard rock's annals as one of the strangest and ultimately most baseless lawsuits ever filed against an entertainment personality. In examining Matthew Trippe, it is clear that he was a mentally unstable human being who, at the time of his filing, was attempting to launch a rock band of his own aptly named "Sixx Pakk", and if nothing else, was seeking as much publicity toward that end as possible.

In his most shameless and ridiculous moments during his interviews with various journalists, Matthew Trippe confused himself on record as Nikki Sixx, and demonstrated to those present, as well as what would later

be a larger listening audience on record how mentally ill he really was, essentially admitting he was lying in the course of the same interview in which he was attempting to prove his credibility, "I went around in the beginning telling everyone I was Nikki Sixx (even after I was out of the band), that I started Mötley Crüe, and I had to come clean because I waaa-aaas lying." Nikki expressed his true feelings for Trippe in a 1989 demo titled 'Say Yeah', which featured the aptly written lines 'go ahead and sue us, everyone else has.' Between countless stutters and rambling inconsistencies, as well as countless television appearances between the years of 1983 and 1985 featuring what is irrefutably and unmistakably Nikki Sixx's presence, both in voice and physical appearance, in interviews, with the band onstage, and in numerous videos, Matthew Trippe's claim was ultimately impossible to stomach among both the entertainment and legal communities.

In the end, the most convincing evidence to rebut Trippe's allegations were the band's actions around Nikki during the period in which Trippe claims to have been impersonating him, namely in the way they still readily referred to Nikki to answer questions in live interviews about the inspiration behind the band's songs and conceptual directions for both the *Shout at the Devil* and Theatre of Pain albums. In short, there is no arguable way that the members of Mötley Crüe, who without hesitation still considered Nikki as their leader during that period would have entrusted the creative direction of the band to someone as inconsistent, mentally unstable, and ultimately, as unreliable, as Matthew Trippe. The latter was evinced in one of many examples during an interview in 1985 with Much Music Television in Canada, where, when asked by a reporter about the inspiration behind the concept for the *Theatre of Pain* LP, lead singer Vince Neil readily turns the floor over to an undoubtedly present Nikki Sixx, replying that "Nikki can probably answer that question better than anyone."

Chapter 12

The End of a Decade, & Doc McGhee... and VINCE NEIL!!!

During the period following the completion of the recording of *Dr. Feelgood* and prior to launching the world tour in support of that LP, Mötley Crüe had one more tough angle to navigate with their break-up from manager Doc McGhee, who the Crüe fired following a blow-out at the Moscow Peace Festival, which McGhee had organized as part of a plea bargain over charges that McGhee had helped smuggle forty thousand pounds of marijuana from Columbia to North Carolina, the result of which saddled McGhee with a $15,000 fine, a five-year suspended prison sentence, and the responsibility for setting up an anti-drug foundation he labeled the 'Make a Difference Foundation'.

As Tommy recalled the events in the band's official biography, which lead up to the blow-out, it was Nikki who made the ultimate decision to fire McGhee, "Doc told us a warm-up show in Moscow would be a great way to kick (*Dr. Feelgood*) off. He explained that everyone would be equal on the bill, there would be no headliners, and everyone would play a stripped-down forty five minute set...When we arrived at the gig, it

started to become clear that this was a total cluster fuck and Doc had told each band something different in order to get them to do the show…(After we and Ozzy and the Scorpions had played), the audience, which was about 125,000 people, started to stream out of the theatre…but then old John (Bon Jovi) made his grand entrance…As soon as he reached the front, the whole stage went BOOM- fireworks and flash pots and pyrotechnics exploded into the air…You need a permit to get those kid of pyrotechnics into Russia, and it was clear that Doc knew all along what Bon Jovi was planning for its show…I hunted Doc down and found him backstage. I walked right up to him and pushed him in his little fat chest, knocking him over onto the ground…As he lay there, Nikki broke the news, 'Doc, you lied to us again. This time you're fucking fired.'"

Though Doc McGhee was fired before *Dr. Feelgood* his retail, and despite the fact that the record hit number one and was an instant smash, he has retrospectively expressed relief at being free of Mötley Crüe, and specifically Nikki Sixx's tentacles, "since Nikki's overdose, I knew that Mötley and I had to split for one simple reason: I didn't like them…I've managed James Brown…Bon Jovi, and Kiss. I've been dragged through the deepest shit by all kinds of mentally ill people. But I have never been through what Mötley Crüe put me through…I've already spent ten years of my life apologizing for that band." Doug Thaler left his partner of over a decade to manage the Crüe exclusively under the mantre of the Top Rock Development Corporation, and they completed the most successful tour of their career.

In the end, the band's break-up with Doc McGhee and Matthew Trippe's lawsuit proved in the end to be just another storm Nikki Sixx and Mötley Crüe would successfully weather as their tour in support of the band's fifth album, *Dr. Feelgood,* roared through the fall and winter of 1989 and into the spring of 1990. With an album that debuted at number 1, and produced four top 40 singles and over 4 million copies sold, Mötley Crüe was truly a force to reckon with, such that as it winds down in August of 1990, the tour has grossed upward of $40 million and had generated a personal take-home of $8 million for each band member after taxes and fees. In May of that year, Nikki finally married his fiancé Brandi Brandt in Hawaii, and soon thereafter she became pregnant with the couples first of three children, Gunner.

On January 25, 1991, Nikki and wife Brandi gave birth to Gunner Nicholas Sixx, he measured 52cm long, and marked what Nikki called one of the happiest days of his life. By this time, though Nikki's marriage to Brandi was already rocky, he had arrived at a place where he was selfless enough to be ready to settle down and try for the family life he had never himself experienced. As a result, where in the past Nikki might have quickly bailed on his relationship with Brandi in the midst of their fighting, he instead focused himself on his new child, and the prospect of having more as he settled into the first stable domestic period in his life. As Nikki recounted the ups and downs of the early years of his marriage to Brandi in the band's official biography, he illustrated his attempts to achieve the latter balance, "the love that had blossomed out of my sobriety during the making of *Dr. Feelgood* was just a momentary obsession egged on by the fact that I hardly ever saw her (during that period), so I didn't know what she was really like. By the time we discovered we weren't right for each other, she was already pregnant with our first child, Gunner. I consoled myself by spending as much time with our children as I could...Fat from the success of *Dr. Feelgood*, with the prodding from my wife Brandi, I had bought a full-on drug-dealer mansion...I ended up in a fifteen-thousand-square-foot mansion full of white marble and tiled pools and sixty-foot ceilings...My overhead expenses were forty thousand dollars a month. That's how much it cost just to wake up and go to sleep every day between my house payments and utility bills. It cost twenty-five hundred dollars in electricity just to cool the house each month, plus I'd insist on keeping my pool heated to ninety-five degrees year-round...(Brandi's) materialism seemed to increase in direct proportion to the wanting of our love...But I couldn't bring myself to leave her because I remembered all too well what my lifer had been like without a father."

As recovery counselor Bob Timmons recalled, Nikki's attempts to make his family life work played a large role in keeping him sober during the first few years following his overdose, "I am sure Nikki's family (played) a role in (keeping him sober in the beginning)." Despite domestic ups and downs, Mötley Crüe was riding high again, and in October, 1991, the band released their first greatest hits retrospective, aptly titled '*Decade Of Decadence*', which debuts at number 2 on Billboard's top 200 album chart. That same year Nikki discussed publicly for the first and only time his plans for a poetry/biographical book, entitled '*An Education in Rebellion*', whose content he described as featuring "all 50 songs I've written for the

band and 40-50 originals, it'll span like nine years of my life and people will see what it's like to come from nothing to something and the hell that's been raised in between. Some of it will definitely curl your hair. I'm gonna be on the shit list of many women. There'll be a firing squad in each city."

The band toured briefly in support of the album, and topped off the year by successfully renegotiated their record contract with Elektra to include a new five-album deal, with a cumulative $25 million advance at $5 million per record, and additionally including a revised royalty rate in excess of $2.18 per unit for CD sales, and $1.50 per unit for cassette and LP sales, on both their existing catalogue and any new material. In reflecting on the band's success to date, Nikki reflected a certain sense of infallibility at the time, based largely on the fact that, by his calculation, Mötley Crüe had reached a point in their career where Nikki had developed the confidence to "see us being around 10 years from now more than I could in the early days see us lasting ten years. We've gone through all the turmoil and all the things that would have possibly stopped it from lasting." Ironically, a little band from Seattle, who Nikki was the first prominent metal-era personality to endorse on Head Bangers Ball in 1991, "Nirvana, one of my favorite new bands", would start a wave of alternative rock known as Grunge that would not only threaten to make obsolete the genre of hard-rock that Mötley Crüe had been largely responsible for spawning, but also would help to shape the odd new direction that the band would take their sound with their next studio release, Mötley Crüe, a few years later in 1994.

Sadly, despite the fact that Nikki had worked so hard to reconnect his band with their fans over the past three years, on February 12, 1992, Mötley Crüe, led by Nikki Sixx, would vote unanimously to fire lead vocalist Vince Neil from the group, beginning a new era in the band's career that would mark ups and downs commercially, personally, and musically. As the band ended the first phase of their career with Vince, Nikki described their musical direction as one which was far removed from what fans traditionally associated with Mötley Crüe, and while it would prove their diversity as a musical entity, it would alienate both their record label and much of their fan base throughout the first half of the 1990s, "We're going back into writing, we're planning on doing something musically a little different than we've done, experimenting…The only way

I could put it is a cross between the Sex Pistols and Led Zepplin, if that makes any sense. Musically were really heading off in a weird direction, so we're going to take another year or so writing." That direction would prove to be wrong for what the band had represented in the 1980s with Vince Neil, but was a perfect fit for the alternative-rock background of new front-man John Corabi, who would become a musical soul mate of Nikki's for years to come.

Chapter 13

Hooligan's Holiday

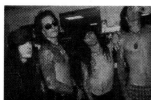 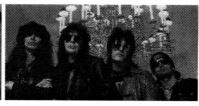

Vince Neil's departure from the Crüe's fold allowed Nikki a natural abandon from the traditional L.A. hard rock sound that had defined the band for over a decade, and the freedom to explore the new alternative musical sound scape that rock had become overnight in the fall of 1992. Nirvana's breakout marked the end of an era, but in the same time the dawn of the perfectly alternative commercial medium required for Nikki and co. to properly explore the new sound the band had been heading toward for the past year. While Vince Neil had not fit into this mold, his would-be replacement, The Scream front man John Corabi did. Nikki had stumbled across Corabi in the course of The Scream's debut LP, which he later plugged in an interview while answering a question concerning his favorite releases from the year 1991.

As Corabi described the two's introduction, it was a bit of both luck and fate that brought Mötley Crüe their new front man shortly following Vince's departure, ""it all began with this issue of Spin Magazine with a series of top 10 favorite album lists among rockstars, and Motley Crue's Nikki Sixx had listed *Let It Scream* as one of his favorite albums of 1991. That blew me away. The funny thing was I had never been much of a Motley Crue fan, but I still appreciated the press and the weight of his endorsement. So when we got home, I decided I wanted to call his

management office and thank him for the plug. Honestly, that was my only ambition with the phone call, but things took a slightly different turn. I remember the day vividly --- February 14, 1992. I had dialed the number to Top Rock Management to pass the message along my thanks to Nikki for the *Spin* plug. Beyond that, my managers had suggested when they got me the number that maybe I could reach out to Nikki about him maybe contributing toward what they were hoping might be the next Scream record … or perhaps for my solo record. The last thing anyone expected was that I would get a job offer. Even though we'd toured with bands like the Bullet Boys and Dangerous Toys, those bands were more our contemporaries, so it wasn't really like being among anyone like Gene Simmons or Ian Gillan. My point being that when it came to placing a call to someone like Nikki Sixx, whose band was legendary and largely credited with starting our genre in the context of L.A. hard rock, I was a little nervous. Motley Crue was on a whole other level than bands like ours, I looked at any opportunity to work with Nikki Sixx as something of a mentor-student relationship, where it came to the possibility of writing together."

Detailing the circumstances of the day his life changed forever, the singer/ guitarist recalled that "the phone rang, the receptionist at Top Rock --- her name was Stephanie --- picked up. I just blurted out, 'This is John Corabi of The Scream. I wanted to leave a message for Nikki Sixx. Is that possible?' And I don't know to this day if Sixx, who is the most manipulative dude I know in this business, was baiting me with that plug in *Spin*, was expecting my call, but this girl was quiet for a second before kicking into high gear. 'Oh, oh, hold on. Can I get a number where he can reach you?' Surprised, I gave her my home number, and she promised to have someone get back to me. I told her it was no big deal (as I wasn't expecting much), replying that 'I just called to thank him for the plug in *Spin Magazine* and maybe see if Nikki would be into doing some writing for the next Scream record?' I hung up the receiver and turned to walk out the door to head to a gig with The Scream. But the phone rang. It was that quick that my life changed, because my wife picked up. The voice on the other end said, 'Hi, it's Nikki Sixx. Is John Corabi there?' Val must have thought it was one of our friends playing a practical joke, because she just handed me the phone with an expression on her face that spelled disbelief. So I said hello, and was greeted with, 'John? It's Nikki.' And I said, 'Nikki who?' Of course, he replied, 'Nikki Sixx.' And I said, 'Oh …' That was all

I could think to come back with because I wasn't sure if it was someone playing a practical joke or not. But he continued, 'Here's the deal: Tommy and I are in the car, and we're actually out shopping right now for our wives for Valentines Day.' I heard Tommy in the background ('Hey, dude!') I started with my thanks for the *Spin* plug, but Nikki cut me off with, 'Hey, what are you doing right now?' I told him I had a gig that night in Orange County. He kept going with, 'Listen, I'm not going to beat around the bush, so let me get right to the point. We have been having some issues with our singer and, basically, Vince Neil isn't in the band any more. So we'd love to have you come down and jam maybe …' I interrupted with nervous disbelief, "You're asking me to come down and sing with you?' So Nikki continued, 'Just for now to come down, see if it works, how it goes. The problem is, you can't say a word to anyone.' The call waiting cut in, so I hopped over to get rid of it --- it was John Alderete, my bass player --- and got back on with Nikki. He said, 'Here's the deal. You can't tell anyone that you're getting together and jamming with us because nobody knows about it. We haven't put out a press release or anything yet, because everything went down yesterday. Me and Tommy, we really dig your record, and we'd love you to come down and jam with us, to see how it goes."

Reflecting their excitement, former vocalist John Corabi recalls that "the night before my audition for Motley back in February of 1992, I remember having a conversation with Nikki the night before, and telling him straight up that I didn't want to be a puppet, and being really up front about the fact that they had some material that I really didn't want to sing at all, basically like 'I want to contribute, I want to write. I don't want to sing *Girls, Girls, Girls*.' And I think he wanted to get away from that sound a little bit, because surprisingly, Sixx was really receptive on behalf of the band, and came back at me with, 'Yeah, that's what we want too. We want somebody that's going to contribute, going to be willing to write, try new things. So that's cool.' When the day of the audition arrived, Corabi remembered that "I showed up around 11 A.M., and whatever calm I built up was immediately erased. I had had some success with The Scream, but these guys were on another level entirely. It was like jumping from *Sanford and Son* to *Lifestyles of the Rich and Famous*. I pulled into the parking lot and parked my piece of shit Mercury among $80,000 Mercedes-Benzes and Ferraris. I tip-toed into the lobby and could hear Motley Crue jamming on an old Jimi Hendrix song I immediately recognized as "Angel." Their day-

to-day guy Mike Amato met me in the lobby and led me through these doors into a massive rehearsal hall; it was bigger than most places I'd ever played with The Scream. The sound that hit me when I walked in was perfect and thundering ---- and it was louder than hell! It was tight and primal, it created a picture in my head of porn queen Jenna Jameson racing naked down a California highway on a fucking Harley! These guys were at the top of the mountain, and nobody could knock them down."

Finding himself instantly at ease with the band, John explained that "I met Nikki first, then Tommy and Mick, and we all got right to it and just started rapping. Nikki asked, 'So what do you feel like singing?' Again I reminded him that I wasn't familiar with a lot of their stuff and told him, 'I just got off the road from touring a week ago. Can we maybe do a couple of covers?' They were into that, so we settled on 'Helter Skelter,' which was in their catalog anyway. They launched into the main riff, so I grabbed the mike and started singing ... 'When I get to the bottom, I go back to the top, of the slide and I stop, and turn, and go for a ride, then I ...' Tommy just stopped playing, and panic immediately welled up within me. Tommy just put his head down and started shaking it, and I hadn't even gotten half-way through the first verse. I couldn't see his face, so I didn't know whether he was laughing or crying or what, but I could see him shaking his head ... back and forth, back and forth. I, of course, thought the worst. He didn't let me know what the fuck he was thinking and just said, 'Let's try something else.' So I said, 'How about 'Jailhouse Rock'?" That one was also one they'd covered live on the *Girls* tour and album, so we launched into that, and we probably got about two-thirds through it before Tommy stopped playing again. This time I was even more worried but that much more fucking curious. I got a partial answer in that Tommy wanted to turn the P.A. down, because apparently Vince had never pushed as hard as I did with his voice. As Tommy told me later, when I had hit the first note of '*Helter Skelter*,' I just about ripped out his eardrum because my volume was so high. It had impressed him, but also startled him, so he was just laughing to himself at the stark difference right off the bat. By the time we got through '*Jailhouse Rock*,' they had heard enough of the covers and wanted to delve into their own catalog. I didn't know this at the time, so I was still going on gut, but we launched --- volume adjusted --- into '*Don't Go Away Mad (Just Go Away),*' and I was going off their lyric sheet but trying a few different things with the vocals, which I could see from the looks on their faces, they were all digging. We ran through a couple more tunes and then

called it a day. They didn't let on about what they thought of me, but they did ask me to come back the next day and jam, so I thought that was a positive sign. The other telling thing they said was that there would be some management people in attendance the second day, another good sign. When I walked in this time, the guys were all there, but so were Nikki's wife Brandi, Mick's wife Amy ... and an army of suits. OK, now *this* is the audition, I remember thinking. All the management guys were there --- Doug Thaler, Chuck Shapiro, David Rudick --- and they were polite enough, but it was definitely a little tense."

Revealing how immediately the band gelled creatively, Corabi explained that "on the second day of my audition, once we got started, I remember Tommy was like 'So, you want to jam on some other shit?' And this was, I think in hindsight, the real deal sealer, the turning point if there was any doubt on the band's part, because looked around at Mick's guitar rack, and asked if I could check out one of his axes, and the guys in the band just all started staring wild-eyed at each other, and Tommy was like 'Fuck dude, no way! You play guitar?!!' They had no idea at that point I even played guitar, and with Vince, it had always been for show, so I plugged in, and we jumped into this old blues tune called *Reefer Headed Woman*. So I was popping off the lyrics, and in between Mick's licks, I would throw in a few, and they were clearly impressed. Because we finished that tune, and literally jumped right into jamming off a riff I showed them for what became *Hammered*. That was like the second day I'd ever played with these guys, and we were already writing. So I showed it to Mick, and then we started it together, Tommy came in with a beat, then Nikki chimed in with a bass line, and just went at it, fucking free form! It rocked! So we fucked around with that, and I started humming out lyrical melodies into the mic, and it just took form into the skeleton of *Hammered*. So when we finished with that, they were like 'Dude, we got this fucking acoustic thing we want you to check out. So let's just try this, we have this idea we want to hear what you feel of it?' That was the first time I felt like they really trusted me, we were bonding in real time, but it felt fucking unreal. So then Mick whips out this bad ass acoustic guitar, and Nikki handed me these lyrics and hummed out this melody, and they just started into it. So I just sang the lyrics out loud how they sounded accordingly to the melody he'd given me in my head, 'Little old man contemplates suicide twice a day...' So we ran through what they had written of that song, which up to that point was the acoustic part that opens it. So as we played

through it, and mind you this is just over the course of a few run throughs, they were digging the inflections and different things I was doing with it vocally, so then they stop again- in mid-song. This time, I took it as a good sign because I had become used to that happening. In addition to the originals, I remember we started running through part of '*Dr. Feelgood,*' and Tommy stopped playing again."

Using the moment as an excuse to "relieve the elephant-size piss I had been holding all day, I ran off to take care of that, which gave Motley another chance to have a meeting to discuss the day's events. When I came back in the room, the scene was very different. Mick and Nikki had put down their guitars, and Tommy had come out from behind the drum kit. They were all just sitting there, looking at me for what seemed like a full minute. No one said anything, but I'd been eavesdropping from the hall and had heard Tommy and Nikki going back and forth, saying, 'The dude plays guitar, harmonica and sings the blues great. He's got cool riffs, and we just played him our new shit and catalog, and it all sounded killer ... on every song!' Tommy broke the silence and just laid it all out for me, 'Well, dude, it doesn't take a fucking rocket scientist to figure it out: You're the guy. You're the new singer for Motley Crue.' I was stunned. Nikki took advantage of my silence by saying, "you can't say anything to anybody --- you have to keep this completely quiet. Say nothing to nobody, and we'll figure it out as we go. But be here tomorrow at noon. We've got rehearsal. Our songwriting process, from that third day jamming on, went like this- someone would come in with a riff, whether it be Tommy, or Mick, or Nikki, or myself- like Tommy came in with the middle riff to '*Uncle Jack*', and he'd show it to Mick and I, and we'd start jamming it, then Tommy would come in with a beat, and Nikki would join in with a bass part- Nikki was a really riff-oriented bass player, which was always cool. Anyway, we'd all just jam on the idea, and I would sing into the mic, just bullshitting a melody idea for the verse, and we'd just really hone and develop the idea as a team until we had the rough skeleton for a song. Then we'd each like add our own life to it, until we had the flesh on the bone, and then highlight it with little solos, like adding the facial features, coloring- creatively, it really was a living process, like creating a living being. And when that particular song was done, it added like another personality to the band, that's why at one point we considered calling that record *Personality # 9*, or *Til Death Do Us Part*, because the album musically really was a reflection of the band's own personally. For me, Motley had a comradery

that I have never had before with any of my other bands. Mainly I guess because, the one thing I couldn't believe, is that from the jump, they immediately made me feel like an equal. When I spoke about parts or creative input, they were very receptive to my ideas. When I offered something they didn't really dig, they were very cool about saying so. It was like, I instantly felt like one of the guys. So immediately, we started working on *'Misunderstood'* and *'Hammered'*. They just had a truckload of immediate confidence in me, and really treated me like a brother."

Continuing, John explained that a certain serendipity hung in the air during the band's rehearsals that informed the direction of their writing, such that "for the first few months I was in Motley, basically throughout the spring of 1992, we were full on into writing the album, and I was showing up at the rehearsal studio every day, basically going to work, but it didn't feel like work. It felt so natural. We were rehearsing at this place called Audible Sound in Burbank, 5 days a week, working on material, and our routine was we would write for 2 or 3 weeks, then go in and do a demo for another week or so. Then we would go back into the studio, so we kept stockpiling songs, and in some cases, we would go back and change them completely. Our process of going into the rehearsal with riffs, working on the songs, getting them together, so it was methodical, but very creative. We wrote most of that album during the rehearsal, before it had been publicly announced to the world that I had joined the band. It was sort of this weird process through which the songs would come about, some of it was deliberate conceptually with an idea Nikki had lyrically, or something Tommy had musically, or Mick or myself, but alot of it just came about out of the serendipity of the whole thing. By complete accident, but felt really deliberate, like it was supposed to be, it fit. And we'd start at whatever point A was for a given song, and just go where the creative flow took us. Honestly, lyrically, I've never had an easier time writing lyrics than with Nikki Sixx. And as easy as it was, they're probably some of the best lyrics I've ever written- with that guy. As a band, the creative chemistry was amazing. For instance, with *'Misunderstood'*, they had the acoustic part already written, along with the lyrics for the acoustic part. And we'd just jam it out from there, and it was building and building to the point where we didn't know exactly where to go with it, but knew it just needed to explode. Like there was one mindset within the band that the song should stay acoustic, all the way through. Then I remember at one point sitting there, on a break, and I picked up my electric guitar and suggested the first

riff that the song goes into when it becomes electric. And the guys just flipped, so we went with it. It was very spontaneous. And Tommy would come in with a drum part, and Mick and I would flesh the riff out further, into Zepplin territory. We really wanted the song to be Zepplin-esque, as well as the album to reflect that derivative overall."

While the band's musical collaborations and contributions were split pretty equally among the four, John recalled that the process of lyrical writing was more centered between he and Nikki Sixx, such that "Nikki and I, writing on that record, pretty much jumped right in, like from the day I was inducted into the band at rehearsal. I probably connected with Nikki most on the personal level. And I think because he had been the one to first contact me, and because we wrote lyrics together, I was spending a little more time with Nikki than with the rest of the guys at first. Like when were first plotting the album's lyrics, he would actually confide in me, like seek out my opinion, and say 'Well, I really want to do something different on this album. How do you feel about this song, or how do you feel about that song?' talking about songs from their catalog, like asking my opinion about a set list, where most singers would have just sung whatever they were asked to without question. I was probably prepared to as well, but when he offered me the chance to inject myself, I was like "Well, I've never really liked *Girls, Girls, Girls*. But I like *Wildside*. I can't picture myself singing *Girls* live." And he was cool with it. Also, after a very brief while, like maybe a couple weeks, we'd be working on lyrics for the new album, and rehearsal would finish, and Nikki would still want to work, and would say "Crab, why don't you come up and stay at my house, and just come to rehearsal with me the next day, and we'll work." So I'd bring clothes with me from Hollywood, and after rehearsal, leave with Nikki, go back to his house, write lyrics with him at night, work the next morning before rehearsal, and then head back to rehearsal."

Continuing, John explained that "every song we had on the *94* record, Nikki and I sat in a room together, with notepads, we used to have three notepads- the one that I was writing on, one in the middle, and the one that Nikki was writing on. And Nikki would jot down certain things, write out certain things, and the middle note pad, was what we would both bring our ideas together on and turn into the verse. There's not a song on that record, even *Drift Away*, which for the most part I had written when I was still in *The Scream*, even that- we learned the song as a band, and I gave the

lyrics to Nikki, who wasn't sure about a few words- that might be considered a little soft for Motley. He made his suggestions- and it went that way for every song on that record. We sat in a room, and wrote the lyrics together. Every song. In certain cases, Nikki would come up with key concepts or phrases- like on *Til Death Do Us Part*- 'When you look into my eyes, tell me what you see?' It was kind of bouncing off each other, but such an easy thing to do, it was weird. We would bounce off of each other, and Nikki would come up with something really ingenious or clever, and then I would compliment him. There was alot of pop culture references fused into that album. And when he's writing, Nikki will sit down and go, 'Okay, I have to come up with something right here.' And I'm the type of lyricist who will sit there for four hours, thinking about a line, trying out different rhymes, trying to make the perfect line. But in the time it will take me to come up with the line I think is great, Nikki will have come up with 500 things, until he finds the thing. And he'll take the last half of idea 399, and put it together with the first half of idea 18, and go through this process of elimination. But he's quick, like bang, bang, bang. His mind works like that. And so when we were writing together, I would sift through his ideas as he threw them out, and elaborate on the ones I dug, like 'Well, I like what you're doing here, but don't like the way this ending sounds, and rolls off my tongue.' And he would be like, 'Okay, cool, cool, what do you think?' And we'd come up with a line that we both dug. I think Nikki really elevated me to be better, and I think though our collaboration, I elevated Nikki to be a better lyricist. Because collectively, we really started coming up with some really, really clever things, clever ways of wording things. I would explain to Nikki that at times, I wanted us to be as deliberately vague as possible, so listeners would have to use their minds and own sense of interpretation to get it. Because he was used to being alot more direct with his lyrics, and I was more the former, so I think we meshed well, and he dug it. With the 94 album, I think we gave Motley fans something to think about for the first time in a certain way. And usually, we'd had a musical idea down before we started lyrics for a song."

Another area Corabi identified as existing immediately for the band in the course of their writing for the album was an instant trust between the four of them that Crue allowed for an open exchange of ideas that only made the material stronger, such that "I didn't like a beat Tommy was playing, I'd tell him, and if he didn't like a riff Mick or I were pursuing,

he'd tell us or suggest ways to make it more cool. It was a very open thing, and the first time the band had really written as a full band. Like sometimes Tommy would go 'Sixx, Crab, I'm really digging the lyrics, but what do you guys mean by that third sentence? I'm not feeling it?' It was a democracy, so everybody had a right to ask about everything. That little part in the liner notes of the album that says 'written by Motley Crue as a band' is ABSOLUTELY true. I mean, we each put in more based on our own individual strengths." According to Corabi, the band did so much writing during this period that they ended up with more than could even fit on what was Motley Crue's fullest album of material ever to date, explaining that "there's other stuff too that nobody's ever heard from that time period, like *'Hell on High Heels'*, that we recorded, which ended up being the single off the *New Tattoo* album. And the band just took the title from that song and reused it, but the music sounds TOTALLY different, alien from the tune Vince sings on. Ours was so Zeppeliny it was ridiculous, it was this sick groove, a killer tune. But we never had that right chorus for it. We had the title, but after listening to it, we were like 'I don't know man... Love the verses, love the prechorus, love the riffs, love the solo- hate the chorus.' It just never became fully Motley'd. There's another song called *'Ditch that Bitch'*, which would NEVER see the light of day on radio. Never. The lyrics are so crude and retarded, and it was a funny joke song we did, but probably had one of the greatest drum tracks anyone would EVER hear from Tommy. It had this maniacal double bass, crazy insane drum track. Nobody will ever hear it, which is a shame for the drum track."

This experimental approach to Mötley Crüe's new sound was exactly that which Nikki had been seeking out, and as Mötley's new musical direction found them, the band took on several new dynamics that truly worked to redefine their sound. Most importantly, Nikki trusted in Corabi's musical talent and songwriting instinct enough to turn over some of that autonomy to the new front man, such that, in the album's liner notes, the Crüe stated proudly and explicitly that "this album was written as a band." Once the band had amassed an album's worth of material, they headed up to Van Couver to Little Mountain Studios with producer Bob Rock in the early spring of 1993 to begin recording. As former vocalist John Corabi recalled the band's set-up in the studio, "the first few days was like a building thing, all the little ISO areas we were going to be sitting in. We recorded in one main room, Studio A, and they had to set up these ISO

booths, these glass walls we could actually see each other through. So while Tommy would be tracking his drums, we would all be in the same room playing live, amps on and all. Anyway, Tommy was isolated, and our amps were isolated, and they'd built these tents so that none of the sound from our amps or the drums would bleed, but so we'd all have eye contact with each other. So Mick and I were together in one room, and Nikki was in another room, and Tommy in his own. It was a trip."

In the studio, the band also acted very much as a team creatively, absent of a designated leader. As a result, Mötley Crüe initially intended to title their new album *'Til Death Do Us Part'*, and, as Corabi remembered, even went out and got a group tattoo bearing the latter inscription, "(it felt like) trying to get rid of your old skin to have the shiny new one. I thought it was really cool just from some of the personal things I was going through so it didn't end up mattering whether it was the album cover or not, I just thought it was cool. So I had that tattooed on my right leg from my ass cheek all the way down to my knee. And it was funny, we *were* laughing about it because we wound up not using " *'Til Death Do Us Part'* as the album title and we wound up not using that album cover, but if you listen to the lyrics to the song you know it's a pretty valid song anyway, whether it was the album title or not. I just like what it stands for."

From the former vocalist's recollection, their producer ran such a tight-ship with Motley, and was so hands-on with the band in the studio that "Bob Rock actually sat in the room with us on some days, like while we were working the songs up. We actually fucked with him at one point, called a prop store and got him a throne, crown and cape- because he would set his chair up so he was elevated above the rest of us so he could see all of us, and talk to us through headphones. He had his own mic, and had a guitar, and alot of times, we would all work on the shit together. It was a cool time, we were being really creative, which naturally provided for a few tense moments in the studio, where Bob wouldn't like a certain song or part, and he was a real stickler for things. His process was like this: he would set in the room, and was very clear and concise with everything he said, and when he was critical, he would say, 'This could be a really great song, but could be and where it is right now are two different things. I think it needs a bridge, I think you and Nikki should go back and really work on these lyrics. I'm not real familiar with your work, but I know Nikki can do better.' He just really strived for us to constantly push

ourselves, and just be the best we could be. Between pre-production and once we went into record, alot more work actually went into the songs in the studio. It was really a give and take thing, where sometimes Bob would sit there, and plant that one seed of doubt in your head, and it would actually help you grow to a better place with the song. Like with *Hammered*, he would sit there and go, 'Do you guys think this is as good as it can be?' And if anybody sits there and asks ANY artist, 'Do you think that's as good as it can be?', its going to naturally spark you to sit there and consider its not by the very fact that the question was asked."

Elaborating further on Bob Rock's approach to recording the band over the course of the '94 album, Corabi explained that "Bob Rock knew we wouldn't have brought the songs to him if we didn't feel we were at a place where we felt they were ready, and it was his job as our producer to tell us when he felt they weren't. And then to help recommend ways we could improve on their weaknesses. So alot of times, we would go off after that, completely dissect the song, and would wind up keeping 70% of the song, but go all the way out the left, and then swing around in the outfield, then come all the way back into the right again, and realize that the song's parts worked, but we just needed this one extra thing to tie it all together. The music was great, but the lyrics weren't just right, or we needed to tweak the melody more. In some cases, the song was great, but maybe Bob felt it was missing an intro, so we'd work on the intro to the point where we felt it rocked! That happened with *'Hooligan's Holiday'*, the intro was added later. Then we might take a second listen to the verse, and decide to take another pass at it- and when I say the verse, I mean we would dissect every word of every line of the verse, the melody, the guitar work, the bass work, the drum pattern Tommy was playing. We would strip it down to its most bare essentials, then start rebuilding it, stacking things on top of it, layering it till we felt the verse and the intro worked great together. Then we'd work on the chorus. And there were times when Bob would suggest something, and we wouldn't agree. Or where Bob would suggest changing something, and we as a band would remain adamant, and Bob wouldn't agree. But the one thing in hindsight I realize now is that Bob pushed us to get the best product possible, and if it meant getting us angry to motivate or move us, he'd do it. So there was a definite method to the king's madness. In some ways, it was the King Solomon's Theory, cut the baby in half, and we'll call it a day. It was a push-and-pull thing, but it definitely worked. As much as I was intimidated by Bob, I think Nikki and Tommy

are equally as intimidated by Bob. So when Bob would draw the line, it was like the word of God came down. He was able to control all those egos, and even though we had our creative differences, and would argue and bicker, Bob was always able to sit down and talk about it, and give you his reasons in a convincing way. His biggest strength as a producer is hard to identify, because there are so many."

Recalling some of his favorite moments in the course of collaborating with Bob Rock and the rest of the band on the making of the '94 album, John Corabi recalls one moment in particular during "the mixing on Poison Apples, Bob Rock ran through the effect that you hear at the opening of the song, which makes it sound much more compressed and quieter than it actually is. And we all got a kick out of it, because we decided to play this little inside joke on fans where, when they had the CD on, once the song first started, they would reach over to turn up their volume knob even louder, thinking something was wrong with the stereo, and when the full song kicked in, just be blown the fuck away! When the band kicks in, we were just thinking it would blow out all their speakers." Another of Corabi's favorite personal memories in the course of collaborating with Bob Rock was the recording of *'Hooligan's Holiday'*, where the song was actually re-written into what became the album's single from Rock's suggestions, wherein "originally, *Hooligan's Holiday* was more of a double-time song, like *Highway Star*, it was twice as fast. That was the way Nikki and I had originally wrote it, it was almost like *Live Wire*'s pace. But once we played it for Bob, he said 'Its cool, its got a very Deep Purple-esque, *Live Wire* vibe, but its a little dated.' So we sat down and tore it apart, and we were running tape, and I don't know whether it was Bob or Tommy's idea, but Tommy started playing the beat in half-time, and we all started following, and came up with the intro, and the whole song re-wrote itself in that day. It was amazing, and that ended up being our single off the album. We just broke that song down, and the intro is a more subtle, broken down version of the chorus. It was just another experiment from the fucking mad scientist, Bob Rock, and I really respected him when we were done, because he made not only made the best possible album we could have as a band, but he motivated us individually to creatively really step up to the plate, and really working on writing, and playing their hearts out. And I really think it shows on that record. Just Tommy Lee alone on that album, he never did a record before or after that where he played as masterfully as he did on the *94* album. If you ask fans, critics, even

Tommy, he will tell you. Another bad ass one was '*Misunderstood*', where the guys had never had an orchestra before, so Bob Rock had the Van Couver City Orchestra come in and set up, and Tommy and I were sitting in the room with them, watching them do there thing, just freaking out, looking at each other, thinking "we have a 63-piece orchestra playing our song right now!" It was surreal. And we had headphones on while they were playing it, and it just sounded so majestic, it was insane."

In sum, Corabi for his part, feels as many of Motley's core fans that the '94 record was, by far, the band's most musically accomplished and sophisticated substance-wise, namely because of "the chemistry and combination of us four guys doing that record, with Bob Rock to boot- there was just something really magical about it. It was just all about genuine admiration- that time period, that two years writing and recording that album, working with that band, I never felt like I was close too, or worked better with, anybody in my life. From the writing and recording, to the open-mindedness we all had, it just worked, for all of us- for Tommy, for Nikki, for Mick, for Bob Rock and for Me. I think the five of us, in that two years, put together one of the most underrated rock records in history. And I say that proudly, that record was way ahead of itself. We took our time too, and spared no expense, because that record cost $3 million to produce. In my opinion personally, given the climate for bands like Motley Crue at the time based on what fans associated them with from the 1980s, that record was worth every fucking penny we spent to come out of the studio with what we did. It just was an amazing record, and every fucking fan I encounter, to this day, counts it as among their favorites in the catalog. Still to this day, I think it was really the band's most accomplished album musically, it was certainly their most layered and sophisticated- in terms of the versatility in musical arrangement and depth lyrically and conceptually. It really was new territory creatively for all of us in the same time, which made it a pretty even playing field artistically. As musicians, they really rose to the top of their game too. It was really cool, because Mick played his ass off, Nikki played his ass off, Tommy played his ass off, but I'm sorry dude, as far as overall playing, honing their instrument, playing their instrument, being really creative, and coming up with really cool, clever parts- its completely cocky of me to say this- but on the Motley record, they elevated themselves to a place that they hadn't been before, and haven't been since."

In Bob Rock's own recollection of the making of the '94 album, he echoes much of what Corabi himself concluded in terms of the band being in a place they very much wanted to be musically. Still, the producer has a slightly different take looking back on the record in terms of where the band succeeded and failed in their choice to record with Corabi as opposed to Vince Neil. As Bob Rock sees it, "that record only worked on the level that it made them happy at the time, but it wasn't the same. John Corabi was a lot more involved in the songwriting, and Tommy was too. I think there was a lot of comparison to Zepplin in the sound of that record, I think I would say one of the things with that, the band's sound got more sophisticated, it was very timely though. In that time period, the Black Album had come out, so had Nevermind, and realistically, the only rock band that I can think of- the two of them were Guns N' Roses and Metallica- who really survived the whole transition from 80s Metal to Grunge, and it was because of their musical sophistication and their songwriting, and kind of what they meant to people. And I think Motley suffered a bit because they were kind of the kings of the L.A. Glam thing, so with the '94 record, they were trying to head in a different direction more relevant musically with the times. I think they were trying to make the change to something more meaningful with the 90s, which is what everyone wanted, but it just didn't work. In a funny way, that probably wouldn't have worked with Vince either, so it probably worked out for the best that they took a break. When we made the 94 album, to me it was a great sonically-sounding record, its got some great riffs. But obviously I'm not happy with it because it didn't succeed commercially on the level I wish it would have."

That same sentiment by the band's original three members eventually booted Corabi from the fold and reunited Motley Crue with Vince Neil, but their decision had little to do with musical substance. On that level, even Bob Rock will quickly point out that John Corabi offered Motley Crue something perhaps more musically akin to what they naturally were as a rock band, explaining that "Corabi is a classic kind of Steven Tyler-ish kind of singer who wrote very blues-based, 70s-based kind of rock. Paul Rogers, all those kind of things that Motley had always wanted Vince to kind of do. But in a funny way, John's voice is almost sympathetic to the music, and that's not what was good for the band." Ironically, as Bob Rock saw it, what Tommy Lee, Nikki Sixx and Mick Mars loved about John Corabi's musical contribution to Motley Crue "almost made Motley bland.

That's to me what it was, it was kind of like, 'Yeah great, he can sing.' And all the songs, Nikki changed the way he wrote lyrics, it was about other things they were trying to do. Then musically, they felt they could go to different places, and it really just didn't work." While everyone within the band circa-1994 agreed that Motley Crue needed to part with Vince to go where they wanted to musically in context of the times, Bob Rock has the most logical outlook on the band in terms of what inevitably works best about them to date with Vince Neil as front man, explaining that "I think musically the album was fine, it was them trying to adapt with what was going on, and they did it with a different singer, and it was very much like they had divorced themselves from Vince, gone out and got a new girlfriend, and were sitting there going 'Wow, this feels really, really good.' But it wasn't necessarily better, it was just different. And I think after John left, Tommy struggled, and continues to struggle, with the limitations I think he sees that Vince has as a vocalist. Tommy, being on the road this time, has finally realized- enjoy what it is. The combination of the four of you guys is something very unique, and its very good, stop criticizing, stop wanting it to be something else because what it is is great."

As then-manage Doug Thaler recounted from a devil's advocate perspective in the band's official biography, "after a few months, the Corabi album already cost as much as every prior Mötley record combined…So I called a band meeting in Vancouver and passed around some spreadsheets…Nikki took the spreadsheets and threw them at me, 'You're killing all my creativity.'…Fourteen months and two million dollars later, the record was finally finished." Critically, the mood was far more positive, with Rolling Stone Magazine praising the fact that with "their new album (Motley Crue are) celebrating the power of the Zeitgeist, the minute changes in the musical winds that have kept the band aloft all this time – from its origins as the only metal outfit beloved of punk-dominated Los Angeles to pretentious poseurs and meat-and-potatoes hard rockers heavy on the riffs and light on the introspection – without drastically changing its sound. This seventh effort's major innovation is the loss of singer Vince Neil and the arrival of his welcome replacement, John Corabi…. Hiring a relative unknown to front a hugely popular 13-year-old group is not a decision tight-pantsed dummies would make. It recognizes that super groups are invariably less than the sum of their chubby parts, and it wins the band a game, workhorse musician with everything to prove. The Crue's best quality…is that old metal mainstay: chops. Each of the 12

songs here stars a whomping chord progression determined to imprint itself on listeners' skulls. The band chugs, noodles and finger picks soulfully, raising visions of Metallica on the hardest tunes (*'Uncle Jack,' 'Poison Apples,'* and *'Welcome to the Numb'*) and Guns n' Roses on the fast and slow ends (*'Hammered,'* and *'Misunderstood'*). If the music seems samey…Corabi keeps it fresh. He has an impressive high-range yowl that's never nasal, and he bellows his heart out on the clichéd lyrics as if he has just thought of them. But the Crue have always left the philosophizing and menacing to other bands; Motley Crue achieves what it sets out to do: keep the riffs coming and mean every word."

Chapter 14

The Exit of John Corabi / Return of Vince Neil

Unfortunately many of the band's instincts on Mötley Crüe's 1994 self-titled album proved to be way off commercially, as the LP was far from the smash success that they hoped it would be. Despite debuting at # 7 on Billboard's Top 200 Chart, the album barely went gold in the States, and scanned roughly a million copies worldwide, a far cry from the band's multi-platinum heydays with Vince Neil. Worse than lackluster album sales, which were to be expected to some degree with the band's alternative line up and release of a new album in the midst of the Grunge era, was the arena tour that followed. Though the tour began relatively strong, as it neared its conclusion, the band was forced to cancel the remaining dates due to poor attendance. The message was clear- Crüe heads wanted Vince back, and the band was beginning to listen. Though it would take some coaxing from new manager Allen Kovac, the band soon caved into the pressure of their record label, management, their respective financial situations, and good old fashioned common sense.

As Nikki reasoned shortly following the firing of Corabi and rehiring of Vince Neil, "well, (the album with John Corabi) wasn't Mötley Crüe. Probably, we should have used a different name, anything would have been fine, but we used Mötley Crüe and that's what people expected. People had expectations as to what the songs should have been sung like by the singer. That's why everybody was confused, people don't like to be confused." Nikki could have viewed the pride-swallowing move to hire Neil back as a failure, and he did, but not as the band's failure, more as the failure of an experiment that Mötley Crüe had tried for a while musically. By that logic, bringing Vince Neil back into the fold was not something to be

disappointed over, but rather, something to look forward to in that it both pleased the fans, and offered Mötley an opportunity at a second chance that many bands did not get offered.

As Sixx argued, "there is no reason to be disappointed in something you gave a 100 percent to. If I couldn't get back a 100 percent in result, then maybe I would be disappointed…To John Corabi, we pay a lot of respect to him and I love him, he's our good friend. Probably somewhere in John's mind, he was thinking that he was going to do something that didn't suit him. Between Mötley Crüe's original four members chemistry, it only exists between the four members. We were trying to make something different with John. But to think about making music with Vince, and to make music with our chemistry, we found out that this is the right thing for this band. To do side projects or solo projects are a good outlet, but none of us think that it more important than giving up this band. Mötley Crüe with a different singer made a creative outlet, Vince did his own band, and I did my own side project and Tommy did something outside, but our real focus is Mötley Crüe with the original line up. It just takes time to realize…to find out that we made a mistake."

Ultimately the hiring of John Corabi had been a misjudgment on Nikki's part commercially, but had been right on personally in terms of what he had sought to accomplish musically during the early half of the 1990s. Elektra Records has lost millions of dollars on Mötley Crüe's self-titled 1994 LP, and were looking to make good on some of the $25 million that had underwrote on the band during their experimental period. As a result, in 1996, due to a combination of financial and managerial pressure, Nikki Sixx and company welcomed Vince Neil back into the fold, finally having come to terms with the fact that their future as a band depended commercially on it. Perhaps Nikki had in some way foreseen the fall of grunge, perhaps it was pure business instinct that persuaded him to go along with Vince's return, but either way, by mid-1996, Mötley Crüe was in the studio trying to replant the heart of a sound they had uprooted six years earlier in the hopes of repairing the commercial damage among fans that had been done by the split.

In some ways, the band's hands were tied to the decision by a coupling of fate and their respective commercial failures independent of one another before they ever really had a chance to question it, as lead

vocalist recalled in the band's official biography, "I began to see realize…the big picture, and the big picture was that I wasn't going to make it on my own as a solo artist and Mötley Crüe weren't going to make it on their own as an alternative-rock band…Before the meeting, I didn't really want to be back in Mötley Crüe. I just wanted to bury the hatchet, get my quarter-share of the brand name I deserved, and move on. But…Kovac fertilized a seed that just kept growing. When…I saw Nikki and Tommy…we eventually came around to the idea that we needed to be together."

An important element of what made things work differently for the Crüe this time was the fact that Nikki was free of having to write 1980's style rock for Vince Neil, a large part of what had inhibited him creatively at the time when Vince was let go. 1996 was a truly awkward period for the rock genre, it was a confused time in which a band like Mötley Crüe could slip back into the spotlight and withstand their nerdy Microsoft-land critics who had risen from their Friday-night-at-home status during hair metal's heyday into the forefront when Grunge had broke and gave them a voice with which to lash out at the mainstream. Grunge had suddenly made Nerds cool with bands like Presidents of the United States and Weezer, there were virtually no bad-boys, and definitely no hair-spray. Still, when Mötley Crüe began their return to the forefront of rock in 1996, they had an updated look which embodied both hard-rock glam and elements of what was fast becoming Grunge's return to the back alley look and sound, producing an industrial soundscape that was vacant of favoritism to either trend.

Nikki explained at the time why the band's reentry into rock's confused, and therein vulnerable, mainstream was at the time appropriate by explaining some of why he felt the band's sound and look was at the time relevant again, "I'm very sensitive to what is popular. I'm always checking what is happening now and what is in style. I'm interested in the British style. I like rockabilly and old punk too…but like Green Day, they're no good, they're just pretending, they're no good, they're just pretending, the real thing is okay. Something offensive, very sharp, I'll kill you and your mother too! Drink your milk and eat cookies, sing pretty pop songs about the earth, that sucks! Eat shit! But I love popular stuff and you probably understand that I feel very weird about visual stuff. I keep doing crazy shit. Tommy is just like me, but Mick is like an anchor, he doesn't

like to change. Vince is getting closer to Mick's side, more than Tommy's and my side. It's funny, Tommy and I did things before anybody else did. We shaved our hair off during the *Dr. Feelgood* time, nobody did it then, we were the first. We did piercing before everybody, we tattooed half of our bodies before it was trendy."

Continuing, he pointed out that "at the beginning of the *Dr. Feelgood* tour, I still remember when we were on stage wearing army boots and cutoff pants. Nobody was wearing that then, everybody looking at us and saying what the hell are you wearing? Putting on makeup, nail polish and wearing shorts and army boots! Then right after suddenly it became a trend! I started that, but I don't want to say that, but I want to say that this band has an element in style that people want to follow. If the four members in the band's clothes are the same, it is clear that the focus is to make a trend, but if two members are dressed a little weird and the other two are not so crazy, it turns out to be a good balance don't you think? Vince has a concept that is connected to sex that relates to music, he's a very sensual guy. I'm very dark and devious. As you can say, *Wildside* is Tommy. Mick is very secretive, his playing is always perfect and he never moves at all, we can trust him, he's always there. Those elements are clear on *Girls, Girls, Girls*, I love girls. But my favorite kind of girl is a lewd girl wearing tattoos and body piercing. 'I can die anytime' that kind of woman. Vince likes beautiful blonde women, Tommy wants women that are made of rubber. Mick wants a woman who can smoke with him. We're all really strange, but that's what's cool. That's why we're back together again."

In that light, Nikki's next job was to explain to fans and critics alike how Vince would fit back into Mötley's musical mold given the fact that he had been fired four years earlier for what Nikki had characterized as a disinterest in the direction the band had been heading in musically. Sixx explained the answer as simply that the time was right, and that all four band members were again on the same page, and ready to move forward, "there needed to be a change. You could lump us in with all the rest, but only the shit went down the toilet, the imitators. Bad imitations. The same thing has happened with rap-rock. It's just the industry, it happens every decade. But the great ones will stick around…As usual the band is always making changes musically, when we talked to Vince again, we let him listen to a couple songs and we listened to his music too. My head could see that we are going in one direction. After finishing with the lawyers and the

money stuff, staying in one room together made me feel that this is the band, the four members that started making rock n' roll together." While the band's attitude to the press and public was upbeat, they had a clear goal with Vince Neil back in the fold, and that was to conquer the turf Mötley Crüe felt they never should have lost in the first place. Still, at the same time, Nikki displayed a clear discomfort with dwelling on the Corabi period, namely in what had gone wrong, "certainly we canceled the end of the tour, but now people want to know about the future, not the past. About the past, I've already spoken about it and it's enough. Talking about the past can easily become a melodrama. It's already a melodrama. It's time to go forward and get back to the main story…(that Mötley Crüe is back.)"

Chapter 15

Generation Swine

Generation Swine, like its predecessor, represented Motley Crue's darkest commercial period but in the same time, perhaps among their brightest creatively. Produced with Scott Humphrey, this album marked the return of original front man Vince Neil to the band's fold, and the Crue's second attempt to depart from what had been their traditional sound prior to Corabi's joining. Even though John's vocals were nowhere to be found on the commercial release, his creative fingerprints were all over the album behind the scenes. So much in fact that Corabi's vocals had to be stripped from most of the album's tracks when Vince came back to re-record them, with John acting in some instances as vocal coach to Neil. It was an odd arrangement that reflected the bizarre period the band was attempting to fit into commercially, with grunge dying out and rock beginning its decent back to the basics Motley Crue had represented in its heyday.

Recruiting Protools pro Scott Humphrey to co-produce the record with Nikki and Tommy greatly assisted the band in capturing the disenfranchised sound rock favored in the moment, while still making that format work within Mötley Crüe's traditional medium was difficult as

certain stylistic elements of the band's sound, with Nikki summarizing the greatest advantages Humphrey offered by elaborating on his technical background, "Scott was a professional editor, he got a huge amount of money then he made a great sound, for drummers who can't make the right sound they want or drunk bassists or lazy guitarists are able to make a great sound through him. So we decided to work together with him. I'd rather work at a top level than crawling in the ditch. We can record directly into the hard drive, recording and editing and cutting and adding stuff, we're able to do that kind of work…(The recording experience was) very comfortable. (Scott's) a musician and he's got a good musical sense. The situation for a producer to communicate with somebody is very useful, he can do the experimental stuff we want to do. He's very good at computer technology, that's why we're doing that kind of work with him. It's not only powerful rock n' roll. I just said to you that we were working in our home studio together, and we always said let's work and make a record together. Nothing is taken seriously, me and Tommy are hard workers, we're always the first people in the studio and the last people to leave. We have the responsibility as spokesmen for the band, we have to control the vision of the music. Mötley Crüe has to be Mötley Crüe. Working together with outside producers, lets us relax and move on to the next step sound wise."

In describing his songwriting process for the Generation Swine album, Nikki explained at the time that he was seeking to branch out lyrically without losing sight of the material fitting Vince's medium, though Sixx was clearly pushing singer Vince Neil to move closer to the experimental, and further from the traditional Sex-Party standard he was used to singing about, "there is no base, there is no related emotion or mood, it's just coming out from inside me. Everything depends on what is coming out first, the music or the lyrics, I work from my gut. I write for myself. I'm an egoist, for myself I write about other people… Just let them talk. I'm a very fast writer, too fast. Sometimes I don't know what I'm writing about, sometimes I have to read what I wrote again and even I won't understand what I wrote… For Mötley Crüe my lyrics are sung by Vince, so I have to think about Vince singing the songs. It's a very different way…Everything has space where you can talk or negotiate, even with Vince leaving and coming back. There is space to talk about something no matter what it is, even at the time when he might have come back to us or not come back to us. It all depends on what is happening, nothing is written in stone…My

lyrics are taking one moment of myself, when Vince sings it cuts a moment of his emotion." Fortunately, as Nikki recalled, Vince proved to be flexible in the ways Sixx and Humphrey needed him to be for the recording of the band's most alternative album to date, explaining that "(Vince thinks) about the melody lines or giving ideas here and there, he knows what kind of stuff he likes, so if he doesn't he'll tell me. Vince is a very easy-going guy, for the songs he likes, he'll say, 'This is great! So let's rock!' So when he's not comfortable with something, he'll tell us, so I ask him what he thinks and I change whatever needs to be done. So he works with us very well, in a situation where a person doesn't play an instrument, of course the process is different, a person has to be creative at a different level."

For the band's creative epicenter- Sixx and Tommy Lee- they both seemed to enjoy the recording process for *Generation Swine*, with Lee contrasting it with the 94 album as "(a cooler) experience…We had…(studios) set up in (both my and Nikki's garages). I'd pull up to it around noon. I'd work on something, then Nikki would roll out of his house - 'What are you working on?' Then he'd dive in. We'd work a few hours, then eventually make our way upstairs to the studio to work on something else. It was great because there was none of that stuffy studio vibe. You know - where you're saying 'we gotta get a song done.' The relaxed environment made the songs better." Nikki elaborated on the band's new recording process, explaining that its technical simplicity ultimately allowed the band more room to explore musically, "we're doing almost everything in digital, before sometimes we did stuff in digital but most of the time, at first we record into the hard drive then change it to digital, then we will play with it and add some small stuff around it so you can feel the originality of the band." Expanding even more-in depthly, Sixx explained that "recording is always done in different ways…(This album) was the most fun. I don't know about easy. The easiest album is the first one. After that it gets progressively more and more difficult because you have to push your own envelope to create. If that's the kind of artist you are and you don't want to repeat yourself…Some of them are recorded live, actually there's song called, *A Rat Like Me* I wrote, and right away we recorded it live, but sometimes for example a song called, *Kiss The Sky* it was written by me, Tommy and John in my garage, right away we recorded a demo and put it in the computer then we added other instruments. We did play it as a band. But a song called, *Let Us Prey* was recorded live with the band. We did the middle section with an industrial

sound until we reached a psychotic sound, but after leaving it for a year we realized that we didn't like the psychotic part so we erased it...(With Shout at the Devil '97), we took the basic track and sped the track up. Tommy went in and cut a whole new feel to the drums then I went in and turned off the guitars, but left the lead vocal alone. We wrote a new verse to the song then Mick went in and played over the top of that and then Vince went in to add embellishments. We all did the shouts and added some loops and samples then we mixed. It. It went very quickly. It only took a couple of days."

Tommy Lee seemed particularly excited about the advancements the band had made in their recording process, proclaiming that "technology is fucking awesome dude! I think back and I go like 'How did people ever make fucking records back then?' I mean, I made them back then, when it was like 'Ok, we got the fucking drum track, bring in the guitar player.' It was like the mythology of the same old bullshit- 'Ok, guitar overdubs, bass overdubs. Got the bass and drums? OK, guitars.' For fucking two weeks- Werman, Bob Rock, fucking tape machines is like the old school way of doing things, but everybody did it that way. Its like now, you can do things backwards, forwards, start in the middle, wherever the fuck you want. Its definitely an enhancement, technology, it fucking rules!" Lee seemed to feel particularly kindred with co-producer Scott Humphrey, with *Generation Swine* marking the start of what would become a decade+ long collaboration, with the drummer explaining that "Scott's always pushed me to the fucking limit. He's always like 'This is not good enough.' He doesn't settle, its awesome, he's always pushing you to your maximum fucking potential. And he doesn't really settle for 'Mmmm, than's good.' Its like good isn't ever good enough. And just, from years and years of working with him, everything I know now, from driving the computer to recording and editing, I learned from him, by sitting next to him, while he was working with Bob Rock. And Bob Rock would say to Scott, 'Ok, go sew it all together', and Scott would be in there for hours, and I would just sit there and watch him, like every fucking day. For fucking ever, I watched him. And by watching is how you learn. You learn by watching and doing, you don't learn by reading, you know what I'm saying? So just by watching what he did, and knowing how things worked, and then literally understanding the possibilities by watching, like 'Oh really, you can do that!' And then all of a sudden, your mind starts expanding with possibilities and everything. So he sort of taught me the possibilities of alot

of things. I didn't know you could do that, and then I'm like 'Well, if you can do that, then I can take this part, and put this part over here, and do this', and by watching, I learned so much. And then I started realizing what was capable, what the possibilities were, and was like 'Oh, oh my God, we can do that!' The possibilities are endless working with Scott. Sometimes we start with just a beat, and as you're auditioning beats, you try a different beat, as the song's playing. Try a different guitar part, that's the cool thing about Scott. He's always open to trying everything. He's never like 'Nope.' He's always like 'Yeah, let's try it.' And by trying all these other ideas, you eventually find the one, and are like 'That's it!' You know? And that's how he works, he's always open to trying fucking everything, which is awesome. Some guys aren't like that at all, as producers. They're like 'Nope, that's it. This is the way we're doing it.' And you go 'Wait! Its my record!' "

Still, for excited as Sixx and Lee seemed to be about their new LP's creative process, behind the scenes, some involved in the recording of *Generation Swine*- including the band's members- would agree that it was Motley Crue's most frustrating studio experience to date. Nikki for one would concede in the band's authorized autobiography that "we all moved into my drug-dealer mansion. We set up the drums in my oak-walled office, the mixing desk in the bathroom, and the Marshall stacks along the marble hallways while my three children terrorized us and Brandi screamed at me with the regularity of an alarm clock with a snooze button." Aside from what the band's members outlined in their authorized autobiography, *The Dirt*, in a more candid and un-spun dialogue, producer Scott Humphrey, recalls that from making the record, "I grew as a producer in learning more what not to do, but at the same time, it was kind of a unique situation for me, because I really didn't have a hit record at that point as a producer. So I think in some ways I backed down more than I should have. I don't know, maybe there's a way, I don't know if its necessarily of standing up, but of finding alternate ways to get what I wanted out of it. I just think my approach could have been a little bit different. I think also coming into it, I really felt we started that record off not having songs completed, there was way too much writing going on in the studio, and I decided that going into it. But I think Nikki was really adamant about 'Well, we'll finish the songs as we're recording them, that's the way I want to do it.' And that's the way we ended up doing it. One thing I learned from that is never go into the studio unless you have your songs and your

arrangements worked out. Nikki is… loud. You know when he's in the room, because he never shuts up. He's always talking, he talks more than he listens. I think its best when you're making music to use your ears to listen alot, rather than talk alot. Use your ears and listen to the music rather than talk too much about it. Everyone will agree upon it when they hear it. Or they won't agree when they hear it, but you can't get anywhere until you're actually doing it and listening to it. As a writer, Nikki's written so many songs for Motley, there's some really genius stuff that he wrote, I just wish I could have been there when he was writing it. That was kind of a unique experience, that record, because the songs weren't there, they didn't really have any songs. And Tommy and Nikki asked me to produce it, and I said 'You guys don't really have any songs', right from the get go when we started with Corabi, I said 'We've got alot of ideas, but I don't hear one single finished song.' "

Perhaps the figure producer Scott Humphrey found himself most sympathetic toward in looking back on the nightmare of recording *Generation Swine* was John Corabi, with Scott recalling that "I think there was continuity musically between the albums with Corabi and Neil, but the problem with *Generation Swine* was we started with John Corabi. And the prior record he'd sang on wasn't successful, and the tour wasn't successful, and everyone was really in a bad way, especially John. Everyone was really negative and really kind of a bad vibe going on, cause the last record flopped. There was this great big record, that they spent $3 million making, and I wouldn't have wanted to be in John Corabi's position at that point. It wasn't very positive, that's for sure. That's a good lesson in how you want to always come into any record as positively and as open as you can, and getting everyone to work together as a team, because its really the chemistry of the people involved that gives you the results." Where Humphrey found himself on one page as a producer- the right one in terms of where Nikki and Tommy wanted the band's sound to be- it was not the one Scott felt Motley needed to be on to produce a successful comeback record, explaining that "Nikki really wanted to do something different on that record, and wanted to make a record that wasn't necessarily a Motley Crue record. I was really into the early Motley records, and I wanted to bring that back, do something that was more like Too Fast for Love, and Nikki Sixx was trying to something that was more current with the time, like Nine Inch Nails or something else that was going on." To further complicate matters, Scott wasn't charged with just recording vocals, but

actually re-recording them to fit a new singer entirely, such that "it was tough because the songs, to some degree, were already done. And Vince would come into sing them, and you'd think, 'Oh shit, this isn't going to work, the key's wrong, we have to change this, we have to re-record this.' It just didn't fit because the songs were written originally for John with John singing them. Then Vince came into sing them, and it just didn't work at all, we had to rework alot of stuff, and try to not only- the keys of the songs, but also certain things that were right for John that weren't right for Vince."

More than a personal disconnect between himself and Nikki, Scott felt that the overarching issue during recording was how the bassist and songwriter's seeming inability to take his producer's suggestions to heart went against the point of Scott's purpose in the process. As Humphrey saw it, "for the most part, the greatest records are the product of the chemistry between a producer and a band working together, and trying out everyone's ideas, and to that extent, trying somebody's idea- it may be the guitar player who has an idea, and the singer goes 'Oh that sucks', but its not necessarily the idea that he has, but the process of him trying the idea, making the mistake, alot of times is the magic. Or I'll attempt to do something, and plug into the wrong piece of equipment and all of the sudden this crazy sound comes out and I'll go 'Wow, that's it! That's the one we're looking for.' That turns out being the signature sound for this song that's going to make it stand out. So, positivity is important toward trying everyone's ideas out. That happens with alot of bands, I notice, where they'll be one guy in the band that will kind of run the show, and there might be a tendency for somebody else to have an idea, and the guy whose running the band will shut that person down. I'm always curious to try those ideas, when somebody says 'Let's try this', and someone else says 'No, that sucks.' That's usually when I go 'Ok, we definitely have to record this.' Cause there's a chance that this is going to be the magic. For instance, when I worked with Motley, Nikki was always reminding me that 'Well, you know, I've sold alot more records than you', and cite that as a reason why he wanted to go with his suggestion vs. yours. So, that's kind of an awkward position to be in, you have to kind of what you're dealing with, who you are, and what success you've had vs. the band you're working with, you have to know when to back down is I guess what I'm saying. You have to know when to back down and go 'Ok, this guy's pulling out his discography and putting it against mine.' How that issue

came up in recording Generation Swine was, for instance, in giving input or suggestions, it really depends, alot of lyricists are really touchy on that subject. Specifically, Nikki Sixx doesn't like to go down that road, he takes it really personally. And at the same time, I'm trying to be the objective one here, I'm trying to be the one who heard the song for the first time, and have it make sense to the listener."

Where the latter horn-locking became especially tenuous was in the course of picking a single, which Scott did not hear in the material the band had selected for the album. As producer, Humphrey in hindsight seems to feel that was the biggest handicap for the album's commercial chances of success, namely that "I didn't hear a hit, and I remember telling Nikki- letting him know specifically that I didn't think they had a single, I just didn't think they had the right song for the record. I don't necessarily have an ABC process for that, it was just an instinct thing where just really didn't think they had it, didn't have a no-brainer single. A single should be something that's memorable from the first time you hear it, you hear it down for the first time, and go 'Wow, I love that.' It shouldn't require 2 or 3 or 4 listens, it should have some type of instant gratification to a listener. And sometimes that's hard after listening to a song a hundred times through, or a thousand times through- when you have that song right off, it just seems to me like an instinct you have where you go 'Yeah, this seems like it could work.' For instance, I felt like when Rob and I finished *Dragula*, I didn't think it would be as successful as it was, but when we finished it, I thought 'Yeah, this sounds like a really good first single. I feel really strongly about this.' He felt really strongly about it. Its just a feeling you have, you don't ever really know, and I've been involved with alot of projects where I've heard people, Nikki Sixx being one of them, go 'This is an absolute smash hit!' And just thinking to myself, well maybe I'm just not hearing it, and as it turns out, you go 'Oh, my instincts were confirmed.' That's not always fair either though, because I think there's alot of songs that are potentially a great single, and potentially hits, but because the timing wasn't right, or because the label wasn't there, or promotion wasn't there, this didn't work. In any event, I felt that was their biggest weakness when *Generation Swine* was released."

John Corabi's experience recording *Generation Swine* was even more frustrating than Scott's, as he was the Singer Who Wasn't There, even though he was almost every day. Perhaps the first vocalist in the history of

rock n' roll to be fired from a band, then asked to come in and teach the replacement singer how to perform the songs for an album he was fired off of, that irony was not lost on Corabi. As John recalled, "when we first began writing again, it felt like the old Motley, at least as I knew them. So that's how it began in the summer of 1995, I had a few ideas, and Nikki had a few ideas, and Tommy and Mick had some shit, so we all got together in a room with Scott Humphrey, and just started working in earnest on the record- and Gung Ho too! And we were like, 'Motley's going to go back to its roots, we're going to back to the *Shout at the Devil-Too Fast for Love* days, like a big, raw fucking in-you-face band! But as we began working with producer Scott Humphrey, who had distinguished himself as a Pro-Tools master under our last producer, Bob Rock's tutelage, but as a producer in his own right boasted a more hybrid-electronica background, it became clear the latter was more the sound both Nikki and Tommy wanted to go for on the new album. For me personally, being a team player, I was ready to head in whatever direction the guys felt would be most true to our own evolution musically as a band. It was funny too, because despite the fact that we were trying to write vintage songs against a futuristic recording soundscape, I was still into it, at least to the degree that I was giving it my best shot. I would come in with lyrics, or song ideas, that, had we been all sitting around in a circle together like we had done writing the first album, in a rehearsal hall, rather than in Nikki's garage-turned-spacecraft recording studio, we might have had an easier time fleshing out our ideas into clearly defined demos that I could have followed along with as they developed. Instead, these songs we were trying to do were like fucking alien life forms, and instead of fighting with them, Nikki, Tommy and Scott were like scientists sitting behind the glass of their cockpit/control room trying to study them, giving me a million different musical directions to try out at once. Seriously dude, this rig they had set up looked like a space ship from 2001: Space Odyssey, and I would go into the studio, and look through the glass at them feeling like part of the experiment."

Continuing, John explained that "our first problem clearly was where we were recording because it was the most fucked up contraption I'd ever seen in my life. Nikki had this amazing studio built into his house, and didn't know how to run it, any of it. He was lost. It would have been easier for him to take lessons flying a jumbo jet. He's got all this gear, all this shit, and he's got no clue, Tommy's got no clue. Scott was alot more adept at the protools stuff, but there'd be times when the board wouldn't

work, or Scott's computer would crash, we were constantly calling tech support guys. I'd be in the middle of a sentence, singing a sentence, and something would break down, and I would have to sit around for 6 hours. It was cursed. Then, instead of having like a headphone box, the thing coming out of the jacks in the wall into the vocal booth ran through like a CD player, and then the headphones came out of the CD player like headphones out of a CD player! It was like this fucking bizarre contraption, and it was never right for me. It never sounded right, they could not get this awesome tone or sound in my fucking headphones. So I would start singing, and I would see their faces through the glass like 'What the fuck did he just sing?' And I'm looking through the window like 'What's up?' And their like 'Dude, what are you doing?' And I'm like 'Well, first of all, the tape that I have of the song that we originally started writing- that we wrote five days ago, I have a cassette, I wrote lyrics, I have a melody for it, but in the five days since we wrote the song, its totally changed.' On top of that, Scott and Tommy were really in synch on all this hybrid-rocktronica stuff that went on to work really well for Tommy as a solo artist, but while he was still in the band, just didn't meld quite the way it needed to with all the classic and modern rock and metal influences Nikki and he were trying to reflect in the sound at the same time. And so I'd be standing in this vocal booth of sorts, and Tommy would be going 'Yeah dude, sing something heavy like Pantera, but lush like Oasis.' And Scott would go 'Cheap Trick, dude Cheap Trick!' And Nikki's like 'Yeah, but I'm kind of hearing old Bowie-Sisters of Mercy vibe.' And so other than Cheap Trick and maybe Oasis, I had no fucking idea what these people were talking about. Who the fuck is Sisters of Mercy and Pantera? It was just a fucking nightmare, fighting all the time. And even worse, with Nikki and Tommy co-producing, we really couldn't function as a band solely, which is what we should have been doing, rather than trying to wear both hats, which really worked to dilute and alienate our focus, as well as trigger a whole other level of infighting that we wouldn't have had with say Bob Rock, who wouldn't have been afraid to put us in our places. That was a big fucking problem, the band had no gravity, we were just kind of floating out there with nobody to pull us back into orbit."

Corabi found another major malfunction of the band's recording process on *Generation Swine* to be the recording equipment itself. With Protools still a very new digital recording medium in 1996, the band was in some ways learning as they went along, or in more politically correct

terms, experimenting, which according to John, "was just eating us alive musically. When you're recording in Protools, there's this natural evolution that happens because of the expanse of the technology, creative directions that happen accidentally, overlap one another, and they all seem cool because of the design of the software. There's really no concept of mistake, because everything at the time was so experimental, so any ideas we thought we had solidly down for a song could become fluid at any given moment someone would come up with something new, and it was impossible to keep straight on a basic, vocal level. So Tommy and Scott would get together, and Tommy did his Protool thing on his drums to make them sound like Tommy, but then they'd come across this new effect so Tommy would change the drums around, and throw some effect on them, so they were different. And then Nikki would hear it, and go 'Wait, hey, check this bass line out', and completely write a different bass line, and Mick or I would come and do a rhythm guitar. So that by the time I would come in to do the vocals, it was an entirely different song than we had originally written. And so I would go into the booth with all these contraptions buzzing around me, shit breaking down, and three guys sitting in front of me, all three with staunch egos, not wanting to budge with their opinions. So had we stuck to the original blueprints for the songs we'd had going in while we were recording, there was all sorts of new directions we could have gone in with regard to overdubs and effects, that would have made the record sound alot more focused, rather than like one big fucking distraction from what we were supposed to be doing in the studio. Had we done that, the band would have worked together as a team much more successfully in the studio, rather than acting as this half-man/half-machine sort of entity."

Where Corabi and Sixx had been equal collaborators on the band's lyrical material an album earlier, on this new voyage as Corabi termed it, there was no synergy between the two artists, such that "when I would come into sing in the morning, the songs would be completely different lyrically and musically from when I left off 2 days prior to whenever we were next recording. I'd have lyrics to match what had become the old song, despite the fact that we had just written it, and they would go 'Oh I don't know dude, just sing something.' And as a singer, I have to live with something for a couple days to be comfortable with it, so I was feeling kind of sketchy behind the mic, its like Ray Charles driving. I would talk to them, and go 'I'm not getting this, what are you guys hearing?' And they're

like regurgitating the same shit from before, sounding like a fucking computer rather than a producer, and so I'm like getting even more desperate, going 'OK, then sing me something- give me half a line, something I can build on, cause I am not getting what you're saying.' And their like 'Well, I don't know dude, I don't know what were hearing, but what you sang ain't it.' And the fucked up thing is now that all the dust has cleared and the years have passed, we can laugh about it! Individually they'll admit it was a fucking mess, but, like then, no one can ever come together to move past it, they still need to point the finger at one another. I'll be at Tommy's house now, six years later, and he'll be like 'Yeah dude, I don't know how you didn't just commit suicide. We had no fucking idea what we were doing.' Looking back, recording that album with Motley was the worst fucking time of my life, trying to be creative, I was miserable."

Whether the band was torturing John toward the end of getting the best product, or as part of a larger strategy to push him out of the band altogether, the method behind Motley Crue's recording madness was working toward both ends. The story of John's exit and Vince's re-entry is well documented, and while it was unusual to the public, to John, it was the first normalcy he'd had throughout the entire process, explaining that "once the band finally made the formal decision to rehire Vince, Allen Kovac played up on that point, going on with the fact that 'You know, in all honesty John, you're going to make more money out of the band than you would make in the band. You've got 8 or 9 songs you wrote on this record with the guys, and you're going to start seeing coin from record one.' My routine after that, through the fall of 1996, was to spend my days continuing to go and work with Motley Crue- and Vince Neil- on completing *Generation Swine*. I'd normally come down during the day in the afternoons, probably maybe 3 days of the week, and that was a fucking trip in and of itself because Vince was officially back with the band, and it was a little nerve-racking at first meeting and working with him, mainly because I'd always heard there was some really bad blood between him and the rest of the band, and I didn't want him to think I had anything to do with it. I'll never forget the day I met him, because for all my anxiety, it turned out to be really low key. He was just sitting down in Nikki's garage by himself, and I was there doing some guitar parts. And the guys were working with them, trying to see if my parts would fit into this tune, and I went downstairs, sat with Vince in the garage, and he offered me a beer."

Continuing in his description of the bizarre conclusion to the recording of *Generation Swine*, John explained that "the way it played itself out that day was, I sat there in a chair next to him, and he was the first one to extend the olive branch, like 'Hey man, no hard feelings or anything?' And truthfully, I felt really at ease with him, maybe because we had the fact that we had both been the lead singer of this beast called Motley Crue, for better or worse, in common for a good chunk of our lives. And so I was like 'Naw man, I understand why the record company is doing this, and for whatever its worth, its nice to finally meet ya.' And he was like 'That's cool', and we had a really cool, laid back conversation, very mellow. And between he and I, it stayed that way despite what could have been a dynamic loaded with alot of tension and friction, whether anyone had intended it or not. And after a short while, it got to the point where we had a routine again amid all the natural craziness that seemed to accompany that band, no matter what direction it took itself in. I would get to Nikki's at like 10 in the morning, do guitar tracks mostly, and he would come in around 2, and there was a natural, and circumstantial, overlap that developed there. Because most every day we would break and have lunch, and I would sit right there with him around a table in Nikki's kitchen, and it would be me, Nikki, Vince, Scott Humphrey, Tommy and Mick working together like an almost functional band. Also, after working on that god damn record in almost complete functional disarray for the better part of two years, the guys had finally gotten like a working prototype for their recording process, in terms of the studio set up. What they had finally done was take Nikki's equipment upstairs in the studio above his garage, and put Tommy's recording gear in another set up in Nikki's bedroom. So it was really literally domestic, in line with this whole theme of a dysfunctional family, so alot of times me, Tommy and Scott would be upstairs doing guitars, and Nikki would be downstairs with Vince doing vocals, like trying to get him to redo my vocals!!! And there'd usually be a point where we'd finish doing guitars, and Vince would then at that point come upstairs and sing in the booth upstairs, while I'd be in the room. And I'd almost always be like 'Ok guys, I'll see you tomorrow', and they'd usually go 'Wait a minute, Vince is going to sing whatever today, '*Let Us Prey*' for example, so can you just kind of hang out in case we need any help with him getting these vocal parts?' And we had this little fucking bizarre, oddball routine that just sort of worked because of how strange things had gotten anyway by that point. I think we were all like 'What the fuck, it

can't get any stranger.' And for the most part, they'd play him what I sang, line by line, to get the melody, and he would sing it."

Oddly enough, for as strange as things had been for John in his own attempts to record vocals for the album, as Vince Neil's vocal instructor, the job became a lot easier, to where "there were a couple times, when we were doing *Kiss the Sky* for example, where they wanted him to pronounce certain words in a certain way that I'd originally pronounced them on the tape. This was a literal process, where they'd be like 'God, Vince's not getting it, he's not getting it', so I'd be sitting in the back of the room sipping a Vodka Crannie with Tommy, and Scott and Nikki'd go 'Hey Crab, can you pop in there with Vince and show him how to sing this?' And I'd be like 'Yeah dude, if he's cool with it.' Cause there was still alot of ego going there, although, really, between Vince and I, it usually seemed pretty comfortable. The dynamic between us in the vocal booth was almost always fine, I think now because he knew I didn't have any agenda with him- I'd shown him I was cool about the whole thing, and wasn't going to try and fuck with him or anything to get back at the band. And so I was like basically his default vocal coach, and he took direction well. And sometimes it worked, and other times, it didn't, and he didn't get worked up or anything when it didn't. I think alot of that was probably because he knew there were some things in the sound Crue was after on that record that his voice was suited for, and some things it wasn't. So even though they canned that tune, when I had gone into the booth with Vince to try and coach him on how to sing it, the band was like 'Alright, can you sing it?' And on two notes, I'd sing the song, and Vince would sit there and listen to it, and go 'Ok that's cool', and then go and sing the song, no problem. But on the second note, all this time prior they had been busting my balls, saying 'You need vocal lessons, something's wrong with your voice', and then when I was going in and singing with Vince, they were changing their tune completely, going 'Fuck Crab, you sound amazing! What did you do differently? Your voice sounds amazing, God dude! That's weird, cause we couldn't get anything out of you before, now you're singing like a bird.' And it was just a reflection of how warped things had gotten, and ironically, the one thing I think that did come from my being forced out of the band was it allowed Motley Crue as an entity to complete its own cycle as this monstrous machine that was totally overloaded with expectation at the time that Vince re-entered the fold."

The buzz from that expectation would succeed in making Motley Crue- along with Kiss- almost singularly responsible for re-starting hard rock's commercial resurgence in late 1997 when the band hit the road again with Neil, bringing thousands of fans out of the musical woodwork in what became the most debaucherous rock n' roll tour America had seen in years. In that spirit, Nikki explained the meaning behind the album's title as "(alluding) to everything we've never stood for…Everything we've railed against. But in reality even we are part of *Generation Swine*, in a way. Everyone wants to succeed, make money, be successful. But what happens is you end up becoming a bit of a pig. If you spend your money on yourself and what's around you, and don't give to charity, or give of yourself, or reach out to help the homeless or runaway kids or something like that, let's face it…you're a bit of a swine. We've been pigs just like everyone else. We're just rubbing our face in the mud. There's only one Mother Theresa and one Pope, everyone on down is a pig!"

In the course of seeking to buck their own system, Nikki explained that the band had embraced the alternative sound of Generation Swine as "a breath of fresh air against bands who copied other artists and missed the point by 300 fucking miles…I wasn't putting on lipstick and blowing kisses to myself in the mirror. We put makeup on to look ugly. We fought because we were pissed off. Mötley Crüe has always been about being honest. It usually got us in a shitload of trouble, but when we went to bed at night we felt good because we knew we told the truth. We never played the game. In fact, we believe if it's working - it should be broken." At the time, shaking their fans out of what they had traditionally regarded Mötley Crüe as representing was the only way the band could ever progress musically. Tommy elaborated on the latter, pointing out that "music has gone through another crazy phase…We welcome the changes. We've always refused to be pigeonholed." Vince Neil agreed, pointing out in true Mötley style that "Music seems to need a kick in the ass right now. Believe me, we're grateful that we were able to influence a lot of bands, now we're ready to shake things up again…In a way the vacation from each other did us some good."

Upon release on June 24, 1997, *Generation Swine* quickly went gold, it made a loud announcement at # 6 on the Billboard Top 200 Album chart, moving 86,000 copies in its first week of sales, and what the band lost in album sales they were quickly regaining on the road rebirthing the genre

they had begun almost 17 years earlier. Rolling Stone Magazine complimented the record as "loaded with cutting-edge production and grinding industrial effects", remarking on the album's "sleazy, drawling vocal, punchy staccato guitars and lurching electronics create the perfect union of ZZ Top celebration and Nine Inch Nails self-immolation," ultimately concluding that the band can "still send shivers down the boniest spines."

Chapter 16

58

 1996/1997 had proved to be a progressive but challenging one for Nikki Sixx. On the positive end, he had ended his destructive relationship with first wife Brandi Brandt, had successfully reunited the original line-up of Mötley Crüe, and was on the way to finishing production on the band's seventh album, and winning joint custody of his three children. In all, things were looking up for Nikki following an extremely debilitating fight with his record label over the fate of temporary Crüe front man John Corabi, which he had lost, and an extremely abusive separation from wife Brandi Brandt, in which Sixx had filed for divorce following his learning of an extramarital affair Brandt had allegedly been having. In addition, Nikki had discovered the internet, and was quickly embracing the new forum through which to communicate with a lost legion of fans he was aggressively attempting to regain a connection with, both personally and commercially. In truth, Nikki Sixx was very much alone again, and in need of companionship, and again his fans filled part of the void. Sixx elaborated at the time on the discovery of the internet as a means to connect with fans, explaining that "I got into computers via music - I use them in my home recording studio. Then I got a personal laptop and this America On-Line account and I was hooked. I find the Internet to be a great way to get feedback on my music. I love the feedback and use it a lot. We even sometimes put fans on the guest lists."

Out of his newfound love for the internet as a way to stay in touch with fans, Sixx established the first-ever online diary, which became a regular forum through which he could share his family life with fans in a much more intimate setting than even his songwriting, at times, would allow. For the first time, we not only heard what happened in the world of Mötley Crüe, but also heard why it happened, and most importantly, how it affected the band internally. It allowed for an honesty to exist between rock band and fans that was rarely found within the culture, with the possible exception of the energy and connection that can exist in a live setting. Nikki's diary had become a sanctuary where fans could come for glimpses inside the head and heart of the band, offering a full range of emotions encompassing everything in the way of a connection a rock fan longs to feel with his or her favorite musical hero. Where in the 1980's, fans had been restricted to interviews and headlines to learn about the latest happenings of Mötley Crüe's wild heyday, the dawn of the internet had redefined the boundaries of accessibility between rock fan and rock star. The web now offered a direct line of communication that became, in the cases of many bands, essential to their continued survival. Such contact allow bands to reach a dramatically expanded grassroots rock audience of fans with instant updates regarding the latest news in recording and touring news at band sites, and the previously unprecedented opportunity for fans to directly contact band members directly via E-mail. Mötley Crüe was one of the first bands to establish a major online presence, offering live downloads of their concerts, virtual chats with fans, daily news updates into the band's tour and recording activities, and into the mayhem that followed wherever they seemed to go while on the road. The center of this world in Mötley terms was Nikki Sixx's rock and roll diary. The first of its kind, it was updated daily with posts offering a brutal honesty about the recording process, life on the road, the press, the state of rock, his family, and a host of other previously unavailable moments in the band's life and their fans hearts that had for years been as rare as a bootleg.

In the beginning, Nikki's e-mails to fans were more in the form of answers to questions on shows or tour dates, as evinced in an early correspondence to fans in which Nikki admitted that "I get up to 200 e-mails a week. Sometimes more…I can't type real well so they're usually short." Now, rather than having to wait until after an album's release to read in an interview about what the recording process had been like for a particular song, Nikki was free to share the process with fans as it unfolded,

creating a channel for feedback that ultimately improved the content of both Mötley and Nikki's solo projects as he prepared for the release of both Generation Swine and his solo project, *58*, "the new album (Generation Swine) is going to rip your assholes apart. We got 22 tunes, Double album??? Hmmmmm, maybe, maybe not. A lot of extra goodies…Lots of music, just wait and see…I just finished a side project called '1958'…Songs are kool, so kool. We did it in 26 daze. I do a lot of lead vox, and play bass of course…Its very Lou Reed meets Sly and the Family Stone. Lyrics are Hunter S. Thompson and William Borroughs on Cocaine. Its dark, and great hooks. As soon as I decide who gets it I will bootleg some to you freaks."

58's primary album producer Dave Darling recalled the project's conceptual aim as "kind of a polarity span, like really hard, industrial Roxy Music. The musical genesis of the project really was Nikki and I had been friends for a long time, but we had never really worked together. I had just finished the second Boxing Ghandis record, which was a pretty tough record for me. And I think Nikki was a little bogged down with what turned out to be *Generation Swine*- they had already gone in and started, then stopped, and we were both just pissing and moaning about how tough it was to make these records because it was so serious. But going in, we really did have an agenda, which was to make it everything our respective records that we were working on was not. And that was completely collaborative, no arguments. We decided early on that if it ever came a point where we had any disagreements on anything, we would literally arm-wrestle for it. We both did that knowing that we're about the same strength in the arm, so it was a mute point. I don't believe there was ever a point on this record where we disagreed on anything though, or took time even discussing anything that much. For the most part, we just said 'I love it, let's do it.' And I think Nikki'd agree that if we could make all our records like this we'd probably do nothing but these records because it was fun, interesting, engaging. That process was so enjoyable and creatively freeing, and also wild fun. It was completely free from everything that is difficult about record making. I think it was very therapeutic for both of us. Every time we went into work on a song, we were working to get something to sound different, or shooting for a (homage) piece. Every time we got there, we'd just look at each other and go 'That's the shit dude. That rocks.' Its one of the few records that after I was done with it, I actually continued to listen to it. I never do that, not on any of the

records I produce, when its done I have to put it away for a while because its tired me out. We really weren't trying to impress anybody, and I can't speak for Nikki, but it's the first record I've ever done that was purely for me. I think we touched on something. Its pretty rare that you get something that has zero desperation attached, zero fear attached. And we'd take turns and go to his studio, or go to my studio, and just decided to write some tunes that were a combination of what we both did, and also sort of reaching back to what both of us really love, which is just like old Glam. I'm a hip hop fan, he's a glam fan. So we were like 'Why don't we try to do kind of an industrial, glam record."

Continuing, Darling explains that "we just started writing, and it went so smooth, and we had so much fun that it was one of those things where you're writing a record and there's no pressure from a record company. There was no record company involved when we started off, it was more for us just like relaxation after doing such hard work on our own records. So once we'd started writing, it went so fast that within two weeks we had like 6 tunes, and we realized we were really enjoying it, so we decided to finish it up as a record. Our songwriting process on this record was very unique for both of us because we did it very differently from our norms. For instance, one thing we did, probably because it was just kind of fun was, he'd start a track, come up with a groove, and bring it over and say, 'Hey, check out this drum groove.' So then we'd actually try to figure out a concept that we wanted to write about. It was completely different from the way either of us had ever written before because we were doing this for fun. So, for example, with '*Song to Slit Your Wrist By*', Nikki came in with this little drum groove, and said 'I think we should write a song with like a Stones-kind of tune, it wasn't about suicide. Its really not about that, its really more of a fuck-you tune.' So what happened from there was: if he started a tune, I had to write the lyrics. If I started a tune, he had to write the lyrics. If I wrote the lyrics, he had to sing it. If he wrote the lyrics, I had to sing it. So we did that on purpose because we were almost trying to embarrass each other in the studio. It was pretty funny. The one song that Nikki and I didn't write the lyrics to was maybe the oddest songs on the record too, *Alone Again (Naturally)*. That was funny because the record was done, and Nikki called up on the road from the Maximum Rock tour, and goes 'Hey dude, we need one more song. You want to do *'Alone Again (Naturally)*?" So I just went, picked up the CD, and just put together a version of it, and decided to put something really hard in at the end, so I

wrote that separately, but musically, that song represents well the fact that there's a lot of hip hop influence on that record overall, on all the songs. It doesn't read that way because hip hop and industrial are so much closer than people realize, there's a certain dirtiness in the tracks, and a certain rhythmic quality that drives everything. Even though we've got huge guitars on the record, its not guitar-driven, its really a rhythm-driven record."

Elaborating on the album's specific songs and how they evolved, Dave explains that "the first track on the record, *Don't Laugh You Might Be Next*, actually started out as a blues guitar riff that I had going on. That's one of the few songs that actually we sat down, recorded the track, and then in a room in about 2 hours together, we wrote the lyrics. I ended up singing it because we flipped a coin. *El Paso*, I came up with in total musically after the record was already done. So I called him up and said 'Dude, you gotta hear this track, it's a slamming dance-industrial kind of thing.' So he came over, and listened to it. And Nikki always carries a book around where he keeps just basically ideas in a journal more than anything else, its not really songwriting ideas. So I said 'Go get something out of your journal and just read it over the track.' That's exactly what that was, what ended up on the record was 15 minutes of him literally just speaking this story he'd written in his journal. I moved the vocal around a little to make it fit, and we wrote a chorus to it because there wasn't a chorus, but all the lyric vocals are just right out of his journal. *Piece of Candy* was actually interesting because it was written concept-down. Nikki actually came in with this idea about internet voyeurism and people who were doing their business on the net for money, and we actually decided to write a song about that, before we'd started the music or anything like that. We'd actually come up with the idea of the girl Candy, and the lyrics were just trying to get a back story on the actual person it was about. We co-wrote the lyrics on that one, and the story was basically about this girl named Candy who was peddling her wears on the internet. We sat down with a drum groove, and him on a bass and me on a guitar, and knocked out the music in about 15 minutes. *Shopping Cart Jesus*, I think Nikki came up with the chorus melody and lyrics, and I wrote the verse lyrics on that, and it started out musically as a track where we were kind of doing this nonsensical Protools cut and paste, fooling around with guitar sounds and stuff. I sang the lead on that track, but if you listen there's a real low voice on the chorus, which is Nikki's original guide track for the melody and lyrics on the chorus. So even for

that, when I put a microphone in front of him, and because he doesn't sing in Crue it was kind of interesting because whenever I'd pop a mic in front of him he'd like say 'Dude, I don't want to sing.' "

Continuing, Darling explains that "*Queer*, that was just another exercise in fucking weirdness. From a technical point of view, *Queer* is also an interesting tune just because if you take away the mix treatment, it really does sound like a Waylon Jennings song. When it came time to do that song, I said 'Why don't we write it like a country record, with a couple of acoustic guitars and a drum beat.' And if you play *Queer* next to *Shopping Cart Jesus*, that's exactly what it sounds like. We were sitting with two acoustic guitars, and I put up a drum groove that was actually taken from off the second Boxing Gandhi's record. Then we just started playing kind of a country song, trying to come up with a concept again to write into. We really didn't write just from lyrics, we always wrote from concept. Like, 'Okay, what's this tune going to be about?' And this is later in the record when we had come up with this idea where: if I write something, you gotta sing it. That was the whole idea, so towards the end, we were trying to write something provocative that would be a little difficult for the other person to sing. So once we'd come up with the concept, I was actually able to squeeze out enough lyrics quickly enough to make him sing it. He was a little uncomfortable singing it. But that's Nikki singing on that. *Song to Slit Your Wrist By* was pretty much all Nikki, he came in with the whole tune pretty much already done. He didn't have the verses completely done, but he did have the chorus and we knew that we wanted to do sort of an industrial Rolling Stones tune. We both sang on it. Its split up pretty crazily, I think I start the tune, then he came in on the second half of the verse, and we both sang the chorus, but I'm the higher voice and he's the lower voice. *Stormy*, we pounded that one out together. I think Nikki came up with the riff, the four-chord change at the very top, and we didn't have a chorus till the end of tune. Its just very simple and should be, its about his daughter, its beautiful. While I was doing some recording on the musical track, he sat down with a piece of paper and came up with all the verse lyrics. That's Nikki singing it too, and he did a hell of a job. *All My Heroes Are Dead Now* was one of the ones where we decided we wanted to do a homage to Bowie. So the musical track was entirely done before any of the lyrics ever even got written, and we had tried to come up with something that was hugely atmospheric, it was considerably different from what ended up on the record. It was more of a slow-

strumming guitar with a pad, and Nikki came up with just the concept of *'All my heroes are dead.'* Then we'd talk about it, and got a list basically of all the people who were influential to us who were dead, and tried to come up with some common ground about what might have been going through these people's minds at the time. We co-wrote the lyrics, the first verse was pretty much all Nikki, I think I came up with the 'Veil' line, but that's about it. The second verse was both of us."

Focusing further in on the pair's approach to writing the album's lyrics, Darling explains that "pretty much all the lyrics, with the exception of *Slit, El Paso* and *Stormy*, everything else we sat down in a room, and went through a process of 'That sounds pretty good, let's try that, now let's change this, now let's try that other line.' As a songwriter, he's brilliant in his clarity. He comes up with an idea and doesn't second-guess himself, ever, and he completely opens up to just basically spilling out onto the paper, and cleans it up later. A lot of people don't let that process flow freely, but he's utterly clear as far as that goes. I write with a lot of other people, and for a lot of writers, lyric writing is a painful, difficult experience, where it needs to be or not is not my business. But with Nikki its just not that way. Another strength I think of his is he's one of those people who writes from concept down, which generally is a great way to do it. Its not just coming up with a clever line and filling it out to become an entire tune. Unfortunately, that's pretty standard, let's face it: I've got a chorus, and what people start doing is filling in lyrics that are adequate, and that's it. Whereas, if you start from a concept, you find yourself constantly pushing to get the point across of what it is you're trying to describe. And Nikki's very good at that. I don't think there's any secret about the fact that one of the reasons we worked so well together is that we're really very different. I kind of put a lot of brainwork into the writing, and am kind of overly-analytical, which is got its upsides and its downsides. Where Nikki's got a clear style that just cuts through the bullshit, so there were times when we had tunes that were really simple, had the point, and were all there, but didn't really have any nuance. And I'm a little bit better at actually popping in nuance. And really coming from where we come from, our musical backgrounds are utterly different. I come from a sort of fairly literate funk band that was politically active, and Nikki comes from a huge, mega-pop rock situation. So I think that's why we gelled as well as we did, he felt pretty comfortable with leaving ideas to

me to make a little more colorful, and I felt comfortable fishing for the big picture ideas from him, because he does that so much better than me."

While Darling and Sixx manned the majority of the album's production, Scott Humphrey also worked on parts of the album's experimental sonic soundscape, recounting one such experimental recording session as "a good example actually of doing vocals at 8 O'clock in the morning. A couple times, doing vocals on the 58 record, I couldn't get what I wanted out of Nikki, and I'd show up at his place early in the morning to do some comping or something for the Generation Swine album, it'd be 8 or 8:30 in the morning, and he'd be getting ready to work out with his trainer, and I'd go 'Hey, why don't you come in here and sing.' And he'd go 'I just got out of bed, I haven't even had a coffee yet.' And I'd go 'Yeah, I know, that's why I want you to come in here and sing.' And a couple of those vocals we used were from the 8 o'clock in the morning vocal sessions, cause his voice sounded so fucking bizarre cause he hadn't even spoken a word yet." Concerning the album's groundbreaking programming and cutting-edge Protools mixing, Darling and Scott Humphrey primarily helmed the latter, with Darling explaining that "we had the record recorded, and the recording had been done about half at my studio, and half with Scott recording at Nikki's studio. And it was what it was, and then we decided to put it out as a record, and made the conscious decision to try and go back and do some additional work on the songs. Because the original mixes were much more simple, it wasn't quite this everything and the whole kitchen sink thing that we ended up with. It's a huge thing, so when we actually started finishing and then mixing at the same time, I'd actually pop up to Scott's studio, The Chop Shop, and for six hours, we'd just sit, pull up a tune, and purposely put in as much cut and paste as we thought the song could handle. We'd fire up some synthesizers and do some synth guitars, and were just constantly just looking for ways we could push it for what it was. And most of the mixes are those that we did at Scott's studio. I think the only exceptions were *Candy, El Paso, Who We Are, and Alone Again (Naturally)* I mixed with Jeff Peters. Also, the mixes we did on *58* are entirely different from the other things I've mixed. Of course, you generally have to adjust your mixing style depending on what it is you're mixing. A lot of the stuff I mix is so different, for instance, if I'm mixing a Brian Setzer record with the big band orchestra, that's obviously a little different from the *58* mixes. Something like a Meredith Brooks record has a little more to do with it,

believe it or not. On the first record I did with Meredith, cut and paste was really the sound of the day, which has changed somewhat. But at the time, it was really a big deal to use your technology, and to be able to taste the technology a little bit on the record. So for the 58 record, it was utterly different for all of us because there was no label there telling us what to do. So in mixing, we took advantage of that big time, and said 'You know what, since there's nobody to tell us what to do, we're not only going to do anything we want, but everything we want.' That freedom led to a lot of times where we'd be sitting there in mixing, looking at the speakers, listening to the tune, thinking 'How can we fuck this up? What can we do that will fuck this up beyond belief? Literally."

Continuing, Darling explains that because of the freedom he and Nikki had in mixing the record, especially with Scott Humphrey in the mix, "on that particular record, there were more guitar petals used in the mixing than actually outboard gear. We tried everything we could possibly think of. Back then is when the technology was actually pretty exciting, so we tried to utilize it as much as possible. At the time, most of us really didn't know could be done- Scott did, he was at the time arguably the best Protools operator on the planet. I think that with a very short period- maybe two or three years- in the very beginnings of very aggressive Protools work, the shit was harder to do then. You had to figure out how to do it, and today the manipulations in Protools have become so refined now that pretty anybody with $1000 can do it like a pro. At the time, we had to figure out how to do that and make it work- how to flip pans, how to insert the board. We really did a lot of analog-digital hybrid, where we ran everything out. Scott had a whole-wall Polyfusion machine at his studio at the time, that we called our secret weapon. It had filters, and we'd say 'Well, I love this song, its all good, but that voice just sounds way too normal. Lets run it through the machine, spin some knobs, and see what happens.' So I think that's probably a period with a lot of hardcore cut-work, and not cut to correct, but deliberately to try and fuck everything up. A lot of Protools purpose was to pitch correct or autotune, we weren't trying to go there with the 58 record. One of the things we did that was kind of interesting on that record was for all the Protools we used, as aggressively as we did, we didn't really manipulate the vocals to correct as much as we did to fuck them up. So if the vocals were out of tune, it was because that's what we wanted them to be. That would probably have more to do with my background, I was at the time into

technology, but also a little *Blood on the Tracks*. So we'd be sitting there listening to a vocal that sounded out of tune over a track that was musically just like completely air-tight, and we thought that was pretty cool. That was the era when most of us who were somewhat hip to the technology when it first came about, were starting to hybridize hip hop into rock records, so you started to hear a lot more rhythm-oriented stuff, a lot more cut and paste just by nature of the technology. Hip Hop up to that point was basically a MPC-60 and a sampler. So we just started using our Protools rigs as an MPC-60 and a sampler, so for instance, the beats on the *58* record I did almost entirely with an MPC-2000. Also, we used Scott's Polyfusion rig a lot. So right out of the gate, you hear that in a lot of the murky quality of some of the tunes. We went for a lot of usage of compression, and the Polyfusion I'd say is number one. Also my hip-hop approach in cutting the samples at the time, it was new. We'd take loops and just cut the shit out of them, and this is before we had the Reason software, so we had to do it by hand and trigger the shit. *58*, to date, is my favorite record I think I've done."

As technology continued to broaden his horizons- professionally and personally-Nikki became more comfortable communicating with fans so nakedly in a forum that offered anonymity in one respect but in another a completely new channel of communication between fans and their long beloved and tortured rock star. This medium offered Sixx what was at the time a revolutionary opportunity to develop genuine relationships between himself and fans in which they could share openly with one another reciprocally, such that Nikki could both offer advice as well as ask for it, on any number of subjects. With the latter in mind, as the year moved on, Nikki began creating the online Rock N Roll Diary, the first of its kind, and at the time, with all that was transpiring in his life, an extremely candid forum. The latter was largely true because in this same time, Nikki began dating the answer to all of his personal prayers for a soul mate, Donna D'Errico, and fans hungry for insight into the mind and heart of their lonely hero suddenly had backstage access into Nikki's hopes, his apprehensions, his raw emotions, his awe, and most importantly, his love as it had bloomed for Donna D'Errico. In a way, Donna D'Errico was also an answer to thousands of Nikki's fans who had long suffered with him in his search for an inner peace and sanctity that would truly reconcile the pain of his past.

Nikki Sixx and Donna D'Errico had been introduced via a blind date by Tommy Lee's then-wife Pamela Anderson on the set of Bay Watch. Nikki fell in love within the first night of their meeting, as he explained in the course of writing the Donna-inspired song "'*Afraid*', (which) was triggered by the first meeting that I ever had with my wife. On our first date, I fell in love, head over heels in love, with my wife. And about five o'clock in the morning, we'd been talking all night, and she looked at me, and she looked at the house. She looked at all the pictures of my kids, and she said 'I'm in over my head.' Because I was going through a divorce. She was a single mother, and she had a career as an actress. And her life was just fine without this crazy fuckin' rock n roller with all this baggage. And she went, 'I gotta go.' And I was like, 'You cannot go, ever. I'm gonna be with you the rest of my life. It's what my heart is telling me.' And she drove away, and I wrote 'Afraid'. She's so afraid, she's gotta go. She's scared. The song…was inspired by that moment, the emotion of what I felt like. I was trying to express what she's feeling, y'know?"

As a creative result of the latter, Sixx was in a position to write therapeutically through all the apprehension and anxiety that accompanied his new romance in light of the clarity it gave him about who he was meant to spend his life with, as a result progressing in a very short period of months from a love, rooted and therein entangled in both fear and ambition, to a love that grew out of its confusion into a beautiful constellation of two stars who had been lost until their fates had collided. In celebration of the latter analogy, Nikki composed '*Rocket Ship*' for his new love, which spoke the ode 'From the moon, to the stars, to the sun baby I'm in love', and was described by Nikki as "only a minute long. People said that it could be a hit single, but I wanna ask them why because it's only a minute long. They said to make it twice as long so I asked again why. The lyrics are for Donna and the song is only a minute long because it doesn't need two minutes to say what I want to say."

A year earlier on Christmas Eve of 1996, nine years after Nikki had temporarily ended his life, and following many seasons of emotional rehabilitation and restoration that had ultimately led to this moment, Nikki Sixx and Donna D'Errico had acknowledged fate's knot by tying their own at what was described by Crüe historian Paul Miles as a serene atmosphere " (where) with lots of candles and incense burning, Nikki Sixx and Donna D'Errico…married…in their Malibu home. Donna's three-year-old son

Rhyan and Nikki's three children are present. Sixx wears a sky blue glitter shirt with dark blue velvet pants and gun metal toe nail polish. Donna is barefooted in a tight blue long flowing dress. George Winston's song '*December*' plays on the stereo with the sound of the fireplace crackling at their backs."

Even prior to their union, Nikki and Donna had gone quickly to work on assembling their own family unit, moving into Nikki's new Malibu home together and working diligently to integrate their children into one another's lives. Nikki desperately wanted a family of his own that might as well have come straight out of a fairytale in light of his past attempts and subsequent failures at it, but with Donna, the stars seemed to line up for the Sixx's, shining kindly upon their goal for a happy and healthy domestic life. Nikki offered fans a glimpse into the sunrise of his new domestic bliss in a diary entry, in which he announced to fans "Happy holidaze fruitloops. From the fruitiest of the loops (The Sixxs and D'Erricos)," before continuing with a first look into the couple's family life, "I got a funny story for ya about my better half..We're out in Malibu getting an X-Mas tree and stuff, and we stop and talk to Santa, and I walk up first with Gunner, Rhyan, Storm and Decker. And Donna walks over to this coffee house to get us some Liquid Sunshine. Santa starts spouting off very un-Santa like about drinking, partying and weird stuff, etc, etc. And not paying any attention to the kids. So I walk off and sit down with Donna and tell her what a dickweed Santa is. But then the kids wanna go back and ask Santa for some more stuff. So Donna goes with them this time. Santa starts off again (plus staring down my baby.) Well, she sends the kids back over to me and chews Santa's ass- hard…Ho Ho Ho, don't mess with mama bear!"

The most important the time to Nikki seemed to be maintaining a stable home environment for his children, such that as things began working his way toward that end, Nikki was never shy of thanks for his good family karma, expressing as much in one diary entry wherein he described the day as "soooo nice, here in Malibu. It feels like the first day of summer. We've had so much rain. Its been a bit depressing . It seems that all that's gone for now. Me and Donna had the kids outside all day frolicking and laughing. Life is wonderful to say the least. I am very aware of my fortunes." As Mötley Crüe's profile began to rise in the press following the their comeback with the release of Generation Swine, coupled with the tabloid coverage of both Tommy Lee and Pamela

Anderson, and to a lesser degree, Nikki and Donna's marriages, the sacredness of Nikki's new family unit suddenly had developed a vulnerability to paparazzi exposure.

In keeping with a genuine disdain for the intrusions of the tabloid press and the spirit of Mötley Crüe's bad boy image, Nikki recounted one such encounter in his on-line diary with a mix of humor and warning to future potential media intruders, recounting that "we went to our favorite park today for hanging and playing. Kids were having a blast as usual, and Me, Donna, and our friends…were all chatting when (one of them) said 'There's the pooparazi over there clicking our pix and worse, our kids' pix. So I kept my eye on him. And decided to swing storm around and low and behold, 'Click, click, click.' So I walked over to him and asked if he knew who I was. He said 'Yes.' I told him if he didn't give me the film of me and my kids I was gonna slit his throat (I said it with a smile)…And then asked him if he believed me. He said he did, I smiled again, and held out my hand. He opened his camera, and gladly handed it over. And ran like hell."

In the midst of his romance with Donna D'Errico, the most important thing to both parents were protecting their children, raising them in a loving home that was absent of anything other than the purest possible innocence Nikki felt his children deserved in light of his own abusive childhood, explaining at one point that "on this earth, teaching my kids the differences between good and bad is my responsibility. They are the center of my life, they give inspiration to my soul." In light of the latter, most important to Nikki personally as a parent was his desire to be the father to his children that his own had never been to him in his own youth, such that "they can be themselves no matter what. I endorse them as human beings and give them unconditional love no matter what. And they know that I'm always there for them anytime. Pick up the phone, come in my room, stand next to me onstage all night because you need me, whatever. Unconditional love is the most important thing." With his personally life finally sorted out in terms of his own heart, Nikki now set out on a journey to regain that of his fans.

In the process, it was not lost on him that he would dearly miss his children, and to that end, "(sometimes) I take them with me…Going on tour (is hard because) I don't wanna leave my children." Still, with his new

family, Nikki also had financial responsibilities that had to be met, and Mötley Crüe, if nothing else, was the vehicle by which that obligation was met. As such, for a plethora of reasons, in the summer of 1997, Mötley Crüe made plans to head out on the road again, this time in search of their extended family- the fans. This for Nikki was a moment filled with an equal excitement and expectation as that which he had experienced in falling in love with Donna, as here Nikki was looking to fall in love once again with his fans, and hoping they would follow alike in heart. Their new record was the catalyst through which Mötley Crüe would reunite with the hundreds of thousands of fans in a medium that Nikki hoped would again successfully channel a mutual "energy (between the fans and the band), if that moment exploded…it could be gold dust or just plain dust. You never know which one it will be…I love that great energy… It's like people ask me why I got married with Donna, I can't explain the reason but I love her from the bottom of my heart."

Chapter 17

The Decline of Grunge and Second Coming of Mötley Crüe

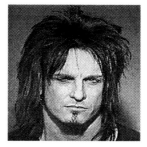

The year 1997 was indeed a dark one for rock n' roll. Hard Rock fans were tiring of grunge's gray skies, overcast with Seattle's played out theme of dreariness. Live audiences had grown weary of watching bands stare at their feet while they played, as Nikki Sixx would later coin the phrase. As ticket sales for alternative rock festivals like Lollapalooza, who had been a surefire hit tour package since 1990, began to falter, it became clear that rock fans were in a holding pattern of sorts. Grunge's tightly wound, angst-filled ball of anxiety had begun to unwind with the suicide of Kurt Cobain in 1995. Pearl

Jam was the exception, having released their first straight-forward rock album in 1996. All of the decades' monster acts, notably including Sound Garden and Alice in Chains, had either broken up, or were experiencing their share of the genre's collective popularity decline, as arenas turned to theatres, and then back into clubs they had first started playing in. In the course of this change in seasons, the playing field began to level as the saturation dried out of rock and roll's bloodstream, and its fan base began to lighten up. If hard rock were ever to be great again, it would clearly require a compromise between the heavier, industrial alt-rock sound of the 1990's superstars and the energetic sound that the celebratory vein of 1980's hard rock bands had conjured, with loud lightshows and skies painted with fireworks.

Before rock fans would be prepared to trade in their flannel for leather again, one sacrificial band would have to, once again, sport heart on tattooed sleeves, and brave out to test the waters before the rest of the genre's stable of artists would dare follow. As they had proven 17 years earlier when they reinvented hard rock in what had become its most volatile and commercially lucrative form for ten years thereafter, Mötley Crüe was, for a second time, called upon to jumpstart Rock n Roll's stalled engine. Mötley Crüe, led fearlessly as always by Nikki Sixx, were up to the challenge. Having recently reunited with longtime singer Vince Neil, the band would release their comeback album to an audience of rabid fans and critics alike; the former seeking to put their heroes back on top of the world, while the latter sought to tear that world to pieces. As one cynical writer from Rolling Stone reported in mid-1997, prior to the release of the band's comeback album, *Generation Swine*, "Mötley Crüe have turned their new album into Elektra, for anyone who cares".

In the context of the entire genre, the question was legitimate at the time. Nikki Sixx's edge for his band had always been that they stood out from the rest of the pack by defining trends ahead of when they became commercial, and escaping their saturation by creating a new fashion with the release of a new record. Mötley Crüe as a band had always evolved with each album, and their fans had clearly evolved with them as listeners. Such that when *Generation Swine* was released in September of 1997, it debuted at # 4 on the Billboard Top 200 with 80.000 sales in its first week. The band would go onto sell over a half million copies of the record. This was unheard of from a rock band at the time identified by the critics as a hair band from the 1980s. It was the tour that followed, however, that truly served to reconnect Mötley

Crüe with its fans, and reassert the band's place as one of Rock's most resilient keepsakes.

Heading into the *Generation Swine* Tour, critics were frothing at the mouth with a mixture of anticipation, inspired partly by the thousands of fans who had snapped up tickets to a listening tour the band performed for the *Generation Swine* album prior to its release. Conversely, music media staples like MTV and Rolling Stone were more interested in ensuring that Mötley Crüe did not succeed in their revival as the resuscitation of the 1980's genre as a whole would clearly depend on the band's success with their new record and tour. Nikki Sixx mirrored reporter's aggressions in interviews when asked about the realistic chances that Mötley Crüe would ever fully regain its stature as one of rock's premier bands, chalking the band's comeback up to business as usual.

In truth, given the immediate way in which Mötley Crüe's fans re-embraced the band, they had never left. Instead, as Nikki Sixx argued, it was the landscape of rock that had changed, but not its skull and bones roots which Mötley epitomized: "It's a new environment out there, we're taking some bricks in the face for rock and roll…We are the underground that's about to explode. Its like 1990 all over again and we're now Nirvana." One immediate indicator of the latter was the ever present controversy that surrounded the band throughout the tour; from the tabloid coverage of Tommy Lee's marriage a year and a half earlier to Baywatch star Pamela Anderson, to the arrests that occurred almost immediately upon the tour's commencing in North Carolina, an incident which made front page headlines nationwide. One of the band's live performance hallmarks was the nightly routine of inviting the fans to join them onstage for the encore of *Helter Skelter*.

Not only did this violate an average of 12 city fire ordinances at each of the cities Mötley played, but it was also unheard of. What gave Mötley Crüe their edge in reconnecting with their fan base so immediately, was that they did so literally. As Nikki Sixx said during one show stop in Peoria, Illinois, in justifying the laws they were breaking by making the convert stage available to fans, it was all in the name of rock and roll " I try to break at least one law every day of my life…So tonight, to say thank you for showing out like you all have to support the band, this is your stage." The event became quick legendary, Mötley Crüe had become the first band ever to allow such anarchy with such regularity. Each night, Security personnel, usually present to keep

fans from gaining access to the stage, were doing just the opposite, helping hundreds of fans onto the stage

For all the noise Mötley Crüe was making throughout 1997, the irony of their comeback laid in the fact that it was largely singular. It was appropriate as they had in fact started the genre that they should be responsible for its revival, but no one else would yet dare to stick their heads out for fear of having it chopped off in the press. Nikki Sixx, Tommy Lee, and the rest of the Crüe stuck their heads voluntarily in the guillotine, daring the press to take a swing: "we're being aggressive…not waiting out the storm. You know, you'll see, like a Guns N Roses, just waiting out the storm. You don't see a lot of bands on the road because they don't want to take the beating. We don't care- we're getting into the ring and going a few rounds." In the course of taking those beatings, Nikki Sixx and company had delivered a few of their own to anyone who tried to get in the way of their good time or that of their fans, all in classic Crüe style. Notoriously, including the arrest in North Carolina, where Nikki Sixx had verbally and physically attacked a security guard for roughing up a fan who was trying to take the stage during the band's nightly encore ritual, the result had been an arrest for battery among a slew of related charges for both Nikki and Tommy. In explaining the situation, Nikki clearly felt that his actions were in the defense of his fans, " we're one of the few bands that stand up for our fans and word has spread- you don't mess with Mötley Crüe fans when the Crüe's in town…I don't want to attack somebody and I don't want to have to defend somebody…(but) we're a rock band and we do what we do…with fucking pride. The bottom line is, we're there to play music and d please our fans, not fight with security. "

It was clearly to the band's relief that they weathered the storm of 1997 alone, as they were able to quickly clear the cobwebs of the 1980's from their updated image. In the spirit of that rejuvenation, the band attempted to focus the media on the fact that they did in fact stand out from their fellow hair band co hearts by holding modern-day legitimacy both on stage, on the charts, and out into the streets if the blood, crowd, and party steered that way. As Nikki described the distinction between Mötley Crüe and later 1980's bands of the genre Nikki's band had started, he quickly sought to point out that Mötley Crüe disagrees largely with what their sound and image had become to the second and third generations of the genre. The bottom line, according to Nikki, was that as irrelevant as those bands were in the media's eyes to what modern rock was, so too were they in Mötley's eyes in terms of what rock

should be about. Clearly, he sought to distinguish Mötley as part of the latter, something relevant, as an influence, and progressive as a contributor, to what would become the next generation of hard rock among the record buying youth: "Nobody's talking about Poison or Warrant- they're talking about us. We're the real deal. When other people were pouting into the camera, we were throwing up on the camera. It was all about trying to die, man- death, destruction, and chaos. Our point was never to be pretty, it was to be ugly. You can see Manson emulating the ugliness of Mötley Crüe and that's the right message. The wrong message was Poison"

The problem was promoters and hair bands alike were beginning to pay attention. It wouldn't be for another full year, till the summer of 1999, during which Mötley Crüe would be released from their contract with Elektra, granting the band full ownership of their Master Catalogue that the 1980's hair band reunion tour circuit would be in full swing, but for the next sixteen months Mötley Crüe would work diligently and unknowingly to lay the path. As Poison would ironically cite a year later in an interview with Metal Edge regarding their own reunion tour with original guitarist C.C.Deville, as their inspiration for wanting to take a chances as a viable draw on the comeback tour circuit, "I think that's what Mötley's doing…they're out there just kicking ass…That's where we're (coming) from."

Mötley Crüe had succeeded in making hard rock commercially viable again. By reintroducing hard rock's live audiences to the bare bones basics of debauchery and excess, they had opened the flood gate for the concept of a prettier version, but alive in the same spirit and adrenaline. A full year and a half earlier, however, this rebirth of the hair band was still nothing more than a peach fuzz concept. Mötley Crüe would go through the release from their major label contract with dignity intact and a new distribution deal with BMG under the umbrella of Mötley Records, where, in addition to releasing their entire catalog, the band would release the only 1980's era Greatest Hits collection to chart in the top 20 of Billboard in years. The tour that followed would be the last with drummer, Tommy Lee, who had in the summer of 1998 served a four-month jail sentence for a spousal abuse conviction, which put the band on tour again in the fall and winter of 1998 to promote the release of their *Greatest Hits* Collection. It was in the course of this tour, and the long dark winter they would trudge through, that Mötley would truly earn their stripes as Hard Rock's true generals. In almost every facet, the *Greatest Hits* tour was unique to most packages. As it was independently

financed, and dictated by controversial factors including Vince Neil's bankruptcy settlement, Tommy Lee's probation, and the band's first independent release via Mötley Records, the success of the tour was pivotal in the band's coming full circle as the new dawn of hard rock was emerging.

With the theme of longevity in mind, the band hit the road in September, 1998 in celebration of their 18 year history, made possible almost solely by the legions of devoted fans that had clung to Mötley through overdoses, murders, prison sentences, and every other breakable law or controversy that could have eaten away at a band. Where most bands would have eroded under such cancerous conditions, Mötley continued to thrive on it. In describing Mötley's odyssey, which was coming full circle during this period, highlighted by the release of the band's Greatest Hits collection, Nikki was clearly seeking to kill several birds at once, deflecting critics with the most authentic deterrent available- the legions of Mötley fans that prove them wrong: "It's funny, the press, a lot of times, like to…build you up to tear you down, right? But its part of the animal, the insecurity and the low self-esteem of the press is basically, 'We can decide what you are and what you are not, based on our little clique and peer pressure.' So, all of a sudden, (Mötley) comes out with a greatest hits and it's like, whoever says these guys suck is really a dumb ass. Cause this is fuckin' some ruthless rock and roll, and the music always has the last word…I think you have to hang out for a couple years if you're really passionate about your music and keep doing it, and then you'll get another shot at it. That's what its all about. You've got to ride out the storm." And through the *Greatest Hits* tour of 1998, Mötley Crüe did just that.

Playing theatres in the dead of winter, the band toured throughout the toughest and driest of concert seasons, managing to gross upward of $9 Million n revenue between Generation Swine and the Greatest Hits Tours collectively. More importantly, as Mötley Crüe had broken it back down to basics in their approach to retaking their place at the top of hard rock, they were developing an almost silent synergy with the acceptance on the part of the mainstream rock press that Mötley Crüe was actually experiencing a quiet but legitimate renaissance. Highlights included the band opening their own retail outlet on Melrose Avenue, in their hometown of Los Angeles, aptly titled S'Crüe, where the band sold their memorabilia exclusively; the first for any rock band in the past twenty

years. To truly mark the opening, the band came home off tour and did an in-store autograph singing for over 4000 fans who turned up, lining over 18 blocks of Melrose to celebrate the opening with their heroes.

That same fall, VH1 debuted Mötley Crüe's Behind the Music, which went on to become the most requested episode in the network's series. The success of the Behind the Music episode, featuring Nikki Sixx discussing his Heroine overdose, outer body experience as he flat lined, and return to consciousness, as his heart was kick started by paramedics. The overdose would become, among fans, VH1's most popular Behind the Music moment of all time. Despite the commercial revitalization the band was experiencing, the independent spirit of their journey was one that kept the band's collective nose in the gutter, and Mötley wouldn't have had it any other way. As Nikki remarked to a reporter in the midst of the tour, describing the tour as a celebratory battle, drenched in the reality of the band's struggle, "very raw, very nasty, very sweaty…cloaked in aggression. Its gonna be…raw raw and explosive, and not glitzy, and not theatrical. Its very in-your-face…Fuckin' keep bringing 'em in the ring, man; I'll knock 'em fuckin' down!"

Mötley Crüe was definitely in the fight of their life, as they sought to reestablish a niche whose notches had been dulled by too many second and third generation imitators over the years. Nikki's real challenge was ultimately in attempting to celebrate Mötley Crüe's legacy and history without drawing what he felt was undeserved attention to the hair bands that had consistently blown Mötley's lead on a legitimate place in Rock and Roll's hierarchy along side bands like Aerosmith and Led Zepplin who had surpassed rock critic pigeonholing; "We're in a bit of a rebuilding process, and I'm aware of that. And we got some baggage, and I'm aware of that. And that's ok, because, again, that's like some kind of a challenge."

While Nikki clearly was annoyed by the seemingly unshakable comparisons to bands of the 1980s, he seemed to find solace in the fact that Mötley's in-your-face approach to touring was giving way to a new genre of hard rock bands in the vein of Korn, Slipknot, Coal Chamber, Kid Rock, and Limp Bizkit, all of whom, at some point, had cited Mötley as an influence in their sound, and most importantly, their approach toward connecting with a live audience. Mötley sought to celebrate the parallel between their influence as a rock band over the next generation of hard rock bands on the Greatest

Hits tour by showcasing a diverse spectrum of multi-genre talent in the show's opening slot, serving as yet another testament to the band's commitment to being continually progressive, as they helped to introduce new acts to their audience: "We've had everything from heavy metal to hip hop to industrial to Southern Rock opening for Mötley Crüe (on this tour). To me, music is music. If it's good, I don't case about the genre. I know a lot of rock fans are more close-minded than that, but it's always been our goal in a way to open them up to other things."

As a songwriter, Nikki's influence was clearly being felt by a new wave of hard rock bands, who repeatedly cited *Too Fast For Love* and *Shout at the Devil* as seminal to their sound's evolution. This vein of comparison and adulation Nikki truly seemed to enjoy and embrace, as it was an acknowledgement of Mötley's respectability historically as an influence, and a testament to their longevity as a relevant element to the next generation of rock and roll: That bands, like Korn, who were on the verge of becoming the Metallica of the millennium, were willing to take ready advice from Nikki Sixx on what composed a hit record is where Nikki drew his greatest source of motivation to press on. Fan adulation wasn't the real reward for Mötley Crüe, it was the respect that came with the fact that bands, like Korn, were willing to listen and learn twenty years after their own birth: "I like Korn a lot. A lot of those bands are in the same situation. I told Twiggy (Ramirez, bassist for Marilyn Manson) the other day, 'If one of you bands write a pop album doing what it is you do, you're gonna be the biggest band in the fucking world.' If Korn could write their '*Paranoid*' or '*Iron Man*', they're gonna be the biggest band in the world. If Manson can write their '*Fame*' or '*Changes*' or '*Golden Years*', then they're gonna be all over the place. You gotta do what you do, but you gotta make it accessible to millions of people. And the way you do that is through melody. You can be the nastiest motherfuckers on the planet, and you can be the fucking loudest and the crunchiest, but when you do "*Detroit Rock City*", the fuckin' stadium goes crazy. Besides it's a great hook." Taking heed to Nikki's advice, Marylyn Manson's *Mechanical Animals*, released to an instant platinum debut atop the Billboard Top 200 with a 1970's glam flavored sound that was immediately reminiscent of David Bowie's seminal Ziggy Stardust.

The irony that history would repeat itself in a mini-rebirth of a genre Mötley Crüe had accidentally spawned almost twenty years earlier was amusing to no one more than Nikki Sixx himself. Nikki viewed the

commercial reacceptance of bands like Poison and Ratt into Ampetheatres in the summer of 1999 as something separate from the band's own rebirth. He sought to drive that point home with every opportunity, as it was an essential element of Mötley Crüe's struggle to regain ground as they trudged on through the late fall of 1998, "I don't feel like we really started with any other bands. We somehow got lumped in with some bands that came out like five years after us. When we first came out, it was the Circle Jerks and Fear. That was what was going down..We basically cut our teeth on punk. And somehow these bands came out once we got successful. (Before) everyone was going, 'That's so uncool.' But when we started, we were so fuckin' uncool...Then all of a sudden we hit, and all these bands copied us...It was never just 'Party dude!' Somebody confused our message. It was about destruction and anarchy...So, for me, it's a bit of an embarrassment that the industry couldn't figure out what to do with us, and they ended up lumping us in with shit."

As Mötley fought their way through the winter of 1998, Nikki summed up Mötley's rock and roll pilgrimage as one very grounded in both commercial and financial reality. As the band stuck to their collective guns through a grueling theatre tour that canvassed parts of the Midwest that bands like Metallica wouldn't touch in the middle of the summer tour season like Duluth, Minnesota and the upper Dakotas, they emerged with a maturity found only within the very upper ranks of hard rock's forefathers. While their durability and aggressive pursuit toward raising hard rock's bar toward its former heights had silenced critics and impressed fans and peers alike, it was Mötley's patience, and commitment to refining the science of being a rock and roll band truly committed to the cause that served justly distinguish the band during this period of reconstruction. As␣Nikki explained to one journalist, " Nothing speaks like being honest and playing music, and our fans get that...What we've done the last few years, we said 'It is what it is. We're not on MTV, we have a core audience, let's go and put together a 2 truck/1 bus tour and stay in b-list hotels. We don't need the biggest lights and more pyro than God...Mötley Crüe is really a band that likes to go over the top. Sometimes you have to be an adult about it."

Bands like Poison couldn't have agreed and disagreed more in the same time. On one hand, bands like Poison and Warrant were waking up to the fact that rock fans were hungry for more of what Mötley was at the time the only band out there serving up. Kiss had embarked on a series of

reunion tours a year earlier, but because they were celebrating their full-makeup heyday from the 1970's with an all-original lineup, they really didn't qualify as an eighties rock act. To that end, when Mötley Crüe announced it was planning a summer ampetheatre tour with The Scorpions as an opening act, Poison immediately followed suit, announced that they would be headlining a reunion tour in the summer of 1999 with original guitarist, CC Deville, back in the fold. To every rock contemporary's disgust, the opening roster of bands would consist of Ratt, Great White, and Slaughter; the bands who had effectively killed off 1980's hard rock, and who Mötley, for over two years, had been fighting to distinguish themselves from. Nevertheless, their struggle had, by default, been that of bands like Poison and Ratt, who followed the path Mötley had laid back into hard rock's holy temple.

With legions of hard rock fans primed by Mötley's two years of almost non-stop touring, reunion tour packages made the rounds of the ampetheatre circuit (with banner slogans like "Rock Never Stops"), decorated in maniacal displays of pyrotechnics and multi-colored light shows, but embodying a humble undertone that came straight from the gut of the work ethic Mötley Crüe had re-established as a live act since going back out on the road in 1997. Fans seemed to respond best to a mix of the two; an appreciative indulgence of bright light shows and long song sets that glorified not only the band and its fans, but the genre itself. The necessary blue-collar pandering that was required to generate an aura of authenticity around such reunion tours, 80's hair band front men like Poison's Bret Michaels were more than eager to embrace and emulate in their own pretour rhetoric: "We're just going to go out there and play for the people who show up to see us...We're just going to go out there and blow shit up and be excited...I think there are going to be a lot of old fans out there, and I think there are going to be a lot of curious new people that have never had the chance to see the style of music we play. "Mötley Crüe had been doing just that for since 1997, and in the summer of 1999, it was time for the bandwagon to follow.

Before the dominos would start to fall again, however, Mötley Crüe would get the one final nod they had so desperately sought with their second coming in 1997, the reconstruction of their fan base though 1998, and reestablishment as one of hard rock's premier acts heading into the millennium. As Metal Edge Editor Paul Gargano concluded regarding the

band's longevity in a review of one of the final *Greatest Hits* dates in late 1999, "Not only are the '80s a decade gone by, the 90's are fading fast and ready to bow to the year 2000. If ever there was a band to usher in the new millennium with a middle finger flipped and a 'Screw You' to all that stand in their way, it's the Crüe. All they need is their fns to give them the chance. Mötley proved their could stand the test of time with *Generation Swine*, now its time to accept…(their) evolution- its marked Mötley's past, and it should be a part of their future." In doing so, he granted the band the one thing they had sought from day one, their independence.

Chapter 18

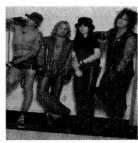

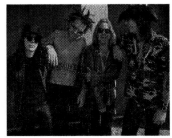

Rodeo

Laughin' like gypsies show to show
Living my life like a rolling stone
This is how my story unfolds
Traveling man, never at home
Can't find love so I sleep alone
This whisky river has a long way to flow
All that I know is life on this road
Long way from home
In this rodeo
Rodeo, rodeo, rodeo, rodeo
Not my home
Another day, another night on stage
Lights go down, time to turn the page
Was this all I ever wanted to be

Six hundred miles the highway calls
Another long day now the hours get small
Riding out this rock and roll rodeo
All that I know is life on this road
Long way from home
In this rodeo

By the time the *Greatest Hits* tour commenced, Nikki Sixx was clearly feeling the pressures from all sides. As both the critics and the band's label sought in an ironic collusion to keep Mötley Crüe from attaining an updated version of their former glory. The effect threatened not only the band's livelihood, but Nikki's own as well, a reality he'd made frankly public to a Spin reporter during the *Generation Swine* tour; complaining that "I have a contact with (Sylvia Rhone, Elektra's new president), and she won't give me my money. I don't understand...I have four kids, a wife. I have house payments, car payments. I have a life. I fucking earned the right to have one of the biggest contracts in rock and roll...Well you know what, motherfucker? You've got a contract and if you want to go up against this band we are a loose cannon. I will make your life miserable." The resistance by rock's corporate bureaucracy only worked to fuel Mötley's fire, causing them to burn with renewed cause toward the prospect of redemption. The first real validation in their quest came in December of 1997, when the band had been released from their contract with Elektra with full ownership of their master catalog as compensation for the $10 million the band was still owed on their contract.

With their future uncertain, Mötley Crüe set out to chart a new course in rock, one that would take them to true independence and out of the hands of Elektra Records with ownership of their entire back-catalog, in the conclusion to a battle that Nikki described at the time as part of the band's larger struggle toward freedom, such that "it had more to do with downright blood in the streets of us against Elektra Records. And it was *bad*, it was nasty. They needed to separate themselves from what they considered to be the *Antichrist*. And we needed to be separated from what we would call the *fuckin' corporate gatekeepers*. Gatekeepers to where we wanted to go in the future. Bob Krasnow signed the band for $25 million in 1991, and started *Decade of Decadence*. It was a great time for us: we had earned that deal, we had earned that royalty rate, we had earned that

advance; we made the company millions and millions and millions of dollars, and they didn't have a problem with that... So Bob Krasnow leaves and in comes a guy named Doug Morris who then switched us to a lady named Sylvia Rhone. And she, in a sense, inherited Bob Krasnow's *Satanic Child,* and every time she went in for her bonuses or her fiscal year or quarterly, there sits this band that she *has* to give this money to, yet she didn't believe in us enough to promote us... And until we had control of our music we weren't going to be able to control our destiny, but in the end it worked out great for them and for us."

The responsibility of controlling their master catalog suited Mötley Crüe more than it would have most bands, as they, largely through Nikki's vision, had the wisdom to know how to shrewdly utilize the opportunity they had been given. This, of course, meant another tour season, as the band activated Mötley Records in partnership with manager Allan Kovac, who in turn had founded Beyond Music and secured a distribution deal with BMG to handle the band's releases. The first under this pact had been the *Greatest Hits* collection that in turn led the band to go back out on the road. The band was now essentially setting their own expectations, and with their new found freedom, the sky seemed the only limit; even in the face of long months away from home, which Nikki himself had come to cherish as he was experiencing his first period of true stability, in his professional, personal, and spiritual journeys. He balanced the three by using the love of his family as the energy source for his professional pursuits, which appeared to offer the most viable source of spiritual gratification as Mötley. The band had always been Nikki's brainchild, moved into their first period of true adulthood: "The band has been working so hard...when it wasn't cool to be a rock and roll band. We're pushing our own envelope...(and) I can't stay home because somebody else needs to stay home for their personal life. Its not really a decision I can make. "

This period had also given Nikki the opportunity to apply his business sense second generationally, to that end founding his own record label Americoma. The label provided him the opportunity to develop a new generation of bands on his terms, rather than those of the Corporate past Mötley Crüe had fought so hard to escape since their reunion two years earlier. As Nikki's business acumen blossomed, he found himself, for the first time, something of an icon; as he was beginning to work, in addition

to establishing Mötley Crüe's legacy, to charting his own: "I'm the kind of guy that can have like five or six paintings going on at the same time, and that keeps it really exciting for me. Having a clothing line is really cool. Then I step over to the other palette and I've got (my solo project) 1958. And then I step over to the other palette and I've got Americoma…I've got four kids and a wife and I live on a fucking ranch…And I've got Mötley…This is what…the last two and a half, three years of hard work (have been) for…We're in the fourth quarter of the game." In this spirit, Nikki Sixx had clearly always been Mötley Crüe's quarterback, and he worked to score all the right touchdowns for his team. Nikki's opportunities only seemed to expand, as his tireless energy was finally working progressively, and paying off for both he and the band, individually collectively: " I invest in myself. I don't believe there's anyone out there who works harder for me than me… I'm into building careers, educating and having the artist pass the education onto the next artist in line. I've been recording and marketing hit albums, touring, designing album art, merchandising and all the other aspects of being in one of the world's biggest bands for 20 years…I'm not anti-majors, I'm anti-not getting paid what I should. My initiative is to teach the young artist what I know."

While Nikki's professional role in the music business was finally coming full circle, it was clearly his marriage to Donna D'Errico and the harmony among their family, specifically with the challenging role as a father of four, that made his hoop unbreakable, and his will toward accomplishment, unbendable. More than anything, it was visibly the first period in Nikki's life that could have been termed by conventional definitions as normal. Most importantly, this period represented everything that Nikki himself had grown up without. Where with Mötley Crüe, Nikki was seeking to have history repeat itself, with his own family life, he was chasing the opposite. Somehow, he managed to use one as a catalyst for the other " I love my kids to death. I get to mend the chain that my father just broke and crushed. I had a really funky childhood, so I get to fix that and feel good about it. I'm really happy, and there's nothing you want more than a happy artist…I live in a 50 acre ranch out in Augora Hills with my wife and four kid…It's pretty awesome. I get the kids off to school and…then get started on the day working with the bands, get in the studio with Mötley Crüe." The synergy between all of the elements of Nikki's home and professional lives made it possible for him to remain

centered enough to put all the baggage of the Crüe's past in a commercial perspective that was palatable to the masses of rock fans who had recently become history students with Mötley's mini-rebirth on VH1. This focus allowed Nikki to take the story of that unparalleled excess and make a lesson out of it for future generations of rock bands and fans alike. This ultimately allowed Nikki to better understand himself in the context of his band's legacy, which, by the dawn of the millennium, had become at least partially defined by the havoc Mötley Crüe's members had reached upon themselves, past what some would have once argued was any point of recognition. Not only was Nikki now able to face his past for what it was, but also understand for himself, and the band's fans, *why* it was "There was a time in my life when I didn't want to live. But right now…the creative juices are really flowing. Whatever it takes to keep your creative juices flowing, it's going to change and you're going to age gracefully or you're going to look stupid. I'm not going to tell you I don't have a firecracker up my ass. I love rock n roll…I take it really seriously. But it's just me being me, I'm not trying to be Nikki in 1983."

Behind the media mask of redemptive sacrifice in the name of rock and roll, there was just sacrifice. The rigor of the road was the same for Mötley Crüe as it had always been; the principle difference is what the band did with their time in-between shows. Because Tommy Lee was on probation for the *Greatest Hits* tour, the band allowed no opportunity for him to get near even the outskirts of trouble for fear it would send him back to prison. As a result, there was no backstage, limited press junket opportunities, and because the band members were in relationships, no infidelity to distract from the listlessness that causes the mind to naturally wander off track. Nikki's thoughts drifted homeward as he clearly missed the family life he had settled into; a pain he lamented of routinely in his online rock and roll diary: "I know we're playing tonight, but I have no idea where. Someone just said to meet in the lobby at 3:30, and like a rock and roll zombie, I just march on, city to city to city, but are these a contradiction of spirit? Smokie rooms filled with barflies or a home filled with children's voices laughing." Nikki clearly tried to have his priorities straight during this period, but their order reshuffled in part based on conflicting ambitions. Where on one hand Nikki sought madly to push the boundaries of Mötley's reach, it put him father from the family life he depended on for the whole engine to turn. Such that it at times seemed like the momentum required to keep that wheel a spin might spin out of

control based on the band's fatigue, as Nikki lamented following one show, "I walk this room like a caged animal…I wait for the drugs to melt my face and shove me down into the crumpled bed and into a dreamscape."

The bottom line testament to Mötley Crüe's durability was that they kept it together. Mötley Crüe was a machine; whether it produced product suited to a million fans or several hundred thousand, the same mix of maturity and measured chaos were expected, and in fact, required of Mötley Crüe by both its fans and the critics. By this point, the media's new contest with Mötley Crüe was hyping up their past debaucheries to see if the band could still live up to the bad boy image they had cultivated over the course of 20 years. On stage, between the necessary petty arrests and mandatory cursing sessions by Vince Neil, the band managed to pull it off. Nikki and his band mates, offstage however, had matured into very different people; calmer people who had begun to view their hallmark antics very much as a job. This view stood very much at odds with the days when they impulsively acted out such behavior. In part, Nikki's diary was designed to furnish fan's insight, and therein an understanding, into how the band coped with their responsibility to an ever-enduring fan base. The diary was another in a series of Mötley firsts that served to, at least partly, redefine how rock bands approached their relationships with fans. Though it would take years before any of rock's latest generation of bands would be on such intimate terms with their listeners: "the reason I invented the rock and roll diary was to let you be a fly on the wall…to see sides of my life that other artists haven't shown you…sometimes we suck and its ok to say it…we bleed onstage for you…we make mistakes in life with you…we stray from our vision and rekindle our fires with you…you're the fans and the voyeurs of the new frontier…enjoy the magic cyber carpet ride through the unexplained…the truth that is both glamorous and hideous."

It was in the course of Mötley's renaissance that Nikki Sixx was at his most open with the fans; maybe in an effort to share the band's second evolution as it happened with the fans that made it possible, or perhaps because he in some way required the feedback to justify his own drive. By providing fans with a backstage pass into the mind of Mötley's mad scientist, Nikki, through sharing his experiences made the connection between fan and band that much more intimate, to where Mötley spirits were unmistakably kindred: "I realize sometimes I let you in..but you really don't know me…its dark and dank and confusing in side me..oh my god,

the artist is honest…crucify him. He should not have bad days, and never share if his glossy little world seems…lost of its shine…He should always sparkle and be that pop star icon cut right out of a magazine…Thanks to pain…I feel a song." In this time of revalidation as a band, Nikki had clearly come full circle as a songwriter. Where he had for years retained sole control over Mötley's songwriting in pursuit of his vision for the band, Nikki in doing so, had also readily acknowledged that his band was not yet where they needed to be musically. More introspectively, however, the omission was an insight into where Nikki felt his weaknesses were as a songwriter.

While he had written the majority of five multi-platinum albums by 1989, Nikki still left the door open for plenty of growth in his craft; which is the first indicator of any true mastery of the art: "I'm not a story writer like Ian Hunter or Phil Lynott and that's my eventual goal; I think I'm evolving towards that." Almost a decade would pass before Nikki would speak with the confidence of a veteran about his range as a songwriter, from subject matter to style, he had clearly reached a point where he was ready to veer from his own band's catalog to focus on applying his talent to developing other artists' material. Where Nikki was personally, as an artist, proved to be fundamental to his confidence in a potential ability to develop a new generation of artists with his own label: "I am…able to write a song about strictly doing the fuckin' dirty, just right on the money, man. This is what it's like when you get down and it gets hard…You wanna talk about sex, hardcore, raw, rock and roll sex? Here…I can write a song about that. I…am able to cover a wide variety of subjects…What I find with a lot of artists is, as they grow, they go 'Well, I don't wanna write about sex, drugs, and rock and roll.' Yeah man, fuck yeah, I wanna write about all that shit. But I also wanna write about political issues. I wanna write about my kids, and I wanna write about the fact that I'm doing a hundred and forty miles an hour down the freeway in my Ferrari, and what it feels like. You gotta be able to touch on more subjects that just a couple. That's what's cool about older bands, y'know?"

In dissecting his craft as a songwriter, Nikki's single greatest gift has rested traditionally in his ability to reflect the raw essence of human emotion, be it love, hate, passion, or aggression, always immediately accessible. Nikki has historically been identified as the soul of Mötley Crüe's sound. Mötley Crüe was, in essence, the messenger for Nikki

Sixx's vision that a generation of bands and fans alike embraced, creating the hard rock genre of the 1980s vein. Nikki was never selfish with his credit regarding the band's role in bringing his songs to life. In describing the translation from his head into what became the final product with a new Mötley Crüe record, Nikki describes the translation as very natural, and at its most literal, conceptually, with the full band's force behind the song's realization: "A lot of the songs I'll be writing, the basics of the song are there. Okay, Vince is going to replace my vocal, and Mick's going to replace the guitar…and you're going to use a real drummer instead of a drum machine or a loop, but the basis is there, and you can build around that." It was as a live band that Mötley Crüe made those songs work in their truest kinetic definition within the context of the band's audience. In that way, Mötley Crüe's song and concept were always a reflection of the band's lifestyle, which became an insanely contented balance of life imitating art as art imitated life. It was a vicious circle that whirled, uninterrupted, for upward of a decade before Nikki's creative radar began to readjust to more mature topics as his life with the birth of children. The commitments to family had begun to exceed in priority over that of the empty indulgences the band had thrived on a decade earlier.

For Nikki personally, it wasn't his marriage to Brandi Brandt, which had produced two boys and a daughter that truly refocused his attention, but Nikki's discovery of his soul mate in second wife Donna D'Errico; mother of his fourth child, a second daughter, and role as adoptive father of Donna's son Rhyan, that truly caused him to settle down. The event of his meeting her, and the night that followed to change the course of his life was captured in the song Afraid, which became Mötley Crüe's single off of their 1997 comeback album, *Generation Swine*, in which Nikki dealt with the issues of love and trust as they exist in the context of second chances. Both Nikki and Donna had come from broken relationships that carried the baggage of children and severe issues relative to trust. In writing *Afraid*, Nikki had sought to explore the transition from the comfort of those inhibitions to their abandon in the face of a risk which is ultimately much more reliable than loneliness rooted in a fear of betrayal: " The song Afraid was triggered by the first meeting that I ever experienced with my wife. On our first date, I fell in love, head over heels in love…And I went…'I'm gonna be with you for the rest of my life,'…and I wrote 'Afraid'. She's so afraid, she's gotta go… The song's not really about Donna, but it was

inspired by that moment…I was trying to express what she's feeling, y'know?"

Nikki's sensitivity to the perils of surviving the life he had always reflected in Mötley Crüe's material. However, as he had aged, Nikki's insights began to turn away from the subject of mere survival, and more poignantly toward the lessons learned from the band's odyssey. The greatest reward lay, possibly, in the fact that Nikki had made something positive out of the experience for fans and listeners to learn from; a role he seemed to eager to indulge in than he ever had when Mötley's fans were faceless blur to Nikki's drug-addled eyes. Evidentially, he felt blessed both in the fact that he had survived his own recklessness, and sought in his second coming to make something constructive of it in the songs he wrote. The pain of his childhood would always be a visible scar in his profile as an artist, yet rather than dealing with it as an introvert, Nikki sought to share the experience with fans in hopes that he would achieve a healing message in his music: "I feel more creative now than 15 years ago, but my soul is cursed. Cause everyday I feel pain and dilemma. It makes me write songs that fix the hole, and lets me realize that my life is blessed. My past leaves me broken, my present and future repairs. God played an evil trick on me. He made me an artist."

As an artist of Nikki's stature, he felt in this time an obligation to share more than his heart with the listening world. With Americoma Records, Nikki began down that path in earnest in early 1999, seeking to impart his knowledge and experience of the business with upcoming bands over the course of two or three records, which implied a genuine commitment on his part to investing back into rock's always fledgling community of rising stars: "(Americoma) is real personal. The focus is on helping the artist understand the business, not keep them in the dark, letting them understand how the business works, why if they do certain things it'll be better for their career in the long run- in other words, spending less money on recording their records, so they recoup quicker, so they start making an income, so they can continue to do this for years and years. What happens a lot of times is, record companies give bands a bunch of money, the band goes and spends all the money, and then they gotta tour solid for like a year to try to even pay that money back. The record company recoups first, and then the artist is sitting there starving to death…because (they are) working so hard to pay back the money they

squandered away. So what we try to do is keep the money low, keep the recording budget low, work in the studios that are reachable for the amount of records you are probably going to sell being a baby band…The concept of the major (labels) and the concept of the independents is so different. Artists want to work with artists."

Part of Nikki's battle against corporate entrapment for up and coming bands clearly was rooted in his own experience as part of a band who had in the course of enjoying the amount of success they had incurred a huge amount of expense that, in retrospect, was at least in Nikki's eyes, excessive and in the long run not in the interest of the band. By divulging all the major label recoupment secrets, a large part of how the industry makes its money off of signed acts, especially those in the developmental phase of their career, where many of the costs are implied and not clearly stated at the outset of a band's rise in popularity, Nikki seemed to be seeking a revenge of sorts on labels like Elektra with whom the band had waged a bitter and very public battle of words prior to their contract dissolution. As an example for the bands who looked up to Mötley Crüe, even in cases where they did not work directly with Nikki and Americoma, he had found a forum to cast a genuine middle finger in the direction of those elements of Corporate Recording America whose bottom line was profit oriented; rather than artist focused. Where artists derivative of Prince had gone to conventionally impossible extremes like changing his name to an unpronounceable symbol in his battle with Warner Bros., the move was ultimately just that, symbolic, and nothing more in the long term of artist's rights.

While Prince had preached publicly in endless interviews about the importance of owning one's Master Recordings, he offered no feasible outlet toward achieving such an end. Privately, he had no real advice on such a recourse as it was an impossible feat for 99 percent of all upcoming artists; as most industry recording contracts are based on label ownership of any artist's master recordings. Furthermore, to make the rhetoric that much more hollow in the long run, artists like Prince had to work with Warner Bros. A&R department to sell his name change commercially, even as he was at odds with the company. Working with the enemy in such a seemingly contradictory fashion was something Nikki Sixx had only been so capable of, as he believed too strongly in his own vision for the band's direction, rather than trusting it to the hands of his corporate handlers.

Ultimately, Mötley Crüe had been one of only a handful of bands to achieve the feat of walking away from their corporate contract with ownership of their master catalog. The latter had only been possible because of the amount of money Elektra had owed the band on future albums they might record.

With Americoma, Nikki sought to take his wartime rhetoric in 1997 against Elektra on the subject of artist developmental support, and give that theme a practical application. In the true Mötley vein of art imitating life, he did just that with Americoma's founding, but made no bones about the fact that the music had to have commercial viability, nor did he attempt to hide the fact that even indie recording America had a corporate ideology in its bottom line. His ultimate goal was to manipulate the system constructively while allowing the necessary roughness and destructive elements of being a raw rock and roll band to exist in order for an authenticity, and in turn legitimacy to exist among potential fans, as was the case with Americoma artist Flash Bastard: "I just signed…Flash Bastard…They're the real deal… I love music and I love a challenge. The money is there (as an Indie) if you are smart and know how you spend it….You can make the same record in $200-$300-a-day studios…(as you can in) $2000-a-day studios… with people that work off the point instead of advances, with everybody betting on the band winning instead of betting on the band failing. A lot of times you've got managers who just want the commission on the advance. They never have to pay back the commission on the advance…but the band has to pay it back. So it's about us educating the bands…and watching people set their careers up. Career is long term, not short term."

Part of Nikki's ideology was rooted in his own outlook on Mötley Crüe as America's biggest corporate indie band, always evolving, always seeking to push the envelope in the name of a progressive debauchery; attainable only via an honesty among artists that corporate record labels could never afford to be capable of. In Nikki's eyes, their only recourse was to design a system which made it nearly impossible for artists to be aware enough of what went on around them to ever witness the truth Nikki spoke so earnestly about with the press. Before anyone else, he clearly felt the latter applied to Mötley Crüe, as they were one of the first multi-platinum bands to truly attempt the journey toward complete financial and artistic independence. Mötley Crüe's own label, Mötley Records, was

Americoma's role model, and that of a generation of up and coming artists who Nikki clearly felt an obligation toward: "We've worked really hard...going through all this shit...with Elektra and starting our own label...(With Mötley), we got lots and lots of cash, and we slowly became bloated with the cash...Now that's rock and roll, (and) sometimes you have to go past that, but I'm saying, young bands don't."

In further describing the alternative that Americoma offered developing artists over conventional record labels, Nikki points first and foremost to a trust that exists between artist and artist that can never exist between record head and artist on the same level, "when Mötley Crüe got our masters back from Elektra Records...we chose to form our own label with Beyond Music, re-release our own catalog, that way we were totally in control; plus we retained ownership...Record companies like to keep artists in the dark. Very few record companies will let an artist know what a VME is, or marketing plans, or the cost of free goods. The list goes on and on. The band knows something about a recording budget, and they don't even know how much of it is recoupable, or if it's all recoupable, or video costs, and they never retain their rights either...So, by starting a record company...I was now able to work directly with the artist, and do the one thing I feel that all artists need, and that's to be educated on the business. So, whether we're talking publishing, or a better way to record an album, because I've recorded so many albums...just actual advice on the recording process, or the setting up of the marketing...it's a great opportunity for the artist...So, if somebody has an opportunity to sit in a room with Nikki Sixx, or sit in a room with Doug Morris...the difference is they're going to have a relationship with me based on art. They're going to have a relationship with Doug Morris based on how much money he can advance them."

Expanding more in-depthly, Sixx reasoned that "record companies are basically banks that manufacture. (Americoma's) concept is to be able to market a product, help brand a product, and educate the artist so they can then take the baton and pass it to a new artist...I think that we all have a position in the music business, and we all have a responsibility. When I was 20, its not the same as I was when I was 30, or 40, and when I'm 50...I should be doing other things (like) maybe setting up the business side of it...Our position isn't damn the record companies, because we are a record company. We also sit down in marketing meetings, we also sit

down and have VMEs, discussing cost breakdowns, and billing, but it's not based on thing (as majors)." The diversity that owning the band's master catalog allowed gave way to new professional opportunities for the band in the period leading into 1999, and would play an integral role in where Nikki would focus over the course of the next two years outside the realm of Mötley Crüe, and in the arena of popular music itself. More immediately, however, the band was finally beginning to achieve its happy medium professionally, and were branching out accordingly into new opportunities that a wave of musical technology had allowed to flourish within the industry: "I'm developing a broadband channel called beyondmusic.com in partnership with Hewlett Packard (NYSE: HWP). Me and (Mötley Crüe singer) Vince Neil are developing the Outlaw Channel. We have programming that will relate to that lifestyle, from a kid in Compton to a kid in Beverly Hills, to a Harley rider in Tennessee. Bikes, tattoos, lifestyle."

With their destiny now truly in Mötley's hands, their first independent release- the Greatest Hits compilation- had gone gold on Mötley Records, completed a subsequent world tour that grossed them over $9 million in combination with the previous year's Generation Swine world tour, and though they'd suffered the loss of drummer Tommy Lee in the spring of 1999, embarked that summer on their most successful ampetheatre tour in over a decade. Mötley Crüe had truly returned, and Nikki Sixx had settled personally into what fate had had in mind for him all along in the way of a family life with his new wife, Donna D'Errico. With his personal affairs in order, and the band in control of their commercial and musical fate, it was time for Mötley Crüe to set out on what would be prove to be the most independent, and ultimately climatic period in the band's almost 20-year history- Maximum Rock!

Chapter 19

Maximum Rock

Building off the momentum the band had established over the past 2 years, Nikki headed straight back into the studio in the spring of 2000 to record the band's 8th studio LP, and first without drummer Tommy Lee, with '*New Tattoo.*' In the course of writing the album, Nikki discovered a new musical muse and collaborator who would stay with him throughout the first half of the millennium in James Michael. Akin to Humphrey and Lee's musical bond, Nikki found in James Michael what he described in one diary post as perhaps his first true songwriting partner, where complete

trust existed to the point where, as Sixx put it, "I enjoy writing with James so much. We click on music and concepts so quick. It just flows...He's one of the most talented guys I've worked...I really click with him...Were on a songwriting binge again...and it looks like we might be producing some acts as well- together and separate."

James Michael explained his first meeting with Sixx as coincidence, wherein "Nikki and I were both on the same label, Beyond, and I had finished my record, and just moved to LA, and was waiting for it to be released, and so was spending alot of time down at the label, going over promo, getting the packaging all together, and he was there because he was running Americoma, his record label, out of the same offices. So we'd pass each other in the halls quite a lot, and I'd heard a rumor that he'd heard an early cut of my record and really dug it, and so one of the times we passed each other, we stopped and kind of stopped and talked, and he seemed to be totally cool and really down to earth. And we just kind of said in passing 'Yeah, we should get together and write sometime.' And I was like 'Yeah, that's cool', and didn't really think it would ever happen, I was just excited to have met him. And when I first moved out to LA it was when Motley was just huge, so I would say I was more- I had an appreciation of what they were doing, and was just very aware of them. I wasn't a fan where I had all their records, but I was certainly a fan of the music scene at that time."

Michael for his own part explained that genesis of their songwriting partnership as on in which "a couple of months after that, I got a call from Nikki, and he said 'Hey listen, I'm starting a new record, and just wondered if you wanted to get together and write a song?' And so he came over to my house, like the following day or week or something like that, and that afternoon we wrote '*Hollywood Ending*' and '*She Needs Rock and Roll*'. And I had written the basics for '*Hollywood Ending*' for Duran Duran, and I don't know what it was, but I ended up just not pitching it to them. So I had this ballad idea for *Hollywood Ending*, and I just played it for Nikki. And he said 'Oh, that's really cool', and immediately- cause it was originally about this guy who was writing this film script, who wanted to write this script where this woman fell in love with him and all this stuff, but I hadn't really nailed it. I'd just gone with the *Hollywood Ending* idea, and then just written a love song around it. And Nikki said 'Man, we should really take this and drive the film script idea home.' Nikki has just

got such a great, twisted mind, that I wouldn't say he's one particular type of writer, cause the writing has we've done, his participation has always been different.

Continuing, James revealed that "the one consistent thing about him is you can mention an idea to him, and his mind immediately comes up with ten ways to improve on it. Or you'll say a phrase, I remember one day I called him and said 'Hey Nikki, I got this idea for a Meatloaf song called *Love You Out Loud*, and the theme of it is I wish I could love you out loud', and he just immediately, right off the bat, without missing a beat said 'Yeah, I wish I could love you out loud, but I keep it to myself.' Things like that are just, that's how he operates, he just emotes these amazing kind of twists. So I'd describe our songwriting interplay as one in which we're bouncing and building off one another. I think it varies, there's been times when he's come up with a riff that ends up being the basis for an entire song, and I will help with the melody and the lyrics. And there's been times when I brought a song in and near its completion, and he would kind of just sprinkle magical dust over parts of it. And visa versa. We've done things both ways. You always know, like if I'm sitting here writing a song by myself, and I get stuck in a certain place, I will just know if he's the right guy to just pick up the phone and go 'What do you think about this?' You just know when its time to finish a song with him."

In all, Nikki and James Michael collaborated on six songs for New Tattoo- including *Treat Me Like the Dog That I Am, New Tattoo, Dragstrip Superstar, She Needs Rock N' Roll, Hollywood Ending,* and *Fake*- roughly half of the album's songs, and among Motley's strongest tunes in years.

Mötley Crüe wasn't the only priority in Nikki's life at this point. In the spring of 2000, while the band was in the studio finishing up New Tattoo, Nikki had also received news that Donna was pregnant with their first child together. Nikki was elated upon receiving the news, "wow, wow, wow… I'm at the studio finishing bass tracks and Donna just called. She said 'I have something to tell you.' I said 'What?' She said 'We're pregnant.' I'm so excited. I feel like I'm gonna pop. Life is wonderful and weird and full of twists and turns. Thank god." As the tour got underway, Nikki went out of his way to strike a balance between his obligations to his band on the road and to his family at home- namely by brining them out into the circus from time to time, such that a typical day on tour with the

family in tow might resemble "the rock n roll family circus...My room's covered in pizza boxes, old news papers, guitars, kids art, and dad's lyrics...Who would've thought years ago I'd be sitting here writing in my diary to you over a computer? Who would've thought I'd still be alive? I always feel grateful- every day and every night. I'm amazed at life. When you've seen the other side, you realize just what temporary means...Storm's been so dad crazy, its just melting me into a puddle of smiles. She gives me gifts every five minutes, she walks into the room and kisses me on the cheek and doesn't say a word, just walks out of the room all happy."

As the summer of 2000 approached, expectations were high for Mötley Crüe. With their first post-Tommy Lee studio album slated to hit stores that summer, supported by a headlining ampetheatre tour with Megadeth and Anthrax in support, this was the moment the band had been building up to with their endless touring and album release schedule since the beginning of 1997. After scoring back to back gold albums with their last Elektra release, *Generation Swine,* and with the band's official *Greatest Hits* records, their first independent release on Mötley Records, the band had also succeeded in reestablishing their live audience, scoring the seventh most successful tour of 1997 with their Mötley Crüe vs. the Earth tour, followed by 1998's *Greatest Hits* tour, and the original Maximum Rock tour in the summer of 1999, which would mark the band's first successful ampetheatre tour in 8 years. In all, they had grossed 9 million dollars from touring alone in that two-year period, and had sold close to 2 million records, including the re-release of their master catalog, and a live album, which sold a healthy 150,000 copies. Under their joint venture with BMG/Beyond, Mötley Crüe was the first hard rock band to compete on a major corporate playing field as an independent entity. Where most major label rock acts took in an average of 30% or less of their gross album sales, Mötley Crüe had succeeded in reversing that formula, splitting only their cost of business with BMG and taking home the remaining roughly 70% of proceeds the band's releases generated. As a corporate entity, that is exactly what the band would have become, a tax write off. However, as an independent one, they took greater risks, and generated greater revenue. The band had even managed to launch their own retail outlet in the fall of 1998 in West Hollywood- *S'Crüe*, aptly titled for all of the commercial nay-sayers.

For Nikki, this three-year period of rebirth for the band had been an especially personal victory, as he had been able to make rock and roll's steel dragon breathe fire again when it appeared everyone in some form or another had worked to stomp out Mötley's flame. If it wasn't been the band's record label, critics were constantly lambasting the band's return as the beginning of the hair band revival, which to some degree had been true. Nevertheless, Mötley Crüe had worked its way back to the forefront of hard rock in under three years, and at a time when the newest generation of hard rock bands were readily crediting Crüe among their core influences. VH-1 had featured the band as part of their smash new series, Behind the Music, and the Mötley Crüe Story had gone on to become one of the series most requested episodes, with Nikki Sixx's recollection of his fatal heroine overdose ranking the most popular scene from any episode among fans in the show's anniversary polls. As Nikki remarked to one journalist, he was at his happiest in the midst of the band's comeback hoopla, "I'm not going to tell you that I don't have a fire cracker up my ass. I love rock n' roll. I would give any mother fucker on stage a run for his money. I take it really seriously…Just fucking rock out with your cock out until you don't want it anymore. I still love it!" So much so that he kept the band moving at full steam ahead into the spring of 2000, setting the stage for the release of a new album and a summer tour that would be the band's most ambitious outing yet in the second phase of their remarkable career. Everything considered, the stakes for the band were high.

Added to assist Mötley Crüe in their climb toward Maximum Rock was veteran metal act Megadeth, fronted by snotty front man Dave Mustang, former rhythm guitarist for Metallica, and respected indie rock band Anthrax, both of whom Nikki had fought to get on the tour's bill. Mötley's touring support roster had always been unique and uncharacteristic of fellow bands within the genre. Where for example Poison had toured with bands like Cinderella and Dokken on their comeback trek, Mötley Crüe had chosen to take bands like Cheap Trick, Prodigy, and the Scorpions out on the road in place of more 80's friendly acts. Designed in part to flip off the hair band tag, the band's off-beat tour support choices also reflected their independent, punk-oriented attitude toward industry conventionalism, something they had largely defied and avoided since reemerging on the scene in early 1997. As Dave Mustang himself had joked concerning the joining of Mötley Crüe and Megadeth on the same bill, the spirit of the tour was definitely one of defiance of

anything conventional, "Mötley Crüe and Megadeth have had such different levels of success, that we don't really hang out all that much, or have all that much in common (outside of the tour)."

To make matters even more challenging, Mötley Crüe was having bad luck with drummers- following Tommy Lee's departure, the band had enlisted Ozzy Osbourne veteran skins hitter Randy Castillo to replace him, and following one tour and an album, he had developed stomach cancer just prior to the beginning of the second Maximum Rock tour, which put the band in another last minute bind to replace him. As a result, they hired their third drummer in 2 years, Hole's Samantha Maloney, who for the first time introduced a girl into the Mötley fold. For Nikki's part, he enjoyed the spirit of anarchy that the pairing cooked up, pointing out that no one was immune to it on the sophomore summer of Maximum Rock, even among band mates, "there's been times... Oh yeah, we've been in fistfights on stage. I remember times when me and Vince were in a fist fight and we're fucking fighting at this concert when somebody else got in between us and tried to break us up. Well, me and Vince beat the shit out of that person because they were fucking with *our* thing. Like, *our* thing was is *our* thing and we're like fuckin' pit bulls! But if you come into our ring, we're going to watch each other's back. It's really an interesting animal." The band had worked their way back up through the heavy weight ranks to this moment- their title shot, and Nikki was ready to come out swinging. With Megadeth and Anthrax in tow, the Crüe had the perfect undercard, and in true gladiator fashion, the summer tour would even feature a pay-per-view special. Everything had a volatile air, everyone had something to prove, and Mötley Crüe were the band with the most to lose.

With a new album absent fan favorite Tommy Lee, the band's own money on the line with *New Tattoo's* release through Mötley/Beyond Records, and their legacy hanging in the balance, Nikki knew that the summer of 2000 would be a make or break year for Mötley Crüe's future. Still, even in spite of the pressure, he felt that in a way the band had already made their climb back to triumph, just by the fact that they had been able to raise the stakes this high, "we've gone from 2500-4000 seat theatres to 10, 15, 20, 25 thousand people in sheds a night. Hard work pays off every time. If you work at anything hard enough, you will succeed. I know we're living proof of that. This is one belief that this band has passed onto our fans. Thinking about my music and the band's music, we are moving

forward. It's difficult to see everything when you put it in a straight line, you can't say which time is the best…Everything has a time and a place, but I'm now living in the present…We are honest, I'm very proud of that. We are standing on our ground. It's not too proud to make mistakes, and I'm scared to admit that. If I was right all the time, then other people wouldn't accept me then I would resign. This is us, we're Mötley Crüe."

By the time the summer of 1999 rolled around, Mötley Crüe had graduated back to the top ranks of hard rock. They celebrated their victory with a summer tour aptly titled Maximum Rock; with veteran Euro-rock act the Scorpions as an opening act. While Poison had required three opening act slots, filled by b-rate 80's hair bands, to justify their ampetheatre tour bookings with promoters, Mötley Crüe needed to offer no such security in exchange for announcing their first Arena-size tour in nearly 10 years. Mötley Crüe had made a pact, and stuck with their game plan through the entire battle back to the top. As a testament to the fact that the band's relentless efforts in the course of their climb back up the mountain had resonated with their reunited fan base, a month before Mötley Crüe's summer ampetheatre tour was to commence, the band and the rock world were collectively shocked by drummer, founding member, and Nikki's best friend Tommy Lee's announcement that he was leaving the band. His reasons varied from personal artist conflict to the need to spend more time with his recently reunited union with Pamela Anderson, the mother of his two boys. Nikki proved to be the gentleman of the public relations war that ensued shortly thereafter between Lee's and Mötley's camps, as well as among the thousands of fans that had loyalty to Mötley Crüe, and simultaneously to Lee as a member of the group.

Still, Sixx made no bones about the fact that Lee's departure went against the band's arma mada of loyalty to the cause, and that, despite the fact that he was sympathetic, Lee's leaving the band in a lurch was a betrayal regardless of how one spun it in the press: "The thing is, we have a game plan and I don't feel like it would be fair to the fans…to not just follow through with our game plan…This is simply: Tommy doesn't want to do this anymore. What do I do? Do I have to quit too?…I can understand personal turmoil, but I don't know if I'm supposed to quit because somebody else is going through personal stuff. I'm not saying Tommy's a quitter, I'm just saying Tommy's issues are totally different. Mick does not want to quit. Mick wants to see the band make it back to

the top. Vince wants to see the band make it back to the top…(and) has lost 25 pounds, and quit drinking…He's sober, and I'm really proud of it…This band is volatile, we fight."

While at times he seemed to enjoy the balance, at other times, while on the road, Nikki would clearly be incomplete misery without his family, "seems like the boys are restless from the mundane life of hotel to hotel. When you've been touring for almost a year like us, start to get ratty around the edges…I must say, I'm sick of being away from home. I miss Donna and the kids too much." Sadly, as the tour wore on, Nikki began to slip into old behavioral patterns that he had successfully avoided for almost a decade. Among others, he began a brief affair with Mötley Crüe's stand-in for Randy Castillo, Hole drummer Samantha Maloney, a tryst that Donna D'Errico would confirm a year later when she and Nikki were working through a reconciliation based on a split up that resulted largely from the events of the summer of 2000, as substantiated at Chronological Crüe on January 16, 2002, "responding to rumours, Nikki Sixx's wife Donna confirms that Mötley's replacement drummer, Samantha Maloney of Hole, was one of his many infidelities during the band's summer 2000 Maximum Rock tour." Furthermore, Nikki had begun dabbling in drugs again, including heroine among others, and was trying his best in the midst of what was going on off-stage to keep up a front with fans that things were going well.

Sixx admitted as much in a confessionary diary entry he would post a year later, revealing that while on the Maximum Rock tour, "I began to slide into lies and secrecy on the road." In addition to what was fast becoming a personal crisis, Nikki was, as Mötley Crüe's mouthpiece, the man who everyone was turning to for explanation after explanation on rumors of problems with the tour's financial grosses in the midst of Anthrax's firing early on in the summer, the band's slagging album sales despite the fact that they had achieved their first number one chart positioning on Billboard's Singles Rock chart with 'Hell on High Heels'. Nikki did his best to keep the media at bay while he waited to see how the rest of the tour would perform, responding to KNAC.com's inquiry on the latter that "While the band was working hard to keep up a front that was becoming transparent on certain levels to industry insiders, Mötley Crüe seemed internally invulnerable because it was both in their nature to be. It was not the first time that the industry had attempted to outcast Mötley

Crüe, and in the face of possibly losing it all, the band did what they always did- went the all or nothing route."

For Nikki personally, he confided in fans for support during the trying summer, remarking at one point in his on-line Rock n Roll diary that while Mötley Crüe were at the height of their potential vulnerability at the hands of commercial expectation, they were also relying more on their fans than ever before to defy the odds that had stacked up against them, "I think having this diary has a way of keeping me somewhat sane on the road. I've always believed in writing down your feelings. You don't have to be a songwriter or poet to express yourself in written word. I guess at times I share too much truth, but that's always been one of my dreams, to break down the walls between band and fan."

Another element of the stress that wore on Nikki that summer was the constant pressure from law enforcement on the road, such that Nikki replaced Tommy Lee as Mötley Crüe's designated press bad boy, managing to get himself arrested three different times while out on the road. In describing the latter atmosphere, he cited Salt Lake City, Utah, where "the law was uptight that they issued warrants for our arrest even before we played. If we messed up one little bit, we were all going to jail for fourteen days without bail." In another incident, Nikki humorously referred to himself as "the Lenny Bruce of rock n roll. It seems anytime I say or do anything a tiny bit outside their decided lines the police try to arrest me. I'm soooo over it...In Atlanta, I asked the security guy in front of me to stop flashing his flashlight in the fans' faces everytime they put their hands up. He looks up at me and mouths 'Fuck you' while holding up his big fucking middle finger. So I say 'No Fuck you!' and take off my bass and poke it at him...Show goes on. I go to my bus, my kids are hanging all over me, and here comes hawk and says I need to go meet with the police. 'Mr. Sixx, you're under arrest for battery.' 'What??? Battery??? Don't you have to hit someone for that to happen?' Not in America...So I kiss the kids, the wife, and say 'Thanks for flying out to see me, but I guess I'll see ya tomorrow.' Then out of nowhere kool-aid comes running up and says 'OK, for $5000 we can make it all go away.' And I said, 'Fuck that, I didn't do anything.' And he says 'Well, bail is $5000, you're attorney is $5000, and it will cost another 5 grand for airfair to come back here to fight it.' So I payed the cocksucker 5 grand in cash...I got fucking

blackmailed. But that night I slept with the kids and Donna in a hotel instead of Bubba in a jail cell in downtown Atlanta."

Despite the ups and downs of life out on the road, Nikki went out of his way to remain upbeat in his diary entries to fans, often posting positive reviews of the band's shows, in part to keep up the band's mood and momentum among fans, but also to combat negative reports that had begun to come out from certain sources within the tour's camp, namely from Megadeth front man Dave Mustang, chiding Mötley for being so loud with their stage set and remarks to the press and fans that everything was kosher when, in some markets, ticket sales had started to lag, and the tour's opening act, Anthrax, had to be cut early in the summer due to what Mustang claimed was an attempt by Mötley to up their bottom line. Nikki was often combatant with questions over attendance, pointing out that to the band, "it doesn't really matter how many people are there."

Still, in other interviews and online diary posts, Nikki went out of his way to combat such reports by pointing out whenever the band did have higher attendance numbers, "the Indy show was kick ass, great crowd. There had to be 15 or 16 thousand there. Rowdy as fuck!" Still, the truth about the impact of the slagging tour market in the summer of 2000 on Mötley Crüe's tour, among a variety of others, couldn't be completely denied. To that end, Nikki attempted to explain Anthrax's dismissal as part of an attempt to give the band's fans more showtime, "Anthrax wanted to play longer, and we kept getting fined…Our fans are pissed 'cause we're not playing long enough. We had to make a decision. It bummed them out, but the saddest people it bummed out was Mötley Crüe because we fought for Anthrax to be on that tour."

Dave Mustang countered Nikki's version of events with a much grimmer one of this own following the band's departure from the tour at the end of August, 2000, that "they cut Anthrax's pay completely and cut ours down by $5000 instead of sending home one of the extra trucks of bullshit and dancers. If they had sent home all that stuff and just played, all three of us would have been able to play. They told everyone about why Anthrax was not on the tour, and that we both were going to get more time and Megadeth did not get one second more. It was about the money. The tour was a losing venture and should have been shut down sooner. The only reason we even considered playing on that fucking disaster was

because our friends in Anthrax were on it. I would rather have my testicles eaten by Hannibal Lecter than tour with (Mötley) again."

As a mini-public relations war of wit insued, Nikki countered that "Dave has a way of distorting things to make himself seem so wise and on top of it. To be honest, if he was so on top of it why was his band only drawing 500 people a night on the tour??? We were the headliners, so why would se send home production so we could cheat our fans out of a less than over the top show??? Anthrax wasn't cut in pay, they were cut from the tour. Between them and Megadeth they weren't drawing flies (except when Dave opened his mouth and tried to be witty with his onstage banter.) I have much respect for all the guys, but Dave doesn't want to face the fact that this wasn't their show. I was the one who fought for both bands on the tour. I was told from the get go the package wasn't as strong as the headliner. Also, Dave didn't seem so eager to send the background singers home when he was trying to fuck them though, did he???" Amidst the quarreling, fans began to take sides, with Mötley Crüe's official website at one point chiding the band's own fans for contributing to the negative buzz, issuing a statement that explained that as a result of the negativity between camps, "the bulletin board on Megadeth.com has been shut down. This really isn't cool or funny. Maintaining these boards is hard enough as it is. When fans start attacking each others bulletin boards nothing positive can be accomplished. Fighting with Megadeth or Anthrax fans doesn't help anything. Take your energy and promote the record, call radio stations, get the word out that Mötley Crüe has a new album. Do it in a positive way & don't be negative with the this."

In the end, Nikki seemed satisfied with the course Mötley Crüe had charted and run with its new album and tour, "We had a kick ass summer tour. Thank you for letting me share my days, nights, loves and fights with you in my diary. You are the blood in my veins." Little did Nikki's fans know he was, in a way, saying goodbye. As the fall progressed and Nikki readjusted to being home, he experienced what appeared to be a mix of relief and apprehension at the adjustment from being in high-gear on the road to returning to a much calmer domestic existence as he awaited the arrival of his new baby with Donna, such that he described in his on-line diary that for the "first few days (back home) I was in a deep post-tour depression. It happens all the time, but I hadn't felt like this in a long time. I think the fact that we ran everyday into the next for months and months,

right into the tour, and then being plopped down into reality again is a shock to the system…Now that I've settled in, the flipside is how much love is waiting here for you. All the kisses and hugs from the children and Donna. I can't believe how Donna has held this house together, all alone while I've been off on my hi-jinx rock n roll adventures. And that's an award that needs to be given out."

Still, as the fall wore on, Nikki seemed to be successfully readjusting to life off the road, elaborating on the readjustment as a process in which "it took me a while to decompress, and (for) my body to understand that 9:15 didn't mean being onstage and breaking stuff. It meant the day is almost over. On the road, your days start at sundown and goes still sunrise. It's the exact opposite off the road." Aside from a brief Japanese tour planned for the end of November and beginning of December, 2000 just prior to the birth of his daughter, Nikki was spending time working with his songwriting partner James Michael on non-band related material, finalizing details on the release of his bands' long-awaited official biography, *The Dirt*, and trying his best to play the role of husband and father, "Donna is really, really pregnant. It's a magical time. We're not too happy about me leaving the family for the (Japanese tour), but it will be short." As the Japanese tour progressed, Nikki often expressed his desire to be home with his family, though he also seemed delighted at the Japanese fan response to the band, "the show was on fire tonight….I felt like breaking and destroying everything in sight…Now boredom nips in my heels. I'm not sure what to do. Do I wanted the streets in search of something/anything to break the boredom, or ingest a happy fizzy lil pill and wake up to a new day? We leave early for Iwate, then after the show travel to Tokyo, and leave that very am for the last show. 2 more shows."

Still, even as Nikki should have returned home to a domestic bliss with the coming holidays and birth of his new daughter, he expressed a troubling discomfort with his seemingly peaceful surroundings. Whether out of guilt in the face of the home Donna had made for him and his children and in light of his transgressions on the road the past summer that metaphorically spit in the face of that effort, or possibly because he stilled burned for something more in the way of closure on the future of Mötley Crüe, Nikki Sixx was a man in the midst of a deep personal turmoil in the winter of 2000. A sentiment he readily, and sometimes cynically expressed to fans in his on-line diary, "funny, I get e-mails telling me to

'cheer up', and things like that. Very Sweet, but I don't think a 'Band-Aid' is the answer to the question. Sometimes the infection is under the skin." Perhaps following the old line of logic 'too good to be true', Nikki seemed to be questioning his own place in the home he had worked so hard to create for himself, working purposely in ways to disrupt it in an attempt to seek out some truth he found forbidden to him, "I wouldn't call it depression or regression…whatever God has in store for me…Close your eyes and dream of a better tomorrow."

In other moments, Nikki experienced an inevitable happiness with the gifts he had in his life that he could not help but acknowledge, "We're giving a home birth, and we're all ready for our daughter to come (its magical around here)…Its funny how life changes. In fact, its become an expected rush." Nikki also celebrated his 42nd birthday in December of 2000, recounting that "Donna and the kids had some sweet gifts and cake for me…They all love me so much, I'm a lucky man…Why am I so friendly? Probably all the love I got from my family and friends, calls, e-mails, a big thank you to you…Got a nice e-mail from Tommy wishing me happy b-day…I just pounded off a bottle of red wine and an extra treat to fill out the evening." By the time Christmas rolled around, Nikki was in full-on regression, searching back through his own childhood, comparing the contrasts between the two times, and measuring the differences in terms of his own worthiness. It was a form of self-torture that he masked to fans and to his family as best he could, but the pain was still clearly there.

Among the only consolations for Nikki was in looking at what he had been able to provide for his own children, comparatively to what he had done without in his youth, and for Sixx personally, identifying isolated comparisons in terms of the mutual happiness that Christmas Day seemed to bring everyone in spite of their class differences, "I sit here in front of the fire. Its crackling and snapping takes me back. Back in time, when the magic was real, and not all smoke and mirrors. A time when there was a reason to get out of bed with the speed of excitement on Christmas morning, and a reason to hang onto the delirium that only comes at the end of a day filled with wide eyed thrills from a pocket knife left under the tree by a magical man…Thank God for children. They reinvent us in there hopes. When you see them peeking out their bedroom doors trying so

hard to get a quick glimpse of Ole Saint Nick. Its real…Its so real I look forward to it more every year."

Sadly, even in the blissful midst of the family holiday and his daughter's impending birth, Nikki's guilt had privately begun to rear its ugly head, as he would have plenty to confess to in the coming months. Mötley Crüe, for better or worse, had temporarily run its course by the Winter of 2000, and the time had clearly come for Nikki to put the band on the back burner as he began to sort out the mess that would quickly become his personal life, "I think it's going to take a serious, serious recharging of the batteries because we have been completely sucked dry by our own demise…Right now I have no intention of doing anything Mötley Crüe related musically at all." By shedding himself of the pressures of the band for an indefinite period as 2001 began, Nikki allowed some relief from the distraction the band had become toward dealing with the new problems that had arisen his personal life. As a result, the confessions soon began to pour in union with merciful tears that would ultimately cleanse Nikki of his sins and allow him the opportunity to save his family.

Chapter 20

Confessions

"And the truth shall set you free… Dear God, its me and I have a story to tell you, its not like you weren't watching me but this confession need not be so private." - Nikki Sixx, Rock and Roll Diary, June 16, 2001

In the early spring of 2001, Nikki Sixx suffered a mid-life crisis. Where most male egos would have exercised this cycle on a proportional level with the reality that surrounded them, i.e. gotten a pierced ear or traded in the station wagon for a Harley, the ego of a Rock Star naturally defines the aforementioned proportionality in terms that view any conventionalism as a restriction on artistic growth. The fact that that growth was rooted in a tolerated, and in many cases encouraged,

debauchery and complete celebratory excess meant that liberations like a tattoo or a motorcycle for the average domesticated male were already Mötley Crüe's norm. Their definition of rebellion was therein inflated to a completely new level- which for Nikki meant abandoning his responsibilities as a husband and father to act like a 21 year old Sunset Strip misfit with all the trimmings for a destructive period of six months, wherein he, by his own admission, would "move out of our home (two weeks after Donna gave birth)…starting a decent into drugs and drinking and hanging out with low lifes and sluts…while my true best friend laid at home with our new daughter recovering from a c-section alone." Elaborating on their separation in a February, 2001 online diary entry, Sixx shared with fans that "it is a sad day for me to tell you that me and my lovely wife have decided to take a break from our relationship for a while. I still consider her my best friend in the whole world and adore her and our children to death, but sometimes people need to take time away to grow. My dream for us is to have a happy healthy future and to watch our amazing children grow. This isn't the type of thing that is easy to go through in the public eye, we'll try to keep it to ourselves. Thanks for your love and support."

As Mötley Crüe's popularity had been built on defying all conventional norms, not just racing to the edge, but gunning clear over it, Nikki Sixx's life was in a state of complete free fall. For the first time in his life, he had lost control of everything that for years had defined his balance and center. Some of these losses were more deliberate than others, namely the self-imposed hiatus that Mötley Crüe had been put on by Nikki back in November, 2000, when he had concluded that "I've been driving Mötley hard for too many years. Its time to pull back and smell the roses in the garden, and smell the life in front of me. I'm heading into total burn out, so this break is needed, like a junkie needs a fix, I need a fix of nothing. A fix of silence."

The first signs of Nikki's imminent breakdown had come in the fall of 2000, following an incredibly high-pressure culmination of Mötley Crüe's summer ampetheatre tour, Maximum Rock 2000, with Megadeth and Anthrax in support, which had been mixed bag professionally for the band, as their album, New Tattoo, the first studio record in 20 years with drummer Tommy Lee, had by conventional commercial definitions, stiffed, selling just under 150,000 copies, despite a top 40 debut and high

profile promotional spots on Good Morning with Regis and The Tonight Show with Jay Leno, and a Pay Per View. Their concert attendance numbers, as with most of the rock tours that summer, had been up and down, but had averaged a solid 5000 per venue, enough to satisfy their promoter contracts, and ensure that the band could continue to book themselves into venues of such size on future tour outings.

Nevertheless, as Nikki himself acknowledged, the atmosphere for rock and roll was for the first time commercially uncertain following a three-year renaissance that had brought bands like Poison and Def Leppard out of hiatus and back onto the US ampetheatre concert circuit following on the heels of Mötley Crüe and Kiss in 1997, "this whole thing has been really interesting because we'll be somewhere and they'll go, 'Ozzfest was just through there and there was like 7,000 people,' and we'll be like 'Fuck, this is going to be a bad night.' Then we'll go in and there will be 18,000. Then we'll go in some city and hear that Ozzfest had like 26,000 and go, 'This is going to rock,' and there'll be like 4,000. It's hit and miss for all bands right now." For Mötley Crüe personally, their four-year climb back to the top had been a grueling journey that kept the band on an almost constant tour cycle while simultaneously burdening them with control of their master catalogue, which logistically made for a million more mini-headaches than the average rock band would be capable of handling.

Adding a third dimension to the mayhem, the personal lives of Tommy Lee, Vince Neil, and Nikki Sixx had all been a full-time, headline filled affair, from Tommy Lee's highly publicized prison-term for spousal abuse, to the tour-related arrests that marred Tommy and Nikki, and Vince Neil's bankruptcy obligations that the band was forced to take on as they had effectively put up the band's assets up as collateral against Vince's debts. All the while, the band had also to contend with a demanding release schedule under their pack with Beyond Records and distributor BMG. While the release of their catalog in 1999 via Mötley Records, as well as a Live Album and a Greatest Hits collection, had grossed the band $12 million in earnings, well more than they would have made staying with Elektra, the stress that accompanied that success was ever-present, and for Nikki Sixx in particular, a more defined burden as he was the keeper of the kingdom-under-construction's keys. On the road, away from his family, Nikki, throughout the summer of 2000 and fall of 2001, had struggled to reconcile what direction in his life was most important to follow at the

time, considering he was being pulled in several at once. The most important element of this inner-struggle was the fact that Nikki had always been a juggler, a multi-tasked ring-leader able and eager to take on the world from every direction at once.

Now, for the first time, the exhaustion of that role was beginning to take its collective toll, and Nikki's biggest challenge was becoming not whether he could or couldn't handle the roles he had played for years, but whether he wanted to. In many ways, it seemed Nikki had grown tired of being Nikki Sixx, and his restlessness for a distraction, in lue of a change of direction was becoming evident, no where more so than in his tour diary, where he wrote late one night on the road "sleep evades me. Always leaning into my head are new ideas and plans. Why can't I ever just be quiet? But I know silence won't comfort me. I'm still tossing and turning through this tragedy called life. Wasting time sleeping is like 'dying too young'…we all try, but some of us have to survive. So we're punished with restless anxiety, eager eyes darting as our greasy fingers run through out hair until it becomes matted with nervousness. I try to make sense of this non-sense, but its' useless. Sleep depravation? Masturbation? World Domination? Gimmie something to conquer."

In the meanwhile between figuring out what that new direction would be, Nikki got into trouble as patience could not compete with his restlessness for a more immediate remedy. This marked the beginning of his free fall, wherein he would take on an identity that made him appear a stranger to everyone who he loved most, beginning with wife and children. While he would maintain a surface of some normalcy, taking production jobs and servicing his children's birthdays with requisite dad-presence, Nikki's heart was no longer in the life had had for so many years longed and fought for. As he would remember months later, following the spring's mayhem, his restlessness had just been the periphery of something much deeper within the fabric of a man who had for years struggled to reconcile his own joy as a father and family man in the face of the absence of that very focal element of his own childhood, such that "last summer, I was on tour and under more stress than I ever (had) been in my life. Everything seemed to be on a hot button all of a sudden. The years and years of the pressure plate had finally built to a boiling point inside me…I had started to hide behind sleeping pills to mask my anxiety at night and was dabbling in drinking even though I knew it was wrong…something I don't do well and

have never done to Donna since our marriage five years ago…In coming to terms with my insanity, I needed to tell Donna of my wrong doings, and the Truth…Out of respect for her and my kids, I want her to be able to hold her head up with dignity rather than humiliation…I'm not speaking to you God but to my wife when I say I'm sorry and I regret every moment that I wasn't with you, I mean it from the core of my soul. I can't believe I did what I did to you. First I lost my dignity, then I took hers away, then I lost my family. Donna, I hope you are willing to forgive me and we can watch our kids grow up together as one…(as) I cheated on my wife with pigs and whores who weren't worthy of licking the bottom of her shoes…Of course, I came home a complete fucking wreck, detached, depressed, and unable to enjoy Donna's pregnancy, or be there as a father, friend or husband. So a time that should have been shrouded in celebration was veiled in confrontations and disappointments. We were at an all time low considering it should have been the happiest time of our lives…At this point…I become asshole of the year. After years of talking about having a baby together the wonderful day finally came, only to be a bittersweet entry into the world for our sweet little daughter. I finally lost all sanity and control of my mind, and I moved out of our home (two weeks after Donna gave birth). I can't understand this nor explain this, I can only regret this." In response to Nikki's confession- which he'd made publicly on the band's website via his online diary- she replied in kind with her feeling that "as far as Nikki's confession, I really don't have much to say. My heart is broke, and I guess I have a decision to make."

As Nikki's mess had spilled off the road and into his home life, in a transition where the potential for destruction was dangerously seamless, Nikki no longer had a stage to go out and vent on every night, nor an audience with which to share his aggression. Instead, he focused on being as solid a presence in his splintered family's life as possible, sharing in a mid-spring, 2001 diary entry that "I spent the day with Donna and all the kids. Frankie is so damn cute. You know that feeling, like you just want to squeeze them a little too hard? And Donna, she looks amazing. We miss each other, but we know its not our time right now…Donna and Frankie are amazing. I am so in love with my daughter. Me and Donna are spending time together working through our personnel stuff. She's awesome, she's the girl of my dreams." By Easter, things seemed to be improving on a personal front, with Nikki checking in via his online diary that "hey guys and gals…me and the Kids did the Easter egg hunt thang, and had a food

fight by the pool (Ice Cream and ready whip). Storm turned seven on Sunday so we had a little B-day party for her. Its odd doing it alone, but I'm trying to be present for everything while I'm off the road and giving my life some meaning besides work...I've sorta gone underground lately, haven't really been writing or working. It feels good to focus my heart on my kids and friends...I sometimes wonder how I kept going for so many years without a break...Its nice to step outta the limelight and the drama."

With the bright Southern California sun shining down on his dreary demeanor, Nikki began to see the light shining clarity down on him, such that as April turned into May, Nikki's too was experiencing a change of seasons, "I've been spending more and more time with Donna and the family and all I can say is...What the fuck was I thinking??? The pursuit of happiness is a wonderful journey, even when you stray from the path and find yourself lost up your own ass...I wanted to tell you all that me and my soul lover are going to make it work...We are head over heels in love and can't shake it...We got work to do, but...I can't wait to move back in and live in harmony...Frankie is cuter than ever, all the kids are excited about summer, and me and Donna are head over heels in love...Life is a battleground, you either live or die, but in the end, you live the life you lived rather than the fight you won...We choose life...What the hell was wrong with me??? I must have lost my mind...At some point, I came out of my haze of self pity, and saw what I had lost and the damage I had done. I had broken up my family, I had confused my kids."

In May, Donna accompanied Nikki to a promotional for the release of the band's official biography, referring in online postings to Nikki as "my husband", appearing by his side at every public appearance. As Sixx worked on repairing his marriage throughout the summer of 2001, he was clearly taking a protective tone where tabloid rumor was concerned, commenting in one diary entry to fans that "it was really uncool of E Online to report that I filed for divorce and am seeking custody of Donna and I's daughter. They are 100% in the wrong. First I Have not filed...The one that saddens me is that I would ever seek total custody of our daughter. Donna is the best mom on the planet...Has been to my kids and is to Rhy and Frankie...We will raise her together...Don't assume."

By the summer's end, Sixx and D'Errico seemed to have turned the corner toward a future together, with Nikki reporting excitedly to fans that

"I wanted to tell you all that me and my soul lover are gonna make it work. Nikki and Donna are meant to be together. We're head over heels in love and can't shake it. We're off on a vacation for the next few days. We got work to do but what the hell…This wonder woman that I married has taken me back on the understanding that we are soul mates. All my extra screwing around left me empty and longing for my lover…and left her feeling betrayed and with low self esteem. This is for her to see, you to see and us all to learn (from)…I'm so excited. I can't wait to move back in and live in harmony. (And Chaos.) What the hell was wrong with me??? I must a lost my mind. The whole family is X-static. NIKKI, DONNA, GUNNER, RHYAN, STORM, DECKER, AND FRANKIE-JEAN MARY SIXX."

Still, while their story had had a happy ending, Donna was remarkably candid in her own description of just how hard their recovery process had been on her, beginning with the revelation that Nikki had left her "when (Frankie Jean) was two weeks old- and I still had staples in my stomach and was hobbling around the house, he left, and this was probably the toughest thing that I've been through. It was really hard, very difficult, but on his own free will he volunteered to go into rehab. So I took him back…In fact I just got a tattoo, a Japanese symbol on my back that means to 'endure'. Nikki is a great guy, a great father, its been really tough. I'm glad he's back." Sixx, echoing Donna's "there once was a fuck from smell, who fell off his wagon one day. He fucked up his life and cheated on his wife with pig whore groupie sluts that would make a man gay…(So I've spent the summer) first (in) rehab, and now spending the first quality time with my family in years… Donna didn't deserve what I put her through. She's (the most) sweet, loving, wonderful (not to mention the fucking hottest) wife a man could ever ask for."

Nikki's personal peace would be rattled along with the greater world's in the wake of the World Trade Center tragedy on September 11, 2001, Nikki seemed in a better place with his public comments on the subject, answering as a father over many rock stars who took more loaded positions on the whole issue, trying to relate themselves commercially to the tragedy without staking out a position that held any real resonation with fans who were themselves looking for a perspective from which to view the tragedy. Nikki's point of view was grounded in his role as a parent, and surprisingly from his past political rhetoric, firmly in line with the sitting

administration, who would traditionally have been at odds with everything Mötley Crüe stood for ideologically, such that to Sixx, "it is something I never thought we would see on our shores. I never thought out children would have to ask the question they had to ask on that day. And I hope we find a higher road to dealing with this than we did with Pearl Harbor. Not for any reason other than killing more innocent people. I believe the attack on terrorism is the way to stop this action from happening again. I am 100% behind George Bush so far."

The fall of 2001, for Nikki professionally, marked its own unexpected transition as he, for the first time, began to branch out beyond the limitations of Mötley Crüe as a songwriter, realizing that the independence he sought was in fact available to him if he wanted it. It was a move that Nikki was in ways aching to make, but arguably not yet ready for without Mötley Crüe as a safety net. Nevertheless, he knew within himself that he needed to grow for the sake of basic artistic survival, whereafter the commercial translation was immediately huge, such that Nikki had to embrace the opportunity for its growth potential, artistically and spiritually, "I was asked to write a song for Santana's next album...Of course song writing is a huge passion of mine that is sometimes forgotten about. People listen to music to judge it, but we forget that the music being played needs to be written, it doesn't just happen. It's a craft, and one I like sharing with other artists. Of course Crüe's my love, and always will be, but this is a nice change for a while. In the next six months, I hope to write and produce a lot of music for others."

In the course of spreading his wings during this period as a songwriter and producer, wherein he spent his days "writing lots, (exploring) lots of production offers, I've also been working with JVC...James Michael (and I) finished a big epic song for Meat Loaf...Also on the producing side, I'll be going into the studio to produce one sing for an artist from England (on Columbia) called OVERSEER. He is very Fat Boy Slim or Prodigyish...I'm taking to MEEGS and DEZ from Coal Chamber into help make it a pissed off angry monster. Its..a blast for me to cut completely loose in this style of music...Monday is pre-production for Overseer, Tuesday, finishing a song...for Deanna Carter."

As the year approached its end, Nikki shared with fans via his online diary that "I'm sort of pretending I'm not in Mötley Crüe for a while, a

nice mental break from the 20 years of it…Mick…just turned 50. He's doing pretty well, but his condition comes and goes. It breaks my heart to see such a sweet person in so much pain…(I talked to Tommy) a couple of days ago- his father passed away…(I talked to Vince) yesterday, he wanted Tommy's number…(In terms of Vince's physical condition), I don't wonder what happened, I know, its called alcohol and age. We all get it. The only way is to die young or quit drinking. I did both… I have to cut myself free and reinvent my reason for being an artist. This is a magical time full of love and music for me…I'm going underground for sometime."

Chapter 21

Lessons in Letting Go

As the new millennium unfolded, Mötley Crüe, fresh off four almost-solid years of touring and recording, began their well-deserved two-year hiatus. Their legacy as hard rock's most durable bad boys had been secured through a consistent barrage of media moments and retrospective and celebratory documentaries of the band's decadent life and times, highlights of which included the release of the wildly popular VH1 Behind the Music, documenting among other notorious moments in the band's press catalog Tommy Lee's tumulus marriage to Pamela Anderson and Nikki Sixx's legendary and temporarily legal heroine overdose; and the release of the band's official biography, *The Dirt*, which went onto sell over 300,000 copies and become a NY Times Best Seller, and one of the best selling rock and roll biographies in history. For Nikki Sixx, the comeback had been a landmark, but privately also a realization that the band may have peaked. For a man whose whole life had been making Mötley Crüe the most notorious rock band in the world, Nikki Sixx felt it now time to take a step back and study the future above and beyond his achievements with the band, examining his legacy in terms of its broader place in hard rock's annals.

In this light, Nikki chose to use his break from Mötley Crüe as a time to utilize his role as a songwriter as a means by which to look outside of the Mötley box and toward the future. On a personal level, this largely self-elected break was dually designed to give Nikki an opportunity to watch his children grow up, as he and his briefly-estranged wife Donna D'Errico had reconciled in the summer of 2001, following a stint in rehab. In a diary entry in July, 2002, Nikki, in recalling the state of his life just a year prior as Mötley's comeback was winding down, reflected on coming full-circle within himself, both as a songwriter and as a family man, noting the balance that he had attained by devoting himself solely to his two greatest loves, recalling that "a year ago…How many can remember where they were exactly a year ago unless it was life changing? Well, I can…I was separated from my wife and kids. I was in the middle of the desert in a rehab…This year I get to wake up not in a dorm room full of kicking junkies' but in me and my wife's wedding bed…life is always within grasp if you can only see what you want. I saw and see what I wanted. I wanted my wife back in my life. She's withstood some pretty low blows and even on the web the bombs keep coming. You'd think that the innocent one would be spared. Fast-forward a year in the life…. It's our 1st 4th back together….I hope we can be a symbol of hope that no matter how bad it gets, there is always hope…I feel so alive musically this summer. Creativity comes when I detach from the drama …It feels so good to just be taking care of my world, and not anybody else's. .Just to clarify, I'm reflecting. Not projecting…its where I am, and where I've been…not really where I'm going. I'm tired of knowing the results. I want to leave a little up to chance. Right now I'm in automatic…I'm not grinding the gears, in fact I'm just right where I wanna be. I'm being a songwriter."

As time turns and turns, so too did the creative wheels in Nikki's mind. Most geniuses think in real time, and Sixx's constant thirst to explore life through song, using song as a reflection of life via Mötley Crüe, had by the end of the millennium, become something of a routine. With Mötley Crüe, Nikki had in reality developed a comfortable platform to exercise his lust for life imitating art and visa versa through song, such that it had become repetitious, even to Nikki. Facing the reality that without Tommy Lee, the band had commercially traveled on as far as it could, their 2000 release New Tattoo selling just under 200,000 in the States with Ozzy Osbourne drummer Randy Castillo behind the skins, Sixx was in dire need of a personal reinvigoration. He admitted as much in a diary entry to

fans concerning his rationale for such an extended break from the band, noting that he needed to burn again in a way that for the first time, Mötley Crüe could not offer him. While taking a risk with putting the band on ice, without the safety net of the Crüe's catalog and song formula, Nikki was in reality was forcing himself into a position where he had to grow as a writer, in effect expanding his palate to be conscious of a whole new generation of listening appetites.

As Sixx elaborated on his need for a break, "I'm going..to disconnect, and do some things in life that I never get to do. They'll recharge me in the way that when I come back, I will be…full of energy. Its very depleting (being on the road), its very wearing, and its abusive to the body, the soul, the mind. I wake up and my fingers are bloody. My arms are bruised. I'm stiff and I can't move because I abuse myself onstage…Its worth it because I love it, but its like anything else. Like a race car, you can only run it at 250 miles an hour around a track for so long before you have to stop off and get some fuel…(I can do) everything from family to simply decompressing and being able to write music not under a dark pressure cooker…I will make another 58 record. Its (representative of) such a freedom. Me and Dave just get together and bang it out. We had a lot of fun doing it, but I was telling my wife the other day, I can't wait to go home and be able to just go into my studio, and have her go 'Wow, that's really cool. Who are you writing that for?' Nobody! To (just) write music is sometimes the most fulfilling thing that can happen to an artist. To be able to go 'Ok, I'm writing the next Mötley record, or 58 record', that just sometimes depletes you. You sometimes just put so much into it, and sometimes just taking a drum loop or some crazy outbound gear and just going crazy and having no intention of anyone ever hearing it (is what you need.)"

The most important element of what Sixx viewed as his next creative evolution was to clarify to fans that it was not lost on Nikki that he had the opportunity to branch out as a songwriter because of the band's success- essentially that he had not forgotten his roots, and was in fact celebrating them by writing for a new generation of bands some of which had a shot at becoming rock and roll's next Mötley Crüe. Within his realization that he needed to move beyond what had become the natural limits of Mötley Crüe, Nikki was in essence beginning to move onto the next phase of his life as an artist, at peace with himself in a way he had been struggling to

reach for 20 years prior, "Yes I am a bass player (in Mötley Crüe). Yes I'm in a band, and yes, I'm a performer, but I've always thought myself a songwriter first, but sometimes that gets muddied being in a band…people forget. (Or worse, you do) But what feeds my soul is the vision and the follow through of a song, a melody and a lyric. Mötley Crüe has been a great vehicle for my songwriting. It's been a place to vent, but it seems in my desire to have down time from the band I forgot I needed a outlet for this madness that bubbles and boils, tugs and overflows in my head. My creativity (or insanity) needs a place to spill or I just die (or end up trying to kill myself). I'm in a new place now, but its funny, cause it smells, tastes and feels just like the old place. I'm in my creative zone again."

In truth, Nikki's evolution beyond the confines of Mötley Crüe as a songwriter had begun in 2000, when he had teamed with James Michael to compose the majority of the material from the band's 2000 release New Tattoo. As the two artists shared the same management and record label with fellow rocker Meat Loaf, soon, they found themselves expanding their partnership to include material developed commercially for other artists of a multitude of genres to record. For Nikki, writing with Michael for the New Tattoo record had been an ideal test run for what would become his primary occupation during Mötley Crüe's two-year hiatus. As Michael described his partnership with Sixx, it was definitely an attraction of opposites that added up to make a perfect songwriting partnership capable of reaching out stylistically to all ends of the musical songscape, "Nikki and I musically come from very different backgrounds. But lyrically, we are both pretty twisted. And I think that working with him enabled me musically to explore things that I wouldn't have if I was just writing songs for myself. And I think also, given my background in rock music, it provided me an outlet to write some heavier material." Nikki began his songwriting expansion process by using the type of musical style he had spent 20 years crafting through Mötley Crüe, straight hard rock, as point zero, therein allowing him to expanded a song at a time to eventually include lighter material of the sort James Michael recorded, principally pop rock, "I enjoy writing with James so much. We click on music and concepts so quick. It just flows…He's one of the most talented guys I've worked…I really click with him…Were on a songwriting binge again…(and) it looks like we might be producing some acts as well.(together and separate)"

As they began thereafter what would go on to become a wildly-successful songwriting collaboration, James Michael explained that through working with Nikki, "I think that my process of deciding which songs to collaborate on and which to keep to myself has changed over time. I have, I used to be very possessive and very selfish over songs, and it was very rare for me to reach out, or let somebody else even have a stab at it. But I think working with Nikki, we got together, and within that month, we wrote most of that record- *New Tattoo*. I think what that did was that opened up my eyes to the fact that if you let go of some of that selfishness, and you share with somebody, immediately your productivity is just gonna go through the roof. Also, when Nikki and I first sat down to write, that first day we were writing, he was like 'Hey, I just want you to know that when I enter the room to write with somebody, it doesn't matter if I write only one lick, and you write the rest of it, or if I write the whole thing, and you write just one little bit- we split it 50/50.' And it was just a good thing to establish. I always said this about Nikki, for as chaotic as his mind is- in a wonderful way- and I mean that as a huge compliment. For as crazy and twisted as his mind is, he's a very thorough, organized business man. And that's always impressed me. And it happens time and time again, that the people who are most successful at what they do, there is that common thing- they have learned how to harness the beast. His catalog of creations is going to be a wonderful retirement for him. Nikki and I musically come from very different backgrounds. But lyrically, we are both pretty twisted. And I think that working with him enabled me musically to explore things that I wouldn't have if I was just writing songs for myself. And I think also, given my background in rock music, it provided me an outlet to write some heavier material. The two biggest things I've took from my work with Nikki is, from a business standpoint- it is really such a cliche- but if you want something done, you've got to do it yourself, so make sure you have your ass covered. And from a creative standpoint, its learn to let go."

Throughout 2002, as Vince Neil was out touring endlessly as a solo act to continue his quest to escape a Bankruptcy filing from 1995, cranking out Mötley Crüe classics night after night on package tours with other 80s-era Mötley derivatives including Tesla, Poison, and Skid Row, Nikki remained in Los Angeles, earning a living principally as a songwriter for other artists. As Nikki himself recalled the evolution post-New Tattoo, both with James Michael and subsequently with other songwriters, he was in effect reconciling his past in terms of his future, establishing a continuity

between the two that allowed his talent to remain fluid and progressive, drawing from a well of creativity that ran 40 million records deep and a generation wide, and traveled an entire nation of musical styles, "I've had the opportunity to write with a lot of new writers lately and am continuing down that road…What a journey…There is so much talent out there to learn from…As a writer, I mostly write pop songs. Mötley played them heavy, but anybody can do them in there own style…Ive been writing alot of different styles of music…. The world is open to good songs, they always transcend styles…Next month I'll being going to Nashville to write, and will also be in Florida and Atlanta as well. I'm starting a weekly writer jam season here at my studio in LA…I am recapturing the fire that shook me up as a teenager, the desire to just do it only for doing it." While Nikki may have been writing to feed his own soul, his talent was naturally branching out to include a variety of new, more commercial styles of music which naturally implied a new listening audience. In that spirit, he viewed the songs he wrote for other artists as "just like my baby, but someday it grows up independently, I make songs but they grow up without me. I'm content when a song lives a long time and when people like a song we make."

Beyond his own on-line diary to fans, the media was beginning to take note as well, as the list of artists who were either expressing interest in having Nikki write for them, or who were in fact purchasing his songs became famous enough to include the likes of Faith Hill, Santana, the Backstreet Boys, Meat Loaf, and younger and heavier hard rock groups including Drowning Pool, Overseer, Saliva, and Tantric. Nikki's ego was naturally drawn to the attention, but the gratification he clearly felt from being able to make a living and continue a commercial presence in the music industry without having to rely on Mötley Crüe clearly and equally fueled him. As he explained to MTV during a Q&A session on his transition into a songwriter-for-hire, Nikki used the opportunity to further distance himself from the limitations of the hair-band label that Mötley Crüe had fought so hard over the second half of the 1990s to shed, attacking the pigeon-holing by addressing the bottom line of any longevity in the record business, the quality of the music, "I just think a great song is a great song… so there's no use to just saying, 'I am a rock and roll songwriter.' I'm a songwriter, and if I look back on Mötley Crüe's career, I've written everything from punk rock to power pop to boogie rock to beautiful ballads…When you write with and for somebody else, you write

(something) and then it's gone. Your baby's gone and you have no control of whether it ends up on the record, if it even gets recorded, or if it gets recorded the way you might have envisioned it. It's a lesson in letting go."

By letting go of Mötley Crüe for a while, Nikki was in effect opening the doors to work with a whole new generation of hard rock bands who had grown up on Mötley Crüe, and specifically, Nikki Sixx's songwriting and style. In essence, he would become something of a father figure to the next wave of Mötley Crüe offspring, and he would help to curdle them along in the most influential of ways, through their songwriting. It was an important and appropriate role for Sixx, but also an acknowledgement by the millennium's multi-platinum role models of rebellion of Mötley Crüe's place in their roots and evolution, and above all else's, of Nikki's. Not surprisingly, many of the millennium's fastest rising hard rock and metal acts lined up at the chance to become students of Sixx's tutelage, and Nikki was happy to pass on his knowledge and experience both as a songwriter and producer, as the collaboration of rock and roll generations both fed his creative soul and kept him current and in the spotlight. If nothing else, the interest on the part of the newer generation of hard rockers was an acknowledgement or sorts of Sixx's status as the mad scientist of LA hard rock. As Butch Walker of the Marvelous 3 explained when asked about his working relationship with Nikki Sixx and the underlying motive to his interest, "he's like my bigger brother that I never had. At least, that's how I feel. I found out he dug the marv3 and freaked out, cuz you know, I have a scrapbook of Nikki from when I was 8th grade. He was everything I wanted to be. "

Dez, the lead singer for Coal Chamber, shared Walker's sentiments, remarking that "everybody knows that I grew up on Nikki. He's one of my idols. He's a smart guy, a real smart cookie. He's been through it all. Now we've gotten to befriend each other. He's gotten to know my personality and I've gotten to know him. He's just a really smart, caring, really down to earth, cool guy. I couldn't say enough about Nikki." The Crüe's fan base could have chosen to view Nikki's decision to focus his energies on writing and producing music with new acts in place of Mötley during the band's hiatus as a sell out to the traditional hard rock fan base the Crüe's was now composed of, almost approaching the classic rock genre. With Mötley Crüe however, because the majority of new bands Nikki was writing and producing had a sound that was a direct derivative of the Crüe's, due

largely to the fact that most of these bands' members grew up as part of the aforementioned fan base, Nikki was instead creating a new creative channel through which to keep in touch with his fans.

In settling into his routine as a songwriter-for-hire, Nikki chose to build a home studio and work from a more relaxed atmosphere than that of the conventional $1000.00-a-day commercial recording studio. He had begun this routine two years earlier in 1999 when he and wife Donna D'Errico had moved from Los Angeles to an opulent, 2000-acre ranch in Agoura Hills, which Nikki described at the time as "a great place for the kids to grow up…We're a new generation family…We moved here because of the school district, and because its away from Los Angeles and close to the beach." In addition, Nikki chose the property in an effort to fulfill his life-long dream of building a state-of-the-art recording studio complex where new bands he was developing through his label at the time, Americoma Records, could live and work on new music. With the subsequent demise of Americoma Records in the fall of 2001 due to a lack of corporate funding and the failure of Laidlaw's debut record, Nikki's plans were scaled back to reflect a more realistic scenario wherein his focus had turned from developing new artists personally to strictly writing and producing one-off tracks for them, leaning his priorities more in a creative direction and away from that of the business end of developing new acts, which had only served to get in the way. In reality, Nikki had taken on too much at one time when in late 2000 when he was attempting to write, record, and mount Mötley Crüe's first full on tour without Tommy Lee or a major label behind the band, run a start-up in Americoma Records while managing two acts, FlashBastard and Laidlaw, and participate in a clothing line, Outlaw Clothing, with wife Donna D'Errico, as well as be a husband and father to four existing children and a new baby on the way.

He admitted as much in the summer of 2001 when he made the decision to put not only Mötley Crüe, but also Americoma Records (a lifelong dream), on a 2 year hiatus and focus solely on his own creative growth, and the task of repairing his marriage with Donna, "I've decided to put Mötley and Americoma on the backburner, (the label) till I can only do a record label…We found the trust factor high with the Artist but the ability to reach the audience without corporate funding (lacking). We plan on moving to a major in the next few months and relaunching…I've had many gifts in this life, many I owe directly to (the fans) for following me on

my path of music. Every dollar I've ever made or spent came directly in one way or another from music. I have given you the gift of Mötley Crüe and rock n roll in my interpretation, and (now) you've given me the freedom to continue on and have a wonderful life. You've touched my family in your support and I want to thank you for that." Sadly, it sounded almost like Nikki was saying goodbye to Mötley Crüe, at least for a while. Fortunately, Nikki followed up in a later diary entry to fans confirming that gift from fans in time off would produce fruits for eager ears in the coming future, wherein Nikki planned "next year…to give you some great music. Thank you for allowing me that gift."

In the course of reprioritizing, Nikki's decision to set up his studio from home turned out to be the best career decision he had made in recent years. As he described it, the coupling of his family and his music created the perfect artistic synergy, allowing him to balance both evenly for the first time since his five year marriage to Donna, "(our) home is a very creative place…The studio has its own special vibe…I like the idea of not having to go anywhere. I get a hundred times more done here at my house. I can come downstairs in the middle of the night, or I can be sitting here fucking around on my guitar when I'll get a great idea, and then I can throw a loop and put it down real quick. After that, I can just move on with my day. There are some very odd times songs have been written in this house…It can happen at 7 in the morning when I'm up getting the kids off to school, and then there are other times inspiration will hit early in the morning after I've been up all night. It goes either way."

The key to Nikki's successful interplay between domestic responsibilities and professional pursuits during this period laid principally with his wife, Donna, who acted not only as a super-mom to their five children, but also as the most supportive personal partner Nikki had ever had in his corner. Where Mötley Crüe had grand musical and financial interests motivating their bond over the course of the 1980s and 1990s, Nikki had largely avoided dealing with his personal life until his marriage to Brandi Brandt, which had ended disastrously between the two. With Donna, Nikki had found the perfect partner with whom to share in the family life he had never himself had, and so desperately craved. As Donna herself revealed in an interview with Entertainment Tonight following Nikki's stint in rehab in the summer of 2001 and return to his family, the principle catalyst in uniting Nikki and Donna was their newborn daughter,

Frankie Jean, "Apparently Nikki was doing some things he shouldn't have been doing…He's been very remorseful, and making amends, and I'm getting into Al-Anon, so things are looking up… Nikki is a great guy, a great father. I'm glad he's back."

Donna's willingness to forgive Nikki and take him back into the couple's home and life clearly provided Sixx with the appropriate faculties (foundation, inspiration and motivation) required to take hold of his domestic reigns, establish a routine that worked in terms of his responsibilities as a father and husband, and enter his first real period of peace as a family man and artist. All of the aforementioned began with a deep remorse and subsequent appreciation for his soul mate and partner in life, Donna D'Errico, "can I take a moment to tell you about my love for my better half? She's the sweetest lady I've ever met. The greatest mom, the most loving wife and smart as hell to boot…I'm deeper in love with her than I ever was in our five years together. There is truth in the words 'You don't know what you've got till its gone.' When happiness is staring you right in the face, how could one not see it? I guess God has a way of teaching us through our own mistakes." Nikki's playing the full-time family man role also gave him the opportunity to get behind his wife's professional pursuits, a favor he was both proud and enthusiastically happy to return, "Donna is opening a huge health spa, and she's hard at work on the design and development of it. She's the shining example of health and survival in this big bad world. I can't wait for the opening. This place is going to be like nothing you've ever seen before…The spa will be called DK RENU."

The Sixx's home life during this period was surprisingly orderly and regimented in contrast to the chaotic disarray of the past 15 years of Nikki's life. In reality, Nikki was experiencing his first real period as a full-time father of five, and upon examination, the Sixx's home life was really no different than that of the average millennium family, with two career-oriented divorcee partners, each bringing children, all school age, (implying the standard addition in responsibilities) from previous relationships to the table, along with their respective personal issues. As wife Donna described a large part of their routine, trafficking their children from one event to another "living out in (Agoura Hills), its at least 45 minutes to get anywhere…And that's a lot of time (the kids sit) in the car. It gets boring for them, they get cranky, so…we put a video game system and DVD (in the suburban), so the kids can have their own headphones so

you don't have to hear it…and they either watch a movie or play videogames.. Everybody's happy. No one's compromising, and no one is arguing in back. Some people might say 'Well, isn't that like an electronic-babysitter thing?' But you know what? They don't do it at home. They aren't allowed to watch TV or play video games from Monday through Friday, except in the car, and only with permission. So its not like they're constantly doing it 24/7 at home and it just carries over into the car…(Also)…Nikki and I are also (also) able to start a conversation…(and) finish it without getting interrupted."

Part of what seemed to make Nikki and Donna work so well together on a basic level was their natural compatibility, and in addition to a natural appreciation and support for one another's continued professional ambitions, they shared in a mutual desire to establish and maintain a stable family life for their five children. As Nikki described the magic of all of the aforementioned ingredients working together to create a home life he had dreamed of with Mötley Crüe fans for over two decades via songs of decadence, like Public Enemy # 1, and introspection and longing, captured through ballads like Rodeo and Home Sweet Home, for the first time in his life, it was clear that he was comfortable and at peace out of the spotlight, off stage, basking not in the glow of his celebrity, but of his family life. For Nikki where at 23 he needed the adoration of thousands of fans, the bottom line at 43 was that the love of his family was adulation enough, "Life seems to have a silver lining I haven't seen in years today. I'm looking at a picture of all the kids in a pumpkin patch that Donna…It warms my heart to see their smiles and to know my wife and family are together. Where we live there is fog laying over the Santa Monica mountains this morning. Its keeping it cooler than it should be and its fine by us. We live in a 200 acre basin that we call 'The Magic Valley.' This is where we can be normal and undisturbed. This is where we laugh and make fun of how life is on the outside. This is where Donna cooks her fabulous meals and we sit around the table and tell gory stories of the day. We laugh a lot around here. This is a funny house. If you were a fly on the wall, you'd think this was a sitcom." Ironically, by this point, Nikki seemed too to have made peace with his ex-wife and the mother of his first three children, Brandi Brandt, who ironically lived only a short distance from Nikki, and shared custody with his children in a week-on, week-off arrangement, which he described as a simple on in which "they live with me and Donna for seven days, then

their mom's for seven days (one mile away). They just come over whenever they want too. Its very relaxed."

While Nikki had successfully settled into a stable home life during this period, his creative fires still burned wild as he sought to control them in the most honed and productive fashion. While continuing to work with new artists, he also could not lead a life completely void of Mötley Crüe, as the band's official biography had sold upward of three hundred thousand copies in the United States, and was now being licensed overseas and developed into a major motion picture, such that "the book is doing so well that we're now having meetings with major movie companies and directors about making the book into a movie. Pretty wild doing these huge meetings with the companies and finding out they're all Crüe heads." To tame what could have become an overwhelming plate during this seemingly calm period in Nikki's life, he stuck close to the routines of writing and his family, the two constants which had quelled his the potential for the straying that had almost cost him his family in 2000 and early 2001.

It seemed in a way bittersweet attention, as Nikki had originally sought the band's hiatus as a break from dealing with the inevitably busy demands Mötley Crüe still invited, seeming in a way to surprise even Nikki in that he found it "amazing how much is going on with the band. I really thought we could disappear for a few years. At least we're not touring or recording. I've been writing a lot of killer up-tempo heavy metal and rock n roll. Writing with James Michael a lot too. I really click with him. He asked me to write a few tunes on his next album, that will be fun. The home is (peacefully)…quiet today. Donna's sleeping next to Frankie, and all the kids are immersed in cartoons and video games (they're not allowed to watch TV or play video games Sunday night through Friday afternoons)." In the end of the day, Nikki was happiest just to have the down time to appreciate the beauty embedded within the simplicity of his family life, comparatively to the recklessly chaotic machinery of the twenty years prior.

In reflecting, Nikki seemed to have come full circle, almost cynically, in fully appreciating the role that his fans' adoration as a young rock star had played in compensating what he had been without as a child in the way of loved. In the same time, he also could now recognize the double-edged nature of the love he received from fans, laying principally in its inherent decadence, wherein Nikki had been encouraged to run wild in the potentially lethal indulgences that fueled both the rebellion of his music while simultaneously fueling his band's record sales, with a deliberately

blurred line being toed to separate what was too much from what was enough, and therein creating an avenue for an uncontrollable and dangerously harmful excess that no one who truly cared for Nikki would have ever intentionally encouraged. Ultimately, he recognized that the opportunity for the love of a genuine family that his recklessness had almost cost him was not worth it in the end. That he had almost blown that chance twice with his Maximum Rock tour indulgences, including an affair with temporary Hole drummer Samantha Maloney and his slip briefly back into his heroine habit, sobered Nikki in a way he had not before experienced.

For the first time, he seemed to display not only a guilt, but also a perspective on what he could have lost, and the impact that the blow would have ultimately had on him, "Sitting here, the billowing smoke around me is making my halo slightly dingy looking. Like I give a fuck after all the drugs I've done over the last 25 years… They say (I do at least) expectations are premeditated on resentments. So I'll just shut my eyes and swallow and not hope for the best. Maybe it will be better coming up than going down. Maybe its ok, to just be ok…Oh god, how did this turn into a life lesson. I guess cause its all a life lesson. Its to quiet to make noise and too noisy to just sit here quietly." Looking back further during this period in a manner that was almost poetically mocking, Nikki continued his reflection, remarking candidly that "if you were me, you would have blown your head off. Its something I'll never forgive myself for …I feel blessed that I am still able to have her in my life."

Through a coupling of genuine remorse and subsequent reconciliation of the darkest and most destructive demons within himself, Nikki was now able to outwardly project a positive perspective and resolve toward moving forward in life with his own family. Where for years, Sixx had indulged a natural inclination toward rebellion against anything that had resembled or represented a healthy and happy family, through both his songs and his decadent personal actions based on an inherent insecurity over ever achieving that balance for himself, Nikki now had the experience of real peace within his own family to combat what he had in the past viewed as a threat to the walls he had built up around the memories of a painful childhood. Whether he had built those walls to cage his most painful memories, or to protect his inner child from their haunting in later life, Nikki, at 43, seemed to have finally woken from the nightmare of his past

and embraced a new life of love and happiness with Donna and their children, filled with a happy medium of both professional and personal gratification and reward.

In describing the aforementioned balance in a diary entry in the spring of 2002, Nikki told of "A perfect day (where he) Woke up at 6:30 AM, went to Starbucks. 7 AM, went around corner to a morning A.A. meeting. 8 AM, met Donna and took the kiddies to school. 9 AM, came home, did a little business and an interview. 11 AM, went to the studio and wrote a song *pretty good day to be alive*. 3 P.M., got a massage. 6:00 P.M., left for the "Fashion for Freedom" Event with Donna. 8 P.M. – 12 P.M., hung out with Donna while she did press and walked the runway in cool threads and over a million dollars in jewels. Watched a very drunk Rod Stewart 'when asked by the press', would you take a picture with Nikki Sixx, say 'Ok, where is she?' Haha…Then he stumbled off into a bush..Wow! 1 A.M., sat in Burger King parking lot with wife, both dressed to the nines ((still wearing the jewelry)), and ate cheeseburgers and smoking cigarettes. 2 A.M., feel into a deep sleep….A perfect day, , wouldn't you say?"

Chapter 22

2002

Nikki Sixx began 2002 by ending his ability to produce children with a vasectomy, quipping in his online diary to fans that "this old bird dog…Finally took it in the chops…well not exactly the chops…but there was chopping involved ((not cocaine you sicko's))…Ah the glory of

yesterday fades me into the pasture…nothing but a porch and a tail to wag for this old dog…that's right…My rightful owner..The master of the house so to speak had this dog fixed…That's right…The nutz… Now Im shooting blanks…I know I can still do the dirty…But we won't have to put the dirty lil ba&*%*rd through college…I must confess: when that needle went in,I saw god…and of course god saw me….saw me whine like a bitch that is..,but you get your nutz in a vise by a chop happy doc, and lets see you do it gracefully….I think NOT. I can't wait to try out the new shooter…..word has it…You get to be a better aim when you ain't worried about whether or not you hit the target…Whats that mean?? Hell, if I know..just sounded good…Now I gotta go do the vasectomy shuffle to the studio."

In the studio, Nikki was busy working on a variety of projects, seeming to be at a bit of an impasse on which of those to focus most fully on in his new *almost* Motley-free existence, revealing in a Feb. 2nd Diary entry that "practicing patience is something I've never been good at, but in learning the trade of sitting on my hands, I'm seeing thing starting to work themselves out. In a few weeks, I'll need to make a decision on what I'll do for the next few months. Its good to know the Crue is in hibernation for at least 9 more months, so I can let that monster recharge under the bed. Even when the Crue sleeps, it seems to eat up lots of my energy and time. We have the movie deal in the works, the paperback coming in April and a DVD Greatest Hits coming this summer. Or course, none of this happens without hundreds of phone calls and meetings and God Damn emails. Not exactly what I call making music, so I feel the need to set into action what it is I do. Play bass God damnit… Today was a good start, I played bass on some of Butch Walker's solo album- fucking great songwriter…I'm going back Monday to do some more tracking, and Butch thinks he's getting a great deal, cause all I want is coffee, cigarettes, and to laugh a lot. I think its me that's really getting the most outta it. It just feels good to play rock n' roll…So I've been talking to the guys a lot. Talked to Vinnie, he's going to Europe to jam, talked to Tommy (he's playing me his new record Sat.), talked to Randy Castillo (he's got a new band with Mike Inez), talked to Mick Mars (He's just chillin' with his strat)…Donna breaks new ground on her spa (D K Renu) tomorrow. How fucking cool is that?"

By this time, Nikki was excited on his own front about a new band he was quietly putting together with L.A. Guns founder Tracii Guns, who

explained that "the Brides of Destruction (originally named Cockstar) came to be after a conversation I had with Taime on the way to Vegas to do a Pussycat gig. I told Taime about an idea I had for a band called DEVIL. Taime, Tracii, Nikki and some spooky drummer we would have to find. Taime said he would get a hold of Nikki for me and, he never did. So anyway when I get an idea I won't stop till I get an answer. I was on tour and I was drunk and I was talking to Cherie Kress our webmaster for the LA GUNS site. I told her my idea and she said she would run it by Nikki. I didnt think I would get a reply since I also thought Nikki didn't dig me but, the next day she e-mailed me: 'Nikki would love to talk to you.' So I...wrote him a quick note. It said, 'Hey dude. Let's start a band.' He wrote me right back and goes, 'OK.' Holy shit. Now what?...We just did e-mail for a few days...and I guess he liked what I was saying...so we started talking on the phone. He was already in the process of trying to put a new band together. His manager at the time used to be my manager and now he's our manager. He really wanted us to do a 'supergroup' thing. Me and Nikki decided to just make the best band we can...We talked about all sorts of players. He was already kinda trying to put a super group together and I wanted to just put a great band together. So we compromised and figured that we were kinda super enough so now we needed to find someone young and freaky who was into old school metal but, who was also not stuck there, and obviously had to be able to really sing and not be intimidated by fronting a band with guys like Nikki and me."

For his own part, Sixx recalled of the new musical union that, prior to hooking up with Guns, "Slash and I are friends and we had talked. We'd considered doing this project together, but he had a different vision for what he wanted to do. He really wanted to work with Duff, Izzy and Matt, and that's very comfortable to him. That's important. So, that didn't happen with us, but then Brides of Destruction happened, obviously, with Tracii and I think it's good. I kind of like to think that it's a real healthy competitiveness...I've known Tracii for a long time and hung out with him and stuff but we'd never played together before...I've always been a fan of Tracii's. Loved L.A. Guns. He really willed this band to happen...I got an e-mail from Tracii Guns; it just said, 'I wanna rock!' He basically forced me to get in the band with him. Anyhow, that is the birth of Brides of Destruction. A fan gave us the name. We are a...living, breathing machine." The formation of the band brought Nikki and former Crue singer John Corabi back together, with Corabi recalling the true genesis of

the band as being born "during the summer of 2001, when I was on tour at the time with Ratt, and we were doing this package thing- Ratt, Dokken, Warrant, Firehouse, and L.A. Guns. So I was basically talking to Tracii every day, and we'd been rapping about life and he'd told me he was thinking about putting this thing together with Nikki. So somewhere in the middle of our tour, Tracii had a chance to come home, and he and Nikki recorded this track, a cover of an old Sweet tune. So when he came back out on the road, he played it for me, and was like 'Man, this came out really good. We might get another guitar player. I even talked to Nikki, and we think you'd be perfect for this thing, it'd be great. You can sing, you can play guitar', all this other kind of shit. So near the end of the tour, Nikki calls me and says, 'Hey, I've been talking with Tracii, and he really wants you to check this thing out.' And Nikki was making some jokes, like 'Yeah, fuck dude, apparently we're stuck with each other- *Till Death Do Us Part.*' Because back in Motley we'd both gotten the same tattoo on our leg. So he was making jokes, really light-hearted stuff, and he left it at 'When you get back to L.A., we'll jam.' So I said, 'Alright.' "

Unlike the way things had worked out with Motley, with B.O.D., Sixx initially felt "John was a shoe-in because his style and vocal ability was totally congruent with the sound. John and Tracii compliment each other very well." In rounding out the band's initial line-up, lead guitarist Tracii Guns explained that "Adam Hamilton turned me onto London. I first saw pictures and thought, 'Man, this is the biggest rock freak I had ever seen, can he sing?' Yes. The guy can sing anything from Mary Had a little lamb to AXL to Phil Anselmo (doesn't mean he will sing like either of them). So we did a demo of *'No You Don't'* by SWEET and the guy is just natural as hell, so we decided on London. Crab was the natural choice for the other guitarist because he can also sing and looks like a serial killer. Kris Kohls was our first choice for drummer because he looked the part, played the part and he's a funny motherfucker...I knew Kris Kohls from Adema. He's been my friend for the past ten years. We've always wanted to be in a serious band together. I called him and he was into it. Nikki went and saw him play with Adema on Ozzfest that summer. Nikki called me and said, 'Yep! That's our guy. He's funny. He's a great drummer. He looks like us. Cool, he's in.' We had a band and I couldn't get off tour fast enough. I was thinking, 'C'mon hurry! Let's go!' After the tour, we all got the studio together. Went in, rehearsed the first three days and sounded like ass! It sucked so bad! Nobody was saying anything! We were just uncomfortable

and it was really weird. It eventually started coming together…So anyway that's how the band got together. YOU CAN BLAME IT ON CHERIE FOR MAKING IT A REALITY."

Once Sixx and Guns had settled on the band's line-up, rhythm guitarist John Corabi next recalled that "when I got home, we went into Klown Studios, more or less rehearsing material to record. Nikki and Tracii wanted to get together at Klown Studios every day at like 3 in the afternoon to rehearse, and there were other days when the singer, London, could only come in at night to play, so it was kind of a set schedule. So I went in, pretty much learned their first batch of four songs, which included *I Got A Gun, Revolution, You'll Only Get So Far*, and another one. So I started jamming along, and kind of coming up with lots of weird little guitar parts, stuff like that, and Nikki was like 'That's cool Crab! It's a hook.' Like I came up with this part for *I Got a Gun*, this little pulsing thing, and right there at that point, it started to get weird. Nikki made a fuss over that guitar part, Stevo- our producer, was making a fuss, and Kovac was there that day, Nikki's manager, and he was buzzing about it. I think it was just emblematic of their excitement over what I guess they thought I brought to the band."

Once the band's line-up had been rounded out and rehearsals had begun, Tracii Guns recalled feeling a bit star-struck, admitting he was "a little bit in awe that we were doing this. I didn't sit and take it for granted. I was like, 'Wow, man!' I'd seen MÖTLEY CRÜE when I was like 16 at The Troubadour in L.A. and it made me reinvent my guitar playing. Because at that point I had pretty much already went through all VAN HALEN and Randy Rhoads and I was only playing punk rock, it was just like I didn't care anymore. And then I saw them. And I was like, 'Oh my fucking god, that's the way to do it. You mix it all together.' So for him to actually say yeah, let's do it, you know, it kind of scared the shit out of me. Be careful what you wish for." Of the band's aforementioned punk-roots, Sixx commented that "Tracii Guns and I have punk roots and are metal heads, so those roots are showing. We've been described as punk metal, high energy rock," while singer London further added that "I'd say from our past influences and we draw from one another."

As well as Sixx's personal and musical endeavors were going at this point, as March ended, tragedy struck the entire Motley- and broader rock-

world when Sixx reported via his online diary on 3/27 a "sad, sad day. Last night, Randy Castillo (former drummer for Lita Ford, Ozzy Ozbourne, and Motley Crue) died from complications of cancer. Randy was recently hospitalized with the flu, and it was more than his body could take while also fighting cancer. He was a sweet and funny man, always had a smile on his face, and was loved by his fans and fellow musicians alike. He will be surely missed from this planet, and I'm sure he is rocking the halls of Heaven with the great musicians that preceded him. My heart felt sympathies go out to his family, girlfriend, friends, and fans. God bless you Rrrrrrrrrandy, we will miss you." Ozzy Osbourne further commented of the loss that "I am heartbroken about the passing of one of my dearest friends…I will see you on the other side, Randy. I love you."

As the spring neared its end, Sixx updated fans via a late May online diary entry of his goings-on, beginning with a philosophical musing on "the problem with instant gratification, is it takes to long, but as the road narrows I learn to experience the bends and curves as much as I used to only enjoy the step inclines and hard drop offs sometimes the purr of a automatic beats the push and pull of a 5 speed…I know some of you are thinking, oh no, not another soapbox attack from a demented rock star hiding behind a computer somewhere in cyberhell (i.e. see * the wizard of oz*). But just to clarify I'm reflecting, not projecting…Its where I am, and where I've been…not really where I'm going. I'm tired of knowing the results. I want to leave a little up to chance. Right now I'm in automatic, I'm not grinding the gears. In fact I'm just right where I wanna be. I'm being a songwriter… Yes I am a bass player, yes I'm in a band, and yes, I'm a performer… but I've always thought myself a songwriter first. But sometimes that gets muddied being in a band… people forget. (Or worse, you do)…But what feeds my soul is the vision and the follow through of a song, a melody and a lyric. Motley Crue has been a great vehicle for my songwriting (as well as some of the other guys)…It's been a place to vent, but it seems in my desire to have down time from the band I forgot I needed a outlet for this madness that bubbles and boils, tugs and overflows in my head…My creativity (or insanity) needs a place to spill or I just die (or end up trying to kill myself)…I'm in a new place now, but its funny, cause it smells, tastes and feels just like the old place. I'm in my creative zone again…I've had the opportunity to write with a lot of new writers lately and am continuing down that road…what a journey…. there is so much talent out there to learn from…As a writer, I mostly write pop

songs…Motley played them heavy, but anybody can do them, in there own style I've been writing…A lot of different styles of music…the world is open to good songs. They always transcend styles…As an example, rumor has it Tim McGraw may be interested in cutting home sweet home. Next month ill being going to Nashville to write, and will also be in Fla. and Atlanta as well. I'm starting a weekly writer jam season here at my studio in L.A. I am recapturing the fire that shook me up as a teenager…the desire to just do it only for doing it." Sadly, in late June, Nikki experienced another pair of personal tragedies when he reported via his online diary that "my deepest sympathies go out to the friends, families, and fans of Robbin Crosby (Ratt) and Dee Dee Ramone (The Ramones), who both passed away this week. You will both be missed."

As the summer of 2002 wore on, re B.O.D., Sixx finally decided to give fans "a little bit of news. For the Rumor mill: Yes I'm thinking of starting a new band…cause its doesn't look like Tommy, Vince, Nikki and Mars are gonna be on stage anytime too soon together…NO, this is not the demise of Motley Crue…The boxset is being finalized…. At the moment it's called (((addicted))) and the packaging is a huge pill bottle. Its pretty bad ass…were trying to not have a boxset that's in a box, imagine that…Ha. I feel so alive musically this summer. Creativity comes when I detach from the drama…It feels so good to just be taking care of my world, and not anybody else's. I'm finally building a rehearsal / writing studio on our ranch. That should be the start of some great jam sessions and songwriting…I can't wait…Marshall stacks on 10..…Yeah right in the backyard.…Been hanging with Mars a lot…He's doing much better…its grossly exaggerated how ill he is. For gods sake, its like people have always predicted our deaths…can't we just die when its our time?"

On a personal note, Sixx shared with fans over a reflective July 4th diary entry that "a year ago: how many can remember where they were exactly a year ago unless it was life changing? Well, I can. I was separated from my wife and kids. I was in the middle of the desert in a rehab. This year I get to wake up not in a dorm room full of kicking junkies' but in me and my wife's wedding bed. Life is always within grasp if you can only see what you want. I saw and see what I wanted. I wanted my wife back in my life. She's withstood some pretty low blows and even on the web the bombs keep coming. You'd think that the innocent one would be spared. Fast-forward a year in the life.… It's our 1^{st} 4th back together. I hope we

can be a symbol of hope that no matter how bad it gets, there is always hope. I love you Donna, with all my heart and soul. Happy 4th."

Heading into August, Nikki took a break from rehearsals with the Brides, announcing via his on-line diary that "(Donna, I and the kids are) all in Kona on our family summer vacation (a lot like the Chevy Chase 'Vacation' movies). We're off to see the Lava flow with the kids, seems like a once in a lifetime opportunity for us to do together. Gone to Maui quite a few times, but this place is by far my fav of the two so far. After this, I go to Chicago to the Tattoo the Earth events (I'm a part owner), and then home for two days. Then we're off to Georgia for a wedding and then I'm off to Oakland for another Tattoo the Earth event. Looking forward to getting back to L.A. to start on a new music project. Life is good, thank you, Donna the bona in Kona, N. Sixx."

As the band continued to rehearse throughout the summer, with Nikki clearly believing 100% in the project's potential, with Corabi recalling that "originally, Tracii was like 'Okay, Allen Kovack, along with Nikki, are going to finance and fund this whole thing, so money's gonna be no problem. They're gonna put everybody on salary, and when we get a record deal, they'll recoup.' So after I was in the band like a month, and hadn't seen a dime yet, Nikki went to Allen, and was like 'Hey Allen, these guys need some money.' And Allen was like 'What the fuck do you want me to do about it?' So Nikki ended up paying everyone out of his own pocket."

On September 2nd, Nikki was ready to formally out the band to fans, announcing via his online diary that "I've been up to all good. As always I'm into many different projects. One that I'm involved with is the "Tattoo the earth" festivals. We did two this summer as well as another coming in Oct. Another is a co- partnership with dragonfly clothing. we just unveiled to the buyers at the magic show in Vegas my line, its called **NSIXX** and it's the cool dragonfly-styled button up shirt but it will have my tattoos as the basis for the artwork. Again more on that later…Been knee deep in getting all the T's crossed and I's dotted with Paramount Pictures and MTV Films for the Motley Crue movie. If all goes well there will be a farewell tour, and amazing soundtrack and a movie all hitting in late 2003- early 2004. My new (band's)… been finishing demos at my house until Tracii and Kris return from tour. I'd say it's a cross

between Shout-era Crue, first GnR, Soungarden and Jane's Addiction. Damn does this band cook...London is one of the best singers I've ever heard...Imagine if Ian Gillian and old school Axl had a baby...it would come out sounding kinda like London. I can't believe that's his name...I mean come on, they say God has a sense of humor, but gimmie a break. Donna's spa was set back a bit due to construction. Its mind-blowing to see her setting this place up. She's so on it. The transition from actress to business owner and back again is a bit weird I'm sure, but she's and entrepreneur and she does it with grace///she seems to kick ass in anything she does...Donna and I went to Ozzfest on sat and hung with everybody. Great to see to Tommy up there doing his thing...he was fucking good.. His band is awesome...Me and Donna had a killer time..What a day (AND NIGHT)... I started boxing again and training. I foresee some local live shows coming up in a few months for the new band...Gotta pop that cherry someplace..,might as well do it in our own backyard. Wanna come? All in all, life is just about perfect...Sixx"

Guitarist John Corabi further recalled of the band's goings-on during the fall of 2002 that "we had a couple of shows scheduled, so we played Ventura Theatre, then the House of Blues in Anaheim. And people were digging the band in general." Meanwhile, on a creative front, guitarist Tracii Guns reported to fans via his own online blog that "I have been writing and recording everyday on...new songs for my new band...Nikki and London have been writing on the weekends, and their songs sound great...The new stuff is pretty heavy with lots of energy and London is simply amazing. His voice over our music just doesn't sound typical (HE'S AMAZING)...Adam will be playing guitar, keyboards and weird sounds in the band. So between jammin' with L.A. GUNS and writing for COCKSTAR, I have been playing guitar at least 4 or 5 hours a day so. My playing is at its best game for the moment, so I am happy...Today COCKSTAR hit the rehearsal room...Who ever said Nikki can't play the bass is insane. Kris and Nikki sound like a steam engine running through an Indy 500 track at 1000 horsepower (JUST MONSTEROUS). We worked on a couple of new songs and faked our way through some CRUE stuff, basically a day of...playing together. Crab came in for a bit and Jammed with us, of course it sounded great cause John is a great guitar player...All in All I think we are off to a good start...now if Sixx will stop reading the Advocate during practice, everything will be great, GUNS, On the relentless hunt for Real Rock and Roll."

Reciprocating the love, Sixx in a diary entry of his own from the end of September updated fans on the personal and professional fact that "I feel like I'm on a creative high at the moment...and feeling is living.... isn't it? Now I know I like to let you in on details way in advance sometimes, and there have been those who say too close too. Of course I see the problem with sharing in advance in such public places as our message boards. The naysayers just want to find something to complain or point out... ((Like if the bass player of the band you like is playing and writing with another band, then his band must be OVER))...it always amuses me...these same people existed 25 year ago in my life...and 20 and 15...and 10 and 5 years ago too...If someone doubting my ability to pull something off was a... Ah fuck it, I love those assholes... Anyway...Donna is wonderful (we just celebrated meeting 6 years ago)) we've been thru heaven and hell together...it feels like we've grown closer due to a certain persons addiction, were so head over heels in love and it just gets stronger everyday. Nothing ever could separate us, we've become one. Kids are awesome. I'll post some pictures soon...I got the funniest pictures of Frankie posing on my Harley. Anyway, like any parent (even cockstars) we tend to gush on and on about our kids. As far a rehearsals go, I feel the same kind of magic I felt when Motley first reh in 1981. Last week we wrote and put together 6 new songs. Its really flowing easy...I'm jazzed about Kris Kohls drumming. I hope not to take anything away from him by saying this, but he plays and hits a bit like Tommy used too. We're locking up really good. I feel like we've been in a band before... Weird eh?? Tracii Guns is never short on riffs and ideas...I'm blown away by him and his positive energy...I've always been a fan, but I guess I wasn't paying too close attention. This little bastard burns...damn.... Up next in the sixslinger position has been Mr. John Corabi...nothing but sheer cool on rhythm gtr...ideas for days...Voice from hell and fills in nicely with smoking cigarettes and relentless sarcasm. I love the dueling guitars and double lead vocal ability of this BAND...And by the way, there are no singers from L.A. that I've found who scream like London (our bands singer). He's from South Carolina...And he's a fucking monster...We will start recording six new songs next week. Were not sure of the destination yet. We've had two major offers already but were a bit gun shy of major labels. This is so pure; it would have to be the right company to win us over. HERES THE FIRST 6 COCKSTAR TUNES TO ROLL OFF THE FLOOR: 1. *I GOT A GUN, 2.YOU'LL ONLY GET SO FAR, 3.DOGS OF HOLLYWOOD, 4.SET THE FIRE, 5.SMELL A REVOLUTION, 6.NATURAL*

BORN KILLERS, AND LINE-UP: LONDON-VOCALS, TRACII GUNS-LEAD GUITARS-VOX, KRIS KOHLS-DRUMS, NIKKI-SIXX BASS-VOX, and JOHN CORABI-GUITAR-VOX."

Advancing quickly with his new band as the fall progressed, in early October Nikki checked in with fans via his online diary to report that "we had to change the band name...too many outlets((radio etc. etc..)) were very uncomfortable with the name...we didn't want any roadblocks to the music....So...name change. MOTORDOG We will be done in the studio in a few days...ill get some music on the web soon." By October 23rd, Nikki checked back in from the band's official website to report that their band's final and official "name is Brides of Destruction...I came up with Cockstar. Some of our radio associates were like, 'You are on drugs dude. We are not playing a song by Cockstar.' Hence, BOD...The Brides....Whichever you want to call us :) We will finish up 2 more songs this week...so far mixed and finished are: IVE GOT A GUN & NATURAL BORN KILLERS." Nikki further chimed in for his own part that "on the motley front...things are quiet for now....micks getting together some musicans to start jamming with too. I'm so #$*%@ excited about the new band, I cant believe I have two killer guitarist and two singers. I mean most bands don't even have one. Feeling snotty like a new bride should."

By early November, due to scheduling conflicts, the band had to replace Adema drummer Kris Kohls with Scott Coogan, with Nikki beginning by explaining that "Kris came in at first, and we really liked Kris. He was the original drummer, and Tracii introduced us to Kris and brought him in. We thought he was a really good fit. Unfortunately, or fortunately however you want to look at it, he, like me and Tracii, was in another band. His band was getting ready to ramp up and start doing stuff, not like us, with Mötley being completely off and Tracii in kind of a limbo position with L.A. Guns. So, he had to go back and start working. We had just gotten started working, so we needed another drummer. Fortunately, or unfortunately, who knows, because then we met Scott Coogan." Tracii Guns further added that "Kris left. He had to go record an album with Adema. Stevo Bruno, who produced our record, also owns the rehearsal studio and the recording studio where we recorded the album. He said he had the drummer for us. Again, we were like, 'Whatever. Everybody's got our guy.' It was Scot. Steve dragged me down to see Scott play in his band which is like a Zeppelin-Beatles-Cream cover band. Scotty actually played

drums and was the lead singer. As soon as I walked in and saw that guy I was like, 'Oh my god!' We stole him. He didn't show up for his first day of rehearsals so we knew he really was a rock star! His first day! We cursed his name all afternoon on that Monday and he showed up Tuesday…Scott Coogan is absolutely the best drummer LA has to offer, and we lucked out because he is also funny as hell." With their new drummer intact, Nikki reported his creative fires as burning even higher, so much so that "I can't sleep, ears are still ringing, melodies running thru my head. We rehearsed all week, got to know Scott as a drummer. Next week is all about more songs. We will start taking meetings with labels now. At the end of the week we meet up with some producers…We're burning it up in rehearsal. We have 14 songs we're working…and the gel is setting in, something is happening."

That happening would turn out to be the band's debut public performance, which Nikki announced in a December 2nd online diary entry "we confirmed we're gonna do our first show this Saturday. We will be playing with Mudvayne and Taproot at the Ventura Theatre. We will also be at the House of Blues on the 18th in Anihiem. I guess its about time to lose our virginity." When highlighting his favorite musical aspects of his new band, Nikki, beginning with Tracii Guns, shared that "that little guy is a shredder. He is amazing… I didn't know how good he was, better than people probably even think. He shreds on the record a lot. I could say anything to the guy. The other day I said 'At this part of the song I want you to write the longest riff you can write but it has to be cool, like as cool as *The Ocean* by Led Zeppelin' and he goes 'Like this?' and just keeps going and going and the rest of us just go, 'YEAH!!' It's crazy! This band is unique in a lot of ways. We have a drummer who is a lead singer. We have a rhythm guitar player named John Corabi who is a lead singer and I have a lead singer in London LeGrand. He is basically a basket case. He is an incredible talent. He is a rock star and he doesn't even know he is a rock star. You have Traci and me as well. I don't see any limits. We can do anything." Tracii added of the band's musical strengths that "the Brides I feel have a unique sound because we blend a lot of old school guitar solos with different kinds of heavier modern riffs and London has the ability to be in one song and then go… go from a sweet ballad type of voice to a New York street vender type of scat to a middle eastern trippy kinda vibe (he is very hip)… I think you bring that raw Crue/Guns kinda attitude and mix it up with new stuff and you have the Brides." Following the gig, Nikki

shared with fans that "we didn't play anything from the first demo…We've progressed on and those songs don't really fit as well with the new ones. We played: *Hellraiser's Ball, I Don't Care, Right Before You Crack, Brace Yourself, Shout at the Devil* and *Livewire*. Thanks, we had a F'n blast."

Chapter 23

"I get to watch my kids grow up, to be with my wife and do some things that I haven't gotten to do in a long time- forever actually."- Nikki Sixx, 2003

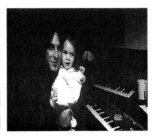

2003

Fans seemed excited that Nikki Sixx had rung in the new year with wedding bells, having decided to make the walk down the proverbial aisle one more time with former Crue bandmate John Corabi and founding Guns N' Roses member Tracii Guns, also lead guitarist for L.A. Guns, taking news of the Brides of Destruction officialy public in early 2003. Recalling the twist of fate by which he and Sixx had been once again reunited after such an acrimonious divorce 6 years earlier, BOD rhythm guitarist John Corabi recalled that "when we'd first spoke about it, Nikki was making some jokes, like 'Yeah, fuck dude, apparently we're stuck with each other- *Till Death Do Us Part*.' Because back in Motley we'd both gotten

the same tattoo on our leg." While the band had been writing and demoing at Klown studios throughout the latter half of 2002, on the 8th of January, the band kicked off the new year by tracking six new songs, including *I Don't Care, Brace Yourself, Life, Crash, Going Out,* and *Shut The F@ck Up.* While Nikki's musical focus was clearly centered away from Motley Crue, within that world, the band- via their various management channels- had collectively agreed upon XXX director Rich Wilkes as scribe for the film adaption of their 2001 best-selling autobiography, The Dirt. On the 16th, Nikki attended the Hard Rock Vault's grand opening in Orlando, Florida, appearing along other rock superstars including AC/DC singer Brian Johnson, former Guns N' Roses members Duff McKagan and Slash, Pantera's Dimebag Darrell and Vinnie Paul, Twisted Sister's Dee Snider, Zakk Wylde, and Disturbed.

Sadly, amid all the positives in Nikki's life, tragedy struck when stepson Rhyan D'Errico's biological father died of a heart attack, prompting Nikki and Donna to report on Sixx's online diary that "last Tuesday, Donna and I received a very sad phone call. Rhyan's (Donna's son) father was found dead from a heart attack. How does one go about telling your child your Dad is dead. I've been raising Rhy as my son (and he is to me) for 7 years, but there is no bond stronger than that of your dad. I always respected that and to see that shattered is heartbreaking for Donna and myself. We just returned from the viewing. To see a 9-year-old boy standing there by the casket in his tennis shoes crying is an image that will be hard to shake. I thought if any of you wanted to post anything nice we would let him read it. He needs to hear nice things right now. God bless. And thank you. Nikki and Donna." Sixx dealt with his sadness by diving headlong back into work at Klown Studios on the Brides of Destruction album, where the band's new lead singer London LeGrand began laying lead vocals over the band's 8 demos. In explaining why he picked an unknown singer to front the band, Sixx summed LeGrand up as "our little secret weapon! He's from South Carolina and he was working here in Los Angeles as a hair stylist. He's a 25 year old, new school/old school, I don't know, he's a trip. He's a rock star and doesn't even know it. He's awesome! To me, he has a lot of the same thought processes as Mick Mars. When we were kids, someone said, 'Hey Mick, what's your favorite color?' and he goes, 'Clear!' and I was like, 'WOW! Why didn't I think of that?' Mick's mind is different than anybody else's, and London has that kind of weird mind. When we're writing music, he does something and I'm like, 'What

the fuck? Where did he come up with that?' It's amazing to me, it's baffling."

Elaborating on LeGrand's entry into the band, lead guitarist Tracii Guns recalled that "we couldn't think of anybody. The day before I left on tour, Adam Hamilton - who plays bass with LA Guns now - he gave me a picture of this guy London. He said this guy was our guy. I saw the picture and said, 'There is no way this guy can sing! He looks too cool.' You know, the two never equate with each other. You can't have a guy that looks amazing and can sing in this day and age. Especially with guys that are kinda jaded, like me and Nikki. My girlfriend made me email Nikki the picture of London. I did. He thought he looked great but had the same opinion. 'This guy looks too cool. He probably can't sing.' I told him I had to go on tour. I was on tour and a couple of weeks later London called me on my cell phone and said, 'Dude! Do you want to hear me sing or what?' I did. That was the first time I had ever talked to him! He started wailing over the phone! He was playing an acoustic guitar, screaming, doing all this weird indian shit with his voice. This guy is not just a good singer, he's an extraordinary singer. I called Nikki right away and hooked them up. By the time I was on my first break from the tour they had written a couple of tunes together. When I got home we all got together at my house. Adam was playing drums, although he's the bass player for LA Guns. We did a demo at my house. London was in. That was it. Damn! We had a great singer." Elaborating further on the discovery of London, Sixx fully credited Guns with finding the band's "singer, London, who is a hairdresser. I wasn't sold, but Tracii's smart; he had the guy learn 'Set me Free' by the Sweet and got me to come over, and I see this guy who's larger than life. He looks like a rock star, then he starts to sing. I think, I've never had this before."

Even as Nikki and Co. focused on wrapping their demo throughout the month of January, Crue business continued to intrude. Some was positive, with Chronological Cure reporting that "following the demise of Beyond Records, Mötley Crüe signed a deal with Universal Music Enterprises to re-release all of their albums with bonus tracks on April 1. The band is to receive about $5 million in advances against a royalty rate of around twenty five percent. A new greatest hits album is also being prepared for a March 4 release, followed by DVD releases of Lewd, Crüed & Tattooed and VH1 Behind the Music: Mötley Crüe the following month.

A greatest hits style video collection is planned for later in the year, as well as a career-spanning box set for the holiday season." On the negative front where the band was concerned, the long-rumored chances for a full-scale Crue reunion seemed even further diminished as the dischord between drummer Tommy Lee and singer Vince Neil seemed to have reached an all time high, with Lee commenting publicly on his website that Neil, via his participation in the VH1 Surreal Life reality show, had "sunk to an all-time low…dragging (down) what's left of a once-great band…(as) Rock stars don't do talent shows." Ironic given Tommy would star in several network reality series- including the reality show RockStar: Supernova on NBC- in the years to come, for the moment, dark clouds continued to hang over Motleyland. The clouds cleared a little for the band as the month ended, in real time with the confidential settlement of a lawsuit brought a year earlier by legendary record producer Tom Werman against the band and their label, Beyond Records, regarding royalties from the Crue catalog re-issue. At Sixx's direction, the lawsuit had been quietly resolved with a number that made Werman "very happy."

Heading into February with his focus squarely on the Brides of Destruction, Sixx updated fans via his online diary of his various goings-on, reporting that "we just finished the last set of songs. We went in with 6, came out with 5 done, plus the 4 from before. We have 3 that just need a little work to finish as well. Scott played drums to the older songs replacing Kris Kohl's drums so it all sounds like its from the same band/sessions. Tracii and I are working with Shaun to get the Brides site up soon. Probably just have a few pages to get started, but at least we can put some of the new tunes up for you to preview. We're in the final stage of deciding on which producer will handle the album duties. More on that when we decide." Where Motley was concerned, Sixx elaborated on the band's re-issues deal with Universal, reporting to fans that "someof you know we signed a deal with Universal to distribute our catalog. There won't be anything in the way of asking old fans to purchase these since we've already released them with bonus tracks. We will try to make them as cool as possible for future Crueheads of course. I'm excited about releasing the DVD Greatest Hits. Those videos are classic and I think a lot of newer fans have a hard time seeing them. Mick's doing great, we see each other often. He says 'Hey,' not a lot to talk about in the land of Crue. I'm really focused on the Brides' music and deals. The other exciting thing for me is the NSIXX clothing line- we have 16 Men's and 16 Women's

items, some are available, some will be ready to show at Magic in Vegas this month. It's a work in progress. A lot of (new) ideas in my life which keeps me creative. I will express my disappointment with Vans for using me in their print campaign without my consent. But, that's what lawyers are for… Enjoy what you have. NSIXX."

During that same month, Sixx received news that Jackass star Johnnie Knoxville had auditioned to play the legendary bassist in the big-screen adaption of The Dirt, with Sixx commenting after the pair's initial meeting that "I felt pretty comfortable thinking about him doing it after I walked outside from the meeting at Paramount and he was peeing on the tire of some executive. He has the right attitude." Heading into the middle of the month, Nikki turned his attention to his latest clothing line launch, N. Sixx, reporting to fans via a Feb. 15th diary entry that "me and Donna are off to Vegas for the magic show Monday evening. Were unveiling the NSIXX line at the Dragonfly booth all week. Were showing both the men's and woman's line. I'm really excited about the quality of the clothes. I'll be there, so stop by and ill sign something for you. It will be the usual magic shenanigans and business dinners every night and ill be doing TV and radio everyday to promote the line. Somewhere in the middle me and Donna will hopefully get away to play (with each other). The brides are doing a photo shoot for the website Monday at around noon and ill be on KTLA Monday AM."

Still, in spite of how well things appeared to be progressing for BOD, the aforementioned photo shoot would not feature rhythm guitarist John Corabi, who shocked fans by announcing in mid-February he had departed the band. Naturally, the band sought to put a positive spin on Corabi's departure, with Sixx recalling that, back in the fall of 2002 when the band was initially forming, "we got together with John Corabi, playing rhythm, and a drummer named Scot Coogan, who, as far as I'm concerned, is one of the best drummers: Tommy Lee, Taylor Hawkins, and then there is Scot Coogan. I felt like I was home again… John was kind of coming down to rehearsals. We were just kind of feeling it out. You know, what happened was that the first set of songs that we wrote were just us kind of getting to know each other. Some of the songs on the record like 'Natural Born Killer' and 'Revolution' are kind of a more pop flavor with a little punk and metal thrown in there. Then as the band started to get to know each other, then we became more metal and punk with a pop overtone. In other words, it

was backwards. I think that John, being a singer and a songwriter in his own right, kind of was like, 'You know, I'm not sure where this is going. This isn't really where I'm coming from.' I think the first set of songs was about where he was coming from…As we progressed, it got punkier. We started writing songs like 'I Don't Care' and 'Shut the Fuck Up,' and John didn't get it…I think he was just striving to be his own musician too. He kind of wanted to do his own thing. He kind of organically kind of came in, and then he just kind of came out. He never really officially came in. It's kind of like a really nice splinter. We've known him for so long, and we really were just kind of jamming…John wanted to focus on his solo stuff. He's a great singer and songwriter."

Elaborating further on the band's official explanation of Corabi's departure, lead guitarist Tracii Guns explained that, as the group's sound evolved, "all of a sudden, we just got really aggressive, I think…We were rehearsing for a couple of months and writing and changing drummers. Me and Nikki always knew where we wanted to go, and everyone around us just had to kind of be patient. All of a sudden, about two months in, I brought in music for stuff like 'I Don't Care' and 'Shut The Fuck Up'. Nikki was like, 'Yeah, yeah, yeah, yeah, yeah. Let's do it.' Those aren't the only heavy songs we wrote. We wrote all these songs in a period of time. John…he's like a classic Zeppelin rock guy. He likes the really heavy stuff, but it's not really his cup of tea. He just bowed out and said, 'You know guys, this is your thing. Go rock!' " Sixx's online diary post was equally as diplomatic, with the bassist reporting to fans that "as you've heard, Mr. Corabi has left the building. We're all the greatest of friends and there is nothing but respect and love for each other. We each have our own journey and as long as we don't end up in Journey. Well, you get the idea. I really wanted a second guitarist, but I guess I'm doomed to playing only with one guitarist. Can't really complain about Mick Mars or Tracii Guns, except they're both short, haha. We've reh up a bunch of new tunes."

From Corabi's vantage point, his departure from BOD had a far different- not quite as harmonious- tone to it. As the rhythm guitarist recalled, the differences he had with BOD were not so much between he and the band's musical direction, but rather between he and Guns, such that "I just felt like, at the time, Tracii was maybe intimidated by me or something. Because, for instance, we'd be in rehearsal writing, and Nikki would look at me and say 'Hey crab, come up with a cool guitar part for

this.' And Tracii would go 'Naw I got it.' Or I would go 'Hey Nikki, check out this riff.' And he'd go, 'Aw yeah, that's cool, that's cool Crab!' And Tracii would jump in and say something like 'Yeah, but I don't think it fits.' This time, I didn't feel like I was going head to head with Nikki, rather I felt like there was some kind of weird competition going on between Tracii and I. And apparently, quite a few people I've worked with have said 'Tracii's like that, its got to be his vision, his input.' So I'm like 'Okay.' I like Tracii personally, I think he's a great dude, but I couldn't be in a band with him because I have to be creatively involved. I'm not going to be happy playing a guitar part that someone else tells me to play in an original situation. Its different with Ratt because that's a money gig, but this was just out of hand. So as the spring went on, we continued writing, and it got weird because this uncomfortable dynamic began developing between me and Tracii where Nikki would defer to me a lot on coming up with cool little parts for the songs, which Tracii just did not dig. So after a while, I guess Tracii bitched about it enough to Nikki like 'This is my band', or whatever, that Nikki started calling on me less for that. So I was annoyed at the fact that they were starting to cut me out of the writing, both creatively, but also because it affected my potential publishing cut. So that kind of pissed me off."

According to Corabi, the final "straw that broke the camel's back for me was when we went to have a meeting with Bob Rock to get his input on our demo. Prior to the meeting, we had finished up our second batch of four or five songs, and Tracii had more to do with those songs than the previous four we'd all written together. I guess he wanted the material to be heavier, like *Shut the Fuck Up, Two Times Dead*, and so on. So after we finished that demo, which I still played on, Tracii was like 'Fuck yeah, fuck yeah, this is heavier, this is where is should be, this is how it should be! This shit is kicking ass, we're gonna kick so much ass, we're gonna be huge!' He was really walking around with an inflated rooster chest. So I went along with the program, but for my own taste, wasn't sure if it was right. I wasn't sure the songs were as good as they could be. So we were starting to get some press, and Nikki kept saying 'Bob wants to do the record, Bob wants to do the record.' So Nikki and Kovac set up this meeting with Bob Rock, and ahead of time, we sent him a copy of the demo, I think there were 7 or 8 songs on it, and he lived with it for a couple days. So the day of the meeting, we went to this Hotel in Beverly Hills, and it was a Sunday morning sometime in the later Spring of 2002.

So we go down, the whole band, have breakfast with Bob, and afterward, Bob's like 'Come on up to my room, and let's critique this fucker.' Which is in typical Bob Rock fashion."

Continuing, Corabi recalled that "we get upstairs, and Bob critiqued, and was very honest, and he liked certain parts of the music, but there were other parts he felt were contrived. He kind of looked at me and Nikki at one point, and said 'Look, I've worked with you two guys, and I know you guys can do better. I know it. I know you can do better lyrics, better this and better that.' And the whole situation just started to rub me the wrong way at that point because Tracii all of a sudden jumped up and said 'See, I told you guys, I told you guys,' trying to suck up to Bob. So I just sat there thinking to myself, 'Wait a minute. You've been walking around for fucking 3 weeks like a rooster, now you're telling me that all these criticisms that Bob has about the record you're in full agreement with. Even Nikki, in talking with him since, has admitted 'Yeah, that was a little weird on Tracii's part.' I felt like he'd sandbagged us. Also, I can't see anybody getting into a room with Bob Rock and not being a little in awe of the guy. He has a very intimidating presence about him. Even Nikki, to this day I think is still in awe of Bob Rock, because Bob's one of the few guys who can actually stare at Nikki and tell him what to change about a song without Nikki wanting to bite back and rip his head off. Nikki really respects Bob's opinion, so I think there was a little intimidation there on everybody's part, but Tracii was engaging in all-out ass kissing. Like every suggestion Bob made, Tracii was all over it like it was his own. It annoyed me in a big way because most of the negative comments Bob had were for the songs Tracii had insisted on writing himself, and denying me input on. So I took Bob's comments as part of the band, but he really wasn't telling me I could do better, he was telling Tracii in essence. So Bob wrapped the meeting up by giving us some suggestions on the demo, saying 'Okay, I think you guys should do this, take this song in this direction, that song in that direction, get a little nastier with the lyrics.' So we listened to what he had to say, and from that meeting I took away that Bob had listened to the stuff and it hadn't really knocked him out. So in the end, he passed on the whole thing. So that was on a Sunday, and I think later in the week, we all got together, chewed on what Bob had had to say, processed it, and all left rehearsal."

In detailing his version of how he was dismissed from BOD, Corabi concluded by recalling that "a day or so later, I got a call from Nikki, and he was like 'Hey Crab, how ya doing buddy. Listen, here's the deal, apparently- I don't know why- but Tracii doesn't really feel that comfortable writing the way that we're writing.' So I paused for a second, then responded, 'What do you mean?' And Nikki continues, 'Well, the whole get-into-a-room-and-jam idea, Tracii doesn't dig that. So what we're going to do is, Tracii's gonna write the riffs, bring them to me, and he and I will get them all worked out, then work them up with Scotti (the drummer), and once we get the songs all done and written, we'll bring you and London in.' So I can't lie and say I was totally shell-shocked at that, but my reply was "Okay, well I have a two part answer for you: A.) If that's what it takes to be a team player, okay, fine. If that's what's required here. B.) You know what Nikki, I'm sick of this, I'm pissed about it.' And he goes, 'What do you mean?' And I go, 'Look dude, I know I can write, I know I can write with you. I think Tracii's got his britches on a little too tight, and I'm not fucking buying this. I want to be creative too. I ain't digging this whole fucking vibe.' So then I went on, and was just honest about my reaction to Tracii at the meeting with Bob, and said 'Look, I did not appreciate the fact that after walking around like a rooster for three weeks, Tracii just sat the meeting and cowered at everything Bob Rock said. Now, you're telling me that I can't write. Tracii doesn't feel comfortable with that, but who the fuck is Tracii Guns? I'm not digging this, I'm sorry, just for the record, I'm laying it out there.' So he goes, 'No, that's cool. We're just gonna try it.' So I sat and thought about it, and it wasn't just bothering me, it was pissing me off. So I just decided, if I can't write, and be a part of this creatively, I'm not getting anything out of it at all, not to mention the publishing aspect given how little money I'd been seeing up to that point. So literally, maybe two days later, when I'd pretty much decided to leave the band, I was picking up the phone to call Tracii and it rang, and it was fate because it was Tracii on the other line. So he goes 'Hey Crab, listen, you're probably going to hate me for the rest of your life for this phone call…' And I stopped him, and I go 'Well dude, if you're gonna tell me what I think you're gonna tell me, I'm not gonna hate you at all. Because in all honesty, I was just walking to the phone to call and tell you guys that I'm thinking about leaving.' And I think it was a big relief off his shoulders, because no one likes to make that kind of a call. So we tried to keep it upbeat, and they wanted me to fill out this press statement that said we were parting on good terms, and I agreed, and

Tracii goes 'Nikki and I decided we're gonna give you some money, so you don't feel like you're leaving totally empty handed.' So I took the cash, and enrolled in truck driving school so I could have something to do when Ratt wasn't on the road to support my kid. The only thing that pissed me off a little was I heard after that from some friends of mine who'd been down at the studio that Tracii was being a little *dickish* with his comments regarding why I'd left, just talking shit, like how stupid it was that I was going to be a truck driver, that I was leaving *Brides of Destruction* to be a truck driver. And the fact was, if I hadn't agreed to leave voluntarily, Tracii had been fully prepared to kick me out on my ass anyway.

With the band whittled down to a punk-rock foursome, Nikki updated fans near the end of February on BOD's progress, including a veiled report on the aforementioned meeting with Bob Rock, reporting in a February 28th diary entry that "the Brides have met with producers and we have our heart set on one (you know him.) He gave us some working orders, so we're heading back into Klown Studios to bust out some more tunes. Basically, up the aggression ((not a problem.) There won't be any ballads on this album. Our intention is to have an album with the energy of AC/DC, Plasmatics, old Priest, Kiss meets a Sex Pistols type album. We can get sensitive later, Hahahaha." Offering fans a more in-depth look at his creative epicenter of operations at the time, Sixx explained that "we work out of Klown Studios. We rehearse there then we record there. We are not the only band that does that there. It is really a creative hotbed."

Reporting on his other goings-on, Sixx updated fans on his new clothing venture, N6 Clothing, a partnership with Dragonfly Clothing, with the bassist recalling that the concept was "born out of a meeting I had with Edward Dada, who owns Dragonfly Clothing… I had a clothing line before called Outlaw, and it just didn't fly. I invested hundreds of thousands of dollars, and it just lost money. It was like a bleeding, dying pig. My partners wouldn't listen to me, and it became very frustrating. But in all fairness, I did not understand the clothing business as I do now…I had always wanted to do a clothing line that was based on tattoos…(and Ed) loved the idea, because he's really about lifestyle. He does a lot of really cool lifestyle stuff with bands and he does a lot of cool stuff on his own as well…(So) it just clicked…We saw eye-to-eye on tattoos being the thread that ties all the clothes together. That comes in many different forms whether it's in graphic design or in cut and sew design or in embroidery.

That is the mainstay in both the men's and the women's line…We started with a few items and they sold out. We introduced a few more items and they sold out. Now we are off and running. We have two complete lines - a men's and a women's line -- being developed as we speak…The first (lines were based on tattoos.) They have themes as well. We have everything from tribal to rock n roll to Japanese style. There are so many interesting visuals when it comes to tattooing that we are able to lift from and use or reinvent…I bring a fresh attitude to the business. When we are sitting down in a meeting I suggest things that they never have thought of. For instance, I may suggest we use radio as a way to get the message out and they go, 'Wow, really? Radio would be cool.' I am like, 'All the cool radio stations could give away the clothes.' Other clothing companies don't think like that. Because I am from rock n roll, I think of music first."

Elaborating on the line's progress during the same month via an online diary entry, Nikki excitedly reported that "N. Sixx Clothing by Dragonfly (Male and Felame) is in over 150 accounts, so needless to say now its getting real, and really busy. We can't design it fast enough for the buyers. This is a quality problem I agree, but still it's a grind. This is the most creative I've ever felt outside of music…I have 100% say in the clothes, and a vision I believe in, which is clothes and tattoos blended together. Right now, I'm using all the graphic artists and experiences and factories of Dragonfly. Eventually N.Sixx will be its own stand alone company…You can get it in Hot Topic, Macy's, and other stores…We are getting huge support by places like Hot Topic. There are so many people who are excited about it. I mean, clothing is clothing. You can adjust it to a certain point but most people like the same things. They like jeans and they like t-shirts or button down shirts. How do I do something different that has been done a hundred times before me? I am not trying to re-invent the wheel; I am just trying to put a cooler mag on it… It's a little bit of an entrepreneurial thing, but it's exciting for me. In rock & roll, I write a song, then I've got to shop the song, then I've got to record the song, wait to put an album out, then wait to get it out to the public, and it's a long process. It's one that I'm used to, but as is the case with any artist, I'm impatient. This gives me instant gratification. Every month we have new stuff… It's just amazing. It's very interesting, the garment business. I'm very excited about it. I'm getting to meet a lot of cool, creative people and it's very similar to rock & roll."

As March began, Sixx stayed in touch with fans re his countless goings-on, reporting on the subject of BOD that "we did a photo shoot with John Harrel for the website. They were sent off to Shaun so the final stages of the site are in the works. I think you'll be pleased. In speaking with some major acts about having us support, we're close to making a decision. We would have to tour without album being finished, which is fine with us. We have a nice selection of music mixed and pressed. Of course they're demos, and looks like a lot of them won't make the record. So we may make them available at www.bridesofdestruction.com. We (Brides) go back in tomorrow to turn up the heat. Probably play a few gigs around L.A. to try out the new stuff." Unfortunately, Sixx's outlook was not so sunny where Motley Crue was concerned, with the bassist appearing to lash out a bit at his being "embarrassed that Crue members tour and don't stand on their own musically. I support playing a couple songs, but for God's sake, try to have some kinda class and not play 99% Motley music. Someday there just might be a Crue tour, isn't that what that's for?" Still, in the same online posting, Nikki cleared up for Crue fans any worry over the band's long-term health, clarifying for the record that he held "NO, (none) ill feeling towards any of the guys in the Crue. I simply have a belief that running the songs into the ground while the band is off the road is a huge mistake. I understand some of you would love to hear Crue songs all night long, but when doing solo stuff, I believe you should mostly stand on the material and salt and pepper the set with Motley's music. When I saw Joe Perry on his solo club tours in the early 80s' he didn't do a whole set of Aerosmith, he did 2 songs. I use that template for myself as has Tommy and would Mick. In the end, there is a Motley Crue. We do NOT need a Crue cover band...I love Vince, but if you ate turkey and stuffing every day how excited would you be for Thanksgiving dinner. No bones about it, I live and breath Mick Mars, Nikki Sixx, Vince Neil and Tommy Lee. Always will be proud and hope to do the name and the music justice for generations to come."

One positive piece of Crue-related news that month involved the re-release of the band's 1998 Greatest Hits album through Universal Music Enterprises label Hip-O Records, and on a personal note, Sixx's signing with Regan Books for what would become his personal autobiography, 'The Heroin Diaries.' That same month, Sixx also appeared in a cameo for Saliva's 'Rest in Pieces' video, a hit single which Sixx had co-written with longtime writing partner James Michael the previous year. As the month

came to an end, the Brides of Destruction launched their official website, offering fans the first listen to full-length versions of forthcoming album tracks including *'I Don't Care,' '2x Dead (Goin' Out),' 'Life,' 'Only So Far,' 'Revolution,' 'I've Got A Gun,' 'Brace Yourself,' 'Natural Born Killer,'* and *'Shut The F@ck Up.'* Of the band's forthcoming debut studio LP, Nikki also reported to fans via his online diary that, heading into April, the band would "finalize our record deals and go make the album in 6-8 weeks…We were the other band that was up for the opening slot on the Kiss/Aerosmith tour and we were honored to be considered, right til the bitter end, considering we havenm't even recorded a record yet…Says a lot about the Kiss-Aero guys to consider and unsigned band for support. We're happy for Saliva and now have a little more time to focus on the new music. Actually, the phone's been ringing off the hook since the Saliva track is taking off, so looks like more writing for other Artists is in the works… More to come (always.)"

As April began, Chronological Crue reported on the Motley front that "the Crüe re-release all of their albums through the Universal Music Enterprises division Hip-O Records. The albums also feature the Japanese bonus tracks from the Crucial Crüe releases, along with video clips. The releases include *Too Fast for Love, Shout at the Devil, Theatre of Pain, Girls, Girls, Girls, Dr. Feelgood, Mötley Crüe, Generation Swine, Supersonic and Demonic Relics, Live: Entertainment or Death,* and *New Tattoo.*" Updating fans personally on the status of all-things Motley- even as the band's inner-dischord continued- Sixx revealed that the band was taking maximum advantage of the control they had over their master catalog, such that "the entire catalog comes out on April 1st. That is exciting for us as we are one of the few bands that actually own our own catalog. As a business, we can find people to partner up with in an interesting way. In this case it is Universal Music. They are going to do the best possible job, we believe. We are going to license our music to them for a number of years and they

are going to keep it out in the bloodstream so that when people come along they are going to be able to get Motley Crue. That is why a lot of bands are with majors. They have the distribution in place… There will be a few things on there. The idea is not to make people go out and re-buy them. We just want them to be available for people who want to get a new album. We are going to release a box set of our career at some time in the future. That is going to be fun. We are going to release, for the first time, all of our videos on DVD…We've already signed on with Paramount and MTV films (for the movie version of the Dirt.)…It'll go into production in the latter part of this year. I signed on as an executive producer to maintain creative control." Addressing the constantly-posed question regarding a reunion that clearly seemed to be in demand among fans and journalists, Sixx said only that "if you do (see a reunion), it'll only be once. If we play together again, it should be an HONEST farewell tour, and go out as a band you can never see again, that you can only hear about."

Clearly focused on his new band Brides of Destruction over Motley Crue where new music was concerned, Sixx and co. appeared on Rockline on the 3rd of April, debuting some of their new tunes, and revealing that the band had signed a Japanese deal with Universal Records, and that they had settled on Steve Bruno as producer for the band's debut LP, with Sixx explaining that the Bruno was "the best, not only in terms of being a great producer, but also in terms of great songwriting ideas." In addition to his writing for BOD, Nikki's side-career as a ghost-writer for other signed acts had flourished commercially to the point that, according to an update from Sixx at the time, "I have written the new single for Saliva called '*Rest In Pieces.*' It looks like we are going to have a #1 album in Europe for the new Meat Loaf album. I wrote four songs for that. Check out the song '*Man of Steel.*'" Elaborating on his selection process for which songs ended up on the Brides LP vs. those which he designated as more appropriate for other artists to record, Nikki explained that "I'm writing songs for other artists, but there were some songs I had written that I was saving for myself. I showed them to the band and they were like, 'Oh my god man, these are unbelievable hits! These are great songs!' The thing was, we hadn't become the Brides yet. What we had was a bunch of us playing some really good songs, so the next step was to write together. We did our second set of demos and from that, there was a song that leaked out onto the Internet, called '*Shut The Fuck Up.*' People were freaking out [when they heard it]. That stuff's got all the elements; it's got the heavier side to it, the pop

sensibilities, it's got more speed. Now we're back at the studio again trying to push our envelope, and see where that goes. We started off more song oriented and now were closer to metal and punk."

Weighing in on the band's broader writing process as the spring wore on, BOD member Tracii Guns explained that "when it comes to songwriting, there are a lot of ways this band does it. For instance, I bring a riff idea into rehearsal, we beat it around for a while and turn it into a nice arrangement; then either London or Sixx comes up with any lyric or melody ideas…Inspiration for me comes from many places. Sometimes I can just pick up an unfamiliar guitar and new music just starts pouring out. Sometimes I sit down with a drum machine and just start jamming over something I wouldn't normally jam to. The ultimate is when you are just jamming with the guys in the band and the magic happens. When the inspiration comes from within the band that is the ultimate…Another way is, Nikki and London get together and write complete songs, then bring them in and I twist them around and beef them up a bit. Another way we do is to get together with a friend of Nikki's, like James Michael who is a pro 'outside' writer, he and Nikki write songs together for other bands and artists, i.e. Meat Loaf." Offering his own perspective on the process, lead singer London Legrand, not surprisingly, revealed that "so far Nikki and Tracii write the music. Some lyrics and melody lines were already completed finished songs, but they also hand me songs with no lyrics and melody lines and tell me to see what I come up with. Once done I come in and we take what's done and collaborate on it until the shit's bangin'… I prefer certain keys to sing in. They're smart enough to know what's best for the song, how many times have you seen a band with a singer you didn't like and came to the conclusion that the band sucked? The musicians were probably amazing, but they didn't get credit where credit was due. I'm happy to say that they're professional enough to give what will allow me to represent with integrity…Nikki IS a hook master. It's good to feed off, but my answer is either or, some may feel more comfortable one way, and others another…The tune decides the title of the song, words come from what you feel from the music."

As the spring wound down, Nikki took time out from his busy work schedule in early May to accompany daughter Storm to an Avril Lavine concert, where he was swarmed backstage by millennium Crueheads including Michelle Branch and Sum 41, reaffirming his band's relevance

among every sub-genre from pop rock to punk pop. Ironically, that same month, Nikki and Tommy appeared publicly for one of only a handful of times since 1999, offering fans some small measure of renewed hope concerning a future Crue reunion via their personal one. Attending the 'Meat Loaf & Friends All-Star Jam & Pool Party' at the Palms' Hotel's Skin nightclub in Las Vegas, Sixx and Lee hung out throughout the evening, even as lead singer- absent from the event despite his residing in the same town- publicly for the first time blamed the delayed Motley Crue reunion squarely on Nikki and his focus on the Brides of Destruction. Addressing his relations with the band's other members, Neil revealed that "I haven't talked to Mick in a couple of years and I haven't talked to Tommy in years so... it doesn't really matter." To make matters appear even worse, the band's lead singer announced that his forthcoming live album, recorded at the Crue's almamada, the Whiskey-A-Go Go, was, in effect, a farewell "gift for the fans. If anybody collects any Mötley stuff it's kind of like a final tribute thing to get me singing Mötley Crüe stuff."

Still, heading into the summer, while the status of Motley Crue as a band remained in question, personal wounds among the band's two founders appeared to be on the mend. Addressing the possibility formally, Nikki explained that where a reunion was concerned, "I like to make decisions based on what's right and what's wrong for Mötley Crüe. At some point, I think we would all like to play live again. Whether or not that happens, it's out of my control. Either Vince Neil's going to get sober and really lean and come back and kick ass like only Vince Neil can do – because he's a badass mofo when he's got his shit together – or it's not happening. That's where Tommy's at, too. Unless it's 1989 on steroids, I'm not interested in doing it." As June began, Sixx's musical attentions were again focused primarily on the Brides of Destruction, who by this point had had chosen producer Steve Thompson, veteran producer of such super-star acts as Madonna, Red Hot Chili Peppers, Rollins Band, Tesla and Korn, to mix the band's debut LP, whose tracking was well-underway. Updating fans on the status of all-things Sixx as the month neared an end, Nikki reported via his online diary that he'd "received a great call from Larry Flynt's office. They're giving Hustler magazine a facelift. They've always used just woman on the cover (except when MÖTLEY CRÜE was on in 1997). They asked me and [wife] Donna to do the cover together (shot yesterday) and the interview is pretty extensive on both our on going projects and life. We had a blast to say the least.... nothing to get excited

about in Hustler tradition for us of course. Larry is and will always be a icon of independence, so it was a honor to do the mag. Since there's a shift in image for the mag I'm sure there will be a lot of press that will include Donna and myself... I believe the mag comes out in Sept... I've been burning the candle at both ends wrapping up business because were going to check out for 2 weeks and go hide in Mexico. No cells, no managers, no Internet. No business. No nuthing...See ya soon...N6."

Returning from his 2-week Mexican jaunt as July unfolded, Nikki and Tommy continued their public healing process, appearing together in a series of interviews discussing Motley Crue's legacy as part of the band's forthcoming video DVD release. On the Crue front, the band also utilized the lucrative ownership of their master catalog to issue, via Hip-O Records, their very own *'Motley Crue: 20th Century Masters'* as part of Universal's highly-successful 'Millennium Collection' series. Digitally remastered, the album's tracks included such Crue-classics as Piece Of Your Action, Shout At The Devil, Too Young To Fall In Love, Home Sweet Home, Girls Girls Girls, All In The Name Of..., Kickstart My Heart, Rock & Roll Junkie, Anarchy In The U.K., Hooligan's Holiday, Generation Swine and Hell on High Heels. Seeking to further heal the very public wounds the band had sustained since their forced hiatus in 2001, Nikki wound down the month of July by making peace with Vince Neil, providing Crue fans with the positive update via his online diary that "had a great talk with Vince the other day. We hadn't spoke in a bit but as usual, things have gotten misconstrued and blown out of context. (Lawyers are on step above paparazzi.) Gode I love clarity, in the end we both want the same thing as Tommy and Mick, we wanna kick some fucking ass on tour." Further re-inforcing the notion that the band may have finally begun an unofficial regrouping process, Nikki also shared with fans that "it was great having Tommy come to the N. Sixx/Dragonfly Party (at the Galaxy Theatre). But that club was lame, they were playing rave music all night. Fucking hell, I kept saying play some metal. Finally, we just left, too fucking boring for me." Vince further fanned the flame of excitement on the Crue reunion front by announcing at a month-end Skin Pool Lounge party in his home-town of Las Vegas that the band would in fact re-unite for a reunion tour the following summer. Nailing down the rumor officially, Nikki ended his July diary entry by sharing with fans that, as a result of the band's personal reunion, where the likelihood of a professional one was concerned, "I can feel the big gears starting to creek and groan as

the massive machine starts to move. Wait till it picks up speed, it fucking hurts when it runs you over."

As the summer wound into its last month of August, Sixx was progressing steadily toward the conclusion of work on the Brides of Destruction's debut LP, even as the evolution of his clothing line and possible Motley Crue reunion clearly appeared to be competing for his time. Concerning the status of the band's on-going negotiations for the album's U.S. release, guitarist Tracii Guns reported via the band's web diary that "I just talked to Nikki. After we deliver to Japan, we will try to get at least a license or distribution. At that point we will pickup where we left off. So The Brides are not over, it's just not a full-blown band at this point until we need to be somewhere, so I will put something new together to occupy my time until the CD comes out." Sixx's ability to focus as intently as he had earlier in the year seemed somewhat fragmented when, in the course of a brief update to his online diary on August 11th, he reported that the BOD "album will be mixed by Steve Thompson, album will have Scott Coogan on 5 tracks and Kris Kohls on 5 tracks; album will have Corabi on whole album on 2nd guitar; album will be out this year in Japan and licensed around the world after." Focusing in more depth (i.e. full sentence form) on why his attention was so divided, Nikki explained that "I have too many things going on to tour unless album take off. Love the music, onto Motley, speak to Tommy, Vince and Mick daily." BOD guitarist further reinforced the credibility of the Motley Crue reunion's progress by reporting that "depending on Mötley Crüe's schedule, The Brides will surely do some live dates after the release of the CD. Still, as the summer wound down, and with Motley Crue's future as a live band far from certain, Sixx did confirm that those Crue fans who were waiting for any new music whatsoever from Sixx would be treated to the BOD album's US release before year end, reporting on the 15th of August that "Steve Thompson is mixing the Brides album as we speak. Bad ass! Balls to the wall, it sounds insane. The album (surprise) will be out this year. Ye haa."

The fall of 2003 began as crazily-paced as ever for Sixx, with Chronological Crue reporting that, among his many other ventures, "JVC will launch a new multi-million dollar national branding campaign this fall, featuring movie, music and extreme sports celebrities that appeal to the campaign's twenty-five to thirty-four-year-old target market. The new

campaign, comprised of print, outdoor, broadcast and Internet elements, includes the husband/wife team of Nikki and Donna, award-winning filmmaker Jerry Bruckheimer, multi-Platinum rock band Nickelback, singer/songwriter Lisa Loeb, and world champion snowboarder and mountain biker Shaun Palmer. The campaign will feature separate print and outdoor ads starring Bruckheimer, Loeb, Palmer and Nickelback, while Nikki and Donna will appear together with their two-year-old daughter Frankie-Jean. Media will include publications in the men's, women's, music fan, musician, and entertainment categories, including Blender, Cosmopolitan, Entertainment Weekly, FHM, Guitar Player, Playboy, Premier, Spin, and others. The broadcast component will include closed-captioning sponsorship spots on major market television news programs. A series of full-motion video spots featuring interviews and other video footage with each celebrity will run on a variety of websites."

Updating fans about Motley's various goings-on via a mid-September online diary entry, Nikki began by explaining that he "wanted to update you on some Crue news: we have a new label (Universal Music) and they do a Millennium series of bands they work the catalog of, so we will be added to the series. Universal Europe wants to do a Definitive 3 CD/1DVD package for Europe only. Title is 'Loud as Fuck'. Our DVD Greatest Video Hits will be out November 11 of this year. Finally, it will have every video we ever did. Our boxset is called 'Music to Crash Your Car To.' I'm hoping for it to be out this year, but most likely first quarter of 04. We've scraped pretty hard with the re-releases so this is really a collector package, and you won't find any new music, but if you don't have all the music and extras for some reason, it's a nice way to get the whole career in one shot. Boxsets don't always sell a lot but I think it's a cool thing to have. The writer is 80% done with the first draft of 'The Dirt' movie. I know he's been spending time with Tommy. Paramount is ready to greenlight the $ as soon as they approve the script, I speak to Tommy, Mick and Vince quite often, but I know Vince has some resentments that need to be ironed out. But if everybody wants to do a Crue tour, I'm there. At this point for me, a Motley Crue tour is not about the money. I'd really like to go out and give one last kick in the ass tour where everybody- including the band- walk away with a smile on their face. In the end, I'm powerless. Sixx."

Of the band's long-rumored film adaption of their 2001 Bestseller *'The Dirt'*, Nikki reported of its developmental progress that "as executive producer for the movie, I have to oversee a lot of stuff. The casting part scares me a lot, because it's got to be *really perfect*. There's been talk of getting a guy like Johnny Depp, Keanu Reeves, or Kevin Bacon, because they're also musicians. Obviously, those are some *really serious* names. I have this saying: Expectations are like premeditated resentment. I don't want to get my hopes up... We have signed with Paramount Pictures/MTV Pictures and we have hired the guy who wrote XXX to write this. It is going to be made...To be honest with you, it is not just based on rock n roll. It is a story of survival very much like the book. You will sense the brotherhood and the survival of that brotherhood and everything that we had to go through to become what we were. The things that made us what we were also tore us apart. I think the story is demographically huge. It is not just a rock star movie...That's the concept behind the movie. Egotistically I know that certain band members would love to think that this is about them, but to be honest with you, we're the least important part of the scenario -- the band and even the music. It's really a story of survival. It's a human story, and I think that's why a lot of people will relate to it. The last thing this movie will be is a botched up version of *Rock Star* or something. It's just not going to happen...This band is really magical."

Indeed, amid all of his other goings-on throughout the fall of 2003, Nikki Sixx seemed to have made the making of amens between himself and Motley's other members a personal priority. Ironically, where in the past the most resistant member had been Tommy Lee, this time the main source of disinterest seemed to rest with Vince Neil, who- in a departure from the upbeat tone of his late-summer update on inner-Crue relations- told the Edmonton Sun in early September that "Nikki's trying to get everyone back together. Tommy's already agreed to do it; Mick's already agreed to do it. I really don't want to do it. I'm having too much fun doing my own thing. There's no brain damage, it's fun, you just go out and play. Basically nobody likes each other in Mötley Crüe, so why would I put myself in that kind of position when I'm perfectly happy doing what I'm doing now?"

To counter the latter dissension from the official party line that the band was on a friendly hiatus, Nikki replied on the status of the band's

reunion prospects that it had been prevented to date first and foremost by the health of guitarist Mick Mars, with Sixx positively reporting to fans by the fall of 2003 that "Mick is doing so much better. His health has really turned around. He is mobile and he is playing again. To be honest with you, it would have been impossible for Motley to tour. We don't have our original drummer and our guitar player is ill. We needed this downtime. We needed the time after all these years to unplug and reevaluate." Elaborating, the spinmaster further reasoned that "I think that if Motley is to go out and tour then everyone will have to be what they once were but better or there won't be a tour. That is simply it. We want this to be the best Motley Crue every. Vince Neal is the greatest front man I have ever performed with. Mick Mars is a monster on guitar. Tommy is the craziest sane drummer I have ever met. We do something that nobody else does. I want that one more time for everybody. I want to call it a farewell. It may not happen but I am willing if all the pieces are in place."

The bassist in his response to Neil's negativity also acknowledged the latter in his concession that the tour plans had also been partially impeded by the fact that "Tommy had left the band. His relationship with Vince had deteriorated to a point where he just didn't want be around him; so I said 'Let's pull the plug till Tommy gets being a solo artist out of his system.' " Nikki also laid some of the blame for the delayed reunion plans at Vince's feet, "I said I'm going to do one of two things: either Vince Neil's going to get sober and really lean and fucking come back and kick ass like *only* Vince Neil can do -- because he's a bad ass motherfucker when he's got his shit together... or not! And he goes 'Really?' And I go 'Yeah!' It's not about crippling [what I have going on] out there, because I have too many things that are positive to go out and do negative stuff. That's where Tommy's at, too...That's mine and Tommy's belief. Unless Vince totally has his shit together, why would we go out and do it?... as Mötley Crüe, it will be the four of us -- and the four of us at the best we can be -- or there won't be one. I extend my faith on this. Extending your faith in something you can't see is like God, it's like religion. It's like having a religion towards a God, and I extend my faith that Vince will find the right road and we will be able to, as brothers, do this wonderfully. If not, I know that I have done something that I'm very proud of and I don't need deface it... At some point, I think we would all like to play live again. Whether or not that happens, it's out of my control. Either Vince Neil's going to get sober and really lean and fucking come back and kick ass like *only* Vince Neil can do—

because he's a bad ass motherfucker when he's got his shit together—or it's not happening. That's where Tommy's at, too. Unless it's 1989 on steroids, I'm not interested in doing it."

As the month of September approached an end, Meatloaf released his first new studio album in nearly a decade, featuring four singles co-written by Nikki Sixx and James Michael, including *'Couldn't Have Said it Better,' 'Love You Out Loud', and 'Man of Steel.'* In spite of the latter positive news, Nikki ended the month on a down-note, filing suit against skateboard-themed magazine Thrasher Magazine and Vans shoe company, with Chronological Crue reporting that the defendants had "allegedly using his image in an ad without his permission, after they used photographs of him with pro-skater Tony Trujillo at a San Francisco ceremony organized by Thrasher magazine and sponsored by Vans. Nikki agreed to present Trujillo with a Skater of the Year award at the ceremony on 7 December 2002, because he knew Trujillo was a Mötley Crüe fan but was later surprised to see photos taken at the ceremony in an ad for Trujillo's signature Vans shoes. The lawsuit says the caption above one of the photos, "Live Fast, Die Young," is "somewhat reminiscent of the title of Mötley Crüe's first album *Too Fast For Love*. The lawsuit also notes that Nikki has his own clothing line, N.Sixx by Dragonfly, which seeks out the same youthful consumers targeted by Vans. Vans attorney Craig Gosselin said the company had not seen the lawsuit, but planned to fight it."

October of 2003 began on an upbeat note with Donna D'Errico opening a new business, ZenSpa, in Calabasas. Partnered with husband Nikki Sixx in the venture, D'Errico explained the concept behind the Spa as one wherein "I wanted a place where people could go and escape. These times are stressful, with everyone going a million miles an hour. I started reading Zen philosophy and fell in love with it. Also, there were no great spas where I live. I had to keep driving to Beverly Hills. They weren't very personal, and I wanted a place where people felt at home…The spa is 5,000 feet, and I designed it myself. It is a mix of Tibetan monastery and American rustic. It's really very soothing. The spa is for both men and women, and we have very unique techniques. We have what we call the classical-rock massage. Rock, meaning music. JVC donated wireless headphones. There are three albums you can choose from: Pink Floyd's Dark Side of the Moon, Moody Blues or Vivaldi's Four Seasons. It is the length of the whole album, and the massage therapists time the massages to

the music. I wanted something in homage to my husband. When you think of massage, you don't normally think of rock 'n' roll, but it works."

Perhaps seeking to find a similar sense of balance with longtime bandmate Vince Neil, who seemed at the moment to publicly be the odd-man-out where the topic of a Motley Crue reunion was concerned, Nikki joined Neil onstage during a solo show at the Key Club on the 15th, much to the delight of Crue fans in attendance, as well as to 80s hair metal guests including Cinderella's Fred Coury, Faster Pussycat's Taime Downe, DJ Ashba, Tuff's Stevie Rachelle, Poison's C.C. Deville, and former Kiss lead guitarist Bruce Kulick. Later in the month, Sixx again extended the olive branch by donating his customized '57 Chevy to Neil's annual Skylar Neil Memorial Golf Tournament auction. As the month neared its end, Sixx also opened his house to Motley guitarist Mick Mars, whose own abode was undergoing renovations. Sixx ended the month on a note that clearly rang out in a much more harmonious fashion than many of the previous ones he and Vince had exchanged throughout previous months, with Neil visiting Sixx at length in L.A., culminating with Sixx's coming to the singer's defense online, lashing out at detractors by angrily addressing "the assholes who put Vinnie down… don't fuck with us… we're allowed to fight and dog each other. That's what brothers do…but anybody else…You can fuck off!"

Heading into November, Nikki seemed to be balancing the demands of Brides of Destruction's impending album release and the reconstruction of Motley Crue, reporting that the LP, now titled *'Here Comes the Brides'*, would be released via Universal Records in Japan in December, while announcing that the band's debut LP would finally see a State-side street date via a three-album deal he and the band had signed with Sanctuary Records for Europe and North America through his production company 12-11 Productions. Where Motley-related release dates were concerned, Chronological Crue reported that, on the 11th of November, "Universal Music and Mötley Records release Greatest Video Hits on DVD, containing every video clip the band has ever made. It is the first time all Mötley Crüe videos have been provided on DVD; twenty seven videos in total in new 5.1 mixes and stereo remastered audio, including six alternative videos that are uncensored, remixed or alternate versions. A new interview segment with Nikki and Tommy is also included. Fans have the ability to choose the play sequence of the videos with a personal play-

list feature. The long-awaited first volume of the three-part box set titled *Music to Crash Your Car To Vol.1* is also released. The four discs included present tracks from the band's first four albums, including the original Leathür Records version of *Too Fast For Love*, with deluxe packaging."

Addressing the ever-spreading rumors of a full-scale Motley Crue reunion in 2004, Nikki cooled the rumor flame some by reporting that the biggest obstacle- as a band- now centered around the fact that "it's been hard to get Vince and Tommy on the same page as far as wanting to play together. I think all that water's under the bridge now." Following up from his comments earlier in the fall to journalists regarding the band's reunion chances, Nikki indicated that the sentiment from formerly opposed band members had turned, such that, "the other day I turned on Howard Stern, and Vince is bagging on me about not touring. And I thought, Fuck, we agreed not to tour. We decided, after the movie, let's go do a tour. Besides, the communication between Tommy and Vince needs to be open. I'd like to put tickets on sale in 2004 and go out in 2005; so we're only a year away." With that more positive outlook on the band's future, Nikki sought to further wet fans' beaks at the prospects of a full-blown reunion by indicating that Motley Crue as a business was still fully-functioning, wherein "Neither myself nor Tommy nor Mick nor Vince would be interested in doing another tour unless it was with the original band members. I think that we'd said we would take a couple years off, and that's the best thing we could have done. I feel more passionate about Mötley Crüe now than I did two years ago, and I'm able to deal with the day-by-day stuff, as I always have, but not feel the pressure to do something because of a schedule. I like to make decisions based on simply what's right and what's wrong for the band. At some point, I think that we would all like to (play live again.)" In the absence of a formal reunion, Sixx, heading into the year's end, was focused once again on the Brides of Destruction's commercial debut, heading to Canada on the 12th for a promotional campaign and series of meetings with Sanctuary Records' Canadian staff to discuss the album's coming release. The following week, Nikki and company continued their press campaign with a round of interviews with Japanese press to accompany the album's Japanese retail release on Christmas day.

Re-focused in the press on promoting the musical project he had decided to focus fully on while Motley made its mind up re their future,

Nikki likened his excitement regarding the forthcoming release of the Brides' debut LP "I'm really, really passionate about it, the way I was passionate about Mötley Crüe in the beginning…That is what I like about the Brides of Destruction. It reminds me of *Too Fast For Love*…The Brides are a total kick in the can. I'm going to shove the Brides down everyone's throats." Sixx sought in a way to spin his excitement about the Brides into a partial explanation for fans on why the Motley Crue reunion hadn't happened yet, explaining that "I keep excited about stuff by keeping stuff fresh. Like, I wasn't excited about Mötley Crüe anymore. It was too much work. It was difficult to move quickly. When I move slowly, I fall asleep. I will, at some point, stop, and will probably never start again. I'm the kind of person that would go to St. Thomas and then just never come back again. Just, I'm gone! When I'm sixty, I'll be down there cutting coconuts on the beach. (And someone will say to me) 'Dude, what about all these things you have going?' and I'm like, 'I'm done.' That's how I work. I'm full on, very excited about stuff, and when stuff gets slow or cumbersome or it's immature, I'm not interested anymore. And if I'm not interested, I can't put my energy into it. Without my energy it doesn't move forward. But I also burn out, because I go so hard. I love it, but it's probably not healthy. I'm sure there's some twelve-step program for me out there. Workaholics Anonymous. So, there you go, what drives me is passion."

Reflecting on yet another crazy year in his remarkable life, Sixx, in a holiday-themed diary entry addressed to his fans, beginning by quipping that "I went AWOL yesterday. My manager's office left messages for me saying, 'Are you okay?' I go so full on, from 6:30 in the morning until one in the morning *every day*. Yesterday, I walked in the house, and no one was in the house -- which is really rare. There are always people in this house; always songwriters, always maids, always nannies, always kids, my wife, her business partners. I walked in and there was *no* body in the house. And I sat on the couch just for one second, thinking, 'Ok, gotta go! Gotta go to rehearsal!' And I just, I couldn't move. It was silent here. It was so bizarre. And I just passed out and slept until 6 o'clock at night, sat up for like an hour and then slept all night until this morning. I guess that's the thing, I go really hard at everything I do and then I crash, totally…I'd like to say happy holidays to all rock 'n' roll fans across the planet…Xmas is upon us, but no rest for the wicked. One last dirty deed needed to be done before all turns quiet for a few weeks. I did the cover of Bass Player mag today. Also did Guitar World mag with Tracii and Guitar One too… It was a walk down

memory lane shooting with Neil Zlozower…a true rock 'n' roll legend he is, adorning his walls are his photos from the '70s, '80, '90s and so on. The room seems sticky with the ghosts of the past and him being the sage of anarchy seems like a fitting way to end a very creative year. Happy holidays. Xxis Ikkin."

Chapter 24

2004

After celebrating the end of 2003 with the public unveiling of the Brides of Destruction on the Tonight Show, Nikki's attentions heading into 2004 were squarely focused on promoting the band's forthcoming debut studio LP, '*Here Come the Brides*,' which the band's label, Sanctuary Records, had scheduled for a March release. For his fans, the Brides project seemed the best Nikki had to offer in the way of new music of any kind for the near future, a reality he reinforced by characterizing the inner-chaos within the band such that, at the time, "MÖTLEY is a dysfunctional band, at best! Communication is not always really open. One of the biggest problems is that Vince has his own manager, and Tommy has his own manager, very much like a lot of bands. MÖTLEY CRÜE has a manager who manages me and Mick and MÖTLEY CRÜE. So, when we're making decisions for MÖTLEY CRÜE, we're making the decisions, and a lot of times, Vince is out of the decision process. Being out of the band really is being out of the decision process. A lot of things that are done for the betterment of the group aren't always individually based. They aren't self-serving, but they're all of us serving. So, what happens is that people start feeling like, 'What do you mean we're doing a movie?' Then we sit down

and we talked about doing a movie. We said we were going to take a hiatus, and three years later, we have gone and got the movie and all this stuff. Vince is like, 'I'm not involved, so I'm not doing it.' Then I have to sit down with Vince and show him that this is all the stuff that we said we were going to do. A lot of it is his management not being involved in the process, because they don't manage the band. Now, we've sort of gotten rid of his manager and Tommy's manager. They are sort of on the sidelines. They still manage those guys as solo artists, but now everyone is in the same camp, and we've kind of gone, 'Yeah, OK,' and now it's all making sense."

Even as Sixx offered up the Brides side project to tide Crue fans over until the band's inevitable reunion, the abrupt departure of rhythm guitarist John Corabi in late 2003 had been a disappointment for Motley fans who saw it as the closest thing to a reunion they could ask for until the real thing materialized. In addressing the departure, Sixx explained that "(in the beginning), John was kind of coming down to rehearsals. We were just kind of feeling it out. You know, what happened was that the first set of songs that we wrote were just us kind of getting to know each other. Some of the songs on the record like 'Natural Born Killer' (and 'Revolution') . . . are kind of a more pop flavor with a little punk and metal thrown in there. Then as the band started to get to know each other, then we became more metal and punk with a pop overtone. In other words, it was backwards. I think that John, being a singer and a songwriter in his own right, kind of was like, 'You know, I'm not sure where this is going. This isn't really where I'm coming from.' I think the first set of songs was about where he was coming from. I think he was just striving to be his own musician too. He kind of wanted to do his own thing. He kind of organically kind of came in, and then he just kind of came out. He never really officially came in. It's kind of like a really nice splinter. We've known him for so long, and we really were just kind of jamming." Elaborating, Brides bandmate Tracii Guns added that "all of a sudden, we just got really aggressive, I think…We were rehearsing for a couple of months and writing and changing drummers. Me and Nikki always knew where we wanted to go, and everyone around us just had to kind of be patient. All of a sudden, about two months in, I brought in music for stuff like 'I Don't Care' and 'Shut The Fuck Up'. Nikki was like, 'Yeah, yeah, yeah, yeah, yeah. Let's do it.' Those aren't the only heavy songs we wrote. We wrote all these songs in a period of time. John…he's like a classic ZEPPELIN rock

guy. He likes the really heavy stuff, but it's not really his cup of tea. He just bowed out and said, 'You know guys, this is your thing. Go rock!' "

Even as the band launched their pre-release promotional campaign as January wore on, it was obvious Nikki was creatively hungry, reporting via his online website that "we're on a mission from hell to write a double album. If it happens, fine. if not… Well, we're gonna have a fuckload of music to choose from for the next album. Of course, our first album isn't even out yet (March 9), but if you're gonna take a stab at an epic masterpiece, you better get a running start… Fuck the naysayers…Rock n roll will destroy the world." Addressing the band's impending tour plans- the first time Motley fans would have the opportunity to see Sixx performing live in any capacity since 2001- Nikki seemed equally as excited, declaring that "I cant wait to lose our virginity on tour… Offers are coming in…Every bride needs a good fucking to start of the marriage…don't you agree?" While the band demoed new material through the end of the month, Nikki took out time to accompany wife Donna, along with sons Gunner and Rhyan, to the premier of her newest movie, 'Comic Book,' thereafter traveling to New York for a few days with D'Errico to accompany her on promotional commitments for the movie. Amid the trip, in an update to fans in his online diary, Sixx also answered another rumor involving wife Donna and an alleged sex tape that had surfaced online, commenting that "Donna's parody of the Paris Hilton sex tape to promote her new movie had me laughing my ass off… As she said today (with a smirk), 'To make it in Hollywood anymore, it seems like you need a sex tape.' She was funny as fuck on 'Howard Stern', I like the way they ran out of control with her stories of misadventure…Too much fun for one day…It's cold as fuck here [in New York], I hope we can fly out tomorrow… The news says it might get bad…real bad…Guess ill be stranded in the hotel with her…Now that would just suck…(not)!" In another humorous domestic note to round out the month, KORN frontman Jonathan Davis reported that he and Sixx had become friends due to that of their children, who were classmates, with Davis explaining that "it's funny, because his best friend is Nikki Sixx's son. It's pretty cool. I run into Nikki at our sons' school and we talk about what classes the boys are taking…It's a trip. He's a good guy. But imagine if those two boys started a band in the future. It'd be pretty kick-ass."

As February began, so too did BOD's official promotional campaign for their forthcoming LP, with Nikki reporting that- among the band's other forthcoming appearances- "we will also play on Sunset Blvd. on March 10th (at Tower Records) and do a in-store afterwards...More shit to come." Bandmate Tracii Guns elaborated on the band's promotional schedule for the month, reporting in to fans on February 3rd that "we had our European press day today, All the band members were present, we covered seven European territories. We just basically talked about everything from our past to our future and how great our fans are considering we have only played twice and our first record doesn't come out for another month. We also talked about our touring options and it looks like we will be covering some serious ground in the next eight months with some fucking killer bands that we will name when everything is confirmed...We got too proof our MTV ad... it's only 30 seconds but it is pretty brutal and to the point...After a full day of press, Nikki and I went to go look at the BRIDES OF DESTRUCTION billboard that was put up on the front of the Rainbow yesterday (looks great)...We will be shooting the performance part of the 'Shut The Fuck Up' video this coming Monday. 'Jimmy Kimmel' show is now going to be on Thursday, March 11th. The Tower Records on Sunset will have us doing an in-store and live performance on the 10th. It will be sometime in the evening after Nikki's taping for 'Jimmy Kimmel' that night...The Sanctuary street team has been kicking ass getting the word out on the record release...We start rehearsals on February 23rd so... IT'S TIME TO START THIS BASTARD ROLLIN!!!"

On the 9th, the band shot their video for 'Shut the Fuck Up!' with director Paul Brown, while Sixx was in the midst of fielding touring offers for the band, including an opening slot on Kiss's forthcoming summer tour. Still, when rumors surfaced that Poison would be the second band on the bill, in effect reducing the Brides to their opening act- rather than Kiss's- Nikki quickly shot down the possibility to fans in his online diary, declaring that there was "no way in fucking hell would we ever, ever tour with a fucking band like Poison. We have had talks with Kiss and I told them very clearly that we would not do the tour if they used Poison. That would be the death of us... I will not be attached to that kind of fake bullshit." Commenting further on Nikki's objections, BOD guitarist Tracii Guns explained that "(Kiss manager Doc McGhee) called Nikki and said 'you guys can stop calling me. You've got the tour!' Then we found out it was

with Poison and Nikki has something with Poison…Playing to a 30+ non record buying audience at 6pm is not a good enough reason for the BRIDES to do the tour. However if there was a band with a younger audience going on after us, that would make sense. Otherwise we would just start out headlining and playing to our fanbase that already exists at night and do a full set in clubs, which is something we may have to do. I know that the arena tour sounds exciting but that doesn't make it the right thing to do. Not to mention the ticket price would make it near impossible for a lot of younger people to go. Nikki can't stand POISON and you know what? It's a free country and he can express himself anyway he wants too." Elaborating even more in-depthly in the highly-publicized aftermath of Nikki's rejection of the Kiss offer, he confirmed that "on the tour front, yes, KISS's manager told me we had the tour if we wanted it. I did explain to them it would depend on who is the special guest. We really appreciate such a cool offer, but it's important for us to feel comfortable with the package. Sometimes you tour for the betterment of the package, but as a new band we are trying to *like* the packages. I freaked when I saw it was announced that POISON was part of the tour because I told them that was not an option for the BRIDES. As far as my opinion, it isn't personal. They're cool guys and I have no beef with them as people. I JUST DON'T wanna tour with the band…'I was in negotiations and said it depends who else is on the tour. If you're going to do a nostalgia thing, we're not interested. If you go get JET or THE DARKNESS, it sounds like fun…All of a sudden they come back with KISS, the BRIDES and POISON! There ain't no way in hell I'm doing that tour. I will not play with fucking POISON. There are followers and leaders. I'm not into followers."

Winding up the month, Nikki reported in some non-Brides news that "my partnership with Dragonfly clothing is up and I will be announcing in the next 30 days my new partner for N.Sixx clothing. I had a good run with Dragonfly and learned a lot about the business. I have been in New York over the last few months hammering out a deal with a major company and as soon as I sign (the deal) you be the first to hear about it. The new line will take off where the current line ends." As March began, Nikki found himself much more focused on promoting the Brides' impending March street date, which was preceded by engagements including he and bandmate Tracii Guns' co-hosting gig on Headbanger's Ball on March 6th; a highly visible musical performance on the Tonight Show on the 8th, as well as an appearance on the nationally-syndicated Rockline radio show on the

20th. Updating fans ahead of the album's release via his online diary, Nikki reported on the bands' touring plans and related promotional goings-on that "we're confirmed on the Download Festival in England in June. Headliners are METALLICA. We are routing a headline tour of 1,200 seaters to start off for April, but were still in talks about some other possible opportunities…I've received a lot of e-mails about bands you would like to see us tour with. Most of them I've forward to our agency. Thank you … Speaking of radio…because of the heat the stations are getting, I'm seeing radio jumping on *'I Don't Care'* and playing it…That's not a bad thing…but we will continue to work *'S.T.F.U.'*… In the end I've always believed to let the fans vote on what they really want to hear at radio…London did his first 15-hour day of press with me yesterday….he held up great…it is a brain drain to do it all day into the night…god bless young blood….Back to smella…New York rocked as usual…Can't wait to play 'Leno' Monday."

Following the band's Tonight Show appearance, on Tuesday, March 9th, the retail release of the BOD's debut LP was celebrated with a live in-store set featuring songs including *'Natural Born Killers,' 'Shut the Fuck Up,' 'Brace Yourself,' 'Life,'* and *'I Don't Care'* at Tower Records in Sunset Blvd. The packed gig was followed by the announcement that the band would perform a week later on CBS' 'The Late Show with Craig Kilborn.' Critical reaction to the album was favorable all around, with Rolling Stone Magazine commenting that the band's debut "waxes nostalgic in a good way…The Brides marry garage rock with live-wire riffage that recalls vintage Crue…Throughout, Brides show today's whippersnappers how to deliver real cock-rock shock." Clearly elated at the positive reaction to his newest musical endeavor, Nikki shared with fans via his on-line dairy following the album's release that "the Tower in-store was so much fun. Tracii said it's really our first gig, and he's correct in the fact that it was all on us…I was blown away by the support from fans. People came from Australia, Japan, Mexico and all over the States. Of course many of you saw 'The Tonight Show With Jay Leno' and I think it was pretty good, but not up to par for this band. Being human, nerves inch there way into such performances. I'm sure 'The Late Late Show With Craig Kilborn' on Monday will feel better to us all. What can I say, it's only rock n roll…Now, the funniest part of all this: somehow, somewhere people started calling us a punk band….as much as I love punk, I think that's a stretch. I hear metal, rock, pop and ya maybe some punk. I think we have a

lot more depth to us than maybe even we know. There's a lot of talent in this band. And we're just getting started…I want to thank everybody for the support. Fuck, what can I say…It feels new again."

Commenting further in overall terms on the critical reaction to the band, Nikki explained that "I've seen us reviewed as anything from a punk band, a garage band, a heavy-metal band, a new rock band…(We've even been described as) a supergroup. I'm like, 'Where the [expletive] did you get that?' We're just a fucking band. Either you like [expletive] loud guitars and snotty lyrics or you don't…I don't really give a fuck…You know, rock 'n' roll cliché is only a cliché because of the followers. Take grunge cliché — well you know Eddie Vedder to me was a pioneer in that genre, but all the other bands with the flannel and that shit, that became a cliché. Like Eddie Vedder, unfortunately, you look at him and you're like fuck, he's like this fucking cliché, with his fuckin' army jacket and his army shorts and you know … but that's who he is. And Johnny Thunders, from the NEW YORK DOLLS, people can say that's a cliché, who he was -- you know the heroin addict and that kind of raunchy, snotty guitar, but that's who he was. Was Hemingway a cliché because he was the tortured, alcoholic writer? Or was he really being who he was? Or Burroughs with his heroin addiction and his gentleman's suit. Or are they originators and the other people behind them made them into clichés?…The funniest of all of them is me. I'm the one I can laugh at the most. I am the rock 'n' roll cliché aren't I? Hell yeah! Tattoos head to toe, leather pants, greasy black hair, playmate wife who used to be on 'Baywatch'. You know, life is good."

Debuting at #92 on Billboard's Top 200 Album Chart with first-week soundscan of 13,694 units, Nikki's 'indie' side-project was still the subject of major press as the month wound down, including an appearance on Dennis Miller's TV show and a guest-hosting gig on MTV's Headbanger's Ball. On the 23rd, BOD officially announced their 'Honeymoon from Hell' tour, whose initial dates included a US run beginning on Apr. 30 - Clifton Park, NY - Northern Lights; May 01 - Springfield, VA – Jaxx; May 02 - Norfolk, VA - The NorVa; May 03 - Baltimore, MD – Thunderdome; May 05 - New York, NY – CBGB; May 06 - Boston, MA - Paradise Rock Club; May 07 - Hartford, CT - Webster Theatre/Underground; May 08 - Sayreville, NJ - Starland Ballroom; May 09 - Philadelphia, PA - The Trocadero/Balcony Bar; May 11 - Toronto, Ontario - Opera House; May 12 - Pittsburgh, PA - Mr. Smalls Fun House/Theatre; May 13 - Cleveland,

OH - Odeon Concert Club; May 14 - Detroit, MI - Majestic Theatre; and May 15 - Chicago, IL - Metro, before heading into an early summer European run of live dates that included Jun. 06 - Donington, UK - Download Festival; Jun. 16 – Helsinki, FIN @ Tavastia; Jun. 17 – Helsinki, FIN @ Tavastia; Jun. 18 – Oslo, NOR – Oslo Spektrum (w/ ALICE COOPER); and Jun. 19 – Gothenburg, SWE – Metaltown (w/ ALICE COOPER).

Reflecting in advance on his first time out on the road following several years off, Nikki shared with fans his opening observation that "all things new were done once before. As I sit here putting together the set list for the BRIDES tour, I'm feeling excited and guilty. I've been home for four years now and I've grown roots. I'm excited about touring and I'm excited about the unknown. But I've had to bridge the conversation with my kids and wife about being gone. My son (Gunner) asked me 'How long?' I said, 'I don't know. It could be a couple months or it could be longer.' It's up to the fans. It's part of the unknown…I've spent most of my life on the road and my wife understands that it's a huge part of who I am… In fact, it was her who told me its time to go do this… God bless her…(We) go into rehearsal this week…We're getting the set together, the amps and guitars tuned up (cleaned up even)…cleaning up is dirty work…As far as songs live… We will play the whole album live (duh)… plus we have unreleased BRIDES songs were gonna play too…we took it to heart what you all wanna hear from (the GUNS and CRÜE era) and it seems that its your wish for us to play old stuff…not even the hits…so we're gonna work up a bunch of songs and see how it sounds…Thanks for your input."

As April got underway, the band had begun tour rehearsals, promising fans a 90 minute set with fan-recordings (via camera, digital video, etc) allowed at all shows. BOD also settled on the tour's opening acts, with Nikki reporting to fans via his online diary that "we're excited about the support bands for the upcoming BRIDES tour. The bands are AMEN and LIVING THINGS. We went thru a lot of bands and really love what both of these bands are doing. Also great early support on the new single, 'I Don't Care' from radio…As of now, we tour thru may in America… June in Europe. July back in the States. Then Japan and Australia in August…Hope to see ya there in yer wedding dress….P.S. I believe we will hit Florida, Texas and the West Coast in July…and the surrounding

states…The (merchandise) is in-fucking-sane…I can't wait for you to see this stuff… Well, there's not much left to say…It's time to let the music do the talking."

Launched on April 30th, Nikki checked in with fans in the early days of May, reporting that "we've done 2 gigs so far… I guess you could say we've had our cherry busted…It's the first time for us to all be in a hotel and hanging out together…The gear is showing up. Turn on the radio. We're on the radio here. It's just like, 'Wow, it's happening!'…(It's like) the first day of school. And we are going to sit in the back of the class and throw things. We're those guys…Tonight we're in Norfolk, Va. Going onstage in an hour…LIVING THINGS' first gig was last night…Cool fuckers…They came in from Paris… jet lagged as hell…Really love their music…AMEN, what can I say… Nicest guys in the world backstage, but onstage they're fucking evil…Goddamn… We need more bands like AMEN…Cool to see everyone singing all the BRIDES lyrics… I'm having so much fun… Feel so new, so raw… so damn real…. It's a blast to kick out some CRÜE and L.A. GUNS tunes, too…Gotta pay respect." BOD found their momentum briefly interrupted on the 9th of May when they were stopped by border agents just outside Canada and refused entry due to past felonies on the part of band members. Following the incident, Nikki commented that "I'm at a hotel by the airport in Philly. The band is back at the bus, probably on their way to some other hotel. We can't play Toronto due to past felonies in our camp, so I'm flying home for two days to see Donna and the kids. The promoter usually has these legal matters covered and worked out but he dropped the ball and we've been denied entry into Canada. I feel bad for the fans up there. The Fuse has been very supportive of the BRIDES as have the fans and we really wanted to play. Rather than sit in a hotel for a few days I'm going to grab a 7 am flight home."

Reporting into fans again shortly after landing back in L.A., Nikki began by admitting that, as much fun as he was having on the road with BOD, "it's nice to sleep in a bed. As much as I love the bus, a day off with room service and a bed was much needed. We decided to do this tour down and dirty. We only take hotels on days off. And if you look at our tour dates you can see, those are very few as well…I wanted to say thanks to all the rock fans coming out to see us. We're having a great time, I see you are too…again thanks." Forced to cancel their Canadian gigs, the band

encountered another temporary setback later in the month when, following the band's gig in Minnesota, they were forced to rush singer London LeGrand to the hospital on the way to Denver, with Nikki explaining in the aftermath of the band's scare that "the show last night was a nightmare for London... We've all been either sick or on the edge of getting sick...but when he woke yesterday he couldn't even talk... We keep thinking it would pass. But it didn't. About 6 pm we took him to the emergency room and the doctor told him not to sing. His voice was completely closed up and it could damage his voice. He got a cortisone shot and walking out whispered, 'I don't care what he says we gotta play tonight.' I called Vince [Neil] and he told me a few of his tricks he uses when he's been sick on tour. (Thanks bro!)" As the month of May came to a close for BOD, Nikki seemed creatively content with his latest project, sharing with fans via his online diary that, even while on the road supporting their debut LP, "more than ever I'm excited to go make our new album. Playing live on your first album always defines what your second record will be like...I think we've had a sky hook attached to the back of the bus cause every time we pull into town it starts raining...not that I mind. I love the rain. It's perfect for writing music...We're writing for the next album out here on the road... We're very focused on what were going to deliver... Basically, it's the same jump CRÜE made from '*Too Fast For Love*' to '*Shout At The Devil*'...We will be recording the next album later this year."

As May ended and June began, Nikki prepared to depart following a few days off with his family for the European leg of BOD's tour, giving fans a rare peak into his life off the road, reporting that "I'm home with [wife] Donna and the kids. Life is grand and then some. I'm sitting here at 7 a.m. on our ranch with windows wide open, watching the sunshine creeping in over the mountains, listening to the '70s station on XM Radio. I feel lucky to have the gifts I've received from the life. I get to live a life of a split personality and maximize them both. Any of you who have kids know the love you receive from them, It's like nothing else you'll ever receive or feel. Some of you have seen the rise and fall and rise of me as a man. Some of you have been there all along. Some of you are new to the adventure. I love looking out in the crowd seeing new rock fans standing next to old school rockers next to rednecks. What a cool fucking mix. Music has reached a place where it blurs the lines (again). The mixture of humans and styles. Actually it reminds me a lot of the '70s. The radio stations used to play BLACK SABBATH next to the BEE GEES next to THE SWEET next

to THE BEATLES. As a songwriter I can't imagine not having all that music to draw from. I sometimes think that's why songwriters have become so one-dimensional sounding in the last few years. When you're learning your craft now, what do you have to draw from radio wise? You have to bounce all over the dial to get that kind of variety. Enough ranting from me. I need more coffee."

Turning his attentions to the forthcoming European summer tour, Nikki continued, announcing to fans that "I'm so excited about touring Europe, I haven't been there in quite a few years. As for America, we had the best time becoming a band on the tour. Before we left we didn't really know who we were as a band. It takes time to figure it out. Now more than ever I'm excited to go make our new album. Playing live on your first album always defines what your second record will be like. I look at 'Too Fast For Love' and where we went with 'Shout At The Devil' and understand it was all about what happened live before we recorded ….I believe we are on the same path with the BRIDES…it will be more focused and harder…less parts and more of a straight-to-the-point style…me and Tracii want to keep the song lengths down (mostly) and the tempos up. We have some killer new songs (anthems)…again we cant wait to record. Probably in the next 4 months we will start….Two more days of soaking up all this love (it's like money in the bank) before I board that big bird to Germany. Then its all bloody knuckles and black eyes…Donna's coming out the last week of the tour…then the real trouble starts… I'll try to update you out there but I have no idea what the Internet ability is at some of these shows…. Fuck, I cant wait to see ALICE COOPER (were doing about 7 shows with him and TURBONEGRO). I left him a message yesterday asking him if I could play bass on the encores…. I'm such a fan…Have a great holiday."

Touching down in the U.K. as June began, Sixx and co. played their first European show before tens of thousands of fans as part of the Donnington Festival in , England. Following the Donnington gig, Nikki attended the Metal Hammer Awards on June 7th, where Nikki was honored with a lifetime achievement 'Spirit of Metal' Award. Reflecting afterward to fans via his online diary on the band's first wild first week on tour in Europe, Sixx reported that the "last few days have been a blur. Too much fun for one band. Hung with all the guys from DROWNING POOL, HATEBREED, DAMAGEPLAN, KORN, SOIL, LIFE OF AGONY, ILL

NINO, SLAYER, SILVERTIDE, SLIPKNOT, H.I.M....etc...Wow, we all had the best fucking time (loved watching these guys do there thing)...When BRIDES took the stage, I looked over and everybody was there... We played the smaller tent. We opened with 'Shut The Fuck Up' and to hear 12,000 kids all do the chorus together was insane.... I mean, have you ever heard 12,000 people shout 'Shut the fuck up' together?? I haven't...(Monday) night was the Metal Hammer Awards. I got the Spirit Of Metal Hammer award....Nice feeling. I'll have to take a picture and post it in the wedding album. Of course, all us bands hung out again last night. Dimebag, me and Ville from H.I.M. did a photo shoot yesterday afternoon and Dime was smashed when we started.... Of course at the end of the (Hammer Awards) we had to carry him out... Dime's fucking hardcore...Love that fucker....Rock 'n' roll...Tracii and Dime smashed the fuck outta a Gibson Explorer while the Gibson rep stood by in horror.... Maybe Gibson should treat their bands a little better... Every day has been hours of press every day...Tomorrow we do more fucking press and then the headline London show. Then off to Italy."

On the 20th of the month, BOD announced that, with their European tour going as commercially well as it was, that a brief Australian leg to the tour had been added, including dates on Aug. 12 - Prince of Wales – Melbourne, AUS (w/ SEBASROCKETS, TEARGAS) and the Aug. 13 - Gaelic Club – Sydney, AUS (w/ HELL CITY GLAMOURS, THE SPECIMENS). Still, even as the BOD were out front in high gear, behind the scenes Sixx had already begun quietly brainstorming with manager Allen Kovac on how to kickstart a long-promised Motley Crue reunion, with Chronological Crue reporting on the 29th of June that "to accomplish a Mötley Crüe reunion tour, an agreement is reached this month for the band to now be co-managed by Allen Kovac of Tenth Street Entertainment, Vince's individual manager Burt Stein of B Entertainment, and Tommy's individual manager Carl Stubner of Carl Stubner Productions (Stubner is also the individual manager of Mick Fleetwood as well as being a co-manager of Fleetwood Mac). Kovac and Tenth Street reduce their traditional 15% management commission to 12.813%, enabling Stein and Stubner to receive management commissions for services to Mötley Crüe at an agreed rate of 1.875% and 1.563% respectively. Mötley Crüe now pays a higher total commission so that each of the managers is responsible for the band's management and subsequent successes or failures. Kovac acts

as the band's lead manager and supplies the resources through his company to execute the band's strategy."

Returning to the U.S. for the month of July, Nikki took what seemed to be an open-ended break from BOD business to attend to an agenda that he reported in his online diary as including "the good, the bad and the ugly. The good: Finally Donna and I are taking the kids on a vacation. 10 days of nothing but sun, sun and more sun. A well-deserved break for all...The bad: The BRIDES have passed on anymore American touring this year. We are in talks to go back to Europe as a headliner in 2500 seaters in October or November. Europe reacts so good to live bands, America reacts to better to radio. We've yet to crack radio in America. Playing all those festivals in Europe really exposed us to a lot of new fans...we will do America and Canada on the next album. Sorry guys...The ugly: I'm afraid the ugly is I will be suing Dragonfly Clothing. They have never accounted to me (no matter how many times I've asked) or paid me what they owe me. We grossed millions of dollars in sales and I've yet to see hardly a dime. Now that it's all said and done I'm being told this isn't uncommon for this company. The sad part is brothers run the company and the father oversees the company. The father begged me to help his sons get off drugs and straighten up. At that point I was in too deep and decided to give it my all, only to get fucked over. Half the company has quit and the other half are planning on leaving as we speak. All I can say is, remember Elektra Records? How about Vans?? You're next. See you in court."

Following his return from a well-earned family vacation, Nikki departed the U.S. once again to complete his final round of BOD touring obligations in the Pacific Rim. The band began with a pair of sold-out Japanese shows, including a headlining spot at the Osaka Summer Sonic Festival before heading to Melbourne, Australia to kick off 3 sold-out concerts. Reflecting on the BOD's first tour as it wound down, Nikki reported in what felt like a fare-well of sorts- in context of BOD- to fans via his online diary that "tonight is the last night of the Australian (BRIDES OF DESTRUCTION) shows. All sold out and all amazing. The Aussies treated us like gold and I hope they feel the same. The lessons I've learned (more confirmed what I already knew and always believed) from touring the world with the BRIDES is rock 'n' roll is alive and real music matters. The core is about to sore. Admittedly style is cool, musically and visually. Yes, we walk the rock. And I'm proud to list bands that not only have

musical but visual integrity dripping off their very being. Funny how time clears away the past so we can clearly see. Isn't it so obvious now that alternative was so much about fashion? (when all they said was were rebelling against bands that worry about image) I mean, I never seen so many bands with all the same clothes and haircuts in my life. I wonder now if the wardrobe designers weren't in on helping to tear down what rock 'n' roll has always been about. (rebelling). What was so different about alternative to the contrived pop shit of today? Excuse me for rambling, Red Bull and lack of sex does that to a man. I guess I've always worn my opinions on my sleeve. Makes for an easy target. Of course opinions are like assholes, everybody has one. But I always say, 'You'd be a real asshole to not have an opinion.' Makes for a nice catch 22, doesn't it?! Also, opinions can change, which makes for nice a contradiction (ah, yes, with that I firmly place another target upon my back). Let me take this moment to say I've been led down the road a few times only to back out scratching my head, wondering... Sixx, what the fuck were you thinking?' There was a time when I thought some of the music out there wasn't half bad (now I wonder if it was even half good). Now I think I must've been on drugs (oh ya, I was). I mean...what the fuck is up with rap??? What once was a music breed out of a real lifestyle has become a corporate onslaught of rubbish. Oh god, and DJs...(if I hear, scratchity scratch in one more song, I'll puke). Enough already. I mean, Guitar Center was at one point selling more turntables than guitars.... Fucking hell... They should've changed the name to Turntable Center already...Well, I leave you with enough ammunition to load up your sharp shooters and take aim. Beware the bullshit...Rock 'n' roll is alive and breathing in my heart." It was also very much alive in the hearts of Motley Crue fans, enough to kickstart a formal campaign by European concert promoter to resurrect the band.

Arriving ack in the U.S. to a whirlwind of rumors swirling around the internet that a Motley Crue reunion was impending, Sixx's public comments earlier in the spring had been elusive- whether deliberate or otherwise misleading in an effort to further raise speculative hype, such that, according to Sixx at the time, "Mötley is a dysfunctional band, at best! Communication is not always really open. One of the biggest problems is that Vince has his own manager, and Tommy has his own manager, very much like a lot of bands. Mötley Crüe has a manager who manages me and Mick and Mötley Crüe. So, when we're making decisions for Mötley Crüe, we're making the decisions, and a lot of times, Vince is out of the decision

process. Being out of the band really is being out of the decision process. A lot of things that are done for the betterment of the group aren't always individually based. They aren't self-serving, but they're all of us serving. So, what happens is that people start feeling like, 'What do you mean we're doing a movie?' Then we sit down and we talked about doing a movie. We said we were going to take a hiatus, and three years later, we have gone and got the movie and all this stuff. Vince is like, 'I'm not involved, so I'm not doing it.' Then I have to sit down with Vince and show him that this is all the stuff that we said we were going to do. A lot of it is his management not being involved in the process, because they don't manage the band. Now, we've sort of gotten rid of his manager and Tommy's manager. They are sort of on the sidelines. They still manage those guys as solo artists, but now everyone is in the same camp, and we've kind of gone, 'Yeah, OK,' and now it's all making sense."

Still, when he'd been pressed during the early summer while on tour with BOD, Nikki had seemed more open to the possibility of a reunion, commenting that if it happened, "it'll only be once. If we play together again, it should be an HONEST farewell tour, and go out as a band you can never see again, that you can only hear about… It's nice to hear that fans, bands, promoters and agents would like to see a Motley Crue tour. But right now I know Vince is booking tons of live shows, Tommy is busy promoting a book and doing his reality show and Mick is in rehabilitation after surgery (Who knows when and if he would feel up to it even if there was a tour) It takes four guys to do it. It hasn't happened since 1999…All I know is all four of us haven't been in the same room in six years. In the world of Motley, I'd say don't hold your breath." In spite of Nikki's public denials, with public pressure building, by the middle of August, the cat was out of the bag, with singer Vince Neil reporting that "two weeks ago in L.A., Tommy, Nikki, myself and Mick by phone sat in a room together with all the attorneys to see if we even wanted to do this…The fans are asking for it and I think it's time. It's a good thing and a good time to put a 'period' on the MÖTLEY CRÜE story. After, we'll call it quits and go back to doing what we've been doing for the past few years. It'll be closure for me — and this won't go on to be seven or eight 'farewell tours' like KISS or CHER… Everyone is on board and 95% committed. It's definitely time."

In spite of Neil's comments and the broader hype that continued to build in support of the band's reunion, significant obstacles still remained to re-assembling the Crue, beginning with the literal re-construction of guitarist Mick Mars, who could no longer walk due to the severity of his crippling Angoloid Spondalitis disease. In describing the reality of how crushing the impact of the disease during Motley's hiatus had been on him physically, Mars explained at the time that "it changes up your spine, it affects your eyes, you can't see as clear with them. Right now, my disease has gone up to my brain stem and into my throat and stuff - I have one vocal cord working and the other is dead. I have a team of doctors trying to figure out how to get it back so that I can have a full voice again. It's like there are bones growing over your bones and shifting it up - like if you were to put a brace on your back, then try and stand up, you can't do it. It gets to your hands, it gets in your elbows, it gets in your knees, any place there are joints. It starts in the hips, and that's why I had the one replaced and need to do another one. It has nothing to do with age - you could be 17 or 18 years old and have it, and what happens is, they need to cut it out, or it goes through your whole body…And you go to the doctor, and they give you the quick fix, so I had to get myself off that whole thing, too. They don't try to treat it, they just give you pain pills. Well, why don't you do anything about it? Overseas they do things, they have remedies, and they work like eighty percent of the time, but over here, the doctors really don't seem to know a lot about it, and it's really upsetting."

While Mars underwent dual hip replacements, Nikki privately continued lobbying drummer Tommy Lee, whose reluctance to rejoin the band was proving equally as challenging as Mars' healing process, and quickly becoming the band's collectively. Beginning with the drummer's reply during the band's initial meeting to the proposition of a reunion that "going out and playing the same songs I have for 20 years with you guys doesn't excite me all that much," Sixx and Kovac had later strategized that new music might be the only way to interest Lee. With Nikki's reasoning that new material was in order, first because "we've pretty much depleted the vaults," he disappeared into the studio, devoting the balance of August to beginning that process. Resurfacing several days in to September with a report for fans via his online diary, Nikki had clearly been working around the clock, revealing that "(I've) been doing alot of songwriting for (Motley)…With regards to the direction of the new material, they're very MÖTLEY sounding, I'd say *'Dr. Feelgood'* meets *'Shout At the Devil'*. I think

you're gonna freak out when you hear these. It's true rock 'n' roll. Nothing more, nothing less."

Continuing, Sixx's next update reflected progress in the daunting task of reuniting the Crue, in as much as it had begun in the studio, with Nikki reporting on the 12th of September that "I'm in Vegas with Vince right now. He's singing on some demos. He sounds amazing, looks amazing as well. We're loving the new tunes and having a blast…He sang the best I've heard in in years…Of course, these are demos and we're looking at recording them (properly) in the very near future." Keeping his word, by the 17th, Nikki followed up with another update for fans, reporting that "I have finished up the production on the MÖTLEY demos. I feel real strong about the songs. They're on their way to Bob Rock to get his input. I look forward to re-recording the songs now that everybody will have a clear understanding of the direction of the music." For producer Rock, who had remained close to Nikki throughout Motley's hiatus and had been pivotal in luring Tommy back to the studio, the prospect of a new Motley Crue reunion was appropriate and timely for all the band's members. As Rock reasoned in looking back on his work with the Crue on their first new studio material with Tommy Lee in over 6 years, "I think the Brides is good, but its more of the same stuff. Its almost like Tommy's stuff, its kind of good, but its like the *Methods of Mayhem* stuff, that's so Tommy. Its so sympathetic to what Tommy wants, its Tommy's world. So the Brides of Destruction is sort of Nikki's world. There isn't really a Vince thing or a Mars thing, maybe Vince had a solo album or whatever, and really that summed up what Vince individually is about. But the thing is, I think with any great group, for instance, the new Joe Perry album is exactly what you'd expect from Joe Perry on his own. The guys in Brides of Destruction, basically Nikki was leading, so he got to do exactly what he wanted, exactly what his version of what his version of what it should be. I think his version of what it should be is best translated by Tommy, Mick and Vince. Bringing their qualities into his mix makes Motley what it is. So its not that the Brides wasn't good, it just didn't work as well as it does with the four men of Motley. In my opinion, it's the same with Tommy."

By the beginning of October, Tommy had in fact completed work on 3 of the 4 new tunes which Nikki had written in mind for the group's reunion, which also took another step toward fruition when guitarist Mick Mars' underwent hip replacement surgery at Cedars Sinai Hospital in Los

Angeles on the 4th. Upon successful conclusion of the operation, Mars' surgeon Dr. Brad Penenberg had reported that "the surgery went extremely well and I expect him to be walking with the help of a physical therapist as early as Wednesday morning." Following the operation, Nikki also reported to fans that "I was with Mick today…He looks amazing. I can't believe he just had his hip replaced and he's already walking around crackin' jokes… Strong motherfucker….He said thanks to everybody for the good wishes." Adding his own public statement- perhaps to keep fans' interest publicly, and Tommy's privately- manager Allen Kovac pointed to the success of Mars' operation as indicative of the Crue's collective resilience as a band, commenting that "Mötley Crüe is a gang of musicians that climbed the mountain of rock to success. A healthy Mick Mars gives hope to all those who love one of rock's most passionate and aggressive bands." The appeal seemed to resonate with Tommy, who later would concede that seeing Mars for the first time in years following the operation was "fuckin' strange…seeing Mick was really freakin' me out…Really freakin' me out. I was sitting there…when he walked in, and I was like, 'Whoah!' It made me extremely sad - it's just fuckin' crazy! The doctors are saying he's going to be fine by February, but they must know something I don't know. We're all supporting him, and we're all being buds, but it looks painful. I don't know what to say. It's quite a shocker, actually."

While Lee might have still been warming to his band's reunion, Sixx and producer Bob Rock were thick as thieves, both in the studio and out, with the producer even attending an October 7th benefit at Green Acres Estate, where the City of Hope Spirit of Life Award was presented to Van Toffler. Still, in spite of the band's behind the scenes progress, throughout the month Nikki would remain publicly uncommitted to confirmation of the reunion, commenting following Mars' operation that "(no one) knows when and if he would feel up to it even if there was a tour. It takes four guys to do it and it hasn't happened since 1999. All I know is all four of us haven't been in the same room in six years, so in the world of Mötley I'd say don't hold your breath." Clarifying Sixx's statement, producer Bob Rock confirmed to the Los Angeles Times that while the band had in fact recorded new material, because of Protools digital recording technology, unlike the band's analog heyday, "I didn't say they were all in the same room at the same time." Perhaps seeking to further flesh out Rock's statement, Sixx did add to his inconclusive commentary regarding the band's touring future that while he wasn't "sure where they will turn

up...like any good splinter, I'm sure they will work themselves out and break through to the surface sometime. Who knows, not me."

Drummer Tommy Lee even got in on the game of teasing fans with uncertainty even as signs of the opposite mounted, confirming that "I did get together with Nikki and record a couple of tracks...But as far as all four of us being in a room together and deciding to go on a tour, that's just a rumor. We haven't decided that yet. Mick [Mars] just got hip-replacement surgery; he's been really ill for a while. So no, we haven't been able to do that." Echoing the band's official line of denials, singer Vince Neil added that "at one point, I thought (the reunion tour) was definitely on — now, I don't now. You know, if it happens, it happens — if it don't, it don't. I'm gonna let other people worry about it. You know, I'm not gonna change my, you know, my schedule of anything to conform with something that might or might not happen...I don't have any details to give out. It could be or it couldn't be. We're not sure what we're doing. Everybody's got their own things going right now. I've been on tour since April, I've got a new record coming out next year and Tommy's doing his book thing and whatever. It's hard to get four busy guys together to do something as massive as a MÖTLEY CRÜE reunion." Still, in spite of the band's repeated public denials that a Crue reunion was eminent, Sixx did confirm for fans as October came to a close that so too would his active involvement in the Brides of Destruction.

As 2004 approached its conclusion, so too did the speculation about whether Motley Crue would in fact reunite for a world tour in 2005, with Mick Mars' recovery progressing to the point that the band had in fact united for a top-secret reunion shoot in the early part of the month. Moreover, Tommy Lee had concluded an October book tour promotion his NY Times Best-Selling personal Autobiography, 'Tommyland', prompting his manager to confirm to Motley's that "this is doable." By the 19th, Nikki Sixx publicly confirmed for fans via his online diary that while the band still had to work through "a lot of issues...(there has been) some progress...We (all) got on the phone over a week ago and it felt good. We talked about how this promoter in England came to us with all this info on how there's a huge buzz on the CRÜE (worldwide) and is pushing for us to tour. (Again, it's the fans who create the excitement for a band)...We all agreed to get together in the flesh and did a few things that we will be able to look at in a couple weeks." Still, in spite of Nikki's best attempts to

keep any official announcements by the band under wraps, within a week of his post, an official casting call for the band's new single, '*If I Die Tomorrow,*' had gone out to the AP, seeking a "brunette, female, caucasian, light hispanic or light mixed ethnicity (exotic), 18 to 24 yrs old, hot, great body, voluptuous. Must be able to act and must have curves. She will be in every scene of this video. Great exposure, VH1 is doing a behind-the-scenes show and launch for this."

The truth of the Crue's impending public reunion announcement was further confirmed by radio personality Eddie Trunk's announcement on November 26th on NYC's Q104.3 that he had been booked by VH1 to interview the band in early December about their reunion. More officially, on November 29th, Motley's management company announced the early spring, 2005 release of the '*Red, White & Crue Anthology*', a 2-cd set featuring the band's greatest hits, as well as 3 of the 4 new songs they had recorded during the fall. By the beginning of December, MTV.com officially reported that the "Original Lineup Of Motley Crue Reuniting For World Tour…Five years after an ugly divorce, the original lineup of 1980s hair-metal legends Mötley Crüe reunited and returned to where it all started Monday night for a small concert with a big announcement: 'We're baaaaack,' as Vince Neil put it…The Crüe will kick off the Red, White & Crüe Tour … Better Live Than Dead on February 17 in Ft. Lauderdale, Florida, hitting about 25 U.S. cities before venturing to South America and Europe…Rumors of a Mötley reunion have been floating around for a few months, although fans wondered whether drummer Tommy Lee would be a part, being that he vowed to never play Crüe tunes again when he left the group in 1999. When a reporter asked which bandmember called him, Lee answered, "I don't think that's important. What's important is the fans want it. This one's for the fans." Signifying being back from the dead, Neil, Sixx, Lee and guitarist Mick Mars arrived together for the announcement and concert in a hearse…The Crüe treated fans in ripped jeans (mostly the guys) and skimpy lingerie (some of the gals) to a five-song set that included old favorites '*Dr. Feelgood,*' '*Shout at the Devil,*' '*Girls, Girls, Girls,*' '*Wild Side*' and a new song called '*If I Die Tomorrow,*' which will appear on a 37-song retrospective, *Red, White & Crüe*, due February 1. The newly recorded '*Sick Love Song*' and a cover of the Rolling Stones' '*Street Fighting Man*' will also appear on the album…The group's next live gig will come Friday on the 'Jimmy Kimmel Live' show, followed by a December 14 appearance at Spike TV's Video Game Awards. Following the first round of

foreign dates, the band will return to the U.S. in August and September for a string of amphitheater shows and will finish the year touring Australia, New Zealand and Japan. Details on the show are still being worked out, but the band said to expect something big."

"We're professional liars...I looked right at this radio station guy's face in this interview and said, 'Dude, there's no way we're getting back together.' I got a call from him (saying) 'Thanks, fucker.' " – Nikki Sixx, Rolling Stone Magazine, Dec. 2004

Chapter 25

Motley Crue is Back!!

 As the band finally and officially lifted the lid off their long-rumored reunion, December of 2004 proved to be a whirlwind for the group, promoting the reunion tour, which the band had booked independently of a major promoter, in classic Crue-betting-on-their-fans style, and it was paying off in spades. Selling out Madison Square Garden in 7 minutes, with their booking agent reporting the band's sales to manager Allan Kovac as a "comeback of Led Zeppelin-like proportions." Still, while all four band members were on board with fans' instantaneous demand for the reunion, drummer Tommy Lee for one explained his primary motivation for going along with the expedited pace as being a result of "What's important right here right now...(which) is the fans want it...(But) I'm going to be really honest with you, I just think this is all really rushed."Beginning with the band's new material for the 'Red, White & Crue' anthology, with Vince explaining of their creation that "Nikki wrote all of it, I had nothing to do with the songs, zero--I just came in and sang. I did demos with Nikki in Vegas, four or five songs, then I just went to L.A. and did the four songs in three days."

Elaborating in greater depth on the songs' creation, Sixx explained that "when we tracked the four new songs, we weren't all there at the same time. Tommy was doing a book tour (and his show), Vince was doing gigs (and his TV show) and Mick was in surgery. Welcome to my crazy world. This is how it had to work. We played the guitars (scratch tracks) until Mick was out of the hospital and he could do his own parts…I wrote a song with the lead singer and guitar player from a band called Simple Plan. No, we didn't do their song. I also wrote with Bryan Adams and others in my career. I love to write with all kinds of artists, you would be surprised at the cool music I've been involved in when collaborating with others. I love it. Also, when Saliva did Rest in Pieces, did Mötley write their single because I'm in the Crüe? No. I also wrote with Stacey from American Hi-Fi recently… We feel (the new song) is a breath of fresh air for us… It's us evolving and growing, and we don't really give a fuck about rules. We just want to make music."

Tracii Guns, Nikki's ex-Brides of Destruction bandmate, seemed less than excited about the band's new HIT single, *If I Die Tomorrow*, commenting via his online diary that while "I am the biggest Mötley fan in the world and this new song sucks donkey's ass, elephant's ass and my mom's ass. Vince's voice has never been better and they made him sing this shit. I am embarrassed. Yes, Nikki's my best friend, but I ain't goin' along with this one 'cause I would look like a donkey's donkey. Look at it this way… If I brought in a song like that for Brides, I would surely get fired and Nikki would be very vocal with his opinion as well. That's what friends do. Unfortunately, friends don't always listen to each other." In response, Tracii would soon thereafter report that "Nikki had me banned (from posting on Crue's official message board…HAHAHAHA HAHAHA HAHA… It's an honor to be banned by Nikki Sixx. How do I get hooked up with these egomaniacs???? I just WANNA ROCK!!!!"

In rebutting Guns' posting, Nikki denied responsibility for the ban, explaining that "I don't have any idea. I'm not in the Brides. Maybe the webmaster had his fill of the bullshit." Elaborating in greater length on his time in BOD, Nikki reasoned that to pull off a reunion with such monstrous demand, "I put my heart and soul into the new Crüe. So there, I said it…disappointed in a friend. As far as heart and soul, I put it into the Brides too. I used every connection of mine for the band (got us a record deal, merch deal and world tour on my name), pulled favors and

funded it myself. So do I believe in it? Fuck yes, or I wouldn't have done that for us. Do I believe they can go on without me? Hell yes." Tracii shortly thereafter announced of the Brides' future that "I have had great talks with London and Scot and we have decided to move forward with the Brides of Destruction. We are gonna take it slow and make sure we get the right guy to fill in for Nikki. As you know Nikki has to leave for now and there is a possibility that he may not ever come back to the Brides, so whether or not the new bass player is temporary or not we have to choose assuming that he will be a permanent member of the Brides brotherhood. We are finishing up the new songs right now. As soon as we find our new brother we will go straight into rehearsal and recording. The wedding is over. Let's get the reception cookin'."

Back on planet Motley, addressing the question of how pivotal Mick Mars' medical condition had been to motivating the group's reconciliation, singer Vince Neil bluntly confirmed that "Mick's health was a huge concern…He was so frail. Tommy and I had our doubts about whether he was going to be able to do this show. I think without the motivation of Motley, Mick would still be sitting in his house talking to the walls…This whole concept of Mötley coming back together probably saved Mick's life---It gave him something to do, something to hope for. Without doing this, Mick probably wouldn't have had the surgery, he probably wouldn't have gone to the hospital, he'd have just laid around doing whatever it was he was doing, and one day we'd get a phone call saying that he died in his sleep---That's something that none of us wanted to happen. I see this as a sort of divine inspiration---This Mötley thing gave him something to kind of live for." Ever-positive Nikki Sixx the skepticism, instead imploring fans to "give the guy some respect. He is the man of steel. He's had surgery, recorded new music, done photo sessions, interviews, a video, and is right-now playing like a motherfucker. Amazing – I wish I had his strength."

Rolling Stone Magazine reported of his deterioration months before band had quietly begun making plans for a reunion that "if Mick Mars wasn't onstage every night watching barely legal girls flash him their tits, he might be dead. Less than a year ago, before the fifty-three-year-old Mötley Crüe guitarist reunited with his bandmates for what has become one of 2005's most successful tours, he was holed up in a tiny Los Angeles town house, sleeping on an inflatable mattress. His face was framed by a wiry,

overgrown beard, he weighed a hundred pounds, and he couldn't walk unassisted. He had been in a major depression since he split up with his longtime girlfriend — the third in a string of gold diggers he had a tendency to hook up with — and had been forced to move out of his home after it became contaminated with killer mold that gave him such a severe case of pneumonia that his doctor gave him two days to live. He was hooked on OxyContin and taking enough of the painkiller that he was convinced aliens were trying to abduct him. Mars was, in essence, a goner... The guitarist has suffered most of his life from a congenital degenerative bone disease called ankylosing spondylitis, which has made the vertebrae in his spine gradually fuse together, preventing him from standing fully upright. By last fall, his condition had progressed to the point that he needed to have his right hip replaced — a procedure that Kovac and Mars' bandmates convinced him to undergo. 'I told him that it would be easier to get a superstar guitar player like Dave Navarro than to help him get better,' says Kovac. 'But we wanted to do this tour with him, or it wouldn't have been the real Mötley Crüe.' "

Elaborating on the latter, longtime producer Bob Rock, who'd produced the band's first studio material since 1999, felt no one other than the four members of Motley Crue could have authentically lived up to the band's legend, reasoning that "if I had produced the *Brides of Destruction*, I would have done it as a favor to Nikki. And I did consider doing it as a favor, but to me, and I'm speaking very candidly here, its kind of like with Tommy's got an immense amount of talent, and this is what always gets groups- Nikki can do *Brides of Destruction* or *58*, Tommy can do *Methods of Mayhem*, or his solo albums, or whatever, and there's gonna be a certain amount of people who are really gonna like it. But the collective of the four guys, just look at it as something unique, and that unique thing. And there's a reason why it works, through that collective force. You can do all those other records all you want, and have a really great time, but both co-exist, and eventually you will always come back around full-circle to Motley Crue. My philosophy is- with any band, an individual's mind will ruin anything good. Basically, logic in bands and individual personalities destroy bands. In music, there's a certain amount of logic, but I think its underrated that rock music, and heavy rock music. Both are as artistic as classical or jazz, and there's a dynamic into it that's very delicate and mysterious, much like some of the greatest bands and artists of our time. It's a delicate balance, within all those personalities, the time, the music-

there's so many things that come into it. I think working with both Motley and Metallica through the years, as well as any other band that I've had a long relationship with, its just realistically individual personalities, and those people and their thoughts and their logic, and some of the things they come up with just ruins the music and the bands. It's just what bands do right from the Beatles right up to whose falling apart at the moment. It's impossible to completely prevent it, much like you can't reverse the divorce rate either. I think today- more than ever- is the generation of me. And I think musicians are definitely, first and foremost, huge in terms of egos and the ME factor in today's music and today's culture is huge. I think that's why the divorce rate is the way it is, and why so many bands fall apart. That trademark of Motley Crue, is something they've worked very hard for almost 25 years to create. That's what I think works best for them in the long run."

Mars, for his own part, explained that "I refuse to be exploited. We all have reasons to come back. They have their side projects, but I don't think those are anything too serious. It's really rough for me being out on the road, it's rough keeping up with the schedule. It's rough enough for a healthy guy, but I weigh 112 pounds and I'm not fully recovered yet, and I've done all this stuff already that's really wearing me down faster than I can heal...There's a lot of flying around, playing live at radio stations, then playing live at night, doing promotions like Macintosh - two, three, four places in a day. Even on a Lear jet, I still couldn't get healthy...It's kind of like if you wake up from a deep sleep, and have to go straight to work and can't go back to sleep - you're going to be tired. You need to catch up on sleep before you can really be awake. I have to be healthy before I really start working again." Vince Neil, elaborating further on the real-time state of Mars' health in context of the band's rigorous promotional schedule, reported that "Mick's very frail, but he's always been that way. Now he's extremely frail, and I'm just trusting in his doctors that he's going to get healthier and healthier. Mick had a hard day yesterday at the photo shoot, and today at the video shoot, those are long days---He's only got to be onstage for an hour and forty five minutes, and we're going to make it as comfortable as possible for him." Drummer Tommy Lee added that "my heart wants Mick to get well, and then let's go fuckin' rip it, it'll be awesome for one last time. But he's not in good health right now, and a lot of this doesn't feel good to me. Everyone else is in a good headspace here, but if I were running the show, I'd wait 'till he was absolutely one hundred

percent, then go fuckin' rip it. This is scarin' me, but the doctors are saying he's gonna be fine."

Mars would need the strength given the band's ambitious tour plans, with Rolling Stone Magazine quipping of the production that naysayers shouldn't "even suggest that the world was not desperately awaiting a Motley Crue reunion. Because it was, and they knew it, which is why the Crue is back, with all four original members hitting the road to violate each other's probations and respect each other's higher powers." Discussing the specifics of the tour, aptly-titled the 'Carnival of Sins,' which had hit Pollstar's # 1 Slot by December 17th, Nikki Sixx excitedly announced via his online diary to fans: "Here we go, buckle up and hold on tight. The engines are engaged and the runway is clear for takeoff. Lights, action, rock 'n' roll. Here we go again on Dysfunction Junction Airlines. We only guarantee one thing, it's gonna be unpredictable. God must love a drama, or he wouldn't have created Mötley Crüe. Like going to the car races, so many of us hopefully will see a car crash. Macabre in nature... we expect to be entertained. We won't disappoint. The journey starts here." Tommy Lee added that "we're meeting with some very, very crazy people right now. They're all as crazy as us, so I can't tell you what the outcome is 'cos I don't have a crystal ball. But I can just pretty much guarantee when you get all these people in the same room, there's going to be some fucked up shit that's going to happen...From what I know, it's something like 35 shows in America, then Europe, Japan, (and) Australia." Addressing the question of choosing a supporting act on what had quickly become one of rock's hottest tour bills, Nikki explained that "we are in the midst of looking for someone we respect and would be refreshing and cool, so it's a little premature right now. Now that the shows are selling out, we're looking for people to be a part of this tour."

With fans and the industry looking toward 2005 and beyond, the gamble the band had played with booking the first leg of their reunion tour independent of skeptical promoters had paying off handsomely. Nikki summed up all the hype over the band's reunion by concluding that "I'd think there is something to celebrate for all four of us to be doing this, and the fact that we don't do what people want or expect is the heart of Mötley Crüe." Perhaps the band's only down note that December came with the news that dear and longtime friend, Pantera guitarist 'Dimebag' Darrell Abbott had been murdered onstage by a crazed fan, inspiring Sixx to comment via his online diary in an ode addressed directly to the guitarist that "Dime, I will never forget all the times you made us laugh. I'm so happy we got to spend the day together in London recently. We should all live our lives as full as you have. I will miss you, as will all of us. This is a sad day." As Chronological Crue reported, the band capped their whirlwind promotion with a December 31st performance "on The Tonight Show with Jay Leno to a huge, live national TV audience, including a simulcast on huge Sony screens into Times Square, New York City. As Leno introduces the band, he announces that, per intense fan demand, they are adding twenty five new dates to their Red, White & Crüe Tour 2005 … Better Live Than Dead. The band rips through a tight performance of *Girls, Girls, Girls* with Vince wishing Tommy a "Happy Fucking New Year" mid-song. The band then plays *Dr. Feelgood* to bring the show and 2004 to a close. NBC edits out the offending word for West Coast viewers after airing live without a five-second delay to East Coast viewers." Heading into their long-awaited 2005 reunion tour, the sky was the limit for a band who had defied their own expectations- along with the rest of the world, inspiring Rolling Stone Magazine to muse that "It was only a matter of time, though, before the kind of Eighties nostalgia that has put leg warmers back on the market and New Wave back on the radio resuscitated Mötley Crüe. As comebacks go, this one is monstrous."

Chapter 26

The *Carnival of Sins*

Motley rang in the New Year in true Crue fashion, earning a lifetime ban from NBC as a band because of Vince Neil's utterance of the F-bomb to Tommy Lee while live on air- ironically enough in a positive context considering their negative history toward one another in the years prior. In response, the band sued the network, earning them another mega-wave of press, including the Associated Press/CBS News' report on the lawsuit, which explained that "the network banned the band for using an obscenity on the 'Tonight Show' on New Year's Eve. In a federal lawsuit filed in Los Angeles, Motley Crue claims the ban violates the group's free speech rights and has hurt its sales. The band also asserts that the ban was an effort to mollify the Federal Communications Commission, which has taken a hardline approach to the use of on-air obscenities. Details of the lawsuit were reported by the New York Times, which reported that "the FCC looked into the 'Tonight Show' incident. Motley Crue rocker Vince Neil dropped the F-word while wishing bandmate Tommy Lee a Happy New Year. 'Happy Fucking New Year, Tommy!' Neil said to Tommy Lee shortly after midnight. The remark was heard by viewers in the East but was edited out before a taped version of the show aired on the West Coast.

Leno normally tapes his show for broadcast later in the evening but does a live version for New Year's Eve. He had never a problem with profanities before, although the word has slipped out from time to time on other programs. 'We meant no harm, but it feels that we're being singled out unfairly,' Nikki Sixx, the band's bassist, told the Times. 'This is a discrimination issue, pure and simple.' NBC issued the following statement: 'To ensure compliance with its broadcast standards, NBC has the right to decide not to invite back guests who violate those standards and use an expletive during a live entertainment program. The lawsuit Motley Crue has filed against us is meritless. The FCC, in a ruling issued last year, said the F-word should never be used on over-the-air radio or television programs."

In spite of the set-back, the band was again dominating the controversy category in the press, as had been a tradition at the outset of any huge year for the Crue, and by the very start of January, 2005, word of Motley Crue's reunion had already spread like a California canyon fire. Engulfing the rock genre in a storm of excitement that lit a fire thereafter under the collective ass of hard rock, Rolling Stone Magazine qualified the band's momentum by reporting that "as comebacks go, this one is monstrous." Commenting for the band's part on all of the aforementioned, Nikki Sixx began by reasoning that "as far as the FCC probe and MÖTLEY CRÜE (On 'Leno'), wouldn't our country be better served if our government put their resources in better places? This is just proof that we are moving backwards. A four-letter word slip-up after midnight is not world news, but considering their ridiculous stance, I will say it reeks of the 1950s…Anyway, doesn't Motley Crue usually do the probing?…About Mick Mars and all the rumors of his replacement? He was the guy whose bone disease had tore him physically down and wore out his hip. He was the one who said 'I'm gonna get this fucking hip replaced,' so you guys better be ready 'cause I wanna go kick ass. We are, he has and the rest, as they say, is history…See you CRÜEheads on tour!"

While the lawsuit made headlines, the Crue's reunion tour was the true toast of most towns across America, fueled in large part by the buzz surrounding the 'Bring the Crue' campaign, which had been launched by fans- in conjunction with regional promoters- in response to the instantaneous sell-out of the band's first leg of announced comeback dates. With campaigns (thriving) in over 30 additional markets, Motley quickly

shot to the top of Pollstar's Top 50 Concert Chart, prompting Crue manager Allen Kovac to issue a statement confirming that "as soon as the initial tickets went on sale for the tour, we got offers for seventy more cities…but we can only schedule twenty five North American shows because of our European schedule, so Mötley Crüe has let the fans decide where they are going." Underscoring just how amazing the response was, drummer Tommy Lee- seeming the most surprised of any band member by fans' reaction- admitted amid the hoopla that "I was apprehensive before we started…I wondered, 'Does anybody care?' I'm blown away. Maybe I forgot how much people liked us."

For his part, singer Vince Neil- with whom Nikki had remained close during the band's hiatus- commented that "I guess everybody has their own reason for doing it… Mine is really the excitement of doing it--I can tour forever, and I love it, and I have been, it's fun for me. But to do it again with the guys, even if it's just one more time, doing it again, and the fans that haven't seen us, watching a new generation of kids enjoy it, that, to me, is really, really exciting. That's cool…There's so much shit to do at a Mötley show, and that's the difference to me-- The realism…I definitely think that music does (need that)…Right now it's like the bubble gum '70s. It's sad to say, but it really is--It's the prefab crap! When you've got the younger brothers & sisters of people that are doing stuff, just because they've got the money to make their brothers & sisters stars, that's sad…The fans are still fanatics, and there's still that rush--- When we play 'Wild Side', people get fucking wild. We've got the shit going on, girls dancing on stages, the visuals, the lights, it builds you up into a frenzy, it's part of Mötley Crüe. And this will be full-blown Mötley Crüe--- What you remember, and what you've heard about… I think the world is ready for some rock 'n' roll."

Elaborating in more detail on how the reunion came together as quickly as it did, Sixx explained that "it was time to get everybody's schedules cleared and get back to the mother ship, so to speak. That was a bit difficult. The core of it was, we either want to do it or we don't want to do it. Once we got to that place, it sort of took on a life of its own. None of us had a crystal ball. We knew the band would have an insane show. When tickets went on sale, would it be 1,000 or 2,000 people, or the numbers that it ended up being? We didn't know. We were blown away. I forget what the first date was, but Madison Square Garden was one

of the earlier ones. The band's never been over-the-top huge on the East Coast, and some of those first shows went clean in a very short amount of time... A lot of the promoters didn't jump onboard. We rented the buildings ourselves. So, later, when they wanted us to come back, we said, 'Well, it's going to cost you, because we just made all the money and why would we give any to you now?' "

With demand firmly established, the bands' attentions were fully focused on meeting it with a stage show that lived up to both the legend of the Crue's past live debaucheries, and that answered the new wave of hype that had accompanied their recent comeback with a punch only Motley's live shows could pack. To that end, Nikki Sixx- in describing what the Crue was putting together behind the scenes, commented that "I think rock shows are dated and passe if there's not something theatrical about them...Where's the new Steven Tyler, Johnny Rotten and the Ramones? Stop boring us. Let's blow some shit up! Let's be politically incorrect. Let's fucking whip our dicks out onstage. It's time! All the sickos are coming out for this tour -- if you go, you're gonna get laid...People have always said that Mötley Crüe is a rock and roll circus in a dark, demented, and unhealthy way. So I guess you can say we're taking the circus on the road...It's about what happens on stage, whether we can deliver it in a hungry way that is who we are in our hearts. It doesn't matter if we're 20 or 30 or what. Time doesn't fuckin' matter, it's the attitude. And I love that. Johnny Thunders was that way, it doesn't matter. Some cats, Iggy Pop, they're going to always have that hunger. So if your album sells, that's cool, more people find out about you, more people get turned on to what we're really about...which is a live rock and roll band."

Elaborating further on the technical side of assembling such a spectacle, Sixx recalled that "one of the first things I noticed is, all the people that were hired on as our crew or (for) the overall project said, 'Oh, my God, I've been so bored for the last 10 years. I am so excited to be on a Motley Crue tour.' We were like, 'What do you mean?' They were like, 'Dude, we've been out doing these safe tours.' We met with pyro companies and said, 'OK, we want to blow the bass player up, we want the drummer to fly, drums to explode in the air,' and everybody is like, 'Thank you.' We're like, 'What are you talking about?' They go, 'Well, you know, the last 10 years we've been doing tours and for the grand finale bands would say, 'OK, we want some sparks.' You guys in one

song have more than 10 bands have in their show.'...(So) for us it was hard containing (ourselves). In other words, there was 100 things we wanted to do that financially- and some of them physically were not possible. We sort of go all the way to the outside at first. Like, 'OK, if we had a 36-truck tour, we'd each have to invest $4 million out of our pockets just for the first leg.' So, you know, for us, it's a balance between being smart (about) business and being not smart (but) creative...You realize that adding three trucks, you have to add $6 to the ticket, let's say. Then you're like, 'Those three trucks could be condensed if they're not hard goods but soft goods.' So you start to go, 'If we do this, this can affect the ticket price and this looks just as big, so why don't we do that and keep the ticket price reachable?' We also knew we had a younger audience that was coming to see the band for the first time."

As an introduction to the live show- which featured no opening act to allow the band the full two and a half hours to pack in 25 years of hits- Chronological Crue reported that "the coveted opening slot for each show on Mötley Crüe's *Red, White, and Crüe* 2005...Better Live Than Dead' tour will be a twenty-minute animated movie called Disaster!, directed by Roy Wood who was part of the team behind MTV's Celebrity Death Match. Hand-picked by Nikki, who knows the filmmakers; the claymation film features the band and is a parody of action films like Twister and Armageddon." Addressing fans' concerns over whether the band could physically handle the rigors of such a lengthy show- especially in light of Mick Mars' recent dual hip replacement surgeries- Sixx explained that "our show is over two hours long. First, it's a big portion of the first two records, then an intermission. Mick called me last night and said, 'I don't know about this fucking intermission shit! Once we get rockin', I don't wanna stop!' He wants to work up a twenty-minute guitar solo. There are no worries there. Mick Mars is ready to fucking crush!...(Just last fall, it) was as bad as it was going to get when (Mick) was in the hospital and he was inches from death...He pulled himself together and pulled himself through it and he's onstage shredding every night and starting to put on weight. He's always in a great mood... I'm pretty fucking scarred up from bashing myself onstage. My hands are fucked up. But nothing like Tommy (Lee). He's a war zone. He puts so much into his drumming that his body is thrashed...(But) we're all so happy. I feel very blessed. All the shows are selling out."

Amid final rehearsals for their impending tour, on February 2nd, 2005, the band released a retrospective anthology, patriotically entitled *'Red, White & Crue'*, featuring three new songs, Sick Love Song, a cover of Street Fighting Man, and the band's hit single, *'If I Die Tomorrow.'* Reflecting once again the monstrous demand among fans for the band's return, the hits collection- the band's third- debuted in Billboard Magazine's Top 200 Album Chart at # 6, moving 90,305 units in its debut week, and at # 2 on Canada's version of the same chart. Further certifying that Crue was back BASED on a wildly popular demand, Rolling Stone Magazine's review of 'Red, White and Crue' began by chiding naysayers not to "even suggest that the world was not desperately awaiting a Motley Crue reunion. Because it was, and they knew it, which is why the Crue is back, with all four original members hitting the road to violate each other's probations and respect each other's higher powers. What better way to celebrate than a two-CD hit collection? Well, maybe a one-CD hit collection. All the real classics fit snugly into the first half, but *'Looks That Kill,' 'Kickstart My Heart'* and *'Too Young to Fall in Love'* still sound so insanely great, they put you in the mood to try the second disc. That's where you catch up on…(the fact that) they're still the Crue."

In commenting on the album's packaging and chart performance, Nikki Sixx- who not surprisingly had first conceived of the idea- explained that "it was a compilation record that was really put together for the new fans. We have a growing new fan base, and we said, 'We going on the road, let's do a few songs, we really don't have time to do a whole album.'

We wanted to get out now, and play now, and the timing was right. There were all these people calling radio stations, 'bring the Crue, bring the Crue', demanding us to come play...And we're like, now's the time. Tommy's thing was going to be open, Vince's thing, and my thing, and Mick had just gotten the surgery and it was the best thing for Mick to get out on the road and not just sit at home. So we cut four songs, and put three of them on this compilation...There's *'If I Die Tomorrow,'* there's a song called *'Sick Love Song'* that we are playing live, and there's *'Street Fighting Man'* by the Stones that we cut a really kind of cool version, and then we did a song called, *'I'm a Liar and that's the Truth'* which I thought would have been a great first single because we were telling everybody that we weren't getting back together when we were in the studio actually recording. We were denying it, we would leave the studio separately and shit like that. We wanted to try it on, to see how it would fit. We didn't want to get everybody's expectations up, didn't want to be a cocktease... So for a compilation, even though it is basically 40 songs, to go #6 on the charts out of the box and to have, I think 'If I Die Tomorrow' is #2 across the nation at radio ... Yeah, I'm fuckin' blown away!"

As February got underway, Nikki took out time from his busy Crue tour prep to settle his long-pending VANS lawsuit, with Chronological Crue reporting an outcome to the case wherein "a Los Angeles Superior Court jury reaches a verdict in his favour and awards $600,000 for the commercial use of his likeness without his permission. The jury also awards interest, expert witness costs, and attorneys' fees in the settlement, which will boost the judgement's total award to approximately $1 million. With his wife accompanying him in court, Nikki took the stand in his case against Vans Inc., the sneaker and lifestyle company that owns a majority interest in the annual Vans Warped tour and was recently acquired by Greensboro-based Vanity Fair Corp. The jury found that photos of Nikki and pro-skater Tony Trujillo from a San Francisco Skater of the Year award ceremony organized by Thrasher magazine and sponsored by Vans, were used by the company without his permission as part of a national ad campaign for Trujillo's signature shoe line. The photo appeared in eight mainstream publications, including Revolver, Maxim, Stuff, FHM, Blender and Alternative Press with the caption, 'Live Fast, Die Young,' which bore a said resemblance to the title of Mötley Crüe's first album *Too Fast for Love*. The image was also used for online advertising and for point-of-purchase retail displays at skate parks around the U.S. The lawsuit also noted Nikki

had his own clothing line, N.Sixx by Dragonfly, targeting the same youth market as Vans. Nikki's attorneys Caroline Mankey and Skip Miller of the L.A. firm of Christensen, Miller, Fink, Jacobs, Glaser, Weil and Shapiro LLP say, 'This outcome will hopefully deter other large companies from trying to get away with appropriating artists' images without securing proper permission and offering compensation.' "

Commenting for his part on the courtroom victory against VANS, Nikki explained that he knew even prior to the verdict that "I was going to win…It was so great, cause the Van's attorney is talking, talking, talking - he's just trying to make me look so bad. And finally I just lean into the microphone, and I go, 'Excuse me, sir' - and the jury's there, and I go, 'I am not a shoe salesman, I am a rock star.' And it was like silence. It was ice cold. And he just looked at me, and I stared at him, and he looked down. Dude, he caved. It was awesome. If I'm going to sell shoes, I want to fuckin' be paid for it. Because I'm not a shoe salesman. You know what, I could roll over and walk away from this thing. I'm real busy, no time to be chasing around this company. But if people don't stand up and do this, it's going to happen to other people. For me it was about fighting the system again. It was saying, 'You know what, you don't do this, it's not ok.' You can't do this, you can't take a picture of someone who has built their image up, I don't care who it is - who's next, Ozzy, or any other pop culture icon? You can't do that. You can't use that for your business, it's not ok."

On the 15th of that same month, the Crue performed a pre-tour warm-up show in San Juan, Puerto Rico, before officially kicking off their come-back tour on the 17th in Ft. Lauterdale, Florida. The true spirit of debauchery driving the band's over-the-top the band's Carnival of Sins tour was captured in an MTV's article covering its kickoff, wherein the network reported that "a three-foot tall man - four with the Mohawk - in a sequined jacket teeters around the floor of the Grand Olympic Auditorium on platform heels, gleefully swigging from a red plastic gasoline can. Nearby, three female acrobats in elaborate-yet-barely-there costumes (think Cirque du Soleil staffed by Suicide Girls) writhe playfully and grind in time to the drumbeats pumping through the house PA system. Soon, three hulking figures in coveralls and demonic clown masks lurch onto the floor, inching toward the others who have now assembled in front of a makeshift photography studio. It's fitting that a towering red and white big top looms behind them, but the ringmasters have yet to arrive. You see, Tommy Lee

is busy hurling his drumsticks one at a time into the ground and watching as they either shatter or soar back up in the air. 'Look at our world, man,' bassist Nikki Sixx declares to no one in particular, surveying the mayhem that the band has dubbed 'The Rock and Roll Circus' (with no apologies to the Rolling Stones ... or to anyone, for that matter). Yes, Mötley Crüe are back, and with them comes the return of the big, loud rock spectacle. After years of strife, bitterness and wanton excess (and that was *before* their split six years ago), the band behind 'The Dirt' has reassembled, reconciled and returned to the road for an unlikely reunion that kicked off Thursday night in Fort Lauderdale, Florida. As the band worked the kinks out of that show last week in L.A. and unveiled the cast of characters that will help them this time around, it was apparent that they were crunk before it was cool, and they hadn't planned to tone things down one bit. 'It's a lot to try to top ourselves,' Sixx said. 'When we sit down and start doing the tour, we're like, 'What do we do to top ourselves?' Not only that, we change our sound, we change our look, we change the perception of what rock and roll is every single time.' From leather and studs to sequins and spandex to denim and leather (again, some things never go out of style) the Crüe brought a new look each time they rolled through town during their heyday, and consistently tried to one-up their past stage shows (as anyone who ever saw Tommy Lee play a drumkit that elevated and whirled 360 degrees in the air like that giant spinning pirate ship at your local carnival can attest). 'Tommy is doing the craziest things he's ever done,' Vince Neil said of the new tour. 'We're playing longer than we've ever played, more songs than we've ever played. This is the biggest thing we've ever done ... ever.' 'It's a freak show,' Sixx summarized. Some might suggest that's an appropriate way to label the band as well, given the decades of dysfunction that precede the tour. But it's all smiles as the band preps for the tour, with the bulk of the ribbing being good-natured. Neil stealthily rests a photographer's test shot on the top of Sixx's hat while the bassist chats with one of the show's acrobats, Tommy slips one of the clown's devil horns up his nose just before the shoot and Nikki crashes into Mick and Tommy, interrupting their interview. 'You see these guys, man?' Lee said, in a mock plea for sympathy and help. The reunited and still somewhat chummy Crüe hope to keep details of the tour under wraps, but ticket holders can expect fire, acrobatics, claymation and a departure from most of the rock offerings that have snaked across the country of late. 'Everything you've seen in the last 15 years in the music business — don't

expect that,' Sixx promised. 'It's a whole different animal. The Crüe's back.' "

Checking in w/a journalist from Florida a few days in to the tour on February 23rd, Sixx reported that "(we're) doing good…I'm in Florida…(We've) only done one (show in) Puerto Rico, but Puerto Rico doesn't really count…(because) the people count, but it wasn't really a show, it was just a musical rehearsal…(Last night was our first show, and) considering how much we have going, production-wise and the whole trip, I'm surprised- totally surprised- that it was so good. We've never in twenty-four years run through our show before the show, and we've never in that many years played that long, even in rehearsal. We're notoriously fuckin' lazy. We'd rather drink and fuck than rehearse…So with that being said, last night we played- someone said- two and a half hours. We didn't even know, we just wrote down a set list that we liked, and we're like 'Well, this might be a bit long!' Not for us, but even some fans were like, 'I love you guys, but I went to see Metallica and they played for like two hours and I was like 'ok', and you guys played like a half hour longer than that, so …'But I don't know, I don't think we're going to change anything."

Elaborating further on the visual landscape of the band's (always-??) live show, Nikki explained that "(the show opens with) an intro …we're in a mini-movie, and it'll be coming to theaters, so it was fun for us to create something to start our show. And basically, the movie is called Disaster: the Movie, and it's very tongue-in-cheek. Remember how they used to do Airplane and that kind of stuff, that would be a take-off on all of those airplane movies? Well, this is kind of taking the piss out of movies like Armageddon. And it's really fun. Any time we can take a piss up anything, we do - including ourselves. So, that's kind of what it is, it's a setup for that, and it helps lead us into an intermission, and I think the movie is going to be killer. We're actually playing a concert in the movie - claymation versions of ourselves…(We) did all of the voiceover stuff. This concert, everything from the claymation stuff to the pyro cues to the aerialists to the midgets to the stilt walkers, the whole thing is just… it's a lot of fucking detail. So that what I was saying, forget about the fact that we play 25 songs - and most people are like, 'How do you remember that?' and I guess it just gets entrenched in your brain … but there's a lot of details, and that's why I'm surprised - the lighting, the whole thing, kinda all came together last night, and it was cool to see the crew and the band

… and Motley Crue as well … all being like, 'Wow, it worked!' Cause we didn't know, when you put a show like that together. Our problem is, that we're insane."

As insane as the band was onstage for their even crazier audiences, off stage between band members the atmosphere was quite the peaceful opposite, with Sixx explaining an arrangement wherein "we each have our own tour bus. We've never done that before. I've got five kids and I'm married, Tommy's got two kids and he's been married, Vince just got married again, Mick's out of a relationship, Tommy's single as well. We've done a lot in our life, we've covered a lot of miles, done a lot of everything. To have that little bit of space-now, me and Tommy have recording studios built into our bus - but just to have that little bit of space, to actually have a bedroom instead of a bunk, it's really cool. So we said, let's have one big room, that we call the hospitality room, like always, and then let's have four separate dressing rooms, and JVC came in and made us these flat screen tv rolling cases with DVD players and stuff, so it's like each guy has his own space. We all end up in one of the other guy's rooms all the time. It's just weird, we always end up together, and as far as people getting along, every time you turn around they're hanging out. We think it's funny. Him and Vince are just kicking it and all mellow, and I'm the crazy one now. We've switched personalities!" Elaborating on the band's inner-harmony while out on the always-wild road, singer Vince Neil explained that "I don't think the relationships in this band could ever be where they were twenty years ago--Not only because there's been bad blood, but because people have families, people have different agendas, people grow up, they're different, you can't never had that same camaraderie that you had when you're twenty years old, living together above the Whisky-A-Go-Go. That will never happen. Now we're all in our forties. Everyone has their nice houses and cars, it's different." Underscoring just how different the Crue's modern-day traveling routine was from their partying heyday, Nikki detailed a change in focus from drugs in the past to his present day status as "a CNN junkie, Court TV junkie; I am also a newspaper junkie. For me, it's interesting. And anything that feeds my brain is good for song-writing, so between Hustler magazine and USA Today, I get my fill. I actually ask the audience different headline things. Recently, it's been: Michael Jackson, innocent or guilty? It's amazing hearing twenty thousand people all say 'guilty' in unison."

As the sold-out first leg of the Crue's comeback tour rolled on into March, its wild success dictated a Rolling Stone Magazine cover story among a blizzard of related press, including an announcement on Howard Stern's radio show that a second leg of 57 additional U.S. dates had been scheduled based on the success of the 'Bring the Crue' campaign. Beginning in the mid-summer, following the band's European dates, the new dates promised to keep Motley on the road through year's end. As a symbol that the Crue's stock had shot back to the top of pop culture's mainstream, on the 2nd, they rang the New York Stock Exchange on Wall Street, and on the 3rd, played to a sold-out crowd at Madison Square Garden in New York City. The band further announced plans for a new studio album, with Nikki confirming that "we're writing it out here (on the road), which is kind of like how *Shout at the Devil* was written. It was written while we were playing all the time, and we were looking for stuff that worked for us live. And that's the kind of stuff that we're gonna be writing more of...I record little ideas on my acoustic guitar, and then when I plug in my iPod into my computer, it updates it. Then when I get home I open up the files and I start writing songs." Elaborating further, Tommy Lee explained that "Nikki and I both have portable recording studios and I've got hours of material running through my brain. When we're in road mode there is always down time to get ideas out and I do have a few ideas that sound to me like they will make killer Mötley music, so yeah, let's bring it on and get a record done." Clearly a reflection of fan-clamoring for all things Crue, the band's merchandising company, Signatures Network, reported that on the road the band was scoring the highest merchandising sales in company history. Further evidence of the latter came on that same month with McFarlane Toys' announcement that they would be re-releasing a highly-collectible Motley Crue action figures set that summer. In a personal night of celebration for Nikki, during the band's sold-out home-town concert at the L.A. Forum on the 23rd, Motley Crue was presented with a platinum award for their '*Red, White and Crue*' anthology, while during the same night, his eldest son Gunner joined the band onstage, playing guitar alongside his father for '*Helter Skelter.*' Commenting on the glory of the moment, Sixx recalled that "we were onstage and I looked out and there were 15,000 people and they all had their hands in the air. I looked at Mick and I looked at Tommy and I looked at Vince and I just started smiling. I was like, 'Fuck! I can't believe it! We're still here!' "

Heading into April and the tour's Canadian leg of dates, the band announced that the first draft of the scripted version of their best-selling autobiography was complete, with Tommy Lee explaining that "we're just interviewing different directors and at some point we'll make a decision and then the thing will get greenlit, start casting and shoot it." Nikki, for his part, commented that "we had David Fincher to be the director, but Paramount needed him to do a very huge movie and wanted us to wait. In the meantime, we are now meeting with other directors. It will get made, and it will get made right. The project has to be gritty. It's going to be like 'Goodfellas,' the feeling of 'Layer Cake.' It's going to have an underbelly to it." In related film news, the band additionally announced plans to chronicle their massive comeback tour via a live DVD, to be shot in Grand Rapids, Michigan near the month's end, and released in partnership with the tour's promoter, Clear Channel Entertainment. Directed by live-concert veteran Hamish Hamilton, whose previous work had included live concert shoots with Madonna, Peter Gabriel and U2, Clear Channel commented of the partnership that "(we're) excited to be working with Mötley Crüe and Tenth Street Entertainment for the worldwide distribution of this incredible show via digital cinema, TV, DVD and other visual mediums, especially with the Crüe taking the world by storm as they are now." Commenting for the band's part on the forthcoming DVD, which had a reported $3 million production/promotional budget, Nikki explained that "we knew once we got out on the road and people said it's one of the best rock shows they've ever seen that it was something that needed to be documented...We shot it in high-def, we had eighteen cameras, and it has a lot of the behind-the-scenes, putting together of the show." In perhaps the month's only down-note for the band, and one which hit them in the gut, a fan, Tracey Gardner-Tetso, went missing following their sold-out DC-area concert at the MCI Center, prompting the group to take the case to the press, which included a profile on Fox's America's Most Wanted television show, attended by both Tommy and Nikki personally. Commenting on the band's concern, Sixx recalled that "I showed it to the band and we were like, 'we've gotta do something.' We knew a $10,000 reward had been put up, and we decided to match that. But what we really could do was get it national exposure. It's lit a fire. I know there are a lot of people who are very motivated. Everyone's pitching in and it's good karma and hopefully we'll find her alive."

As the spring came to a close, Motley Crue was on top of the world, having grossed over $19 million in concert ticket sales in the first half of 2005. While the band kicked off the month with the announcement that the band planned to end the year with an Australian tour, they were off the road and back home in L.A. for a well-earned break before beginning the summer leg of their 'Carnival of Sins' tour. On the 21st of that month, Motley Crue was chosen by one-time 90s rival KROW to close the legendary radio station's annual Weenie Roast at the Verizon Wireless Amphitheatre in Irvine, California, headlining the festival following appearances from Audioslave, Foo Fighters, Hot Hot Heat, Interpol, Jimmy Eat World, The Killers, My Chemical Romance, MxPx, Queens of the Stone Age, Mars Volta, Alkaline Trio, Bloc Party, The Bravery, Dead 60s, and Transplants. In a formal acknowledgement of the band's return to the forefront of hard rock, KROQ program director Kevin Weatherly concluded that "there's no denying Mötley Crüe's massive appeal and influence. They are rock icons in Los Angeles and across the nation. KROQ listeners always expect the unexpected and they have been known to embrace certain bands outside the conventional alt-rock boundaries. KROQ was the first radio station to ever play Mötley Crüe, and it only took us twenty years to convince them to play the Weenie Roast. I know the other bands are psyched to be sharing the stage with the band that knows how to bring it, Mötley Crüe." In a further nod to the band's return to hip, Nikki took time out while home in L.A. to attend the high-profile premier of the final episode of the legendary Star Wars series, accompanying his wife Donna and son Rhyan to 'Star Wars Episode III: Revenge of the Sith.' The month wrapped with the airing of a VH1 documentary entitled, 'Inside Out: Resurrecting Motley Crue', which detailed the real-time, behind the scenes process of reassembling the band, showing just how monumental the challenge had been. On June 3rd, Motley took Europe by storm with the first of their summer festival dates, rocking a sold-out crowd at the Rock AM Ring Festival in Germany, completing several other such dates across the continent before beginning their own headlining tour in the United Kingdom on the 14th, where the band completed six sold-out dates before tens of thousands of fans. The band's European summer dates included 6.07 | Helsinki, Finland | Icehall Monsters of Millenium; 6.08 | Turku, Finland | Rock in Turku 2005/Ellysee Arena; 6.10 | Oslo, Norway | Spektrum Skooks Out 2005; 6.11 | Solvesborg, Sweden | Sweden Rock Festival; 6.12 | Bologna, Italy | Gods of Metal; 6.14 | Glasgow, Scotland | SECC; 6.15 | Manchester,

England | Evening News Arena; 6.17 | Birmingham, England | NEC; 6.18 | Cardiff, Wales | International Arena and 6.19 | London, England | Wembley, Arena.

During the same month, the band was confirmed for the Ontario, Canada-site of the world-wide LIVE 8 concert, which also featured a reunited Pink Floyd among countless other legends performing at the world's largest peace concert festival in history. Other legends on the roster included Paul McCartney, U2, Madonna, Robbie Williams, Andrea Bocelli, Jamiroquai, Mariah Carey, The Who, Elton John, Bon Jovi, Dido, REM, Sting, Placebo, Faith Hill, The Cure, Duran Duran, Velvet Revolver, Destiny's Child, Coldplay, Dave Matthews Band, P. Diddy, Crosby Stills & Nash, Joss Stone, Jay-Z, Green Day, Annie Lennox, and Stevie Wonder. As June came to a close and the band returned to North America to begin the second U.S. leg of their comeback tour, Sixx and company also received word that Motley Crue would receive their very own star along the Hollywood Walk of Fame, prompting Nikki to comment that "we like the fact that it wasn't something that we bought and paid for. You see a lot of actors and actresses get one right around the time of their big premieres. It was something that happened because people voted for us."

Motley Crue kicked off July before 35,000 rock fans at the Live 8 festival, stepping off stage to the updated news that their tour had ranked as the 6th highest grossing of the year thus far, taking in $21.3 million in tour proceeds, and topped only by U2, Celine Dion, Kenny Chesney, Elton John and the Eagles. Updating fans on the status of the Motley's recording plans amid growing demands for a new studio LP to bring their reunion full circle, Sixx reported via his online diary that "it won't be this year. We're definitely going back to do an album. The hard part is finding the time. This tour keeps adding dates and adding dates, so it's hard to pinpoint when people ask, 'When are you going into the studio?' The only thing you can say is 'When the tour ends.' We don't know when it will end yet. It's more important to have a great record than to rush getting it out. It's important for us to put a great record out." With his attention primarily focused on the band's ongoing tour, Nikki and company returned once again to the road on the 24th in Colorado Springs, this time featuring a host of millennium rock bands as opening acts, including Sum 41, Silvertide, and the Exies. The band rounded out the month on a especially high note by announcing they would be stepping into a supporting slot of their own: opening later in the fall for personal heroes, the Rolling Stones, on the band's fall tour over the course of four concert dates.

As the summer rolled into August, the Crue continued rocking crowds throughout the U.S. and Canada, even as Tommy Lee flew back to L.A. between live dates to promote his new solo album, 'Tommyland: The Ride' and NBC reality show 'Tommy Lee Goes to College.' Commenting on his own non-Motley goings-on even as the tour continued on, Nikki updated fans via his online diary on the status of the 'Heroin Diaries', beginning by explaining that "books are great. I love them I always have my nose in one hand and I have to tell you I'm so excited about 'The Heroin Diaries.' With that being said, I've never been one to wait to follow the same format that's been done over and over before me, so in looking for a new idea, this is the plan: there will be a book. There will be a soundtrack of original music on the book. There will be a movie shot for each song that will tell the story of the 'Heroin Diaries'. They can have a life all their own or when played all together will be a movie of the book. So in the middle of touring, writing new Motley Crue music, this has now become another mission for me to do something totally different in this world. Now the bad news is: this is a huge project, and there is no way I will rush this. The book is done, the songs are halfway written. Then they

will be demoed and we will be shooting the movies hopefully in January. That means probably a July release of everything (in a perfect world.) I need to feel creative or I don't feel. Tommy said the music reminds him of 'The Wall' meets 'Alice in Wonderland' gone bad. Lovely. Speaking of Tommy, I love his album. Great songs, and in the end, that's all we can really focus on as writers. (His) show is a hit and I'm fucking proud."

Continuing, Sixx further revealed to fans that "me and Donna are getting a huge warehouse and turning it into our creative command center. We will have a rehearsal room, recording studio, areas for working on acting (Donna), painting (both of us), photography (both of us), editing bays (video), meeting rooms, etc. She's got two movies she's preparing for, and I'm writing tons of music, so to be out of the house while working is the key to us being able to focus…I'm ranting, no sleep, I gotta pack and I'm off somewhere." In a nod to some of their personal heroes and longtime friends, Motley also featured Alice Cooper and Cheap Trick during some of their sold-out Canadian arena dates. Reflecting on the experience of hosting so many guest during the Crue's summer shows, Nikki reported in his diary entry to fans that "today was the last night with Sum 41, Silvertide and the Exies. Made some great friends…(I'm) gonna miss all the bands alot. The last day of a group of bands traveling the country together is always sad. We bond in music. I would like to thank them all for touring with us." Turning to his personal state at that point in what had been a grueling year of work reclaiming his band's spot at hard rock's top, he revealed that "my heart can't take not seeing Donna and our children, so I'm leaving after the show tomorrow for a quick one-day trip home. God, I miss home. Can't wait to see everybody's faces and lay in my wife's arms…I'm sooo tired, me and Tommy started and finished a song we wrote with Scott and David from the Exies today. No sleep, just straight into the studio to cut a demo, but for now all I can think of is Home Sweet Home…Baby, I'm on my way… We're done with our two shows here in Atlantic City. It was nice to be in a hotel room for 4 days straight, but now its back to the bus. Storm was out with me for a week and we had the best time. The hardest part of touring is not being home, and keeping my head grounded in the middle of all this chaos. I feel like I'm doing a great job. I'm happy to not have drugs and alcohol (as) part of my life anymore, and feel it's the single most important gift I can give my family and fans."

As the fall of 2005 began, Motley Crue took up temporary residency in Nashville, TN, to perform an updated rendition of their classic ballad 'Home Sweet Home' as part of the ReAct Now: Music and Relief alongside Linkin Park frontman Chester Bennington as part of the Hurricane Katrina relief effort, sponsored by the CMT Network. The next day, they enter the studio with producer Desmond Child to record the re-vamped classic as a charity single. At a press conference associated with the recording, Nikki commented on the recording session for the song, which included a 26-piece gospel choir and 25-piece string orchestra, that "Chester was originally scheduled to play the benefit concert in Los Angeles but when he heard what we were doing he wanted to help with this song and video and chose to do his performance in Nashville with us. Chester is a real artist that will be making a difference for a long time. This song, both musically and lyrically, relates to many of the things that are happening now, as the hardest hit areas set out to rebuild." Bennington, for his part, added that "considering they had a show the night before and then another the night after, it's a testament to how awesome a rock band Mötley Crüe is and how much this cause means to them. The chance to perform with these guys for such a great cause is something really special. Hopefully, people will embrace it in the way it was intended. The song really does fit the sentiment and something special happened when we pulled it together. Everyone felt as if they were doing something really important." Motley Crue frontman Vince Neil added that "we tend to be desensitized by the non-stop media coverage of the relief effort, thinking there's nothing more we can do. We're just happy to have a song and a video that keeps the awareness of how monumental this task is and that we have to keep trying to do everything we can to help."

In October, Sixx gave fans a progress report on the band's long-awaited film adaption of their 2001 best-selling autobiography, 'The Dirt,' explaining that the film would eventually "get made, and it will get made right. The project has to be gritty." Meanwhile, back on the road as the band wound down their WILDLY successful reunion tour, Tommy Lee suffered minor burns to his face and arms from malfunctioning pyrotechnics while suspended 30 feet above the stage during his drum solo during the band's Casper, Wyoming show. Commenting on his condition following the accident, which amazingly caused no delays to the Crue's final tour dates, the resilient Lee shared with fans that "I'm getting better. I have first- and second-degree burns on my arms, singed hair, eye lashes,

face, etc. Every day I get better and thank God I'm home tonight! Home for a few weeks then Japan, Australia, Hawaii." As October neared its end, the band celebrated another successful month with the release of their first-ever live concert DVD, filmed in Grand Rapids, Michigan, and capped the month playing a highly-coveted opening slot for legendary hard rock Godfathers the Rolling Stones at the Key Arena in Nikki Sixx's hometown of Seattle, Washington.

The band began November rounding out their opening slot for the Stones in Portland, with Sixx commenting on the once-in-a-rocker's-lifetime opportunity that "backstage we were all hanging out and Mick Jagger told me that he and Charlie Watts watched the whole show. He told me no support band has ever gotten their crowd up on their feet the way we did. It looks like we will be supporting them for some more shows in Europe next year." In another reflection of the band's legacy status in generic American pop culture, Crue frontman Vince Neil dined with former president Bill Clinton at the Las Vegas Palms' hotel N9NE Steakhouse, in an eclectic dinner party that also included former Canadian Prime Minister Jean Chretien, Hollywood producer Steve Bing, billionaires Ron Burkle and eBay founder Pierre Omidyar, and baseball Hall of Famer Reggie Jackson. Back in L.A., Nikki shared with fans via his online diary the discovery of hours of reels of footage from the band's 80s touring heyday, citing among other footage highlights that "I found, like, thirty tapes! One was called Mick Pissing on an Old Lady's Leg in Italy and another Robbing Grave in England." As the month progressed, the band embarked on their first Japanese tour with Tommy Lee in over 6 years, with Buckcherry in support.

As the band's most successful commercial year since Dr. Feelgood in 1989 came toward a close, Crue moved their rock 'n' roll circus from Japan to Australia, visiting the country for the first time in 15 years at Sydney's Superdome. On a day off, Nikki made a pilgrimage to the Fremantle Cemetery gravesite of late AC/DC frontman Bon Scott in Perth, commenting in his online diary of the visit that "we all flew in from Adelaide (Motörhead too) and went straight from the airport to the graveyard. I went with Paul Miles, Jozie and (personal security guard) Kimo. Bon really was an original. Rest in Peace." On the 10th of the month, as the band wrapped up the last of their Australian dates at the Blackjack Festival in Perth, the band celebrated Nikki's 47th birthday, before returning to the States for a final concert of the year at the Blaisdell Arena in Hawaii.

As the year wound down, the hype was winding up on the subject of the only missing piece of the band's reunion- a new studio LP- with Nikki initially commenting via an interview with the radio station WRIF 101.1 FM of the band's future plans that "we go back out on tour in February. We tour into the first week of April. May 1 we start writing and rehearsals for the new music, probably demoing stuff up. We're doing the new album with Bob Rock. And then when it's ready, we're gonna cut it. Our intention is to make the greatest record we've ever made. With that being said, we also believe that if we over think it, it will lose its rawness, so we wanna get in there and just terrorize the music and then just get it on tape. That's the idea, but that's more of in a perfect world. We are very excited about making a new record. I think new music is so important. In a MÖTLEY world, we will probably get closer to getting the album done and then go, 'You know what? We're missing one or two songs,' or something, which we do a lot. We did that…'Kickstart My Heart' was the last song written for the 'Dr. Feelgood' album…(So) we are very excited about making a new record. I think new music is so important. We have a great catalog of music — people love to hear all the hits, and we've been playing obscure songs as well — but new music is really the lifeblood of any rock 'n' roll band. And you have to do it, you have to forge forward. Especially for bands like us and AEROSMITH and AC/DC that have been around for so long. We have to keep making new music or we become nostalgic. Which is, I think, what we all felt about KISS. We go, 'God, we love KISS, we love the show, but it's only trading on the past and not

moving into the future.' So that's where we're at... We are definitely gonna make a new record."

In a Christmas Day update to fans, Nikki shared that he was celebrating Xmas day without wife Donna and step-son Rhyan as the pair had departed for a trip together to Cambodia, sharing that "I'm excited for them, yet it somehow feels sad to be in a somewhat empty house on X-mas. It's just me and Frankie here until tomorrow when Gunner, Storm and Decker come back from their mother's. I wanted to wish all of you a very happy holiday and thank you for a great year. There has been a lot of money raised through the auctions for Running Wild in the Night and that means the world to me and the kids at Covenant House. I hope you get everything you want this holiday and at least everything you need." The band headed into New Years Eve with a celebration of their own, coming full-circle in context of their Hollywood roots with news that on January 25th of 2006 they would be awarded their very own star on the Hollywood Walk of Fame. The band's popularity was further underscored by the news that they had wound up in Pollstar's Top 20 Highest Grossing Bands of 2005, ranking # 11 with just under $40 Million in gross receipts, capping off the year with a concert at The Palace in Detroit before a sold-out crowd. Reflecting back on the roller-costar year of highs the band had rode back on their way back to the top, Sixx mused on the future- with a seeming sense of vindication- that "Motley Crue, collectively and individually, have done things on our own terms. Including doing what we're doing right now. So, we go to do the Billboard Music Awards, right, just to be a presenter, and we walk on stage, and we get a standing ovation from the industry. Tommy looks at me and we're like, 'What the hell?' "

Chapter 27

(Fergie Wearing RU)

The Royal Underground

Topping every expectation 2005 had to offer the band, Motley Crue began 2006 with an announcement that their wildly successfully 2005 'Carnival of Sins' tour would continue. As suprising as their comeback itself- and its subsequent success- was the fact that internally Motley Crue was functioning better than they had in years, so much so that MTV's coverage of the band's 2006 tour announcement, which began with the triumphant headline 'Band defies odds, books tour dates well into next year'- continued with the network's acknowledging that "the reunion no one expected to last has done so for almost a year...The Crüe's Carnival of Sins Tour- one of the biggest-grossing treks of 2005...The band's 2006 touring schedule starts off with an appearance on February 10 at the Civic Center in Columbus, Georgia, and is slated to finish on April Fools' Day in Sioux Falls, South Dakota. They'll continue with another round of European dates and a South American run before entering the studio to start work on the next Crüe LP."

On the subject of what would be the band's first new studio album with Tommy Lee in almost a decade, Nikki Sixx seemed to be the most energized, admitting in early January that "I'm really anxious to start playing new music. I'm panting, I want it so bad. I just looked down at my list, and I have forty-five ideas for songs; Mick's probably got somewhere

between forty and a hundred riffs. Tommy's got a ton of ideas...We did some pretty diverse records throughout our career. We've gone from *Dr. Feelgood* to the (1994 self-titled) John Corabi record to *Generation Swine,* and it was all based on us just being creative. Some of it was more accepted, some of it was less accepted, but if you look at the history of the band, from the first record on, we've always done something fresh...I don't want to be part of that trend where bands that have been around for more than 20 years become mellow...Even with U2, a band I respect, everything has this older, mellower feel to it. You hear that in a lot of rock bands. I don't mind having ballads and medium tempo songs — I just hope we never become a bunch of pussies... You just have to close your eyes and let it happen. The only thing we all agree on is it has to be the best album we've ever made." Elaborating further, guitarist Mick Mars explained that conceptually "for me, I would like to see like a *Sgt. Pepper,* an *Electric Ladyland,* something really outstanding and new. I have a zillion ideas." Even Tommy Lee chimed in on the band's plans for the highly-anticipated new album, commenting that " (insert Tommy quote from 2005 on new LP plans.)"

The fact that the new album would be a group effort- as opposed to 3 new songs the band had recorded for *Red White & Crue*, which were penned largely by Nikki himself, was perhaps the greatest testimonial to the new creative ground the band had broken together during the prior year's tour. While plans for the new album reflected the band's desire to move past nostalgic aspect of their reunion, they did take advantage of the former to keep momentum on the film adaption of the band's best-selling 2001 autobiography 'The Dirt' moving along forward toward production, with Sixx reporting that same month that "the movie is getting some legs. The script's done...(The) Hollywood...movie companies are just freaking out over the script. They love it."

While the band waited for the cameras to start rolling, Hollywood had a more immediate vehicle to star the Crue- literally- when on January 26th, 2006 the band was awarded their spot on the legendary Hollywood Boulevard Walk of Fame. Reflecting Motley Crue's continuing commercial vitality, hundreds of media outlets covered the event, including USA Today, which described a scene wherein "it was girls, girls, girls Wednesday when the bad boys of '80s heavy metal band Motley Crue received the 2,301st star on the Hollywood Walk of Fame... (Nikki) Sixx

joined drummer Tommy Lee, guitarist Mick Mars and singer Vince Neil at the ceremony in front of the Musician's Institute on Hollywood Boulevard…Lee pretended to cry. 'I think there's something in my eye,' he said. Motley Crue formed in Los Angeles in 1981, enduring a breakup, death and drugs to become one of the world's top touring groups with 40 million albums sold." Twenty-five years after their launch from the same streets as local overnight legends to international superstars, Nikki Sixx summed up the monumental moment by telling the hundreds of fans in attendance that "this is a perfect place for us to be."

For Nikki, amid the band's myriad of recent accomplishments, among the most gratifying for the band's founder/songwriter on a personal level- aside from successfully reuniting Motley Crue- was the multi-generational audiences that populated their sold-out shows, ranging from teenagers to 40-somethings. Perhaps solidifying for the band's founder a broader sense of security for Motley Crue's future, Sixx admitted that it was "just amazing to see a younger audience out there…When we made a decision to be a band again, a lot of people were saying, 'You guys are like Def Leppard- your audience is going to be, like, 40-year-olds.' And we were like, 'What the fuck?!' The most exciting part of this has been seeing new faces as well as the original faces- our original fans are wonderful. But as a band, you want to reinvent yourself and you hope you get rediscovered. Black Sabbath is a great example; U2's evolved. They have a new audience and kept the original audience. That's our dream."

The band kicked off the third leg of their 'Carnival of Sins' tour on February 10th in Columbus, Georgia, proceeding on a 3-month trek of dates that included (list tour dates). Checking in via his on-line diary from tour, Nikki reported that "we're back on the road after a nice long break. I mostly spent time with my wife and kids, but I did get some songwriting and a few photo sessions (behind the lens, not in front)…It was a rush to work that end of the lens in the studio. Many many more to come, but for now I'm back in the groove of touring. We have a jam room set up in every city for writing and will take ideas home and finish writing the album…Its hard being away from (the) kids…We plan on adding some new tunes to the set to keep it fresh (mostly for us) since we're not really playing any of the same cities. We just need a few days to settle in before we start working them up…We're three shows in to the tour and so far we've only had a few 'Motley moments.' I blew a front tire on my bus on

the highway. As soon as it blew and bus started to swerve I instantly thought of the Metallica incident. Vince got hit in the face by some asshole with a cup of piss. Last I saw of the guy he was handcuff, face bloodied screaming 'I'm sorry, I'm sorry'….what an idiot…Ah, life on the road."

While touring Canada in March, Sixx checked in from his online diary to update fans on his forthcoming plans for the balance of the year, beginning by reporting that "We've done all the major markets in Canada…and are now playing the smaller towns up here. Halifax was over the top and we're now in Quebec City for a day off. The only downside to Canada this time of year is its colder than hell. I'm sitting here in the hotel reflecting on the last year of touring and I'd say that Rock n' Roll is stronger than ever again." That same month, the Crue would criss-cross from North to South, playing Mexico City near the month's end, where Sixx reported that it was "great to be back in Mexico. The fans are passionate to say the least here…The Mexican stalkerazzi were fucking relentless. The fans were great…One more show before we head back to Texas. Then just 3 more weeks of touring and we're finally done."

As the spring began to wind down, Nikki clearly sounded eager to do so with touring for the summer, which the band had agreed to take off while its members' pursued various solo endeavors. For drummer Tommy Lee, this included staring in a second reality series, 'Rockstar: Supernova', for NBC, in spite of the fact that his band's ban from the network, of which Nikki had the following opinion: "I heard some of the songs and there was some pretty cool stuff there. You always have to give thumbs up to any musician who's making music outside of what they normally do." For Sixx personally, his elaborate agenda for the band's hiatus began with an acknowledgement that while "all's well out here…I look forward to heading back to L.A. in mid-April for a short break before we start rehearsals for the next album…Can't really tell where the music is headed yet, you just have to close your eyes and let it happen. The only thing we all agree on is it has to be the best album we've ever made."

Continuing, Sixx reflected on both the band's past and their future in the same time, asking (rhetorically-??) in another diary entry, "how lucky we are to be able to still do this after twenty-five years. But I feel like Ripped Van Winkle, ready for a mending and hibernation from the volume…We have been working on songs out here on the road, but I'm

excited to not have any distractions when we're home. Good news is my book The Heroin Diaries is 100% finished…The photo shoot is done for (the book), and Paul Brown is working on laying out all the artwork. Its gonna be a huge task considering the vision. I spoke to the publisher and they're really excited about this book. You want them to love it as much as you do if they're gonna get behind it. The more it sells the more awareness on drug and alcohol addiction and the more money it will raise for 'Running Wild in the Night' and 'Covenant House.' Its really a great read now that all the pieces of the puzzle are in place. So many people came to the table to tell their side of the story relating to the actual diary entries…Lemmy wrote a short medical history for the beginning of the book, very demented, like only Lemmy can be. There's an album's worth of songs already written for a soundtrack to the book, ready to record. I'd say its very 70's glam sounding. Bits remind me of Bowie and T-Rex with a darker edge to the melodies and lyrics."

While on the road that spring, Nikki had also resolved his pending litigation with former clothing company partner Dragonfly Clothing- a relationship which had ended most acrimoniously. Addressing his decision to walk away from his lawsuit with the company, Sixx explained to fans in his online diary that "I wanted you guys to know that the company Dragonfly Clothing ripped me off and I chose to not go into litigation with them. It would have been a mess. They showed me how they hide their money in Lebanon and didn't pay taxes on a lot of their income. I know that unlike Vans (who is a public-held company), this would have cost hundreds of thousands of dollars and would have taken my eye off the more important things in life. So it works in their favour, but please know that buying anything with their name and my name together is not approved by me. It is disheartening to know there are still scumbags out there willing to take advantage of someone's hard work, but life is full of lessons and I'm sure their karma is going to come down on them like a nuclear bomb. I know of many different companies and artists who have sued them. Most win, but it's so sticky. I was the fool; shame on me for trusting them. A lot of their employees and sales staff have left and contacted me to do a clothing line. More on that down the road." And indeed there would be.

Motley Crue wrapped the third leg of their tour on April 13th, 2006 as triumphant commercially as they had at the close of 2005. In just the 3 months of touring the band had completed in the spring of 2006, according

to Pollstar, they had played to 234,643 fans over the course of 42 concert dates, grossing upward of $19 million in revenues. In reflection at the band's continued success, Nikki, while grateful for their fortunes, admitted that because "we've been touring, writing and recording for over sixteen months now, I can safely say we need a break. No complaints though." Sadly, he would return home to one filed by his wife of 9 years, Donna D'Errico, seeking an end to their marriage. As reported by People Magazine, "D'Errico cited irreconcilable differences as the reason for the split, according to court documents filed Friday in Superior Court...She is seeking physical custody and joint legal custody of the couple's five-year-old daughter, Frankie-Jean, and her 13-year-old son, Rhyan, from a previous relationship. D'Errico also is seeking spousal support."

The news seemed to come as a shock to Sixx, whose only comment to the press, not surprisingly, identified his children as "my first priority. This is a private matter and I hope you will respect our privacy at this time." Donna, for her part, in a May 7th diary entry appropriately titled 'And then there was one,' updated the split-up as it unfolded in real time, first explaining that "I'm just trying my best to get through this weekend...It is very difficult...(Nikki) got his stuff moved out Friday and I am sorting through my anger and sadness....Last night I went to prince's house party, trying to get my mind off things. His house is dumbfounding, but my mind was elsewhere. All I can say is this: thank God for my friends. They know all too well the cause of my pain, and are helping me to heal- ((again.)) After all, I've been through this once before. Peace and love and joy to all of you--thank you for your support. It means so much. Donna"

Shortly after D'Errico's diary entry, Nikki posted his own on May 10th. Reflecting on the end of his 9-year marriage in its immediate aftermath, Sixx- in spite of all his professional confidence- admitted on a personal level that "sometimes we don't know that we're right where we are supposed to be in life, even when looking down the barrel of a loaded gun. Life has a way of showing us that pain isn't always bad. Sometimes we need to grow from it. I have nothing bad to say, nor will I ever about my life with Donna. She is a wonderful lady, but life doesn't always deal us the hand we want. Powerlessness is a gift I am learning to accept, love is a gift I have recieved and tomorrow is something non of us have the ability to see. Today is all we have. Yesterday is gone, tomorrow may never come, life is strange, wonderful and painful. Pain hurts, but we hardly ever die

from it. Thank you for keeping us in your hearts and not in our wildest dreams did we think we would end up a statistic, but dreams…they're not predictable….God bless."

As the summer began, Motley Crue's plans to begin writing a new studio LP were put on hold by both Sixx's personal situation and Tommy Lee's preparation for his 'Rockstar: Supernova' reality series. Co-produced with Survivor guru Mark Burnett, and co-starring former Metallica bassist Jason Newstead and former touring Guns N' Roses guitarist Gilby Clarke, the show over 10 weeks chronicled Lee and co.'s summer-long quest to find a lead singer for their reality-show *supergroup*. With the group on a well-earned hiatus, Nikki headed off the Motley radar and into the *Royal Underground*. Giving his passion for fashion another try after the failure of both his Outlaw Clothing line and more recently Dragonfly Clothing, Nikki acknowledged early on that "I invested my own money…(in past clothing ventures, and) lost a quarter of a million dollars." With that past in mind, Sixx sought to ensure the third time would be charmed by pairing up with fashion veteran Kelly Gray, former chief executive of the famed St. Johns clothing line.

Explaining how the two initially met during the 2005 'Carnival of Sins' tour, Nikki revealed that "I met Kelly through Tommy. Kelly and Tommy met at an event in Aspen. They became friends. They are both extremely hyper, extremely high energy, they are like two peas in a pod. She was hanging out with Tommy, and she would see me walking the hallway backstage. She told Tommy, she wanted to meet me. The first time we met, she was nervous, and she called me Mr. Sixx. Tommy had told me for some reason I make her nervous. I didn't correct her, when she said Mr. Sixx. She called me that for six weeks. You are talking about a girl, who runs a $400 million company, and some little punky bass player that is letting her call him Mr. Sixx. Tommy thought it was the funniest thing on the planet." Gray, commenting for her own part, indeed admitted that "(Nikki) scared me (the first time we met)…Before the first concert I had Googled Mötley Crüe and looked at their Web page, and the Web page looked so scary I said I couldn't go…We didn't hit it off all that great at first. I was so scared of him that I called him Mr. Sixx."

Continuing on the evolution of their partnership, Nikki explained that "Tommy told me about her history in the fashion business. I knew

somewhat of St. John's. What happened was, she went on my website, and I designed some clothes to be sold for charity. She had bought some of it, and I didn't know it. So after the tour was over, it was a very rocky time, my wife filed for divorce, I had moved out, I was getting settled. All of a sudden, I get a call from Kelly. She said, 'Hey do you want to have lunch.' I bought some of your stuff off of your website. It is actually designed really cool. I think there is a place on the market for something like that.' " Elaborating further, Gray recalled that "(when) we got together for lunch…he talked to me about having a passion for the business. I had always admired his style, which I probably didn't tell him about on tour because I was too afraid of him…(We found we had) this great rapport and great chemistry…and I said, let's go shop the market and see if there are any places that we can penetrate… I found that the market was heavily 'skull'-ed. Everything was torn and shredded and watered-down looks of what designers thought people were wearing onstage. Having a real rock star who has been designing his own clothes since he was a teenager as a partner appeals to me. There would be an authenticity that no other designer could have."

As the concept for the clothing line emerged in the course of their impromptu shopping spree, Sixx explained that "we both decided if there was going to be a new men's line, it was going to have to be comfortable. We had so much in common, with the passion of what the new men's line would look like." Fleshing the line out conceptually based off the duo's initial instincts, Gray recalled that "we thought there was an opening…to take the inspiration and the spirit of the rock industry, but do it with a twist. Real rock stars." An instant headline-grabber based off outward appearances alone, Sixx's hometown paper, the L.A. Times, in an early feature on the head-turning partnership, would observe that "at the moment, they're one of the fashion industry's most unlikely couples." Still, reinforcing the argument that opposites do in fact attract, Gray explained at the outset of their collaboration that "I don't think anyone else could have convinced me to get back into this business, but (Nikki) has a passion for clothing that is unparalleled…I was happy to take a year off, but (Sixx) had a passion for this business that I have only seen in the mirror."

In identifying what attracted him toward working with Gray- beyond their creative chemistry- Sixx pointed to "Kelly's history in the fashion world…(which) is phenomenal. When I first spoke to her I can remember

her asking me some very direct, honest questions coming from a person, who has been in this her whole life. One of her questions was, 'Is it your fantasy to create very cool clothes and do you want to push this?' Kelly is part of this huge corporation. We both had the same answer, if we are involved in it, it has to be cool! We like cool things. We don't sit there and say let's make a line that is rock star oriented. I dress the way I dress, Kelly dresses the way she dresses, we design the way we design based on what we like. It is unique to our own individual tastes. It is the mixing of lots of different ingredients, and being able to take her education and my raw way of looking at the same thing and coming up with something unique to this line…I was always interested in putting it all together…It's like writing a song. You've got to have all those little things—but still it has to be a hit. Kelly…knows how to make a hit." Elaborating further on what made them work well from a business vantage-point, Gray explained that "I'm able to open doors…and the doors that I can't open, Nikki can…I'll be honest with you…I lack the cool factor."

To those unfamiliar with how intimately Sixx had been involved from day one in directing Motley Crue's stylings, he detailed his history with fashion design as dating back to "growing up in the seventies, we shopped in Thrift stores. We manipulated clothing, reconstructed it, whether it was different kinds of threads, different kind of fabrics, and we built our own clothing to make a statement. In the early Motley Crue days, we were wearing women's boots, because they were the only style that we thought was edgy enough to push the image that we wanted to push. Now with Royal Underground I have the opportunity to design clothing for that fits that criteria but is made specifically for men. It has been hard for us. I mean you can wear blues jeans and a tee shirt, or that is about it. Or you have to go up to suits…To me, fashion and music go hand in hand."

Consistent with Nikki's history in Motley Crue, Gray explained of the pair's new venture that "Nikki and I are incredibly hands-on, from the color of the thread to the washes… We design everything together…Nikki's very particular about the denim washes and mineral washes on the T-shirt. I'm particular about the marketing and getting into the stores and talking to the sales associates and getting to know the customers." Elaborating further on the subject, Nikki confirmed that "we are both really involved all the way down to the thread, and color. We like to joke and say that we have a fashion marriage. We will bicker over, a

very minute thing. Sometimes, we will be in the factory, and you can just see all the other people standing around shaking their head going. 'They are fighting over a ribbon!?' Kelly would say that is too big, and I would say it is too small. But you know what? We loved it. It is like with the band, we will fight. Sometimes in Motley Crue, I will say is it a C or C Minor? Eventually someone goes, who gives a fuck! Let's just rock! It is the same with the fashion industry. The people say, 'Guys, no one will even know what the hell you guys fought about.' When you love something enough to go head to toe over it, you know that it is going to come out really good."

As their partnership developed in the wake of Sixx's very public divorce and Gray's single status, in addressing the inevitable question of how deeply the pair's personal chemistry ran, Gray at first teased in response that it was "a question that's asked so often, we choose not to answer." Still, as the line evolved over the summer of 2006, Gray updated her initial reply to explain that "our relationship reminds me somewhat of the working relationship of my mom and dad's (St. John founders Marie and Robert Gray)…It's an unlikely combination, but we're more alike than what people think." Offering an insiders' glimpse into their creative process as design for the first line progressed, Gray recalled one instance in which "it was literally 4 o'clock in the morning, lattes in hand, and Nikki was doing spec sheets himself. And he says, 'You sure a quarter-inch on that seam?' I'm like what? 'That's exactly right.' "

Learning the ins-and-outs of high-end fashion in real time with the line's evolution, Nikki began by explaining a research process that rooted in his being "a sponge for information…If you understand how it works from the bottom up, you can understand how the top works…The Royal Underground line is all across the country. We have been going to different stores. We get to the retail stores, we go in, and we walk the stores. We talk to the sales people. We ask them, what is working and not working and why they feel that our clothing line is valid. We asked them, where do you see us? They say we see you sitting in there with Dolce. There is a very similar thing that we did with Motley Crue. We used to do record in-stores. We used to really love that because, we would be in the city where we would be doing in stores, and the record company would say to us, 'they want you to release a song like Toto for radio.' We would say, 'Dude you don't know what you are talking about. Kids in the street, they are looking for fuckin shit to rip their ass off.' We confirmed where we were

as artists. Sometimes you need that instant feedback. You can get that off the Internet now. But sometimes it gets a bit misconstrued. When we were a young band, and we would get out there face to face with people, it helped to confirm what we were doing, what we were passionate about and what was real. We are finding that now when we walk into the retail stores, they say, 'We can't wait for your stuff. It is going to be perfect.' The managers at the retail stores are telling us, that they are excited about it, and that is how we know that Kelly and I are doing the right thing." Elaborating further, partner Kelly Gray expressed an end-goal of making "Royal Underground a house…The marketing behind this is going to be the most exciting thing I've done in five years."

 The L.A. Times described the company's debut men's line to include "soft Italian leather jackets, classic blue and black jeans, cotton polo shirts in sea-foam green, 100% cashmere sweaters in browns and blacks, some articles embellished with shields and Old English iconography…(and) will deliver, at rock-star prices: A men's suede blazer, with a fleur-de-lis silk-screened on the breast and back, will retail for $1,200; cashmere sweaters for $900; a black Italian leather motorcycle jacket will go for $895; soft cotton T-shirts will be priced at $95. All ($1200) leather jacket linings will be inscribed with lyrics to Mötley Crüe's (music)… Apparel from Newport Beach-based Royal Underground…will begin arriving in high-end stores such as Nordstrom and Neiman Marcus in early November." With the line's retail debut, Sixx reasoned that the high-end price range made fiscal sense because "it is a fine line with a price point that reflects that the materials are a higher end, because we really have a higher end, which includes elaborate construction, elaborate leathers, and cashmere tops. Our jeans are phenomenal, the construction of them, the washes, and the designs are elaborate. So we don't belong on Melrose. We realize that we fit into a certain niche. Neiman Marcus has been extremely supportive, as well as Bloomingdale's, Nordstrom, Fredericks in Los Angeles. There is an age bracket that goes there that I wasn't necessarily aware of that skews as young as it does, and also surpasses the age limit that I thought would wear cool clothes. Let me give you an example. When we were at Neiman Marcus recently, they said the men's section on Friday or Saturday night in the store is visited by shoppers that are basically 21 to 40 years old. They are looking for cool, hip, and comfortable clothes. The men's market is growing faster than any other market there is right now. I think men are getting to the point, where they are comfortable accepting themselves a

little bit outside the box, but at the same time, not wanting to be outside the box to the extent that it doesn't really feel comfortable to walk down the street. For us as designers, Kelly and I are constantly using that strategy in men's wear."

Addressing the company's future lines, which Sixx explained evolved "shortly after (we)... designed the first full season. Here we are. We are already two seasons ahead, and getting ready to finalize fall one and go into Fall two. We have four seasons a year. We travel around the world together developing these individual lines that all sort of speak to each other, and are unique enough to keep it exciting...We have not at this point launched the women's line. There are some things on the horizon that we are taking about...I'm excited for women's...With men you are somewhat limited. But with women, you are so much more open...Right now the focus is men. We have been very careful, how many stores that we open our first season. We could have been pigs. We could have gone out there and said we want every single store and went for the mass media slash. But instead, we decided to grow the company, in a sense that we really knew what we were doing. Everybody makes mistakes, whether it is a rock band or new clothing company, you make mistakes. But we didn't want to make mistakes to the extent where we disappoint retail. We have 13 Neiman Marcus stores and about the same for Bloomingdale's. I know that number will grow significantly in season two. After we have been in this for a year, we would have known every single aspect of what works and what doesn't work for Royal Underground. You have to realize that you are talking to two people that are not doing this for money. We want to have a successful business. We have some of the best people in the fashion industry that work with us. This venture wasn't to do this to make money. We are doing this because we have a passion for it. In the end, just like with Motley Crue, I have been very lucky to have a very financially successful career, which allows you the freedom to do whatever you want to do. I think that with Royal Underground, it is the same passion for both of us. We are not doing this to make 25 million the first year. If we wanted to do that, we could have jammed this thing down the throats of the masses. We want to be doing this for years and years. The St. John clothing line has been in business since 1964. That is amazing to be in business that long. You are taking to two people, who are into big time commitments and growing something. This is a long-term goal; building something that we are passionate about. We love it!"

Amid his professional goings-on, Sixx updated fans via his online diary in mid-summer after weeks of silence on the state of his life personally amid the divorce, explaining understandably that "after the tour and after the divorce papers were served, I was dead, rotting and confused. Time seems to heal all wounds; now all that's left are the bruises. In the end, all I really care about are these beautiful kids. I've just been focusing on my kids and making sure they're OK. I feel they're getting what they need in the way of support and love from myself, Donna and Brandi. Of course, there's the lawyers, lawyers, lawyers- draining, emotionally and financially- but this isn't my first rodeo, but I will tell you it's my last. The upside to the downside is I'm on a creative high. I've been on a song-writing binge. I've gotten back into photography too. Funny Farm studios is up and running five or six days a week. I've been writing with DJ Ashba, who works out of Funny Farm, every day, churning out songs with me and a lot of other great songwriters. In an all-out attempt to let go of the outcome, the new songs have no destination at this time. At some point I have to focus on the Aero-Crüe tour and a new album (both of which I'm very excited about). We have a show somewhere in a week or so, and to be honest, I don't have the heart to go do a gig right now, but once the stage lights dim, I always come alive. Sikki is always waiting in the wings. To quote a favorite cliché: What doesn't kill you makes you stronger. I'm living proof of that."

August would prove to be a busy month for Nikki, both in formally announcing a fall co-headlining tour with Aerosmith & Motley Crue entitled the 'Route of All Evil' tour, as well as several trips abroad relative to Royal Underground, the first of which Sixx took at the beginning of the month, reporting in his on-line diary that "I leave on Tuesday for England, India, China and Japan (all in 7 days)…Music is flowing – upheaval does that to you. We've been designing the set, lights and stage for the Aerosmith-Crüe tour plus going to court and family time; I'd say sleep is on the backburner. It's weird to be single. I'm not really a 'go out kinda guy' so I'm just spending all my time with the kids. Summer is winding down and school is gearing up so I won't be too freaked about leaving for tour. Tommy was too kind to offer for me to fly back and forth with him on the jet while we're on tour and he finishes off his Rock Star Supernova show. So I'll be seeing the kids a lot more than I usually do when I tour."

Of Sixx's second trip abroad, which the L.A. Times reported arose in connection to Gray and Sixx's having begun "planning Royal Underground's (debut) line...over the summer...They circumnavigated the globe, visiting six countries in seven days, looking for inspiration in India, touring factories in China, dropping in on London and Dubai. Fashion photographer Paul Brown joined them in Jaipur to shoot photos for the spring brochure, which Gray and Sixx say will look a lot like a rock 'n' roll band's tour program." Elaborating in much more specific detail in his online diary on the second trip abroad near the end of August, Nikki began a real-time documentary by explaining that "I'm sitting in Muscat, Saudi Arabia at the airport as I write this. I woke up today in Jaipur, India, took a private plane to New Delhi (to get around the problems with heightened security from the recent terrorist threats.) Leaving to Dubai (again Saudi) in a hour. The airport is covered in soldiers draped in machine guns and bomb sniffing dogs? I don't know what's odder: me wearing a cowboy hat standing in the security line being searched next to about 20 Muslim woman, all cloaked in black, only their eyes showing; or the fact that I keep getting approached for autographs? Of course, one had to ask if I was Tommy, (another) asked if I was in the Rolling Stones... India was moving, equally to Cambodia for me...They just called for my flight...I'm in Dubai now, with no sleep. When the plane was taking off from Muscat, I thought the plane wasn't gonna get up. It was shaking, rattling and grunting under the weight of the old Swiss Air 707. It has seen its day, years ago. Kelly and Paul Brown were in India with me working, doing a photo session for Royal Underground. We had 3 Bungalows within feet of each other. Between the photo sessions, me and Paul would sneak out to shoot in the streets and soak up the side of India most would like not to acknowledge."

Continuing with his online-documentation of the trip, Nikki touched on a personal front he hadn't in a while, explaining that "I just got off the phone with Frankie, and the only way I could explain where I am was that this is where Aladdin is from (haha.) They just called the plane to Shanghai, I need sleep, running on empty...Shanghai, China: Just got back to my room. I went straight to business meetings from the plane. I have never seen so much traffic in all my life. Worse than Japan, and that's saying alot. I have 30 minutes to wash India from my body and meet in the lobby for dinner. I don't know what time or day it is...Dinner was eclectic, something I'm not new to, so I rolled with the punches. I guess I really should explain why I'm traveling all the way around the world just a few

days…I'm involved in a clothing line with Kelly Gray. Our line is developed and going into production as I type away here in Shanghai, but really we're two seasons ahead in design and development. There's a lot of research and design in every line, and we have a lot of partners, both overseas and in America. There's nothing like face-to-face to get your vision across to your partners, hence the crazy schedule…Off to bed, we have to go 2 hours outside of Shanghai for a meeting then back to the airport to go to Tokyo…Just went shopping at the Tokyo airport. Almost home. I miss the kids so bad. I got them all a bunch of gifts and money from each country. I'm gonna kiss the American soil when I land in L.A. There is no place like home."

Kicking off the fall of 2006 in high gear, the hype which had surrounded MTV News' announcement at the end of the previous spring that "two of rock's hardest-livin', hardest-rockin' acts ever are hooking up for the colossal, 27-date Route of All Evil tour", what had followed had been among the quickest tour sell-outs in rock concert history. A generation-bridging tour that brought two of the biggest hard rock acts together for the first time to perform for a new generation of rock fans, legendary Aerosmith guitarist Joe Perry had excitedly commented of the pairing that "its going to be quite a trip…To me, **MÖTLEY CRÜE** is still a baby band, you know?…I still remember when Motley Crue's first record out. It was exciting to see them blossom. I saw them play a couple small places in L.A., and then…their first big arena show at the Santa Monica Civic Center (in California)…It was that incredible rush when you first break. They really put on a rock show in capital letters. It is always inspiring to play with a band like that…And of that generation of bands, they were the best ones, you know what I mean?' "

Sixx, for his part, felt the pairing made sense on every level, explaining that "I think both bands work together great but they're different enough where it's not going to get boring…It's quite a journey for both bands…I can't believe it…I'm excited but also kind of shocked. We toured for 14 months and now we're going right back on the road again? But for me, to go out with Aerosmith is something that is a dream come true…You know there were a few reasons that Motley Crue and Aerosmith wanted to tour together. One reason was, we both knew that we had some similar audiences, but we also knew we also had different audiences. One of the greatest things was hearing from Aerosmith's

management company that Aerosmith would like to tour with us. Not only do they respect us, but the fact that we have a way younger audience than them. They would like that audience to see them. They are one of the greatest rock and roll bands that there is. Our response to that was, 'That's phenomenal.' You guys have an audience that doesn't come see us as much, because Aerosmith is ten years older than us. So their die-hard fans are older than any audience we have. So it is so interesting to see teens, twenties, thirties, forties, and fifties, all at one concert. The last time I have seen that was at The Rolling Stones, when we opened for them. I will honestly say that was the Rolling Stones audience that was there that night, and not the Motley Crue audience. I know we had fans there, but we were playing with the greatest band in the world."

In detailing how Crue's stage-show for the Aerosmith tour would contrast with that of their last two, Nikki began by conceding that "it's hard to design a show as a co-headliner. There are different rules, concerns and limitations that apply for both bands and you have to have your show mobile and fast to take down; it's a lot of work. With that being said, I hope I'm not building anybody's hopes up to high (mine too), but I think this show (visually) is even better than the Carnival of Sins tour. I don't want to give it away; the Internet sort of kills the element of surprise after the first show anyway." Kicking off on the 5th of September to the usual sold-out audience in Columbus, Ohio, Nikki reported afterward in his online diary that "the first show of the tour was pretty good considering all the little wrinkles that need ironing out. All I saw was smiling faces from the front row all the way to the back of the place. There were a few of the older Aerosmith fans holding their ears, but we like it loud." Throughout the balance of September, the band's tour itinerary took them to: 09/07/06 Hartford, CT New England Dodge Music Center; 09/09/06 Burgettstown, PA Post-Gazette Pavilion; 09/12/06 Darien Center, NY Darien Lake Six Flags; 09/14/06 Holmdel, NJ P.N.C. Bank Arts Center; 09/17/06 Wantagh, NY Nikon @ Jones Beach Theatre; 09/19/06 Wantagh, NY Nikon @ Jones Beach Theatre; 09/21/06 Charlotte, NC Verizon Wireless Amp.; 09/23/06 Camden, NJ Tweeter Center At The Waterfront; 09/26/06 Mansfield, MA Tweeter Center; 09/28/06 Mansfield, MA Tweeter Center; and 09/30/06 Bristow, VA Nissan Pavilion.

Updating fans in his diary near the end of September, Sixx reported that "the tour is killer but the days off are killing me. Damn, not enough time to go home and too much time to sit and stare at the same four walls. DJ Ashba's coming out to write music. We've finished up eight new tracks with no destination in mind; just following our hearts and even more so - our fingers." Continuing on their co-headlining tour with Aerosmith throughout October, Nikki and company criss-crossed America, with dates including: 10/02/06 Toronto, ON Air Canada Centre; 10/05/06 Tinley Park, IL First Midwest Bank Amphitheatre; 10/07/06 East Troy, WI Alpine Valley Music Theatre; 10/09/06 Cincinnati, OH Riverbend Music Center; 10/11/06 Clarkston, MI DTE Energy Music Theatre; 10/13/06 Noblesville, IN Verizon Wireless Music Center; 10/15/06 Maryland Heights, MO UMB Bank Pavilion; 10/17/06 Bonner Springs, KS Verizon Wireless Amphitheater; 10/19/06 Antioch, TN Starwood Amphitheatre; 10/21/06 Virginia Beach, VA Verizon Wireless Virginia Bch. Amp.; and 10/23/06 Raleigh, NC Alltel Pavilion @ Walnut Creek.

Sadly, while everything had come together successfully on the road, back home, the dissolution of Nikki's 9-year marriage to Donna continued as the couple put their Agoura Hills home on the market. According to the official real estate listing, which priced the house at approximately $3 million, "the Spanish-style villa is in a gated community of four homes in Agoura Hills, each on a forty-acre parcel. Built in 1982, the six-thousand-plus-square-foot house has been extensively remodelled over the last five years, including a complete overhaul of the kitchen in 2002 with granite counters, slate floors, hand-hewn oak cabinets, top-of-the-line appliances, a copper sink and a built-in cappuccino machine. The villa has six bedrooms, four-and-a-half bathrooms, a family room, a formal dining room and a bonus room. The master bedroom suite has a balcony, vaulted ceiling, two walk-in cedar-lined closets, a spa tub, a steam shower and a redwood sauna. One of the other bedrooms was designed as Nikki's music studio. The grounds have a pool, spa, meditation garden, vegetable garden, playground and mountain views. A river-rock waterfall accents the house's double-door entry, which is reached by a private drive."

In an update to fans as October's tour dates neared an end, Nikki reported in his online diary that "the other night my friend John Rich from Big & Rich came on stage and played *Don't Go Away Mad* with us in Nashville. Fun times. We met a few years ago while writing music together

and have been fast friends ever since. Royal Underground is shipping this week and all the clothes have arrived in L.A. and we're packing them up for the stores. Tommy stole one of our shirts right off my back the other day and Steven Tyler won't take off the cashmere hoodies - I'd say that's a good sign. Last show tonight and we go home for a ten-day break. I can't wait to lay my head on my own pillow and to wrap my arms around my kids. Hell yeah, life is good… Thank you for everything… This has been a hell of a year… good and bad… but we survive."

Heading into November and the Crue's final trek of dates with Aerosmith, their touring itinerary took the bands' to: 11/02/06 Mountain View, CA Shoreline Amphitheatre; 11/04/06 Las Vegas, NV MGM Grand Garden Arena; 11/07/06 Los Angeles, CA Hollywood Bowl; 11/09/06 Chula Vista, CA Coors Amphitheatre; 11/11/06 Devore, CA Hyundai Pavilion Of Glen Helen; 11/13/06 Phoenix, AZ Cricket Pavilion; 11/15/06 Dallas, TX Smirnoff Music Centre; 11/17/06 Selma, TX Verizon Wireless Amphitheatre; 11/17/06 Selma, TX Verizon Wireless Amphitheatre; 11/19/06 The Woodlands, TX C.W. Mitchell Pavilion; 11/22/06 Tampa, FL Ford Amphitheatre @ State Fairgrds; and finally on 11/24/06 West Palm Beach, FL Sound Advice Amphitheatre. In a reflection of the artistic comradery that had defined the tour, as dates began to wind down, audiences more and more frequently found themselves treated to show-ending jams between members of both bands on stage together, including a November 15th Dallas date where Mick Mars jammed with the band on the blues standard, '*Stop Messin'*. Commenting on the jam as part of a larger summary of the professional and personal synergy the bands had shared throughout the tour, Aerosmith guitarist Joe Perry recalled that "(Mick) really ripped it up and we had a great time. He's got great blues chops even though he plays classic metal in the Crüe. I have a feeling we may do this again before the tour is over. I gave him a DVD of the song for a present and he gave me one of his favorite fuzztones effects pedals. Like I said before, these guys have been great to tour with. Not only are they great to play with but Nikki even outfitted us with his new clothing line."

Taking time out during the same tour stop to make an in-store appearance at Neiman-Marcus in Houston in support of his newly launched 'Royal Underground' clothing line, Sixx also updated his fans on the general state of his life on the road via

his online diary. Reflecting the wear of the road on him personally as he worked over the Thanksgiving holiday, Nikki lamented the fact that "the kids are all home having Thanksgiving and I'm still on tour. This is the second Thanksgiving in a row away from home. The end of the tour is almost here and room service (a cold turkey sandwich) is almost here too. There are no plans to do anything at this point and that's fine by me, 'cause I'm burnt out and as grateful as I am, I'm ready to go home and stay home. This has been a stressful year and I can't wait for the ball to drop on 2006 and welcome 2007 in." As the tour wound down heading into December, its success was reflected via its nomination for 'Most Creative Tour Package' as part of Pollstar's annual Concert Industry Awards. Ending the tour on a personal high note, Nikki was invited to join Aerosmith during the pair's final concert date in Van Couver, Canada, whereafter Nikki excitedly recalled that "they asked me to play Helter Skelter on stage with them tonight and it was a dream come true (not to mention we kicked some fucking ass). I'm so pumped right now thinking back on rocking up the stage with my heroes. The Aerosmith guys have been the easiest band to tour with in our career. No drama, no competition. We all hung out together and had a blast. I'll miss them and I know they feel the same."

As the tour and year came to a simultaneous close, for Nikki it seemed a time of reflection, both on his monumental triumphs professionally, and equally as considerable losses personally in the context of his relationship with Donna D'Errico coming to a close. Speaking personally to fans via his online diary, Sixx conceded the latter in admitting that "for me, this has been the hardest year of my life I've experienced in almost as long as I can remember. Going through a divorce during a tour is another level of stress I don't wish on anybody. But we get through what we have to get through and now it's time to focus on the most important things in my life: my children and my sobriety. Someone asked me how I didn't go into a downward spiral and I told them because it isn't an option anymore in my life."

In addressing the future, Sixx focused first on the long-awaited new studio album from Motley Crue, revealing that while "there's a lot of (new) music…I don't feel any urgency…I guess in a perfect world, the movie and the album and the tour would all kind of come at the same time. But in the Motley world, I doubt it…We're writing a lot of great music right now

and when it's ready, it'll be ready…(but) we are definitely gonna make a new record…with Bob Rock…Our intention is to make the greatest record we've ever made. With that being said, we also believe that if we over think it, it will lose its rawness, so we wanna get in there and just terrorize the music and then just get it on tape. That's the idea, but that's more of in a perfect world. In a MÖTLEY world, we will probably get closer to getting the album done and then go, 'You know what? We're missing one or two songs,' or something, which we do a lot. We did that? 'Kickstart My Heart' was the last song written for the *'Dr. Feelgood'* album."

Continuing with his reasoning on why the band's taking their time was so important, Sixx focused on the quality of his band's new product, explaining that "I think new music is so important. We have a great catalog of music. People love to hear all the hits, and we've been playing obscure songs as well, but new music is really the lifeblood of any rock 'n' roll band. And you have to do it, you have to forge forward. Especially for bands like us and Aerosmith and AC/DC that have been around for so long. We have to keep making new music or we become nostalgic… For me, it's a very uncomfortable feeling to live in the past. If you're not growing, I think you're stagnating. If you're stagnating, you're dying. There's always gonna be an edge to the band. That's just who we are, but at the same time, we're progressing as people, and the music comes out of people, so that's what happens. That's why bands change and sometimes fans as like, 'Why are you changing?' It's because we change, and if you don't change, I feel sorry for you."

Expanding his year-end reflections to address the revitalized, multi-generational fan base Motley would be targeting with their next studio album, Nikki concluded by recognizing their new music would have to incorporate and reflect the fact that "fans grow up, and as some people get older, they're not listening to as much music. Life's not just about being in the bedroom listening to music. They have families or they're married or they have jobs. Some of them go that way, some of them change their taste in music, and at the same time, you get new fans. There's a new generation of Mötley Crüe fans out there (and) a percentage of original fans, and that works for me." As he began the process of looking to the future, both personally, and professionally where Motley Crue and his countless other ventures were concerned, Nikki signed off to fans with the promise that "I'm heading into the creative underground for a while, hopefully to

resurface recharged and ready to come out swinging. How long? However long it takes."

Chapter 27

"It's just a year of giving back for me, dude, no strings attached." – Nikki Sixx 2007

"The first thing I think about in the morning and the last thing I think about at night are my kids...I'm really proud to be a single father, and not a single rock star. I gotta tell you, the bar is so high for me in meeting someone [to date], it weeds out about 99 percent of the population. To let them into our life, that's a big decision that I take very seriously."- Nikki Sixx

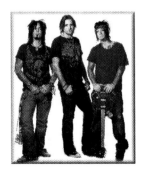

The Heroin Diaries

If 2005/6 were about getting Motley Crue's house back in order, 2007's focus for Nikki Sixx was in doing so on a personal level, revealing to fans at the end of 2006 in his online diary that "this has been the hardest year of my life I've experienced in almost as long as I can remember.

Going through a divorce during a tour is another level of stress. I don't wish on anybody. But we get through what we have to get through and now its time to focus on the most important things in my life: my children and my sobriety. Someone asked me how I didn't go into a downward spiral and I told them because it isn't an option anymore in my life." Sixx's commitment to focusing selflessly on his children via sobriety reflected a clear and deep understanding of how one directly and permanently impacted the other. Not surprisingly, he would still find a way to reference his own past with the latter in reverse to reinforce the path he had chosen to take this time out, via his professional focus the highly anticipated release of the *Heroin Diaries* book later in the year. Still, as the year began, Nikki clearly had his priorities in order, and that focus on family and sobriety- the very thing he had ran from via drug abuse in his past- was paying off, as Sixx reported in late January via his online diary entry, remarking that "sitting here soaking up the love of my kids, all I can think about is how everybody in the house laughs alot, a lot more than I can remember in a long time. Yes, its different being a single dad and having a career, but different in a better way. I have a lot more to do daily and I take it very seriously. I've not found anybody worthy of really dating and that's okay by me. My kids come first, then my career, and last my social life. I can live without the last two but not the first."

While his custody battle with recent ex-wife Donna D'Errico over 6-year-old daughter Frankie Jean was still pending; Nikki's joint custody of his three children with first wife Brandi Brandt, which dictated one week with each parent, remained intact. Having put his Agora Hills ranch up for sale, Sixx had moved with sons Gunnar 16 and Decker 12, and daughter Storm 13, into a new 6-bedroom, 7-bathroom Mediterranean-style home. In elaborating on the layout of his new house, Nikki first explained that "I'm a single father and make all decorating decisions myself…(Its) funky eclectic mixed with antiques and overstuffed furniture with classic macabre fabrics…(The walls of my living room are lined with) hundreds of crosses. Any time I see a cross or a rosary, I have to buy it. I'm not even Catholic or Christian — or Buddhist or Jewish. I'm spiritual. So anything to me that symbolizes good, I'm attracted to it…(My home also has many) antique rugs…(I bought) at swap meets. I've gotten a couple of rugs over the years, like Persian rugs, that I've paid through the nose for. And then I've gotten some where you don't know if they're real or not, and I've found out later a couple of them were real — and you sit there and go, I bought

this rug for $13, and it's worth $13,000. Not that I would ever go sell it, but it feels good to know I got a bargain."

Getting a bit more personal for fans, Nikki in describing his bedroom began by deeming it the most unkempt room in his home, largely due to the fact that "I'm a clothes whore, and probably I change my clothes like four or five times a day. My one spoiled-rock-star thing that I do is: I put on a shirt and then I throw it on the floor and try another one on. I put on a suit, then throw it on the floor. It's just a constant battle, me and clothes…(My closet is also loaded with) suits. Some that I've designed. Some are from this amazing suit-maker in Los Angeles called Lords, and they have the most amazing Italian fabrics that you can choose from. They're not cut like you would imagine. They're very slim. The (trouser) pockets are slits at the top. You don't wear belts with them. They're very rock 'n' roll looking- very British-rock-star looking. I just love suits. I'm really on a suit kick right now. It's addictive. I guess if I can get addicted to heroin, it's OK to get addicted to buying suits…The bed's never made. It looks like a war zone…(On my nightstand, there are also) lots of books. The one on top is a book called 'The Child Within,' and that book is amazing. As you progress down the road you get further and further from your childhood, and to me that whole thing of peeling the onion — the psychology of it — is mind-blowing. Those formative years are so impactful to the rest of your life. I find it so intriguing."

Outside his inner-domain, Sixx described the most-trafficked part of his home as "the kitchen. As most homeowners know, is the heart of the house. Our kitchen is nice, but I'm not so into the aesthetics. Emotionally, it's the most special room in the house. It's where everything happens. I mean, the kids are doing their homework, their friends running in and out. A lot of, like, 'Hi/Bye!' Grand Central Station, so to speak." In describing elements of his routine as a newly-single father, Nikki began by explaining that, as a rule, "we have no secrets in our family. And see, I'm just their father. I'm a dork to them. I'm not cool at all. They love me more than life itself, and I love them right back, but there's nothing cool about dad. I'm just this guy that makes them do their homework…I've always hopped from relationship to relationship ever since I was a kid, so I'm glad to have been able to go through a divorce, stay sober, be a good father and stay single. I have all these people going, 'Wow, being a single rock star must be amazing,' and I go, 'No, it's actually really boring.' And I like it. I've

sort of set this bar of things I want to do, and there's just not enough hours in the day to share it with anybody else…I'm really passionate about being a good parent trying not to recreate anything from my childhood, that could affect my children."

In sharing a bit about his children's own personal development- in context of his professional public profile- Nikki seemed relieved, reasoning that "sometimes they say the apple doesn't fall too far from the tree. In my case, I am pretty fortunate. They're pretty balanced, cool kids, going through pretty much the same thing all the other kids go through. There's nothing unique about me as a parent. I am a parent. My kids are kids. We do the best we can do. I don't think they know a lot about what I do, other than that I am in this crazy band, Mötley Crüe…Every day, I wake up, and the first thing I think of is my kids. Then I do what I do with my life, which is to be a creative person no matter what I do—I have a clothing line with Kelly Gray that's doing really great, and I'm a photographer, a songwriter, and I have the band Sixx:A.M., which did a soundtrack to the book, and then Mötley Crüe. Then the day ends, and I'm back to my kids again. Because I know that these years, I'll never get them back."

When addressing the wildly infamous subject of his drug-fueled heydays in context of advising his own children on the subject, Sixx explained that "I'm not unlike any other parent. I worry about it because it's in their family history. I could lock my children in their rooms, shackled to a wall, and if they wanted to get out and go down the same road as me, they're going to figure out how to do it. Addicts are the most witty, clever people there are. All I can do with my kids, and I think I'm doing the same thing in the book, is say, behind door No. 1 is this. Behind door No. 2, there's this option. It's not my choice to pick the door for you. I just don't want it to be a surprise… There are no pink elephants in our family. We talk. My job as a parent is no different from my job as an author. You need to tread lightly and show experience and options. I could chain my kids to a wall, and if there's something they want to do, they'll figure out how to do it…In the end, I can only enforce the law so much underneath the roof of our house. In life, I can't enforce any laws. I can only say, 'Read the book. It describes your choices—pick it.' I am not a preacher. I don't want to stand on a soapbox and tell people, 'Don't drink. Don't use drugs.' With my kids, I say 'Don't drink. Don't do drugs.' But when they turn 21, they can drink. I hope they never use drugs, but people make their own

decisions. When they're old enough, they are going to have the chance to make their own decisions. I just hope I have given them enough love and support, and the ability to come and talk to me if they need to."

Elaborating more in-depthly on the subject, Nikki conceded that "it's difficult. We've obviously had these conversations on a surface level. I've never dived into the details that are in the book, and I don't think that would be age appropriate at this time in their lives. I'm no different than any other parent. I'm sure that my kids are really no different than any other teenagers and soon to be teenagers. It's out there. There's peer pressure. It's in front of them. Their friends do it, their friends are going to have an influence on them. I can lead by example, but obviously I worry about it. I can't control it, you can't control anything. Control is a huge farce that human beings believe in. They believe they can control anything. You can lead by example and say this is my story, and people will then make their own decisions. A lot of people like myself said, well I see the red flags, but I'm going to do it. People make their own decisions…They say that alcoholism is a disease, and that it gets passed on from generation to generation. Trust me, I've told my kids about that: 'You've got the crazy gene in you, guys. When it comes time to kick back with the buddies, drink a beer, and watch a football game, just realize that there will be a day when that thing turns on you. So you better keep an eye on it.' Because I have a lot of friends who come from alcoholic families, and they aren't alcoholics, because someone explained it to them…(There is a) difference statistically between families that talk about drug addiction and ones that don't. The kids that can say 'I see where this is going' have a much better chance of not becoming addicts, because they have been educated, if only through their parents. For me, I never knew what addiction was. I just knew my heroes, like (New York Dolls guitarist) Johnny Thunders, did heroin. I didn't have a father, it looked good to me…I went from a dysfunctional childhood to one of the biggest bands in the world…and that even amplified the dysfunction that was still festering. Sold-out tours and platinum records and all the stuff that comes with fame -- none of it was filling the hole."

Relying on his own children as a motivation for sobriety, Nikki seemed to couple that with the other constant in his life: his passion for creating, explaining that collectively "they all feed my soul so to speak. If I go back to being a very young kid, it's all the creativity that I was

constantly getting my fingers in, whether it was writing or forming bands or even designing clothes as a young kid, my own style and that's always sort of fed my soul. It's an important part of at least personally who I am. It makes me feel balanced. I don't really feel I'm doing much different in 2007 than I was when I was seven…I've always been driven, but I just haven't known where I was going. I have a very entrepreneurial brain, and sometimes I have to stop myself. I literally could have up to 20 projects going at once, but my quality of life would go to hell if I did that. First and foremost, the most important job in my life is raising my children. After that comes my career. Motley Crue is something I'll do for a very long time. With all the things I'm doing, I have a pretty full life. It's hard work but it's exciting, and enjoyable."

Professionally, with Motley Crue on hiatus, Sixx spent much of the spring preparing for the release of the 'Heroin Diaries.' A brutally honest look at rock's literal bottom, the book spoke from the heart of Sixx's re-birth following his now-legendary lethal overdose, beginning with the past life he'd led prior thereto, it was a story that he seemed only fully-able to tell now, 20 years after the fact of life that had first opened his eyes to sobriety. In facing his addiction, Nikki explained that he couldn't be fully free of it until he more importantly faced the roots of its cause: his own childhood, reasoning that "it's sort of like I was an orphan of fate. I was living in this void of non-information and I took that into my teenage years. With hormones and angst fueling it, all the things that we do as teenagers helped me become a runaway. I took off on a path that was heading towards where this book takes us. But, it was really in me being able to write the overview of everything that I really actually got clarity in my own life, actually got to kind of close the chapter…Going into one of the hardest times of my life, which was going through a very difficult divorce and staying sober through that, because in the past, when I look back historically, when it got too painful I would have used something to kill the pain. And I actually have got to a place in my life where I'm able to deal with the issues head-on and not run from them, and a lot of it probably has to do with this book giving me some not only awareness but some closure."

Conscious of the *poor millionaire rockstar* label that historically has attached itself to such recountings of debauchery, Nikki first sought to set his story apart by both pointing to both his band's position in inventing their rock genre, and within that culture, the sheer excess of Sixx's drug

abuse from even the most extreme norms of partying within rock culture in the 80s, explaining that "it was a different world then, in the '80s in the Hollywood hair-metal scene. It's interesting because we were kind of lumped in with an era of bands that seems a little bit like it doesn't really fit. We really came from a '70s-rooted combination of punk and heavy metal. And a lot of the bands that came after us were influenced by us but really didn't understand that we were the Sex Pistols and AC/DC put together, that we were The Dolls and Black Sabbath put together, that we were 'Search and Destroy' by the Stooges but with the swagger of Aerosmith, and that the crash-and-burn mentality came from punk rock and that the swagger came from being a peacock. And it was interesting to me because I was probably emulating my heroes in a lot of ways. So when I hear later, 'Oh, these bands in the '80s, they really partied,' I kind of think, 'Man, they probably did.' They probably just partied but our story is a little darker and a more gritty and a little bit more on the destructive side than the, 'Sex, drugs and rock n' roll, woohoo!', you know, it was a little more dangerous than that. And I felt for me personally it was a lot more dangerous than that."

Elaborating in more personal depth, Nikki seemed eager to preface his story by pointing out that it was NOT a victim's tale, such that "I'm not going to say that we didn't celebrate, and I'm not going to say we didn't have a lot of fun. But for some human beings, type A personalities, you know, we go 0 to 100. And I'm almost, at times, grateful of that because it is part of what drives me to…be a real artist where some people would say, 'Well wouldn't it be better if you go just to 0 to 55 and not break the speed limit like everybody else?' And I don't know, you know. I guess I would live longer, but there's something exciting about being right on the edge and I had to pull that in, in my addiction, but I don't have to pull it in anywhere else…I'm not going to tell you I did not have a lot of fun—I had a gas. I'm not going to apologize for wrecked Ferraris and destroyed hotel rooms. That's not what this is about; this about unpeeling my own onion and getting to the core issue and realizing why addiction played such a part in my life. It was a Band-Aid for something that was painful, and I didn't even know what it was. I was downward spiraling and I didn't know why. (Mötley Crüe) was climbing the ladder, but I was climbing the ladder and had a noose around my neck at the same time; if I slipped, I was definitely not going to make it. I have to take responsibility for my own actions…(so in this book) I didn't try to conceal anything. It's just that I was a

millionaire, living in a mansion and could buy whatever drugs I wanted. Imagine being in the most pain you can be in, where your bones ache, your skin feels like it's peeling off, you're shaking uncontrollably and shit's running down your leg, and then knowing there's something in arm's reach that'll make it all go away. Look at laboratory rats; they always go back to the source of relief."

Among Nikki's initial source of relief from the haunting pain of his childhood- long before his Heroin habit- came from that of keeping diaries, with Sixx recalling that "I've kept diaries since late '79 or early '80 until now…If you knew me it'd be more surprising if I didn't have them. I'm always documenting my day, things I've accomplished and failed at. I'm always writing…The earliest diaries were '78, '79." Embodying both a personal and professional purpose, Sixx explained that, where creativity was concerned, "I used to carry a book around and draw pictures of what the stage set would look like, ideas, band names, that kind of stuff. By the beginning of Mötley Crüe, I felt like I really had something to write down." Still, on a personal level even as the band began their rapid rise toward the top, Nikki battled an incredibly painful inner-loneliness wherein, "there was a part of me that believed the diary was the only thing I could trust. It was a way of saying what I really felt… That's how I communicated…I had to or I would go crazy and even as I was going crazy I had to write it down to see if what I was seeing and hearing and feeling was real."

As he heard the roar of fan-filled crowds growing louder with Motley Crue's own ever-expanding popularity, Nikki explained that his diaries grew in volume, admitting that, at the time, "to be honest they were my only friend. The only thing that helped keep me even a little bit sane in an insane time…Some of the ones from the *Shout at the Devil* era are really raw and barbaric — like, 'Slept with four girls. Two were on their period. Can't remember any of their names. Me and Vince got in a fistfight. Sold-out show. 100,000 people. Nikki.' And then the next one would be, 'I miss my grandparents.'…(Another one from the time read) 'on tour with Saxon. Biff's being great. Rest of the band are drunk. Fucked two chicks. Life sucks.'…By the time I got to about '85, my writing really started flowing…When things started really popping in my life, I got more consistent with it. Every time I'd fill up a book or two I'd take them to my storage unit, where I have a big box of them."

Even as his band's world-wide popularity continued to expand, Sixx grew more isolated from the world around him. In addition to a drug habit that continued to grow in the same time, Nikki also relied ever-more readily on his diary as a refuge, reasoning that, at the time, "I don't think a discipline as much as a necessity. I was hanging on by my fingertips on the edge. It was the only thing that gave me strength to hold on another day, the relationship with a pen and paper. That kept me from slipping…I really felt no connection with anybody or anything on the planet. I was happy to be gone; it just didn't matter to me…I've always been really influenced by beat generation writers. For me, to be able to document my moment-by-moment demise and downward spiral, it was poetic to me and cathartic and I got into it, like it was my only friend… I have a vivid memory, it was during the Theater of Pain tour, and I believe we were shooting the 'Home Sweet Home' video. I was walking to stage, and Tommy looks at me and goes, 'Why you so bummed out all the time?' I looked at him and said, 'You would never understand.' That's it in a nutshell — I didn't think anyone else would understand, so I kept it to myself."

Continuing, Nikki pushed the point even further by revealing that his heroin habit fueled that of keeping a diary, explaining that "it was my relationship with the pen and paper that probably stopped me from killing myself. To be honest with you, it was my only friend. It was the one person I could tell my darkest secret to and that wouldn't tell anybody else. It was the one person that I knew would be there in the morning and that wouldn't abandon me. And that relationship with the pen and paper, as sick as it got at times--there were times when I was reading through the journals and diaries I was going, 'I'm fucking lying to myself.' I mean, it'll be like I'll say I haven't done any drugs in three days, and then three days later I'll be like, 'Dear Diary, I've been lying to you. I've been doing drugs.' I mean, that's like literally the diary of a madman at that point. It's actually lying to myself in my own diaries because I really felt this was the only person I had to talk to. It was really, just really, insane." As his depression and drug-addiction spiraled further out of control toward its famed end, Nikki recalled that "at the time…I was barricaded with my disease in my house. The pen and paper was almost like my only friend. I was going through something and I didn't know what; I didn't know how to express it to anybody, so I expressed it on paper…I never shared it with anybody. I don't share my diaries, and I'll tell you that I'll never publish any of my other diaries. They're personal."

Explaining the origins of the book and beyond, Nikki explained that- habitually- "I have kept a diary always and I still do. I write every day. What was really interesting is my diaries have evolved. And that actually, believe it or not, became a very important time in my writing because I got into the habit of writing the feelings and writing what I was seeing visually. Really my favorite writers are beat writers, and I've always loved the tempo of the way they write, and my writing kind of has that. Quite a few years ago, I don't know 10 years ago maybe, I got a book called *The Artist's Way* and it confirmed a lot of things for me, which was stream of consciousness and quieting the critic. The drugs were quieting the critic. They were allowing me to say whatever I wanted to say and not worrying if anyone else would criticize that because no one was going to read them because, let's face it, that's why they put locks on diaries, right? That's why you hide them at the bottom of your sock drawer or no one knows about them because you're going to tell your deepest, darkest secrets. So I've learned--and really it was 20 years ago, but I think I started writing more like that at that time, more expressive, and this book, *The Artist's Way*, it's phenomenal for writers actually, just to allow yourself to write without stopping, without asking yourself if that made any sense because none of it matters if it makes sense or doesn't, it just has to come out."

When Sixx finally read back through the diaries almost 20 years and a new lifetime of perspective later, he explained his initial inspiration to publish the diaries documenting the height of his addiction between 1986 and 1987 as growing from his own after-shock, recalling that "one day I started digging through (the box of diaries)…and I began reading about the inception of the band, and how I loved the Sex Pistols and the first Van Halen record, and thinking things like what if a band could look like the New York Dolls, but sound like AC/DC—teenage fantasy stuff. Next I read about the formation of the band, the creation of (first album) *Too Fast For Love*, the next record *Shout At The Devil* and how we're playing in front of 70,000 people who are singing our songs. 'Home Sweet Home' is a huge success for us and I'm amazed this is all happening. As I'm reading I notice how I'm doing more and more drugs and how the writing is less playful. Then, I hit the '86 era, and I'm reading my diary entries for hours and I'm in shock. I'm thinking, 'Where is the guy with all the dreams?'…I got this moment where I was reflecting on my life. I remember it was brutally hot that day and I was just sweating, and when the ones from '86 to '87, all

kinds of feelings came up. It made me cry, it made me laugh, it made me question things."

His quest for answers to those questions would begin with the decision on a personal level to publish the 1986-1987 diary, recalling that inner process as one initially sparked by the fact that "I hadn't read those diaries in years — since I wrote them. And when I did, it was like reading someone else's diary. I couldn't believe I was still alive. I mean, I knew how bad I was, but some of the entries, the psychosis, the insanity- I couldn't believe I got out of it...(Also, just my) overall unconcern for life. There was no (thought that) 'I might die from this.' You think that you're invincible. I remember the pain being so huge at times, because pain bubbles. It's not always there poking you...We had a really good time, to be honest with you, when we were out there doing what we were doing. That particular year, the reason I time-capsuled it was because the bottom for me, personally, had started to fall out, and I didn't know why. I was able to ask a lot of questions inside the actual journals that I really didn't have an answer to."

Beyond answers to why he had sunk so deep into his depression/addiction, Sixx also discovered by reading through the raw diaries that "there were so many incidents that I'd forgotten. One of the most moving parts for me was (reading about how) I had actually died from a drug overdose, was brought back by the paramedics, then went back to my house to do (drugs) again. I've been able to revisit that in memory (but) to see what I wrote about it, I didn't even remember writing that. It was difficult and healing...(because) what it shows is that a dysfunctional family can have a massive impact on youth. Those formative years, from about zero to 7, those are important years. For me, they were completely fucked-up...(and) my choice was eventually to run away from home." As a runaway, though his chosen road led to Hollywood and eventually to stardom, Sixx explained that pinpointing that beginning- in context of his work 20 years later with homeless teens who followed the same road and never made it- allowed him to broaden his vision for the book beyond the personal realm. Elaborating on the professional break-through he made with how to make the biggest impact with the publication of his diaries, Sixx began by explaining that "twenty years ago, I didn't know what the hell was going on. I'm lucky to have been through enough time to have figured it out, and I thought it was time to expose that for people who have

similar issues...I thought, you know what, somebody else could read this and it could help them."

Well before he could achieve the latter, Sixx next seemed to realize that he still had the ghost he was 20 years earlier to face, as well as those of his dark, lonely childhood. It was the lack of answers to the question of why he'd been abandoned by his parents that had haunted him for years- and whose pain he'd first answered with drug abuse. Perhaps recognizing the role honesty about the former had played in his recovery from the latter, Nikki began to frame the *Heroin Diaries* as a broader platform for the truth to set him free once and for all from his demons. Beginning with taking responsibility for who he was at the time, Nikki explained that "I don't want to close the door on the past, I want to see as far down the hallway as I can, so to speak. It's only through being able to look back and see clearly that there is story back there that I can move forward. And I think that's true with all people, no matter what you're dealing with, if it's heartbreak or an addiction or other crosses you have to bear in your life. You can look back and say that's where I was then, look how far I've come now. A lot of times people say something happened and I don't ever want to talk about it again. To me, there's always a fear it may rear its head again, because we don't want to expose the truth, we don't want to expose that raw nerve, we don't want to feel uncomfortable. It's through feeling uncomfortable that I've actually become more comfortable in my skin."

Elaborating even more in-depthly on his ultimate vision for what would quite literally be 'an open book for the whole world to read,' Nikki reasoned that "(as) with any human being, there are so many layers. There's the public persona of Nikki Sixx, and there's a very private side that only my very close friends and family know. What I tried to do with *The Heroin Diaries* was to throw out everything—you get to see what it's like now, you get to see what it was like way back when I was a kid, you get to see what it was like when it looked all glitter and gold. I think reading this book would be a very interesting process in seeing the evolution of somebody...But there's a piece of *The Heroin Diaries* that I think is important for people to read, because the story ends in success. The recovery is the piece that's important to me. I'm willing to throw myself under the bus and let you see the ugly, dirty truth. To read that, people also have to read about what comes out on the other side. And it's not an evangelist or a preacher, it's not on a soapbox for anti-drugs or alcohol—it's just sharing one person's

experience out of a billion people out there. If I can raise some awareness to a global epidemic and give money to a charity that deals with at-risk youth, then this year is a year of giving back—and I've had so many years of receiving...It's been 20 years since I was an addict, and it seems almost like I was another person; it was another life. I wanted to show that human beings, no matter what the adversity, can survive... That particular year, the reason I time-capsuled it was because the bottom for me, personally, had started to fall out, and I didn't know why. I was able to ask a lot of questions inside the actual journals that I really didn't have an answer to. Twenty years ago, I didn't know what the hell was going on. I'm lucky to have been through enough time to have figured it out, and I thought it was time to expose that for people who have similar issues...When you start diving into the book, you realize it isn't really about heroin. It is about addiction, yes. But it's about abandonment, unhealthy role models, depression, and becoming anti-social out of fear...That's what I like about the word recovery...you're recovering something about yourself."

Nikki's next step in the process of telling the entire story behind the pain that had motivated his drug addiction involved pulling the weeds that time had allowed to grow from his own past, asking for everyone's side of his story- both those who were closest to him, as well as those who he'd alienated from his life. Seeking an uncensored account of the truth, Nikki reasoned that the time was right to ask the aforementioned given that "it was 20 years ago...There's a lot of water under the bridge, there's a lot of recovery under the bridge and there's a lot of growth under the bridge, so for me the only fear would be if people—including myself—could not be brutally honest, could not do something that would be willing to peel the skin back from the face and show the muscle and the bone and the blood beneath it, because otherwise we're just going to have another fluff piece and the last thing we need is another book by another artist that's just a bunch of fluff...I sat down with everybody, and I said, 'I need you to be so honest. Don't worry about my feelings. Don't worry about my image. You can say 'I hate his fucking guts,' and it's going to be ok.' Giving people that safety net was such an important part of the book. I think we get to a place that needs to be gotten to...I think it was an important part of the story for everyone to be able to voice what it was like at that time. For me, it's not who I am now, so it doesn't really feel bad to me. I feel bad for them, that they had to live through that. But that's not who I am today, and that's not what my relationship with them is like today. But it was an important part

of the story to see where addiction takes you in all your relationships. My band was degenerating, my personal life, my health, my sanity…That's where it goes."

Sacrificing spin for the sake of his story's authenticity- and ultimately for that of the greater causes he was trying to help save in the process of coming fully clean- Nikki candidly offered that "I want people to know what a fucking bastard I was…If I had released these diaries as they were and just wrote my overview story or tried to show how clever I was with my writing, I would have given the message to the readers that would have been something along the lines of 'well woe me, a multi-millionaire rock star selling out arenas and who can have anything and everything he wants…oh and he has a drug problem and now he's going to say oh it was bad'…that's what it would have sounded like to them. So it needed to have a little more of a fly on the wall perspective of having been there. Though having a relationship with the pen and paper was wonderful and very important to the core of the story, I wanted to also have other people's interpretation of this story. That way you can see what happens in the extended world. You can see the perspective of the family of the person who is going through the crisis as well as with band members and musicians that I've associated with and ex-managers, ex-girlfriends, publicists and people that were living day by day with me. We also brought in my mother, my sister and my grandfather. What all this allowed me to see was that if I looked back as far I could see, there was a dysfunction for me that kind of started off on the wrong foot. And that is telling as afar as psychologically looking at the story. To do the imprint across the top of it as a writer today and actually be able to write my story from my teenage years until now, really allowed me to close the chapter on it all. And show I think, a very true and rounded story instead of it being just from one person solely."

Toward that end, Sixx began with the three people who had been closest to him during both the highs and hells of an addiction their collective fame and fortune had fueled throughout the past 25 years: his bandmates in Motley Crue. According to Nikki, "I originally talked to Motley Crue. I wanted them to be brutally honest and tell me how it was for them. I just felt this 'because we're a band, because we're a gang, because we're friends,' they didn't want to go to my face and say 'You were this or you were that. Ian, who did a lot of the heavy lifting and

organization of the book, came in and did hours and hours of extensive interviews with the band members and really they all just got into a very comfortable zone. He was able to get from them that brutal honesty that I think is so important. The diaries are so honest that we needed that kind of honest commentary from people who were there at the time."

From that baseline, Sixx next recalled that the reconstruction process turned to one where "once we had that I was feeling...like something was missing...(in) the part of the story that...(addressed) the extended family and the immediate family reaction and experience. So working with Ian Gittins, who did the bulk of the heavy lifting on doing the interviews and compiling hours and hours of interview footage and putting it together for me to dissect and go through, I was able to get a clearer picture of what it was like for the band members, friends, ex-girlfriends, ex managers...Next we interviewed my...mother and my sister and my grandfather and it really--for me personally, and I think for the reader, you get to understand that you're dealing with a person that set off in life with a bunch of misinformation and a very unstable childhood...(So by) getting my mother, sister and grandfather to come in and really get their interpretation reflected back on my childhood - finding out that no one can really tell me It's sort of like I was an orphan of fate. I was living in this void of non-information. I took that into my teenage years and with hormones and angst and fueling it with all the things we do as teenagers, becoming a runaway. I took it on a path that was heading towards where this book takes us. It was in me being able to write the overview of the entire thing that I really got clarity in my own life. I actually got to close the chapter...I wanted to be able to take that, what I had discovered and experienced, and do my overview writing of it, to actually write the book on top of it, to paint a clear picture of how my experience was and how I got from A to B to C to D to E to right into the addiction, into recovery, into going into finishing the book."

Once Nikki had completed the process of assembling his story's supporting cast, he admitted yet another stage in the journey of completing the broader book began- one that in part moved forward only through personal reflection on how his actions had affected those around him. In looking back on this step in his journey, Sixx conceded that it would have been easier on him personally to skip it entirely, reasoning that "as human beings we tend to want to close the door on our pasts. But for me, this

book and soundtrack reveal what's down the hallway, and go deeper. For me…(in the end it was) a good thing." From that point, Nikki next explained that "when I started reading (the supporting characters' stories)…all kinds of emotions came up. It was through laughing and being in shock and wonderment—why I would do the things I did?…Then it was figuring out how to spin the story to not be one of just decadence. Obviously, I was in a place to be able to write a happy ending, but I was like, 'Okay, so I can have a happy ending, but what was it like for people that were dealing with me?' " In offering what he seemed to consider one of the more poignant examples of that practice in action, Nikki pointed to Vanity, admitting that "considering where she's at in her life…(she) really put herself out there in a way that was unexpected. She really did share with the reader where she's at today and what it was like for her then. I think it was really brave." Perhaps even braver still was Sixx's own admission that "my relationship with…(my immediate family) would've been very different if I had not made some of the choices I made. With that being said, it's never too late. I've tried to mend fences, even though sometimes the fences are miles and miles long and it's a lot of work. In my case, I formed my own family because I didn't really feel that I had a family. I have my children, which are near and dear to my heart and my number one priority in my life, but in going back and trying to repair stuff with my sister and my mother, my father has passed away, is important. I won't lie to you and tell that it's easy."

Once Sixx had completed the process of interviewing all of the Heroin Diaries' relevant principles, he recalled encountering yet another challenge, explaining that "for me, the battle was how to say it and not to preach it. It was a way to share it and get the right message across and a way to expose my experience and not impose my own beliefs. That was important to me and was part of the challenge that I really believe we rose to…I think you're gonna take from it what you wanna take from it. I do believe that if you read the book from beginning to end you're going to walk away from it with a story. Yes, it's journals; yes, it's diary entries, but the way I was able to frame it as a writer, and the way Sixx AM were able to frame the songs, it tells a complete story. When I read William Burroughs' 'Junkie,' it didn't have an ending. It was just a snapshot in time and if I would have only released the diaries, I think it could have been a dangerous thing to publish. In this case, it is helpful to see the full story, to see the arc of the beginning and the end. For the reader, if they have a

problem, or if they know somebody that this might be influential to, it will be important, I think...I'm not real good at leaving things unsaid. This is the truth. If it upsets people, I'm sorry. I wrote down what I was feeling at that time. And I allowed those around me to comment (in the book) with what they felt was their truth. I think it paints a well-rounded story. I wanted to let many voices tell one story to get a true understanding of what addiction can be, will be and will always be."

With principle work finished on the Heroin Diaries manuscript, Nikki recalled feeling that the project was incomplete without a musical counterpart. Reflecting back upon the creation of the very first soundtrack to an autobiography once he'd handed the album in, Nikki proudly concluded that "we've created something that hasn't been done before, a soundtrack to a book...We wanted the album to come first before the book because, like a sound track for a movie, the sound track comes first and then the movie comes second. Then, people kind of get into the story of the movie and they go back and get re-inspired by the soundtrack. We wanted to use that model. We felt really good about that. We think that it gives the music—initially you can get the record and you'd go, 'Wow this is really cool.' Then, you get the book and you go, 'I need to go back and listen to the record some more,' because now I see maybe that song there will mean something different to them. I think giving an album that kind of open interpretations is really cool."

Within Rock N' Roll historically, concept albums have either been brilliant masterpieces or confusing, self-indulgent messes that often no one but the artist himself can buy into, leaving out the audience that matters: record buyers. One famous instance of the latter was *Quadraphenia,* which followed-up the Who's revolutionary *TOMMY,* or *Graffiti Bridge*, which followed up Prince's era-shaping Purple Rain. Perhaps conscious of the latter, when Nikki Sixx first announced that he would release Rock N' Roll's first rock opera scored to accompany an autobiography, he pointed out that "it was phenomenal for me when the editor of Billboard Magazine said to me, it doesn't sound like *Quadraphenia* or *The Wall.*" In elaborating on what he was aiming to sonically visualize with what he explained was a "a story with a beginning, middle and an end. That is what we wanted to achieve. We wanted to follow the book, wanted to be able to take elements of the book like relapse, which can deal with not just drugs and alcohol, but with life...It made sense to do an album...As an artist you're

influenced by your feelings. The greatest love songs and hate songs are written from conflict. We thought, 'This is conflict, let's score a soundtrack.' But it's more than that, too. It's a book that has a destination." Nikki further explained that "I think it's been awhile since there's been a concept record. This record deals in a subject matter that is very dear to my heart, which is the downward spiral and the recovery of a human being. I think a lot of people can relate to that, whether it's love, drugs, alcohol, anything else that we all take two steps forward and one step back in life. For those people that are really inspired by the book, the album is a great companion to that, even though they both do stand on their own."

Still, while Sixx may have had commercial expectations for his biography, where its musical counterpart was concerned, he explained that "our expectations were absolutely zero. We had the outlook that we were doing something that we don't believe has ever been done before, which is scoring a soundtrack to a book. That it was for us complete freedom as producers and songwriters to not really have to reach into anything. The album takes you on a journey musically, lyrically and it does go left and very far to the left and very far to the right. And for us, it was complete freedom to do that because we had no expectations. We never expected to be on radio and the fact that it is doing so well at radio is just icing on the cake. It's fantastic. It gives us faith in not following a standard, as far as songwriters and producers…to not really have to niche into anything…We had no expectations when we made the music, which was very freeing. We're all three songwriters and we're all three producers and we are all three very good friends."

In collaborating once again with James Michael, his writing partner of almost a decade, along with new (Funny Farm Studios) co-owner/producer/guitarist DJ Ashba, Nikki had assembled a team of writers whose creative synergy he felt worked first and foremost because "we're all extremely good friends…I met James probably somewhere seven, eight years ago. We had written for not only Motley Crue, but we had written for Meatloaf and Saliva and became very good friends. We have done all kinds of song writing together. DJ and me got together as friends. We started writing music and the same chemistry between me and him. We ended working with Drowning Pool, Marion Raven and Trapped and as that, me and him, we are very, very close friends and we share a studio together called Funny Farm Studios. So, it was just natural to get all three

of us together because you had a bass player/producer/song writer, guitar player/producer/song writer and a vocalist/producer/song writer. It was like we didn't need anybody else and we basically laughed the whole time. We just had the best time because we're such good friends and it was such a fresh exciting experience to have no boundaries...I've always known how talented both of these guys are, and it's sort of an honor for me to be able to get their names out there. There's always a need for new talent, and these guys have both got a lot of experience and they're both songwriters and producers. James, DJ and myself basically wrote and produced this project together—three heads with one vision, inspired by the book...They had been around for the whole time I was putting (the book) together, talking about it, sharing my experiences and reading snippets. We'd talked about scoring a concept record. Before I met DJ, me and James originally had some conversations. Between the three of us, we've written a lot of songs with and for other artists; chemically, it just seemed like the right thing to do. Those guys are selfless, and we were able to tell the story in a selfless way—almost taking myself out of the book 20 years ago and turn it into a character."

Elaborating on how his harrowing diaries developed their musical counterpart as the trio began writing in the studio, Nikki recalled that "once the galleys were together, James and D.J...sat down and read them...When I showed them the galleys and the artwork, we basically all said the same thing at the same time: 'It's a movie.' It was like a movie in our heads, so we just scored the soundtrack to that movie...James felt like we were doing a little bit of a rock opera, a masterpiece or an epic album...And we were able to follow a story line and be inspired by that, and all reach internally and say, 'This feels like...' Like a song like 'Accidents Can Happen,' which is a song that deals in relapse, and there's relapse in the book and it touches people because it's a real issue, and it's a song written by artists who really are moved by something. So this whole project has just been a bit like an art project, I mean, the way the book looks, the way it reads, the way the album sounds, it's very artistic and it was exciting for us because we went, 'You know, this isn't for radio. It's not for MTV. It's not for VH1. It just is.'...We wanted to get a cohesive picture lyrically, melodically and conceptually. I feel we achieved it. We broke formula in a lot of places even though we are songwriters. A lot of the stuff wouldn't play on the radio, but we never had that in mind...We feel really grateful we were able to make a record with no expectations.

We didn't expect it to be on the radio, we didn't expect it to get the type of response it's getting. We didn't make it for a specific audience, we just made the record for us."

Shedding further light on the concept album's evolution, co-producer/writer James Michael recalled that "I would say that it wasn't much of a choice Nikki came down to. This is something that he has been conceptualizing for many many years; in fact we spoke about The Heroin Diaries about 5 or 6 years ago. He was only discovering the diaries, and we had a conversation. We were writing for other artists at the time, and we both thought, 'Wouldn't it be cool to make a soundtrack to this?' Because the stories and the journal entries are so theatrical and so dramatic that it seemed like a neat idea. We had talked about that idea several years ago, and then it really wasn't until a few years later when Nikki and DJ got together that it seemed like a reality. I've said this all along, and I still believe that DJ is the missing link that turned this from a concept into a record. As soon as he came into the picture, Nikki and DJ started writing stuff. They started writing these amazing orchestral movements for what was going to be the soundtrack to the book or to the film. I don't believe that there ever was a moment when Nikki said that he could get something down…It's interesting because the reality is that anytime you're writing something personal about yourself, as a songwriter, there are a couple of challenges: Number one, you have to make sure you're writing about something that is universal that everyone can put their own meaning into it, and that it passes the 'who cares' test. Just because you care, it doesn't mean that someone else is going to. Obviously, with this being Nikki's story, people do care about that. The other challenge is how do you bare your soul without exposing yourself to the point where it makes you look ugly? Nikki, to his credit, was so willing to do that, to bare his soul. There were times, honestly, where he created a character who obviously was him, which made the process for him to disconnect from this guy that he's talking about easier. Not to protect himself and to keep it honest was an important process."

Continuing, DJ Ashba recalled that "James and I had written some songs and we wrote and produced with other artists. One day he (Nikki) walked in with a bunch of papers, which eventually were going to be his book, and I started reading it. Then he played me a couple songs and I remember '*Dead Man's Ballet*,' and I was really blown away by it. I've

always been very much into the orchestra soundtrack music. But when I heard 'Dead Man's Ballet', I realized how big we could take this thing theatrically if there weren't any guidelines that we had to follow. Nikki was really good at giving us a wide-open canvas to paint on. He kind of lived this story and also—if this was ever to become a movie—he would know every scene in the movie. He was really good when me and James were writing it; he painted a vivid picture along with words from the book to be able to write to. It made the writing process really easy...We didn't know what we were going to do when we first started. We went for kind of a cool record that is going to do whatever we want to do with no rules and no expectations."

In contrasting his latest project for those Motley Crue fans who were otherwise eagerly awaiting the now two-years-in-the-making new band studio LP, Nikki explained that fans could still "hear the Sixx:A.M. project and see my influence. At the same time you can hear stuff that DJ and James have done on their own and see their influence as well. Something magical happened with the three of us. It was something that I haven't ever experienced outside of Motley Crue." Still, a spirit of release from the Crue's obvious commercial considerations paced the album's writing and recording, resulting in an atmosphere wherein, according to Nikki, "James Michael, my lead singer, told me this is the most effortless thing that he's ever done. It's just effortless. All the songs, everything just flowed. I can't think of one bad experience during this whole time. It's just been so freeing to go, 'This is what the song is. It's 12 minutes long.' No one says, 'This could be a single if you made it three.' And no one says anything like that. We just did everything we did the way we wanted to do it, and then people started listening to it and started getting attached to it. We actually just finished five more songs, like, different interpretations of the songs on the record just for the hell of it. In fact, it's like we're just so excited about the music that we just keep creating...They both had the book and had read it and was really living with it as we were writing because there's songs that would be inspired by James, something that happened in his life. He goes, 'Gosh when this happened, it reminds me of kind of what happened with you.' As artists, it wasn't like: this is Nikki's thing...It was like me and James and DJ and constantly massaging the feelings that we were getting off of the pages of the book and how they related to each of us individually whether it was coming from me, DJ or James, all three of us sometimes, individually. It was always the same vision, even though it was coming from

three guys...Scoring the music was the most freeing musical experience I have had in years...The album wrote itself."

Detailing the physical recording process, Nikki recalled that "James Michael, DJ Ashba and I did everything ourselves. We programmed everything...(I played) most of the record was played with a '59 Fender P-Bass which is kind of my favorite studio bass. And for most of the stuff I just recorded through a '64 Fender Bassman. I used no effects and no nothing. I was just one microphone in the middle of the room and that was it...(James) does do a lot of behind the scenes stuff. He's a phenomenal writer, a phenomenal producer, an amazing engineer. D.J. is equally talented as a writer and guitar player and producer." Delving into the writing of some of the album's specific songs, beginning with the album's massive hit single, *'Life is Beautiful,'* Sixx explained that "you can look back and I think you should always be able to look back. You don't want to close the door on you past experiences. You need to look back and open your eyes and see where you came from. One of the lines in *'Life is Beautiful'* says 'I was waiting for my hearse but what came next was so much worse. I took a trail of blood to find my way back home.' I took a 180 in my life and I survived it. That is exciting to me to look in the rear. That is why I am raising money for this charity. I want people to say 'Fuck yeah! That is fucking badass!' " Turning to another of the album's singles, *'Accidents Can Happen,'* Nikki recalled that "this was an issue we thought we needed to address. Relapse is a real core issue. I believe human beings in general take two steps forward and one step back and that's a relapse, weather it is in love or some other issue."

The result, according to Sixx, was "a double album of music. We just were so open and there were no rules. If it was a 12 minute song or if it was a 1 minute song, it just was whatever the song needed if it had a heavier feel or more of an acoustic feel, if it had a more orchestrated feel. Whatever the song called for and wherever it went with the three of us is where ever we went. It went very quickly. We probably had over 30 songs and I would say about eight months. It was quite quick to be honest with you...We recorded over the past nine months — it's such a musical journey. It takes us from a needle to a pen to a musical note, all with no expectation except for maybe changing one kid's life. It follows the book. It was a musical purge. It just exploded out of (us). DJ Ashba and James Michael are really talented. We all just really felt passionately about making

music inspired by the book...And it was difficult but very important to hone it down to the thirteen songs...The track listing was very important to us, actually—having *'Christmas In Hell'* at the beginning, *'Intermission'* obviously in the middle, and *'Life After Death'* ending the journey...We definitely did our very best to take you on the same journey that the book does." In keeping with the model of independence he applied to the album's creation, Sixx's retail plan for the album's commercial release was equally as independent-minded, such that "we have a distribution deal, which is what the major labels do best. Now, it's all changed. You can make a record in your bedroom and cross-market it on Myspace.com, reaching millions of people in no time. We didn't need a major label."

While he'd always planned on releasing the album, one of the last places Nikki explained he expected to wind up at the conclusion of its recording process was in another new band, revealing that "believe it or not, it started out as, and probably still is, three producers and three songwriters. As we finished the project, people started going, 'You guys, this is so ground breaking and interesting that I know you're going to want to do it again.' So how's somebody going to know to find it like if it's just called the 'Heroin Diaries' Soundtrack? So we struggled with the idea, but we came up with a name, which is Sixx: AM...(So) We just formed the band. We didn't plan on that. We didn't plan on being on the radio, and at this point we're really not planning on touring. I know we are planning on playing some television shows and maybe doing some intimate small stuff. There seems to be a lot of desire. It would have to be something quite spectacular. The idea of going out and playing clubs isn't that exciting. It has to be more than that. There is more out there. With all these multi-media platforms and portals to creative stuff, it is very exciting. Opportunity, I'm sure will arise, and we'll make a decision then...(Not too long) ago, we weren't even a rock band! Me, DJ and James were just making a soundtrack to the book. But people kept saying this is really, really spectacular and radio was really interested in playing it. And people were then saying *'it's got to be by somebody'*. So begrudgingly for me, we kind of agreed...As far as what's next, do they make a movie out of this do we do a tour? I just don't know as it's all speculative. At the moment, it is all coming at us one day at a time and we're really excited."

With an August 17th release planned for the 'Heroin Diaries' soundtrack, almost two months ahead preceding that of the book, no one-

not even Sixx himself- could have predicted the smash success that the album's lead off single, *'Life is Beautiful'*, which would blaze up the Billboard Rock Singles Chart following its release. Once word was out about Nikki's side-project, Sixx:AM, which he had brilliantly positioned to hype in real time with the Heroin Diaries, promoting both at once, as Nikki recalled it, "was a very enjoyable process. A lot of times you have a band, you have a tour, you have an album, you have a single, you work radio, you work press. It's all very planned. But in this case we made a record and leaked the song out through MySpace. It started to pick up momentum and radio picked up on it. Then we took it to radio and it ended up being the most added song in the country and then climbed the charts. We said why? They said it's moving, it's a great piece of music. We just formed the band Sixx A.M. because people had to go buy the album by somebody. It's not me, and it's not James and it's not D.J., it's all of us as producers and songwriters. I was driving down the road yesterday and looked down at my Sirius radio, and it said Sixx A.M., *'Life Is Beautiful.'* I said, how is that possible? And that there's so much excitement attached to it, that radio is really embracing it, people are really attached to it emotionally on one level or another, whether it's the book or the soundtrack, they're really feeling connected to the songs that they're hearing. And to me it's like a win-win-win…It's exciting for me that Motley Crue fans find this exciting, but it's also very exciting that there's new fans, people that weren't Motley Crue fans that are attracted to this. So, it's a great feeling."

Beyond his personal goals of closure with the Heroin Diaries, professionally and publicly, for Sixx, launching his broader ambitions for the book "was a long process because the original feeling was to publish those diaries based on my belief that I could raise awareness of this global epidemic and what it's like, whether you're down in the streets or in a private jet…It's an epidemic and a problem. I wanted to share my experience, and by getting through that experience share a little hope, a little faith that people can get out of it. That's where it started…There's a benefit to publishing this because I'm exposing myself and exposing an issue. I want to do some good…This is my story—it inspired a soundtrack and we're raising a lot of money and a lot of awareness for kids who don't even have a chance to get to the question of 'Wouldn't it be better to be a fucked-up rock star and make great music than be a sober rock star and not make good music?' These kids can't even afford a pillow, much less a guitar

pick. We choose to put ourselves in these positions sometimes, but a lot of times...what happens when you're young the choice is taken from us." Using the success of the Heroin Diaries to give that choice for the first time to a new generation of runaways, Sixx earmarked 25% of his personal net proceeds from the sales of both the Heroin Diaries book and soundtrack for a charity program he founded with the Los Angeles-based Covenant House, which, according to their press release, "provides services in 21 cities, 15 in the U.S., to homeless and runaway youth, including advocacy, health care, education, vocational preparation, drug abuse treatment and prevention programs, legal services, recreation, transitional living programs, street and community outreach and aftercare."

Elaborating on why he felt the organization was an ideal partner, Sixx explained that "Covenant House is an organization that has been dealing with at-risk youth for a long time. They have an infrastructure set up that is so phenomenal. They have an outreach program where they go get kids off the street...They talk to (the kids) and sometimes it may take up to 20 times before they get them to come in and get help...A lot of the kids in Covenant House come from the foster care system; when they turn 18 years old, they cut 'em loose, and they have nowhere to go...They pull kids off the street and they get them into detox if they're on drugs, if they need

therapy or protection, they have a place to eat and sleep...They get them into a program that helps clean up their head and clean up their body. Then they can help them get education, financial planning, and eventually they get them into apartments and get them to work...They'll help in all different situations like addiction, alcoholism and sexual abuse. They get

them into a program of recovery and education and eventually, back into the system."

Continuing, Sixx explained that "there are some wonderful, fantastic places that deal with teenagers, from shelters all the way across to places that actually have more infrastructure. But something about Covenant House that really struck me was how the people at Covenant House have a plan for the future. They walk these kids—these adolescents, these lost souls—through the process of getting up on their own feet." Recalling from his own experience as a runaway that "music is what got me out from spiraling into someplace that I could have," Sixx sought to afford a new generation the same shot at escape "by setting up a music program called *Running Wild In The Night*...One thing for me was, I didn't know a place like this existed when I was young." Founded on the rationale that "when they bring these kids off the street and start getting to the core issues dealing with it all...(then) the recovery part starts and a creative outlet for them to plug into is (key)," Sixx further reasoned that the program was a necessary incentive "to give them another reason to stick with it...The music program inside Covenant House is an important part of the program for me because music did so much to help me in my life. If we can give back to some of these kids through a music or art program, it will help get them off the street. Some of these kids have ended up in a position where they are completely helpless and they turn to prostitution, drugs and gangs. Every opportunity we can give them to get them to stick to the program will help them continue the process of recovery."

Elaborating on his broader goals for the program, Nikki explained that "my goal is to bring awareness and income to Covenant House. So these programs being set up will be in place for years and years to come and maybe, just maybe One (hopefully more) kids will stick out the Covenant House program and get back on their feet and have an opportunity to do something positive with their life...Maybe changing someone else's life in return and so on and so on...We have different people helping us out with it at the various locations. If there's a kid who comes in with raw musical talent, he'll get to refine it and maybe he'll go on to do something and change his life in the process...(One) of my fantasies is that one day someone's going to be doing an interview like this, and they're gonna say, 'I was homeless and strung out and I found this place called Covenant House and I got into the music program that this guy named Nikki Sixx started,

and it saved my life and I'm now making music for other people…That would be an amazing circle."

Still, in acknowledgement of how far he had yet to go in fully realizing what was ultimately a global vision for Running Wild in the Night, Nikki conceded that "nobody is going to help these kids unless there's an awareness. So 25% of my proceeds…go to the charity…which is different than the proceeds because, as we know with any business, there are a lot of people getting pieces. So I'm really pretty much giving it all away to help this amazing charity…So many of my friends in the industry and people who own guitar and amp companies are coming forward and saying 'We want to be part of this.'…We've raised in the beginning about a quarter of a million dollars, which came from bands on my web site buying stage clothes, collectible stuff and donating money. There's some wonderful people out there that sort of put us on a payroll plan where they donate a certain amount of money a month to the program. We've now built and accumulated up enough money. We're now starting to build out the music rooms and getting everything put in place. We have some wonderful companies that are coming forward and donating equipment. That's a big part of it because you can eat up a lot of this money in just buying equipment and stuff. Covenant House has rooms that they've designated for this and we're getting them set up. So, we're getting companies to come in, bands to come in, people to buy the book and come in. We're getting the programs just set up. One of the biggest things that we need is money for is the music teachers because one of my biggest fears was that we would start the program and we would run out of money because you're asking people to come in and work as a job, they need to be paid. Everyone can't donate all the time. Some people can say we're going to donate 100 guitars, like Ovation has done, and that's wonderful. Then, somebody can say, 'We're going to give all the amplifiers and we'll give them mixing consoles.' That's wonderful, but the actual human labor, people need to pay their bills and stuff, so we need to pay for music teachers and etc. etc. etc.

Continuing, Sixx explained that "we're really getting it…set up like a good business, which is important because I want this thing to build and grow not only in America, but in Canada and Mexico…In America we are working with Covenant House. I am looking for other charities in other territories to raise money for them when the book goes on sale in the UK,

Scotland, Italy, Germany, etc. I do believe this is a global issue with run away kids and issues with parents. We need to just help out a little there... I was just in the U.K. and we're talking about finding the perfect destination point for money that's generated overseas to help kids that are in United Kingdom at this time, too. Hopefully, it'll spread country by country. It's a long process and it's a lifetime commitment...In the end, it's really those kids that have the ability to change the future—whether it's global warming, music and arts, whatever they decide to get into and make a difference in our system. I know this: it resonated with me because that's how it started for me—I was a runaway and I was angry and I was alienated, and music saved me."

Not merely a fundraiser and public spokesman for the program, Sixx was as invested personally as a mentor to those children his charity sought to save. Well before he hit the road in the fall of 2007 to promote his book via speeches to larger crowds about the perils of addiction, Nikki had already spent time throughout the spring and summer sharing his story with groups of former runaways at Covenant House's various Los Angeles-area chapters. Clearly a reflection of the environment they'd only recently been rescued from, Sixx readily admitted encountering many of the toughest crowds of his career in the course of working with "a lot of kids who are very, very challenging...Gang kids. Drug abuse. Alcohol abuse. Abandoned kids, which is a huge theme in this book. I skip all the regular poetry that I know they'd hate and I bring this to them and they make this connection to it that I couldn't get them to make with Robert Frost or something like that...I want to hit people over the head with a two-by-four. I want their attention...This is about brutal honesty...and laying it all out on the table so that there's no secrets, so that we can safely say, 'This is (messed) up. Don't go there. This is not the stairway to heaven. This is definitely the highway to hell.'...I'm interested in sharing my very private experience in a year of my life, showing that I was able to answer my own questions from inside my diaries - questions that were painful to me - and being able to find myself through recovery. And I guess what I see is that I've recovered something I lost, which was to be an artist, always...I'm having people come up all the time to me and saying, 'Thank you for writing this book. It's my story."

Continuing, Nikki explained that "my time as a runaway was limited compared to these kids. I spent a tenth of the time that a lot of these kids

spend on the street…I mean, it's an epidemic that's global…and all I'm trying to do is share my personal experience and maybe bring awareness by throwing myself under the bus, so to speak. If someone will buy the book because they just want to see what it's like to see somebody fall apart at the seams, or if they want to buy it because they know somebody in the extended family that went through something and they can personally feel that they can relate to it, that buying the book and the CD creates awareness, and can bring more money-- then I'm going to do that. Well, I didn't mean to cheapen the situation by that suggestion. It's always encouraging when people are faced with something they feel is so insurmountable, to see others who actually achieve that, and that's exactly what you are doing with your stuff. Oh, no, no, and I didn't think you did. My brain thinks of 1,000 things a day and trust me, I have thought about all different ways to implement this and bring awareness, and it's tricky to do this and do it credibly, not to exploit but to make awareness yet to still be an artist, to still be a rock n' roller and not be someone on a soapbox. It's a balancing act."

ACTIVE ROCK NATIONAL AIRPLAY
Powered By nielsen BDS

Issue Date: 12/7/2007

#	LW	WEEKS ON	TITLE ARTIST IMPRINT / PROMOTIONAL LABEL	PLAYS TW	+/-	AUDIENCE MILLIONS	RANK
			NO. 1				
1	1	15	**FAKE IT** SEETHER WIND-UP 5 week(s) at number 1	1855	-12	6.904	1
2	3	21	**LIFE IS BEAUTIFUL** SIXX: A.M. ELEVEN SEVEN	1602	+5	5.754	2
3	4	18	**RISE TODAY** ALTER BRIDGE UNIVERSAL REPUBLIC	1445	+17	4.599	4
4	2	18	**THE PRETENDER** FOO FIGHTERS ROSWELL/RCA/RMG	1401	-220	5.751	3
5	6	12	**EMPTY WALLS** SERJ TANKIAN SERJICAL STRIKE/REPRISE	1371	+41	4.126	5
6	5	20	**BECOMING THE BULL** ATREYU HOLLYWOOD	1353	+15	3.418	8
7	7	11	**ALMOST EASY** AVENGED SEVENFOLD HOPELESS/WARNER BROS.	1251	+25	3.694	6
8	9	9	**PSYCHO** PUDDLE OF MUDD FLAWLESS/GEFFEN	1108	+110	3.333	9
9	8	9	**GOOD TIMES BAD TIMES** GODSMACK UNIVERSAL REPUBLIC	1057	+27	3.419	7
10	11	14	**BROKEN AGAIN** ANOTHER ANIMAL UNIVERSAL REPUBLIC	911	+17	2.664	12
11	10	13	**HOLY DIVER** KILLSWITCH ENGAGE ROADRUNNER	886	-16	2.57	13
12	12	16	**TEN TON BRICK** HURT CAPITOL	875	+34	2.019	17
13	13	10	**HOLD ON** KORN VIRGIN	866	+26	2.197	15
14	15	23	**BLEED IT OUT** LINKIN PARK WARNER BROS.	783	-2	3.069	11
15	18	8	**DULL BOY** MUDVAYNE EPIC	741	+65	1.672	20
16	16	46	**PARALYZER** FINGER ELEVEN WIND-UP	718	-26	3.138	10
17	14	32	**NEVER TOO LATE** THREE DAYS GRACE JIVE/ZOMBA	709	-83	2.411	14
18	19	20	**THE BLEEDING** FIVE FINGER DEATH PUNCH FIRM	679	+31	1.649	21
19	21	8	**UNTIL THE END** BREAKING BENJAMIN HOLLYWOOD	625	+35	1.849	18
20	17	21	**ALCOHAULIN' ASS** HELLYEAH EPIC	590	-96	2.192	16
21	22	7	**SHADOW OF THE DAY** LINKIN PARK WARNER BROS.	562	+20	1.675	19
22	23	10	**LET GO** RED ESSENTIAL/RED	548	+33	0.877	31
23	27	3	**AMEN** KID ROCK TOP DOG/ATLANTIC	528	+102	1.631	22
24	24	15	**FALLING ON** FINGER ELEVEN WIND-UP	489	+14	1.188	24
25	25	9	**NOTHING TO LOSE** OPERATOR ATLANTIC	474	+20	1.038	26

Released on September 18th, following the late-August release of the book's soundtrack, which debuted at #62 on the Billboard Top 200 Album Chart, moving over 10,000 copies in its first week of sales, the proper 400+ page Heroin Diaries book posted a much higher debut, at # 7 on the New York Times Best Seller list. The aforementioned newspaper would celebrate Sixx's book as "a new model for the rock bio." At his first official signing for the book, at Border's in West Hollywood, several thousand fans showed up, inspiring Lita Weissman, the District Marketing Manager at Borders reported that "we've had many book signings here at Borders but this was absolutely one of the biggest." The book's soundtrack continued to perform as well as the book, with the lead single 'Life is Beautiful' entering the Top 10 on Billboard's Rock Singles Chart, climbing to # 5 by mid-October. Of the book's success, Nikki commented that "I had no expectations for the project. But it's a nice feeling when you do something completely from a selfless place and then you see it connect with people." The book would go on to sell over a half-million copies, while is accompanying soundtrack would move in excess of 200,000 copies, making it the best-selling book soundtrack album of all time.

Sixx's fashion company, Royal Underground, continued to flourish commercially during the fall of 2007 at such high-line retailers as Bloomingdale's, Neiman Marcus and Nordstrom, with its Men's ware line entering a third season at retail, and Nikki announcing that "we're getting ready to launch the women's and jewelry lines. We're getting lots of requests from buyers at certain retail stores. It's great to see it next to brands like Diesel and Juicy...The enormous demand we received from our retailers was a pleasant surprise. Expanding into jewelry is the obvious next step." Partner Kelly Gray elaborated further, sharing that "when Nikki and I saw the premiere items Mitchell (Binder of King Baby) designed for our jewelry collection, we knew immediately that we found the right partner for Royal Underground...Both Nikki and I continue to wear these special order, diamond and 18K white gold rings every day." Design partner Mitchell Binder added that "after viewing the cutting edge Royal Underground clothing line, it became irresistible to work with Nikki and Kelly...I'm very pleased to partner with them on their first jewelry collection." Gray further added that the company would be launching its first-ever women's line in November, sharing that "when I started to find myself jealous of Nikki's clothes, I couldn't stop thinking about the possibility of a women's clothing line...We knew we wanted to be in

women's,' Gray says. 'We had gotten requests when our customers were going to the men's department to get cashmeres. I love launching during the holidays. It's so much more exciting. There's so many more people in the stores. But boy, we're feeling it now." Nikki added that "it's almost more exciting to design women's because with men, there is a limit to how far they can make everything go, fashion-wise."

Amid the success he was experiencing with his solo project, back on the Motley front, things had turned ugly with the band's lawsuit filed against Tommy Lee's manager, Carl Stubner. As Chronological Crue reported, "Mötley Crüe files an amended complaint containing newly obtained evidence in its breach of fiduciary duties and constructive fraud lawsuit against artist manager Carl Stubner and his three companies Sanctuary Group, Inc., Sanctuary Artist Management, Inc. and Carl Stubner Productions, Inc. A press release issued by the band says, "The evidence, consisting of statements from band members Vince Neil, Nikki Sixx and Mick Mars as well as ten sworn declarations from key professionals associated with the band, demonstrates beyond any question that Stubner was a manager of Mötley Crüe and not just the manager of drummer Tommy Lee as he has previously claimed in press releases and legal filings. The newly obtained evidence supports and confirms allegations in the amended complaint filed in Los Angeles Superior Court that Stubner breached his fiduciary duties to Mötley Crüe by orchestrating a scheme for his personal financial gain at the expense and to the detriment of the band. Even though he received approximately a million dollars in commissions from Mötley Crüe, Stubner used his positions as the band's manager and the manager of one of the band members to demand a higher commission for himself. The amended complaint contends that his motivation was pure greed. The new evidence also confirms that Stubner demanded tickets from the band that he resold at 'scalper' prices for his own gain. The lawsuit seeks compensatory damages of more than $20 million for lost earnings and profits resulting from the Defendants' actions. The lawsuit also seeks punitive damages because, as claimed in the amended complaint, the defendants' 'despicable' actions were undertaken 'fraudulently, maliciously and oppressively.' As a shock to fans, the court documents reveal that Tommy 'recently informed Nikki and Mick, the shareholders of Mötley Crüe, Inc., that he was resigning from the band and his resignation was accepted.' As the two shareholders of Mötley Crüe Inc., Nikki and Mick have complete control of the entity that owns and

controls all Mötley Crüe business and assets including the rights to the name, trademarks, copyrights, logos, artwork and the right to license the brand. Since 2004, Vince and Tommy have been employees and/or agents of the Mötley Crüe entity."

Taking to the media airwaves to clarify- and perhaps protect- his multi-million dollar position in the band, Tommy Lee declared that "I am a founding member of Mötley Crüe. Based on internal band issues aired publicly, my future with the band is uncertain. I have tried to meet with my band-mates repeatedly without success but have informed them that I'm not walking away from my band of twenty-five years. It troubles me that the current legal issues, which were filed by the corporations against my personal manager, are separating us and causing more dysfunction. I hope we can work this out amongst ourselves." Guitarist Mick Mars sought to clarify amid all the attorney back and forth that "Tommy Lee has been my and Nikki's friend for longer than anyone. This band is not going to sue Tommy Lee. We will hold Carl Stubner and Sanctuary accountable." The band's attorney further clarify that "this band is not going to sue Tommy Lee; this lawsuit is not about Tommy Lee. It is about Carl Stubner's tactics that we contend harmed Mötley Crüe and cost the band millions of dollars." Nikki additionally added, concerning the merits of the band's legal action, that "there are witnesses to Carl Stubner's threats and demands for more money for himself. Managers have to be held to higher standards in the music business just like they are in other industries."

On another legal front as the fall of 2007 wore on, Sixx and soon-to-be-ex wife Donna D'Errico finally settled their divorce in November of that year, with D'Errico shocking everyone following the proceedings by waving alimony/spousal support of any kind, in spite of the millions of dollars Nikki had brought in during their 9 year marriage. D'Errico, explaining her side of the divorce's goings-on, began by underscoring the difficulty of the challenge she faced throughout the proceedings due to the fact that "my former husband is Nikki Sixx of Motley Crue, which has a huge fan base. He's very well liked and especially so right now because of his new book, The Heroin Diaries. I watch him promoting the book and I know that people are seeing only what he wants them to see. Like you, I have stories made up about me that are very painful. Behind the scenes with Nikki is just like any other woman divorcing a narcissist/abuser... I raised Nikki's three kids for 10 years and came to love them very much.

When we separated, I rented a house large enough for all of them to come visit. They never came. I was devastated and couldn't understand why until I found out he was telling them things about me that weren't true. He told them I kept them from their biological mom. That just wasn't true, but it made a good story - and made me look bad. He is very good at manipulation and using words to his advantage. That's why I came to find your website - I was looking for information about narcissism… Nikki was always making up stories about me that were just outrageous and I felt I had to rebut each one. It became scary to see how he defined me with his stories… He said that I said bad things about Brandi - his first wife - to his daughter after the divorce. I raised the kids for ten years and I miss them so much. He's kept them apart from me and it is a painful event. He made up a very convoluted story about his daughter in the backseat of a car, hiding from me, and overhearing me tell her nanny stories about her mom…It was such a blow to both of us - we still talk about it. My heart breaks when I see the sadness in Rhyan's eyes when he knows Nikki left him when he left the house. You see, Rhyan's biological father is dead and Nikki raised him, financially supported him, and proclaimed him his full son to the world online and in his personal writings (even tattooing his name on his leg and putting him in his will as a full child of his), referring to him as 'son' and with Rhyan calling him 'Dad'---for all practical purposes Nikki WAS and still IS Rhyan's dad. I don't know what the legalities involved with that are in California, but legalities or no- Nikki is Rhyan's father. And he abandoned him, deserted him, and rejected him. Rhyan became suicidal over that rejection and Nikki severing the relationship with his other siblings…and Nikki could not have cared less. His behavior and treatment and psychological abuse and harm of Rhyan has been horrific. Rhyan still suffers a great deal. I don't want to minimize it…I have had to help him overcome being rejected by his father and having the other kids alienated from him, too. He is doing great now."

Of her decision to ultimately walk away from the marriage with NO claim on any of Sixx's assets nor monies earned during their almost 9 years of marriage, she explained that "I fired my former attorney two days before trial and went in by myself on the day of the trial and asked for a continuance…I thought I was stuck with my former attorney who didn't do discovery, who threatened to quit if I didn't sign a custody agreement, and ignored me so much that there were hearings I didn't even know about. I kept asking and asking for information and none was forthcoming. It was

very hard to deal with. I knew Nikki was hiding assets like he did with his first wife. I said, 'Enough!' fired him and asked for a continuance. I got it...I wanted to hang in there and fight for what was fair for the sake of my children and for the principle of it all for women and mothers everywhere, but one can only withstand being stalked, followed, photographed, and mercilessly attacked and defamed by the other party for so long...It is against my principles and my faith to engage in a tit-for-tat, so I chose to cut my losses and retain my self-respect...I am glad it's over. I pretty much went through the entire gamut of emotions, but I got through it. My children have always kept me grounded and I stayed focused on them and getting them through this intact and happy...I am finally free." T

Though the divorce itself was finished, D'Errico did plan to exorcise some of her demons from the experience via a tell-all book, explaining that once "news of the...book leaked out...some fans of my former husband twisted things around about it a bit that made it sound quite ugly. In reality, though, that book will take the reader through what it is like when your spouse enters rehab--what leads up to it, and what it is like to be left behind with a baby and child alone. While I'm sure it is difficult to be the one going through rehab, what the loved ones are put through is never really focused on. It is rehab from the perspective of the spouse left behind...Many people have asked me about my career and various life events and I want to thank them for their interest. I hope this book gives them answers and also provides a road map for others - how to become happy, raise kids and move on during good times and bad. I've learned so much and I want to share my life lessons with people everywhere." Ultimately, while she appeared happy to have her marriage ended, D'Errico still seemed to be suffering amid the loss of her 3 step-children from Nikki's marriage to Brandi Brandt, sharing in one diary entry following the divorce that "there are three people who used to be in my life who I miss alot. I still think of them often, and still love them very much. Not sure what they have been manipulated into believing or remembering about me, but I hope one day to have them back in my life again. Until then, I wish them happiness and hope for the very best for them. I hope their lives are full of smiles and happiness. But there is an empty place in my heart that awaits their return. Someday."

Heading into the holidays, Nikki addressed the fan demand for a Sixx A.M. tour by clarifying that while "there has been a lot of rumors that we

might tour, I wanted you to hear from us directly that there are no tour plans at this point. This is a very magical project to us and we do play on making other albums and the dream would be tour someday, but that day is not as close as radio and press is announcing." The band did shoot a second video to follow up the wild success of 'Life is Beautiful,' with James Michael commenting that "the video shoot for Accident's Can Happen was amazing. Paul Brown was back in the Director's chair for this one. I have to say that I have never been so impressed and amazed with a person's talent and vision as I am with Paul. He is a true artist. Nikki, DJ and I had a great time and I think I can speak for all of us when I say we fell in love with this song all over again during the shoot. It was a long day, but one I'll never forget. We got to the set around 7am and the entire San Fernando valley was covered in a heavy layer of fog... rare for L.A. but in many ways a gift, as it created an eerie but beautiful setting for the first few hours of the shoot. As with all video shoots, there were many, many takes from every imaginable angle, but as the day wore on and the fog burned away we began seeing playbacks, and at that point it became clear that Paul's vision had exceeded anything we could have anticipated. We ended our final shot right as the sun was setting and we all stood there staring as it disappeared... feeling grateful for everything."

Reflecting back on his most personally turbulent and professionally successful year in many, Nikki seemed to first and foremost draw a natural correlation between his success and sobriety, on both a personal and professional level, reasoning that "I'm just trying to make progress everyday as a human being...I look at my own experience in this. This last album, *The Heroin Diaries Soundtrack*, I think is among my best work artistically. If you listen to it lyrically, the cleverness and the twists and turns, it is the best music I have been able to produce. It tells me I don't have to do the drugs. The father and mother issues, the battle with God, the anti-social behavior because I didn't have a firm grip on reality. I never was in a single school long enough to form a long lasting relationship. The father that abandoned me, it made me feel worthless at best. I lived in a mansion with a private jet and yet something was missing. Until you can get back to that core...where I am at now in my life, fuck! I am so comfortable in my skin. I am so happy. '*Dr. Feelgood*' was one of the best albums we made and we made it clean. With some people, maybe it works for them. God bless them if that works for them. There is a saying that some people have to die so the rest of us can live. I personally believed I

was the person that had to die so the rest could live. I was always the person willing to throw myself under the bus like Keith Moon, Hendrix, Kurt Cobain and Janis Joplin for the betterment of the story. Now I don't endorse that story at all. What music do you think Hendrix would have made if he pulled his shit together? What music would Bon Scott have done if he would have not died. Those are questions we'll never have answers too, but for me personally, I am going to have a very creative rest of my life."

Looking into the future, Sixx seemed particularly focused on warding off the "fuckin' demons...I don't ever want them to get ahold of me again. I'm actually very passionate about being alive and I never was. So I'm sort of fond of keeping the door open and keeping an eye on those motherfuckers back there..I've adjusted my values and the people that are in my life, so that I don't find that to be -it's not really difficult... Darkness can be funny. It can be quirky. There are different ways that that stuff comes out as a creative person. But the actual conflicted, twisted, decaying, rotting soul? That's not me. No more. Now, I've got a new band, a soundtrack album, a book, a clothing line, photography, I'm a single father, I'm a producer and a songwriter, I'm still in Motley Crue, and it's like, 'Fuck yeah!' All cylinders are firing and it feels great...I mean, I get tired. I get burnt out. I have to take time and shut it down just like anybody else. But it's my excitement in life to watch somebody walk down the street wearing one of our jackets, or to see somebody carrying the book. That's what gets me off... I feel that I'm at a crossroads in my life. I've got a hell of a lot going on right now that's really good- I'm writing songs for people like Meat Loaf and Marion Raven, I have a very successful clothing company with Kelly Gray (Royal Underground Clothing), I've written this book, I'm making new music (Sixx AM). It's a good time for me. But more importantly, I have my children and they made me think about things...If I go back to being a very young kid, it's all the creativity that I was constantly getting my fingers in, whether it was writing or forming bands or even designing clothes as a young kid, my own style and that's always sort of fed my soul. It's an important part of at least personally who I am. It makes me feel balanced. I don't really feel I'm doing much different in 2007 than I was when I was seven...To be able to be a creative person and write this book and music, design a fashion line and write and play in Motley Crue tells me I've picked the right path."

Chapter 29

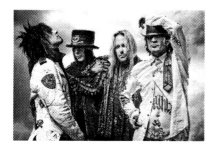

The Saints of Los Angeles Head Out On Cruefest!

With his divorce behind him and the wildly successful promotional campaign for 'Heroin Diaries' winding down, Nikki Sixx kicked off 2008 by firing up the machine that is Motley Crue. The first issue on his considerably lengthy list was settling legal matters between the band and drummer Tommy Lee's manager Carl Stubner, whom the band had very publicly sued back in the fall of 2007, causing the drummer's future with Crue to be called into question. Nikki had worked to fuel that fire- perhaps by strategic design to pressure Lee's camp into settling- by remarking in a September 25th, 2007 interview on the Howard Stern Radio Show that the band "should be fine without Tommy", and by November of that year, Sixx had confirmed that "he's out of the band, that's just the way it is…Tommy kept fucking around and I said, 'You know what dude, you've got to knock it off.' He said, 'I fucking quit.' I said, 'Fine. I still love you but I don't have time for this.'" Still, Tommy stated contrarily on the record that "I have tried to meet with my band-mates repeatedly without success but have informed them that I'm not walking away from my band of 25 years…I hope we can work this out amongst ourselves."

While the status of Lee's future with Motley remained in question, Nikki was quietly hammering away in his studio with songwriting partner James Michael and guitarist Mick Mars on songs for what would be the

band's first new studio LP in almost a decade. By the end of January, Sixx updated fans via his online diary that he had completed "10 songs…for the new Crue album so far, I'm very proud of the songs. I think we're onto some of the better songs we've had in years, time will tell of course. A couple of song titles on the Crue album are called '*A Scar on Hollywood Blvd.,*' and '*Saints of Los Angeles*'. As its been leaked out before this is no surprise, but the album is called '*The Dirt*,' and lyrically follows the story of the Motley Crue bestseller 'The Dirt.' Its challenging and exciting to have to write the songs into time capsules spreading over years…Mick Mars and I started writing…(and) I had done a record with James Michael and DJ Ash for my side project, and we had such an amazing chemistry together that me and Mick and James and DJ were just on a songwriting mission from hell. It was amazing. We brought in another friend called Marty Frederickson. Doing the whole *Heroin Diaries* project really helped me to focus on a specific issue. Like, instead of writing a love song, make it about a moment. Make it about the kiss. So for this, what we really wanted to do is take the concept of the autobiography, *The Dirt*, and make it into songs. I was really trying lyrically to do that, and to work so closely with Mick and really develop the phenomenal songs working with James and Marty and DJ Ash…I've written a lot of songs with Mick Mars of course, along with James Michael, Marti Frederickson, and DJ Ashba. The chemistry in the studio as we're writing is unbelievable. I look forward to leaking some to you all in the next few months…What a fucking great year. I can feel it in my bones…08 is gonna blow your mind."

On a personal note, Nikki would report in the same diary post that he was "proudly not smoking still and sober 7 years this july. Amazing the decisions you make when you think of others first, and you get that by becoming selfless and that is a huge part of getting to the core of your issues." Not the only one moving on from the past, Chronological Crue reported near the end of January that "Nikki's ex-wife Donna D'Errico is reportedly shopping for a publisher for a proposed book titled Letters from Rehab, which consists of letters that Donna received from Nikki during his rehab stint in 2001 and her thoughts on their content. D'Errico is also looking to publish her memoir titled Both Eyes Forward with a firm focus on her marriage and divorce from Nikki."

Heading into February, on February 11th, Robin Leach reported in his gossip blog that "Mötley Crüe rocker Vince Neil had 110-million reasons to

smile for his birthday blowout weekend here — just two days earlier Vince, Tommy Lee, Nikki Sixx and Mick Mars signed a $100-million+ mega deal to produce three albums and perform three world tours for the giant LiveNation entertainment conglomerate." Nikki quickly rebutted the report by stating unequivocally that "Motley Crue has not signed any deals. Any information reported to the contrary is false and misleading, though he did throw fans a bone with the added news that the band "will most likely hit the road in the summer of 2008."

With the word out on the street that the band would be touring, Sixx did update fans on the mystery regarding drummer Tommy Lee's status in the band, confirming one deal they had signed was a settlement to their lawsuit with Tommy Lee's manager Carl Stubner. To that end, the band's official website, Motley.com, confirmed the lawsuit's "successful completion of the undisclosed terms arrived at by the warring parties." Tommy Lee further reassured fans with an end of February update that, in spite of reports to the contrary, such that, according to the drummer, "I never quit! Silly rumours! We're all together! We're goin' on a world tour starting July 4th!" Sixx further added confirmation of the reconciliation by verifying that "Tommy's in the band. It's the original band and we got rid of the external problems. Now the band is a band, and we don't have outside problems…We always get along when we don't have all those fucking people from the outside trying to push and pull and do the things they do."

In another upbeat moment for Nikki as the year progressed, on March 7th, Chronological Crue reported that "Nikki and Kat Von D go public with their relationship via MySpace. On his profile, Nikki captions a photo of them taken at a tattoo competition in Santa Barbara with 'My other half, I love this woman….' Kat captions a different photo of the couple on her MySpace profile with 'Never thought I'd fall in love like THIS. He OWNS my heart' while Nikki comments below, 'Never saw it coming, but it mowed us down like a freight train… Hell Yeahhhh, Love is in the air.' The couple spends Kat's birthday weekend at New York City's Bowery Hotel and get matching tattoos of a Bowery Boy."

Sixx elaborated on the blooming romance between the two by confirming that "yes, Kat and myself are together and we've been 'just friends' since last summer. She was going thru a brutal divorce (as was I) and we were friends. Along the way, she met a great guy (Orbi) and we

were friends through that too. They broke up and we were still 'just friends'...I've never had a friend become the girl. Yes, it caught us both by surprise, as I'm sure some of you. Its understandable, on her TV show, she is still in a relationship (welcome to TV, its not live), point being: we understand that some of you don't. Its cool. With that being said, we are very, very happy together. I hope it shows in our art and music. Nothing is better for artists than complete connection...When I felt myself falling for her, she was all walls and brigades, an invisible bodyguard on call everytime I tried even to allude to or use the evil smirk to get close to her heart. So if you think bad of anyone, let it be me."

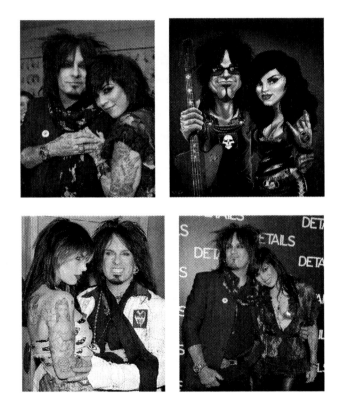

As happy as he seemed about his new romance, on another personal front, tragedy struck on March 11th when Nikki reported that "a dear friend, Bob Timmons, not only a friend of mine but countless others recently passed on. He saved not only my life, but so many others he single-handedly effected millions of people's lives. I miss him dearly

already. We spoke quite a bit in the last year. One of the kindest things I've heard in my life was when he told me he was proud of me for giving back thru the 'Heroin Diaries' and for staying sober during hard times. To hear that from such a great man warmed my heart, and I felt like what it must of felt like if my own father had given me such praise....His time here was done and I feel good in knowing that's the destiny for all of us. He taught me a lot about recovery, and I hope to pass that. My time is up, it's the least we can do, lead by sober example to those who still struggle...You helped us all see how to live free from addiction, and I can say it loud even, thank you. Bob, I know you're watching, and we all hope to do you proud. Thank you for sharing your life with us. Love You, Nikki."

Back in the studio, Nikki stayed focused through all of the aforementioned on crafting the band's next studio LP, revealing of his writing process with longtime Crue guitarist Mick Mars that, as with their creative back-and-forth in the course of writing past albums, "he has a bunch of riffs, I have a bunch of riffs. I usually stop him half way through his riff, and go, 'Change that note, and change that note.' And then I play, and I ask, 'What about this part?' and he goes, 'What if you changed that part?' and I go, 'Good idea.' And I just start singing something over it, and there's some naughty little lyric with some sarcasm dripping off of it. Like, 'Don't go away mad, just go away' just came in one minute. It will kick-start my heart. It just comes. It seems that the times that we try so hard to craft stuff, it ends up sounding processed." Expanding on the band's broader input into the writing process, Sixx recalled that "the biggest thought process behind this record was that Mick said, 'I want loud guitars.' Vince said, 'Great songs.' And I said, 'Snotty lyrics.' Okay, that's it, guys. But to be honest with you, we did say, 'Let's do something we haven't done— Let's tell a story from beginning to end.' " Sharing with fans that the band was VERY much back together as writing progressed, Nikki announced that "I fucking love this new Motley Crue album. Tommy's kickin' ass, Vince sounds insane and Mars is shredding on guitars…(so) the studio has been flowing nicely. We were all together again today plotting, planning, designing, listening and the band seems to have the old bite back, but we will let you be the judge of that when its time. I do know the people around us- the ones we can trust- are feeling the maGic from the songs, so maybe its not only in our head…It doesn't feel like one song is better or worse than any other. It feels so good to be excited about something you've worked on so hard. I'm so excited for you all to hear it…This is

one of those albums that I just feel it in my stomach that something's happening with the band…There's a newfound energy in the songs. It's just a rebirth of that really dirty, rock and roll side of Motley Crue."

Touching on the business side of making an album in 2008 vs. 1988, Nikki shared that "we recorded it all out in Los Angeles in different studios. Today, that whole thing about spending $2,000 an hour in some recording studio is ridiculous. We don't do that anymore. We own our own equipment. It's small, it's compact. You get in, you get out. I'm not into sitting there and fidgeting at a console for days about a guitar sound. I mean, you plug it in, it sounds fuckin' good, and you go. Rock & roll is dirty, and it's bad, and it's either clever or it's not clever." Offering fans a further peak inside his recording , Nikki explained that wherein the past "I first started out playing a 1976 Thunderbird and then when that fell apart, I ended up playing B. C. Rich and played that for awhile. Then I went to the Kramer Thunderbird and from there I went to Gibson and have been with them for the past 20 odd years playing the Thunderbird. And I also have my own signature model bass called the Blackbird which is kind of a customized Thunderbird. "

Co-producer James Michael added on the album's progress that "I've been locked away in the studio for the last couple months (co-producing)…the new Mötley Crüe record and can I just say that it is truly incredible! The songs are stellar and the band is at the top of their game, rocking harder than ever. I get chills every morning when I step into the studio and hear playback on what we did the night before. I am so proud of this record. You're going to fucking love it!!!" To celebrate the album's home-grown theme, Nikki shared with fans that- as he'd done in ode to most anything he'd held close to his heart in the past- he planned to take out time get "tattooed…I think its time to step it up, I'm feeling the itch. Kat's gonna do one probably this weekend. I've been wanting to get 'Los Angeles' tattooed on me for ages and then the other day I noticed Kat has it on her left shoulder. We both have had so much happen in our lives in this city, why not make it permanent. The band started it here, I've died here, had kids, married and divorced here. My life is Los Angeles."

As recording wrapped on the band's new LP and attentions turned to planning their summer tour, Nikki's plate got fuller still with the news, as reported by Billboard Magazine, on April 4th that "Motley Crue/Sixx:

A.M. bassist Nikki Sixx has been named the president of Eleven Seven Records, Billboard can reveal…Sixx will oversee a roster that includes Buckcherry, Trapt, Drowning Pool, Marion Raven and up-and-coming rock outfit Chosen Son." Nikki commented of his promotion that he felt qualified because "I've had enough success and enough misfires in a career that's lasted over 25 years, that I can go back and draw on that experience, and I think that's helpful for the artists…They say the music you listen to in your formative years stays with you and leaves an impression for the rest of your life. For me, the things that I fell in love with happened in the '70s, when artists were nurtured by record companies and it wasn't about singles. It was about bodies of work, an album. If you go back and look at it, artists would break on, like, the second single, third album. Bands don't have that opportunity now. You're dropped, bro. You're done by your second single, if you even make it to the second single. I understand quarterly billing, how the record companies run. I see models that are successful, and how you market the product to the fans. That's what I love about Eleven Seven (and) that's what I love about (Eleven Seven founder) Allen Kovac. It's the community of artists that work together, whether they work with the president or with each other…I find it very interesting to take the artist's craft, the art, the music, the image, and get it out there. It comes under the heading of 'record company president,' but it's a little more than that."

Elaborating more in-depthly on why he felt his aforementioned experience would hold weight with the new generation of Millennium rockers he would be seeking to bring into the Eleven Seven fold, Sixx reasoned that "when I go into rehearsal rooms and meet with bands, they're genuinely excited to be with me because of what I've done as an artist, not because of anything else. There's that whole celebrity rock star thing, and artists are into artists who have been able to achieve success their way…With younger artists, it's definitely going to be an asset. Younger artists don't understand the business and when people don't understand something, they're sometimes fearful of it or overly trusting, and those are two bad things. If you're overly trusting and you're in bed with the wrong people, you're definitely gonna get fucked. But if you're fearful and bury your head in the sand, you might sabotage your career…What I know about Eleven Seven is they believe in the artists being artists, making music for fans and not making it for radio. I want artists to know that that's a strong point for me -- being an artist and being smart enough to have

relationships for them -- which in the end is for all of us…(So) I'll sit down and look at it and we'll figure out as a company what we can do to make sure a band stays on the road and how we can work with radio the best to keep the band in front of people because we believe in the band… I spend a lot of time with a lot of producers and songwriters, and I'm seeing a lot of bands in garages with ripped-up jeans and Marshall stacks, playing as loud as they can play, just being snotty and not caring about what anybody thinks. There's a thing happening where people are saying, 'it doesn't matter what I do, it's not gonna be successful anyway 'cause the record companies are going under and radio is so controlled they won't play us this way.' It's almost like it's been a blessing. Artists are going, 'Fuck it, let's just fuckin' rock, man.' When I was a kid playing in bar bands, we didn't care about any of that. We just knew that we loved Iggy & the Stooges. We liked the music that we liked and we just played it as loud as we could play it. And one day I ended up in one of the biggest bands in the world with that attitude. I think that if other artists keep doing that -- and I'm seeing it -- that's what's gonna happen. We're gonna have a lot of new, great music."

In answering the question of how he managed juggling the dueling duties of running Motley Crue and a record label with a healthy artist stable, Nikki admitted that "the day-to-day stuff, the really grueling, hard, daily stuff, I don't do. It's something I know I'm not good at. I'm not good at sitting in an office. I have an office in my home, I have my weekly updates, and I work with the artists." When not in the 'office,' Nikki was in his real place of work, the recording studio, wrapping work on the Crue's new album, sharing with Billboard that "it's just about finished. I've got to tell you, I've been writing songs for a long time, and there's something magical on this record. You make records, and you do the very best that you can do and you like them. And then sometimes you listen back and you go, 'You know, about 50% of that album was really magical and 50% was just kinda jammin' and rock'n'rollin and it was cool.' This is one of those albums that I just feel it in my stomach that something's happening with the band. There's a newfound energy in the songs. It's just a rebirth of that really dirty, rock and roll side of Motley Crue." By April 12th, Nikki gave fans another update on the band's rapid movement toward completion and release of an album that was now officially titled 'Saints of Los Angeles,' with Sixx shedding light via an online diary entry on just how far along the band's release prep was that "the album's done, the video's done, the artwork is done, the photo sessions are all wrapped up and the

single is ready to go to radio, rehearsals start tomorrow; wow… it's been so busy, it feels like I'm leaving a few things out… and I probably am. I know a lot of you have heard 'Saints of Los Angeles' on the web… If you like the single, just wait 'till you see the video. OK, my eyes are red, and its a rare night to not have to work, so I'm gonna sit back and feel good about all the hard work. I hope you all like it as much as we do."

In even more exciting news for fans, on April 15th, as Rolling Stone Magazine reported, "in what can only be dubbed the loudest press conference on Earth, the four original members of Mötley Crüe unveiled plans for their first ever Crüe Fest national rock tour and their first studio album together in ten years, *Saints of Los Angeles*, to a packed Avalon in Hollywood Tuesday afternoon." Continuing, USA Today revealed that the 41-city "summer rock festival will feature the four original members of Motley Crue — singer Vince Neil, bassist Nikki Sixx, guitarist Mick Mars and drummer Tommy Lee —as well as Buckcherry, Papa Roach, Sixx:A.M. and Trapt." Arguably a reflection of the band's ever-present star power, Billboard Magazine further reported that the band- following in the footsteps of superstar artists like Madonna, U2 and Jay Z- had partnered with "Los Angeles-based Live Nation…(as well as other) partners for Crue Fest '08…(including) JVC Mobile Audio, MTV's 'Rock Band,' Best Buy, Fuse TV, Lotus and TheRockvine.com. 'Rock Band' will sponsor an area at each tour stop where concertgoers can play the game. In addition, a Crue Fest '08 sampler, featuring tracks from each band on the tour, will be available exclusively at Best Buy beginning June 17." Commenting for the band's part on the announcement, drummer Tommy Lee excitedly shared that "we've been wanting to do this forever…And we're finally doing it…Hopefully this thing transpires into somewhat of an Ozzfest and carries on for years and years and years…which would be badass. And I could tell you one thing for sure, we are gonna have more fun than humans are allowed to fucking have!" Reuters further reported that the " *'Saints of Los Angeles'* the first single from the group's upcoming album, will be available for download for 99 cents beginning on Tuesday via Microsoft Corp's Xbox Live Marketplace and on Thursday via Sony Corp's PlayStation store, said Viacom Inc's MTV Games. Rock Band went on sale last November, and now has more than 80 tracks available for download in addition to the 58 tracks in the original game." To top off their truly colossal announcement, Motley Crue debuted their new single that night on Jimmy Kimmel Live, joined on stage at the song's conclusion by Cruefest tourmates Josh Todd

of Buckcherry, Jacoby Shaddix of Papa Roach, James Michael of Sixx: A.M. and Chris Brown of Trapt.

Calling on the A&R skills that had helped him land his recently-announced V.P. position at Eleven-Seven, in commenting on the band's selection criteria for picking the festival's supporting acts, Nikki explained that they were "looking for bands that lived the rock and roll lifestyle because that's what we're taking around the country is rock and roll and the lifestyle…And they all look and smell and, I imagine some of you will find out, will taste like rock stars." Leaving much of the partying to the next generation of rock 'n' roll bad boys, Tommy explained the band's off-stage routine at that point in their almost 30-year career as one where "the second we hit the stage, everything is exactly the same…But when the house lights go up these days, everybody leaves and goes back to their hotel room or bus or airplane or whatever. It's different now. People have families and kids."

Checking in with fans by middle-May, Sixx reported that "I've been busy finishing the album and preparing the tour. Besides the usual stuff, I've been diving back into a few books that are really inspirational to me and helps to clear away any road blocks that our crazy lives (full of crazymakers) tend to bring. Katherine and I have been up to our eyeballs in both 'The Four Agreements' as well as 'The Mastery of Love,' both by Don Miguel Ruiz. Simple concepts for complicated lives. Kat was shooting a movie in North Carolina, so I went out to visit her for a few days, had a blast. Beautiful beaches and cool people, we needed it. Music wise, different tones for different moods: Average White Band, Ruth Brown, Wynona Carr, Jack Johnson, Sly and the Family Stone, and of course Josh Rouse is a great way for anybody to start the day. Mid-day has me addicted to Mars Volta, Omar Rodriguez-Lopez, Bigelf, Dirty Pretty Things, and Eagles of Death Metal. End of day for me lately has been a combo of Sigur Ros, Air and assorted old jazz (Red Garland, Oscar Peterson or Charlie Parker.) All in all, just feeding the mind before I leave on tour. Been doing a lot of booking flights for my kids to come and go this summer while I'm on the road. We're all looking forward to just hanging out, traveling and seeing the country together this summer. Thank you for all the support and donations for the kids at Covenant House. We were able to give them a check for over $250,000.00. A lot of kids' lives will be

changed with that, and I think we're just getting started. Thank you, Nikki."

Prior to hitting the road on their very first festival tour, Motley Crue's 9th studio LP, 'Saints of Los Angeles,' was released on June 24th, 2008, triumphantly debuting at # 4 on the Billboard Top 200 Album Chart, their highest charting studio album since 1989's *'Dr. Feelgood.'* Moving 100,000 copies in its first week of sales, the album was a fan and critical smash, with Rolling Stone Magazine highlighting the thematic inspiration from the band's 2001 best-selling autobiography 'The Dirt' as helping "the Crüe connect to their old sound: Much of *Saints* rocks with the same raucous fun as their Eighties albums, delivering glam guitars and arena-size choruses." Heaping similar praise on the band, their hometown newspaper, the L.A. Times, honed in on the album's "energy…thanks in part to the presence of drummer Tommy Lee, who drives *'Down at the Whisky'* and *'Chicks=Trouble'* like somebody with a head full of stimulants." Billboard Magazine, meanwhile, similarly celebrated the album as "a welcome…return to form for these aging miscreants. The Crüe are at their best when they mine the manic, punk-infused glam metal of the pre-saturated, mid-'80s Sunset Strip, something they get right…The performances and subject matter are as raucous and sadistic as the book upon which they're based…*Saints of Los Angeles* is the best thing they've laid to tape since their codpiece heydays."

Discussing what they felt the album reflected in context of their broader legacy, singer Vince Neil reasoned that the album "represents us, Mötley Crüe, growing up in Los Angeles and the sights, sounds, and smells of Los Angeles. The songs are amazing. The stories are amazing," while guitarist Mick Mars explained that "it sounds to me like vintage Crüe - meaning Feelgood, Girls, Girls, Girls and that kind of stuff - but at the same time, it's more modern sounding. The rawness from back then is on the album, but the songs are more modern. They fit into the genre today, instead of sounding like it's 1980. It's modern, but it's Mötley too." Nikki seemed most satisfied with the fact that "for the first record we've done in ten years, it's really, really, really good. I got to tell ya. I'm very excited…There's a sound with Mötley Crüe, and it comes with Vince's voice, which is such an important part of the show, and Mick's guitar. And the way Tommy and me play together is an important part of it. When we're all together, it really is Mötley Crüe, but we've done albums, like

Generation Swine, where we went left of center just to see what it felt like. But this album feels a little truer our core. You hear something like '*Saints of Los Angeles*' and you don't go, 'Who's this? It kind of sounds like Mötley Crüe.' You go, 'Fuck, new Mötley Crüe!' It would be like AC/DC coming on the radio with a new record, or Aerosmith. You either like the band or you don't like the band. It's not the band trying to make you like them. It's the band doing what they do. And that's our strong point."

Turning discussion to the band's upcoming first-ever Cruefest, Nikki explained that as excited as the band was about touring on their new material, "it's nice to have that catalogue of music, and it's nice to have the legacy. I think rock and roll is gonna be back in a big fucking way here. You have so many options out there, from video games to the Internet. You're on your iPhone, and you're watching YouTube videos. What's going to make someone go out and go to a show? It takes a lot to get me to leave my house to go see something. But if you have to give 100 percent, like with Alice Cooper and Bowie and Slade — those fucking bands gave 150 percent. It was about fashion, it was about music, it was about pushing the envelope. You got to give people a lot to make them really want to come out and see you and buy your records and say, 'I fucking dig this band because they give me something…I think we're still like a band that goes out and tears it up and I don't really pay attention. That's my fucking problem. Someone goes to me the other day, 'I don't think you've realized what you've done,' and I go, 'What do you mean?' and he says 'Well, you just walk around the streets like you're just some guy,' and I say, 'Well I am some guy!' and he goes 'No dude, you don't understand. You guys are becoming those guys that you grew up with!' And I'm like, "Oh! Well that's kind of cool.' "

The band spent much of June prepping for their Cruefest tour kick-off, including a high-profile appearance on Larry King Live on June 20th to promote the release of *Saints of Los Angeles.* During their heavy media schedule, Nikki took out time to address the long-rumored film-adaption of 'The Dirt,' explaining that "we're trying to get them out of the way to make this movie that should have been made a long time ago. MTV has become bogged down in its own way. It's a channel that used to be hip and has now actually become unhip. We signed with them because we believed they were right, but they haven't come to the table. We need to find the right partner. They are not the right partner." The band rounded out the month with a June 25th appearance on the Late Show with David Letterman, with Nikki updating fans on a personal front that ahead of leaving on tour, girlfriend Kat Von D had "done a huge piece on my right ribcage: it's an angel I took a photo of in a cemetery when I was in Milan, Italy. Underneath it, from my lower back wrapping around to my lower stomach, it says Los Angeles. The detail blows my mind. She's just about finished with portraits of all my children on my left calf; they cover every inch of my leg. I can just look down whenever I miss them and see their faces. They're all from photos I took of them - something so personal about having her tattoo my own photography on me. The fact that we're so in love, so in synch and so much on the same path in life makes us even closer during and after the tattoo experience. Obviously I've never been in love with my tattoo artist before, so this is a pretty big high for both of us. It's all about the ones we love - like the tattoo of my grandfather on my left thigh she just finished. You should have seen his face when he saw it. I think after eighty years on earth and all he has done and seen, this one totally blew everything else away and blew his mind. He's pretty smitten with Kat too; that just put him over the top. I finally met my other half. Yes, I'm happy as hell. This is gonna be a great year for both of us."

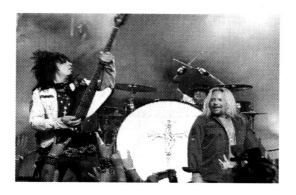

Kicking off the tour's first date before 8,700 fans at Cruzan Amphitheatre in West Palm Beach, Florida, Rolling Stone Magazine reported that "this summer...(the band is) headlining the inaugural Crüe Fest, with Buckcherry, Papa Roach, Trapt and Sixx's side project Sixx: A.M. The tour runs from July 1st to August 31st; tickets range from $30 to $99. 'Our production is sick, dude,' promises Lee. 'There's nothing worse than going to watch a band and the light guys are all stoned.' 'Maybe Crüe Fest is about a lifestyle,' Neil says. And what is the Crüe lifestyle in 2008? 'Sex, sex and rock & roll!'... 'At the end of the day, we're just like a couple of old ladies with a tight bra,' Lee says later. 'We can be naggy little bitches. But you know what? When we all get in a room together, there's something real magical that the four of us do that nobody else does.' "

The band's July trek across the U.S. included July 3's Tampa, Florida date at the Ford Ampetheatre; July 5's stop at The Verizon Wireless Ampetheatre stop in Charolette, NC; July 6's Virginia Beach stop at the same sponsor's arena; July 8's Long Island's Jones Beach Ampetheatre; July 9's show at the Darien Lake Performing Arts Center in Buffalo; July 10's stop at the Bayfest in Sarnia, Ontario; July 12's stop at Philadelphia's Susquehanna Bank Center; July 13's show at the Nissan Pavilion in Washington DC; July 15's stop at the DTE Energy Music Ampetheatre in Detroit; July 16's show at the First Midwest Bank Ampetheatre in Chicago; July 18's stop at the Verizon Wireless Music Center in Indianapolis; July 19's show at the Marcus Ampetheatre in Milwaukee; July 20's stop at the Verizon Wireless Ampetheatre in St. Louis; July 22's show at the Toyota Center in Houston; July 23's stop at Verizon Wireless Ampetheatre in San Antonio; July 24's show at Superpages.com Center; July 26's show at Journal Pavilion at Albuquerque; July 27's stop at Fiddler's Green Ampetheatre in Denver; July 29's show at USANA Ampetheatre in Salt Lake City; and July 31's date at the Cricket Wireless Pavilion in Phoenix. Of the band's broader touring plans past the summer, drummer Tommy Lee reported that "I just saw a rough itinerary but I don't want to quote any dates just in case they shift around but we're definitely coming there. I think what we're going to do when we head over to Europe, Australia, New Zealand and Japan is bring maybe one or two bands with us - it might be Buckcherry or Papa Roach. Then what we wanted to do in each country was support the local talent there, so maybe have three Australian bands, and so on."

Heading into August, the sold-out tour took a break in the band's hometown to receive what Chronological Crue reported as "an official day named after it by the City of Los Angeles' mayor's office. From now on, July 31 will be known as 'Mötley Crüe Day' in honor of the band. The band members are presented with commemorative documents from Mayor Tony Villar at a press conference at Guitar Center on Sunset Boulevard in Hollywood." On a personal note- in a tribute to longtime Motley Crue guitarist Mick Mars- Nikki shared that "Katherine tattooed a killer portrait of Mick on my leg and we got to surprise him with it at the Los Angeles Crüe Fest show. It was a pretty emotional roller coaster ride to share the whole experience with Katherine, from the beginning of the idea to the end when we finally show Mick." With the tattoo session filmed to air on L.A. Ink, Kat Von D said of the experience that "at first, when Nikki brought the idea of getting this tattoo done, I thought how cool it would be to celebrate a friendship between two people over three decades! We decided it would be so rad to do the tattoo without telling Mick, so on the show, you'll be able to see the tattoo process, as well as the entire High Voltage crew rockin' it out at Crüe Fest in Los Angeles, which to me, was by far one of the greatest shows from the tour - amazing energy!" Mick, for his own part, expressed feeling "shocked and honoured. Nikki getting a tattoo of me is the most amazing thing anyone has ever done for me. It is a huge honour to have Nikki as my band mate and friend."

Hitting the road for a second leg of the summer tour in August, Crue continued their sold-out traveling festival, beginning with their August 1st stop at the Mandalay Bay Events Center in Las Vegas; the August 2nd stop at their hometown of L.A. at the Glen Helen Pavilion; August 5th's Sacramento show at the Sleep Train Ampetheatre; their August 6th stop at the the Shoreline Ampetheatre in Mountain View, California; August 8th's stop in Nikki's childhood hometown of Seattle, WA at the White River Ampetheatre; August 9th's show in Portland at the Rose Garden; August 11's show at the General Motors Palace in Van Couver; August 13's stop at the Rexall Place in Edmonton, Alberta; August 14th's Calgary show at the Pengrowth Saddledome; August 15th's show in Saskatoon at the Credit Union Centre; August 17th's Winnipeg show at the MTS Center; August 19th's return to the states with a show at Cincinnati's Riverbend Music Center; August 20th's Cleveland, OH show at the Blossom Music Center; August 22's show at the Comcast Center for the Performing Arts in Boston; August 23rd's PNC Bank Arts Center show in South Jersey;

August 24th's Monteville, Connecticut stop at the Mohegan Sun Arena; August 28th's show at the Molson Ampetheatre in Toronto; August 29th's stop at the Saratoga Performing Arts Center in Albany, NY; August 30th's Scranton, PA show at the Toyota Pavilion at Montage Mountain; and August 31st end-of-summer show at the Post-Gazette Pavilion in Pittsburg.

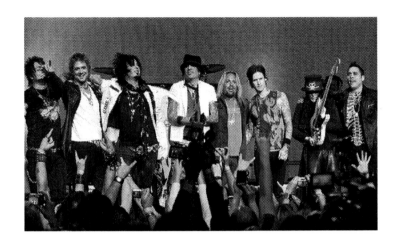

As the band took a brief break in September before hitting the international tour circuit, Nikki, reflecting back on the band's success following almost $40 million in ticket sales, quipped in response to suggestions that their new album/tour was a comeback- (forgetting their massive one 3 years earlier in 2005 with the 'Carnival of Sins' tour)- that "every Mötley Crüe record and tour is the big comeback. We're off tour right now and I imagine that we're already getting written off again…It's been over a week, and I'm sure I'll be hearing that we've broken up. But we do what we do as a band—We continue to make music and tour, and probably will forever." As the band hit the road again, internationally this time, in early October, beginning in Mexico, Nikki shared with fans in an October 8th diary entry that "Mexico has been wonderful to us. The fans are so kind and welcoming. We've had some great shows down here, but now it's time to say goodbye. Today we're off to Argentina for our first visit ever. I can't believe we're finally going to South America to play. The band is ecstatic, to say the least. It's getting harder and harder for me to take pictures unless it really moves me. My photography studio back in Los Angeles is under construction and should be 90% done by the time I

return. Words, so many damn words, flowing out of my head, it's almost like torture. I've written eight songs, poems, love stories or rancid notes from hell all in the last two days (I never really understand when I'm writing what the hell it is I'm doing). I guess we could say Mexico has inspired me."

Continuing with fan updates via his online diary as the South American leg of the band's world tour progressed, Sixx revealed that "Argentina stole our hearts. The people, their spirit and the beauty of Buenos Aires all came to a head last night as we hit the stage. We've never been here - a first - and then it happened: the sky opened up, and I swear to God, he was smiling on us. I've never seen it rain like that. The rain came and came and came, on the band, on the crowd, on the equipment, harder and harder… everything and everybody soaked to the core and all it did was make us smile bigger and play harder. The crowd all chanting and jumping in time to the music and the band pushing harder and harder with the rain. Thank you Argentina. They say the first cut is the deepest, if so, you hit bone - we love you… After the success of Mexico and Argentina, we're sitting on pins and needles to hit the stage. We're hearing the fans have been waiting so long for Mötley that it's going to be insane. We can't wait. I've been hearing from fans from Indonesia, Thailand, Philippines and all around Malaysia and how they're travelling to the Singapore show."

Still, his creative fires would be temporarily dimmed a bit when, at an October 15th show in Guadalajara, Mexico, Tommy Lee reported that "into the second song (of the show)…I smell fire! I'm thinking, 'Oh must be the new smoke machines… whatever! And then I'm like, 'Wait a minute - that's a fucking FIRE I smell!' So I come to find out Nikki's dressing room is in a full-on blaze and mine's next door! You know shit is crazy when you see your Tour Manager and security runnin' around like it's a riot… haha! Well, not so funny now 'cause it's really happening and they're pullin' personal items out of my room, dodging flames 'n smoke because Nikki's room is torched! So sad; he lost EVERYTHING but his passport and a few credit cards! Cameras, computer, cell phone, wardrobe, etc! WOW - what a Bday! RED HOT!" The fire didn't seem to phase Sixx in any major way, who trekked onto the Pacific Rim, reporting following the band's headlining set at the Loud Park Festival in Japan, that "We had a bad-ass show in Tokyo and there were a ton of cool bands on the bill."

Heading into the end of the year, the band's tour had been so successful that they quickly announced a proper *'Saints of Los Angeles'* tour, scheduled for the spring of 2009, with bands Hinder, Theory of a Deadman and The Last Vegas supporting the Crue on the road. Vince Neil and Tommy Lee both began work on their respective solo projects, Vince collaborating with Desmond Child on his first new solo studio LP since 1995, while Tommy picked up where he'd left off with Scott Humphrey in 2005 to begin work on the follow-up to his Methods of Mayhem debut almost a decade earlier. Appearing to have mastered Nikki's long-sought after balance of juggling band and individual solo projects in the same time, Tommy Lee underscored the latter achievement by announcing that, based on the success of their first outing, in 2009, "we're gonna do a Crüe Fest 2, and hopefully we're gonna add another stage, which we didn't have on this one. You know, it was the first one. But hopefully we'll have a second stage and more bands too." The band capped their wildly-successful year with another career highlight when, on December 12th, they were nominated for a Grammy Award- the third in their 27 year career- for 'Best Hard Rock Performance' for *'Saints of Los Angeles,'* as well as a nomination for a Billboard Touring Award for Cruefest. Heading into 2009, Nikki's life and times were crazier than ever in a professional context, but personally, he seemed very much at peace amid it all, reasoning in year-end reflection that "the truth is bands run in cycles, and you have highs, and you have lows. And I think that was the beginning of a high. I think that we will be running on full tilt here for a while, because it feels so good."

Chapter 30

 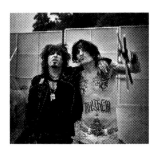

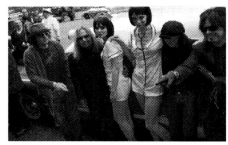

2009 and Beyond…

Nikki Sixx rang in 2009 by signing a new publishing deal with Downtown Music Publishing, wherein the company would handle administration for his entire song catalog, encompassing exclusive synch rights for the Motley Crue master catalog, with company president Justin Kalifowitz announcing that "Through this innovative partnership, Nikki's publishing copyrights and Motley's master recordings will now be marketed and promoted in lock-step. Combined with Eleven Seven's premier roster, we can now offer the licensing community a destination for the best in both iconic and contemporary rock music." Taking a chance on a smaller publishing outfit than his prior administrator, Warner Chappell, Nikki reasoned that signing the deal made sense "in a time of industry consolidation, signing with a boutique publisher who can focus on thousands of songs instead of millions is just smart business." In the same time, back on planet Motley, the band was busy plotting their second

annual Cruefest, with Tommy Lee revealing of the prospective supporting act line-up that "there's offers going around all over the place. We actually talked about that a little. Rob Zombie's name came up. Godsmack. Alice Cooper. I'd like to switch it up, add a little bit more variety this year. I think it'd be fun to inject that."

On February 2nd, Motley Crue hit the road for the second leg of their 'Saints of Los Angeles' tour in San Diego, with Hinder, Theory of a Deadman, and Last Vegas in tow. Seeking as always to keep the road show fresh, Nikki shared of the band's nightly setlist, which on average ran just over 2 hours, that "we're gonna change some songs around. It's exciting to go out and play new songs, break out some songs we haven't played in a while." In the early dates of the tour, the band played back-to-back Friday/Saturday night sold-out shows at the Hard Rock Café's The Joint theatre to maximum 4000 capacity crowds, marking the final concerts the venue would host before it permanently closed its doors. Vince Neil, a Las Vegas resident, shared of the farewell that "there was a tear in my eye when I sang Home Sweet Home at the end. All of us up on stage were a little teary eyed. We'd been told we were specially selected to close it down as the final act, and that felt very special. It was an honour, and as fast as we went through the show, it was suddenly the end. It felt strange that that was it. Before we went on stage, the Hard Rock executives gave each of us a guitar that they'd taken off the walls and mounted on plaques to commemorate the night. They also gave us photographs of all the times we'd played The Joint, so it was pretty sentimental." A few days later, the band's Grammy nomination for 'Best Hard Rock Performance' was lost to category competitor Mars Volta, which inspired good rock 'n' roll sportsman Nikki to comment that "the Mars Volta is one of my fave bands and they do deserve it, 100%, so congrats from me to them."

As the band's tour rolled on, the Crue appeared in perfect harmony, with Vince Neil sharing of their plans for the year that "we're now one year in with nine more to go on our ten-year world tour contract (with LiveNation). I'm loving it. This is the fun part, and it all feels great. The whole second year is planned out. We've got American cities through the end of March. We have April off, which is when I'll return home to Vegas for the Dr. Feelgood (rock club restaurant) opening (in Las Vegas) and get the Rio tattoo shop underway. In May and June, we'll hopscotch Europe before starting the second Crüe Fest here at home for July, August and

September. We get October off for vacation and then return to Europe in November for the missed cities and go back to Australia and Asia in December. It never stops, but we'll be back here for the holidays again. On top of that, I've got my solo record coming out in November." On a particularly sentimental tour stop for Nikki in Cheap Trick's hometown of Rockford, IL, where the band invited guitarist Rick Neilsen on stage to jam for 'Jailhouse Rock' before giving him a ride home in Sixx's tourbus. Thereafter, Nikki stayed into the weehours of the night reminiscing with one of his closer friends from the 1980s heyday, sharing that "I haven't been by his house since 1985 or so, and let's just say, it's a rather foggy memory but this one is burnt into my memory banks with a branding iron. We ended up, for hours and hours, looking at his wonderful guitar collection, and what a collection it is: I played (well sort of, haha) *Jailhouse Rock* on Elvis's acoustic, strummed on John Lennon's and Jimi Hendrix's guitars and a few other insane classics that left me speechless. And last but not least, the many stories of legends long since gone; an amazing night. The heart of this man, the legacy of his music and his band's influence touch me still to this day." Nikki also spent time while on the road during this time working on demos for Sixx A.M.'s follow-up to the Heroin Diaries soundtrack, sharing with fans via his online diary that "I can't really tell you what the concept is, because I think I'd just be kind of blowing the surprise, like telling what you're getting for Christmas before it comes. But it's gonna be a pretty powerful record. You know, sonically it does fall in line with the Heroin Diaries record, but I think we're stretching out in certain ways where we can take in other styles of music and expand upon them."

As February neared its end, Chronological Crue reported that "Mötley Crüe announces they will hit the road again this summer with some of rock's top touring acts for Crüe Fest 2: The White Trash Circus. The Live Nation produced tour will visit thirty cities across North America beginning July 19 in Camden, NJ through September 5 in Darien Lake, NY. Full tour details, including the line up, will be revealed at a major press conference broadcast from FUSE TV studios in New York on March 16, before Mötley Crüe hits the stage at Madison Square Garden that evening. Last summer's multi-artist inaugural Crüe Fest that played for nearly half a million rock fans was the most successful touring rock festival of the summer season. Crüe Fest was also the number ten tour overall for the summer of 2008, according to Rolling Stone. Crüe Fest attracted strategic partners including MTV's Rock Band Game, FUSE Television,

JVC Mobile Electronics, Clear Channel Radio, Best Buy and Fender Guitars, which resulted in a nomination for a 2008 Billboard Award for Concert Marketing & Promotion. Tommy says, 'Last year at Crüe Fest, we set out to have more fun than humans are allowed to have. We succeeded beyond that. This year, we are going to top that and I guarantee we will.'...To celebrate this year's twentieth anniversary of the release of Dr. Feelgood, Mötley plans to theme their Crüe Fest 2 tour with imagery inspired by Dr. Feelgood. Nikki says, 'On this summer's Crüe Fest we really wanted to give the fans something they've never seen before. And since it's the 20th anniversary of the release of *Dr. Feelgood*, we figured what better way to celebrate than to play it live TOP TO BOTTOM every night.' "

The celebration of the Crue's catalog continued in early March with American Idol winner and country music superstar Carrie Underwood's announcement that she had recorded a remake of the band's classic ballad *'Home Sweet Home,'* with Nikki reacting to the news by reporting that "I spoke to Carrie a while ago and she wanted to cover the song, and I was actually going to fly down to Nashville and play bass on it, but it was during the holidays, and I was just spending time with my family. After she cut it we spoke, and she was excited about it. In the end, the thing is, I think we both want to write songs together. She writes pop songs and I think I'm a pop songwriter, however the songs are performed." In a further nod to the song's legacy with pop music audiences, American Idol announced it as the farewell song that would be played weekly as each of the show's 16 final contestants were eliminated leading up the May finale, where the tribute would culminate with Vince Neil joining Underwood on stage for a live duet performance of her re-make of the hit. Underwood shared with fans of her decision to re-record the song that "I've always loved this song, and besides being fitting for 'Idol', to me."

As the band's *'Saints of Los Angeles'* tour rolled on through the middle of March, portions of their live show in Connecticut was filmed for a live broadcast on Jimmy Kimmel Live, including *'White Trash Circus,' 'Don't Go Away Mad (Just Go Away)'*, and *'Same Ole Situation.'* The next day, on the 16th, the band held a midtown Manhattan news conference on Fuse TV to announce their formal line-up for the second annual Cruefest, which the band had decided would feature Godsmack, Theory of a Deadman, and Drowning Pool plus introduce Charm City Devils. At the conference,

Nikki further announced that the band would celebrate the 20th anniversary of 'Dr. Feelgood's release by playing the album top-to-bottom for the first time in as many years, explaining that "we had talked about doing Dr. Feelgood in its entirety…well, we had actually wrestled with that, *Shout at the Devil, Girls, Girls, Girls*, and when we decided on *Feelgood,* it was only after that that we realized it was twenty years. It looks like a big master plan, but it wasn't." As part of the band's media appearances supporting the announcement of Cruefest 2, Nikki appeared on the 17th on Fox New's 'On the Record with Greta Van Sustren', which was filmed live backstage at the band's sold-out show at Madison Square Garden. During the interview, Nikki shared with Greta that "Cruefest starts in July. It will be our second one. And this is the end of the Saints of Los Angeles tour ending here, well actually, we're ending in Maine. But we feel like this is the grand finale at the Garden."

In a testament to the band's indomitable popularity, and combating the notion that the recession made such grand tour plans seem non-sensible financially, Nikki reasoned that while "Albums sales are down. People aren't buying books, they're not buying merchandise, they're not going to concerts…we believe that if you give real quality, you really care about what you're doing, people, they're looking for something…They just

cancelled Ozzfest this year. And people were asking us, and we're going out with our second Cruefest, but we're not seeing the numbers be affected, but we're also doing it a little different. We don't have three stages. We have one stage. We might be adding a second stage…The thing is, with a Motley Crue, what our fans know is that we try to keep the ticket prices down and we try to keep the pyro and the volume up…We really work on the numbers so it works right. We are just not throwing good money after bad money. We are really trying to make it right so we keep the ticket prices down. And it is a lot of work, it's a lot of responsibility for four guys who didn't go to high school…So, a lot of times, we do not put as much money in our pocket as people would think, because we choose to invest in our career. We choose to invest in doing this -- we have been doing this for 27 years. It must work. We always give back. We always give as much as we can to the show. We're always 150 percent with our energy and our time. And people keep coming."

The band wound up the second leg of their 'Saints of Los Angeles' concert tour on the 18th of March in Portland, and began April with the release of their 2-DVD of 'Cruefest' 2008, filmed in Toronto at the Molson Amphitheater on 28 August 2008 by director P.R. Brown, debuting at # 2 on the Billboard's Top Music Video Chart, selling in excess of in its first week of sales. Checking in with fans via his online diary on break from the road, Nikki shared with fans of his off-road goings-on that "the one difference on a creative level from touring is having my creative workspace to build the impossible. I always love when I can pull outta thin air a song, book, design, etc. but mostly lately it's been all about my photography. I've done about six full shoots and six smaller still-life shoots as well. I've displayed some of it on my MySpace under Nikki Sixx Photography, but it by no means comes even close to what I have created or have plans for as a photographer…The new songs for Sixx: A.M. are all so inspiring; it feels like we may have topped ourselves on this album coming up, and can't wait for you to hear what it sounds like. Keep an ear and an eyeball here and maybe a surprise might get dropped in the next few months." During the May portion of their break from the road, Crue kept busy with a guest appearance on the season finale of Fox's 'Bones', performing 'Dr. Feelgood' to a viewing audience of 11.3 million viewers.

Nikki and company hit the road again in late May, kicking off the European leg of their *Saints of Los Angeles* tour in Moscow, their first since the Moscow Peace Festival 20 years earlier, thereafter hitting European territories including Scandinavia, Germany and Bulgaria among other more traditional spots including London and Paris. As the tour wrapped in early July, Nikki shared via a July 2nd diary entry with fans that "we're back from Europe. We played to a ton of new Crueheads and saw some beautiful new places. A big Thank you to all the fans who came out to see us live. We had a blast.I am enjoying some down time before our American shows. See ya all soon, Nikki." The band spent the first half of July in rehearsals for their second annual Cruefest kickoff on July 19th, sharing with fans in a diary entry preceding the tour's start via another online diary entry to fans that "(I) drug my tired ass back from production rehearsal day 3.The set is insane. All new stage. All new lighting, pyro and video. Tons of new music. Some of these songs have never been played live before so were still blowing off the cobwebs .To honest it sounds pretty damn good. This is my fav set so far and feels so good be doing something new production wise. I can't wait to see your faces when the show starts…its pretty sick, beginning to end…I have to say, this show really is a labor of love for us but the real credit goes to all the crew. They have been working around the

clock for over a month on this. That is the part fans don't see. It doesn't matter if it's a Broadway play, a rock show or even a movie. Sometimes the real stars of the show are behind the curtain. Thank you guys, so much."

A few days later, Nikki and company hit the road yet again in response to fan demand for the band's Cruefest 2, with Rolling Stone Magazine reporting in a review of the tour's kick-off that "Motley Crue gave a loud-and-lewd commentary on health care reform in Camden, New Jersey, Sunday night when they kicked off the opening night of Crüe Fest 2 with a start-to-finish run through *Dr. Feelgood* to mark the six-million-selling album's 20th anniversary. Capping a daylong loud-fest of heaviosity from Godsmack, Theory of a Dead Man, Drowning Pool and the Charm City Devils, the Crüe's set commenced with spectacle of a sexy nurse pushing some poor soul in a wheelchair across the lip of the stage in front of a black curtain... She then proceeded to inject the patient with a syringe the size of a rowboat oar, and after a piercing scream the curtain fell away to reveal the Crüe blaring the opening chords of *Dr. Feelgood*'s title track from inside a bright white, stobe-flashed padded cell, dressed in white lab coats. After capping 'Slice Of Your Pie' with the coda of the Beatles' 'She's So Heavy,' the padded cell gave way to reveal a giant, two-story tiled wall backdrop - shades of Pink Floyd's *The Wall* - tinted surgical scrubs green. The stage design was no doubt intended to mirror the album's underlining theme of waking up from a nightmarish sickness (remember, *Dr. Feelgood* was the notoriously hard-partying Crüe's post-rehab album), it also served as a not so subtle reminder that we are all trapped inside an oppressive and dysfunctional health care system. Hold you in our wheelchair you can feel our disease, indeed. Buttressed by a shapely pair of back-up singers in thigh-highs and dominatrix-corsets, the Crüe looked hale and healthy, with Vince Neil rocking white leather chaps, Nikki Sixx sporting a pair of shit-kicking frankenboots, Mick Mars donning his trademark black Zorro hat and Tommy Lee, as per usual, shirtless and graffiti-ed with tattoos. After the B.S.-detecting of 'Same Ol' Situation (S.O.S.),' Lee came out from behind the drum kit to address the crowd ('What's up, fuckin' bitches?!?') and pump them up for the rest of the set ('We got titties!') before returning to the drums to do what he does best, i.e. beat on things. Mötley Crüe rounded out *Dr. Feelgood*'s trifecta of hits with '*Kick Start My Heart*' and '*Don't Go Away Mad (Just Go Away),*' dug up metallic nuggets like '*Shout At The Devil*' and a pyro-blasted '*Live Wire*' and then closed out Crüe Fest 2

with a lighter-riffic *'Home Sweet Home'* and a righteous romp through *'Girls, Girls, Girls,'* their riotous ode to the pole-workers of America."

Following the smashing success of the debut of Cruefest II, Nikki offered fans via his online diary an inside look into just how much work was invested in getting the tour off the ground by revealing that "opening night was a week long for us and the crew. Working, re- working, building and re-building so when the lights finally went down we were all so in sync. I knew the crew was tired but I could see how proud they were at the same time. 95% of everything went off fantastic, and for a first show that's amazing. It really took a lot of people to make it run that smoothly…so I want to thank 'Everybody' in Camden and Philly for busting ass including all the other bands on Crue Fest 2. What made me and the guys smile was hearing reports that fans were having a great time at the main stage and the Monster Energy stage, all day and night long. Now the Circus begins, the trucks are rolling, the show's begun. This tour lasts till beginning of September. After that, some shows in Canada and maybe go back to Europe for selected arena dates, but besides that were pulling off the road till summer of 2011. On a side note, just so you all know what we go thru daily with press. It's always a struggle to get what YOU have to say and not what THEY want you to say in the press. This is nothing new, but check this clown out. I did an interview with the Wall Street Journal, you would think they would be smart enuff not to hire a stupid writer for such a reputable newspaper. I agreed to do the interview because it was supposed to be a piece on 'The Business of Crüe Fest 2' and I'm really proud of what we've created and the way we are able to offer a full day rock experience for the fans for the price of one Mötley show. None the less, he kept asking lame question after lame question, I keep directing him to what were doing right now and what the interview was really about, which at that moment was about working on a huge production, top to bottom, putting together a huge festival for rock fans and making sure all 10 bands on tour were happy and getting what they needed. I also told him were trying to keep details of the production we were about to launch quiet so opening night is just that for the fans, like opening a X-Mas present. Somehow, the interview got into talking about Twitter and I explain to him my thoughts and OVER exposure through TOO much info on the net…Of course he turns it around that 'I hate the internet' and you just scratch your head and wonder: why would a guy do that? Worse, why would The Wall Street Journal hire someone with such a small brain?

Motley was one of the first to use the internet to get information to fans, using downloads (free and paid for) to get our music around the world, to offer exclusive content to our fans, etc, etc…Before music players became popular we were the first band to endorse one called Real Player (which became Rhapsody), so it doesn't sound like we hate the internet… But we do hate doing press with people who twist the story to make a gossipy headline to make themselves look like they have the inside track at the expense of the fans and the artist? Maybe you wanna ask the writer yourself what his problem is. (kamauhigh@yahoo.com)…The essence of the point I was making (as I spoke on my iPhone with all of its new cool apps) is that there are elements of the internet that I think are not cool – like why do people need to know where someone is at the moment or what they are thinking that second – on Twitter? I'm off to go do emails and to get this up on my MySpace page (strange for a guy who the Wall Street Journal says 'hates the internet'). I wanted to check in and let you know that we had a Blast last night in Camden and look forward to seeing all of you, at the shows or on the internet..hahhaha.. Love and Padded cells, Nikki…"

Conclusion

"Isn't music soothing? Its kinda like being in a cocoon with just a razorblade and a memory…I live music. I hear it in my sleep, its always there…since I was just a lad. It possessed me." - Nikki Sixx

A Star in Rock 'N' Roll's Sky…

Ultimately, Nikki Sixx will be remembered for shaping his own brand of rock, writing and re-writing the rulebook on how to break every one in the context of conventional anything the record business had seen before Motley Crue took the Hollywood scene by storm, inspiring Billboard Magazine to conclude as a result that "Mötley Crüe were one of the most influential hair metal bands of the '80s, boasting a striking visual presence and hedonistic reputation rivaled only by Guns N' Roses. By combining

Alice Cooper's shock rock with the bluesy, metallic stomp of the New York Dolls and Aerosmith, they helped establish hair metal as a commercial genre." Rolling Stone Magazine, meanwhile, has honored Motley Crue for the fact that they "parlayed whip-lash hard-rock songs, melodic power ballads and a hedonistic image into platinum-level heavy-metal superstardom," further celebrating the band's legacy coming full circle by noting that "all four members of Mötley Crüe convened in 2008 to record *Saints of Los Angeles*...The title track holds the honor of being the first single to be debuted in the influential *Rock Band* video game series, and the album debuted at Number Four."

Amazingly, the band's full potential was almost never realized, with Nikki sharing following the band's initial break-up in 2001 that "the one mistake I made was letting this go. I think we were on a roll; we had a lot of attention and we could've kept their attention. We blew an opportunity that not many people get. The high point was that we continuously changed our look, our logo and our sound. We never repeated ourselves." His role in resurrecting Motley Crue in 2004 was also pivotal, which legendary record producer Bob Rock attributed to the fact that "Nikki is definitely the leader of the band, but I would also say the guy he works with if he wants to work on something solid is to work with Mars. When he wants to work on the energy of the music its Tommy. Tommy's the guy who, left to his own devices, Motley would be the most esoteric and muso kind of band, and if it was Mick Mars, it would be almost too rootsy and bluesy, so I think Nikki is the wildness factor in all of it, he's the blood of it. But those other guys, working with Nikki- this is the great thing about bands- it's the combination of the three of them that gives Motley its sound. And realistically, when any of those three components are missing, it just doesn't work. Much like Vince, Vince is the sound of Motley Crue, and Vince works with Motley Crue, and not necessarily without Motley Crue. And I'm not sure the other guys work without Vince. Its just, whatever they do, they do it well together. To me, the life blood and driving force of Motley Crue is Nikki Sixx. I think Tommy, Vince and Mick make that work into a functioning kind of band, and bring all those other elements to make it work. But the lifeblood is definitely Nikki, and as of late, Nikki has done his best to reign everybody in to get them to work."

For fans, above all else, Nikki will be remembered always as the lost boys' poet; the rebel's advocate; the songwriter who didn't just pass by

smash alley and write about its in the name of social conscience, but who actually understood its composition, breathed in its desperate filth and lived among its glorious vermin; who rose out of Hollywood's gutters through rock 'n' roll as a street kid who did good, but never forgot where he came from. Nikki was always able to keep an extremely accurate finger on the pulse of the disenfranchised because their struggle was a reflection of his own internally. In that vein, he was able to speak for a generation through his music, ultimately to a much broader audience then any one tortured child could ever pray for, such that his loyalty to, and ability to authentically speak for, the underdog has become legendary.

As a result, many music historians, including long time Sixx confidant and renowned rock journalist Lonn Friend, predict that "Nikki Sixx will be remembered as having one of the great, loud, tortured decadent pens of any songwriter of the heavy metal era. It is a tortured pen too, because any lyric that is born of addiction and self examination, and inner turmoil, and lost love, and wasted years and wasted blood cells, that's the compost of great songwriting… I think Nikki's driven by his need to perform and his need to exercise his demons through his music…I think that Nikki Sixx was able to write the screenplay of a decadent time in a period of Los Angeles that transcended the city into like a greater Rock N Roll Universe." Legendary producer and A&R man Tom Werman has summarized the crux of Nikki's influence as being largely a result of his gift for ground-breaking songwriting which bred a new kind of brutal honesty in what was top-40 music at the time, which made him "one of the leaders. I think he paved the way for a lot of people to be very graphic while being poppy, not to feel that in order to be good songwriters, they had to couch their thoughts in musical phrases. At the time, you had not heard songs like Nikki's. Nikki was a real pioneer."

A central component to Nikki's professional success has been his equal personally commitment to sobriety, which Bob Timmons rationalizes as principally possible by the fact that "he has been in recovery for some period of time now, and…just that he's really committed to his recovery, and staying clean for himself and his family." Like many a legend of pop culture decadence before him- Johnny Thunders, Ian Hunter, William S. Burroughs, or perhaps Jim Morrison- Nikki Sixx rode the snake, as a Hollywood runaway all the way to worldwide fame, giving fans an education in rebellion along the way. To purge his demons he first had to

party with them, and though he sacrificed a part of his life along that path, what Nikki Sixx hollowed in the way of the past has ultimately allowed him his future, and the chance to shine eternally among the brightest stars in rock n roll's sky...

Author Bio

Nashville-based music biographer Jake Brown has had twenty-four books published to date, including 'Rick Rubin: In the Studio;' 'Heart: in the Studio' (Authorized, co-written with Ann and Nancy Wilson); 'Motorhead: in the Studio' (Authorized, co-written with Lemmy Kilmister); Dr. Dre: In the Studio'; 'Meat Puppets: in the Studio' (Authorized, co-written with Curt and Cris Kirkwood); 'Suge Knight: The Rise, Fall and Rise of Death Row Records'; '50 Cent: No Holds Barred'; 'Biggie Smalls: Ready to Die', 'Tupac: In the Studio' (authorized by the estate), as well as titles on Kanye West, R. Kelly, Jay Z, the Black Eyed Peas, 'AC/DC: in the Studio' (Due, Sept., 2010); 'Red Hot Chili Peppers: In the Studio'; 'Alice in Chains: In the Studio', 'Jane's Addiction: in the Studio' (Due, Oct. 2010); 'Tori Amos: in the Studio', (Due June, 2011)'; Tracii Guns' authorized memoir (Due, summer 2011); and the Behind the Boards Rock Producers Anthology Series. Brown was also a featured author in Rick James' recently published autobiography, Memoirs of Rick James: Confessions of a Super Freak, and co-author of 'What the Hell Was I Thinking?!! Confessions of the World's Most Controversial Sex Symbol- An Authorized Autobiography, by Jasmin St. Claire w/Jake Brown'; and in February 2008, appeared as the official biographer of record on Fuse TV's Live Through This: Nikki Sixx TV special. Brown has received additional press in national publications including USA TODAY, MTV.com, The New York Post, Vibe, NPR, TV Guide, Billboard Magazine, Revolver Magazine, and Publishers Weekly. Brown was recently nominated alongside Lemmy Kilmister for the 2010 Nominee for 2010 Association for Recorded Sound Collections Awards in category of category of Excellence in Historical Recorded Sound Research. Brown is also owner of the hard rock label Versailles Records, distributed nationally by Big Daddy Music/MVD Distribution, celebrating its 10th anniversary in business this year.

Bonus 2-CD Sampler
(Featuring Music Inspired by the songs of Nikki Sixx)

Select Band Bios/Pictures:

ENDALL

Mike Vittoria-Vocals
Gareth Shihadeh-Guitars
Charlie Marotta-Bass Guitar
Chris Shea-Drums

Formed in 2007, Endall recently came off playing the Bamboozle festival at Giants Stadium last May, headlined by No Doubt and Fall Out Boy. Along with playing multiple shows in NJ, NY, SI, and PA, they have recorded numerous demos and have just finished a 5 song EP of their strongest material to date. They took part last February in the 13th annual Millennium Music Confrence in Harrisburg, PA as well. Endall combines hard rocking grooves and in-depth lyric writing. Endall's live show is full of unbound energy and passion. myspace.com/endallnj

Brake Vegas

Brake Vegas resides deep in the Heart of Texas and have set out to conquer the world with nothing but the most in your face, raw, rock n' roll. Starting in late 2009, they have already recorded their first cd together entitled "Strap Up EP", have done a nationwide tour and set attendance records across Texas. These boys are ready to leave the stables of Texas behind them to pursue life on the open road with unbreakable wills and uncrushable dreams. This anthemic brand of rock' n' roll is sure to light the fire inside every dormant rock enthusiasts. Visit them at: www.myspace.com/brakevegas or brakevegas@gmail.com

Dark Star Revolt

song title: America

Are you happy with Your America? Corrupt government officials, political payoffs, high taxes, high gas prices, expensive health care, freedom with their exceptions...This is NOT the America we grew up with. Let Dark Star Revolt take you to a NEW AMERICA! Dark Star Revolt is a politically and sexually charged 4-piece rock band founded in 2006. An infectious blend of heavy, melodic, and the rythmic rock defines our sound and makes us who we are, masters of the stage. We are the truth bringers: the walls of deceit and false propoganda are exposed and torn down, and a NEW AMERICA is revealed. http://www.myspace.com/darkstarrevolt or http://www.DarkStarRevolt.com

Stalled formerly was a rock band from Dallas, Texas, whose members are now in bands Inside of Eden, Page 9 and Say Our Goodbyes. The bands' web sites are www.myspace.com/stalledmusic, www.myspace.com/page9 and www.myspace.com/sayourgoodbyes. Stalled won the Virgin Megastores National Battle of the Bands and the opportunity to meet with Virgin executives and representatives of Immergent Records in Los Angeles. The band was a finalist in the NAMM Texas School Jam Battle of the Bands and the North Texas Battle of the Bands sponsored by the University of North Texas, the Texas Music Project and the John Lennon Educational Tour Bus.

Revmatic

REVMATIC consists of Nathan Yetter on Vocals and Guitar, Jay Hopkins on Guitar, Keith Daigle on Bass and Rob Baker on Drums. In 2008 they released their third album entitled "Cold Blooded Demon". The Heavy Metal Addiction website review said that the band is "High energy, raw, in your face, modern Heavy Metal & Hard Rock that you could hear on today's Rock radio". A review from Keith Bergman of Blabbermouth.com said, "REVMATIC are definitely on their way to great things, and they're something the world needs more of…a radio-friendly hard rock band that doesn't forget their balls, or their distortion pedals, on the way to the studio." Revmatic MYSPACE: www.myspace.com/revmatic or info@revmatic.com

Unkle Skelly

UNKLE SKELLY- Vincent Furnier is to Alice Cooper, James Osterberg is to Iggy Pop and Brian Warner is to Marilyn Manson as this mysterian is to Unkle Skelly. Born and raised in small town Ontario, Canada, just minutes from the Detroit Rock City Border where he would go see all of his heroes live in the flesh. The proximity to the Detroit border is no shocker, given the primal rock 'n roll energy on such tracks as "Death Trip," "Crop Circle Disco" and "B33920," the latter a full throttle tilt to one of his heroes, Charlie Manson. All these songs and more can be heard on "The Unkle Skelly Project," and on myspace. By the end of 2010, a new batch of tunes and some more shows with or without his performing band the Dented Halos is what is on the horizon for Skelly. www.myspace.com/ thecrazyworldofunkleskelly e-mail Unkle Skelly at halo_central@hotmail.com

Strikeforce

Strikeforce- are you ready" c+p 2009 stoneface music (ascap) *music by jackson *lyrics by jackson,nasty strikeforce is : band line up *duke jackson- lead guitar *jim burdette - drums * *timex -vocals *joe council-bass produced by duke jackson at 420 studios in st.louis, mo. strikeforce

has toured with the biggest names in rock-dokken, michael schenker, joan jett, 38.special, steelheart, night ranger, ratt, to many to mention! strikeforce has played clubs,arenas,and festivals all over the u.s.a. including rocklahoma, america biggest metal/rockfest! strikeforce is currently recording a new cd, and plan on playing as many shows as possible to keep the metal moving!

Warmachine

Hailing from Toronto, Canada, WARMACHINE is a promising, young four-piece hard rock/metal band. Their music consists of incorporating classic heavy metal influenced riffs, intertwining them with tasteful, catchy dual guitar melodies and harmonies, along with exceptional soloing and soaring vocals.

In late 2004 the band entered the studio to record their debut album, which was co-produced by Murray Daigle & David Ellefson (ex-MEGADETH). "The Beginning of the End" debuted in Feb. 2006 via Nightmare Records, and was an extremely successful release.

WARMACHINE's second full length album "Left for Dead", will be released in late September 2009. Contact:www.warmachineonline.com or www.myspace.com/warmachine/

I Me Mine

I Me Mine is from Phoenix, Arizona. Their first album called "Death and Taxes" came out in 2007 and their second in 2009 named "Beyond the Body Electric". Andy and Cyd draw from their rock and blues roots to create a rich layered guitar sound. John & Jeff make up the rhythm section infusing the songs with classic "in your face" rhythms. Mary energizes the songs with well-balanced melodies and evocative lyrics. I Me Mine's goal is to write unique and meaningful songs and to perform them with positive energy and style. Check them out at www.myspace.com/imemineband.

Pillow Theory

Pillow Theory is a NYC quartet who delivers a high-powered dynamic sound while successfully genre hopping under the modern rock umbrella (metal, punk, pop, free jazz). ROLLINGSTONE.com described this group's sound as "introspective groovalicious pop rock"! The band released their sophomore album OUTPATIENCE (available on iTunes), recorded by Steve Albini (Nirvana, Pixies, NIN). With Albini, they were able to manipulate their ever-changing moods to blend a sporadic yet cohesive sound. The album displays a delicate balance between heavy and light with change ups that may seem bizarre on paper, but work eloquently in sound. www.myspace.com/pillowtheory or pillowtheory@yahoo.com

Afterlife

Formed in 08 the band Afterlife consist of five very different personalities. After undergoing several lineup changes all the pieces came together with Sam Keys (Bass guitar&vocals), Jason Miller (Lead guitar), Adrian Thompson(guitar), Doug Jones(Drums) and Andrew Staley(Lead Vocals). With the intent on taking the listener on a journey Afterlife thrive on the craft of songwriting. Heavy Vocals, Shredding Guitars a Thunderous Bass and Blistering Drums combined with a unique stage presence the Afterlife is for real and is here to stay. WHERE WILL YOU GO WHEN YOU DIE??? www.myspace.com/afterlife6

2 Ft. Whore

2 Ft. Whore- The band was formed in 2007 by Greg Wilson. Initially, Wilson had begun discussions of forming a Metal Band in the Baltimore, Maryland area. In February 2008 and after some lineup changes, he completed the lineup. Greg Wilson/Lead Singer, Mark Roby/Singer, Baron Springfield/Bassist, Patrick Liberatore/

Drums, Brad Holbrook/Guitarist.

The band sends a theatrical flare to the stage with some wild twists while performing. 2Ft. Whore entered Orion Sound Studio, Baltimore Md. in March 2008. They completed a 5 song Demo that received positive reviews. In 2008, the band toured between Pennsylvania, Delaware and Maryland completing 15 shows. They've written 11 songs and continue to write music.

Sonic Rebellion

Andy Smith: Vocals
Lefty Ali: Guitar
Dustin Smith: Bass
Sean Pokress: Drums

Wet Coma has ignited the music scene in the bars of New York City where they have honed a combustive sound reminiscent of 1970's riff-based hard rock. Blistering guitar, swankily anchored bass lines, cataclysmic drums and lyrically taut shotgun vocals combine to energize the listener. They have completed their debut album which was mastered at Sterling Sound Studios in Manhattan. Music has also been featured in two films and an off-Broadway play, played regularly on a few radio spots like westsidewill., Reddog radio and Juniors Cave.

Art Flesh Gordon
Art Flesh Gordon- guitarist/ singer/ songwriter/soundtrack artist. I was born to deaf parents in Long Island New York raised in New Jersey. Music has always been a big part of my life. My early influences were Black Sabbath/Deep Purple/Uriah Heep/Bowie etc.. Later on i became a metal head-Motley Crue/ Loudness/ Scorpions etc.. At the age of 13 i got my first guitar a Les Paul copy.

I'm a self taught guitarist i basically trained my ear picking songs off records. I played in a few kickass bands most notably a band called Matriarch. We did a song on the L'Amour Rocks compilation disc "Red Dawn" on Mercenary Records same label as the Goo Goo Dolls at the time. The disc was made to celebrate the sixth year anniversary of Brooklyn's world famous rock club

L'Amour. Bands like Ratt, White Lion, Accept, Wasp, Yngwie Malmsteen, Queensryche, Mettalica and Twisted 'f*cking' Sister started their career in this club. We were a steady headliner there. Currently im a solo artist doing and seeking film soundtracks.

(film music credits) "KILLING HOLLY", "SHADOWS OVER SUGAR", "NIGHTMARE COLLECTION 2", "HOUSE OF PAIN", "CONTROL TOWER" to name a few.. http://www.myspace.com/fleshgordonmusic or artegordon@gmail.com

ShutterStone

"ShutterStone" can best be described as a whirlwind of emotion filled with a flair for the dramatic, Derek Selke. The bands new album "Between Chaos and Confusion" proves to be just that. Featured are eleven tracks that engulf the terms rock, pop and circumstance, and really make the hair stand up on the back of ones neck. Driving rock anthems like "Merry Go Round" and "Makes Me Feel, are mixed with the epic proportions of songs like Light My Way, Anywhere But Here, and the ever so haunting "The End of Everything is Nothing". Catch the band on tour this fall and pick up a copy of their new CD "Between Chaos and Confusion" this September. www.shutterstonemusic.com or www.myspace.com/shutterstone

U.S.A.D. (Urban Search and Destroy)

Started in New Orleans, Lousiana in 2006 by bass player and lead vocalist Joshua A.D., U.S.A.D. was the violent reaction against lame rock music taking itself too seriously. They released a popular music video for their first song "Collar Popper" in 2006 from their debut album "The Recline of Western Civilization". A second video for the tune "Hell's the Kinda Place" followed and was quickly banned from YouTube. The band won Loyola University's Battle of the Bands in 2007, relocated to Chicago in 2008, and now currently resides in Los Angeles, CA.website: www.myspace.com/urbansearchanddestroy

Seventh Hour

Seventh Hour is one of the hottest hard rock/alternative bands today. Based out of the Raleigh, NC area. "Seventh Hour" is comprised of four of rock's most talented musicians. Seventh Hour is the perfect combination of hardwork, dedication, drive, quality talent, stage presence, as well as experience and that's what makes this band work. Between the four band members, they performed throughout the U.S. sharing the stage with some of rock's biggest and most well known acts such as Godsmack, Fuel, Saliva, Chevelle, **Seether**, Hinder, LA Guns, **Stuck Mojo**, Kings X, and more. Check Seventh Hour out at www.myspace.com/seventhhournc.

Judged By Twelve

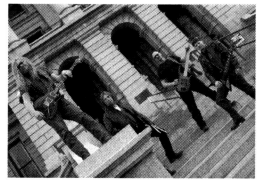

Judged By Twelve- Forged in the wasteland better known as Denver, Colorado, Judged By Twelve is ripping their way into the metal scene with their debut LP, "*Divine Justice*". This compilation of wailing vocals, ripping guitars, grooving rhythms and solid bass, blend the elements together to concoct a release chock full of spine-tingling anthems. With tracks like "*Stand Up!*," the music of Judged By Twelve appeals to metal fans and non-metal fans alike. Judged By Twelve is: right to left: Doug Howard, Dana Heinrich, Andy Squire and Dustin Bowles. Photo by Lisa Siciliano at Dogdazephoto.com. Look for Judged By Twelve to be a major player in the metal landscape in years to come. Contact Email: Doug@judgedby12.com Website: http://www.judgedby12.com

Fire

FIRE is a group of 5 guys with one goal in common, to bring metal back to the streets. Out the ashes of The GraveYard Studios in St. Paul, MN. FIRE has

quickly spread all over the Twin Cities. With lead guitarist and FIRE founder, Michael "NOODLES" De La Rosa, Ty Hall on bass, Tim Bruley on drums, Steve "STRETCH" Prodger on 2nd guitar, and M."LONGHAIR" Annis the Frontman/Power vocalist Completes a line-up that is second to none. We are in the studio now to release New CD this Fall, and ready to take the Cities on Flame! For information e-mail MDelar4666@msn.com and www.myspace.com/noodles1313 for tour dates

Stroke of Midnight

Stroke of Midnight is: Mark Fiutem – Guitars, Marty Martin – Vocals, Freddy Perez – Drums, John Michael - Bass

Stroke of Midnight is an Orlando based metal band that came together in 2008 to turn back the hands of time. We were growing tired of the current music scene, with all the growling "extreme" metal bands & their lack of style & finesse, so we've been working hard to re-invent metal using the influences of classic bands like Motley Crue, Iron Maiden, KISS, Megadeth & King Diamond as a template for our new breed of music. Our new CD is in the works & should be available by November 2009, keep checking our website.
Email: strokeofmidnightband@gmail.com
or MySpace: www.myspace.com/strokeofmidnighttheband

Eat The Skin

Eat The Skin is a new music project inspired by the drama and behavior of the evolving world around us.' Twisted Metal' captures the drama of being

incarcerated and the madness that ensues.' If there's only one thing' reminds us of one of our most basic human needs, love. ' Hot n Leather' takes a close look at the art that is a women's body, while reminding one that sex will never leave rock n roll. Finally, inspired by a short story by Shad Everett from Eat The Skin ' New World Order takes a look into the future of humanity where the new world government has implanted chips in the citizens of the world. myspace: myspace.com/eattheskin email eattheskinband@aol.com

ROB

"ROB" the artist whose name is the acronym for his self titled debut CD "Rise On Belief", an album filled with the influences of legendary rock artists like Jimi Hendrix, Motley Crue, The Rolling Stones, Red Hot Chili Peppers and Lenny Kravitz. His my space is (myspace.com/robhoagland), he also has a EPK on sonicbids (sonicbid.com/rob4) (cdbaby.com/cd/robsounds)

Pou Piam

In the music world of today where teen pop stars reign supreme with unoriginal and uninspiring material, Pou Piam stands as the hard rock antithesis; a tangible and legitimate rock alternative for a new generation. At only 18 years old Pou Piam has created reckless rock music that has garnered rave reviews from listeners and publications from all over the world. If you're looking for loud, aggressive, modern hard rock with a vintage edge, and most importantly, attitude: look no further – Pou Piam is here.

DEK

THE DEAD END KIDZ(DEK) are a 5 piece band that hail from New York. DEK was formed in the mid 1990's. DEK has received favorable reviews in such prestigious magazine's as BILLBOARD and THE VILLAGE VOICE in the US, and other publications World Wide such as BURNN! in Japan. With influences like KISS, Aerosmith, Van Halen, AC/DC, DEK has formed a hard rocking sound

that will satisfy any rock or metal fan. DEK released their second cd titled UNFINISHED BUSINESS(which is now available on iTunes and many other

download sites!). The cd was recorded/co-produced and mixed by MICKY JAMES(known for his work with the CRISS ANGEL show). So, be on the lookout for THE DEAD END KIDZ and remember our motto--if it's too loud.............TOO BAD! email: johnerigo@aol.com
myspace: http://www.myspace.com/dekmusic ,
twitter:http://twitter.com/thedeadendkidz
FaceBook:http://www.facebook.com/pages/THE-DEAD-END-KIDZ/6323764485
itunes:http://itunes.apple.com/WebObjects/MZStore.woa/wa/viewAlbum?id=274622470&s=143441

American Disaster Party

Imagine classic rock & roll dipped in diesel and Katrina-scum, lit up like a cigarette hand-rolled with magnesium shavings. This is American Disaster Party, formed in 2007. Guitarist/ vocalists Johnny Feral & Sean Reynolds, drummer Chris Brooks, and bassist Lamar Williamson began to give voice to the frustration of a city on the brink of collapse with their own brand of shameless, low-slung, dirty rock'n'roll. They've performed for sold-out audiences in New Orleans theatres, at the Cyclecide Bike Rodeo and VoodooFest 2008. The band appeared at VooDooFest 2009.

Email: americandisasterparty@gmail.com;
myspace: myspace.com/americandisasterparty.

Mouthful

Mouthful is a rock band based out of Orange County, CA lead by the Infamous Kitty. The outlaw rockers are heavily influenced by strong female vocalists and hard rock bands such as Pat Benatar, Heart, Joan Jett, Godsmack, Creed, and Metallica. Members of Mouthful have performed extensively together, and participated in various projects over the years in the LA area. Sound quality is a priority and the band exclusively uses Sennheiser, Mesa, Gibson and Tama equipment. Bass player, Chris Schafer, is endorsed by ESP.

"Fist" was recorded and produced by Grammy and Emmy winning producer Dave Jenkins. Currently, Mouthful plans to record a full-length album within the next year.
Contact: www.MouthfulRocks.com, scarlettstarlett@hotmail.com

Wounded Soul

Wounded Soul has created a new sound, a blend of hard edgy rock including honest lyrics, powerful female vocals, and explosive head-banging music.

Launching in 2003 onto the NC music scene, they have opened for major acts, have released a successful debut album, and have a strong web presence on Myspace and Facebook. Wounded Soul will have several songs available for download in the Rock Band 2 video game in early 2010, and have a new album due out soon after. Their adrenaline-pumping shows, audience interaction, and high energy sound provide awesome experiences for those who love live music. Contact them at band@woundedsoul.com
or http://www.woundedsoul.com/

Stealing December

Formed in 2005, Delaware rock band Stealing December enjoyed early success opening for bands like Paramore, Boys Like Girls and Stroke 9, before beating out over 5,000 hopefuls to win the '06 "Zippo Hot Tour" competition. This gave them the opportunity to embark on a 20-date U.S. tour with (Hed) p.e. and multi-platinum recording artists Papa Roach. Upon returning home, the band wrote and recorded its debut CD, "Put it

To Flame," which can be found on sites like iTunes and Napster. For more information, also visit www.stealingdecember.com and www.myspace.com/stealingdecember.

Overloaded

John Sullens- Rhythm Guitar, Michael Massie- Bass, Erik Kluiber- Lead Guitar, Chris Gillen- Vocals, Lorenzo Gonzalez- Drums.

Motley Crue's emergence in the early 80's was a seminal moment in the lives and careers of every member of OverloadeD. Motley Crue's raw style, sound and energy were a major influence on OverloadeD, who quickly became known as one of Detroit's baddest, best, and hardest partying bands. Opening for Motley Crue for their Crue-Year's-Eve Bash in 2005 at The Palace of Auburn Hills was a great honor. www.myspace.com/overloaded

Mongrel

Mongrel is an aggressive punk/rock/metal band on Screaming Ferret Wreckords. Called "the hardest working band in Boston" in Metal Edge Magazine and featured in Revolver Magazine, Mongrel has played with such bands as The Misfits, Korn, GWAR, Fear, Otep, Prong, Dizzy Reed of Gn'R, etc.
Mongrel's 1st full length cd "Fear, Lies & Propaganda" was re-issued in 2008 and their new ep "Revenge" and full length cd "This Means War" will be coming out in late 2009/early 2010. Contact the band at MongrelBand@yahoo.com or visit www.myspace.com/Mongrel for more info.

Mongrel can also be found at www.facebook.com/MongrelBand, www.reverbnation.com/MongrelBand & www.twitter.com/MongrelBand

Space Vacation

Space Vacation is a San Francisco traditional Heavy Metal influenced by the New Wave of British Heavy Metal and Bay Area Thrash. They take pride in playing in standard tuning and provide melodic powerful vocals, to a beat that would give mere mortals heart failure. Space Vacation is comprised of brothers Scott (guitar and

vocals) and Jay (bass) Shapiro and Andrew Headrick (drums). Their debut release, "Space Vacation" can be purchased through iTunes.
Contact: thespacevacation@gmail.com; myspace.com/spacevacation

Black Horse North

BLACK HORSE NORTH based out of Memphis, TN. is a hard rock music ministry dedicated to spreading the good news of our Lord and Savior Jesus Christ. This three piece group comes with the experience of live performing, studio sessions, and most importantly - life. Black Horse North brings forth a

modern sound with a message of hope and healing that is quick and powerful. With Teddie Stutts-Guitar, vocals, Shane Black-Bass, bkg vocals, Chris Peel-Drums you will find three musicians that play all types of venues and dedicated to the cause of delivering positive music with attitude!

Booking: blackhorsenorth@yahoo.com or www.myspace.com/blackhorsenorth

Speedfreak

"Speedfreak is a groove metal band from Chicago. Founding members Memphis (Guitars) and Tommy Kooch (vocals) assembled the band in 2006, and have never

looked back. Rounding out the lineup are Balow (Brewcussion) and Dirty Steve (Bass). The music can be described as a blend of the grooves of Down and 90's Metallica, blended with the fiery lead guitar of Zakk Wylde, and the raunchiness of Motley Crue and Guns 'N' Roses. They are currently recording their debut album, to be released in late 2009 or early 2010. Speedfreak can be reached at speedfreakrock@gmail.com, or at www.myspace.com/speedfreakrock."

Look Afraid

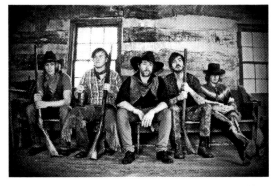

Ohio's Look Afraid have taken the definition of bad-ass to a whole new level with their dangerous and sexy brand of high voltage rock n' roll. After winning $10,000 in an international talent competition hosted by Famecast.com in late 2007, the band have released a string of four EP's, including 2009's Hired Guns. Their intense and unpredictable live show has earned Look Afraid a dedicated legion of "Fraidy Cat" fans, and there's always room for one more. Check out LookAfraid.com for more on these up and coming rock phenoms! www.lookafraid.com

Primary Drive

Drive: To push, propel, or press onward forcibly; urge forward
The word "Drive" describes the band to it's exact definition.
They are outcasts
They are vagabonds
They are boundless
They are insane
They are the sum of the past and the future
They are Rock n Roll
They are Primary Drive

Primary Drive are working on their debut EP to be released Fall 2009. Check them out at www.myspace.com/primarydriveband and www.primarydriveband.com

The New Enemy

Despite having just formed in 2008, Toronto Canada's The New Enemy has already achieved great success on multiple fronts - Touring in Canada and the Unites States, outstanding reviews in magazines and blogs, international radio play and live-

to-air performances, charity events and donations, compilation CD appearances, music videos, countless podcasts, music in a movie trailer seen worldwide, and numerous interviews on radio and in magazines. The New Enemy has played with bands including Agnostic Front, Madball, and SNFU. Following up their debut CD "Outsourced EP", The New Enemy will be releasing their second EP in the Fall of 2009. Learn more at www.myspace.com/thenewenemy

Tranquil Destination

Song 1:Fish Outa Water -
Words,music, electric guitar by: Jared Hannes
Acoustic Guitar: Kenny Haley
Drums: Eric 'Sol' Cooke
Bass Guitar: Duncan Galvin

Song 2: Firefly
Acoustic and Bass Guitar: Kenny Haley
Words and Guitar by: Jared Hannes
Drums: Eric 'Sol" Cooke
Piano: Matt Kebbe
Backing Vocals: Rachel Drake

Recorded at Opal Studios Portland, OR
Produced, engineered, mixed, and mastered By: Kevin Hahn

Cheap Thrill
Danni Trash - Guitar; Kriss Sinn - Drums; Sam Ugly - Bass; Gary Kum - Vocals.

Cheap Thrill is a "Sleazy Gutter Blues" Rock N' Roll band hailing from the industrial wasteland of Eerie, Pa. Their music is a blend of Punk, Rock, and Blues. Their live show is a harmonious display of the perfect trainwreck, filled with chaos, disorder, and emotion.

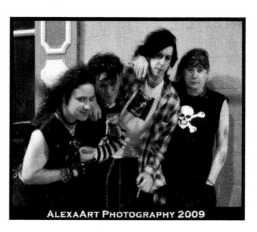

Cheap Thrill's self titled debut E.P. is out now
You can check them out at www.myspace.com/cheapthrillband

Fear The State

Fear The State, a four piece Hard Rock band with roots in metal and punk, have power and force much like a wrecking ball. The guitars are thick, the bass and drums are steady and the vocals are precise. All the members of Fear the State take the words of their song Live Again to heart, grabbing the opportunities and, in turn, the successes that come their way...and successes have come their way. From simple things, like being one of the last bands to take the fabled stage at CBGB's and being voted The Best New Group In Connecticut by the readers of the Hartford Advocate to working with Clint Lowery of Sevendust in his solo project to opening arena shows for acts like Korn & Godsmack. Fear the State strives for bigger and better things always. But that's not what this band is all about. Marc Amendola, Jim Dizm, Neal Pearson and Jeff Sobon would still be Fear the State without all of the success that has come their way for one simple reason...the music.
www.fearthestate.com, www.myspace.com/fearthestate or info@fearthestate.com, booking - (203)589-5033

The Stalking Distance

'The Stalking Distance are a five piece band hailing from the underbelly of Sacramento, CA's rock scene, and taking it by storm, as well as every other town they play. They've been hailed as "the next big thing" to come out of Sacramento behind the great Deftones, and bring a new original sound to the forefront of heavy music. All five members have a uniquely different style they each bring to the band, which has molded this incredible sound that has been characterized as a happy medium between bands like Snot and Avenged Sevenfold. They will be releasing their self-titled second EP in early September which will showcase all brand new songs for the many fans that grow daily, and grow with every show. They pride themselves on bringing every fan an experience they will soon not forget, with a high intensity, adrenaline rushed set that has left other bands they've played with saying, "You guys stole the show." So if you ever find

yourself in need of some aggressive, heavy, fast, melodic punk-metal turn on your radio station, hit the myspace at www.myspace.com/thestalkingdistance, or come see a show. The Stalking Distance is here to stay and looking to make their mark on the world of rock 'n roll.'

Dying Breed

Dying Breed has dominated the Tidewater Virginia indie hard rock scene for more than a decade, working tirelessly to build a large and devoted fan base. Their tenacious work ethic has recently paid dividends in the form of numerous local, regional and national accolades, including recognition in Rolling Stone Magazine and on MTV2. Dying Breed has been privileged to share the stage with hard rock heavyweights KISS, Godsmack, L.A. Guns, Saliva, Fuel and Lynch Mob, just to name a few. The band is now set to break out nationally with their debut CD release, *Dying Breed*. Visit Dying Breed at http://myspace.com/dyingbreedva.

Vertical Reign

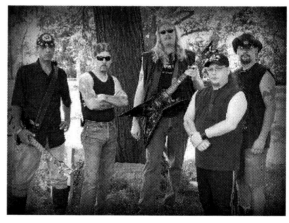

Formed in 2007, Vertical Reign embarked on their rock n roll mission, which has led them far beyond their hometown of Columbus, Ohio. This hard rock outfit pounds out their songs night after night, delivering pure, amped up, straight rock and roll. After releasing their first EP Roll the Dice in 2007, the band quickly went back into the studio to create their second chapter titled Vertical Reign 2008. The shows continue on throughout the state of Ohio and the tunes continue to be heard all over through internet radio. The third CD is in the works and will be released in 2010. Myspace link www.myspace.com/verticalreign, E-mail rad_animal@yahoo.com

SkyScreamers- Can You Hear Me Now?!!
(Written by A. Shuchard/J. Brown/R. Reiter)

Rose Reiter- All lead and Backing Vocals
Alex Schuchard- All lead and rhythm guitars
Jake Brown- Producer, All drums (programmed and live), keyboards, bass, and related instrumentation

Canada-based singer/songwriter and lead vocalist Rose Reiter cannot be stylistically confined to any one genre, with a voice that ranges as broadly across the sonic spectrum of styles as her pallet of influences, which run from Annie Lennox, Peter Gabriel, Sarah McLachlan and Sade all the way to Led Zeppelin, Genesis, Pink Floyd, and Stevie Wonder. Rose has appeared on numerous compilations distributed world-wide, along with solo album releases including 2002's 'What I Don't Get' and 2006's 'REal.' Check her out at www.myspace.com/rosereiter or www.rosereiter.com

NYC-based artist and lead guitarist Alex Schuchard first picked up his dad's Paul Reid Smith at age 11, and has been strumming ever since, bringing an eclectic style of playing that blends alt-and-70's classic rock into a sound that reflects influences ranging from Jane's Addiction and the Pixies all the way to the Rolling Stones and The White Stripes. Schuchard also runs the critically-acclaimed Space B Art Gallery in New York's Chelsea District. Check out his work online at www.spaceb.com

Producer/rhythm keeper Jake Brown, who rounds out the line-up on drums (live and programmed), keyboards, bass and related instrumentation, brings a rock/industrial-electronica hybrid of influences to the project, including Ministry, Beck, Siouxsie and the Banshees, Trent Reznor, Morcheeba, Dr. Dre, the Sugar Cubes, Prince, NIN, Jane's Addiction, Sonic Youth, the Cowboy Junkies, and a host of other influences. As a record producer, Brown's other forthcoming projects

include a star-studded Dr. Dre Tribute LP, the UFOlogy-themed industrial/electronica project 'The Conspiracy Channel' (www.myspace.com/theconspiracychannel), and art-rock/trip hop concept project The Haunted Heads (www.myspace.com/thehauntedheads)

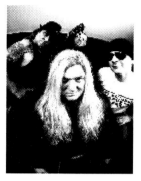

Gate 1 is: TC - vocals and guitars, Nik Blonder - drums, Mike Murphy – bass, Barry Seiver – guitar. Seiver described the band's debut album "Maximum Pumping" as 'modern rock in concept, almost punk in delivery, classic in tone and instrumental application, simplicity in structure, hooky, enjoyable hard rock 'n' roll'. The album is available on iTunes, Rhapsody and other online outlets. Coming from Washington DC area Gate 1 gained strong local following after opening for national touring acts including UFO, Adler's Appetite, King's X, Y&T and Kix at Jaxx Nightclub in Springfield, VA. For more on Gate 1 visit www.gateone.info

Aslut members are Andrew Olson, Glenn Eberhardt, Marty Myers, Justyn Vandyke. If you haven't heard of the band Aslut, you should. After forming in 2008, the band stomped the streets of Tulsa, Oklahoma with a live, very raw, unedited mix of their stick to your guns approach with brutal twists on Hardcore, Punk and Metal. The release of "From Birth to Beast" has enabled the band to reach their fans worldwide through radio airwaves far and wide with standout tracks like "Mob Mentality", "Whiskey and Rice" and "First Act of Violence". The combined musical tastes of the band are extremely wide and the lyrical intentions thus far focus on many political and social issues that have effectively showcased Punk and

Hardcore music at its best. Aslut is currently working on new material for a second album that will combine more of their metal background. Tour dates and the new album are slated for mid summer 2010. We would like to extend a warm thank you and appreciation to A.I.C. for their accomplishments throughout their career. The footprint these guys have made and continue to make in the music industry demands respect. As fans of the band we are delighted to hear that they 're still kickin ass, taken names later and doing what A.I.C. should be doing. To contact Aslut: myspace.com/aslutlive or www.aslutlive.com. Aslut is a DIY band and would like to hear from you. Fans, compilations, zines, interviews, reviews and all in the underground scene.

Loaded Dice www.loaded-dice.com
Roland Edger / lead vocals / guitar
Danny Jones / bass / backing vocals
Daniel Rogers / guitar / backing vocals
Curtis Johnson / drums / percussion / backing vocals

When Loaded Dice released their cd "Back In The Alley" engineered by Dave Pittman at Sound Works Recording for Delinquent Records it quickly became a favorite of rocker fans worldwide and has paved the rock n roll road for Loaded Dice to earned a great deal of exposure. The 11-track cd features ten studio cuts, one live cut and an enhanced video for the title track, produced by Cavalier Pictures best known for the movie "The Sting of the Viper". Loaded Dice has well-written, hard-driving songs from an impressive catalog of releases throughout their career in the music industry , A strong, solid rock n roll band screamin' When The Dice Roll... You're Gonna Rock !!! www.loaded-dice.com

Saints and Saviors - Change is not coming. Change is here. No longer are the days of the packaged band that have been loosely labeled 'rock'. No longer does the public have to listen to the same song in a different key. No longer will they put up with the newest trend at the expense of originality. These are the days when you do it your own way, the way rock was meant to be. We are loud. We are proud. We are Saints and Saviors.
EPK
www.ourstage.com/epk/saintsandsaviors
MYSPACE www.myspace.com/saintsandsaviors

Space Vacation is a San Francisco Traditional Heavy Metal band influenced by the New Wave of British Heavy Metal and Bay Area Thrash. They take pride in playing in standard tuning and provide melodic powerful vocals, to a beat that would give mere mortals heart failure. Space Vacation is comprised of brothers Scott (guitar and vocals) and Jay (bass) Shapiro and Andrew Headrick (drums). Their debut release, "Space Vacation," can be purchased

through iTunes. Visit the band online at www.myspace.com/spacevacation

At the age of six, singer/songwriter, Andrew Santagata received his first guitar and a copy of KISS Alive II, and the rest is history. Fast forward a few years…Andrew has been a member of two semi-regional east coast acts, A Breed Apart and his solo band Santagata. Since joining A Breed Apart in 2003, Andrew has already had the opportunity to play the Locobazooka! festival four years in a row. The first three years, A Breed Apart played the main stage alongside such acts as Alice In Chains, Disturbed, Buckcherry, Shinedown, Saliva, Damageplan (RIP Dime), while playing to crowds of thousands of people with huge response. Then in 2007, Andrew returned to Locobazooka with his new solo band, Santagata, sharing the bill with such acts as Alice Cooper, Heaven and Hell (Black Sabbath with Dio) and Queensryche. At Locobazooka 2007, Santagata released their first CD titled 'A Fire Inside'. All four tracks from this CD were licensed over to Versailles Records for various compilations. Then in 2008 Andrew reunited with A Breed Apart one last time for their third, and Andrew's final release with the band, 'Creates A Scar'. Supporting 'Creates A Scar' included a slot on the Rock The Ink festival with headliners Godsmack. Currently in 2009, Andrew is gearing up for the release of his first ever digital box set entitled "15 Years: The Box - The Good, The Bad and The Ugly", and is also planning to hit the stages this summer with a show that is a little bit different from the last time you saw him, this time he will be performing with his new band Grind Haus (A Tribute to Classic Rock), and he will also be hitting the studio to record some new solo material for release sometime in 2009.

For more on Andrew please visit his official sites @
www.Myspace.com/AndrewSantagataMusic and
www.Soundclick.com/AndrewSantagata
Katet- Keith Gaillard: Vocals, Mike Mavrakos: Guitar & Backing Vocals, Jason Pike: Bass, Bill Melanson: Drums

Katet is comprised of four musicians from Boston, MA with extraordinary chemistry bringing together a variety of influences. As a unit, this band offers tight grooves, strong riffs, and compelling lyrics with an enormous amount of energy live. Their CD "Quantum Journey" was released spring 2009 by Versailles Records with a special guest appearance from Michael Sweet from the bands Stryper & Boston singing backup vocals on the song "Still Forgiven". Katet's song